PAINTING CULTURE

Withdrawn from stock

Dublin Public Libraries

D0320590

P A I N T I N G

The Making of an Aboriginal High Art

Objects / Histories

Critical Perspectives on

Art, Material Culture,

and Representation

A series edited by

Nicholas Thomas

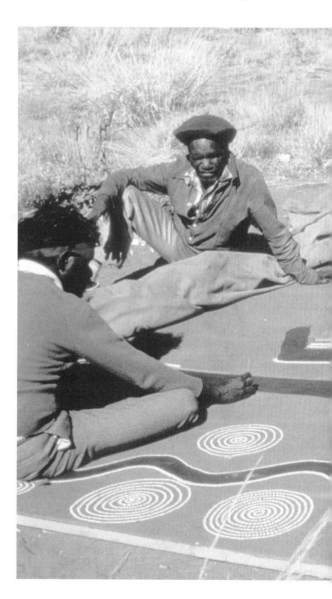

CULTURE
Fred R. Myers

DUKE UNIVERSITY PRESS *Durham and London 2002*

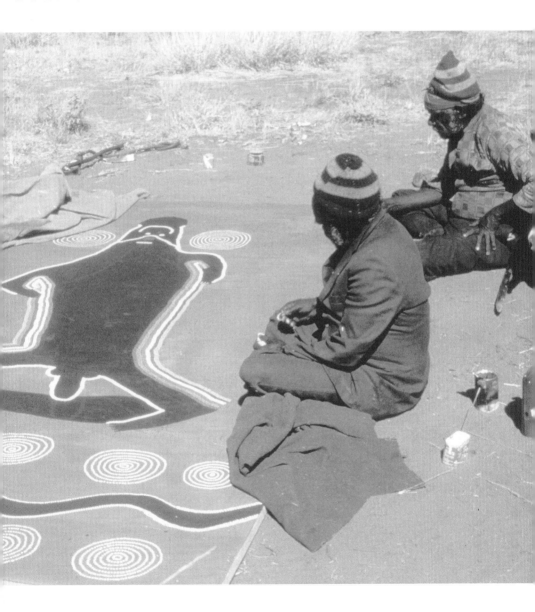

© 2002 Duke University Press

All rights reserved

Printed in the United States of America on acid-free paper ∞

Typeset in Minion by Tseng Information Systems, Inc.

Library of Congress Cataloging-in-Publication Data

appear on the last printed page of this book.

For Faye and Samantha

This book contains images and names of deceased people that may be sensitive to some Aboriginal communities in Central Australia. Please consult with knowledgeable local people before sharing it with members of the community.

Contents

Acknowledgments

This book has been long in the making. I began imagining there was something to say about the circulation of Aboriginal culture in late 1988, having just returned from a period of fieldwork and participating in the Asia Society exhibition *Dreamings: The Art of Aboriginal Australia*. Don Brenneis's invitation to present a lecture at the Society for Cultural Anthropology's 1989 annual meetings crystallized a broader research project concerned with the ways in which Pintupi people were engaging with the universalizing discourses of the West into a paper of more than one hundred pages that I gradually reduced to speakable length. This became the outline of a research project and the present book.

It has been a work of love as well as of loss. So many of the people about whom I write are no longer with us, and through this book and its research, I have been able to reengage with their legacies and our shared histories. The process has allowed me to maintain the "shared identity" with my Pintupi friends (about which I wrote in my earlier monograph) that has partially made up for this loss.

Like many cultural productions, this book owes much to chance convergences and histories that have forced me to make what I call "intercultural space" the focus of my thinking, beyond the everyday life in remote communities. Perhaps I would not have pursued the project so determinedly were it not for the birth of my daughter and the limitations her medical condition placed on my travel abroad. In every way, I owe the existence of this book to Faye Ginsburg's encouragement to write about what I knew and to accept the value of the present. Her own interest in, and insights into, how people make culture inspired me to try something new. Working and living with Faye has deeply changed the way I think. This book is dedicated to Faye and to our daughter, Samantha. It could not be otherwise.

The list of those who have helped make the book possible is very long. First and foremost, my debt is to the Pintupi painters who welcomed me into their painting camps and entrusted me with their stories, their memories, and their

images. Among the many who helped, in particular, I wish to acknowledge Shorty Lungkarta Tjungurrayi, Freddy West Tjakamarra, Yanyatjarri Tjakamarra, Charley Tjaruru Tjungurrayi, and Wuta Wuta Tjangala for their friendship and help. Although they have now all died, I hope I am able to help carry their messages just a little further.

My thanks to the art coordinators who have shared their knowledge and stories and food with me over the years, as well as life in the bush, and whose work has been so devoted to the development of Aboriginal art. Peter Fannin, Dick Kimber, John Kean, Andrew Crocker, Daphne Williams, Felicity Wright, Christine Lennard, and Paul Sweeney have been friends and supporters as well as informants. A special word of thanks to Dick and to Daphne, who have shared their yarns, their humor, and their knowledge of the people of Central Australia with me for over a quarter of a century as Alice Springs became the "cosmopolitan" place it now is.

Other participants in the making of Aboriginal art have also been generous. Special thanks to Anthony Wallis and Robert Edwards in Australia and Andrew Pekarik in New York for all their help and their openness to my questions. A number of participants in the world of Aboriginal art have also been helpful. I thank Anthony Burke, Margaret Carnegie, Rodney Gooch, Christopher Hodges, Gabrielle Pizzi, and Roslyn Premont.

I am equally indebted to a particular community of scholars with whom I have shared a life of research and writing. Françoise Dussart, Peter Sutton, and Christopher Anderson all generously included me in the Asia Society exhibition and assisted my subsequent research into Aboriginal art worlds. Françoise and Peter read chapters of this manuscript and generously provided me with their interpretations of events. I thank Françoise especially for including me so graciously in studying the French exhibition of Aboriginal art and also for her extraordinary understanding of Aboriginal painting. Nic Peterson and Jon Altman each helped me with an understanding of the history of the Aboriginal arts and crafts industry, and I thank them for encouraging me in research that they might just as well have done themselves. As guides to the problems of indigeneity in Australia for nearly thirty years, Jeremy Beckett and Annette Hamilton have given me a platform on which to build. For their friendship and their interventions on my behalf, I am enduringly grateful. Mike Niblett's research assistance in scouring the Australia Council archives was invaluable. Thanks to Vivien Johnson for her reading of an early draft of the manuscript and her helpful suggestions, and to Toby Miller and Terry Smith for their guidance through the mysteries of Australian political culture and art. Nicholas Thomas invited me to a conference in which I crystallized many of the ideas that underlie this book, and he gave a thoughtful reading of the book manu-

script. Finally, I thank Howard Morphy for his prodigious effort in reading this manuscript more than once and offering crucial editorial suggestions. Howard's support of my transformation into an area he pioneered has been remarkable and typically generous.

Over the years, an ongoing dialogue with my friend George Marcus has been central to the trajectory of this work. This resulted initially in our jointly edited book *The Traffic in Culture* and has extended beyond that into the question of what kinds of subjects and sites should make up a contemporary anthropology. My conversations with him have encouraged me to think that this book has something to offer the future, not just as an example of a multisited ethnography, but because it tracks the "complicity" that brings anthropologists, their disciplines, and their subjects together in changing ways.

That my friend Bobby West and I should have been able to come together in Sydney in 2000 to see his father's painting and those of his elder relatives receiving national recognition is a sign of such changes that mark the transformation of our field and of the worlds of indigenous people. It has been my extraordinary good fortune to know Pintupi people over such a historically significant period. I have learned so much more from them than I can say. They have given me an opportunity to learn from others as the painters—through their paintings and their other projects—entered into a broader set of relationships of indigenous activity in Australia, as in the exhibition in Sydney, curated by Hetti Perkins, whose own father had been taken away from his Aboriginal family to be educated. Hetti's invitation to participate in the project celebrating Papunya Tula painting, and her editorial advice on my essay for their catalog, have made me realize the positive prospects that can exist for indigenous cultural futures and for overcoming what Marcia Langton has called Australia's "culture wars." These new alignments represent the future for indigenous people in Australia, and Western Desert acrylic painting is part of the story. It is my deepest hope that this book will be part of their history and part of a history that indigenous people in Australia will want to have. For them, who have given me so much, I hope this might be a gift worth the waiting.

For their gifts to this prestation, I thank Joan O'Donnell for her herculean labors in helping shave the manuscript to size, to Meg McLagan and Maggie Fishman for their work in transcribing interviews, and to Jessica Winegar for her editorial assistance.

Prologue

In the chilly winter morning on the outskirts of Papunya Aboriginal community, an older Aboriginal man wearing a frayed suit jacket and the locally popular knitted cap sits cross-legged on the desert ground next to a ten-by-twelve-foot stretched canvas, brush in hand. Wuta Wuta Tjangala chats animatedly with the men who are helping him paint this work. Some of their names are familiar now to those who follow Western Desert Aboriginal painting — Timmy Payungu, Yala Yala Gibbs — but they have joined Wuta Wuta as part of the everyday sociability that takes place around the activity of painting. Wuta Wuta expects that this painting, a commission, will bring him the motorcar he wants — preferably a four-wheel-drive Toyota Landcruiser — to visit his home country west of Papunya. Yumari (Mother-in-Law Place) is the subject of several paintings by Wuta Wuta, a subject identified with him in the Pintupi community.

Wuta Wuta wants to take his sons back to live west of Papunya, and he hopes the Australian government will support their move with medical assistance, a water bore (a well drilled to reach subsurface water), and transportation. He wants to take his sons "so they won't drink and die," referring to the ravages of alcohol abuse in Aboriginal communities. Like many Pintupi living at Papunya, he is concerned to "look after" his country out to the west, fearing that an oil company might sneak in without permission and steal its "gold" — its value, its sacred sites — or "touch" its dangerous places.

In the Australian winter of 1981, on 17 July, this home country is more than a subject of nostalgia. There is a good deal of talk of moving west. People are "getting jealous about country," Wuta Wuta and his friend Pinta Pinta declare, and this may cause trouble. Papunya is not Pintupi country. While Wuta Wuta is completing his masterpiece, *Yumari 1981*, tense meetings are taking place between the Pintupi and other Papunya residents. When the Pintupi meet with Department of Aboriginal Affairs representatives to discuss their desire to split off from the rest of Papunya and move out west (Myers 1986a), they do so at this painting place.

The younger and somewhat more secular men engage in their meeting, while Wuta Wuta is preoccupied with his canvas. It is painted on the giant stretcher Vivien Johnson (1994) identifies as the one Clifford Possum used for his great paintings. Wuta Wuta knew that his *Dreaming* was invaluable, and even I realized that this painting was something special, with its unique iconography for the figures and its combination of Wuta Wuta's two most frequently painted stories — the related tales of the Old Man (Yina) and of Tjuntamurtu, the mythological being left behind by traveling women whom the Old Man scared into hiding in a cave.

The iconography of this painting incorporates a complex association of ancestral myths that cross Wuta Wuta's country — the wavy path of *lirru,* the king brown snake from Central Mt. Wedge (Karinyarra) that traveled westward through Pintupi country; the circles that represent the *kanaputa* women seen by this snake as he passed westward by the great salty Lake Mackay (Wilkinkarra); the Two Women *(Kungka kutjarra)* who were frightened off at Ngurrapalangunya by the Old Man (Yina), represented indexically and metaphorically by his penis. The figure at the top is Tjuntamurtu (Short Legs), the mythological being whose incarnation is Wuta Wuta himself, burrowed into the cave of Ngurrapalangunya, surrounded by circles representing hills and rocks.

Pointing to the canvas, Wuta Wuta tries to explain its significance in his limited English. "Danger" (dangerous), he tells me. But his son-in-law, the painter Timmy Payungu, more gifted in translation and always happy to show his own knowledge, corrects this. "It isn't dangerous," he says. "It is *dear.* Danger means that it can kill."

Timmy Payungu was certainly correct. I photographed the painting as it was being made, with Wuta Wuta's son-in-law and brother-in-law helping. Years later, I saw it again, reproduced in the catalog for the "Dreamings" exhibition at the New York Asia Society (P. Sutton 1988) — an amazing event from the perspective of Pintupi painting's limited appeal in 1981. The painting's history epitomized some of the broader trajectories of Aboriginal art as it moved from the bush to the Aboriginal Arts Board to world recognition in overseas exhibition. The painting had literally disappeared for several years from the possession of the Aboriginal Arts Board, leading to accusations of theft in disputes that arose over control of Aboriginal art institutions. The subject of numerous written pieces, Wuta Wuta's masterpiece evokes in its production and history the meaningful tensions of contemporary Aboriginal art.

Although recognized by collectors and curators now as a master, a great artist, my gifted and charismatic friend Wuta Wuta Tjangala was not a lone painter whose work came to be recognized and sought after simply by virtue of its own

excellence. Wuta Wuta sold his paintings through an Aboriginal-controlled arts cooperative, funded in part by the Australian federal government's Council for the Arts, and he entered his work into exhibitions, collections, and a variety of texts that sustain what participants refer to as "the market." Not all of his paintings were so valuable in monetary terms, which was a source of perplexity and confusion to him. When a visitor to Papunya in 1974 asked Wuta Wuta how much he wanted for a small painting, the painter responded in his usual dramatic voice, "Ten million thousand dollars!" I didn't know if he was being mischievous, if he really didn't understand money values, or if he simply meant to express his sense of sacred value. The going rate at the time for paintings of this size was thirty-five dollars Australian, however, which he accepted. The buyer probably didn't remember the painter's name, although he would be more likely to recognize it now. I imagine the painting might be worth as much as five to ten thousand dollars on the secondary auction market today.

Introduction: From Ethnoaesthetics to Art History

Elements of white Australia feel sorry for destitute Aboriginal artist Johnny Warangkula Tjupurrula, who discovered this week from his camp near a creek bed that a long-forgotten painting he sold for a pittance fetched $206,000 at a Sotheby's auction in Melbourne.

But Warangkula, who along with other Australian artists would like to see a percentage of the resale royalties of his work, saves his pity for those who don't know or understand their heritage. — Marica Ceresa, "Master Painter Will Settle for a Toyota"

This is a book about the acrylic paintings produced by Western Desert Australian Aboriginal people and the processes through which the paintings have entered the international art market as a result of the imaginings of diverse people. It is not what I first went to Australia to study. The people I went to study are known through many forms of representation, but these paintings are probably the most enduring medium by which the people I knew have made their presence known.

I am interested in the circulation of cultural products from a particular group of people in Central Australia, those known conventionally as "Pintupi." This was not the name of a preexisting tribal group but a name acquired by those Western Desert people whose path of movement and kinship ties brought them into contact with white Australia at Papunya (Myers 1986a, 28–29). Until forty years ago, most of the people known as Pintupi—the master painter Wuta Wuta Tjangala among them—were foragers. As hunters and gatherers, they pursued their lives in Australia's Western Desert without any part in the cash economy. Like many other foragers, as documented and explored elsewhere (Myers 1986a), their movements were dictated not only by the availability of game, vegetable foods, and water sources but also by the organizational requirements of a complex regional system of social relations.

Among the last of the uncontacted Aboriginal people in remote Australia, most Pintupi came in from the bush in the 1950s and 1960s in the "Pintubi patrols"—

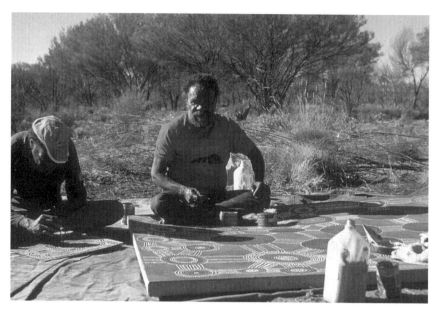

Wuta Wuta Tjangala at Yinyilingki, July 1979, painting *Kaakurutintjinya.*
Charley Tjaruru Tjungurrayi is to his side. Photo by Fred Myers.

moves that were highly publicized (Lockwood 1964; Long 1964a, 1964b; Thomson 1975) and equally controversial (Nathan and Leichleitner 1983; Long 1993). They were settled on government reserves, principally at Papunya in the Northern Territory, where approximately one thousand Aboriginal people of different language groups had come to live in a project of directed assimilation organized by the government's Welfare Branch. At Papunya, for reasons I will discuss more fully, they became dependent on European goods and services and necessarily involved with the cash economy.

Like most other Aborigines, these Western Desert people had and still have a rich ceremonial and ritual life in which songs, myths, and elaborate body decorations, as well as constructed objects, are combined in performances that reenact the somewhat mysterious events that gave the world its physical form and social order. Men and women of the Western Desert take great interest in their religious knowledge and its dramatic, sensually rich performance.

It was in 1971 at Papunya that a group of Pintupi, Luritja, Arrernte, Anmatyerre, and Warlpiri men began to turn traditional designs involved in ritual and body decoration and cave painting into a new and partly commoditized form — acrylic paintings on flat surfaces (Bardon 1979, 1991; Megaw 1982). Vincent Megaw has pointed out that this art cannot really be described as "traditional" (1982, 203), since it began with interactions with a cultural outsider, Geoff Bardon (see chap-

ter 4), and was initially more realistic than it later became. The works are produced for sale to outsiders, using acrylic paint on canvas and wood. They are not produced for local use (but see Dussart 1997). Nonetheless the formal elements and inspiration for most of the paintings, early and late, grew out of an indigenous system of representation in visual media.

When I first lived with the Pintupi at Yayayi, Northern Territory, from 1973 to 1975,[1] the production and sale of paintings by mature, initiated men was well established, largely through the support of the federally funded Aboriginal Arts Board and sales to occasional tourists. Since then, the artist-controlled company Papunya Tula Artists has expanded its activities and commercial outlets. Most often, the Company's (as it is known) arts adviser—housed first in Papunya and later, in the early 1980s, in Alice Springs—visited the painters·every few weeks in the settlements or outstations where they lived. On these occasions, he or she usually paid them for the paintings they produced and commissioned new ones. Despite the new audience and function, Pintupi painters continued to think of their commercial paintings as related to, and derived from, their ceremonial designs, associated with important myths and therefore possessing value other than that established in the marketplace.

Pintupi explain that a painting is not important primarily for the quality of its execution. Neither are the paintings, as they might appear, abstract. In the communities of Yayayi, Yinyilingki, Papunya, New Bore, and Warlungurru (Kintore) in the Northern Territory and Kiwirrkura in Western Australia, I uniformly heard the same account. You must tell people, the artists instructed me, that these paintings are "from the Dreaming," that they are "not made up," and that they are "dear." From that discursive tradition, these objects began their long trajectory of circulation and recognition, arriving eventually in Australia's cultural centers—Sydney, Adelaide, Canberra, and Melbourne—as well as in New York, Paris, and London. In 1988 this Aboriginal art emphatically became "fine art" with *Dreamings: The Art of Aboriginal Australia,* the highly publicized and popular exhibition at the Asia Society Gallery in New York. This trajectory was the reverse, in part, of my own— from the cosmopolitan centers of the United States to the Australian hinterlands where Aboriginal people continued to live in close connection to their indigenous traditions and practices.

Yayayi 1973

I arrived at Yayayi in July 1973, a Ph.D. student twenty-five years of age, eager to learn something of Aboriginal life but as uncertain as any other novice about what exactly it would be. That it would involve Aboriginal relationships to place was

sure, however, given the salience these had acquired in scholarly consideration of Aboriginal life (Birdsell 1970; Hiatt 1962; Meggitt 1962; Stanner 1965). My home for the next twenty-two months, Yayayi was a soakage in a bend of Ilili Creek, twenty-six miles west of Papunya, where about three hundred Pintupi-speaking Aboriginal people had come to live in May of that year. Originally a camping place on the soakage and subsequently little more than a windmill-driven bore, a few plastic water pipes, and some canvas army tents on the side of a dry creek bed, the community nonetheless had an Aboriginal history, visible in the contrasting pattern of camps established on the east side by the "old Pintupi" and on the west by the "new Pintupi."

In the east, the old Pintupi, who had experienced longer and more directed contact with Lutheran missionaries and government officials, had cleared off all the ground cover and placed their camps in fairly close proximity to each other. The new Pintupi, who had come eastward in response to the much publicized "Pintubi patrols" (Lockwood 1964; Long 1964a, 1964b), built their camps in a more dispersed fashion and had scarcely cleared off the space between them. None of the inhabitants of Yayayi were living on land to which they had traditional rights of any magnitude. Pintupi-speaking people had migrated eastward in waves — toward Hermannsburg, Haasts Bluff, and Papunya — for some years. Leaving behind the deeper desert to the west, these "people from the west" had joined with an emerging aggregation of Arrernte-, Luritja-, and Warlpiri-speaking people at different supply depots.

By the late 1960s and early 1970s, dissatisfaction with the political situation at Papunya led many of the western migrants toward more autonomous community forms. The community at Yayayi had formed as a breakaway outstation from the larger government-operated settlement of Papunya. Not the first such attempt, this move from Papunya occurred under the more favorable auspices of policy changes in the Department of Aboriginal Affairs, as the Labor government of Prime Minister Gough Whitlam put into practice its emphasis on Aboriginal "self-determination."

It was a hopeful moment, and my generation expected or imagined that "self-determination" would provide a powerful answer to the malaise, illness, and despair of Aboriginal life. Although the Aborigines' aspiration to be themselves was strong, the content of self-determination was not established. The forms that Aboriginal aspirations for political, social, and cultural autonomy were to take emerged over time, and in ways that observers like me have often comprehended only in retrospect; they have included riots, assertions of "Black Power," the outstation (or homelands) movement, land rights, control over health services, religious movements, and demands for sovereignty.

None of these formulations of self-determination, however, imagined a return to the past, to a way of life without the presence of European goods and services. Instead they have been hybrid constructions, engaged with the presence of the Australian settler state and partly aware of minority developments elsewhere in the world. It is within this history that the structures and practices of acrylic painting and its circulation can best be understood, as objectifications of local culture into new and changing contexts of social relationships. Acrylic painting should be reckoned on a continuum of Aboriginal productions of culture that we would ultimately understand as forms of activism within a multicultural context.

I make the point in this way to engage from the start with the capacity of Aboriginal acrylic painting to objectify political aspirations and identity, as well as indigenous aesthetic sensibilities. I intend to represent the local sense of "making visible" *(yurtininpa),* the power of such objects to affect those they engage and to elicit reciprocal recognition from the settlers and their state. Far from being the mere victims that liberal discourse supposed, Aboriginal people—Yarnangu, as the Pintupi speak their identity—have engaged the settler state with their own political tactics and practices. Objectifying one's identity in activities of exchange with others lies at the heart of traditional self-production as organized in ceremonies (Myers 1986a, 1988a), in which shared social identities are made visible in the project of revelation, or showing esoteric knowledge and images to others. Making visible is conceived equally as a giving of ancestral value. Believing in the power and intrinsic value of what they give, Aboriginal people throughout Australia have usually understood such giving as affecting both the recipient and the giver.

As will be made clear, it is typically through exchanges of what Pintupi circumscribe in the notion of "country" *(ngurra)* that objectifications of local identities—as different, autonomous, or similar, as "we mob"—are produced and realized in Aboriginal contexts. The heritage of these practices and understandings is reorganized in relation to the new identities and contexts established through the intrusion of Euro-Australian settlement.

Acrylic paintings carry some of these understandings as they articulate in their circulation new relationships of power and self-revelation. In the early phase of acrylic painting's invention in Papunya and then Yayayi, many painters understood the paintings as being "given [*yungu*] to Canberra," to an entity understood somewhat undifferentiatedly as "the government." This giving—at once a declaration of one's own value and an engagement with the recipient—represented the insertion of the paintings into an existing (if problematic) flow of goods, money, and services between Aboriginal people and the state. The makers of the paintings understood themselves to be "giving" their culture, and they believed that these

objectifications of their culture were in themselves efficacious performances of an identity and of rights that the viewer/recipient should recognize.

The circulation of acrylic paintings was not (and is not) contained easily within a single regime of value. Neither simply commodity nor fully sacred object, painting in Yayayi and Papunya was initially inserted into the discourse and practices of work. Painting fitted comfortably into the long-prevailing association between ritual and business as the activity that makes the world go round: in much of Central Australia, "business" is the English word used to refer to ritual, marking at once its importance as a comparative value and its significance as a kind of productive activity. This was a weak articulation of what might be called a revelatory regime of value with a different political economy of work. Eventually painting became more fitted to other regimes of value organized around the concepts of art and commodity, on the one hand, and identity and the politics of indigeneity, on the other. These shifts were not accidental, I will argue, but represent changing relationships and projects between the Australian state and segments of the Aboriginal and Euro-Australian populations.

Intercultural Space

The most obvious narrative of this movement—as an intercultural biography of things (Kopytoff 1986)—would be one of circulation, from local Aboriginal communities to the global or cosmopolitan venues in which these paintings now appear. That is the story I wish to tell, but the plot is different. It was by no means inevitable that acrylic paintings would achieve the success they have. To present the story ethnographically and historically, as it has been known by the complex network of participants who made it, the plot must be more attuned to the ironies, incongruities, and human dramas—the social fields—through which the transformation came to pass.

It seems ironic that Aboriginal people, who were once despised as representing the lowest levels of savagery (B. Attwood 1996; Broome 1996) and considered to demonstrate such limited cultural achievement, became so important for their art. Indeed, Peter Fannin (an early adviser to the Aboriginal painters) imagined the art could be "a powerful antidote to the widely held view of a Central Australian aborigine as lazy, slovenly, and without penetrating world view" (Fannin 1974c). Painting represented a radical reformulation of Aborigines' value in Western eyes and draws attention to the shifting processes of what I will call "intercultural space," the variable space of colonialism, primitivism, and globalization.

Several analytically distinguishable concerns involving the "intercultural" are

drawn together in the movement of acrylic paintings, evidencing relationships that articulate different modes of cultural production. As a researcher, I began this project broadly with the problem of indigenous people's identities in contemporary nation-states. I continue to regard acrylic paintings and their representation as providing a significant instance of this problem, as a medium through which Aboriginal people have come to be known to others and through which they and their meanings participate in and influence the complex field of relations that settler states comprise. This book is an attempt to understand exactly what happened and how it happened. How did acrylic painting come to be a valued, meaningful signifying practice? Using the framework of "signifying practice" is deliberate, and my answer to these questions should establish that the availability of meaning *in* the paintings is not an adequate answer. One must show how the paintings were *made* to have a meaning, in practice.

Part of the capacity of these intercultural objects to represent, or to say something, lies in their engagement not only with the Aboriginal system of meaning and social relations but also with available discourses and institutions of the arts in the dominant Euro-Australian society. In tracing their movement from the local contexts of their making to the distant and cosmopolitan places where they are circulated, exhibited, and purchased, one must follow their paths through the intertwined arenas of cultural production in both the Australian nation-state and the specific social worlds of art, each of which has discourses for assessing value in cultural form and difference.

A second concern of this book, then, is with a new anthropology of art that treats the category of art in a critical fashion. That is, I understand that to designate cultural products as art is itself a signifying practice, not a simple category of analysis. This leads me to turn my attention to the institutions and practices that *make* objects into art.

Finally, my focus on what has become known through Arjun Appadurai's work (1986) as "the social life of things"—a focus on the intercultural and the circulating—suggests a serious limit to any stable notions of cultural context within which cultural forms can be interpreted. The once-productive conception of anthropology's goal as delineating a "universe of signs" (Geertz 1973) seems diminished in this regard (T. Turner 1991, 292). I address my attention, therefore, to the *making* of meaning and to the social relations within which this occurs. At the broadest level, my analysis is organized around the institutions and practices implied by the more self-conscious concept of "cultural production" and a recognition of heterogeneous fields of practice and representation.

The transformations involved in cultural production engage two kinds of theo-

retical work—one involving the changing intercultural situation of indigenous people and their cultural practices, and another involving the question of "fine art" and what makes an "art object." However distinct the histories of thinking about these issues have been, they necessarily come together in this study. Thinking about the movement of Aboriginal art necessitates paying attention to the institutions in and through which culture is made (produced), rather than simply sifting through abstracted categories. Too many people and institutions are involved in producing Aboriginal art, making it something more than a "local product" produced entirely within the frameworks of local Aboriginal communities. The challenge of this study lies in the interculturality of the art and in the varying, multiple sites of this intercultural activity—the institutions through which intercultural relations are mediated.

Working within these conditions is difficult for anthropologists, not least because of the strangely altered place of ethnographic knowledge itself, knowledge that becomes inescapably part of what it represents. In this sense, the circulation of Aboriginal paintings exemplifies the contemporary conditions of anthropological practice delineated so presciently by George Marcus (Marcus and Fischer 1986; Marcus 1998). The predicament is a general one for many of us conducting research now. Increasingly, our knowledge of a society, a place, or a phenomenon is not gathered over the single year or two that functionalist anthropology once transformed into a picture of a system, but rather involves a bewildering set of dislocations. "When everything changes," as Clifford Geertz has written (1995, 2), "from the small and immediate to the vast and abstract—the object of study, the world immediately around it, the student, the world immediately around him, and the wider world around them both—there seems to be no place to stand so as to locate just what has altered and how."

In *After the Fact*, Geertz found an elegant way to resolve this epistemological problem of being here now, looking back at what one knew then. He persuades us that his "accounts of change, in my town, my profession, my world, and myself" do not call for "plotted narrative, measurement, reminiscence, or structural progression" (1995, 3). But such a projection of ethnographic knowledge cannot be conducted in anything like the trope of Bronislaw Malinowski's figural and heroic ethnographer, set down all alone on the beach of Kiriwina.

This is a story I cannot tell with ethnography alone, and certainly not through ethnography innocent of its own historical, social, and cultural groundedness. I am concerned to articulate what sort of order one can expect in this situation of knowing and its effects on the possibilities of narration. My interest in preserving the ethnographic immediacies of a time different from my current narrative,

to preserve myself *then* (for example) as an item of data and even a distinctive voice, has an additional dimension, vital to plotting the story. My own blindnesses and lacunae inform the reality of that which we know as "Aboriginal art," indicative of a moment in its existence. With what voice can I discuss, for example, my understandings or misunderstandings of acrylic painting in 1973 or 1974, from the perspective of a current writing? I did not know Aboriginal painting then as what I perceive it to be now—a sign of an emerging Australian national identity not quite yet brought into social being.

This is nonetheless a story in which ethnographic knowledge and practice, dispersed and multisited (Marcus 1998), but also challenged in its more authoritative voice (Clifford 1988d; Michaels 1988), is central. A straightforward narration of the development of acrylic painting thus proves difficult. The worlds of bush and city seemed so separate then, with my white Australian friends as guides to, but hardly players in, the world that (I now perceive) they and I shared with the painters of Central Australia. Necessarily, therefore, this is also a book about a certain disciplinary moment, and about the contemporary vicissitudes of anthropology and ethnographic knowledge.

The Disciplinary Moment: Problems with Representation

I began writing this book in late 1988, at a time in which the situation of Aboriginal people in Australia and the world underwent significant change. The year was more or less the midpoint in my own research with, and writing about, Aboriginal people, which began in 1973. During this sabbatical from my teaching, I meant to turn my attention to the ways that Pintupi people engaged a range of "universalizing" discourses from the West. I was, of course, overtaken by events. It was "The Year of Australia," and the United States was flooded by images and tourist promotions as Australians marked the two hundredth anniversary of their continent's settlement—or domination—by those called "whitefellas" by the indigenous inhabitants and known to themselves as "Europeans."

Aboriginal activists appeared initially to have been cut out of these events of national celebration, but as others have pointed out (Beckett 1988; B. Attwood 1996), they actually managed to use the intrinsic drama of the circumstances to highlight their history of subjugation and struggle. If the Anzac memorial (Kapferer 1988) or the Tall Ships (or the Holden car [Taussig 1993] or the America's Cup) represented significant internal projections of Australian national identity, these competed with other, alternative forms—including Aboriginal art—that had greater potential to objectify an Australian identity abroad. In a lovely piece of reverse

historical staging, for example, the mischievous Koori activist Burnum Burnum traveled to England and laid claim to that island, planting the Aboriginal flag. While the land rights issue, as the principal arena of Aboriginal identity, declined in the face of increasing white backlash and decreasing support from the federal government, the surge of publicity about Aboriginal deaths in police custody provided a shift in the locus of Aboriginal political activity and changed the primary public representation of "the Aboriginal" from that of the tradition-oriented and "primitive" innocent, deserving of support to maintain his or her spiritual ties to the land, to that of more directly oppressed and dominated young Aboriginal men dying in the jails of rural Australian towns.

Throughout this bicentennial year, and more perhaps than at any other time I had known, images of Australia and of Aborigines made their way into American consciousness. Bruce Chatwin's (1987) *Songlines* became a best-seller, its popularity far outstripping any anthropological treatment of Aboriginal culture (though borrowing heavily from anthropology). Paul Hogan's film character in *Crocodile Dundee,* fictive kin to the Aboriginal Kakadu people of the far North, also caught America's eye with his unconventional, fearless bravado and premodern tie to place (Hamilton 1990; Morris 1988; Morton 1991).

Everybody *here* — that is, from where I now speak, in the United States — seemed to want to go *there.* In the world of the arts, however, much from Australia came here — especially Aboriginal art, which seemed to be reaching a boom. This was more true of the acrylic paintings from Central Australia than of the previously popular bark paintings from the North. In New York, there were several different shows of Aboriginal art in 1988 and 1989. Indeed, both within and outside of Australia, their "art" — usually along with their spiritual tie to the landscape — came to be the representation of Aboriginal culture itself, of Aboriginal identity (Moore and Muecke 1984).

With the growing reliance on tourism for the economy, Aborigines and Aboriginal culture were clearly becoming critical to Australia's self-representation, part of its place as a frontier and a land of natural grandeur. Aboriginal faces, designs, and icons appeared — along with kangaroos, Ayers Rock, cockatoos, and koala bears — on every souvenir tea towel and plate. In July and August 1988, Aboriginal images were everywhere in Alice Springs, for example, appearing on buses, motels, and shop signs; Aboriginal artifacts, paintings, and designs were in every sort of retail shop. Even Kmart was selling Aboriginal art. The Central Australian Aboriginal Media Association had just won the site license for the new satellite downlink to the Northern Territory (Ginsburg 1991, 1993a, 1993b). Aboriginal people were a political and cultural presence.

Spurred by political interests on the part of Aboriginal people and economic interests on the part of the Australian state, there was a dramatic intensification in the representation of Aboriginal culture and Aboriginal identity. Many people—popular writers, art historians, conservationists, critics, activists, and the Australian counterculture—had entered the fray. So common has this become that our intellectual attention is now as much engaged by these productions of representation as it once was by Aboriginal people themselves. The multiplication of mediations constitutes a serious challenge to the conventions of anthropology. As the task of representing Aboriginal culture was moved out of its disciplinary harbor, and the politics and practices of representation were changing, a significant sector of criticism emerged from what was perceived as "the art world." We continue to experience these changes within the discipline, as its objects, its audiences, and its competitors change. It is what Marcus (1998) means by "instability," a "competition" over the representation of Aboriginal culture and the new audiences.

Anthropologists have sometimes argued for the superiority of their own knowledge or against the inaccuracy of what is written by others (Hodge and Mishra 1991; Muecke 1996; Trigger 1993), and there are certainly grounds for this reaction. At first, these representations seemed to many anthropologists simply to be either in error or ethnocentric, lacking the kind of knowledge firsthand experience would provide. Are there, as Chatwin implies, Aboriginal activists steeped in Heidegger? Can one separate an Aboriginal philosophy from the everyday politics and practices of life, as Muecke (Benterrak, Muecke, and Roe 1984) appears to do? Are Aboriginal people the "caring, sharing" minority that some activists have rhetorically deployed in their image making, or are they, as von Sturmer wrote in 1989 (see chapter 10), rather more challenging to convenient sympathy?

Yet the appeal of many representations is not to the court and canons of scientific judgment and disciplinary discernment. This is a question not merely of "the popular" but more of the "populist" suspicions of authority. Even before the landmark moment of the High Court's Mabo decision, representations of Aboriginal culture seemed to have jumped free of disciplinary control (B. Attwood 1996; Myers 1988b). This partly reflects a growing struggle with anthropology's own implications, bemoaned by some and celebrated by others, of its/our own knowledge as culturally grounded and therefore relativized. Anthropology is, after all, a Western discipline, and our writing is an act of representation.

James Clifford's (1988c) well-known article "On Ethnographic Authority"—emphasizing the rhetorical structure of what he took to be Malinowski's (and anthropology's) concern to secure disciplinary authority over the representation of non-Western peoples against missionaries and government officials—has made it

difficult to argue that disputes about "facts" might be more than disciplinary turf wars. Indeed, at the heart of the problem may be the growing recognition that disciplines create their own objects (society, culture, systems) — a recognition of disciplinary partialities. Aborigines themselves, at times, have resented anthropological constructions of "Aboriginal tradition," seeing these to have worked against Aboriginal projects of self-fashioning or inventions of tradition. Attempts at pan-Aboriginality, claims of special spirituality, or assertions that "Aboriginality" is "in the blood" have been challenging examples (Keeffe 1988; Hollinsworth 1992) in which anthropological adjudications of cultural authenticity have faced contemporary constructs, even as some of the images of Aboriginality may themselves owe much to anthropology (B. Attwood 1996, xxv; Maddock 1991). In a sense, the anthropologist's stance in representing Aboriginal cultures recapitulates the situation of participant observation itself — a situation that Clifford (1988d, 93) has also called "the ironic stance of being *in* culture while looking at it" — now on anthropology's home ground, however. *Our* representations are part of *their* world (see Myers 1986b; Povinelli 1995; N. Williams 1986).

In periods of smoother disciplinary sailing, the inherited genres provide satisfactory solutions, and anxieties can be allayed with method. This is no longer the case, and probably no more insistently than with indigenous minorities in settler states where anthropology has been deeply suspect — a position well known in the writings of Vine Deloria for Native North Americans, with common parallels in Australia. I am hardly exempt from these changes. Referring to just this moment of transition, Eric Michaels's (1987a) review of my monograph (1986a) denounced me as "the last of the ethnographers" for concerning myself with the totalizing logic of traditional Western Desert social life. Of course, the disappearance of the traditional object of anthropology has long been announced. Michaels was heralding, perhaps, a different change: Who would read a detailed ethnography of the kinship relationships involved in Aboriginal painting when we have Chatwin's *Songlines?* Is there still a role for the scholarly book once trade publishing moves into "our" territory?

These cases should be understood not as nostalgia for an anthropology past but as evidence of a sea change, the collapse of a previously more stable framework for anthropology. Rather than confronting alternative (nonanthropological) representations as limited or erroneous, we can regard all of this cultural production — transactions in the Aboriginal image — as itself an empirical condition worthy of our study, a condition indeed of Aboriginal social life. Because the construction of an identity is one of the pressing problems of contemporary Aboriginal life, the activity of representation itself becomes an important object of study. It is an

increasing problem for Aboriginal people to define themselves in relationship to the universalizing discourses of the West, in which they—Aborigines, the Aboriginal, and Aboriginality—are signifiers. In a variety of discourses, they stand for something, and part of the project of this book is to examine how they come to be attached to a signified.

Marcus and Fischer (1986) took the crisis of representation as the appropriate moment for experimentation in ethnographic writing, a call for alternative stylistics and form. I prefer to tease out the anxieties and their source in the context of representation, as itself an ethnographic opportunity. The anxieties of being inside and outside of the relationships of representation could not be allayed with methods of achieving objectivity for the "truth" of Aboriginal culture or of merging our identity with theirs. These methods worked best when "they" and "we" were separate, and "they" were presented to the world through us. But anthropological accounts of Aboriginal land tenure—reified and removed from the contexts of local practice and from anthropology itself—had already boomeranged and been used in court to limit Aboriginal claims to their own land (N. Williams 1986). Aboriginal culture had new stakes, and it had new translations.

The Field

The first Western Desert acrylic paintings I actually saw were in Alice Springs, before I arrived in any Aboriginal community. Pat Hogan had been selling (and documenting) the work from the painters at Papunya (see Hogan 1985; Maughan and Zimmer 1985), and she ran the Stuart Art Centre, a small gallery showing Papunya Tula paintings in the Stuart Caravan Park on Larapinta Drive. I was trying to set up fieldwork with Pintupi people then living at Yayayi, 160 miles to the west, and I came to know Hogan as a possible contact with an Aboriginal community. I didn't know what strenuous battles were being waged for control over the painting project, but innocence can be helpful, too. That Pat Hogan was "very fond" of the Pintupi was what I learned and that she hoped someone would "work with them."

The last line of my journal before I left for Papunya had a hopeful note about Pat's offer of help in getting permission and a disappointingly cursory mention of the paintings—nothing of what they looked like, how many there were, or how they were displayed. "Anyway," I wrote, "it looks good at Papunya and Pat sent a telegram to Laurie Owens (the superintendent) there, which may set things in good stead. The Pintupi have beautiful paintings" (Wednesday, 18 July 1973).

In the innocuous phrase "beautiful paintings," I can hear only my desperate

hope to find some Aboriginal community who would accept me. Perhaps I did not want to define myself by an "intercultural" activity, or perhaps I marked these objects off as ephemeral and peripheral, all the more so because they were such an obvious aesthetic frivolity. But painting was not going to be my research topic. I was looking for deeper forms, things less dominated by relations to whites, in search of what Malinowski called the "ethnographer's magic," by which he is able to evoke the real spirit of the natives, the true picture of tribal life (Malinowski [1922] 1984, 6). Like Malinowski's ethnographer, I hoped to put the "white man's compound" behind me, out of view. In the end, this was not possible.

Now, almost before starting, I want to discuss the broad field of social relations in which knowledge of Pintupi painting is to be understood. I draw courage in doing so from Gillian Cowlishaw (1999), who has written brilliantly on the complexity of social fields such as race relations and their absence or exclusion from texts, as if they were merely a practical obstacle for field-workers. Another personal anecdote will perhaps evoke the context in which anthropologists acquire (or lose) cultural capital in the field of cultural production.

A couple of years ago, I learned quite by chance that some people had wondered that I did not notice "what was going on," that effectively I had ignored the most publicly celebrated component of Aboriginal cultural production of the time. This could be a criticism or limitation of my expert status, as the only anthropologist who had done extensive research in this community. Such challenges to anthropologists are, of course, part of the "territoriality" that has always been endemic to the field, but the truth is that I did not publish much about painting until 1989. I did pay quite a lot of attention to acrylic painting and its producers, as will become clear, but the way in which it articulated with the institutions of Australian society threatened to undermine my participation in local life, as well as my concern for its enduring themes.

My ambivalences about entering the world of Aboriginal art are central to the project of this book. I regarded the representations and understandings of Pintupi practices as uninformed and inadequate, even popular. To me, it seemed that what was "going on" within the local communities was quite different from the ethnocentrically scripted accounts. Moreover, the activities around the production and sale of the art were so fraught that I found it convenient to pay little attention. In any case, I had no car, no radio, no newspaper, and the "pain of doing without," to borrow a phrase, admirably concentrates the mind on what is before one: the local situation.

The importance that the larger, predominantly white Australian society has ascribed to Aboriginal painting far outstrips its significance *within* the communities of the painters. Not only did painting have a somewhat precarious existence for

many years, but in contrast to the centrality it had in public representations of Aboriginal people in the southern Australian media, it was rarely—if ever—the driving force of community attention as Aboriginal people saw it. Moreover, in its circulation, the phenomenon of Aboriginal art seemed to be owned by whites, a kind of "whitefella business" (Tonkinson 1982) that I believed it necessary to avoid. I also did not understand how to approach this rather complex field of what I now see as intercultural production, a field of which my knowledge and desires— for what Aboriginal people "really" thought—were themselves a part.

Since 1988 I have embarked on a study of the multilocale circulation and transformation of Western Desert acrylic painting, using a variety of materials—ethnographic, interview, archival documents, journalistic accounts, and so on. Using archival materials and my own field notes, I am also "returning" to situations that engaged me previously, but with different questions. I am attempting to make a different sort of contribution than those that have dominated consideration of the art—an anthropological contribution based on many years of fieldwork and association with the painters, as well as limited ethnography of the exhibition scenes. As I have gone back over my notebooks and archival documents to see what that world looked like at different times and from particular locations, my notes, memories, and earlier practices have been subjected to a different "I"— one that considers the processes and practices of knowing Pintupi painting as an example of the "traffic in culture" (Marcus and Myers 1995).

This story, then, connects two odysseys. The project of "following" the circulation of acrylic paintings produced by Western Desert Aboriginal people from the Papunya area has meant for me also following one thread of my own life as an anthropologist engaged with the life-worlds and circumstances of some Aboriginal people in Central Australia. The point of the story, however, is not to articulate the change in me or in anthropology but to say something about the broader movement in the world—of shifted boundaries and junctures—in which Aboriginal people now live and throughout which their objects and representations circulate. In these movements, the once-conventional notions of "us" and "them"— whitefella and blackfella, European and Aboriginal, Australian and Aboriginal, Western and Other—have been reshuffled, the absolute sense of difference destabilized.

So as I write about myself now, engaged in a new research project on Aboriginal art, looking back at myself then, such a task is an epistemological necessity, not a revelation. The goal is to gain some purchase on the locations—the contexts—in which knowledge and understanding are sought and, to continue the commodity metaphor, "produced."

Methods

I believe that understanding these intercultural objects requires both method-ological and theoretical revisions in the anthropology of art in the direction of a greater self-consciousness about the heterogeneity of meanings, audiences, and privileged locations of understanding (Marcus and Myers 1995). The project also makes significant demands on the usual narrative strategies of the monograph, whose author must navigate a range of historical, geographic, and social loca-tions — not, finally, in the service of a magisterial complete knowledge, but rather with the goal of sustaining a sense of the varied, competing sorts of knowledge that have existed in "knowing" Pintupi painting. It is this partiality, competition, and incompleteness that I attempt to gloss with the phrase "traffic in culture."

There is, to be sure, a theoretical position to guide such a study, even if it is one that has been discovered along with the study itself, and if the complex ethnographic phenomena I describe cannot be reduced entirely to its terms. As an anthropologist, the position I am trying to develop is one that examines the discourses of art — the deployments of the category "art" and its meanings, in a variety of institutional settings — as a signifying practice. I am concerned with how the discourse(s) about art and art making circulate broadly, within the art world (or art worlds) proper, as well as within the other institutions — primary schools, universities, government funding programs — that might be considered their aux-iliaries. This may appear to be an unusual framework within which to engage non-Western art, but my position is necessitated by the consideration of the intercul-tural flow — circulation — of Aboriginal acrylic paintings and their movement into the category of objects we know as "fine art."

Such a project is more than a reflection on effete categories of the sublime. It is, rather, intimately engaged with some of the most fundamental political and so-cial transformations taking place in the world. The production, circulation, and consumption of these objects constitutes an important dimension not only of self-production but also of the processes of "representing culture" that are so signifi-cant in what Appadurai and Breckenridge have described as the "global cultural ecumene" of the contemporary world (1988, 1). This global ecumene, however, has a shape that local art histories — be they Aboriginal, Native American, or even Euro-Australian — need to chart (Burn et al. 1988).

1 Truth or Beauty: The Revelatory Regime of Pintupi Painting

Rather than grasping objects only as cultural signs and artistic icons, we can return to them, as James Fenton does, their lost status as fetishes—not specimens of a deviant or exotic "fetishism" but *our* own fetishes. This tactic, necessarily personal, would accord to things in collections the power to fixate rather than simply the capacity to edify or inform. African and Oceanian artifacts could once again be *objets sauvages,* sources of fascination with the power to disconcert. Seen in their resistance to classification they could remind us of our *lack* of self-possession, of the artifices we employ to gather a world around us.—James Clifford, "On Collecting Art and Culture"

At Yayayi from 1973 to 1975, the painters located themselves some twenty yards south of the main camp, a camp principally of canvas army tents and other temporary shelters, among the big shady trees along the dry creek of Yayayi. Theirs was the most consistent routine in the Yayayi community. As I reported in my dissertation, the painters spend "most mornings, at least, at their place, near the male ritual area. The painters' day camp cannot be approached [in those years] by women or children and here they sat, joined by non-painters, painting and talking among themselves. I spent many of my mornings here as well, listening to gossip and discussions of mythology and ritual. The composition of the group varied, but there was usually a group there" (Myers 1976, 111).

I listened to the gossip about current events with which people entertained themselves while painting, and I avidly pursued the stories the paintings embodied, both for my own ethnographic work (these were "myths") and so that I could help to document the narratives that art advisers believed contributed to the paintings' salability. These documentations provided the specific stories related to the iconographic form in paintings—stories of the ancestral beings described by Pintupi as *Tjukurrpa,* or Dreaming, who traveled across the face of the land, whose actions left marks on the landscape as its significant features, who defined

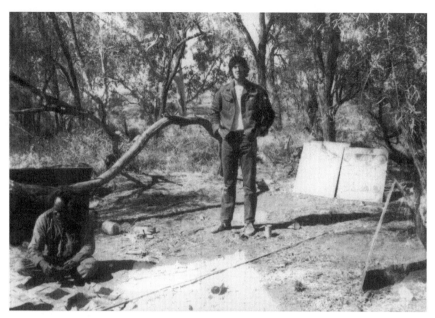

The author at Yayayi painters' camp with Wuta Wuta Tjangala, 1974. Yayayi, N.T.
Photo by Fred Myers.

the meaningful order of being, and who left behind the essence of all future beings (Myers 1986a). Glosses of such stories typically have accompanied the works in sale, proving their "authenticity" to Western buyers by defining the paintings' mythological base and showing that the forms are more than arbitrary, pretty designs. This selection of significance, which allows some Westerners to focus on the "spirituality" or "religiosity" of the paintings, is actually a rather complex and ironic construction that reflects in part the Aboriginal claim of why their paintings are valuable.

In my initial work among Pintupi people, I was concerned primarily with how Western Desert people understood themselves: I looked at the structuring and movement of bands over the land (the practices of territorial and spatial organization) and Pintupi concepts of the self. I came to understand the relationship between spatial organization and identity as dynamic, reflecting the internal politics and contradictions of Pintupi social life (Myers 1986a). Like other anthropologists in the 1970s and 1980s (Anderson and Dussart 1988; Dussart 1988, 1993, 1999; Morphy 1977, 1983b, 1992), I discerned the Aboriginal emphasis in painting to be on the question of individual identity and the acquisition and distribution of authority to reproduce particular designs. But Aboriginal understanding of what

the paintings meant was not simply an internal matter. The painters imagined the circulation of their paintings and the relations this involved with whites to be subsumed within a single cultural model (Myers 1980a, 1980b, 1986a), not intrinsically limited by the supposed boundary of white and black.

These concerns, then, defined my interest at the time in painting in Pintupi communities: the emphasis on which people had the right to depict what stories (and in what places), the conflict between Aboriginal understanding of the value of their paintings (as based on significant and prized religious knowledge and experience) and what the whites paid for them, and the contradiction between the collective economic goals of the artists' cooperative and the relationship of the arts adviser to each participating painter.

The Local: Not Quite Out of the Way

Acrylic paintings are intercultural objects. Their social biography begins in the Aboriginal communities where they are manufactured, but their production is not so simply rendered. The paintings do not fall easily into the category of "primitive art," for example, which is usually reserved for objects as dense with local meanings as these. Deeply resonant of indigenous culture and value, celebrated for their testimony to the survival of those cultural traditions, they are nonetheless objects as much of the present as of the past.

If the "primitivism" debates that rocked anthropology, art history, and cultural studies (Clifford 1988a; Foster 1985; McEvilley 1985; Manning 1985; Price 1989; Rubin 1984; Torgovnick 1990) explored the problem of intercultural movement critically, but from a metropolitan point of view, the circulation of Aboriginal acrylic paintings offers a parallel more grounded in what I call a "local art history" (see chapter 3). The primitivism debates revealed how the opposed categories of "tradition" and "innovation" regulate fabricated boundaries between the modern West and a supposedly premodern Other (Cohodas 1999). But their focus on a generic and general West and its Other threatens to return the study of these paintings to an insignificant place in what Arthur Danto (1986) has delineated as the Hegelian march of a unilineal, world historical "Art History." In the context of settler nations like Australia, the paradigm of authenticity has a more particular combinatorial capacity than that of primitivism.

Those of us who worked in close proximity to the practice of Aboriginal painting struggled to articulate the cultural context of these objects and to explain their meanings as local people understood them. At the time, however, we did not necessarily grasp the processes of which we were part. In this chapter, I attempt to

provide a kind of reflexive double vision: an account of the way in which acrylic paintings were understood in the early stages of their production, along with an account of how I came to know the work.

Based on the cultural meaning of paintings, the discourses applied by the painters I knew, I have come to recognize that consideration of the social practice of painting should guide analysis. Although I began in 1973 and begin here by addressing what anthropologists call "cultural context," I have found the apparent stability of such a concept to be inappropriate for my account. Instead, my interest lies in the unsettled and unsettling nature of the encounter between traditions of theory and practice.

There are numerous possible categories of analysis for Pintupi paintings — transitional art, hybrid art, "art by destination" rather than "art by intention" — but these simple codifications provide little historical or analytical purchase on painting practices. Certainly, a universe of meanings and practices exists within which Pintupi paintings find significance and value for painters. Following Pintupi concerns, therefore, it is necessary first to understand the relationship or reference of these forms to an ontology that lies outside the paintings before one can engage with the visual form itself. The painters stress not their beauty (or aesthetic value) but their referential and ontological truth, defined as their relationship to the Dreaming (see Myers 1989 and hereafter).

But the significance of Pintupi painting does not stop with this manifest articulation of value. Although "aesthetics" as a problem in the Western sense of artistic creativity does not appear to concern the Pintupi much, the vitality of formal organization in the work argues for its importance. Thus it can be shown that the processes of accommodating their own internal values and those of the European market, as with the art of Yirrkala (Morphy 1992; N. Williams 1986), has led to important formal changes (Graburn 1976, 32). The question of "traditional" or "nontraditional," while significant to the "primitive art" collector (Clifford 1988b; Cohodas 1999; Price 1989; Steiner 1994), is of little help in unraveling the processes through which a system of design has been constituted in a complex historical collaboration. Nor does it provide much instruction about the semiotic potentials of elaborated form.

Many observers of tourist art, in Australia and elsewhere, have been concerned with the extent to which this painting is "indigenous" and traditional. There is no simple answer. In my view, the issue itself is a significant example of the collaborative production of Aboriginal cultural and ethnic identity within a white-dominated society. To evaluate Aboriginal practices as either traditional and authentic or, conversely, as touristic is not a simple interpretation of "facts." Our

evaluations are acts of representation, necessarily dialogical and intertextual. What I try to do is lay bare the extent to which such representations, as social facts, are addressed to, assume, or are aware of other competing or contesting representations. The broad dialogism evoked in the work of Bakhtin (1981) has particular significance for anthropology in this regard, in understanding anthropological accounts as presuming a multivocal or polyphonic context. We then recognize cultural translation not as a statement of Aboriginal facts but as an authoritative position in defining meanings.

One cannot hope to escape representation, but there are frameworks that Aboriginal producers insist should be applied in considering the objects, understandings, and practices involved in making images. For some time, however, anthropologists and others have recognized that the so-called "local" for what Anna Tsing (1994) called "out of the way places" is not as autonomously local as it was once thought to be (Clifford 1988d; Wolf 1982). So although I do intend to commence locally, I am anxious to avoid the pitfalls of imagining a pure, original moment of uncontested signification within Aboriginal communities. I do not want to present contemporary Pintupi painting as emanating directly—rather than dialectically and actively—from a preexisting foundation, but I cannot—in light of the painters' own assertions—present it as a simple product of, or imposition by, external authorities. The development of acrylic painting at Papunya has been in historical action.

From the beginning, what these paintings *are* and what they *represent* (both directly and indirectly) have been less obvious than they first appear, and their meaning has been an issue both for the Aboriginal producers and for the Anglo-Australian receivers. The paintings elide taxonomic distinctions essential to the "art-culture system" that Clifford (1988d) has shown to undergird Western ethnographic and art museums. In this system, as Elizabeth Davis has explained, two categories of objects—artistic masterpieces and cultural artifacts—"are subjected to valuation as authentic or inauthentic. . . . For cultural artifacts, value derives from age and exoticism: the less influenced by the 'modern' west an object appears to be, the more authentic it is judged to be" (Davis 1999). Correspondingly, the placement of the paintings within this taxonomic system mediates complex relationships between Aboriginal producers and varying non-Aboriginal consumers.

That the paintings—images painted on masonite board, canvas board, and Belgian linen, sold for cash to outsiders—are "closely related to the old traditional tribal painting of corroborees and cave painting" has always been part of their appeal (Farnham 1972). The main concern of the 1970s for those involved with "Papunya painting," as it was known, was to establish the referential nature of its

images, what they "said."[1] Understood as "story paintings," they were in need of annotation to be appreciated as "fine arts–ethnology," a category the art adviser Peter Fannin used frequently in marketing them. This emphasis drew on, and appealed to, criteria of the prevailing Western art-culture system. Shelley Errington has argued that "iconicity is the hidden specter that continues to haunt Primitive Art," lurking "at the edges of collecting and categorization" (1994, 209). Iconicity, she maintains, has been a central criterion of "what is allowed to count as art" (208).

This iconographic conception corresponded to what the Pintupi painters stressed to me, namely that their paintings are "stories" *(turlku)*, representations of the events in the mythological past of the Dreaming (Tjukurrpa); and that they are "true" *(mularrpa)*, that they are not made up. They were also invariably *somebody's* stories, expressive of an ontological link between persons and places that land rights legislation eventually recognized as a special, spiritual—rather than economic—kinship to place (N. Williams 1986).

The paintings' distinctive aesthetic formulation has also been noted, initially in Geoff Bardon's (1979) discussion of their "haptic," or tactile, quality, and more successfully in the 1990s (Caruana 1993; J. Ryan 1990; and chapter 3). However, as art writers have noted, the paintings were principally rendered in what they call (derisively) the "ethnographic" mode, as requiring information in order to be understood rather than appealing to the direct engagement of the viewer. Clearly, the initial categories of translation are not fully adequate for a set of practices in emergence.

Because Western Desert acrylic paintings are not just "pretty pictures," "art," or even "primitive art," I mean here to introduce the "ethnoaesthetics" of Pintupi painting practice, the local conventions and categories through which the men and women who make them articulate their product. I do this in a particular way that leaves open the broadest potential of painting and paintings to be meaningful to participants. Their beauty, their status as art or primitive art, and even their religiosity may provide appropriate frameworks for rendering them intelligible, but these are not intrinsic or exhaustive qualities of things. They are categorizations of them, arrived at by agreement, domination, hegemony, or consensus. Their application must be accomplished in social action, implicit or explicit, and this usually occurs with some degree of suppression or repression of other, contradictory qualities. If they aren't really produced for local consumption, for ritual use specifically, their status as "authentic" primitive art (Errington 1994; Price 1989) is problematic for collectors who regard them as less vitally linked to the life-world of those who make them. "Authentic" primitive art, an idea thoroughly discred-

ited by the primitivism debates, is generally held "to consist of objects made by 'untouched' cultures for their own uses rather than for sale to 'outsiders' and that these objects are pure in their form and context, uncontaminated by Western influences" (Errington 1994, 201). Yet the Aboriginal producers do regard acrylic paintings as authentic. They are at once commodities and what Annette Weiner (1992) taught us to recognize as "inalienable."

This is a circumstance for which ethnography, as "thick description" (Geertz 1973), is well suited. In using Geertz's phrase, I characterize ethnography as an inscription that does not *reify* culture, does not turn it into a thing. Thick description remains steadfastly contextual in recognizing that categories and conventions are not the causes of action, but are its medium, always potentially at play in the hands of participants faced with a task. Ever since Malinowski recommended leaving the armchair behind, anthropologists have attended to what happens in practical everyday contexts. Ethnographic knowledge aims at context and practice—to provide us with a sense of how things take place "on the ground."

Local conversations such as those that inform Pintupi painting and their explanations to others are one of several discursive levels involved in the social constructions of the objects—levels that range from indigenous accountings to those of governmental policies, art dealers, and art critics. Try as one might to specify the "local," the ethnographer finds that there are no *innocent* accountings of these objects. To describe the paintings as "traditional," "transitional," "authentic," "based on ritual knowledge," or as representing a different ontology, involves distinctive stakes and values in the worlds in which the art circulates. As numerous writers on so-called primitive art have noted (Clifford 1988a; Errington 1998; Price 1989), authenticity—"pure products," as Clifford calls them—is a critical concern to those who appreciate, collect, and analyze non-Western material culture.

One of the central issues of the paintings, then, revolves around their hybrid status as material items, manufactured of introduced materials but claimed by producers to be authentic in local terms (Isaacs 1987; Megaw 1982). Rather than assuming a self-produced local that is simply appropriated, swallowed in the larger circuits of its consumption, some kind of dialogue or intercultural communication must be understood to underlie the meaning of the objects.

First Time: Encountering Meaning

The Western Desert paintings emerge out of a way of life and a set of practices that have changed but that continue to inform and shape Aboriginal social life in Central Australia. This social life was forged under the constraints of foraging and

its sociospatial arrangements (Myers 1986a). Pintupi representations of their own cultural production are deeply entwined with ideas and practices of personhood, cosmology, and the ontological articulation of subjects and objects (Munn 1970, 1973b). With the images said to come from the Dreaming, the emphasis is not on what the painter has done (his or her creativity) but on what is represented, what value that has itself, and on the painter's relationship to it. This ontology, exotic and intriguing for many Westerners, is not remote from real life and politics.

Many anthropologists have found that their informants have told them almost everything they needed to know in their first encounters with them (Silverman 1972). We spend the rest of our time in the field learning the universe of signs within which they addressed us. So it was, in retrospect, the first time the paintings were explained to me. The first mention of painting in my field notes (8 August 1973) is a conversation at Yayayi with two prominent painters who often worked together—Wuta Wuta Tjangala and his brother-in-law, Charley Tjaruru. Altogether a more battered but hardly vanquished witness to the harsher periods of racial domination, growing up at Hermannsburg Mission (Leske 1977), Charley had a longer history than Wuta Wuta of working with whites in Central Australia and more extensive experience in communicating with English speakers. Typically, he took it upon himself to explain, leaving the exclamatory outbursts and roguish demeanor to Wuta Wuta. Probably fifty years old when I first knew him and grown to manhood in the bush, Wuta Wuta embodied more the "traditionality"—the uncontaminated ignorance of whitefella ways—that the Pintupi, as the last of the Desert people, were held to represent.

Pointing to his painting of the Emu Dreaming, his mother's brother's Dreaming, and speaking in a mixture of Aboriginal English and Pintupi, Charley told me it was turlku, which he said meant "corroboree" or "story." Wuta Wuta's painting was a new one, of a place called Yumari, and it is "a big story." Because I was particularly interested in the relationship between people and their country, I must have asked him about rights—"Who can paint a country?" He explained: "One can paint one's own country, one's father's country, one's grandfather's country," and so on. Wuta Wuta's painting was "his father's country."

Charley's explanation then moved to a point whose logic is clear now, but which was uncomfortable at the time because of the implications it held for me. Their "grandfather never got any money for his stories; he lost them," Charley told me. I wasn't quite sure what he meant by "losing" stories,[2] but our conversation had bridged any gap I might have imagined between Dreamings, the sacred endowment of all being, and money. Whatever had occurred in the past, the painters knew better now. Charley was afraid that "white people might steal their country,

steal its stories." Therefore, the artists "should get big money" for the paintings. "Ngurra walytja," he told me, "our country. Ngurra walytjalampatju, for everybody [i.e., all of us]. Ngurra walyltjalampatju, turlkulampatju. Our country, our corroboree story."

"In old times," Charley went on, "if somebody takes [steals] a story, he would be speared; finish." In Pintupi, he reiterated this statement, and I wrote it down: "wakalpayi turlkunguru," which means "they spear because of sacred objects." The stories were "our property; we sell 'em." Wuta Wuta's story, they told me, was one in which old men "sing" (i.e., sorcerize) a man, causing him magically to lose his nose. I now realize they were telling me that the story Wuta Wuta was painting, appropriately in this context, was one used in sorcery punishment of transgressors. It referred to a place known as Tilirangaranya and Yumarinya, his father's country, his own country. It is a big turlku. It has a corroboree associated with it. The story is one about ants biting the penis of an old man. He "had a big prick," they said. This ribald detail, of course, often drew response from whites and Yarnangu (Aborigines) alike, but that wasn't the end of the account. "We belong to that country," they said. "We want to get a windmill, a pump, and go back to the country. Ngurra."

Impressed by their warnings about those who were "speared" for stealing their stories, I took pictures of neither painting. After only a few weeks in the Yayayi community, I had already been threatened by a man who became angry when I wrote down the names of places that other men were willingly providing. Photography, taking the image, would have placed me in an ambiguous position when rights over images, stories, and the land were so much at issue. The men's address to me not only invoked an economy of the image but expressed a position they hoped I, as a white man, would fill: someone who might help them assert their claims, even help them regain their land. Respecting their conventions was only a small part of the expectation.

One can see how painting—in its many meanings—mediates a complex set of relations between Yarnangu and whites. In this first encounter, Charley and Wuta Wuta told me of their concern with money, which they saw as an aspect of the inequality and disadvantage, and perhaps injustice, faced by Aboriginal people. Charley insisted that although they (Aborigines) can't read or write, they have grasped things and are aware of what they are owed. Afraid that white people will steal their country and steal their stories, they want appropriate compensation. Charley stressed that the paintings are of their own country (ngurra walytja), repeating the full, suffixed Pintupi phrase "ngurra walytjalampatju turlkulampatju." The "lampatju" suffix indicates first-person plural exclusive possession, a "we" that

pointedly excludes the listener and everyone but those understood to be "we"—
that is, the Pintupi.

This account mediates a further contextual reality, one never far from Pintupi
thinking in the 1970s. The Pintupi status at Yayayi, as nonowners in other people's
country, was a political problem. That their paintings denoted their own country
is therefore immediately relevant. "We belong to that country," Charley said. "We
want to go back there."

On the day of that first encounter, I wrote in my journal that I "spent a lot of
time with CT who is a painter," noting that he was "very unsatisfied with amount
of money coming back." As a novice field-worker in pursuit of something more
exotic, I was a little suspicious of Charley's constant disgruntled reiterations about
money and politics. He was, as he frequently admitted, a bit "hard," and more ap-
parently angry with whites than were many of his friends. But he was correct that
I needed a lesson about value, suggesting—as I want to underline here—that we
cannot segregate the concerns about money and politics from those of the cos-
mology within the image. Here, in the first account, was an attempt to unify these
regimes of value. Money and politics coexist fully with the cosmology of the Old
Man Dreaming, the subject of so many of Wuta Wuta's paintings.

The context of the painting is clearly associated with the larger set of problems
Yarnangu have in the flow of goods, services, and power in their relations with
whites and what they understand as "the government." These relations, as I even-
tually came to recognize, were understood to be structured in terms of an exchange
model (Myers 1980a). In one local version of such an understanding, the govern-
ment was understood to give them rations, social service payments, and the like
as the obligation that a "boss" or superordinate has to "look after" (kanyininpa)
those from whom he or it expects respect. The following excerpt from my journal
(8 August 1973) illuminates the Pintupi sense that what they experience as a failure
(of payment) in their expectations is "cheating."

> They think somebody (art adviser Peter Fannin) is cheating. It seems more
> a case of misunderstanding. I don't think they understand at all the wider
> economic picture, just as their views of the wider society are pretty much lim-
> ited to immediate experiences. They think Laurie and Graham [Laurie Owens
> and Graham Castine; community advisers and former superintendents] cheat
> them. They say they [the advisers] belong to the "Old Government" that did
> nothing. They [Charley, Pinny, Long Tom, etc.] complained about having to
> pay for bullock which is government and therefore should belong to them
> when they need it. They want what white people have but don't seem to really
> know all that means.

I felt the dissonance of the claims, and my next paragraph is full of rationalization:

> The amount of misunderstanding between cultures is immense; evidence Peter Fannin's exchange with Charley. Neither really understood what [the] other was thinking. Expectations differ; they meet over money. Ken [Hansen, the Summer Institute of Linguistics missionary linguist residing at Yayayi] interpreted between them. But for that, *nothing* would be clear. The men may stop painting; certainly Fannin will now buy paintings like any other individual. I know he's clean [honest], but he really doesn't come across that well.

Finally, I was able to record the transaction and what they thought of it:

> Earlier, Wuta Wuta and Charley took me over and we went to Wuta Wuta's place where he was painting a board with another part of the Yumari Dreaming. This one is a "big" one, of a corroboree with churingas. I also saw one of Charley's Emu Dreamings (his uncle's, he said) which was beautiful, more like Arnhem Land things. Peter bought it for $20. What the men say is that it takes a long time to paint one and that the money is not enough. It is their "property," important. Their grandfathers "lost" the stories (died) and they want money for them.

The value of the knowledge encoded in the paintings is a theme that continued through the 1980s, a theme almost as constant as the emphasis on the Dreaming. Complaints were not restricted to Fannin or any particular art adviser. Let me provide a more direct example:

> Arriving at the painter's camp at 10 a.m., I record Wuta Wuta Tjangala complaining that the "painting man" [John Kean, art adviser in this period] should have given him much more for each of several paintings. Drawing a line in the sand for each item, he lists the paintings: "from the painting of Pinarinya, of Kanaputanya (Lake Mackay), of Kaakurutintjinya (Lake Macdonald), from the story of the Emu Dreaming's travels, from the painting of Kuruyultunya (Wallace Hills), from the painting of the Possum Dreaming."
>
> John should have given him a Toyota from the first four paintings, he says. So, he is going to "court" him. From the last two paintings, he "should have given four hundred thousand dollars! He cheated me. He is giving me rubbish. This is Tingarri, too important, too much" *(Too mucharni panytja yungkutjakumarra. Tingarri too much).* He used to get $400 for a big canvas, he told me, but "I only got $100 this time." . . .
>
> The painting he was making was the X-shaped Yumari painting I eventually

purchased myself. . . . We had recently visited Yumari in Toyota Landcruisers, so I decided to buy this painting, giving him $30 just then, with the promise of another $20 when he was finished. (field notes, Yinyilingki, N.T., 1979)

Although I came to recognize these claims of value and suspicions of cheating as an "ethnographic theme," I can see myself struggling in the journal entries to mediate Pintupi claims of value with my own culture's view of value and the painters' evident suspicion of whites. There is, to my current eye, also a considerable uncertainty and discomfort in my writing, the discomfort no doubt of the coeval presence that Johannes Fabian (1983) saw to be so frequently excluded from the ethnographic present of anthropological writing. My journal goes on:

> They do work at it, but I'm not sure it is very intensive for a whole day. Still it must be rather straining. Tremendous balance in these.
>
> There was talk of fencing Yayayi in, of keeping people out, of *their* deciding. . . . Very suspicious of whites, and I'll never break it down. It was interesting to watch men ask Fannin for tobacco. He gave it, with uncomfortable statements, unsure: "I'll run out soon," etc.—and "poor bugger me, no money." To their view, I think, this must be very hollow, with a house and car. Exactly the same problem for me, though. (8 August 1973)

To whom were the painters talking? I was very aware, in some ways, of the incongruity of my situation. Wuta Wuta and Charley Tjaruru were mature men, authorities in their own culture. Wuta Wuta, at least, had come to maturity in the bush, taken part in revenge expeditions, had children, and was an active ritual participant. While less noble in his self-presentation, Charley Tjaruru had great accomplishments, returning from Hermannsburg to the bush with camels to rescue his relatives in time of drought (Crocker 1987). Wuta Wuta always knew there were many things he could do that I could not, a thought that could at times bring him to gales of mischievous laughter, even though he was pleased at what I managed to learn. I was a mere twenty-five years old and very inexperienced when I first arrived, but being white and having some credentials placed me in a position they understood as relatively powerful. Life on settlements had made them dependent on intermediaries to obtain what they might have gained themselves before; whites were always a valued resource for what they could provide (Collman 1988; Sansom 1980), even if there is less local competition for white patrons—less "hunting for whitefellas"—than local whites have thought.

Charley and Wuta Wuta were appealing to me, appealing perhaps to a power they believed I had. I attempted to convince them and myself that I was not a "boss," that I lacked that sort of power. I could not allow myself to occupy the dif-

ficult position in which Fannin found himself, as a boss *(mayutju)*. Clearly, I felt myself to be put into an uncomfortable position from even that first morning's encounter. I only partly deflected a moral address into anthropological knowledge, and I tried to think what material aid I could offer in selling paintings:

> This morning as I was reading Ken Hansen's *Pintubi Grammar,* Wuta Wuta Tjangala came up to the caravan, coughing outside for my attention. I understood him to say he wanted to get me to ask Ken for his Toyota to shoot kangaroo; tried to say no. But when we went over and he called Ken out, he spoke about selling paintings. Nobody was buying them in Alice Springs. We suggested trying to get them to bigger cities. Problem is they [the painters, the Aborigines] want high prices. Finally I said I would write a letter to U.S. (Peggy Golde) to see if she would be interested and to [William] Davenport for names. Wuta Wuta may think this is a sure thing.
>
> Anyway, he took Ken and me to see his latest 2 paintings, of *Yumari,* a waterhole named after a *tjukurrpa* man who copulated with his *yumari* (mo-in-law) there. The other is a continuation of the story; of a creek; the man goes on and ants bite his genitals. Ken asked about the prices (for my letter), suggesting to Wuta Wuta they might be asking too much. Wuta Wuta grew indignant, saying it was his *own* country he was painting. He wants the money to buy a car so he can take his crippled wife around. (journal, Sunday, 5 August 1973)

In explaining the value of their paintings, at these and other times, the men were not expecting anything much from me directly. It seemed as important for them to have my comprehending validation. I gave it willingly, of course, as an anthropologist; I wasn't usually buying paintings. But people at Yayayi, and later at Yinyilingki and other Pintupi communities, expected that I—like other residents—should help Aboriginal people. Such ideas about help converge with Western ideas of what it means to live in a community, to be a relative.

There was a kind of solution, at least, to my discomfiture as a sympathetic young white man living in an Aboriginal community, a way to place myself simply on the side of the painters. I could begin to satisfy my obligation to help those with whom I lived (to be a "relative," as they wished, rather than just an observer) by translating and recording the story for each painting, by doing the annotations on which—it was supposed, by Peter Fannin and the painters—sale depended. And so I produced "documentation" for the paintings, recording the stories that had come to be regarded as important to their acceptance by buyers (Bardon 1991; Myers 1994a).

This manner of representation provided an agreeable compromise in which the men could offer me their knowledge for their own purposes. At the same time, I realized that I could never be sure precisely what they expected to get for the paintings or even from photographs of the images, so I took no photos of the works for myself.[3] All my documentation therefore consists of my crude drawings of each image and identification of its iconography. I have some hundreds of these in my notes, the official annotations on forms having been sent along with the paintings when they were sold. Documenting the paintings so regularly and thoroughly in the painters' own interests allowed me a distinctive basis for understanding not only how they regarded the politics of representation but also the content of images, the rights to paint, the rate of production, and the content of an individual's artistic repertoire. At times, I have kicked myself for the "failure" to record, especially when I have watched other visitors simply take out their cameras and start shooting. But it takes only a moment's return to a Pintupi community to remember that the rights to images are not freely available.

Looking back on these transactions in meaning, I do not doubt the veracity of what I know. However, I now see my knowledge to have been produced as an "accounting," to have been situated in a context or field of social relations in which distinctive and sometimes incompatible regimes of value overlapped. It was a social field more difficult to constitute because I had an identity and a part in it. My field notes are artifacts of these relationships, filled less with neutral facts than with what Paul Rabinow (1986) meant when he said "representations are social facts." What is recorded in these notes is what people said to me while assuming a position or knowledge I had. They are situated in this way, as "accountings," and they are therefore open to deconstruction, to finding the *aporia* where knowledge is stitched together by the culture makers we call "informants."[4]

Who I Was; What Is a Painting?

By 1979, four years after I left the Pintupi communities in which I had lived so closely, and having completed my dissertation in the United States, I returned for a visit. I was still a white person, someone who could reach out to the wider world and carry a message, but I was also perhaps a "countryman" or a "relative." I had grown used to Yarnangu distinguishing me from other whites as someone who "lived in the camp," "spoke the language," and "gave without saying no."

To be both a relative and a whitefella, or to try not to be both, is the moral incongruity in which the translator — the observer, the field-worker — finds himself. Where does "buying a painting" fit into the relationships I was understood

to have? Let me give the example of some events that took place in late July 1979, quoting again from my field notes:

> We went to Yinyilingki to pick up some corrugated iron that I had taken off of my Toyota and to buy a painting from Shorty Lungkarta [SL]. There I talked with SL, Pinny Tjapaltjarri, Wuta Wuta [WW], Charley Tjaruru [CT], Nyukurti Tjupurrula. SL and Pinny were working on a big painting of WW's. It turned out that the painting I was going to buy was Pinny's although SL, his "father," had done most of it. I paid $50 of which he gave $20 to SL, but it was Pinny who mostly told the story.[5]
>
> CT seemed sorry I was going, genuinely. Unusually, he asked me to photograph his 2 paintings after I photographed those of WW and SL. They sang songs from the painting WW was doing for me, with sacred words about *walka* ("designs" or "marks"), then ____ [painting tools]. I was told how these [words] are "dangerous," that they "belong to *yarnangu* (Aborigines). "It is not a 'brush' — [sacred word] is different." They told me about having to pay for this knowledge with *kunartinpa* [ceremonial gift of meat]. "If not, they 'sing' you and your nose rots, blood comes out."
>
> All of this took place because I'd told SL before that I don't buy paintings to sell but to keep, to look at and get homesick for *them* — to remember them by. Shorty told the other men this to explain that I will miss them. Then, as if in acceptance of this, they start to sing; CT — who has a hard attitude towards Whites — actually says they should do it for the tape recorder! Pinny too seems genuinely interested in me for the first time. CT and WW say they may try to come to see me in my country, as painting men!

In this moment, I understood myself to have been "accepted," and I was deeply gratified. I have supposed that it was important for them that I had returned after my first field trip. But what is clear, too, is that as they decided that I was to be treated as a "countryman," they altered the manner in which they gave the information and knowledge of what a painting is. The decision to consider me as a relative transformed the exchange from the usually vexed relationship of sale to that of gift, equally demanding perhaps, but bringing with it a flood of generosity and concern. I was recognized not as a buyer but as a relative (*walytja*) who cares for them and will miss them.

As we will see more fully, the display of ritual knowledge, even in a painting, is both a revelation of something from the Dreaming and one's rights to a place. It is also a performance of a central component of the identities of those who produce the display. Nonetheless, the further movements of these objects through the

world suggests that instead of regarding any of these discourses for image production as intrinsically the meaning of the paintings, we should consider how this (or other) discourses are drawn on by painters in accounts of their acrylic images. Painting is a source of income, and as the objects move more widely through the world beyond Yayayi, they can be a source of cultural respect. Painting can also become an assertion of personal and sociopolitical identity expressed in rights to place, as it is for Wuta Wuta.

Painting and the Dreaming: A First Translation

Based on the understanding that Aboriginal painters paint their Dreamings (Bardon 1979, 1991; Crocker 1981a; Green 1988; Kimber 1977; Layton 1992; Megaw 1982; Myers 1989), the conventional starting place with Pintupi discourse about their work has been with their iconography, their referentiality. Drawing on Nancy Munn's work with the Warlpiri (1966, 1973a, 1973b), we all knew that the images in the paintings were representational and drew on a system of graphic signs — visual categories, she called them. We knew, too, that they represented events identified as the Dreaming.

The existence of this semantic content is undeniable, but it is not the whole story of the painting, just as the semantic-referential dimension of a speech event does not exhaust its meaning. What the men tried to explain to me, in the examples traced earlier, involves painting as an activity more broadly. They talked about what the paintings represent — the Dreaming (Tjukurrpa) and the country (ngurra) — and they also explained that they learned to paint in ceremonies, through initiation.

There can be little question that the principal significance of the paintings in Yarnangu eyes is bound up with their ideas about the Dreaming, a cultural formulation whose exoticism and sheer difference has drawn almost endless interpretive attention (Eliade 1973; Roheim 1945; Stanner 1956; Strehlow 1947) — so much so that Patrick Wolfe (1991) has recently argued that it is itself a colonial artifact (but see Morphy 1996b). I will return to engage with the Dreaming as a total social fact, but here I want to begin as an outsider learns to relate the concept to the paintings. All the paintings were said to represent stories that concern the traveling of mythical ancestral beings (Dreamings, Tjukurrpa), whose actions Yarnangu understand to have given their world its form and order. Pintupi country is laced with the paths of their travels.

What this actually means or involves is another matter. The painters insist that these representations or images are "not made up," "not made by men," but "come

from the Dreaming" *(tjukurrtjanu).* In this sense, they are described in the same fashion as are persons, customs, and geographic features — all of which are said to have originated in the Dreaming, or as Pintupi people regularly say, "Tjukurrtjanu, mularrarringu" [from the Dreaming, it became real]. They are therefore more valuable than anything humans might invent.

Such signs have the value of revealing truth, since the world as it now exists is conceived to be the result of the actions of the ancestral beings. However, it would be inadequate to conceive of the Dreaming simply as a philosophy, as an explanation of what there is, or as an explanation of "the landscape." The Dreaming is not the landscape itself or principally even an explanation of it, although that is one of its qualities. The landscape instead is how the Dreaming has been materialized, how it has been experienced, a manifestation of it, but it is not an account of what it *is* (see also Poirier 1996).

It is quite common for commentators to point out that the ideas Yarnangu have of the Dreaming are complex, but then to leave the reader in the shadows of mystery. Indeed, this complex of ideas and practices has been naturalized and reified, almost reverently, within the broader national culture of Australia, especially over the past two decades (Gelder and Jacobs 1998). The signification of this very concept is itself produced through a complex set of social practices, involving the extension of stories in space, ritual exchange, and intergenerational transmission. The Dreaming must be considered in all of its materiality as what Mauss called a "total social fact."

When Yarnangu say that a painting or a story is tjukurrpa, they indicate a contrast with events whose status is signified by the word *yurti.* A story or event that is yurti is visible or sensorially present to a subject in some way. A vehicle in the distance becomes yurti, for example, when you can hear or see it, but that which is tjukurrpa cannot be perceived in this way. The Dreaming may also contrast with things said to be mularrpa, which means "actual" or "real" (rather than "fictive" or "lie"). The contrast in this case is not one of simple logic, because the Dreaming is not conceived to be fictitious. Virtual or potential might be better. It is seen as the foundation of the visible, present-day world.

It is easier to grasp the everyday usages, the corpus of stories identified as tjukurrpa. The beings said to be tjukurrpa traveled from place to place, hunting, performing ceremonies, fighting, and finally "going into the ground," where they remain. In so doing, it is understood, they created the world as it now is. The desert is crisscrossed with their paths, the "songlines" to which Chatwin (1987) referred in his popular book. The geography — hills, creeks, lakes, trees — is understood or assumed to be the marks of the ancestors' activities. Here, for example, a man

is known to have danced, and the stones arose to mark his movements; there a woman swung her fighting stick, leaving a gap in the hills. The hills and waterholes are associated with songs, also from the Dreaming, which tell the story of these beings, and from them, the "country" — the named places of Aboriginal life — gets its names. As with most Aboriginal people in Australia before significant contact, the landscape known by the Pintupi manifests itself partly as a series of stories. Limited to this framework, the paintings are "story paintings."

Form and Signs

The shapes and spatial order in the landscape are seen as pointing to or representing ancestral activity through similarity of form — as "iconic," but also as indexically connected to these actions. Pintupi paintings and ceremonial designs are likewise at least partly motivated semiotically as representational. They employ a system of graphic representations that men, women, and children may also use in sand drawings to illustrate narrative meanings in everyday conversation, as Munn (1973a, 196) describes for the Warlpiri (see also Watson 1996). Recognizing the work of such a graphic system and its association with narratives of the country, one way in which people have interpreted paintings is as a mythical aerial view of the Aboriginal landscape, crossed by the passage and activities of ancestral beings.

The iconic elements of this system are circles, arcs, lines, and meanders. A visual element can represent any object to which its shape is "similar"; two people sitting together at a fire, for instance, may be represented by two arcs beside a circle (the fire). As with the Warlpiri graphic system (Munn 1966), each visual element conveys a category, a number of possible meanings. The meaning range of the circle includes camp sites, water holes, fires, vulvas, or circular paths — all items that are conceived as closed in contour and roundish in shape. A line similarly may represent a spear, a penis, a digging stick, a path. In any usage, typically, only one of the classes of meaning is relevant, so that extragraphic knowledge is often necessary to interpret the representation. The necessity of such information is rather important to some of the sacred designs because (1) their meaning cannot be "read" except by those who possess the necessary mythological information, and (2) frequently the designs represent not only events but also the sacred objects used by men in ceremonies. Ambiguity (or multivocality [V. Turner 1969]) constitutes part of their aesthetic force (Morphy 1984, 1992).

Let us schematically examine an example. The painting *Kirpinnga*, by Freddy West Tjakamarra, is conventionally — at one level — a map of his country (right). Circles represent water holes, caves, and hills; meanders signify snakes and their

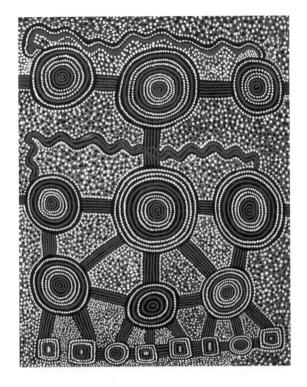

Freddy West's painting *Kirpinnga.* Copyright courtesy Aboriginal Artists Agency Ltd., Sydney, Australia. Photo by Fred Myers.

paths; straight lines represent travel paths. The upper, or northernmost, meander represents the ancestral, poisonous king brown snake (lirru), carrying thunderclouds, from one place (5) past a set of water holes called Yumpuwitiyanya (6), to Nyinminya (7), some water holes and a camp in the west. South of that line, in the center of the painting, is another sacred site, Wartunumanya (2), a cave from which flying ants *(wartunuma)* emerged in the Dreaming. The two rock python *(kuniya)* totemic ancestors passed near this place on their way to the large rockhole Kurukutjarranya (3) from Kumirnga (4), another rockhole. The rock pythons' songs indicate that they saw flying ants rising from the cave as they traveled. At the south, or bottom of the painting, is Kirpinnga (9), a cave inside a hill that has two other named holes or entrances (10 and 11) in the hill. Here yet another set of Dreaming ancestors carried their sacred objects, which they left behind, as represented in the rectilinear figure (8) at the bottom of the painting. The objects have turned to stone and are now relics in the cave. Pintupi requirements of secrecy prevent further disclosure except to point out that the organization of the design as a whole may also represent the shape of a sacred object.

Pintupi ceremonial designs frequently combine the basic elements in more or

less fixed configurations (unlike the transient assemblages of any ordinary story) that come to be linked with the specific Dreaming they depict. Thus the designs tell or reveal a story; they are iconic. But they are more than mere transparent referential instruments. Because they are believed to have been the designs of the ancestral beings themselves, handed down from the Dreaming, the designs are also intrinsically valuable, proof themselves of the Dreaming's existence.[6] Even the word for such designs is considered to be sacred, and knowledge of them, as well as the right to use them, comes usually as a consequence of ritual discipline and revelation, as a gift that must be reciprocated. They are not free.

Furthermore, the reference of these designs is not simply the story, and their referent is not merely the country or the landscape. The more one looks at Aboriginal paintings, the more one comes to understand that a painter doesn't just choose appropriate iconic signs—although iconic they are. Among desert Aborigines, it is well known, some men's designs may be incised on a variety of wooden or stone sacred objects; other designs are made in ceremony in various ways—in body decorations with bird down or vegetable fluff, or with ochres in body, cave, and ground paintings, in painted designs on shields, and so forth (right) (Meggitt 1962; Munn 1973b; Spencer and Gillen 1899). In an important sense, experience with these media provides a technical basis for the kind of design virtuosity expanded in paintings. We can consider this later, but it is also central to the Yarnangu understanding of their paintings with acrylics on various media as transformations of these designs, as still both iconic and indexical representations of the country and of Dreaming events.

As signs, the forms are themselves meaningful. They may be designs (walka) that the ancestors wore on their bodies and contemporary ritual actors wear in ceremonies, or they may be what are understood to be ancestral body decorations that have been metamorphosed onto rock faces, as circle and line designs or ritual objects turned into stone formations, or hills.

As Mountford (1977) discovered when he gave crayons and paper to Pitjantjatjarra men, the resulting image gathers together a number of elements drawn from ritual experience, narrative of myth, and knowledge of the country—a whole set of signs associated with a story. Moreover, the organization of images may reveal distinctive patterns and templates that are not necessarily narratively significant (P. Sutton 1988). Indeed, the template's similarity to, or difference from, those employed in other design contexts may be the information most significant for Yarnangu. That a design is Tingarri or Tjakipirri (Emu) Dreaming will allow participants to recognize their own relationship to it. Differences and continuity of design pattern and contrasts in the assemblage of specific elements provide a visual sys-

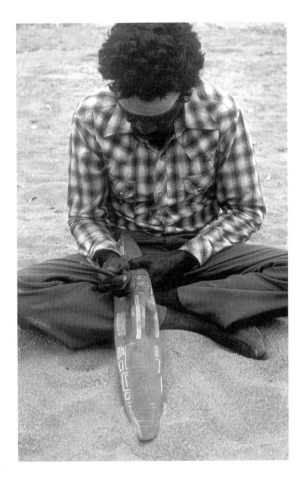

Timmy Payungu Tjapangarti incising shield, 1974. Yayayi, N.T. Photo by Fred Myers.

tem for signifying relationships among custodians of sacred sites — of distinctive and/or shared ownership.

Practices: The Materiality of Tjukurrpa

Ontologically, there is more to understand about the nature of these signs. The country is, as Nancy Munn (1970) brilliantly explained, an objectification of ancestral subjectivity. Places where significant events took place, where power was left behind, or where the ancestors went into the ground and still remain — places where ancestral potency is near — are sacred sites (known in Pintupi as *yarta yarta*).

The country is not the only objectification of such processes. Other parts of

Pintupi life are likewise thought to derive from the Dreaming. Pintupi understand that the Dreamings left behind at various places the creative potency or spiritual essence of all the natural species and of human beings. Thus an individual is said to "have become visible" *(yurtirringu)* — in reference either to "conception" (quickening of the fetus, when the mother first notices she is pregnant, denoting the emergence of the individual onto the physical, phenomenal plane) or to actual birth. The place from which one's spirit comes determines one's Dreaming; he or she is an incarnation of the ancestor who made the place. This understanding of personhood makes place a primary component of an individual's identity. Through conception, people are determined to have come from a particular country, literally to share its essence, and this "consubstantiality" (Munn 1970; Pannell 1995, 30) is the primary basis for "owning" a sacred site. It is one's property in an inalienable sense (Myers 1988a; Weiner 1992), part of one's substantial identity. A person, a yarnangu (literally, "a person," "a body," and, more recently, an Aboriginal person), is considered to have an interest in any place on the track of one's own Dreaming.

As a discursive formation itself, the Dreaming draws together a complex set of practices that one might see as combining what Marcel Mauss ([1938] 1985) theorized as "the category of the person" with what Claude Lévi-Strauss (1962, 1966) understood as the central problem of "totemism." As a "total social fact," the Dreaming discursively and practically articulates personhood and ontology, mediating significantly the sociopolitical relations between people organized spatially (in territorially dispersed groups) and intergenerationally into a system of identity, of similarity and difference, of autonomy and relatedness (Myers 1986a). It is a distinctive mode of cultural production capable of generating and transmitting value. The production of images, within this framework and especially in ritual, is a fundamental medium in which a person's — or a group's — autonomy can be expressed and drawn into relationship with others (Myers 1986a, 1988a).

The practices in which the Dreaming is embedded and the everyday social relations its articulation mediates in Pintupi life are different from those organized by European uses of what we call folklore, mythology, and narrative. European interests in mythology have sometimes obscured the phenomenological status of Aboriginal formations of knowledge. The social existence of such knowledge is not embodied as an abstract lore, in the form of folktales like those gathered by the Grimm brothers. Various Yarnangu are certainly able to formulate such knowledge in the "telling" of myths, but the authoritative existence of knowledge, of the Dreaming, lies in named places that Pintupi call ngurra.

Objectification in this form, the materiality of this knowledge, has distinctive consequences. For one thing, Aboriginal myth and ritual knowledge have ma-

terial qualities beyond the narrative structure; they have extension in space, insofar as the stories are linked to specific places, which may become an important material property in formulating a social identity among those who have rights to the stories. Stories and the ceremonies reenacting them, along with the associated paraphernalia and designs, can also be owned and exchanged; rights to speak and transmit them can become the object of social and political organization. Conversely, it appears that mythological and ritual forms may themselves be shaped by their deployment in such practices (Myers 1986a; Poirier 1996), as when institutions of revelatory instruction create — as an effect — esoteric and mysterious forms of religious knowledge (Barth 1975). Changing social relationships can also lead to reorganizations of mytho-ritual practice, to novel discriminations between, or linkages among, "places."

It is possible to translate, partially, the social practices of image making in terms of their resemblance to practices of intellectual property, of ownership and copyright. Like the rituals, of which they are considered to be part, Yarnangu say that the story-song-design complexes are owned or "held" (kanyinu) by various groups of people. The right to "show" (yurtininpa, "reveal" or "make visible") a ceremony is in the hands of what might be called "owners" of that country (especially those from that Dreaming) and their relatives. It was on such grounds that the men I knew typically painted their own country, painting — in this way — components of their own identity.

Ownership: An Individual's Repertoire

To understand the paintings as part of this system, it may be helpful to refer to a series of paintings made by Wuta Wuta Tjangala. I have chosen to work through this painter's corpus both because of its coherence and because I know it best. I will return to Wuta Wuta's work in chapter 3 in order to consider its formal development. Each painting represents a place that he regards as "his" country — his country because the place was created by *his* Dreaming, because he grew up around it, or because his father died near it. The set illuminates some of the range of possibilities open to a single individual, and close consideration of the series here illustrates both the iconic dimensions of the sign system (as representational) and the indexical reference to Dreaming cycles over which the painter has rights. In the second sense, the paintings signify an important dimension of Wuta Wuta's social identity, dimensions he may share with others who have rights to the same places. As we will see later, not all of their paintings, even of the same places, will look the same.

The Old Man (Yina) Dreaming was one of Wuta Wuta's most typical subjects,

The hill at Sandy Blight Junction, Tjukanyina.

Sketch of *Tjukanyina*.

and I present the paintings in terms of their position in the narrated sequence of the Old Man's journey through Pintupi country. The Old Man began at Kampurarrnga in the Henty Hills and traveled westward, stopping at Tjukanyina (above, executed in 1974), a giant hill marked by a circle (feature 1) where the Old Man was lying down. Feature 2 indicates the spot where the Old Man defecated a sorcery object, and the marks of feature 3 are the tracks of his feet where he squatted to defecate. The square around the central circle is said to be "feces, all around." Feature 4 is his head, where he was lying down, and the other circles represent various water holes in the creek beds flowing down from the hill. The Old Man is known for his travels, and the vertical pathway represents "his road."

From here, the Old Man traveled west toward Ngurrapalangunya (above right), an area comprising three separate named places. The place marked (1) is a cave called Tjuntamurtunya, whose name is derived from a small Dreamtime creature known as Tjuntamurtu (Short Legs), likened by some Pintupi to a gorilla. This was the painter's own Dreaming, the place where he was conceived. The creature

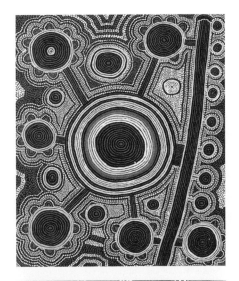

Wuta Wuta's painting
Ngurrapalangunya, 1974.
Copyright courtesy
Aboriginal Artists Agency
Ltd., Sydney, Australia.
Photo by Fred Myers.

Wuta Wuta's painting
Yumarinya, 1979. Copyright
courtesy Aboriginal Artists
Agency Ltd., Sydney,
Australia. Photo by Fred
Myers.

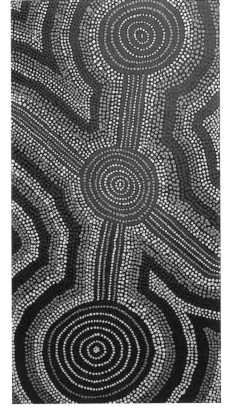

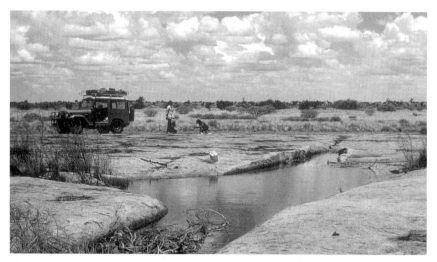

The main rockhole at Yumarinya. October 1974.
Photo by Richard Kimber.

was frightened by the sight of the Old Man, who carried dangerous sorcery objects ("pointing bones," *pungkuninpa*) in his headdress.

Seeing his approach, Tjuntamurtu ran and crawled inside the cave, frantically tossing out the sacred objects stored there. These sacred objects became the hill Wintalynga (4), which lies south of the large claypans (3) of Ngurrapalangu and perpendicular to the hill where Tjuntamurtu was originally left behind by two traveling Tjukurrpa women, Kungka Kutjarra. These two set him down while they danced a woman's dance *(nyanpi)*, and in dancing, their feet created the bare ground of the claypans (3). After rainfall, these claypans are the source of a seed-bearing plant known as *mungilpa*, whose seeds were ground into cakes (2) and eaten in the days when Pintupi lived by foraging. The painter's mother ate these seedcakes, he told me, and thus he was conceived. Therefore his conception Dreaming is said to be Tjuntamurtu, connected both to the Old Man story and to the Two Women Dreaming.

After passing this area, the Old Man went on to Yumarinya (Mother-in-Law Place), now an X-shaped rockhole among the sandhills. The painting represents the rockhole that was created by the body of the Old Man when he lay down (above, and see page 41). Feature 1 of the painting represents the man's navel; feature 2 is his head. Feature 3, another circle, is his crotch, covered by a pubic tassel. The line to the top left, feature 4, represents his legs; and feature 5, another line, represents the man's hairstring belt, which left a mark (a line of color) inside the rockhole.

Feature 6 signifies the Old Man's spear and also the designs he wore on the sides of his body. These are now used to represent him in ceremonial activities. From this spot, the Old Man arose in the night to copulate illicitly with his mother-in-law.

A 1979 painting Wuta Wuta executed on a wooden dish *(pirti)*, represents a named place immediately next to Yumari rockhole (see page 44). It is named *Tilirangaranya* (Light Fire and Stand). Made on a small, carved wooden dish, this painting signifies the salient group of standing rocks left by the Old Man when he lit a fire (1) in the morning after copulating with his mother-in-law and stood (2) beside it for warmth, singing out that he was ready to move on. The horizontal lines of feature 3 represent a vegetable fluff design that the Old Man wore on his thighs, and the wavy line of feature 4 represents the wind made by his testicles as they traveled by themselves.[7]

Finally *Yarrpalangunya* is another point on the Old Man's travel path (see page 45). The curved lines in this 1979 painting signify wind, and the yellow dots depict ants who were biting his penis in punishment for his illicit sexual activity with his mother-in-law, a taboo category of relative. At Yarrpalangunya, in limestone country, a strong wind sprang up, generated by his penis as it flapped in the air.

These are not by any means the only stories Wuta Wuta painted, nor was identity restricted to that objectified in the Old Man Dreaming. He had rights to a broader range of places in his country and their Dreaming on other grounds of kinship and shared residence — the stories of the Emu Dreaming, articulated in his paintings of places such as Rilypalangunya (see page 45), and to Tingarri ancestors for Lake Mackay (or Wilkinkarranya, as it is known), and many others.

Land as a Sign: Place, Identity, Difference

The stories of Wuta Wuta's paintings, his country, are charming and sufficiently mythlike to allow many Westerners to see such paintings as "landscapes," or as the culturally poetic imagination projecting itself onto the landscape. In this sense, the tendency to reify such performances and to treat them as an intellectual structure alone, rather than as an outcome of humanly organized practices, concerns me. If the Dreaming makes of the world a home for its human subjects, it does so as much in social action as in contemplation. The country and the Dreaming are both articulated within a system of social action where their value is formulated by their capacity to delineate relationships of similarity and difference, by their potential as tokens of identity and exchange. The country — a place — is itself a sign

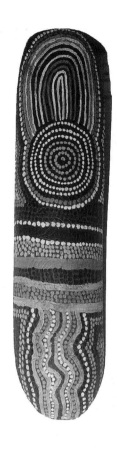

Wuta Wuta's painting *Tilirangaranya* (1979) on wooden carrying dish. Copyright courtesy Aboriginal Artists Agency Ltd., Sydney, Australia. Photo by Fred Myers.

Standing rocks at Tilirangaranya. October 1974. Photo by Richard Kimber.

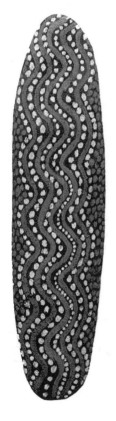

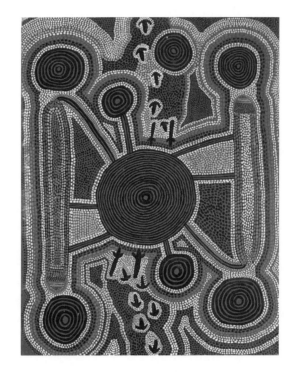

▲ Wuta Wuta's painting *Emu Dreaming at Rilypalangunya*, 1975. Copyright courtesy Aboriginal Artists Agency Ltd., Sydney, Australia. Photo by Fred Myers.

◄ Wuta Wuta's painting *Yarrpalangunya*, 1979, on wooden dish. Copyright courtesy Aboriginal Artists Agency Ltd., Sydney, Australia. Photo by Fred Myers.

entwined in a web of semiosis,[8] in the narrow sense representing what happened in the Dreaming, but it is also in its full materiality a token that enters into a wide range of social relationships.

The term "totemic" has often been used to describe Aboriginal ceremony, referring to an interpenetration of "natural" and "human" in which people typically had special relationships with animal or plant species. In his famous little book *Totemism*, Lévi-Strauss (1962) proposed a view of totemism that has been fruitful for understanding it as a system for classifying people—for organizing human similarity and difference into a comprehensive system by likening these social differences and similarities to those of "natural species." This metaphorization had the consequence, he argued, of making human differences and similarity seem "natural," unchanging, or essential as opposed to historical productions of human action.

Lévi-Strauss emphasized natural species, arguing that their semiotic value was based on their capacity to articulate sameness and difference, but narratives of ancestral travel are able to construct a similar structure, and it is in precisely such a system of identity and difference that "place" is meaningful in Aboriginal Central Australia (Strehlow 1970). "Country" comes to embody identities, possibly in ways that are distinctive or socially specific for the Pintupi, through processes of which Tjukurrpa and the values embodied in paintings are emergent parts.

Almost invariably, as we have seen, Pintupi discussions of country are punctuated by descriptions of what happened in the Dreaming. These stories and the places they endow or describe are owned by particular groups and controlled by men (and women) who have the right to display the ceremony. Where a myth in its entirety may encompass the travels of ancestors through a great number of places and many ceremonies, a Dreaming track links several localized groups. It joins the groups at one level and differentiates them within it. Because initiation (of men) has been necessary for them to gain a wife and to gain access to the religious knowledge that defines adulthood, access to religious knowledge (and its distribution) has structured the defining social relationships of Pintupi social life—that is, the relationship of young men to old men and of women to men—just as it has structured the relationships of locality. However, the meaning of these places, their value, is constructed not by the application of some pure cultural model to blank nature (Ingold 1993) but in activities that constitute relationships within a system of social life that structures difference and similarity among persons. This is a system of practices for which "land" is one medium, and one I have described in great detail elsewhere (Myers 1986a, 1988a, 2000).

For the Pintupi, as foragers whose mode of production and environment re-

quired periodic spatial dispersal and aggregation, the principal problem was that of maintaining one's relationships with people in one's own residence group as well as with those from "far away." Yarnangu had to manage the intense, immediate claims of kinship from those with whom they were living as well as the obligations, desires, and necessities embodied by those living elsewhere. The contradictions involved in managing these different relationships of identity were structured, or mediated, in the existing systems of kinship terminology, marriage exchange, and ceremonial organization. These different institutions of identity and exchange are media for sustaining political relations over space and time in conditions that combine aggregation and dispersal. Their embeddedness in such social processes is central to the way place in general and places in particular acquire sociocultural value.

Place and Identity: Circulations of Tjukurrpa

A person's identification with a named place, with the country, is said to come from the Dreaming, but its actual establishment as social fact always requires acceptance by others who have previously acquired knowledge and control of the stories, objects, and rituals associated with the ancestral beings. Only some of the many bases for claims of identification with places and Dreamings are illustrated in the sequence presented for Wuta Wuta's case (Myers 1986a). The essential feature is that a person's identification with a named place, with country, is brought about through processes of transmission by those who are one's "relatives" (walytja), especially those who looked after him or her as a child. All of a man's or woman's grandchildren may be identified with his or her country, an identification that makes them "one countrymen." Conversely, country is a medium in which the shared identity of a distinctive set of kin, of "one countrymen," is objectified. One's identification with a named place, and its Dreamings, is at once a definition of who one is and a statement of shared identity with others.

Why does this matter? "Holding a country" (kanyininpa ngurra) constitutes an important dimension of enacting one's identity. Recognized identification with named places and the rights to related ceremonies, stories, and designs provides opportunities for a person to be the organizer of a significant event, and therefore the focus of attention. It empowers Yarnangu in this specific sense, and it is no surprise to men such as Charley Tjaruru that exhibition of this knowledge might grant them recognition in far-off Sydney or even England, creating new social ties. Moreover, what might neutrally be regarded as the performance of myth-based ceremonies—ritual reenactments of the Dreaming at a place—by one group of

landowners for others is understood by Yarnangu as a form of "giving" (*yunginpa*) or exchange between people (both men and women) who are equivalent to each other. It can parallel marriage exchange. The ability to exchange ritual and ritual knowledge is the characteristic means of establishing one's autonomy—the capacity to act—and one's identity. When men, whose case I know best, display their ceremonies (give their country) for those who are themselves fully initiated, they expect they will eventually be reciprocated with a display of ritual knowledge, of country, from those to whom they had given. As an element in a cycle of exchange, the display makes people who see the ceremony, in a sense, distant co-owners. Therefore it extends a degree of identity to them as "one countrymen" (those who hold a place collectively), as well as signifying those who have recognized each other by giving their most valued items of exchange into the other's holding. Being an owner, having an identity with country, places a person in a position to participate equally with other fully adult persons: in offering ceremonial roles to others (as part of an exchange) and sharing rights in ritual paraphernalia.

What, then, is the expectation of giving such knowledge and designs to whites, or "to Canberra"? Yarnangu must wonder about this themselves. Do the recipients become obligated? Is a relationship established with them through the gift? These exchanges are not cargoistic, in the sense that Yarnangu *fully* expect great returns. What the painters appear to anticipate is that *some* relationship exists, in which they have done their part through prestation, giving and receiving objects of significance.

The "giving" described so far is different from the revelation of ceremonies to young men who are not yet fully initiated and therefore not fully equal. Yarnangu are concerned with teaching men and women the ritual knowledge necessary to "look after" (kanyininpa, also "hold") the country. They speak of "giving" knowledge or of "making knowledgeable" *(nintininpa)*. Although transmission is involved, the analytical language of "inheritance" and "rights" can be misleading, ontologically misconceived, because what is being transmitted in giving of this order is identity. The emphasis in these processes is not just on getting rights in land but as much on socializing the younger, on the social production of persons who can "hold" the country, a relationship constituted precisely in ritual performance and designs. Image making enters not simply into an economy of rights, imagined as distinct from the rest of social life, but into a system of social reproduction.

It is not just a story—however valuable—that Yarnangu paint when they paint Tjukurrpa or their country. These stories and places embody, through the processes of their exchange and transmission, identities already formulated. Whereas

other personal objects are dispersed at death and not allowed to carry the deceased's identity forward in time, Yarnangu strive to pass on to their successors an identity formulated through ties to named places. I remember how my friend the painter Shorty Lungkarta put pressure on his son Donald to attend his ceremonies and to learn so that he could "pass on" this country. What a father passes on, or transmits, in this way is not personal property that he has created or accumulated himself but an identity that is already objectified in the land.

I had occasion to see these practices at work during a trip I made to the Gibson Desert with Wuta Wuta Tjangala and several others. Wuta Wuta decided he wanted to take us all to see an important place to the north, to *nintintjaku* (show or teach) his *katja* (a term that can mean both "son" and "sister's son"): Ronnie (brother's son), Morris (own son), and Hillary (sister's son). Two other older men opposed this. They said they feared the young men would use the sorcery spells from this place when they were drunk. Keen for knowledge of his country, Ronnie framed his response to their objections in a noteworthy fashion: "All right," he said, "then nobody will ever know about that place when you all die. If people travel around out here, they'll just go up and down this road only." In other words, his irony suggested, the place would be lost.

Wuta Wuta hoped to establish an outstation near the place where his father had died. His brothers, he told me, were nearly dead; only he was still strong enough to "give the country, *katjapirtilu witintjaku,*" for these descendants to hold. This would constitute for them a particular identity as holders of the country. Dick Kimber recorded a few years later how Wuta Wuta took some of his "daughters" to a similar site, which I believe was his own Dreaming place—Ngurrapalangu—whose claypan is a source of the seed-bearing mungilpa plant (see page 41). Although they were not allowed to see in detail the most sacred and secret properties of the site, Wuta Wuta revealed to them where these were to be found, so that—one presumes—they could pass on such knowledge to appropriate male kin (Kimber 1990, 7).

The Pintupi understand social continuity as the giving or passing down of country as an object from generation to generation. The elders—like Wuta Wuta's and Charley's "grandfather" who lost his stories—are said to "lose" or "release" (*wantininpa*) what they have. This giving is, however, understood as a kind of exchange that Annette Weiner called "replacement" (1980), a contribution to the substance and identity of the recipient. Elders consciously attempt to transmit their identity through time by creating the same identity in others, replacing themselves through time as holders of country.

As recipients become owners of particular places, taking on an identity they

share with others, they have also, as it were, acquired an obligation, a responsibility that they can repay only by teaching the next generation. Pintupi stress that men must hold the Law and pass it on. Because men are enormously concerned to pass on their knowledge and identification with places to their "sons" and "sister's sons," ritual or landowning groups effectively represent those previous owners who have held and grown up (that is, the children of "those from one camp") and to whom they subsequently give knowledge of their country. Here, then, is a measure of what kind of value is held to be involved in the knowledge and capacity to produce images of the Dreaming. This knowledge and activity, in its original context, provided younger men with the opportunity and basis to establish themselves as equal and autonomous with other men—and to become capable of investing this value in juniors.

Ontology, Politics, and Value: The Dreaming as Total Social Fact

There are further stakes in local understandings of the person articulated here, stakes that I have attempted to explain in earlier work on the Dreaming as embodying a "practical logic" (Myers 1986a, 48), mediating relationships particularly among equals. Yarnangu typically deny any role in the creation of their culture, insisting that the Dreaming is not "made up by men" but is—rather—a "big Law," which comes from outside human subjectivity. Thus power, authority, and creativity are ascribed to this ontologically prior period. It is not that Pintupi lack what we call creativity or change, but that such processes are structured differently in accordance with the constraints of relations among persons conceived as equal. What we call creativity, the articulation of novel cultural forms, emerges in a negotiation that requires social recognition and is attributed through such processes to more authoritative revelation from outside social life (Myers 1986a; Poirier 1996).

Such theoretical speculations aside, Yarnangu find that knowledge of the Dreaming, of what happened, is empowering and highly valued, but not freely available. It is controlled by elders and can be gained only through processes described as "giving" (yunginpa) or "revealing" (yurtininpa), usually in ceremonies, and requiring reciprocation of gifts, respect, and deference to those who transmitted it. Young men and women—in their own sex-segregated ceremonies—acquire the knowledge necessary to harness the dangerous powers left behind by the Dreaming. Typically, these are rites of passage, and acquisition of this knowledge is experienced as both costly and empowering. They require ceremonial exchange, gifts of meat, called *kunartinpa,* as Shorty Lungkarta and others told me, and as I learned myself whenever I was shown a new ceremony or sacred objects.

General knowledge of the stories may circulate rather freely, but initiates are granted revelation of specific secret (although essential) details of these stories. They may learn, for example, that the object used by the ancestral Native Cat (*kuninka*) to open a cave is not really a digging stick, but rather a ritual artifact. They may learn the true nature of the sorts of designs he wore and how these facts relate to the marks on, or powers invested in, particular places in the landscape. Thus a certain rock is the Native Cat's sacred object turned into stone, and *this* song activates its power. And of course, they learn these not in a neutral manner but in the highly charged atmosphere of ritual discipline and revelation.

Differences in knowledge, then, mark distinctions of status and identity within Western Desert society. Notwithstanding Aboriginal insistence to the contrary, the authoritative versions of knowledge are not necessarily timeless formations. Even the fragmentary historical information we have suggests that some of these differences—which appear as new details or new stories—are motivated by the desire to distinguish or to constitute new social relations (Myers 1986a), to construct new formulations of similarity and difference among people. Myths that at one time were understood to be separate may be "discovered" to actually be linked in the Dreaming, as those identified with the different stories formulate for themselves a new shared identity.

Access to, and control of, sacred sites is restricted. Rituals are performed there, reenacting the events of the Dreaming, and the prerogatives of custodianship of their powers are guarded zealously. They are, in effect, owned by groups of men and women who in turn are responsible for their care. The Old Man series of paintings by Wuta Wuta Tjangala was an artifact of just such relationships and processes.

Imaginings

The particular formulations of ownership vary throughout Aboriginal Australia, but the overall features of these relations of image production are fairly consistent, at least in Central Australia. In articulating their contemporary practices, the painters have drawn on a framework that is not particularly concerned with the usual sources of value for cultural objects marked as "art" in the West. They represent, in fact, the movement of acrylic paintings into the purview of Western viewers and patrons in terms that challenge the ways in which cultural objects are familiarly formulated for us, in terms of an ontology and set of practices drawn from the world of their production, imagining or asserting their circulation to be articulated in the terms of the local economy of exchange, a revelatory regime

of value. The paintings, it was sometimes said, were being given "to Canberra," understood as the site or country of the Australian federal government on whom the Pintupi were dependent, their mayutju, who by virtue of this giving or revelation were thereby drawn into a relationship of monetary obligation or moral identity. For individual purchasers, the gift required appropriate compensation. Although Wuta Wuta's claim that he should have been paid "four hundred thousand dollars" could perhaps not be sustained, the painters did expect that buyers would recognize that payment was for Dreamings, not for execution.

The complexly intersected world of actual narration, of the painters' actual discussion, seeks its reference in broader frameworks. I use "framework" here in a way similar to Howard Morphy's use of "frame" — "in reference to the encompassing set of cultural practices and understandings that defines the meaning of an object in a particular context" (1992, 21). It was, of course, these frameworks that I, as an ethnographer, was attempting to learn.

An ethnoaesthetic reliance on local categories, however, is not enough for understanding that which is found in the work itself—any more than a speech act can be reduced to its semantic content. To grasp the discourses through which Pintupi conceive of their work is necessary but not sufficient as they engage with the intercultural field of social relations. They are very situated framings, and in the light of what we know historically about the development of painting practice (the periods of distinctive styles), these accountings begin to look less stable.

The paintings may be closely related to traditional ritual, but how are we to understand and explain the transfer or transposition of one set of practices onto another? Painting is not ritual, nor is it myth. The meanings and practices of ritual performance, design, and mythical narrative are not a cause—the absolute determinants—of contemporary form but the context in which it is understood. Their deployment occurs in accounts of painting, not as a seamless whole but as a "stitching together" of available discourses. If the meaning of painting as a social activity is to be understood, there is more to be known than its referentiality to the mythic Dreaming.

The difficulty lies in the choice of strategies to represent these practices and discourses; the danger lies in oversystematizing this formation, in making it a different kind of thing than it is "for them." I do need to tack back and forth between the broader frameworks on which participants draw, but I want to avoid substituting my own analytical system, the analytical objectivation (Bourdieu 1977), for their reality. Rather than simply abstracting the discourses that might be said to underlie Pintupi accounts, I have taken up the practices through which Aboriginal producers assign significance to their productions. As Sally Price made clear

in *Primitive Art in Civilized Places* (1989), representations of non-Western art have been haunted by the supposed divide between the unchanging, authentic, and exotic traditional "primitive" and the changing, hybridized, inauthentic contemporary painter. A focus on "pure culture" or "cultural background" would serve to sustain this divide instead of clarifying the way in which culture making takes place in the articulation between different modes of cultural production.

Indigenous accountings and practices are embedded in social processes that are available to interpretation rather than mechanically invoked. In looking more closely at the contexts of producing and accounting for paintings, the fuller—sometimes contradictory—range of meanings that they embody or condense comes into view. Not everything about the painting is inside the frame.

2 Practices of Painting: A Local History and a Vexed Intersection

Usually the problem of meaning in traditional art is managed cross-culturally by offering a reduced, schematised gloss of some figurative meanings associated with non-western and unfamiliar images. . . . This may be justified [for Warlpiri paintings] because for the Warlpiri community, these are in a sense representational paintings, as Nancy Munn has claimed. The "true" and "proper" Warlpiri vision of the landscape is conveyed graphically to the initiated viewer. But something false and damaging may result from the invitation to peek into the painting and select out a few figures to serve as handles in the construction of a meaning satisfying to the uninitiated viewer. Warlpiri designs are learned and employed in many social and ceremonial settings. This learning process is exterior to the painting. Increased aesthetic sophistication or treatises in art criticism provide no substitute. These only rescue the mystery of the ambiguous so that the European observer is able to construct a readable text, indeed may take pride and pleasure in doing just this. The confrontation with the image is reduced to an exercise in cryptography.
— Eric Michaels, "Western Desert Sandpainting and Post-Modernism"

Although Pintupi acrylic paintings are often said to be "about" the country and do in fact tell the stories of the Dreaming, the ways in which Yarnangu conceive the paintings' value go beyond these terms of translation. The interpretive movement from visual image to the landscape as its reference to the Dreaming features it represents or to the story is useful enough in identifying the broad context in which Pintupi account for their paintings. It cannot do justice to the potential meanings of paintings, however; it cannot explain what and how the paintings mean or signify. What the paintings are allowed to "say" or mean in such an account is too limited, reduced to a narrated message about events "out there." Because painting is neither myth nor ritual, there are problems in relying too heavily on such cultural translations of iconography.

It helps to recognize that our representations might be what Pierre Bourdieu (1977) refers to as "objectivations" by the analyst, products of analysis rather than

the reality of a cultural entity in its own right. Emphasis on iconography is doubly an objectivation, reifying a particular project of documentation and focusing on the exotic message, but ignoring the social field in which painting operates, a field that is jointly European and Aboriginal. It is, moreover, a field in which the anthropologist or analyst is a participant. Bourdieu has noted that such objectivations tended to be "intellectualist," the product of a theoretical gaze or a "contemplative eye" (Bourdieu and Wacquant 1992, 69). By this, he means that they picture "all social agents in the image of the scientist (of the scientist reasoning on human practice and not of the acting scientist, the scientist-in-action) or, more precisely, to place the models that the scientist must construct to account for practices into the consciousness of agents, to do as if the constructions that the scientist must produce to understand practices, to account for them, were the main determinants, the actual cause of practices." To recognize the properties of this intercultural field, in this chapter I want to pursue Bourdieu's (1977, 1993) general recommendation for attention to "practices." This necessitates moving away from iconography alone to considering acrylic painting in its contemporary forms as a signifying practice that can enter into a changing field of cultural production. At the same time, if I am not to erase some of acrylic painting's most salient qualities, it necessitates an objectivation of my own engagement in this field.

Greater consideration of the social organization of producing and circulating images is one dimension of this study. The conversations I had with men such as Charley Tjaruru and Wuta Wuta Tjangala did involve practices of painting as an activity more broadly. They talked about what the paintings represent—the Dreaming (Tjukurrpa) and the country (ngurra)—but they also insisted on the importance of having learned to paint in ceremonies, through initiation, expressing their sense of the social dimension of the ways in which people gain knowledge to paint.

Putting Designs in Ritual

Ritual performance provides one of the principal occasions for the making of images that are *tjukurrtjanu*, from the Dreaming. Yarnangu have many types of ritual and ceremony. Each type of ceremony has its own repertoire of images, done on the body or the ground, and distinctive artifacts (sacred objects) made to accompany the performance. How this repertoire of images informs those produced in acrylic paintings is only one dimension of the transposition from ritual to painting. At least as important, especially in light of recent criticisms of modernism in Western art practice, is the organization of image making itself—where, as Eric

Michaels (1988) argues, Aboriginal practices challenge cosmopolitan assumptions. Many writers have pointed to the significance of the ceremonial division of labor into patrimoieties (*kirta*, "owner," and *kurtungurlu*, "manager") or generational moieties, expressive each in its own ways of societal wholeness as an organization of exchange (Munn 1973b; Bell 1983; Maddock 1972; Meggitt 1962; Morphy 1984; Myers 1986a; Tonkinson 1978).

The scene of ritual is evocative, and more casual than such images suggest. Typically, a good deal of time in ceremony is spent on preparation, which occurs in very close proximity to the performance area, but out of sight of children and members of the opposite sex. It may be necessary, for example, to prepare the materials of decoration: *yurtalpa* (vegetable down) is made from pounding the fiber of wild daisies, to which might be added flour, to make white down, or red ocher, for red down; red ocher will be prepared by grinding it with a stone into powder. Usually, songs from the Dreaming involved in the ceremony will be sung throughout the preparations, which can take several hours.

When the materials are ready, they are applied in the appropriate designs — usually on men specified as performers, from the "owner" patrimoiety — by members of the opposite kurtungurlu (manager) category. Yarnangu understand this division of labor, too, as a form of exchange: absolute autonomy is impossible, and one needs others to perform one's own ceremonies. In return for the work of the kurtungurlu, one will eventually take on the same tasks for them. In one of the first ceremonies I observed (Journal, 12 August 1973), decorations were put on the upper body and face of the dancers as they sat or reclined. Timmy Payungu Tjapangarti — then a middle-aged man — decided on the appropriate designs for a ceremony celebrating the ancestral men who traveled along the creek to Haasts Bluff, near to Yayayi. Mulungu, as Timmy was known locally, was decorated for the performance, along with Willy Tjungurrayi of the same patrimoiety, by men of the opposite patrimoiety, including Yanyatjarri Tjampitjinpa and Freddy West Tjakamarra.

In keeping with Pintupi concerns for restrictions on the circulation of ritual knowledge, I cannot be specific about details, but I can give some relevant information. The vegetable down is placed on the body in small bunches with an adhesive that is smeared on in a design with a stick or a finger. When ochers are the principal decorative material, as in most Tingarri ceremonies, the body surface is usually covered with glistening fat before a design is traced, pressed, or smeared onto the skin with a finger dipped in the ocher. At the same time, men construct and decorate a variety of ritual props and sacred objects for the performance: headdresses, shields, and other accompanying objects that were carried by the ancestral figures.

During these preparations, some — but not all — of the men continue to sing, not loudly but fairly steadily. Other men may play cards or prepare tobacco, waiting for the performance. There is often a good deal of conversation and even excited disputation about whether the designs and objects are appropriate, as judged by men. Sometimes the objects and designs are formally shown to the "owners" for their approval. Such moments can provide occasions in which men are able to exercise their distinctive authority over particular stories, designs, and songs, but usually this is somewhat masked by attempts to demonstrate a fellowship of shared authority. Typically, several individuals have significant claims of identity with the Dreaming being enacted. Thus in the context of performance there is an attempt at managing or transforming what might be potentially conflicting claims into an enactment of shared identity (see Myers 1988a).

This enactment of shared identity gives ritual its drama and political significance. If ceremonies ought not to be performed without the permission or presence of everyone with a meaningful interest, then bringing about a successful performance requires diplomacy, knowledge, and managerial skill. Such responsibility is not without risks. To neglect appropriate consultation may be regarded as an unwillingness to recognize another's claims or rights, and such failures can lead to jealousy, feuds, and threats of sorcery; they may be reconciled through compensation.

Unquestionably, those principally identified with the Dreaming being enacted find in ceremonies a moment for personal recognition. During a pause in the singing, Timmy Payungu told me, "This is my Dreaming; we got to bring 'em back now." And the occasions are appreciated for their success. When the ceremony was over, everyone thought this was "a proper good Dreaming," indicating "Number 1" with the thumbs-up sign.

I described in chapter 1 some of the ways in which the "showing" of paintings is put into practice. But the removal of painting practice from its location in the Aboriginal system of exchange has had a range of effects. In the next few sections, I will consider painting, its practices and meanings, as a historical activity in contexts of individuated production, changing audiences and economies of knowledge, and commercial exchange.

Painting

In ceremony, the fabrication of symbolic forms constitutes an individual's identity as part of a larger system of relations with others (Myers 1986a). This may involve cooperation or consultation in production with others who have subsidiary or equivalent rights to the Dreaming story. But at Papunya and Yayayi in the

early 1970s, production for sale outside the system was organized around works by individual artists, and little recognition was given to the shared rights to Dreamings. By mid-1973, painters were individually being given specific canvas boards to paint, and individual authorship was recognized in the practice of exchange. For each painting, the art adviser paid the individual whose painting was bought, recording the "artist's" name as the author. No payments would be made to other "owners" of the same Dreaming, even though I have heard occasional comments from such "owners" that they thought some of the money should have been theirs. In this way, the social organization of acrylic painting at Papunya and among the Pintupi is a distinct departure from that of ritual.

Although a number of painters would typically sit together in the painting camp, each usually worked on his own board. I never knew the painters to inquire of others—or even to consult co-owners—for permission to paint an image. This is a far cry from the more collective approach to sandpaintings or even to body decorations, which are rarely the product of individual effort.

Like these more collective practices, however, the work of acrylic painting places the painter at work on the horizontal plane, "on the ground" (Watson 1996). The process of painting involves first priming the canvas surface with a background color (usually black or red ocher), then painting in with a brush the main features (concentric circles, meanders, connecting lines, and so on). In the final stage, the painter—perhaps with some help from others—fills in the background space with "dots," using a twig, a wooden matchstick, or a brush. Both the design forms and the dots in acrylics are understood as being equivalent to similar usages in ritual, and they are referred to in Pintupi by words that are identified as forbidden to speak, as *milymilypa*—"sacred."

While painting, a man frequently sings or hums the relevant songs, but he does this mostly to himself and is almost never joined by others. Conversation about a range of topics circulates; it may include the Dreaming being depicted, but it can just as easily be gossip from the previous day or plans for hunting in the future.

It seemed clear to me that there was a different physical relationship between the painter and the surface of the canvas or canvas board and the body or ground on which paintings were once principally "put" *(tjurninpa)*. Painters refer to their activity either in the borrowed construction *paintamilarninpa* (combining English "paint" with Pintupi *milarninpa,* "doing") or in the phrase from ritual, *walkatjurninpa,* "putting design." The most typical design practice for Pintupi ritual would be spreading ochers onto the body's surface with the finger, an activity replaced by the use of brushes and paint.

Working with painters at Balgo, however, Christine Watson (1996) has brilliantly drawn attention to the ways in which our descriptions of painting may

have naturalized practices that are deeply embedded in distinctive cosmologies. The idea of putting or placing a design may involve distinctive tactile values for Balgo painters, she argues, which involve a penetration of the surface, "of piercing a medium or producing impressions in a material or ground" (1996, 69). Watson suggests that "the use of the finger as the basic tool in *walkala* makes it a haptic as well as a visual medium. There is a direct connection between the touch of the person indenting the sand and the visual designs they produce" (68). In making this argument, Watson relies partly on an apparent similarity between *walkala,* which is "the main Kukatja word used for drawing on the ground with the finger or a small stick" (63), and *wakala,* which means in Kukatja (as in Pintupi) "spear, pierce, or poke." She argues that "the concept of spearing or poking is fundamental to local definitions of sand drawing" and that the word "*wakarninpa* has now become the dominant word used . . . for painting on canvas" (70). The practice of "piercing" as the type of design production provides for an articulation between different realms, a transmission of the images' essence within the body or surface. The phenomenology of this argument provides possible insight into the relationship between bodily practice and cosmology.

As intriguing as this analysis may be, I never heard anything from the Pintupi painters to support the view that the concept of "putting designs" (walkatjurninpa) has any relationship to the word for "spearing" or "piercing" (wakarninpa). Linguistically, they appear to have entirely different roots. Moreover, the phrases in use to describe the practice of painting are both distinct from the word for "writing" (wakarninpa), which is precisely—and contrastingly—the word for "piercing."

How are we to understand these differences, then, among painters—Kukatja and Pintupi—whose languages and cultural backgrounds are almost identical? Can it be that they have developed distinctive ethnotheories of painting, different aesthetics of the surface? The cerebral propensity of the painting practices that emerged from Papunya and Yayayi suggest precisely this increasing or relative withdrawal of the painter from engagement with the haptic dimensions.

Individuation

The value of Western painting, especially after 1800, has been understood to lie largely in its place in the history of art, in the artist's distinguishing himself or herself, breaking conventions of the past. The practices of the art market (exchange) and the circumstances of previous ownership (indexicality)—family resemblances to the ways in which Yarnangu value designs—are also certainly important to a work's value. While there are, of course, submerged tendencies toward some of the

individualist values of Western art production, Pintupi painters claim to distinguish themselves by knowledge of, and continuity with, predecessors, rather than by originality.

This would appear to mean an invariance in the images produced, but that is not what has occurred. To understand this conundrum requires a local art history. The production of images in a new medium has included a change in the productive process toward a focus on individual work, a change that finds expression in the development of clearly individual styles and greater variation and experimentation.

The current context of painting is one in which a single individual plans and creates a painting, responding to the constraints of the medium, "playing" with the space, creating a "balance." Operating in this fashion has enhanced awareness of the medium and its space. Individuals who have experience of painting in the new medium work differently from others, even though they all have experience of ritual painting. There is also a basis for aesthetics in earlier practices of ritual decoration and incised design work on artifacts such as spear-throwers. The organization of space in *churinga* designs—reported by Roheim (1945), Mountford (1977), and others and valued in recent auctions—is quite easily transferred to two-dimensional spaces.[1]

I have noticed that beginners in the acrylic form have had to learn to be less sloppy with dots and outlines and have adopted as well the paradigmatic application first of primed background, followed by the essential features of circles and lines, and the final addition of dots. Painters communicate with each other about these simple essentials. This is relatively easy, since the painters do not usually work in isolation from each other. In the first several years, they worked in a single area where they saw and were influenced by each others' paintings. The painters I knew in the early 1970s, however, were not influenced by, or much interested in, Western forms, although some, like Turkey Tolson (Megaw 1982, plate 42), could draw and paint in a Western manner. Given the extent of their use of, and familiarity with, Western goods, there is a remarkable degree of isolation from Western art forms in their painting.

With commercialization, a specialized artist's role has emerged. In the course of a year, a painter may do as many as thirty to fifty paintings, many more than a person might have created in ritual contexts. Without the constraints of the ritual situation, with a new medium, and with generally multiplied opportunities to paint, Pintupi artists have developed individual styles, experimented, followed fads, and perhaps developed a growing awareness of the painting as representing a choice in aesthetic value. While increasing volume has stimulated invention in

some ways, too much painting—it has been argued—has resulted in repetitiveness and formulaic painting (Crocker 1981b, 1987, 23–24).

I will consider and illustrate such developments in visual form later. Suffice it to say that the evolution of individual, distinctive styles and aesthetic problems is evident from looking at the work of any of the painters over time. The temperamental differences between men such as Yanyatjarri Tjakamarra and Wuta Wuta Tjangala are particularly powerful in showing the extent to which the paintings are a medium of individual expression and an exploration of form itself.

The designs painted in the new media have a complexity and elaboration that could not, for lack of space and time, be painted on the body. Acrylics have made new colors available, and the flat surfaces on which the Pintupi paint provide a very different space for designs than do the human body or most ceremonial objects. Although some designs, such as those once painted on the back, are transposed directly, others have to be adjusted to include all the elements and still fit the space. In the early 1970s, when the 24 × 36 inch canvas board was mostly used, certain standard forms emerged—among them the X-shaped, seven-circle designs into which many different landscape contents were fitted (Morphy 1992; Myers 1989; P. Sutton 1988) (see chapter 3).

One emergent form is the "map," which represents a wide variety of Dreamings in a painter's country. A good example of this is Yanyatjarri's 1975 painting (painting 259, page 105), which became part of an Aboriginal Land Rights poster (Megaw 1982, 209, plate 36).[2] Traditionally, maps of a sort were drawn on the ground for communication of complex information, but I do not think there was a ceremonial context in which all of these stories were at once relevant and therefore incorporated into a single design. Combining stories in one painting obviously raises questions of how to fill the space and questions of balance and color that traditional ceremonial decoration did not have.

The significance of changing spatial constraints has been noted by art advisers as a way of providing fodder for painterly invention. Andrew Crocker, for example, advised his successors to "change the shapes and size of canvases from painting to painting. This stimulates inventiveness," and "occasionally produce a new colour" (1981b, 6). At Utopia, years later, the art adviser Rodney Gooch regularly produced new shapes and sizes—circular canvases, car doors—for the painters.

Value—Secrecy

Although there was little concern about the process of individualization at Papunya, Pintupi painting has not entirely freed itself from social structuring.

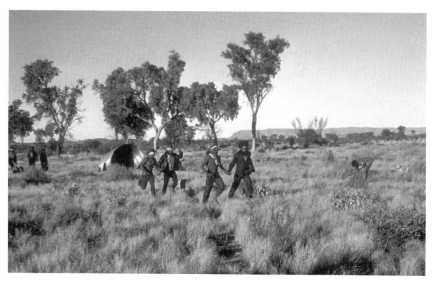

Tingarri novices leaving seclusion and running to women at dawn, Yayayi 1974.
Photo by Fred Myers.

Intercultural circulation of paintings has led to a renegotiation of their form and content, with important aesthetic consequences.

Not just any and all rituals can be—or are—transposed into acrylic paintings. From my arrival in Yayayi in the middle of 1973, I found that many of the Dreamings represented in the paintings I documented were from a cycle of myths referred to as "Tingarri." Usually, Pintupi explained Tingarri as "all the men," referring to several groups of men who are understood to have been traveling, in the manner of present-day postcircumcision novices (called *punyunyu*). Three such "lines" of travel are particularly significant for Pintupi (Myers 1976). Punyunyu novices are secluded, kept away from women and children while they endure long periods of instruction and discipline by senior men. Pintupi men continue to perform Tingarri ceremonies, reenacting the events of the Dreaming. Indeed, the contemporary seclusion and instruction of novices mirrors the traveling of the Tingarri men. Like their Tingarri predecessors, present-day novices are burned with fire. The Tingarri men of myth traveled much as the Pintupi once did, in the old days when they too "revealed" (*yurtinu*) novices, decorating them with Tingarri designs and bringing them from their seclusion (invisibility) into the sight and presence of women, where the novices run out and stand in smoke.

The countless songs and revelatory ceremonies of the Tingarri tradition constitute much of the mythological and mysterious history of Pintupi country, and

passage through it (instruction, initiation in it) is necessary for full (male) adulthood. Most broadly, Tingarri is a category of ceremony, part of the instruction of postcircumcision novices, which is distinct from several other named categories of ceremony about which knowledge is more carefully guarded. Women can hear Tingarri songs, but women are not supposed to view the revelatory ceremonies, know the inner meanings of the songs and myths, or see the body designs clearly.

Tingarri ceremonies deploy two kinds of design, and these provide a substantial basis for much Pintupi painting. The first type of body design, usually applied in a pulverized and dyed vegetable down (*wamulu,* or yurtalpa), is put on the bodies of fully initiated actors in Tingarri ceremonies that reenact significant events in the travels of the Dreaming. The second type of design is applied in various ochers painted on the backs and sometimes the chests of novices by more senior men at various stages during their instruction. These painted designs grow more elaborate as novices reach higher "grades" of advancement.

Although manufactured exclusively for sale to "Europeans," Tingarri paintings were still treated—from 1973 to 1975—with most of the restrictions appropriate to the body designs. Women and children were not allowed near the men's painting area or allowed to see the completed paintings. Throughout this period, the painters stored their work in my caravan, for protection from the elements and from the eyes of the uninitiated. Even young men not yet fully initiated were usually sent away from the painting area as not being "strong" enough to see the designs.

Men expressed a fear of the uninitiated seeing the designs, but it was not clear precisely what danger inhered. In fact, the designs of the Tingarri cycle were said to be "dear" rather than "dangerous." Painters often explained that they had to go through numerous disciplines and painful ordeals—to hunt meat for the older men, and so on, to present the gift of kunartinpa—in order to be taught about these designs. Painters insist that the value of the designs is that they are "true": "We don't make them up" [Ngunytji wiya palyarnin]. The designs are from the Dreaming, "just like the ground itself," and because "dead men have held and lost them" (i.e., passed them on), "the behind mob holds them now." Their truth value is guaranteed by the line of people who have passed them on. It is authorized and legitimate.

The schematic nature of the images in these paintings also makes them semantically ambiguous, a property they share with Yolngu bark paintings (Morphy 1992), so that knowledge depends on knowing how to interpret each design. Access to such knowledge is limited. Thus in 1975, Pintupi said they were not worried about

women from other areas—such as Darwin—seeing their paintings because these women would be ignorant *(ngurrpa)* of the mythological associations. Finally, both the designs and the country represented are associated with the memories of people—now dead—who are identified with them. Both are thus imbued with the sentiments the living hold for the dead.

The emphasis in acrylic paintings on designs from the Tingarri cycle is an outcome of both indigenous and intercultural politics. Because Tingarri tradition is considered less dangerous, they told me, Pintupi have concentrated on it as an acceptable design system for use in salable art. Designs from certain other myth cycles, myth-ritual complexes considered too dangerous and too sacred for exchange in the broader public world, are not represented anymore, although they once were (Bardon 1979, 30, 32). This was not a simple or straightforward choice. It represents, instead, a recognition of something quite distinct from individual patterns of ownership.

Work and Business

The statement that the paintings were "dear" articulates one of two intercultural nexuses of importance, involving intersecting regimes of value, one involving pay and the other visibility. The intersection of indigenous and exogenous notions of "work" was particularly confusing. At Yayayi in the early 1970s, all work for wages was sponsored by the government (Myers 1976, 108–9). Projects included the building of fences and shelters out of bush timber, digging pits for rubbish, collecting firewood, and maintaining gardens. Within this scheme, six artists— Charley Tjaruru Tjungurrayi, Shorty Lungkarta Tjungurrayi, Freddy West Tjakamarra, John Tjakamarra, Wuta Wuta Tjangala, and Yala Yala Gibbs Tjungurrayi— worked as full-time painters. Each of these artists received a government "training allowance" ($A60–80 per fortnight) for his work in addition to money made from the sales of the paintings to Papunya Tula Artists; other men painted part-time. The peculiar conjuncture between the Department of Aboriginal Affairs's political economy and indigenous notions of value, making acrylic painting partly understood by both sides as a kind of "work," actually hid their differences. It was considered by all to be part of the political economy of community life—part of the resource base on which the emerging possibilities of self-determination depended. When the system operated well, each of these artists earned an additional $A140.00 per month, the proceeds of four paintings, beyond their training allowance. The part-time painters might also augment other sources of income through selling the standard $A35 canvas boards (24 × 36 inches).

Nonetheless, while this inclusion of some men in the training allowance scheme subsidized the activities of painting for Papunya Tula, the "painting men" came to expect that they would be paid for the "work" of painting *as well as* receiving up-front payment for the paintings themselves. To the painters, this conjuncture validated their view of painting as cultural reproduction, as business or work at least on a par with other material activities, and indicated the government's acceptance of their values. They expected to be paid, then, for the work of being painters (i.e., training allowance) and then for the paintings themselves, which—as Charley Tjaruru's frequent comments indicated—were their property, to do with as they decided.

Intercultural and Intracultural

From the earliest exhibition of the paintings, there was concern from other Aboriginal people about revealing certain iconography—not so much to whites as to inappropriate Aboriginal people. Apparently, at Yuendumu in August 1972, questions were raised about Shorty Lungkarta's painting that led painters at Papunya to stop making overt visual references to sacred objects and designs that could not be seen by the uninitiated—principally these involved ritual objects and paraphernalia that had commonly been represented in paintings from 1971 to 1973. Some of the painters at Papunya disagreed with the assessments of what could appropriately be revealed, as Vivien Johnson (1994) has written, because their own language group's practices were less restrictive than the practices of those who criticized them.

By 1973 Pintupi painters at Yayayi had largely restricted themselves to Tingarri Dreamings and those classed as similarly acceptable. Of course, these images still contained many references to sacred objects and practices that were restricted. When a group of paintings was exhibited at a Perth museum in 1975, visiting Pitjantjatjarra men requested that forty-four of the forty-six paintings be turned toward the wall as inappropriate for exposure. Subsequently, they demanded and received compensation from the Papunya Pintupi painters because the acrylic designs were images that belonged to them jointly (Kimber 1995 and personal communication), part of their shared "songline."

At the same time that the images have continued to embody forms of collective identity, such experiences and these restrictions have influenced the formal practice of painting and the attitude toward abstraction and ambiguity. Pintupi painters have made their work acceptable by masking or omitting the more esoteric and secret elements of the Tingarri tradition (see Megaw 1982), lending the

work some of its characteristically cerebral and formal focus on design. Furthermore, the separation of acrylic image from ritual practice has intensified a segregation of painterly practice from the social life of ceremony.

By 1979, many men had begun to paint right in their camps, in sight of women and children. When a number of men were present, the painters did separate themselves, but with little of the old care. A sense of the paintings as commercial had also grown. Nonetheless, the men continued to regard the stories as "sacred," refusing to reveal the hidden meanings of their designs to the uninitiated, and they have become ever more reluctant to explain their stories in detail to unknown outsiders.

The Pintupi orientation toward individual painters is not the only way in which acrylic painting has been organized in Western Desert communities. At Yuendumu, for example, group paintings have been more common, growing out of a greater reliance in their initial period on large, collective commissions rather than on single paintings that were produced for sale. Françoise Dussart describes two prevailing features of the politics of painting at Yuendumu, where acrylic painting has retained more of its indexical links to ritual activity: an emphasis on negotiations among painters about which Dreamings will be selected as appropriately representing their joint identities (Dussart 1999), and the circumstance that acrylic paintings may occasionally be used in place of other sacred objects (Dussart 1997). At Balgo, a different dimension of ritual painting practice has become critical: the element of touch as transferring spiritual essence. Christine Watson (1996) describes a continued emphasis on the haptic, or tactile, quality of painting, with the deployment of paint on the canvas more closely replicating the painting of bodies, focusing on the penetration of colors into the surface.

Audience

The change in audience for these symbolic forms has been another transformative element. In ritual use, other knowledgeable men or women will judge the designs by their "fit" with tradition; to be effective, ritual design must be "just like" (i.e., replicate) the Dreaming. And unlike acrylic paintings, ritual designs are destroyed after use, so the circulation of the paintings poses a danger in terms of the control of sacred knowledge. Aware of this problem, the painters decided not to represent clearly any objects or meanings that the uninitiated may not see.

The Pintupi have also learned, mainly from representatives of the Aboriginal Arts Board (see chapter 4) something about the aesthetics of Europeans, and they have responded somewhat to what they believe will sell. As Megaw (1982, 209) also

reports, the sensibilities and marketing strategies of different managers of Papunya Tula Artists have greatly influenced the aesthetic development of the painting in different periods. The degree to which the painters might be influenced by external influences has been a concern of those who frame the work in terms of the criteria of authenticity underlying the category of primitive art, and art advisers such as Andrew Crocker have faced the issue squarely: "Another substantial influence on the painters' style is the criticism, appreciation and predilections of an 'art adviser' in a community. As these have rotated so have changes occurred. The adviser is the person to please; who has, after all, the cheque book and a certain amount of personal authority; who tries to assess the market and rightly or wrongly conveys this feedback to the painters. I have seen it done and done it myself with the best intentions" (Crocker 1987, 26). Pintupi do know that buyers do not like messy paintings; they think Europeans like them to be "flash" (Green 1988). There are also fashions and fads in painting, seen locally, for example in the outburst of paintings that involved Warnampi, or rainbow serpents, in the early 1980s, following successful sales of such paintings by Turkey Tolson and Riley Major. Simply put, the change of audience has transformed the constraints on production of art by removing the concern to transmit faithfully the ritually appropriate representation.

Knowing Painting as an Activity: Embodiment

There are clearly physical and temporal qualities — kinesthetic dimensions — that inform the practice of painting as well. One might draw attention to painting's temporality, as anthropologist Annette Hamilton suggested to me, the way in which a painter sits concentrated for long periods of time while filling in the dots. This practice has a space-time of its own.

Much has been made of dotting. When asked why Western Desert acrylics had so many dots, Andrew Crocker would point out, in the first instance, that the dotting is secondary to the "cursive" designs that establish the painting's formal frame and narrative content. The early paintings, in fact, had few dots; dotting appears "first as a gentle decorative fringe and gradually, over the years, comes to provide an almost inevitable, all-covering bed from which the cursive design stares out" (Crocker 1987, 21). Sometimes painters left the background colored and without dots; on occasion, Crocker writes, "the 'gaps' between cursive design were occupied . . . with a background of hatching and other motifs." One hardly sees this after the early years, and Crocker believes "that these other symbols were too revealing of secret material and that the dots provided a safe alternative" (21). That a dotted background did or could exist in preacrylic forms is clear. The ground

painting in the film *Emu Ritual at Rugiri* (Sandall 1967), a Warlpiri ceremony near Yuendumu, has an extensive dotted background.

Dots have become significant in painterly terms, however. "Today, as far as design goes," Crocker wrote, "for many painters the dots are still secondary; for the more talented they comprise an important part of the composition" (1987, 21). Indeed, many painters do appear to apply dots almost mechanically, simply following the lines around the cursive elements. Crocker's argument is reminiscent of one made by Karel Kupka, the expatriate Czech painter who undertook a brilliant study of Arnhem Land art in the 1950s. Kupka (1962) wrote convincingly that the cross-hatching in-fill of bark paintings had a design effect that flowed from the artist's need to fill in the empty space, to respond to the medium. As Crocker argues, "There is a naturally felt 'horror vacui'—a desire to fill the canvas and in addition enjoy the physical pleasure of painting. This so-called kinesthetic delight appears not to have been examined in depth in the case of Western Desert painters" (1987, 21). Kinesthetic delight notwithstanding, a more plausible argument would be that both cross-hatching and dotting are motivated by an underlying aesthetic interest in producing visual brilliance ("make 'im flash"), along the lines of Morphy's 1989 argument—which applies at some level to central Australia as well as Arnhem Land—that this aesthetic expresses the emanation of ancestral power.[3]

Crocker points out that the painters often sing or hum the songs pertaining to the designs, and he suggests:

> There is a certain rhythm to them not dissimilar to the rhythmic application of dots as the work takes shape. Even when it is finished the hands are worked along the course of the designs in a regular beat as the story is told. This suggests to me very strongly that there is some relationship between ceremonial song and dance movements and the painted stories, probably in crystallising but possibly also in forming design components of the style. A further clue to this is the apparent importance of the tracks left by dancers in the sand and their depiction in the paintings. (Crocker 1987, 21–22)

Indeed, if one listens to the Tingarri cycles as sung, one learns to recognize distinctive verses for "traveling" or linear movement and for "coming together" (sung as "kurrali kurrali yanana tirrima tirrima"), which is performed in ceremony as a line of men moving into a circular round—and marked in a painting design as a circle. It appears that significant transpositions must be taking place between bodily movement and the graphic symbolism of the paintings.

Quite distinct from the usual paces of activity, the intensity of dotting also trans-

poses the practical orientation of many Yarnangu who grew up in the bush. The older folk are rarely to be found with their hands empty; Yanyatjarri Tjampitjinpa, Freddy West, Shorty Lungkarta, Timmy Payungu—and most of the other older painters—were always engaged in some kind of physical activity, making boomerangs, straightening a spear, carving a shield.

However, the technique of predominant dots can become little more than formulaic technique. Although it conveys "an instantly recognisable signature," Crocker worried that it can also enable "run-of-the mill and uninspired painting to pass muster as sufficiently pleasing, decorative work to sell somewhere or others" (1987, 23). Interested in selling the paintings as contemporary art and concerned to sustain a two-tiered framework of Aboriginal art (fine art and tourist quality), Crocker disregards the painters' claims that the dots are from the Dreaming and considers the effects of visual form alone:

> Where a broad expanse of infilling is to be dotted-in, this is often in alternate, regular bands of colour. The ensuing eye-teasing, optical-art effect can give life to otherwise humdrum paintings. This technique is not very demanding of anything save patience and is easily copied by those wishing to produce "Aboriginal" painting even though they may not have the traditional knowledge of subject matter nor of decoration. It allows a painter to produce with little effort workaday, saleable material and to shelter behind the proposition that it is "traditional" and that the most important consideration is the story. This, I would suggest, is the road to disrepute. (Crocker 1987, 23)

Crocker was correct that any mechanical techniques could become tedious, but he did not foresee that some later painters would elaborate the visual effect of the dots into an aesthetically distinct variant of the painting.

Style

There is a marked history in the styles of Papunya painting. Kimber delineates the earliest stage cogently: "The earliest of the transposed art was executed on any and every scrap of flat wood, art-board or linoleum that came to hand. Finger-width strokes were common, artists' brushes were invariably reversed or discarded in favor of traditional Aboriginal brushes made by chewing and abrading a small branch. The design was often vivid against the generally dark priming which Geoff Bardon had taught" (Kimber 1981, 8). Much of this work involved exquisite fine detail, "meticulously miniaturized details, usually a compendium of the contents of ceremonial activity: relevant designs, perhaps the decorated participants and

props, sacred boards, . . . and the like" (Crocker 1987, 25). Paintings of animals, people, and mythological ancestors were common.

Kimber argues that as soon as the works began to be sold, the art began to change, and his are the only firsthand reports of what happened:

> Other Aboriginal people saw the work on display and were angered by what seemed to be a blatant display of certain aspects of the secret-sacred men's world. Almost overnight, . . . all detailed depictions of human figures, sacred and other "dangerous" aspects were removed or modified in shape. In a related reaction, backgrounds began to be painted-in rather than left stark. Patterns of straight lines, arcs, and hatching were common at first, but this soon changed to dots, thus eliminating elements used on some sacred objects. (Kimber 1981, 8)

Crocker also emphasizes the importance of the introduction of larger canvases, as a result of which "the scale of the work more closely matched the traditional contexts: perhaps for this reason dots increased in size and infilling between cursive design became the norm in harmony with ground and body decoration" (Crocker 1987, 26).

Knowing Painting as an Activity: Context

One aspect of the historicity of Pintupi painting practices is the way that the context of painting overlaps many other activities. Looking at my notebooks today, I can see that the paintings appear closely connected to the historical moments of the time in which they were made. As we can recognize in the following example, this context may illuminate some of what the paintings might mean for participants.

On Saturday, 28 July 1979, I visited a group of men who were sitting in a camp a few yards from the domestic area of Yinyilingki. They included Wuta Wuta, Shorty Lungkarta, Jimmy (Warna Tjukurrpa) Tjungurrayi, and Jimmy's son, Neal. Neal "had trouble," as it is phrased in English, having been in a car crash that led to the driver's death. In local Aboriginal law, he was accountable for the death, and the grieving kin wanted revenge — which could be satisfied if he allowed himself to be speared in the thigh. For the moment, this often troubled young man had fled to his Pintupi kin in the remoter community of Yinyilingki for protection until arrangements could be made for the "settling up" ritual.

Wuta Wuta had been painting a wooden dish with an image of Tilirangaranya (see page 44), and Shorty had one of a place near Kintore. While they painted and occasionally explained their images to me, the men discussed arrangements

for the ongoing political events. Warna Tjukurrpa told me he wanted to go south after Neal was speared; he said his *pilyurrpa* (spirit) was "no good" because of his son. He told me that I was a "young fellow number one," in contrast to his son. That day Warna, Neal, and his wife had walked to Warren Creek from Papunya (about fifty miles), where Shorty had picked them up. They wanted to take Neal to Papunya to be speared soon and get the revenge over with. He spoke to Shorty and Wuta Wuta as the latter painted.

Wuta Wuta had wanted to go with Warna after he completed a large painting of Lake Macdonald (Kaakurutintjinya), when he would be paid. Then he would get a vehicle (he said a Toyota) to go with Shorty Lungkarta. Later the community adviser dropped off several people: Pinny Tjapaltjarri, Charley Tjaruru, and Tapa Tapa Tjangala had come to visit. They brought paintings to work on while they camped at Yinyilingki.

All this time, Neal sat with his mother, very near to the painters' place, but said nothing to the men. Pinny, always voluble, informed us he had shot an eagle. So Shorty walked to his camp and brought back a bag of wamulu (ceremonially used down), while Warna Tjukurrpa discussed Neal's problems with his older brother-in-law, Tapa Tapa.

Wuta Wuta told Tapa Tapa and Charley Tjaruru what he was painting, what each part represented. It was Tapa Tapa's country, Kaakurutintjinya (Lake Macdonald). But this was not the only topic. They were also laughing uproariously about the behavior of people who were drunk in Papunya, imitating their antics. Meanwhile Shorty and Warna Tjukurrpa, classificatory brothers, took turns at removing the feathers from the eagle.

After an hour, Neal came over and stood near the men. No one took notice or said anything to him. A few minutes later, he sat next to Wuta Wuta's painting, and Wuta Wuta, his mother's brother, told him to paint some. A passage had occurred. As I wrote in my notes, "I had the feeling before that people were showing disapproval by ignoring him and also that he now knows who will look after him when he is in trouble. This must affect his idea of them."

The event also must have affected Neal's idea of traditional values encoded in activities such as painting—something in which he had not been much involved. At the time, I believed, he had become impressed with the authority of these older men and the foundations that they understood to be their source of power.

Commerce and Its Interpretation: Mediating Value

However the paintings have entered into commerce, as either individual or collective products, their entry into a different regime of exchange value has been vexed

in the dilemma of finding equivalents for exchange. In Yarnangu estimation, the bigger or more important the story—the greater the value attached to the designs in traditional context—the more valuable the painting should be monetarily. In 1974, painters typically received $A35 for a 24 × 6 inch cardboard-backed canvas board; by 1980, a large stretched canvas painting could bring several hundred dollars, and a 3 × 4 foot one would bring $A150–200. In 1988 a similar canvas would have been worth at least $A600.

But dissatisfaction with the amount received for paintings is not entirely straightforward. In my notes of the conversations in 1973 (see chapter 1), painters express dissatisfaction, to be sure, but uncertainty as well. Their assertions are claims—attempts to negotiate a more appropriate value in exchange from whites. Such complaints take place with little conception of bargaining as a way to establish value equivalence, but painters clearly feel that whites are being cheap in regard to things of such value.

In part, this is a more generalized problem. Not surprisingly, the market processes through which value is established in Australia are opaque to people raised in a very different culture, and it is not uncommon for Yarnangu to suspect that they have been cheated. The weight of this suspicion falls particularly on certain intermediaries of the intercultural field, among them the art adviser–manager of the Papunya Tula Artists company. He or she is the painters' mediator vis-à-vis the world of capitalist exchange, and his or her decisions often anger some of the locals. If the adviser regards some paintings as "poor" and unsalable, the judgment may conflict with local values. Papunya Tula Artists is a cooperative, and in theory runs for the good of the collective, but individual painters may feel the art adviser is not looking out for *their* particular interests.

Effectively, too, the manager controls production by handing out and monopolizing (in the name of the cooperative) the distribution of different sizes of stretched canvas for paintings. These reflect his or her calculations of what can be expected to sell, which artist's work is popular, and the actual commissions received from buyers. It is through such processes of selection for commission, if not direct instruction, that a manager's tastes establish a standard mediated to the painters—as many observers have noted (Isaacs 1987; V. Johnson 1990a; Megaw 1982). Some managers have emphasized the referent (the story) of paintings as guaranteeing the authenticity and exotic quality of the paintings, one version of the "traditionalism" that, as Megaw (1982, 209) wrote, made Aboriginal paintings salable or acceptable to the market. Others, for similar reasons, restricted the palette to the four colors that reflect the indigenously available ochers. Peter Fannin—a botanist—seems to have generated an emphasis on "bush tucker" in the paintings

he documented and purchased; Andrew Crocker insisted on "traditional" ochers and high quality of execution. All the art advisers have clearly had a significant effect on the styles produced during their tenure.

The Scene

We cannot leave off discussing the practice of acrylic painting without coming to terms ethnographically with some other prominent dimensions of what I will call "the Aboriginal art scene." Here, as with the "Aboriginal industry" described by Bruce Chatwin in *The Songlines* (1987), there are important intersections of Euro-Australian and Aboriginal identities. My sense is that the Aboriginal art scene is one in which white participants have invested complex emotions.

For example, in 1981 Papunya had factions that involved a countercultural and artistic group, including the poet Billy Marshall-Stoneking (an American expatriate schoolteacher), who saw themselves as more identified *with* Aboriginal people and their culture than had been the case for previous white residents in Aboriginal communities. Some of their subsequent success and self-esteem, in fact, came from brokering Aboriginal culture to others, especially in the arts. Billy gained a reputation as the "translator" of Obed Raggett's stories, and later as a chronicler of Nosepeg Tjupurrula and poet (Marshall-Stoneking 1990). Other white residents, also with literary and artistic ambitions, were involved in bringing Bruce Chatwin to Kintore, events that were included in *The Songlines*. The Cambridge University graduate and former accountant Andrew Crocker, as the adviser of Papunya Tula Artists, occupied a position of some desirability for its cultural capital, but he was resolutely—at times, pugnaciously—committed to an entrepreneurial approach to selling the art. He hobnobbed not with the counterculture but with the rich. Traces of the competition between these people and their factions fill my notebooks of the period, with Billy connecting to the painters through his teaching aide Paul Bruno and his support of the commercially unsuccessful elder Tutama Tjapangarti, who worked for him at the school.

One of Wuta Wuta Tjangala's paintings of Yumari from this period entered into this tension and into my field notes, as whites seemed to vie for precedence in their claims over Aboriginal painting. So, apparently, did I. Wuta Wuta, I noted, was "planning to sell to Andrew [Crocker]." However, his brother's son, Paul Bruno, told him to sell to Billy Marshall-Stoneking (his patron) instead, because Andrew "cheats them." Knowing the pressures under which art advisers worked in getting money for paintings, I got angry at this. I said something, which I didn't remember to record, but amended myself "to say Andrew would probably give good money

to own it himself, had he been there." Paul, I realized, did not seem happy at my going against him and his patron (field notes, 3 July 1981).

These factions had a sociocultural base in differences among whites, in ways that departed from what was once an easy-to-make contrast between "do-gooders" and "racists." Such differences were challenging to the legitimacy of my own analytical approach, and they made it difficult to remain as resolutely local as I had wished. This was evident in another disconcerting conversation in 1981 in Papunya, on a short trip in from my fieldwork base in the nearby community of New Bore. Billy Marshall-Stoneking wanted to know what I thought of the "magical" or "mystical" qualities of acrylic paintings. He had been away during the hot and stormy summer break, and when he returned to his house at Papunya, he discovered that a valued painting he had purchased from Wuta Wuta Tjangala was gone. This disappearance, he told me deadpan, was to be expected. When Wuta Wuta gave it to him, he recounted, the painter had said, "You watch this one. He might walk away."

I found it honestly difficult to give credence to Billy's interpretation of this as Wuta Wuta's prediction that the painting would walk away of its own, because of its sacred power. I had never heard an Aboriginal painter say anything like it. These were man-made depictions of Dreaming stories. My rationalism—a suggestion of more likely explanations, such as theft or misplacement—was implicitly challenged by Billy, as was (I think) my claim to knowledge. If I didn't *believe,* then, where was I? The competition is complicated, because his interest in Aboriginal culture was obviously genuine and has resulted in a good film about Nosepeg Tjupurrula and a book of poetry that rings with the voices of Tutama and others he knew at Papunya.

This was a period in which the social field of painting became unusually complex. In July 1981, another white person entered the scene, also focused on the painting. Tim Johnson spent a month at Papunya performing the duties of art adviser. A well-known artist and countercultural figure from Sydney, Tim and his then-wife, Vivien (a sociologist and now scholar of Aboriginal art), became collectors of Papunya painting in 1978 after being impressed with an exhibition they saw. This may have been their first visit to Papunya, and they occupied the Papunya Tula house while Andrew Crocker was on vacation.

My purchase of two paintings led to a serious argument with Tim. During this period, Tim handed out canvases to many artists, far more than Andrew usually assigned. It was never certain whether this was a strategy of benefit to the Company or, as some believed, a means of generating the greatest range of paintings from which to select for himself. I was planning to leave the field and return to the United States, and I had arranged with Crocker for permission to buy a few paint-

ings from the painters. As it turned out, however, I innocently picked some that Tim may have wanted. He accused me of "cheating the Company." The painting men heard the whole uproar and found it amusing.

Even though Tim and I came to an understanding, I was quite unsettled by this event. My field notes show my suspicions of what seemed to me, the anthropologist, a "fetishizing" of the art objects. "Tim Johnson," I wrote, "is substituting for Andrew [Crocker]. An artist married to Vivien, sociologist at Macquarie University. They are collectors of Western Desert art and he has photographs of many from various collections. Men looked at some with me; many had bullroarers and various sacred designs—which struck Harper Morris [one of the painters] as serious" (7 July 1981).

We did work out our misunderstanding, neither of us being terribly combative. And I recorded in my notebook Tim's explanations, which are informative about the cooperative's situation within the community. Andrew was concerned, Tim said, "that so many paintings are bought at Papunya. These cost the company money for canvas, etc. He says he doesn't mean me, since I told him I'd made arrangements with Andrew [to buy a few]. It is the schoolteachers and the cops all buying." Tim also told me he had talked to Billy Marshall-Stoneking the previous night, and that Billy claimed he wasn't "in competition with the company." Having earlier made some general statements about the way in which whites were very possessive of their relations with Aboriginal people, I told him that I did think Billy was in competition with Andrew. Indeed, it occurs to me now that their tastes represented very different approaches to Aboriginal culture and art itself. Tim shared many of these views with Billy. "Tim," I wrote, "*also* likes Tutama's art [this was a bone of contention for Billy Marshall, who liked it, in contrast to Crocker's taste for more finished work]. He doesn't think Andrew knows art too well. Seemed to believe Billy, although he commented that what Billy said about Wuta Wuta only getting $40 for a *yumari* painting was wrong. (WW told me it was not much, but was $100)."

Certainly, I felt uncomfortable about my foray into the purchase of paintings, as my notes reveal. "Anyway," I wrote, "I think Tim was/is annoyed about people buying paintings (like me) because he'd like first crack. We talked about buying paintings and he said that often when men have one for him (or do one), it will be something he's thought about or a design he has in his house. I didn't say much— only that I must have bad ideas because the ones I commissioned weren't too good" (field notes, 7 July 1981).

I could not be exempt from such comparisons. Later that day, I found that Tim Johnson had been involved in a quarrel with the artist Timmy Payungu, who had

asked Tim to drive him out to the Haasts Bluff turnoff to fix his car. Tim was in charge of the Company vehicle, and the men felt he should help. According to Vivien Johnson, Tim had spent the whole afternoon helping fix that car, but he obviously hadn't banked on the level of obligation expected by the painters. Having spent many hours over the years helping people with failed vehicles and gathering firewood, I found this *very* satisfying. I enjoyed the fantasy and privilege of having a closer relationship with Aboriginal people. I was pleased, then, to be asked to mediate between my Aboriginal friends and Tim Johnson. This demonstrated, I thought, *my* closer association.

> A few days later, Yanyatjarri Tjampitjinpa asked me to go help him tell Tim Johnson the story for his big painting—Tingarri at Kiwirrkuranya [where they now live], where they stopped before Walawala. A big soakage, it was a ceremonial ground in the Dreaming. Billy Tjupurrula and Joseph Tjaru Tjapaltjarri were at the company house at the time. John Tjakamarra was quietly complaining about getting only $300 for his big one. Yanyatjarri was offered $400 but seemed hesitant (though ready to accept). Joseph thought he should get another $100. I told Tim, who gave another $50 (going well over Andrew's guidelines).

These accounts exemplify not only the struggle for control over the representation of Aboriginal life and cultural production but also the jealousies and competition for legitimacy. They are also evidence of a historical change in black-white relations that affects the practice and content of painting. Different mediations come into being around the different relationships whites and Aborigines bring into being.

Of course, Bourdieu has provided a framework in which these trajectories and convergences might be intelligible. "Social agents," he writes, "are the product of history, of the history of the whole social field and of the accumulated experience of a path within the specific subfield. Thus, . . . to understand what professor A or B will do in a given conjuncture or in any ordinary academic situation, we must know what position she occupies in academic space, but also how she got there and from what original point in social space, for the way in which one accedes to a position is inscribed in habitus" (Bourdieu and Wacquant 1992, 136).

The whites make their peace with Aboriginal communities and culture from distinct histories. The more upper-class-identified and commercially oriented English Andrew Crocker and the countercultural American Billy Marshall-Stoneking each worked out their copresence with Aboriginal people, and they did so in ways quite different from the French art collector.

The ambiguity of these relationships is perhaps why it had seemed to me better to avoid getting involved with "Aboriginal art" as a subject. Many others have written about the Aboriginal paintings and seem to have identified themselves substantially in some way with this new presence (T. Johnson 1990; Kimber 1977; Marshall-Stoneking 1988; Megaw 1982). To stress the "art" too much, I thought, was to misrepresent its place in people's lives. In the currently fashionable jargon, one might say that I did not want to have their "art" stand as the essential representation of their culture. I did not reason so presciently at the time, however. Moreover, it did not seem right to be promoting myself academically or in popular culture as a spokesperson; better, I thought, to maintain my role as one of helping *them* to sell their art and not to be an expert on it.

Exhibitions

The practice of painting has engaged the painters in ever larger circuits of social relationship. Increasingly, the painters themselves have traveled to distant venues of art consumption, where they more directly mediate Aboriginal and outside values. There were always a variety of views on what these visits accomplished, but the painters were often pleased to go. As a field-worker in the Aboriginal community, and one who tried to avoid extensive involvement in the business of acrylic painting, I had only a limited sense of what was taking place more distantly.

In March 1981 Charley Tjaruru was selected to visit Melbourne as part of an exhibition in which Papunya Tula was involved. He went with Willy Tjungurrayi to produce the first Papunya screenprints. At that time, it didn't seem to matter much to me where the exhibition was held or what paintings were displayed, because I didn't write down anything like that. My extensive notes attend much more to the several features of local context in which Charley was involved. First, the initiation of Wuta Wuta's son was planned to take place in Papunya, for which Charley Tjaruru (Wartuma)—as brother-in-law—had a part (as a member of the *yirkapiri*, or "mourners"). Second, there was the trouble brewing with Charley's daughter, an adolescent who was betrothed but threatening to elope with a different man. More broadly, Charley was quite concerned with struggles over land rights in the vicinity and threats "to send the Pintupi away," which had raised the possibility of a move to the Kintore Range.

In the midst of this turmoil, Charley came to visit me and told me his wife was "pushing" him to fight over the bestowal problem. He was carrying around his spears, but this was just for show; he didn't want to miss the trip to Melbourne. On his return, as with other such occasional trips by painters, he offered mostly

accounts of dancing with women and how pleased he was with the attention from white people, whom he found to be very friendly. For Charley Tjaruru, the trip partly reflected his close relationship with Andrew Crocker, who later produced probably the first retrospective collection of Charley's work and brought him to England and Europe for exhibitions (Crocker 1987). Because of his complex relationship to both whites and his own culture, Charley was deeply affected by these experiences, more so than many other painters might have been. As his own political position wavered within the Pintupi community, Charley increasingly touted his importance elsewhere in a way similar to claims made by other Aboriginal residents without close kin: "People *here* couldn't harm [me]," he insisted, "because I have a lot of friends overseas!"

At the local level, meaningful developments in the art market — at least in retrospect, as measured by their citation in histories of the development of "the Western Desert art movement" — were not yet registering with the painters. I too was apparently ignorant of the fact that Aboriginal art was included in the *Perspecta '81* exhibition, curated by Bernice Murphy at the Art Gallery of New South Wales, or that this mattered.

A few months later, Andrew Crocker took Charley Tjapangarti and Billy Stockman on a trip to the United States, as part of a larger tour involving Aboriginal performers organized by American dance specialist Spider Kedelsky and the Australian Anthony Wallis. Now much celebrated in Papunya Tula lore as the "Mr. Sandman" exhibition, based on the catalog Crocker published (*Mr. Sandman, Bring Me a Dream* [1981a]), the acrylic painting component was actually quite small. My major concern at the time was that the men would be visiting Los Angeles, where I had been living, and I wouldn't be there to show them my country. I arranged instead for a close friend to take them around. There is nothing in my notes at the time to show that I knew Crocker had sold the exhibition collection to Robert Holmes à Court, but I did know that this was a rather ragtag arrangement. I don't remember much discussion with Charley Tjapangarti except to ask him if he had met my friend. To understand such events would require something considerably beyond engagement with the local community of Aboriginal painters.

It might be convenient to label the changes in the practice of Pintupi image making as "hybridity." This has the advantage, certainly, of drawing attention to the double direction of change and grants significance to what the painters bring to the new activity. My interest, however, is to explore the particular transformations through which the acrylic paintings became commodities of a sort and to show how they

remain as objects expressive of a complex set of meanings and relationships. While they did so in ways that drew resonantly on the sources within Western Desert cultural tradition and the rich signifying potential of painting practice, these objects were formed in a context and within relationships that unsettle and reorganize many of these values in ways commensurate with the emerging social fields linking Aboriginal communities and intersecting segments of broader social fields. Thus the structure of these fields and the identities and backgrounds brought to it by those working within the intercultural spaces will be a vital component of any understanding.

3 The Aesthetic Function and the Practice of Pintupi Painting: A Local Art History

I do not propose to enter into a discussion of the ultimate sources of all esthetic judgements. It is sufficient . . . to recognize that regularity of form and evenness of surface are essential elements of decorative effect, and that these are intimately associated with the feeling of mastery over difficulties; with the pleasure felt by the virtuoso on account of his own powers.

I can give at least a few examples which illustrate that the artist has not in mind the visual effect of his work, but that he is stimulated by the pleasure of making a complex form. — Franz Boas, *Primitive Art*

It might seem obvious to my readers that the Western Desert paintings have aesthetic value (emphasizing the "value") or that the interpretation of such visual languages is itself a worthwhile enterprise for a history of art. Anthropologically, however, it is by no means obvious (Myers 1989, 1994a). Therefore a central concern in this part of the book is to explore the very possibility of considering these paintings under the rubric of "art."

The need to do so came to me a few years ago, in the aftermath of an offhand remark I made about a photograph that shows inexpensive dot paintings in a newsagent's shop in Alice Springs. During a talk, I had shown a series of slides to illustrate the range of production in Western Desert painting. *These,* I indicated casually, with a sweep of my hand, were obviously "tourist art." My remark rang an alarm bell with one of my astute colleagues. She noted my own insistence that Pintupi painters emphasize that the value of their paintings lies in their "truth" — their origins in the Dreaming — rather than in their "beauty." Poorly executed or brilliantly done, such paintings are valued as being from the Dreaming, as almost every art adviser in Central Australia could report, and Pintupi will frequently claim that all paintings deserve a similar price because each represents "a very important Dreaming." Are we entitled, then, to make claims for differences in the production of Pintupi painters — to regard some as "better" and others

as "mere tourist art"—when these categories of evaluation are not discursively established among the painters or within their cultural traditions? Was I departing from a rigorous application of indigenous categories, which do not appear to recognize paintings for their "aesthetic value," and applying my own, Western standards?

As a result of this insight, I began to focus on the emergence of painting as a practice. I had an unusual opportunity to record the production of Pintupi art at a crucial point in the 1970s when the paintings were beginning to gain a market. The practice of painting was beginning to change as a result both of the sheer pleasure of practice and in response to external stimuli such as the need to maintain the secrecy of restricted forms in response to criticism by other Aboriginal groups (Caruana 1993; Kimber 1995; J. Ryan 1990). My contribution to the project of local histories, undertaken from the vantage point of the producers and not based on the march of world historical ages of art's development, is a consideration of the work of two Pintupi painters between August 1973 and May 1975, and on into the early 1980s.

In this chapter, I attempt a particular kind of history of Pintupi painting, one that emphasizes a comprehensive and detailed study of the development of two older Pintupi painters, Yanyatjarri Tjakamarra and Wuta Wuta Tjangala. In this history, one can discern what I will call, following Roman Jakobson (1960), an aesthetic orientation in the paintings of these two men. It is necessary, however, to characterize the particularities of this aesthetic function. The common emphasis on the relationship of acrylic paintings to earlier traditions of image making in ritual should be replaced by more specific local histories of painting as a practice, considering (for example) the relative autonomy and distinctive trajectories of Western Desert painting in distinct communities—Papunya, Balgo, and Yuendumu. I believe that a local art history that places paintings in the context of one artist's practice over time is anthropologically informing and provides insights into qualitative aspects of Pintupi painting—aspects that, while not necessarily equivalent to Western valuations, may demonstrate a synergy with them. But to approach such questions, one needs more local histories of painting as a practice.

Perhaps more importantly, such histories can attend to the intentions of the painters and their work as an extension of their agency (Gell 1999). In this history, I delineate a dynamism and responsiveness of the painters and their art in existence before the significant apparatuses and institutions of the market developed. This dynamism provides the substance of the persuasiveness of the new form, the forces of creative and aesthetic power that engaged what my colleague Howard Morphy called "a few mad passionate individuals, art advisers, anthropologists,

government bureaucrats and others to fight to release the potential of the painters' production" (personal communication, 19 June 2000).

The significance of my notes and records as a local art history was something I did not analyze until recently, until I became interested in the wider context in which the paintings were circulated. The artists, however, were involved in a practice that already articulated with external demands and associated with an embryonic process that was also a process of creating and transforming value in their work. I argue that the relationship of painting practice to discursive categories must be studied in detail to be understood; it cannot simply be inferred from such categories. I wish to show that some painters, at least, evince a serious engagement with painting as a practice that differentiates their works from what is often called "tourist art." Paintings of the tourist type may very well continue to reveal sacred knowledge, as the painters insist they do, and in this sense they are not "inauthentic." However, other paintings demonstrate an engagement with the problem of communicating or rendering information that requires more than the formulaic application of a "template." These qualities surely sustain the claim that Aboriginal acrylic painting should be considered as a serious form of art.

Pintupi acrylic painting hardly lacks for commentators (e.g., Bardon 1979; Caruana 1993; Crocker 1981a, 1987; Kimber 1977; Megaw 1982; J. Ryan 1990). Some of them are deeply concerned with the kind of local differences and stylistic analysis that might allow us to specify the particular artistry of Pintupi painters. For example, Wally Caruana's articulation of the "Pintupi propensity for austere composition" (1993, 114) clearly resonates with Judith Ryan's discussion of the Pintupi style as "linear and cerebral" (J. Ryan 1990). Ryan views the increasing emphasis on Tingarri cycle paintings — observed to have occurred after early criticisms of a Pintupi exposure of secret designs by other Aborigines — as developing a tightly restricted visual language: "Like cadences in a solemn Gregorian chant, a limited number of colours and motifs are ritually repeated. The universe of signs and symbols is an impenetrable and ordered construct which provides a window on to the secret world of the men" (J. Ryan 1990, 29). Caruana (1993, 130) sees the Warlpiri, contrastingly, as more ordered, ornamental, and structured in their attention to the abundance of the land.

Although these accounts are extremely helpful in articulating some general periods in the development of Western Desert painting, there is more to be gained from the local histories I have in mind. The kind of detailed knowledge of the sequences of production that exist for Western artists is often lacking for indigenous art. Few careful and detailed studies of the development of particular painters have been undertaken (Vivien Johnson's work [1994, 1997] is an exception), and

fewer still of these look at actual series of paintings, rather than some "type" pieces thought to represent different moments of development. Moreover, collections do not allow us to engage with the paintings at the level where iconographies and changing painterly practices might be conceived. Objects are sold and dispersed widely through private collections and museums, with assumptions being made about their essential nature, so that the process of practice is lost. Thus evaluations of these paintings tend to be rather superficially aesthetic—based on principles that may have little to do with the painters' own concerns and practices.

Truth or Beauty (or Both)?

There is clearly a difference between Pintupi and Western evaluation of Pintupi images. Pintupi ontology is formulated in a specific set of visual forms that both intrinsically express it and are a component of it (see Munn 1966, 1973a, and 1973b, on the neighboring Warlpiri). As we have seen, the Pintupi are inclined to stress that the images come from the Dreaming, and to deny that these paintings are "made up" by human beings "just for fun"; they may state simply that "it is my Dreaming," emphasizing that the right to display this Dreaming is part of their identity.

Ostensibly, then, Pintupi do not regard one painting as more valuable than another on account of its qualitative properties. Such facts might lead one to conclude that it is inappropriate to apply Western notions of art (Bourdieu 1984, 1993; Price 1989) to these cultural objects—and indeed there has been considerable discussion about the applicability of the category of "aesthetics"—as well as "art"— cross-culturally, or even in the translation of non-Western practices (Overing 1996; Gow 1996; Morphy 1996a). Some anthropologists have insisted that the category "aesthetics" assumes modernist notions of an object detached from context, submitted to the senses of the observer for detached contemplation purely for its formal qualities (Overing 1996; Gow 1996). "It characterizes," Overing writes, "a *specific consciousness of art.* . . . far from having universal appeal, the meaning of aesthetics is intrinsically historical" (1996, 260).

I was initially sympathetic to this viewpoint. Indeed, I should admit that the initial appropriation of Western Desert painting as available to Western aesthetic judgments filled me with dismay. In my first two years of fieldwork with Pintupi people at Yayayi, it was clear that Pintupi did not emphasize culturally the aesthetic qualities of the paintings, and that they had, as far as I could understand, very little in the way of a vocabulary in which the impact of form can be discussed.

Nevertheless, how are we to understand the differences among painters in the

attention they give to their activity, in the interest they take in painting, and in the range of invention their work displays? The practices of Pintupi painting are not contained within the authorizing discourses, although they may be subordinated to them. A concept of art or of aesthetics is not necessary for acts of communication to acquire an emphasis, as Roman Jakobson (1960) put it, "on the message for its own sake" — to acquire, in other words, an aesthetic function. In emphasizing signifying practices rather than semiological systems, what is important about Jakobson's conception — however inherently modernist it might be — is that it imagines the aesthetic function as potentially present in *every* situation of communication, although it might not be the dominant one. A communicative act is not identified with a single function. A poetic (or aesthetic) component of communication may be present without constituting an autonomous, detached aesthetic object.

This brings me, then, to the substantive issues: Pintupi culture valorizes *some* dimensions of the painting — a painting's "truth" in relation to the Dreaming, the right of expression as part of one's identity — but gives no particular discursive support to others, such as the aesthetic function. Paintings are not compared on those grounds, are not evaluated explicitly in terms of their quality. The absence of indigenous discourse, however, need not mean that the paintings lack an aesthetic component — or that a concern with the "palpability of the signs" (Jakobson 1960, 93) is insignificant to some of the actors. My impression is quite otherwise. What Franz Boas (1927) understood as "virtuosity" — the pleasures of the practice, so to speak, in basket making, pottery making, or Northwest Coast wood carving — seems clearly present as a feature of production.[1]

I do not want to claim that the Pintupi painters I have known think of themselves as "artists," with all the cultural baggage that might imply. Yet their practices and products manifest an engagement with the aesthetic function, and this engagement varies from painter to painter. Pintupi painting reveals the pleasure of practice, the elaboration of virtuosity. Using the cases of Yanyatjarri Tjakamarra and Wuta Wuta Tjangala, I can show something of the substance of this aesthetic engagement and discuss some of the properties of the distinctive visual languages that emerged in the course of the development of their painting traditions.

Pintupi Painting: The Periods

The transition in the paintings from 1971 and 1972 is an interesting problem, because it not only offers some insight into painters' intentions and motivations but also allows us to recognize the effect of specific kinds of practice on the images

(Mountford 1977). As Judith Ryan (1990, 24) notes, the earliest paintings have a remarkable similarity to those collected at different times by Norman Tindale and C. P. Mountford, in which the anthropologists had given sheets of cardboard and crayons to Western Desert Aborigines — Yarnangu. In these materials, they transposed the sacred designs traditionally confined to carved boards, body decorations, and elaborate three-dimensional ground paintings. This appears to be the baseline from which Papunya painting emerged.

Papunya Tula — and Pintupi — art acquired a particular form in response to criticisms from other Yarnangu that it violated strictures of religious secrecy for traditions shared between them. The effect of this criticism — an occasion of "trouble," in Aboriginal English — was perhaps a central historical moment in its stylistic development away from naturalistic representation, especially of ritual forms, and toward increasing abstraction. Judith Ryan, for example, sees the increasing deployment of dots after 1972 as a masking of secret referents: "A fundamental change was occurring as the artists themselves . . . assessed the content of their paintings. Other Aboriginal people had seen the paintings for sale to outsiders, and were angered by what seemed to be a blatant display of certain aspects of the secret-sacred men's world. In response to this, all detailed depictions of human figures, fully decorated *tjurunga,* and ceremonial paraphernalia were removed or modified" (1990, 27-28). Ryan describes this transformation in Papunya Tula images, in which emphasis shifted to infilling the background, as a form of "camouflage."

Wally Caruana also describes a transition occurring at this time, set in train by the realization that imagery of a sacred and secret nature was being broadcast to a public who did not possess rights to its deeper significance: "By 1974 the naturalistic elements in paintings became less frequent and the narrative was expressed through conventional symbols which, given their multi-referential range of meanings, allowed the artists to describe their work without reference to secret information. Thus the public story could be separated from the more esoteric meanings" (1993, 110). As Caruana notes, "painters employed a combination of naturalistic or schematic depictions of objects such as shields, spears, axes and sacred emblems used in men's secret ceremonies, with more conventional symbols, all usually painted against monochrome, often dark backgrounds" (109). Subsequently, the painters are argued to have shifted representational strategy away from naturalistic, and therefore recognizable, signs of religious objects or even of ancestral figures. Most writers consider that the increase from 1973 onward in dotting and in the dominance of the concentric circle motif in Pintupi painting — with the concomitant focus on related aesthetic and formal effects — reflects these considerations (Kimber 1995, 133).

While the politics of secrecy may have been a factor in the process of change, it was not a dominant theme of discussions I had with Pintupi artists about their stylistic choices. My closest and most constant engagement with painters was from 1973 to 1975, a period in which I documented all the (270 or so) paintings produced at Yayayi by Pintupi producers for Papunya Tula. The documentation of these early paintings has always intrigued me but never satisfied my curiosity. What do these shapes mean? What are the painters communicating? What is involved in the transition from these forms to those found in subsequent periods of painting? Despite the shifts in overt form, the painters were intensely interested — in their discussions with me — in a range of deep meanings and referents they understood to be in their paintings.

Such questions require a more intricate examination of the whole corpus of painters' work. I propose to look at the bodies of work by individual producers, beginning with their works as I recorded them from 1973 to 1975. I will do this in two sections. The first considers the series of works produced by Yanyatjarri Tjakamarra as evidence of his interest in form, pattern, and design. The second reviews a large set of paintings of the "same story," both by a single painter — Wuta Wuta Tjangala — and by others.

Yanyatjarri Tjakamarra: The Play of Templates

Yanyatjarri Tjakamarra, also known as "Anitjarri no. 3," who died in 1992, was a man with a great talent for painting (right). One of the original members of the Papunya Tula Arts cooperative, his home country was in the southern area of the Gibson Desert that links Pintupi speakers with those who regard their (very similar) language as Ngaatjatjarra. He identified with both groups and was one of the last of the Gibson Desert people to leave their home countries in the late 1960s. In the early 1970s, we spent many hours discussing his country, the Dreamings there, and his travels. I regarded his friendship as a great privilege. Yanyatjarri, a man whose speech was so quiet it could hardly be called a whisper, was deeply contemplative and highly successful as a painter, producing work that was collected by connoisseurs, used in land rights posters, and displayed in New York. One of his paintings is in the contemporary collection at the Metropolitan Museum, and another early work was purchased for what was then a record sum of $75,000 in 1995.

From 1973 to 1975, Yanyatjarri was very active in painting, with an output that may have been stimulated by the intense performance of Tingarri initiations at Yayayi and by a long expedition in June 1974 to visit his main sacred site, the

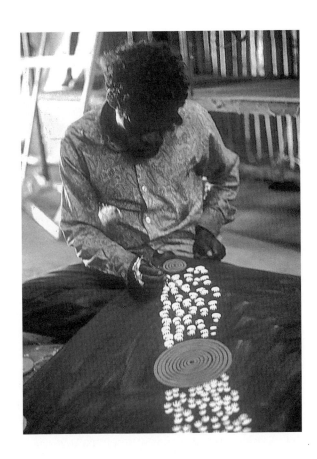

Yanyatjarri Tjakamarra painting, 1975. Photo by Fred Myers.

Tingarri center of Yawalyurrunya. Such reacquaintance with his country, on this and other trips that year, served as a stimulus to the production of related imagery.

The main stories that Yanyatjarri painted, the Dreamings over which he exercised the rights of representation, were the Tingarri cycle, especially that from the area of Kurlkurtanya to Kaakurutintjinya (Lake Macdonald), the kuniya kutjarra (two carpetsnakes), *wati kutjarra* (two men), the *wayurta* (possum) Dreaming that crossed the Tingarri path, and *kutungu* (an old woman, who was a snake).

The chart entitled *Time Series,* based on sketches I made of the paintings over a two-year period, presents all of Yanyatjarri Tjakamarra's paintings in the order of their production (or recording). It shows something of the overall development and his use of various figures across stories of differing content and ritual form. It is also possible to see what occurs in different paintings of the same place, or in the same story — and what iconographies are deployed. I use the term "feature" to refer to numbered distinctive graphic signs in the paintings for which I recorded infor-

mation from the painter. Finally, I should say that my impression of Yanyatjarri's painting is that it involves considerable care and precision, and rather less apparent personal involvement and display than do Wuta Wuta Tjangala's works — more concern with the story than involvement with the ritual. Although Tingarri is his Dreaming, Yanyatjarri painted no stories emphasizing his own Dreaming-place, for example, as Wuta Wuta repeatedly painted Ngurrapalangunya and Charley Tjaruru repeatedly painted Tjitururrnga.

Yanyatjarri's corpus is rich and varied. In seeking to illuminate how he used and elaborated a visual language in his images, I restrict myself to three emblematic themes. First, I want to draw attention to his painting with rectangles, oblongs, and squares, in addition to the more usual circle-grid structures, and the combination of circular and rectilinear shapes that he developed. The second theme is the various developments of the five-circle theme of organization. A third theme is the effect of moving from individual paintings of Dreamings on small canvases to the combination of related Dreamings on large canvases.

The discussion of these themes in Yanyatjarri Tjakamarra's work is divided into three main parts. While I try to keep within the framework of historical sequence in his painting, it is useful to recognize overall frameworks of what might extravagantly be referred to as "experimentation," or more modestly as "exploration." The first part of my discussion will focus on the strategies of representation, embodied mainly in a series of paintings of the Tingarri tradition, following the development of the five-circle grid template in his paintings. The second part of the analysis involves Tjakamarra's deployment of rectilinear images, a practice that is not entirely temporally separate from the five-circle grid development. Finally, I will turn to the effects of painting on larger canvases.

Five-Circle Grids and Body Designs

I can best begin with two early paintings I recorded in sketches. These images involve two sites of the Tingarri, quite conventionally represented in the five-roundel configuration, painted in acrylics on 60 × 90 cm canvas boards. Painting 68 is of Kurlkurtanya (a water hole represented by a circle, feature 1). The image refers in this case to the set of hills where the Tingarri men — a group of young men initiates under the control of kuninka (Native Cat) — came after leaving Yawalyurrunya soakage. The painting includes a number of other named places. At the center of the image is a cave (feature 2), which is near Yawalyurrunya. In the hills nearby is the cave known as Kantawarranya (Yellow-Ocher Place), from which people regularly collect the ocher for ceremonies. The circles on the periphery (fea-

This chart, read top left to bottom right, shows my field sketches of every painting produced by the artist over a two-year period (1973–75), in date order. In each painting certain graphic signs emerged as significant in my discussions with the artist, and these were numbered at the time. I use the term "feature" to refer to them in this chapter. Since the main discussion of the sketches occurs within the text, the captions contain minimal information: the reference number from my field notes, the place and Dreaming to which the painting refers, and the date on which the sketch was made. Many of the sketches are reproduced and discussed later in the chapter. Where this is the case, the individual painting number should serve to make the connection.

Painting 4. *Nyilinya*, carpetsnakes. 19 September 1973.

Painting 68. *Kurlkurtanya*, Tingarri. 19 September 1973.

Painting 70. *Kantawarranya*, Tingarri. 5 March 1974.

Painting 85. *Tjukulapirninya*, Tingarri. 19 March 1974.

Painting 93. *Mulutjitinya*, Tingarri. 25 March 1974.

Painting 98. *Tjuntinya*, two carpetsnakes. 4 April 1974.

Painting 99. *Kirritjinya*, Tingarri. 4 April 1974.

Painting 104. *Tjilingannga*, two carpetsnakes.

Painting 107. *Wakulanya*, Yula. 16 April 1974.

Painting 113. *Rilynga,*
Tingarri. 4 June 1974.

Painting 118. *Tjimanya,*
Tingarri. 4 June 1974.

Painting 153. *Yiitjurunya,*
Tingarri. 6 August 1974.

Painting 154. *Larlitanya,*
wati kutjarra. 6 August 1974.

Painting 169.
Ngumulynga, two boys.
26 August 1974.

Painting 176.
Palykarrpungkunya, two
carpetsnakes. 31 August 1974.

Painting 178.
Maraputanya, wati kutjarra.
3 September 1974.

Painting 179.
Karrkunya, initiation.
3 September 1974.

Painting 188.
Yalkarnintja, Tingarri.
12 September 1974.

Painting 219.
Mingarritalnga, Tingarri.
25 September 1974.

Painting 222.
Pakarangaranya, wati
kutjarra. 3 October 1974.

Painting 230.
Lungkartanya, monitor
lizard. 15 October 1974.

Painting 239.
Piritjitjinya, two
carpetsnakes.
7 November 1974.

Painting 241.
Yiitjurunya, Tingarri.
20 November 1974.

Painting 243.
Mirraturanya (near
Tjimanya), Tingarri.
21 November 1974.

Painting 248.
Kuntarrinytjanya, Tingarri.
27 November 1974.

Painting 257.
Ngaminya, Tingarri/women.
20 December 1974.

Painting 258.
Wangukaratjanya
(from Kurlkurtanya),
Tingarri. 20 December 1974.

Painting 259.
Big Map of Country (Tjuntinya,
etc.), two carpetsnakes,
kutungu, native cat (Tingarri).
21 March 1975.

Painting 260.
Kirritjinya (2) Tingarri.
21 March 1975.

Painting 264.
Yiilytjinya, two carpetsnakes.
10 April 1975.

Painting 265.
Tjilingannga, two carpetsnakes.
10 April 1975.

Painting 68.
Kurlkurtanya, Tingarri.

Painting 70.
Kantawarranya, Tingarri.

ture 3) represent this cave. Pintupi understand the deposits of yellow ocher there as a transformation from the "original" ocher designs (walka) placed on the backs and stomachs of the Tingarri initiates who visited there in the Dreaming.

The second image, painting 70 (see color plate 2), which was said to be Kantawarranya itself, is a five-circle grid that simply intensifies the focus on the central roundel. Both of these images project onto the dimensions of the canvas board the ocher body-design of circles connected by lines worn by Tingarri initiates. (Indeed, the designs on the body are "walka"—and not only icons of the place but indices of it as well.) Walka are themselves aspects *of* the country (*in* the country, so to speak), and they are also aspects of ritual, which is represented itself *by* the country. If the country is a transformation, an objectification, of ancestral ritual, however, it is clear we are faced with an apparently endless play of displacement, a deferral of final referential closure. Yarnangu say that these hills are the place where a large number of Tingarri men stopped to rest on their way toward Lake Macdonald. The hills include among them other distinguishable named places, places whose images Tjakamarra also painted from time to time—Rilynga (a rockhole) and Pilintjinya.

Modifying the Five-Circle Grid

It is worthwhile to trace the ways in which Yanyatjarri modifies the five-circle grid, using it again and again. Painting 93 is again of the Tingarri, still on the path to Lake Macdonald, at Mulutjitinya—a place identified with another relative of Yanyatjarri's, whom he called "father." While Yanyatjarri here combines roundels and rectilinear shapes in an unusual way, the underlying template of organization—which provides an expectation that the painter modifies—is the five-circle grid. The central circle is a water hole, a *walartu* (lake), and the organization of the

Painting 93.
Mulutjitinya, Tingarri.

Painting 118.
Tjimanya, Tingarri.

circles occupies the diagonal. At the central circle, which is probably also a cere-
monial ground, one of the men swung a sacred object that flew off and landed
at feature 3—making a larger water hole here, where it penetrated the ground.
Feature 4 (connecting the circles) is a creek, and the rectilinear shapes 5 and 6 rep-
resent sandhills abutting on the site. Feature 2 is a high hill, and the rectilinear
shapes spinning off from the center, feature 7, are small creeks. The image does
seem to create a sense of centrifugal force, as with a sacred object flying off from its
hair-string, a force connecting the features of the landscape in ancestral activity.

It is also possible for the painter to put other twists on the grid. Painting 118 is
of another Tingarri story, at Tjimanya, but it represents a different group of ini-
tiatory ancestors traveling on a more southerly route. In this painting, the central
roundel represents a soakage. The emphasis of the image is on a water hole right
in the middle of sandhills (the pointed semicircles), without any hills or rocks,
created as a *karnala* (cleared ceremonial ground). The native cat sang out from a
nearby hill, Mirraturanya (see also painting 243 [page 98], constructed in a recti-
linear form), and herded the novices toward Tjimanya, where they lay in a hole,
in the fire, as novices do in the cleared ceremonial ground. This placing of nov-
ices "into the fire" is part of the preparation of Tingarri, and while the pointed
semicircles are said to be sandhills, they also might represent the flickering flames
of the fire, with the central position of the feature reflecting the fire's centrality to
Tingarri initiatory practice. While not overtly representing the five-circle grid, the
whole image formally manipulates the same space as the grid.

Extending the Five-Circle Grid

The basic spatial structures of the five-circle grid can be modified by Yanyatjarri
to quite different effects. For example, painting 179 (page 96) is of an important

site known as Karrkunya (Red-Ocher Place). It consists of a roundel in the center partially surrounded by a larger circle and four semicircular shapes. These four semicircles actually represent the ends of two *kurtitji* (shields), where young men secluded for ceremony are supposed to throw a ceremonial offering of grass. At this place, an initiatory operation on a young man went wrong, and he died. From his blood, one now finds red ocher at the place (feature 3). The central roundel is now a *yapu* (rock).

Painting 222 (page 96) returns to the Wati Kutjarra (two men) theme, at a place called Pakarangaranya (Get Up and Stand Place). The image is built around a central roundel anchoring a more rectilinear set of diagonal structures. This roundel (feature 2) is said to be the water hole at Pakarangaranya, "their camp." The two men are frightened of an attack by *mamu* (demons), and so they stood up from their camp in the center, facing in opposite directions. They turned to stone there. They are represented by the slightly triangular semicircles (feature 1), which indicate a seated person facing outward. On the sides, the men set up obstacles to protect themselves from demons. The diagonal fields (feature 3) sweeping up to the corners represent gravelly areas of small rocks, and feature 4 indicates a gap in the hill made by the men getting up and standing around. In this image, Yanyatjarri continues a pattern: he superimposes fields of small objects (stones, in this case) on more fundamental geographic entities.

The five-circle grid also underlies a series of snake paintings that Yanyatjarri did during this period and subsequently. In painting 239 (page 96), he takes up the story of the two carpetsnakes who were being led around by *nyuuna* (death adder). The story is located at Piritjitjinya, where the snakes are resting. This is said to be a dangerous place where the snakes almost stayed permanently. The organization of the image uses a five-circle structure and the meandering lines that Yanyatjarri almost invariably uses for the snakes. The central circle (feature 1) represents a cave, and the circles marked (2) represent openings out from the cave at the top of the hill. The two snakes wandered around this area, smelling the places and leaving their mark. The circles and rough shapes marked (4) inside the image represent rockholes in the area. The meandering surround line represents the path of the death adder, enclosing the area of the two carpetsnakes he is said to "look after." In this image, the five-circle grid represents a set of interconnected caves and openings to the outside as a two-dimensional, unified form.

It should be apparent that many of the two-carpetsnake paintings are yet another modification of the five-circle grids. Painting 264 (page 96) of the two carpetsnakes at Yiilytjinya (south of Paranya), is similar in form to other paintings of Yanyatjarri's. Feature 1 is the main camp, on a creek made by the meandering path of the carpetsnake. Feature 3 represents eggs that the snake laid and left behind.

These are now large round stones outside the creek, on the plain. From here the snakes eventually went to Nyilinya (painting 4 [page 89]) where Kutungu (old woman) hit one of them in the head and killed, cooked, and ate it on her way to Kiwurnga. The other carpetsnake was killed, Yanyatjarri said, by clever men — not in the Dreaming. Yiilytjinya, however, is a place that men used to go to "make" the carpetsnakes increase. Here one can see the different way in which Yanyatjarri has arranged the story elements to fit the board's shape.

These images are structurally similar to another painting of the two snakes. In painting 98 (page 96), the painter takes up the story of the two carpetsnakes at Tjuntinya — *tjunti* usually refers to a cave. The five-roundel configuration centers on the *piti* (hole) of the death adder who led the two snakes around. This hole is a water hole, and the meandering line that holds the painting together represents the movements of the death adder around this site, among some hills (represented by the outer circles) covered with a vegetation of spinifex and *wangunu* (woolly butt grass) used for food.

Multiplicity as Potency

The five-circle grid contains the potential for extension. Links may be established through circles and lines to other places. These in turn become the focal points for other grids, so that eventually a wider network of relationships is created. We will see later how this process is reflected in the form of the larger canvases that were subsequently produced by the Pintupi painters. At this stage, however, I want to draw attention to the symbolic aspects of multiplicity represented in some of the earlier paintings.

Painting 85 (page 97) is again of the Tingarri, the group of men now traveling further on their way toward Lake Macdonald. At Tjukulapirninya (Many-Rockholes Place) the multiplicity and magnitude of their aggregation is conveyed through the large number of small circles, arrayed around a large central circle. Representing what was said to be "a big water," this circle is also a ceremonial ground (typically a cleared area, scraped free of vegetation) in the Dreaming; here the novices gathered around an upright pole in its center. Before 1973, some painters might have painted such a ceremonial pole directly, but by the time I recorded this example, such visual information was usually being withheld. Instead, another dimension of the place's potency is featured — the size, or sheer number, of the aggregation. The numerous smaller rockholes are transformations of the novices sitting around the rocks. In a sense, the rocks are their bodies, *purlirringu* (turned into stone).

For a subsequent image, painting 99 I have only a poor annotation, unfortu-

Painting 98. *Tjuntinya,*
two carpetsnakes.

Painting 222. *Pakarangaranya,*
wati kutjarra.

Painting 239. *Piritjitjinya,*
two carpetsnakes.

Painting 179. *Karrkunya,*
initiation.

Painting 179. *Karrkunya.*
Copyright courtesy Aboriginal
Artists Agency Ltd., Sydney,
Australia. Photo by Fred Myers.

Painting 264. *Yiilytjinya,*
two carpetsnakes.

Painting 264. *Yiilytjinya.*
Copyright courtesy Aboriginal
Artists Agency Ltd., Sydney,
Australia. Photo by Fred Myers.

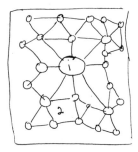

Painting 85. *Tjukulapirninya,*
Tingarri.

Painting 99. *Kirritjinya,*
Tingarri.

Painting 260. *Kirritjinya* (2),
Tingarri.

nately. I include it because it helps to understand the formal means through which multiplicity is presented. Kirritjinya is a Tingarri place en route from Yawalyurru to Lake Macdonald, where a large number of the Tingarri men came, under the direction of the kuninka (native cat). Where they sat, small rockholes abound. At the center, in what looks like a modification of a seven-circle configuration with others added, is the large water hole. Yanyatjarri produced a different representation of this same story much later (painting 260). This later painting emphasizes a particular feature of the story left out of the first image—the Tingarri men's hunting, killing, and cooking of an old man from that site who was hiding underground. Footprints indicate the old man's movements at the site, and his use of a noisy sacred object is alluded to in the curving lines that the artist said stood for a ceremonial necklace *(wila)* worn by initiates. Yet comparison with paintings in various collections suggests there is probably some standard represented by the choice in the first painting, as for example with the Kluge collection's painting of Kirritjinya from Yanyatjarri's "brother," John Tjakamarra, from 1991. He too emphasizes the multiplicity of rockholes and thereby the multiplicity of Tingarri men.

Rectangles and Paths

In mid-1974 a major period of Tingarri initiation was taking place in the Pintupi community at Yayayi. It corresponded—perhaps only coincidentally—with two developments in Yanyatjarri's painting: an increased recourse to rectilinear forms and the appearance of a "path" motif. One can see a sensibility at play here, in exploring the potential of distinctive forms.

Painting 113 returns to the Tingarri story in the hills around Kurlkurtanya and is

Painting 113. *Rilynga,*
Tingarri.

Painting 153. *Yiitjurunya,*
Tingarri.

Painting 243. *Mirraturanya*
(near Tjimanya), Tingarri.

Painting 248. *Kuntarrinytjanya,*
Tingarri.

focused on the place known as Rilynga. Resorting in a striking fashion to rectilin-
ear imagery, this painting emphasizes some of the relationships *among* the places
created in the Tingarri movements as the native cat brought the Tingarri men
toward Lake Macdonald. This narrative emphasis is a common strategy by painters
who wish to indicate the *coinvolvement* of geographically distinguishable features
in a larger story. It also amounts to another version of places that are sometimes
painted separately. Such a painting reveals the significance of the Dreaming, its
truth. At the top, feature 1 is Rilynga, a large rockhole; feature 2 is Pilintjinya,
another water hole; and feature 3 is Kurlkurtanya (see painting 68 [page 92], for
comparison). These water holes occupy the central space of the image, represent-
ing the spatial logic of residing in the area with camps drawing on all three water

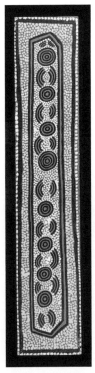

Painting 257. *Ngaminya.*
With permission of the
National Museum of Australia.
Copyright courtesy Aboriginal
Artists Agency Ltd., Sydney,
Australia.

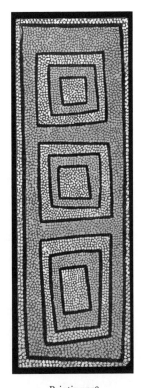

Painting 258.
Wangukaratjanya. With
permission of the National
Museum of Australia.
Copyright courtesy
Aboriginal Artists Agency
Ltd., Sydney, Australia.

sources. The other rectilinear features, organized with the whole as part of a three-column arrangement, represent the hills and rocks that are the Tingarri men in their numbers. Around the outside, dotting represents the mulga scrub around the hills. The native cat's tracks are found within the image along the spaces that the painter identified as "creeks" in the hills.

The next image, painting 153 (see also plate 3) is of Yiitjurunya, a place where the native cat—on its way to rounding up the Tingarri men at Yawalyurrunya—encounters the wayurta (possum) people at the series of *maluri* (claypans) and a soakage known as Yiitjurunya (where the painter's mother's father died). It was painted in acrylics with brush on laminated board. The image emphasizes rectilinear form, once again, in a three-column grid, with a path of wayurta tracks

circling around three sides. The possums, who were from this place, were sitting in their cleared ceremonial grounds (now claypans, feature 2), which are represented by the rectilinear forms typically incised by Western Desert people on sacred boards (Strehlow 1964). While the possums were gathered here at night, singing, the powerful kuninka (native cat) man came into view. He stopped to decorate himself with vegetable down in the design associated with him, and a large bloodwood tree marks the spot at the site. It is unrepresented in this painting but is represented as the central circle in painting 241 (page 91). The possums saw the awe-inspiring large sacred object he carried and, terrified, said nothing to him. As he ran, the native cat used the dramatic and ritualized high-stepping motion typical of ceremonial and anger display contexts, and this is said to have resulted in more claypans. The center square represents a reliable soakage, with smaller ones around, but the rectilinear form presumably alludes to designs on the sacred object he carried—embodying his power.

Painting 243 (page 98) represents another Tingarri site, Mirraturanya, which is a series of swampy claypans where the Tingarri men, women, and novices came together. The men are said to be on the top right area in the image, and the women on the lower left. The novices were "put in the fire" and subsequently "revealed" (brought out of all-male seclusion) at what is now the soakage of Tjimanya. In contrast to the image of Tjimanya (painting 118 [page 93]) that emphasized the fire, the six-feature grid uses rectilinear shapes rather than circles, and all but one of these larger squares were said to be "the swamp," a very big one. The smaller squares at the top periphery are said to be some *kutinpa* (stony rises), the places where the older men directing the proceedings "sang out" to begin. Feature 3 (the small squares on the left, below the first row) represents a stony rise where the area for the novices' fire pit was dug out—where they came to stand while being revealed—and where water can now be found in the swampy area.

Painting 248 (page 98) is more unusual in deploying a combination of circular and rectilinear shapes. The painting represents another point on the path of the Tingarri story from Yawalyurru, at a place called Kuntarrinytjanya (Becoming-Ashamed Place). This place lies on the Tingarri travels beyond Kurlkurtanya, and it is the conception place of Yanyatjarri's youngest brother. The central circle is the rockhole, surrounded by diagonal rectilinear shapes that are identified as sacred objects that the Tingarri men were decorating on their way to this place from Rilynga. The native cat stole these sacred boards, but when he came to this place, he *kuntarringu* (felt ashamed), giving the place its name. The square feature surrounding the sacred objects and the water hole is the hill, and beyond it, the rectilinear shapes indicate the sandhills around the hill.

Rectilinear forms represent a minority of the images Yanyatjarri painted, but

they are far more common in his work than in that of other painters. Painting 257 (page 99) is unusual for this period, being small and very narrow and painted on fiberboard rather than canvas board. I had asked Yanyatjarri to paint a board for me, and when he discovered there were none available of the usual size, he chose to do two paintings on small pieces of fiberboard, a practice that had become less frequent after 1972. The choice of design form may owe considerably to the nature of the paintable surfaces available, surfaces quite similar to the shape of ritual objects themselves. "Ngaaluni patjarnu tjaminpa" [This one bit me when I was a young novice], the painter told me. By this he meant that in his first seclusion as a Tingarri novice, this design was painted on his body by older men and the songs sung. Now, therefore, he has the right to do the same, that is, teach younger men.

The particular design is associated with events relating to Marapintinya, where the women had pierced their nasal septums. The central image is said to be a sacred object, belonging not to men but to women. Women carried these objects as they accompanied the Tingarri men near the Pollock Hills north of Marapintinya. A separate group of traveling Tingarri men was sitting south of them in the Pollock Hills, while the women were north in the sandhills at Ngaminya. Their food, *walpuru*, lies in a line along the sandhill. These women were cooking walpuru, a kind of bush vegetable that is cooked in hot ashes like a yam and of which only the protruding *pina* (ears) are eaten. The circles represent the firm breasts and nipples of a maturing girl, and the half circles represent the edible top part of the walpuru. When cooked, walpuru makes a loud cracking or exploding noise, which frightened the women. The song verse associated with the design was given as follows:

> ma punta palarni
> taarrtarrma
> ma punta palarni
> kinkinma punta . . .

The song refers to the cracking sound — *taarrtarrma* — that frightened the women, so that they ran away.

The next painting, which is numbered 258 (page 99) in my notes, was made at the same time as the *kungka* painting. It was done with acrylics and brush, also on fiberboard. The design is from one of the "men Tingarri" paths. Yanyatjarri said the other (painting 257) was kungka (woman), and this was wati (man).

The rectilinear design reflects the rectilinear incised patterns typically found on sacred boards of Western Desert people. It should be considered simply as a painting of such a board. This story is about the Tingarri men who were sent by the native cat from Yawalyurrunya in the west toward Kaakurutintjinya (Lake Macdonald), where they were all killed. This image represents the events and their

geographic imprint at a place called Wangukaratjanya. The design was glossed to be a schematic map: the two outer features (1) are *pinangu* (small water holes) that hold water just after rainfall, and (2) is a large rockhole where the native cat laid his sacred objects down and cooked his meat (using these objects to shift it in the fire). The dots around the designs represent *yurilpa* (flat clear land).

Imaging the "Path"

During this period of experimentation, Yanyatjarri also developed some other components of visual language. Painting 219 departs from the circle-grid composition and offers an emphasis on a path or a channel of action. It also seems to sustain an interest in more rectilinear forms. This image of the Tingarri story at Mingarritalnga (near Pilintjinya, and part of the Yawalyurru and Kurlkurta cycle) represents the many small rockholes along the creek there. The line around the periphery of the image indicates the hill, and beyond it the painter identified a sandhill. Around the central creek *(karru)* and its rockholes *(walu)*, the painter has included some irregular small shapes he identified as rocks and stones *(purli)*, probably a gravelly area, from the flowing blood of the Tingarri novices, a substance representing their life force and strength. This life force—blood—is flowing down the creek bed, imaged as a broad path through the center of the painting.

In the next two months, Yanyatjarri painted two more images emphasizing the path motif and also showing his mastery over the five-circle grid. Painting 230, interestingly, repeats the figure of a central path to indicate a creek or watercourse. The place is identified as Lungartanya (Blue-Tongued Monitor Lizard Place) and is said to be associated with a kind of sorcery known as *yinirarri,* and it is said that one cannot drink from this water lest one die. The circle in the center is the hole where the blue-tongued lizards were sitting. The daisy shapes in the four corners mark rockholes. This central area is on a hill, from which the creek presumably flows downward, across a stony course—as indicated by the rectilinear forms in the path. The use of a central rectilinear for a creek, from top to bottom, echoes painting 219, done only two weeks previously, although the mythologies are distinct.

Painting 241 is another representation of events at Yiitjurunya, where kuninka (native cat) encountered the possum people at a place known for its series of swampy claypans. This painting should be compared with the rectilinear form of painting 153 (page 98), done three months earlier. The ceremonial grounds cleared by the possums, where they sat singing their ceremonies, are indicated by the two circles at the top (feature 1). The image has a five-circle structure, slightly reorga-

Painting 219. *Mingarritalnga,*
Tingarri.

Painting 230. *Lungkartanya,*
monitor lizard.

Painting 241. *Yiitjurunya,*
Tingarri.

nized by the fields of color. At the bottom of the painting, the native cat is putting on the vegetable down for ceremonial designs, and he created clear areas by the path of his dancing. The central circle (feature 3) is a very large bloodwood tree — a transformation of the native cat putting on his designs. Around the outskirts of the main area, the painter has indicated the presence of a sandhill. It is difficult not to see this painting as building on the use of a vertical rectilinear in constructing a main path for the native cat through the possum people's encampment, perhaps emphasizing more his movement and dancing than in the earlier image.

The Effects of Space: Complex Images

One of the developments that occurred shortly after my main period of fieldwork was the production of large canvases. Working on large canvases involved the development of a number of principles of designs already evident in the earlier series of paintings: the replication of motifs, the use of grids to extend links to other sites, and the combination of Dreamings from different places. One outcome was the "complex map," which incorporated a number of a painter's Dreamings in one representation.

It was only in 1975 that Yanyatjarri began to do larger paintings on canvases. Painting 259 (see page 105; plate 4), the first of these, became a land rights poster, involving most of the painter's major Dreaming stories. The bottom story is of Kutungu, the snake woman who traveled eastward towards Muruntji. Her path across the country is shown. She saw the two carpetsnakes of the second Dreaming, represented by Tjuntinya, one of their water holes (the roundel marked as feature 2), from which they are said to have risen. Feature 3 represents the hole that

the death adder opened for the two carpetsnakes from another place, a cave called Kakalyalyanya (feature 4). This last place has poisonous, yellowish water, which humans cannot drink. Feature 5, the meandering lines, represents the tracks or paths of the two carpetsnakes, and the small circles (feature 6) indicate the meat of the two snakes (probably through reference to the holes made by the snakes in pursuit). At the bottom of the image, the circle marked as feature 7 indicates the place where the snake woman saw the two carpetsnakes digging holes in pursuit of game. At feature 8 the painter has indicated by means of track marks the path of the native cat, angrily pursuing the Tingarri man on his way from Lake Macdonald to Yawalyurru. Feature 9 represents another snake woman figure, this one heading westward from Pangkupirri rockhole, toward a big water hole south of Narurrinya known as Kiwurnga. At the top, feature 1 represents a woman's possum tail necklace, the *mawulyarri,* first spun by this ancestral figure. The white circles at the top of the painting are *pura,* a vegetable food. The woman is said to be hunting by digging for a small animal called *tatjalpa.* At feature 10, the snake woman "went inside" at Kiwurnga. She saw a carpetsnake and speared it where a bloodwood tree now stands. The carpetsnake bit her stick and pulled her in, under the ground. The ceremony of the two carpetsnakes, involving designs in vegetable down and sorcery spells, was "given" to Yanyatjarri when he was a young man—and in return he gave large ceremonial gifts of meat. This grand painting of Yanyatjarri's is partially replicated by one in the Kluge-Ruhe Collection, labeled as *Muruntji Story.*

We can actually compare the effects of the new image size, not only in the comparison of the five-circle grid carpetsnake paintings (page 96) with the Muruntji map but also in the case of the multiple representations of Kurlkurtanya (see five-circle grids and paintings in the time series, pages 89–91). The Kluge-Ruhe Collection's painting by Yanyatjarri entitled *Artists' Country near Kurkuta* (1989.7004.016) is a gracefully arranged series of concentric circles on a dotted background—emphasizing multiplicity (the large number of Tingarri men) and the subdued use of colors. The images from 1973 and also 1974, however, emphasize the specificity of the place and allude to the connected circles and lines used in painting on the bodies of the young men. His brother Simon's painting (1989.7004.014 in the Kluge-Ruhe collection) of the related site of Pilintjinya (see painting 113 of Yanyatjarri [page 98]) and part of the Kurlkurta complex, has the distinctive trademark of his personal style, of merging dots—but also uses the available size to emphasize multiplicity.

Composition and symmetry are not only significant properties of Yanyatjarri Tjakamarra's painting, they constitute major components of the visual organiza-

Painting 259. *Big Map of Country* (Tjuntinya, etc.), two carpetsnakes, kutungu, native cat (Tingarri).

tion of Western Desert painting generally. Indeed, Peter Sutton's study of Western Desert acrylics — based on a sample of three hundred Western Desert acrylics, dating from 1971 to 1987 — outlines some of the central constituents of what he calls the "morphological meaning" of this art, "its visual logic and the way forms come together to create the look of the art" (1988, 59). These constituents are that ceremony is the key locus of Aboriginal classic art; that the renewed recombination of a limited number of elements lies behind the austere economy and the consistency of the art; and that a tension between symmetry and asymmetry is a central force in its aesthetics. More particularly, however, Sutton develops a series of generalizations about the composition of paintings and the role of symmetry within it. These suggest the existence of underlying templates much like those described by Howard Morphy (1992, 150) in Yolngu bark painting as "generative and organizational components of the artistic system" (see also Watson 1996 and Poirier 1991 on Balgo art).

Of course, as Morphy has argued for Arnhem Land, the locus of a dynamic in Yanyatjarri's work requires something other than the reduction of a corpus to the generative rules of a morphology. But it is in the recombination of a limited number of formal elements that he succeeds, especially in bringing rectilinear and circular iconographies into communication — and in this activity one can discern his virtuosity, engaging so many possibilities. There is a "feeling for form developing with technical activities," as Franz Boas suggested (1927, 11). One can observe

the borrowing and relocation of sets of forms from one painting to the next, in which subtle repositionings begin to become very interesting to the accustomed viewer. Moreover, their place in a series makes a good case for a consideration of them as evidence of an emerging practice—one that does not require an ideological formulation of a category "art" or even of "aesthetics" (10).

Such analysis can only provide the beginning for understanding the choices or actual arrangements deployed by a particular painter: the impact of these arrangements may depend on a viewer's or producer's knowing what choices there might be. While the choices of how to represent an object, a place, or a story may rely on a range of conventional (rather than invented) signs—icons and indices—this selection seems based on a recognition of the material quality of the sign vehicle itself (e.g., size, shape, location, color) in relation to other materialized signs. This is precisely the "palpability of signs" that Jakobson (1960, 153) found central to "poetics" or "aesthetics." We can turn from the delineation of morphology, which Sutton emphasized, to a recognition of Yanyatjarri's virtuosity in controlling these possibilities for his own expression.

Yanyatjarri Tjakamarra's paintings, taken over this period of time, show a burst of production around the time of our several trips to visit his country out west. This burst of production is not simply an enthusiasm of quantity. The paintings show, I believe, an exploration of form and color, notable for its variety—for example in the use of rectilinear and roundel forms, as well as their combination. His paintings are rarely the rote application of a template (five- or seven-circle grids), but usually show some further consideration: he builds on a clear set of templates, repeatedly modifying them. The painting of Karrkunya, which uses the same color combination that are part of Maraputanya, makes the template of the five-circle grid work with quite different shapes. The development of the "creek"—central vertical rectilinear—through the plane of the painting also seems to be a discovery he makes. Taken as a whole, and even ignoring the use of color, Yanyatjarri's work is virtuosic in its interest in form.

Wuta Wuta (Uta Uta) Tjangala: Yumari Paintings

In Wuta Wuta Tjangala's paintings, the engagement with form is more mediated (more than in Yanyatjarri's case) through a concern with an expression of his personal identity, an expression that, I believe, attempts to communicate more of his experience of ritual. Generally, the annotations produced for Wuta Wuta's paintings by most recorders are problematic. He spoke almost no English and was, moreover, rather an excitable sort of man, wildly expressive and playful. The series

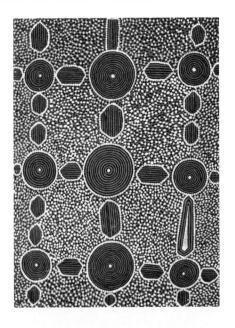

Painting 178. *Maraputanya.*
Copyright courtesy
Aboriginal Artists Agency
Ltd., Sydney, Australia. Photo
by Fred Myers.

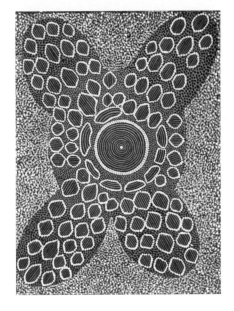

Painting 179. *Karrkunya.*
Copyright courtesy
Aboriginal Artists Agency
Ltd., Sydney, Australia. Photo
by Fred Myers.

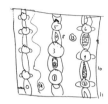

Painting 2. *Tarkurrnga.* Painting 5. *Walinngi.* Painting 11. *Tjapangartiwarnu.*

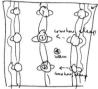

Painting 16. *Yawarrankunya.* Painting 20. *Wilkinkarra.* Painting 28. *Malkanya.*

This chart shows my field sketches of the first six paintings produced by the artist from 1973 to 1975. The sketches are in date order and include the first of his Wilkinkarra paintings.

of paintings Wuta Wuta produced from 1973 to 1975 surprised me in review. He is known best for his masterful paintings of his own Dreaming, at Ngurrapalangu and Yumari, but few of these appear in his rich output for nearly a year. Indeed, it seems that these stories and places began to appear more commonly after we made trips to the region and even more so when the prospects of a return to his country to live increased. This emphasis was also visible in his concern to have his sons gain knowledge of that country—as I recorded elsewhere and will include here.

One should also acknowledge the larger context in which the paintings are produced and articulated, which was introduced to me almost immediately in my fieldwork by Charley Tjaruru and Wuta Wuta. The Pintupi living at Yayayi in 1973 had insecure tenure. They had moved from Papunya, a place dominated by other groups, to this nearby outstation, but at Yayayi they were still residing on land of which they were not the primary custodians. The paintings, by contrast and with significance, denote *their* own country. "We belong to that country," Charley told me about one of Wuta Wuta's paintings in August 1973, soon after I arrived. "We want to get a windmill and a pump, to go back there." As Charley said, "The west is ours." In this context, I think, Wuta Wuta's interest in establishing rights to the place Yumari becomes ever more the focus.

Wilkinkarra

Major emphases of Wuta Wuta's early paintings are the kungka kutjarra (two women), who traverse his country on the way to Wilkinkarra (Lake Mackay), and Wilkinkarra itself. Many painters produced images of Wilkinkarra, of course, but these are especially frequent in Wuta Wuta's work and may reflect the performance of Tingarri ceremonies in 1973 in which reenactments of Wilkinkarra mythological sequences were significant. These were replaced, subsequently, with an intensified emphasis on the Yina (Old Man) Dreaming. At the same time, his close friend and brother-in-law Charley Tjaruru painted a coherent series of the Old Man's travels toward the area that Wuta Wuta emphasizes.

Wuta Wuta's paintings show the development of an extraordinary facility with form, especially in the ways in which he breaks up and organizes the plane of the picture itself—as in paintings 2, 5, 11, 16, 20, and 28 (left). The three-line structure is used quite variously in paintings 2, 11, 16, and 28 and also contrasts with the more cross-shaped designs of paintings 5 and 20. The initial paintings heavily focus on the three-vertical-line grids as a structuring device, but later paintings organize the space far more complexly, as seen in painting 151.

Wuta Wuta draws inspiration from the varied details of story and place to produce varying emphases in his images. This is evident, for example, in the range of ways he represents Wilkinkarra with its story of a different old man and the kanaputa women, whose fire made the salt lake area. He demonstrates his inspiration from the varied details of the stories and places to which he gives varying emphasis in his images. Sometimes the focus is on the straight line-emphasized path (paintings 48 and 62 [page 110]) of the kanaputa women coming from Ngurrapalangu, organized with the seven-circle shape. The "arms" of the latter form (also in painting 115 [page 110]) are the arms of a ceremonial object around a circle that represents the cave into which the initiate young men went from the fire. Sometimes

Painting 151. *Wintalynga.*

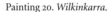

Painting 20. *Wilkinkarra.*

Painting 48. *Wilkinkarra.*

Painting 62. *Kanaputa.*

Painting 115. *Yukurpanya.*

Painting 163. *Wilkinkarra.*

This chart shows my field sketches of some of the paintings relating to Wilkinkarra produced by the artist over a two-year period (1973–75).

the emphasis is more on the ceremonial ground of the Tingarri performance at Wilkinkarra (painting 115), sometimes it is the dancing women and their *ngalyipi* (fiber rope) as in painting 20, and sometimes it is the iconography of the fire that two men lit there (the concentric circles and crescents in painting 163). Each of these narrative choices has different aesthetic effects, as the signs that represent the features have different properties.

The series of paintings done by Charley Tjaruru in this same period, and my discussions with him (he was often more narratively oriented than his friend), indicate that the central features of the old man Yina—who possessed great sorcery power—were his penis and his testicles. In each painting, and when we visited sites, the painters always pointed out the (for them) hilarious stories of the old man, whose penis left its mark at Tjintaranya, whose penis was bitten by ants at Namanya, whose penis and testicles rested separately at Wili rockhole (as the rockhole and the sandhills), whose testicles were stepped on by a dog at Nginananya, and whose penis was erect and swinging in the air as he walked at Tjurrpungkunytjanya, a rocky rise east of Sandy Blight Junction where the Old Man defecated and tried to hide it by lighting a fire (painting 212; see also plate 5).

The iconography of this painting represents an oblong form as his penis and circles as his testicles. These establish an iconography that is no doubt further delineated in ritual objects and representations. Indeed, in that first conversation I had with Wuta Wuta and Charley Tjarurru, the identification of the old man with his penis was central.

Ngurrapalangu

Wuta Wuta undertook many representations of the hills and stories at Ngurrapalangu, a hill and claypan site that was his own conception place. Here the kungka kutjarra (two women) brought a being called Tjuntamurtu (Short Legs). The women were frightened by the approach of the old man, and they fled toward Lake Mackay while Tjuntamurtu ran and crawled inside a cave, frantically tossing out the sacred objects stored there to make room for himself. These sacred objects became the hill Wintalynga in painting 131 (page 112), which lies south of the several large claypans (feature 3) of Ngurrapalangu, itself represented as the cave (feature 1). The hill of Wintalynga is perpendicular to the hill in which the cave is located, where the two traveling women (represented more clearly in painting 151 [page 109]) had originally left Tjuntamurtu behind. They set him down while they danced a woman's dance (nyanpi); in dancing, they created the claypans. After rainfall these claypans are the source of the seed-bearing plant mungilpa, whose seeds are ground into cakes and eaten. The cakes are represented as feature 2. The painter's mother ate these seedcakes, he said, and thus he was conceived. Therefore his conception Dreaming is said to be Tjuntamurtu, connected both to the old man story and to the two women Dreaming (who went to Lake Mackay).

Three paintings particularly draw attention to the representation of the hill of Wintalynga as a sacred object. Each includes a rectilinear shape with small circles along the side: these represent the shaved wooden inserts on the ritual headdress that became the hill. The paintings are 44, 131, and the well-known, frequently

Painting 212.
Tjurrpungkunytjanya.

Wuta Wuta's painting 131,
Ngurrapalangunya, 1974.
Copyright courtesy
Aboriginal Artists Agency
Ltd., Sydney, Australia.
Photo by Fred Myers.

reproduced *Tjangala and 2 Women at Ngurrapalangu,* painted in 1982 (P. Sutton 1988, 135, fig. 177). Painting 151 (page 109), which emphasized Wintalynga, has great resemblances to these. It shows both hills and Wuta Wuta's conception site as bullroarer-shaped forms partially enclosing a centrifugal and radiating seven-circle grid, a template that Wuta Wuta subordinates to the needs of the overall design and the memory of the place. The final painting of Wintalynga that I have (painting 235, right) is built around the five-circle grid and emphasizes the two women making a *murli* (shelter) on the far side of the hill, after fleeing the old man. This painting (painting 235) uses a standard sort of form and uses it to abstract a representation of a somewhat conical shelter seen from above.

Yumari: The Painting of Place

I would like to turn to the Yumari images, two of which have become key examples of the quality of Western Desert acrylic painting (Smith 1990). Any discussion of Wuta Wuta Tjangala's painting requires understanding that for Yarnangu, painting one's country or one's Dreamings is also—or is simply—painting one's identity. We might summarize Pintupi understandings of place or country by seeing these material formations as embodiments or objectifications of the identities of close relatives (Myers 1986a, 1988b). These objectifications come to be associated with the identities of living persons, whose relationships are objectified in them and expressed by them. Yumarinya—or Mother-in-Law Place—was a place where Wuta Wuta Tjangala used to live; it was filled with his memories of experience, of life historical events, and it was very important to him.

How did he come to be identified with this place? Yumari was part of Wuta Wuta's mother's country, or ngurra. She was conceived—her Dreaming—near Yumarinya. His father had moved there when he married her, and he lived in the north, near Yumarinya, with his wife's people, as is common for a time of life. This father subsequently died at Kalturanya, nearby, and is known by that place of his burial.

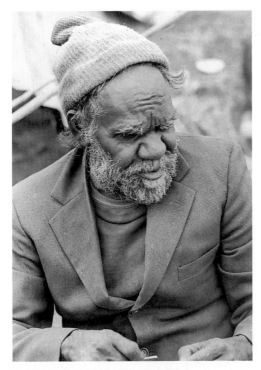

Wuta Wuta Tjangala, 1981. Photo by Fred Myers.

Painting 44.
Ngurrapalangunya.
23 November 1973.

Painting 235. *Wintalynga.*
15 October 1974

Wuta Wuta's conception Dreaming at Ngurrapalangu is linked to Yumari through the activities of Yina (the Old Man). He was on his way to Yumari when he scared the two women at Ngurrapalangu. Both Wuta Wuta and his elder brother claimed Yumarinya through their (shared) mother and her father (Wuta Wuta Tjapanangka) and through their own father, who is buried in the area, as well as through conception. Wuta Wuta can paint these designs and hold that country in ceremony because these rights of identification were given to him by his "one countrymen," recognizing in this manner their relationship. The shared identity is objectified in their mutual identification with the place.

This is an active process. In ritual exchange, and in controlling their sons for initiation and daughters for marriage, Wuta Wuta and others acted as a group, performing ceremonies as "brothers." The place was a vehicle of the shared identity of the younger generation as "sons" of the group of fathers. At the same time, his identification with Yumarinya (and other places) and his right to produce and deploy its stories and images provides Wuta Wuta with something he can exchange with other men—and, in this sense, undergirds his identity as an autonomous, equal man.

Yumari as a site is perhaps best delineated through Wuta Wuta's painting of it in 1979 on a small canvas board. His description of this painting is that the Old Man went to Yumari, now an X-shaped rockhole on a broad rock platform among the sandhills. The painting represents the rockhole, said to have been created by the body of the old man when he lay down. Feature 1 represents the man's navel; feature 2 is his head. Feature 3, another circle, is his crotch, covered by a pubic tassel.

The line to the top left of the 1979 version, feature 4, represents the Old Man's legs, and feature 5 (another line) represents the man's hair-string belt, which left a mark—a line of color—inside the rockhole. Feature 6 signifies the Old Man's spear and also designs he wore on the sides of his body, which are used to represent him in ceremonial activity. From the spot of the rockhole itself (which is indeed strangely like the body of a person lying down), the Old Man arose in the night to copulate illicitly with his mother-in-law (hence the name of the place). Various features at the site are indices of this activity, although they were not noted to be in the painting.

Yumari was the subject of several paintings by Wuta Wuta. The later paintings of Yumari dating from July 1981 were made at Papunya two months after Andrew Crocker and I made a trip out to Yumari with a group of men, led by Wuta Wuta Tjangala (see chapter 2). The iconography of the first Yumari painting of July 1981 differs slightly from some of his earlier ones, and as he explained it, Wuta Wuta spoke of where the bones of his dead relatives (his father, his mother's brother) were buried in this area. He intended to go and live near these bones.

The emphasis on the penis (feature 4) of the Old Man remains, and the x shape of the rockhole also remains central to its representation, articulating a physical landscape form and an ancestral body, bringing the Dreaming close to almost

Sketch of *Yumarinya*

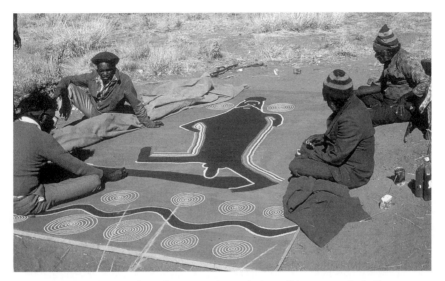

Wuta Wuta Tjangala at work on the masterpiece painting of his country, including Yumarinya, July 1981, Papunya. Photo by Fred Myers.

◄Wuta Wuta Tjangala, sketch of *Yumari*, earlier.

Wuta Wuta Tjangala, sketch of *Yumari*, 1981. ►

ritual representation. The feature marked as the head (1) is almost certainly a ritual headdress, and the small rockholes indicated as feature 3 probably include one small rockhole on the platform that is the vulva of the mother-in-law. The iconography is deployed to fill the rectangular space, and many features of the area are ignored. The emphasis on the shape is quite different from the Yumari painting of the same year included in the *Mr. Sandman* catalog (Crocker 1981a). But I think that something else is also happening in the use of the forms, with the Old Man becoming more and more of a presence — and this may involve Wuta Wuta's increasingly strong expression of his identity, in the context of his aging, but also of the growth of Pintupi autonomy.

Only a few weeks later, while tense meetings were taking place between the

Pintupi and other residents of Papunya, Wuta Wuta was completing what many regard as his masterpiece of *Yumari*, 1981 (see plate 6)—a painting stylistically quite distinct from the previous one. Commissioned for someone (I never knew whom), it is painted on the giant 244 × 366 cm stretcher used by Papunya Tula for its most significant commissions. Such an expanse invited a complex image, which Wuta Wuta provided. While the younger and somewhat more secular men engaged in their meeting, Wuta Wuta was preoccupied with his canvas. When the Pintupi met separately with representatives from the Department of Aboriginal Affairs, to make their case for leaving Papunya and moving west, they did so at this painting place.

I knew this painting was something special, especially in its distinctly different iconography for the figures and for its combination of the two related stories he most often painted—that of Yina (the Old Man) and that of Tjuntamurtu. I photographed the painting as it was being made, with Wuta Wuta's son-in-law and his brother-in-law helping. Years later, I saw it again, reproduced in the catalog for the *Dreamings* exhibition.

It had become common for artists to combine several Dreamings in the large paintings. This painting (see page 115) included Tjuntamurtu—the large figure —and more coded representations of Lirru (king brown snake) Dreaming (feature 1) that crossed from Central Mt. Wedge through Lake Mackay (Wilkinkarra), where it saw the kanaputa women on its way west. Yina is embodied as his penis (the somewhat rectilinear extension, feature 4), presumably also traveling west, and the circles (feature 3) represent the kanaputa women whom the Lirru saw at Wilkinkarra. Other circles represent the two women frightened by the Yina. The central figure—the somewhat naturalistic representation—is therefore Wuta Wuta himself in his incarnation as Tjuntamurtu, surveying and dominating his country. A clearer expression of a painter's identity is difficult to imagine. Pointing to this figure, Wuta Wuta told me, "Here, indeed, I am trying to get a bore." The circles all around the figure represent the rocks around the cave that Tjuntamurtu entered, at the site represented in paintings of Ngurrapalangu and Wintalynga.

In representing his identity in the land, the artist crosses back and forth between the landscape, the figures who created it and which it manifests, and the human incarnations of it. The central figure is not, as some interpretations have suggested, the Old Man—and the penis is not Tjuntamurtu's. If there is a headdress on the head, it is very likely that which is visible in the paintings of Ngurrapalangu and Wintalynga—the sacred object that was tossed out of the cave and became the hill of Wintalynga.

As a brief illumination of the specificity of Wuta Wuta's development of a visual language, I offer a comparison with a few images by his friend and brother-in-law

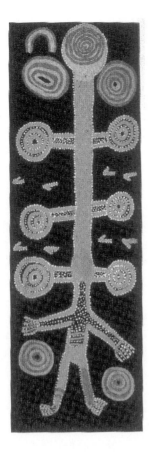

Charley Tjaruru Tjungurrayi, *Old Man's Story at Nginananya.* With permission of the Museums and Art Galleries of the Northern Territory. Copyright courtesy Aboriginal Artists Agency Ltd., Sydney, Australia.

Charley Tjaruru. I do so also to restore a sense of my earliest starting point in this book, with Wuta Wuta and Charley together. Painting on some occasions the same stories as Wuta Wuta, Charley saw Tjuntamurtu differently in his *Pangkalangka 1981.* (Pangkarlangu is another name for Tjuntamurtu.) The painter displays not the grand overseer of the country but the small, frightened creature in the cave, encased in the security of the rock; the fear is palpable, and the features of the face are reduced to the eyes and mouth. The grand figure of the Old Man of Yumari, too, finds its distinct, articulate form in another painting of Charley's, combining what must be the ceremonial regalia of this figure with its most phallic representation.

Conclusion

The capacity of almost every Pintupi man, at one time or another, to take up painting and produce interesting images requires explanation. The answer lies, I

believe, in what Boas called "technical experience," combined with an emerging social context that provides economic, social, and political value for paintings of the Dreaming. Everyday life offered the Pintupi painters I knew many opportunities to practice design and form—in tool making, ritual designs, carving ceremonial boards, and so on. But not every painter has a painterly vocation. Some do, however, and this is my point.

There is no indigenous discourse, at the moment, to capture a sense of people who have a special capacity and interest in form—and certainly not one to valorize it. The painters insist that the paintings are valuable for their reference to the Dreaming. If this situation initially appears to correspond to claims such as those made by Joanna Overing (1996) against a universalization of aesthetics—that "among the Piaroa, there do not exist the 'artist,' the 'art object,' and 'the aesthetically astute subject'"—this is true only at the level of explicit discursive elaboration. An aesthetic sensibility is evident, instead, *in practice:* in the range of paintings, the variety, the inventiveness displayed in the bulk of an individual's production. Some painters manage a few paintings, a few styles, and either quit painting or simply maintain a fairly common stock of images. Others are notable for their invention and experimentation. This capacity—or these interests—had less opportunity for objectification in the precontact social world, but it was not absent. I am led to imagine, therefore, an aesthetic that is deployed in the absence of a specific discourse that valorizes it particularly. In other words, reliance on the discursive apparatus of participants themselves is, in the end, not sufficient to grasp the totalities of their practice.

I draw on—and modify—Jakobson's 1960 understanding of the poetic (or aesthetic) function to argue that any communicative act might have the potential to focus on the message for its own sake, to treat the signs not as transparent to the message but as material forms in their own right. Kupka's 1962 consideration of Arnhem Land bark painters interrogating, as it were, their materials in executing an abstraction or reduction from their cultural world, like Boas's 1927 reflections on technical skill as the basis for virtuosity, emphasizes an aesthetic function that is not discursively elaborated and not necessarily aimed at communicating to a viewer or addressee.

Vivien Johnson (1994), in her analysis of the work of the Anmatyerre artist Clifford Possum, draws attention to his use of varying techniques to communicate his culture's view of the Dreaming. Her study of him as an *intentional* artist—a condition I do not argue for his Pintupi equivalents—suggests a sort of formal self-consciousness. Indeed, the development of a secularized acrylic painting language, in her account, emerged from the application of self-censorship regarding

sacred images. In contrast, she suggests that the Pintupi painters—perhaps less sophisticated in their knowledge of the outside world (see also Kimber 1995)— had a greater difficulty in resolving the problem of deploying images that were regarded as "sacred." I wonder if what she rejects for the Anmatyerre may be more true for the Pintupi—namely, that the "creative tension" in the work of these painters derives from "flirting with taboo subjects" (V. Johnson 1994, 39). The vitality of Pintupi painting seems associated with the rendering of the complex of ritual knowledge and experience onto a two-dimensional plane. In the initial periods, for example, one finds the greatest range of paintings, and one finds this range in the work of the men most dedicated to ritual—such as Wuta Wuta Tjangala, Shorty Lungkarta (who I do not discuss here), and Yanyatjarri Tjakamarra.

This is the stuff of a local art history, suggesting that there is much to be done in trying to understand what has actually been taking place in the practices of painting. At some level, serious students of the visual have implicitly known how to acquire relevant knowledge—they speak of "training their eye"—even if they have not at the same time come to terms *theoretically* with what their knowledge implies about the practitioners. As I will show in later chapters, a generalized "Ab-originality" may no longer comprise the value of the paintings in the art market. The growing Aboriginal art market exhibits a trend toward increasing discrimination and connoisseurship, toward the valuation of some paintings as being "better art" or more valuable than others. It appears that connoisseurship in the art market has begun to grapple with some of the complex organizations of color, space, and form in the paintings. In the chapters that follow, I turn to the institutional formations in which this connoisseurship has come into being and has molded the sensibilities of nonindigenous perception of the paintings. I explore some of the conditions for producing such knowledge in the social formation we know as collecting, and the conditions for producing a genre of activity such as "painting" in the market, arguing that these constitute some of the social and cultural conditions in which aesthetics may emerge as a form of value. At this point, through attending to the synergy between possible aesthetic theories and Pintupi practice, I have focused on the manifestation of a concern with aesthetics in the paintings themselves.

4 Making a Market: Cultural Policy and Modernity in the Outback

If there is one ambition we place above all others, if there is one achievement for which I hope we will be remembered, if there is one cause for which I hope future historians will salute us, it is this: that the government I led removed a stain from our national honour and gave justice and equality to the Aboriginal people. — Gough Whitlam, opening the National Seminar on Aboriginal Arts, Canberra, 21 May 1973.

In the years since 1973, when I began fieldwork at Yayayi, there has emerged an enormous interest in, and market for, a range of objects (and performances) made by Aboriginals. The magnitude is astounding. Estimates are that Aboriginal "arts and crafts" — a catchall phrase that includes everything from fine art quality bark and acrylic on canvas painting to handcrafted boomerangs, carved animals for tourists, tea towels, and T-shirts — generate anywhere from $A18 million to $A50 million in sales per annum. Papunya Tula Artists, representing Aboriginal painters in the small communities of the Western Desert, regularly has had sales of between $A700,000 and $A1 million annually. Hundreds of exhibitions of varying scale and focus have been held in Australia (Altman, McGuigan, and Yu 1989, 78; Perkins and Finke 2000), the United States, Canada, and Europe, many journalistic articles written, catalogs published, government studies made, policies articulated, and so on. This is now a sociocultural phenomenon of considerable weight, sustained by a complex set of practices and institutions.

How did there come to be a market for Papunya Tula Artists? It was not always so. In the early 1970s, participants in the Papunya Tula scene struggled mightily and often fruitlessly to "move the paintings," to generate demand for works made by the forty or so artists involved with the Papunya Tula Artists company. Although the painters have had a consistent view of their work since the beginning — as giving (yunginpa) or showing (yurtininpa) their Dreamings, as something dear (of ultimate and inestimable indigenous value) — this understanding has not neces-

sarily been reflected in the attitudes of those who bought the paintings. Put simply, markets represent a coincidence of evaluation between sellers and buyers, a coincidence that was only partly achieved. The development of a market for Papunya Tula paintings must be understood principally in terms of its shifting definition within the category of fine art. How the local activity known as "painting boards" was transformed into the entity known as "Aboriginal art" is the result not only of this changing criterion—and the painters' artistry—but of larger shifts in the relationship of indigenous people to the state. At a simple level, I am tracing in this chapter the ways in which Papunya Tula was supported. I intend the reader to understand the available meaningful and institutional frameworks—the complex field of cultural production—in which painting could be valued. My analysis is organized around what I take to be the historical thread driving discursive activity: the ongoing problem of cash flow. How were the participants able to generate demand, to keep the cash flowing so that the painters' expectations would be met? More generally, how were cash and culture to be reconciled?

Vivien Johnson has long insisted that the successful development of Papunya Tula Artists is predicated on its having been included in the category of "contemporary Australian Art" (V. Johnson 1994). This was an extraordinary change, a revelation to some who had earlier been involved with Aboriginal crafts. How, from the point of view of the practitioners, was this extraordinary change accomplished? Through what practices have these objects moved into an art-culture system? I use the word "practices" to suggest that the elaboration of discussions about Aboriginal acrylic paintings involved habits of placement and classification bound to ongoing institutional contexts. It is this combination of discourse and institution that gives material effect to classification and makes the idea of a discursive formation useful. Such formations were vital to the development of what became the Aboriginal arts and crafts industry, whose origins lie therefore in a mixture of indigenous aspirations and state projects of governmentality—whether this be in producing citizens, workers, or artists.

A history of discourse frames the history of making a market for Papunya Tula, a history of what anthropologists call "value production." Such an abstraction reminds us that the assignment of cultural value *may* include monetary representation, but thinking in terms of value production implies that economics does not necessarily provide the master discourse for understanding the social biography of acrylic paintings. The deployment of such a discourse is part of the story itself, an event of symbolic transformation. Indeed, the construction of Aboriginal acrylic painting attempts to merge considerations of economic viability and cultural identity. Naturalized or taken-for-granted assumptions concerning mar-

kets and economics, endemic to my own cultural milieu, have been a key problem in any discussion of Western arts, since these are posed — ideologically at least — as transcending or recuperating market-driven utilitarianism (Plattner 1996). If, therefore, I believe that Aboriginal art comes to be represented (or reconstituted) within this discourse, we should be prepared to treat it as an interpretation, as a kind of sociocultural transformation. It was a transformation whose hierarchies were unstable.

These formulations of acrylic painting have been shifting and contested, and with them various formulations of Aboriginality. From 1971 to 1991, Aboriginal art (in the form of acrylic paintings) shifts between the discursive formations of economic development — "art as enterprise" — and the more culturalist framings of "art as cultural and spiritual renewal" or "art as Aboriginal identity." All three frames, it should be noted, offered positive solutions to a perceived social disruption. Far from being simple artifacts of an enduring Western or Australian culture these discourses have pragmatic foundations. As performances of culture, they have been mobilized not only within some general national culture but also within the bureaucratic institutions of the Australian nation-state, by community arts cooperatives and art galleries, and by specific segments of the populace. Such groupings represent different interests, alignments, and identities as they address themselves to the situations of Aboriginal people, to existing representations of Aboriginal culture. The movement of objects outward from small indigenous communities and through these nodes of intersection suggests that general theorizations of cultural flows need political and historical specificity in the changing situation of Australia's national location.

In Australian definitions of, and attention to, the "Aboriginal problem" and its Aboriginal subjects, one might perhaps trace the forward edge of the Australian state's push toward a modernizing governmentality. These arts and their aesthetic values are articulated within the frameworks of broader cultural policies — policies *toward* the culture of some of a government's subjects — and are therefore an aspect of the "governmentality" associated with modern liberal nation-states. Policies for Aboriginal people aimed at protection, assimilation, and self-determination (as they have successively been in the twentieth century) are also themselves culturally formulated or produced. While such policies are increasingly brought under the direction and administration of bureaucracies and producers of specialist knowledge (anthropologists, sociologists, patrol officers, welfare workers) in distinctive institutions, one should recognize that these institutions and practices comprise sites of cultural production and that they have increasingly promoted the centrality of the discourse of economics in assessing production and consumption.

The arts and crafts industry's development (its maturity, and so on) and the policies addressed have often been imagined in terms of impersonal processes of bureaucratic rationalization and commoditization. After all, this is how market surveys proceed. There is another story to be revealed in ethnography, in which these processes are countered, if not resisted. The distinctive history of Aboriginal art markets shows limits in the expected separation of subjects and their objects, a separation that has been countered not only by the strong presence of personal relations, immediacies, and identifications among the participants but also by the value such personal traces continue to have for the particular commodity of Aboriginal "fine art." Orientations to these objects and their circulation seem simultaneously to offer formulations of the identities or personhood of those among whom they circulate. The contradiction between "market" and "art" is enduring. At the point where the personal and the impersonal processes run into each other most directly, for example, one finds the institutional space of the art adviser, whose situation is central to my understanding.

Abstract and general narratives are inadequate to describe a social field occupied by such different participants. One must take a ground-level sensibility to these events, acknowledging that the paintings are circulated, defined, and transformed in meaning and value through a specific network of persons and a range of institutions. The advantage will be that one will not view the "aesthetic" appreciation or recognition gained by the paintings as a universal attribute that could be taken for granted. Instead one can recognize this appreciation as something *produced* in specific historical action and context (T. Miller 1994).

There are alternative analytical frameworks. One could impose on this circulation a neo-Marxian analysis emphasizing the articulation of different modes of production, but the unfinished nature of the Aboriginal art market is better suited to representation through the lens of close ethnography. Here it is possible to sustain the rich, often ironic, sense of the way these new formations put people into different relations to each other.

This is why I am hesitant to circumscribe this nexus as the "art market" or the "arts and crafts industry." To a significant extent, these terms are signs, cultural constructions that define a reality as much as they represent an already existent one. The "market" is not simply the mechanism through which value is assigned to Aboriginal paintings; it is also to be understood as involving a specific attitude toward kinds of cultural value, as enmeshed in debates about value. One learns this surely by living in a Western Desert community. Indeed, the market emerged at least partly in relation to self-conscious planning and policy concerns on the part of the state, which attempted to integrate a range of political, social, and economic goals.

In analyzing the growth and development of the category of Aboriginal fine art, I will characterize three periods or moments: the beginnings (1972–1981), a time of little demand and serious cash flow problems; the boom years (1981–1989), which saw a dramatic growth in sales and exhibition; and the privatization period (1989–2000), with its settling out or establishment of a distinct and calibrated market for Aboriginal fine art.

Origin Stories, Corruption Endings: Art, Culture, Money

The development of Western Desert acrylic painting and the arts and crafts industry are related phenomena, but their histories are not identical. In numbers of sales, Western Desert acrylic paintings are but a small proportion of Aboriginal arts and crafts. Nonetheless, they represent a particularly visible and high-status component, one particularly identified with the rise to prominence and "success" of so-called Aboriginal art.

There is, of course, an origin story for acrylic painting. Such painting, as a culturally hybrid form, grew out of the collaboration between several Aboriginal men living at Papunya and a schoolteacher-artist, Geoffrey Bardon, originally from Sydney, who saw in the designs the men showed him something of great aesthetic value (Bardon 1979, 1991). This aesthetic evaluation was supported by events beyond the settlement. In August 1971, Bardon records, Papunya painter Kaapa Tjampitjinpa's painting *Gulgardi,* submitted by Bardon to the regional art exhibition, shared first prize in the Caltex Art competition in Alice Springs (Kimber 1985), bringing a sense of what Bardon identifies as cultural esteem to the painters, but coded in cash: "That weekend, over $1300 cash was raised from the sale of paintings. It was a sensation at Papunya. The Aboriginal men were jubilant. At least five large cash sales were made during the following months, involving some six hundred paintings by twenty-five men" (1991, 34).

We know of the beginnings of the acrylic art movement primarily through the writing of Bardon (1979, 1991), but also through the record of correspondence with the Aboriginal Arts Board. Although corroborating accounts have been published by others (Hogan 1985; Kimber 1977), some of Bardon's interpretations have also been revised.

There is some political stake, obviously, in different interpretive emphases, in whether the painting originated in "authentic" Aboriginal aspirations and creativity for example, or more through Bardon's leadership. But roughly speaking, the events conform to Bardon's account. Bardon's publications are therefore very much part of the phenomenon themselves—an example of the particular ways in

which the meaning of the paintings was produced. Funded in part by grants from the Aboriginal Arts Board, both of Bardon's books have served also the important function of publicizing the success of Aboriginal acrylic paintings, legitimating the movement for buyers and providing the elementary knowledge necessary for marketing.

Bardon's initial volume (1979) preceded the most significant acceptance of Papunya art, and his book still regarded the work as needing defense. While it presented the particulars of what Bardon did and saw in developing the painting, it did so in the narrowest context—that of the artwork itself and his role as an educator. A major point he developed was the need to encourage Aboriginal culture and identity. The political stakes of representation have been recognized in Bardon's description. Vivien Johnson's interpretation (1990a, 1994) pointedly gave greater emphasis to indigenous agency in the creation of the movement, to the expression of a long-standing desire of the Aboriginal people to project themselves culturally. I draw attention not to questions of truth and falsity but to the discursive frameworks themselves and how these frameworks are managed by writers who are not really external to the social field of Aboriginal art, Bardon among them.

Bardon's emphases on Aboriginal artistic creativity and its value are evident in his 1972 letter of application for a grant from the Australian Council for the Arts to support continuation of his work at the time. Reporting that the painting movement had already earned sales of over $A3,000 from 170 works in just four months, he argued that "the story paintings [as he called them] and designs show great vitality and intelligence and as Gallery Art clearly is a valuable contribution to the reputation of aboriginal culture" (Bardon 1972).

The origin story reveals another dimension of relationships between people across cultures. Delineating the traces of discomfiture in the intercultural social field illuminates the perspectives that various participants had of achievement. Bardon's narrative exemplifies a tendency among art advisers to link their careers —if not their identities—and certainly their reputations to their relationship with, and sympathy for, Aboriginal people, their access to them, their knowledge of them, and so on. Fragile, fractious, and difficult for most subsequent advisers, these relationships combine proximity and cultural distance. Because they demand narrative management, they must rely on the available discursive resources. Such accounts can legitimate one's cultural brokerage on grounds other than financial interest and must engage with the discursive environments of Aboriginal affairs and the art world.

Bardon emphasized the pragmatic obstacles he faced, the insecure future of painting because of cash problems, and the joint interests he shared with the

painters (1991, 34). The obstacles grew worse with time, however, as he strove to meet the expectations the painters had of him, which was to help them. Bardon believed that the superintendent and other whites at the settlement would stop him from taking the paintings to market, not only out of ignorance and a desire to control Aboriginal people's lives, but also and perhaps less consciously because of the way the painting challenged the official policies of assimilation (see hereafter and Bardon 1991, 44; Beier 1986, 1988). Government officials at Papunya, he maintained, tried not only to interfere but effectively to block his continued support, claiming that the paintings were "government paintings," holding back the money the paintings had earned against supposed expenses that were deducted. Almost alone in facing the task of sustaining the men's expectations, Bardon could place himself in something of a heroic and sacrificial role as a cultural broker (as a kind of agent for the painters [1991, 34]). "To create support and a cash flow for the men," he writes, "I seemed to be selling or giving away everything I owned" (44).

Bardon's brokerage was cultural as well as economic, as the standard Papunya practice of documenting the paintings for potential buyers was seen to make them meaningful. Such a document consisted of a sketch or photograph of the painting along with an identification of its key features and their relationship to indigenous narratives of the Dreaming. This is the story of the "story painting," as Bardon conceived it. A record both of the Aboriginal meaning of the design and of its authentic relationship to the indigenous religious realm, the documentation was conceived to be an ethnologically valuable record that also guaranteed that the painting was not just a design somebody had made up. As Bardon began to recognize and understand some of the iconographic motifs, with the help of Obed Raggett, a senior Aboriginal man who worked at the Papunya school, he "drew annotated diagrams to decipher for potential buyers the abstract arrangements in the paintings" (1991, 34). His "relationship developed into something like that between the owner of an art gallery and an artist, my role being to interpret the paintings for the public and to relay feedback to the artist" (34).

This association had deeper value, drawing forth a mutual recognition between the white man and the Aboriginal painters:

> It pleased me that the painters depended on me to do the story diagrams for them. The paintings could not really be sold until this was done and the men cheerfully came to me for this about the time the picture was nearly finished. Despite the language barrier . . . they responded to any praise I would give them. My attitude of course affected the price, since I valued the paintings also. So the recording of the stories was an important ceremony which they enjoyed. Here was a white man wanting to help, who was much accepted by

the community and was really getting the Aborigines that most precious of things: money. (34)

With the initial success and sales, everything had looked good. Indeed, in early 1972, Bardon (42) applied for and received a grant of salary—to support him full time in coordinating Papunya Tula activities—from the Aboriginal Advisory Committee, then housed in the same department as the Office of Aboriginal Affairs.[1] As was often the case in those days, the two branches of the same department worked out the grant between them, recognizing him as having been the "catalyst" or "stimulant."

But the moment of success was short-lived for Bardon, and he describes an opposition toward himself and the project from "Europeans" at the settlement. The white staff on Northern Territory Aboriginal reserves could be very hostile to those who were seen to break ranks or threaten the policy of government control.[2] The weight of this racial solidarity and administrative surveillance fell heavily on Bardon. He felt "as though I was running guns through some kind of frontier or security force. I saw the personal ambitions of the superintendent and the racist police as provocative, and I sensed a certain danger in the whole enterprise" (44).

The particulars are dramatic in this account. Although they may be exaggerated by Bardon's embattled situation, the predicament he describes for what became the role of the art adviser—between two worlds—can be read for its poetic truth about the emotional and physical burdens he endured, and the potential for heroic identifications. His grapplings bring a shadowy light to the troubled context from which Aboriginal acrylic paintings emerged. Bardon's very substance seems drained by the events, as he describes the sense that "what reputation I had . . . [was] being taken from me by stealth by the authorities" (44).

The pressures of the adviser position were intense, and Bardon left in 1972, after just eighteen months, frustrated and depleted by the obstacles he faced from the administration at Papunya and the difficulty of meeting the expectations of the painters. No doubt Bardon—caught in the cross fire of anger, disappointment, and complex identifications—had mixed feelings about what had happened. Other cultural intermediaries certainly came to wonder whether there has been any substance to their relationships with the painters, although few would fall back on the once-common fantasy of the "treacherous blackfella," the untrustworthy "native" of colonialism on whose apparent friendship one cannot rely (Healey 1978). Nervous exhaustion was a more common outcome of these relationships, and Bardon was not the only art adviser to succumb.

Clearly, the contradictions and conflicts raised by the incommensurate systems of value and circulation that define the art objects came to rest heavily on the art

adviser. Despite the apparent successes in recognition, money was always short, and a crisis atmosphere was under way that long endured. But the painters kept on. There were always more whitefellas. The role and histories of these art advisers will be the subject of the next chapter.

Papunya Tula Artists

One enduring result of Bardon's intervention was the formation of an artists' co-operative at Papunya. Named after the local Honey Ant Dreaming site (Pupanyi), Papunya Tula Artists was incorporated with Bardon's help as a company of limited liability in 1972, with eleven original Aboriginal shareholders; by 1974 the artists' cooperative had forty members. Throughout this early period, the producers were almost entirely senior Aboriginal men, and certainly all were postinitiatory, those fully learned in their own ritual heritage.[3] This number has risen at times toward eighty and has come to include some women, but the number of shareholders has remained steady at forty. The cooperative is a community-based enterprise, owned by the Aboriginal shareholders, with emphasis on group decisions and choice of the art adviser. It is a company, but in many respects it resembles the sorts of enterprises commonly known as "art centers" (Altman, McGuigan, and Yu 1989).

Although the wholesaling and retailing of artworks is one of the principal objectives of such centers, at Papunya a particular set of practices emerged that emphasized the artists' group identity and Aboriginal values—quite in line with the emerging national policies of Aboriginal self-determination. Purchases of paintings are managed by the art adviser, with payment usually made at the point of sale. Moreover, advisers have felt obliged to purchase *all* the paintings produced (although they have sometimes been able to reduce the payment for those found unsatisfactory in quality). Similarly, outside retailers seeking material for an exhibition were not, for many years, allowed to specify the works of individual artists but were expected to take a consignment of paintings that included the work of many members of the cooperative. This was consistent with the local Aboriginal insistence that all the work was valuable ("dear"), since it all represented the Dreaming.

Local culture and local history gave another distinctive slant to Papunya Tula, as well. That painting was configured as "work," supported by the government (as discussed in chapter 2), strongly configured the kind of expectations painters had about ongoing support. It did not contribute to a market mentality.

A growing complaint by dealers in the 1990s concerned precisely this practice, which they saw as preventing the true quality work from emerging and maintain-

ing its value, supporting instead inconsistency in quality (see chapter 7). The fine art world's logics or mechanisms of establishing hierarchies of aesthetic quality through "quality control" mean keeping the "cheap" stuff, the "dots for dollars," out of the same circulation as "the good."

The State and the "Aboriginal Problem"

One cannot understand how acrylic paintings circulated beyond Papunya (and its outstations) beginning in the early 1970s without recognizing the role of the Australian state, its policies and institutions, and its changing relationship to Aboriginal people. The social and cultural value of acrylic paintings has generally been articulated within two main (but related) components of this complex — namely, Australia's administration of the "Aboriginal problem" and its development of a consensus managed economy. The components are related, of course, in that both represent areas of social practice submitted to rational, directed planning. In the 1970s and 1980s, these arenas of practice were coordinated by, and identified with, the ascendancy of a distinctive class fraction, the public managerial class or "the bureaucratic bourgeoisie: the public servants, teachers, academics, community workers and art and culture workers, the expanding administrative class which had grown over the previous decade [before Whitlam] as Australia had developed the character of a resource-based industrial democracy" (Barrett 1996, 128). The initial significance of Western Desert painting was defined by the history of government policies regarding Aboriginal people. Papunya itself was representative of a particular form of what was then called the "Aboriginal problem." For much of Australia's history since colonization, from 1788 until the 1930s, the cultures of Aboriginal people were seen as being primitive and inferior, without civilization or rights to land — a history that continues to define the present. As Aboriginal people were being killed or pushed aside ("dying out") along the shifting colonial frontier, nineteenth-century evolutionist theories were used to endorse the policy of displacing or missionizing people for their own "protection." Later views of Aboriginal cultures as either valueless *or* unsustainable within the requirements of modern life led to policies of education and assimilation, to help them "to take their place in a civilised community" (Tatz 1964, 11), at best preserving the Aboriginal bodies but destroying or erasing traditional cultures, which were seen as impediments to progress — too collective, too kinship oriented, too attached to place.[4] These policies were first stated in 1939 and by 1954 had come to be accepted by the government — determined to bring Aboriginals into the mainstream of Australian society — as a commitment to planned, directed change.[5] Changed from a

ration depot to a settlement, Papunya, with its mixture of traditional groups, embodied the project of directed cultural change (Davis, Hunter, and Penny 1977, 23).

With a reputation as perhaps the most "troubled" and seemingly demoralized of the many government enclaves established during the period (Long 1970; Davis, Hunter, and Penny 1977), Papunya was built in the late 1950s to house a population consisting of varied, often displaced language groups. The purpose of the construction of Papunya as part of the Commonwealth government's assimilation policy was to prepare Aboriginal people for entry into the dominant society by "educating" and "training" them (Rowley 1972), but it was known by 1972 as a place with a high morbidity rate, riots, violence, and despair.

It was only in 1967 that Aborigines gained the rights of citizens in Australia. Perhaps a key result of 1967 is that the referendum had made Aborigines a federal responsibility, offering them as a subject of national concern and political technologies. The official policy of the preceding era began to move away from an emphasis on the modernizing fantasy of assimilation and the eradication of Aboriginal culture and its practices toward one of self-determination, the program endorsed by the Australian Labor Party on its election in 1972. The Gove land rights dispute (in 1969) further figured an Aboriginal culture and identity acceptable for national recognition: the "traditionally oriented" Aboriginal with religious and spiritual links to the land—and far from white settlement. This was the Aboriginal identity most whites perceived as circulated in acrylic paintings, not one that overtly confronted white Australians with its copresence and political conflict, but one that could apparently be redeemed without loss or threat.

Accordingly, an important part of the administrative response to the continuing presence, poverty, and high mortality of Aborigines was to find them a place in the economy. The assimilationist programs of training had largely failed to get Aborigines to take up the essentially "worker" role imagined for them. Indeed, reports at Papunya frequently mentioned the difficulty of getting Aboriginal people to adopt a Western concept of work. With the perception of this failure came a sense among administrators and critics that cultural difference needed to be recognized in a different way, that ripping people away from their cultural roots was not good, leading rather to demoralization and despair. These realizations, at least in part, underlay an interest in providing culturally meaningful work. This came to stand as one discursive link to a concern with preserving or maintaining Aboriginal culture(s). Perhaps, it was thought, Aboriginal people would be motivated to participate in their changed situation if they were able to do things that interested them, activities linked to their own cultural values and ways of conduct.

As art advisers whose time with Papunya Tula overlapped with the end of the as-

similationist administrative regime (1971–1972 and 1972–1975 respectively), both Geoff Bardon and later Peter Fannin framed the significance of the art in the context they first knew as schoolteachers there. Bardon (1991) has characterized the policies and administrators of the period before self-determination as being committed to demoralizing Aboriginal people—unable, he writes, to recognize them as human, much less as talented. The counterpoint offered by Papunya Tula's success and the promise he believed it held for Aboriginal self-esteem and independence was especially significant in light of Papunya's reputed demoralization. Bardon's belief in the art's value stands as a stinging indictment of the dreary picture of "Commonwealth government policies, which aimed at terminating Aboriginal traditional life, culture and languages" (Bardon 1991, 36): "The painting movement had brought forth an enormous passion in the desert people to develop their own style and their own sense of self. In a way they were being freed, and redeeming themselves and their culture, by their creativeness" (41–42). Many of the whites who came to Papunya in the later 1970s—such as myself—shared in this humanistic discourse that resonated with self-determination. In this art, Papunya people could express themselves, demonstrate their creativity, and develop their own sense of self. That is, they could find confidence and money, rather than demoralization and despair, in activity linked to their own values.

There is an instability in Bardon's account, a synthesis that does not hold. The economic and cultural valuation of the paintings compete in relative, if not absolute, significance. These aspects of the paintings represent distinguishable visions of Aboriginal personhood and being, necessarily articulated within the context of "Aboriginal policies" and an educated Sydney-sider's understanding of the conditions of modern Australian cultural life. If art could glorify and restore, money was the corruption that undermined Bardon's communion with the men. It turned the men into a "travesty of what they had once been." Writing of his last days in June 1972, Bardon has a recognizable narrative of the destructive effects of capitalism on cultures not built on a monetized economy:

> I seemed to find it much harder to communicate with the painters after that first demand for money and, though I was still liked, I knew somehow everything had changed. While the men were painting, I had witnessed the sense of the glory that the Aboriginal people bring forth in their ceremonies and dances and songs. Now there seemed to me only the stale, sick stench of the camps, the awful physical nearness of the used-up sand, the filth, and the destitution of the alcoholic faces about the tracks and streets. . . .
>
> It was in the painting shed itself that the final blow came. . . . They would

not paint, they said. Nor could I prevail upon them to paint without money. The monstrousness of it was not lost on me as they began to chant in their own languages amongst themselves, then at me: "Money, money, money." (1991, 44)

Caught personally in this political and cultural web, Bardon discerns a familiar shape in money's destruction of artistic and cultural value. "Yet at that very moment," he writes, "the Aboriginal painters had conceptualized a new art form. On the canvases and boards at Papunya something was being made that had never been seen before. But as the door was just about to open onto this new world, there was talk about money and nothing else, and so it seemed to me that the journey was ending just as quickly as it had begun" (45).

Peter Fannin—initially, like Bardon, a Papunya schoolteacher, but one whose background was more sciences than art—eventually succeeded Bardon as art adviser in 1973. Two years after Bardon began, as the settlement had come largely under Aboriginal control, Fannin found Papunya to be more open to the aims of the artists' cooperative, but despair and dependence continued to dominate Aboriginal life. And while he still experienced the somewhat changed political realities as harsh, Fannin resolved the contradiction in what we might now call a kind of "primitivist nostalgia." Through the acrylic paintings, these Aboriginal people's "non-materialist culture" could offer an alternative vision for what Fannin, like numerous other Euro-Australians (Lattas 1992), perceived to be Australia's crass materialism. Fannin saw the art as providing emotional insight into a way of life that is totally different, in a way "no verbal description can hope to match."

For both Aboriginal producers and their white intermediaries, the promise of combining culturally meaningful work with money—cultural maintenance and employment—was an intriguing policy possibility for a situation some saw as desperate. Success in supporting the enterprise probably owed much to the way in which proponents tacked back and forth between the two poles of value. It was in this context that forms of "Aboriginal crafts," therefore, could hope to receive governmental support and interest. In its earliest stage, the "sudden flowering of art in the [Papunya] area" received critical support from H. C. (Nugget) Coombs through the Aboriginal Arts Committee of the Australia Council for the Arts and the Office of Aboriginal Affairs. The nearly legendary former director of Australia's economic recovery after World War II, Coombs subsequently became a central architect not only of the Labor Party's self-determination paradigm but also of the Australia Council (Coombs 1978; Rowse 2000). It should be noted that Bardon's activities at Papunya were supported financially and morally by an emerging new

generation of program officers and bureaucrats in then minor positions in federal offices. (Jennifer Isaacs, particularly significant in this role as Bardon's liaison ultimately with Coombs at the Australia Council,[6] exemplified such persons as part of the remaking of indigenous affairs: starting from a progressive background, her sympathies engaged by the urban politics of Aboriginal activism, Isaacs has remained involved in Aboriginal art.) Discussions at the Australia Council in Sydney supported Bardon's presentation of the resistances and obstacles initially imposed locally against the development of the paintings. Isaacs's notes register just how difficult it was to overcome the predilections of government control of Aboriginal life.[7]

Both in schemes of employment and in those of cultural maintenance, what were known as Aboriginal crafts had received support and interest in the 1960s. Thus the interest in Aboriginal culture is not entirely new, although the early interest was more of a salvage activity. However, these concerns were brought into a new association with support for Papunya Tula.

Money and Art

> The paintings were sold for A$35.00 for a board of dimensions 24 × 36 inches but proceeds became increasingly irregular as production outstripped the financial resources of Papunya Tula Artists Company. (Myers 1976, 109)

Whatever objectives were imagined to be the most significant for Papunya Tula, maintaining the cash flow remained a critical problem. The survival of Papunya Tula was precarious, and the pressures on those managing the economic and cultural venture—mediating conflicting regimes of value as well as rivalry over the position itself—were overwhelming. Papunya Tula did not clearly fall into any standing regime, and different individuals formulated distinct mediations; and in this sense, its fate lay in the hands of historical actors. There was a struggle, for example, to take over the Australia Council grant of salary to Bardon and control of Papunya Tula. The Papunya settlement superintendent (an institution loathed by Bardon for its earlier interference) approached the Arts Board, but his request was successfully protested by Bardon's brother.

Convinced of the value of their painting, and suspicious of local Aboriginal administration, the painters kept on producing. Bardon had arranged sales and exhibitions of the paintings to fund the artists' demands for materials. After his departure, Pat Hogan, who ran the Stuart Art Centre in Alice Springs and had been handling Bardon's consignments, took over, receiving hundreds of paintings between July 1971 and August 1972 (Hogan 1985). Although there were relatively few

buyers, Hogan and others regarded sales of $A3,000 as very promising and were ebullient about the interest shown in the work — which Peter Fannin characterized as "fine art–ethnology," something more than tourist souvenirs.

This compromise formation — fine art and ethnology — was well suited to its object and the social field it came to occupy. In the intercultural world of Aboriginal acrylic painting, recognition and the establishment of artistic reputation followed a fairly conventional path for defining standards of distinction and quality. Competitions such as the Caltex Art Award and the Alice Prize helped to establish the relative quality of the paintings, as did recognition by national arts funding groups. A significant early collection of seventy-eight paintings from the first three consignments to Pat Hogan in 1971 was purchased by Colin Jack-Hinton of the Museums and Art Galleries of the Northern Territory, and there were at times modest sales. The early exhibitions were often quite informal, arranged mostly by art advisers and their friends, mainly in an effort to establish a market. In 1974, for example, Peter Fannin sent fourteen canvases to Melbourne with a friend on the understanding that he would receive 50 percent of the framed sale price. Only two paintings were sold (Fannin 1974b). Much of Papunya Tula's early support came from the application of government policies.

The State and of the Problem of Art Enterprise

Throughout the 1970s, the principal buyers of Papunya paintings (and possibly Aboriginal arts and crafts generally) were two related governmental enterprises — the Aboriginal Arts Board, founded in 1973, of the then Australian Council for the Arts, and Aboriginal Arts and Crafts Pty. Ltd. (AACP). Despite early critical success and interest, throughout the 1970s there was a tremendous problem in maintaining a viable stream of circulation between the artists' great desire to paint and scarce demand, a mismatch that revealed a gap in expectation between market and indigenous value. This could lead, at times, to a large oversupply of paintings at Aboriginal Arts and Crafts, with no cash flowing back to the company to purchase more paintings. Advisers faced the problem of how to purchase enough paintings locally so that they could accumulate enough good works (outside immediate sales) for exhibition without start-up capital. Grants from the newly formed Aboriginal Arts Board became the lifeblood of the cooperative, even paying for the adviser's salary.

These governmental institutions each originated to some extent in distinctive discursive formulations of the Aboriginal situation, increasingly coming to represent the particular objectives of supporting the production of economic and

cultural value. In policy terms, the delineation of this enterprise as economic has tended to increase in importance over time.

Overall, support for Aboriginal arts and crafts has been realized in a fashion identifiable with a "welfare" approach, with distinctive effects in the way economic value and cultural value are linked in the case of remote Aboriginal people. Thus support for Aboriginal arts and crafts was not given directly to producers, in terms of fellowships or income support schemes, but was realized in supporting a marketplace (Pascoe 1981, 63). An approach different from that taken to fine arts more generally, marketplace support was seen as a culturally appropriate strategy for Aboriginal producers. Indeed, Aboriginal representatives to the Arts Board (discussed hereafter) had a significant hand in formulating these policies. In this regard, cultural policy was itself produced in part through the agency of Aboriginal intervention.

Aboriginal Arts and Crafts

A tourism plan for Central Australia had recommended Aboriginal arts and crafts as an important basis for economic development in Aboriginal communities, and in Sydney the urban-based Foundation for Aboriginal Affairs had proposed an arts and crafts presence to give a higher profile to Aboriginal people in the cities (Nicolas Peterson, personal communication, 20 November 1995; Peterson 1983, 60–65). In 1971 this proposal materialized when "the then Office of Aboriginal Affairs established Aboriginal Arts and Crafts Pty Ltd . . . to both wholesale and retail Aboriginal artefacts" (Altman 1988, 52).

The attempt to create a new industry was inaugurated with the choice of a market research officer, Machmud Mackay, as the first appointment to Aboriginal Arts and Crafts (also known as "the Company"). Mackay's brief was "to undertake a survey of production, distribution and marketing of Aboriginal art and craft to place the industry on a sound footing" (Peterson 1983, 60), with the goal of increasing economic returns to artists and craftsmen and helping to stabilize the flow of income. Mackay's solution, as argued in his second report, was the proposal of a tightly controlled market for Aboriginal arts and crafts, rather than a free enterprise arrangement, "because it was the key to the control of the supply, making it possible to influence the quality of the art and craft and the selection of outlets" (ibid.). Aboriginal communities would sell to the Company, which would wholesale to the retail outlets in all the major cities. The Company's special mission—primarily economic in orientation—was to market Aboriginal art and craft work so as to:

—encourage high standards of artistry and craftsmanship with a view to creating greater appreciation of and respect for traditional skills and the preservation of the culture;

—foster the production of arts and crafts as a means of creating employment opportunities;

—ensure maximum possible economic returns to the artists and craftsmen. (Peterson 1983, 61)

This rather synthetic mission was soon subjected to rationalization in an economic direction. After a rapid growth in its subsidies from the Department of Aboriginal Affairs ($A220,086 in 1973–1974), management consultants appointed to study the Company in 1975 suggested that its objectives be redefined with an emphasis on becoming economically self-sufficient (Peterson 1983, 62). The Aboriginal Arts Board was to take on the broader, complementary responsibility for encouraging and reviving pride in, and knowledge of, Aboriginal culture by "assisting the best professional work to emerge in the arts among the Aboriginal people."

The rationalization directive was articulated not only as a consequence of some extravagant failures in Aboriginal expenditure. It owed considerably to the economic downturns facing the entire Australian economy soon after Whitlam's election in 1972. Despite the attempt to split the economic from the cultural, a central problem in these developments remained to manage marketing and promotion in some way consonant with "the integrity of Aboriginal cultural traditions," to avoid what a later marketing study called "the ill effects of commercialisation" (Pascoe 1981).

From an economic point of view, however, marketing itself was not particularly successful. During the early period, and following shortly on the 1975 report, while the Company's wholesaling function expanded, it did so not as a result of increased sales but rather in order to boost production (Peterson 1983, 62). The development was not market driven; 70 percent of production was being bought from some communities by the Arts Board itself. This Keynesian support for a marketplace owed a great deal, as we shall see, to particular agents in the Arts Board, whose own blending of cultures was complex.

The dominant thread of our story is that even as the enterprises of Aboriginal arts and crafts grew in volume, they came to be evaluated in terms of discourses deemed appropriate for "economic enterprises." The literal meaning of these categories seemed to determine the direction of history. There was, on the one hand, budgetary concern about the continuing need for government support. On the

other hand, given the mixed and sometimes contradictory goals imagined for Aboriginal arts and crafts, there were also participants to the policy debates who recognized that assessing the value of government subsidies was not a straightforward matter. Typically anthropologists or people otherwise associated with remote communities, they suggested that the ratio of one dollar of state subsidy generating one dollar for producers was a rather cost-effective intervention.[8] There were also other grounds on which to question rationalizing the single variable of self-sufficiency. Contributors to the same marketing study maintained that artifact production might offer other returns of value to Aboriginal communities: "maintaining cultural life, . . . capitalizing on unique skills, . . . allowing wide community participation, . . . giving individuals an opportunity to earn money, and . . . providing communities with their only export" (Pascoe 1981).

This discourse resonated both with some of the values of local Aboriginal communities and with larger policy values in the Australian political environment at the time. The emphasis on cultural life and expression as enunciated in the list corresponded to themes ushered in with the arrival of Whitlam's government in late 1972 (Alomes 1988; Barrett 1996). Such a policy environment made it possible for Aboriginal art to be attached to these meanings. While such a convergence, or compromise formation, appears to have been rhetorically successful in 1981, the situation began to change significantly in the late 1980s, when the emphasis on the "industry" and its "rationalization" seems with increasing force to have constructed the issue along the lines of economic enterprise—in terms of profitability and moving away from subsidy.

Economic development through arts and crafts did not look an easy task.[9] As the Australian economy began to sink in the late 1970s, discussions of the board of directors of Aboriginal Arts and Crafts, which had once included questions of whether or not it should emphasize fine art or crafts, increasingly centered on how to survive the next funding cut. In this economic framework, it was concluded that institutions such as Papunya Tula or Aboriginal Arts and Crafts were meant to be self-sufficient, not simply to support Aboriginal employment. As soon as Aboriginal Arts and Crafts, and Papunya Tula, began to generate money, the bureaucrats thought they could move them over to what they regarded as "enterprises," reducing subsidies and moving ever farther from such painting as part of local knowledge and practice.

For their part, the artists did not necessarily accept these changes. The attempt to combine a market for art with local community practices converged to generate a central dynamic at Aboriginal Arts and Crafts—the dynamic of cash flow. In these terms, operating expenses had to be covered by the subsidy plus whatever sales

could be generated and money directed back to the communities from which the objects came. The central dynamic of cash flow defined the relationship between Aboriginal producers and a market that they understood to be the government company rather than any abstract economy. The basic problem with cash flow lay in the Company's buying practices: the Company did not buy on consignment, as most dealers would, but instead paid up front (at the point of sale) for whatever objects they acquired, and Aboriginal producers received payment as soon as they transferred their work. Increasingly, as the Company failed to sell as much as was sent to them, a huge stock accumulated, and soon all of their cash/capital was gone, tied up in stock and out to the producers. No new paintings could be purchased—which the producers took as a sign of disrespect, failure on the part of the adviser, and so on, leading to acrimony and recrimination.

In response to such difficulties, a change of operation was made. Because the Company could not continue to acquire more stock, it shifted to a system of waiting until it had an item for sixty days before sending payment. This, it was hoped, might allow the Company to sell some of the work before having to transfer money to the producers.

The sixty-day system, however, merely transferred the problem to the art advisers, whose job it was to collect the work and send it to the Company. Now the advisers had the "workers" angrily asking where *their* money was. Soon both producers and advisers began to sell the best work to outsiders, not to the Company— the only means imaginable to get cash for the painters. Consequently the Company was getting the lower-quality work, unsuitable for sale, which piled up in storerooms and ate up capital. This conflict between two sets of values, between the market for art and community-based enterprise, was experienced as a flaw in Aboriginal Arts and Crafts Propriety Limited. It was also a fundamental problem for those who acted in the role of arts adviser to local communities of producers, a role that is the (pivotal) role in the brokerage or mediation of Aboriginal cultural products to the marketplace and the wider public.

Aboriginal Arts Board

Following the federal election of the Australian Labor Party in December 1972— for the first time in several decades—Aboriginal policy was transformed officially toward the encouragement of self-determination and then to self-management. Both policies emphasized greater respect for Aboriginal culture. At the same time, a broader program of cultural policy put forward by Gough Whitlam as both prime minister and minister for the arts endorsed increased support for the arts gen-

erally. In the expanded and renamed Australian Council for the Arts, a separate Aboriginal Arts Board was established to provide policy and grant support for a range of arts activities, including visual arts, literature, theater, and film. This transformation of the government's role in relation to "culture" was perhaps the salient mark of a new direction in Australian national life, in which the government took responsibility for facilitating the cultural and artistic realization of its citizen-subjects. The inclusion of Aboriginal people suggests the government's willingness to accept indigenous claims that their well-being depended on maintaining their culture.[10]

Funded generously by the federal government, this new organization was unusual in the extent of Aboriginal control, both substantive and procedural, over its decision making. The minutes of the first meeting of the Aboriginal Arts Board, in May 1973, relate that "board members agreed that Aboriginal people should be in charge of promoting the Arts in Aboriginal society and protecting existing cultural values and practices." If governmentalization was coming to represent an overall approach to national problems, the structure of the Aboriginal Arts Board was perhaps overdetermined. At a time when urban-based Aboriginal social movements were putting pressure on the Australian state to have more resources and a greater role in its narratives of the nation by staging dramatic protests such as the Aboriginal Tent Embassy (1972), the state responded by giving money for cultural activity that Aboriginal people could allocate themselves. At the time, Papunya competed with a few other remote-area communities and a number of urban organizations for support. Within this national body, the special interest of director Robert (Bob) Edwards and the presence of local Papunya Tula delegates—such as Tim Leura Tjapaltjarri, Long Jack Phillipus Tjakamarra, and Billy Stockman Tjapaltjarri—were critical in providing support.[11]

It is my impression that a few key individuals were vital in bringing about the mediation of national and local frames. Robert Edwards was preeminent in this regard, and the Arts Board functioning bore his signature. He was greatly affected by his experiences with senior Aboriginal Board members, such as Dick Roughsey, Wandjuk Marika, and Albert Barunga, and their insistence on the essential role of culture in their survival as a people. When I interviewed him in 1994, Edwards still spoke movingly of Barunga's directive to the Aboriginal Arts Board, instructing him, "Our culture, our law is our anchor." For Edwards, the very processes of the Aboriginal Arts Board offered the means through which Aboriginal self-esteem and confidence could be articulated. He defined his own role in these terms—as helping them do things, to advise them and work out ways for it to happen.

As these comments suggest, the Aboriginal Arts Board had a hybrid form, and

A meeting of the Aboriginal Arts Board held in Cairns on 20 June 1975. Left to right: (back row) Raphael Apuatimi, Wandjuk Marika, Bill Reid, Bobby Barrdjaray Nganjmira, Eric Koo'oila, Eddie Mabo, Terry Widders, Harold Blair, Chicka Dixon; (middle row) Vi Stanton, Dick Roughsey, Leila Rankine, Kitty Dick, Brian Syron; (front row, kneeling) David Mowaljari, Ken Colbung, Billy Stockman Tjapaltjarri. Photograph by Michael Andrews, courtesy Bob Edwards.

in Edwards — with his unusual administrative abilities — it found perhaps the right person for its time. At the interface between governmental accountability and local Aboriginal formations, a particular and procedural formulation of Aboriginal self-determination was facilitated by Edwards and his hand-chosen staff. An effective Aboriginal autonomy was accomplished interculturally by allowing Aboriginal members to make the decisions and having an able (largely white Australian) staff who could figure out how to implement Aboriginal objectives in a way acceptable to government accounting: "That's the sort of report we had going to the Board so that no one could question the information they got. But we didn't deal with it in this form. . . . So on one side we had paper for the system going, while on the other side we'd sit around in a circle and talk about it" (Edwards 1994). Aboriginal historical realities were engaged in another important feature in this new organization, as well, in the combination of Aboriginal members on the board from both urban and tribal communities. This brought together Aboriginal people with potentially different and possibly competing agendas, sometimes suspicious of each other despite the rhetoric of Aboriginal unity. Edwards said the effect was

that they would meet together face-to-face to make decisions in the allocation of funding, but they would also do so in visits to different locales in the country to gain knowledge of local conditions.

These transformations were not simply consequences of policy paternalistically handed down. Aboriginal activists, operating under the banner of Black Power, had already shown their political muscle in a variety of outspoken ways. At the founding National Aboriginal Arts Seminar (for four hundred people) in Canberra, just prior to the establishment of the Aboriginal Arts Board itself, bureaucracy and activism were resolved through the diplomacy and organization characteristic of Edwards. An agenda held potentially explosive events to a course that resulted in a number of serious Aboriginal resolutions that authoritatively guided Aboriginal Arts Board policies. Their authority, however, also gave the Arts Board a degree of institutional independence from the very activists who had produced them.[12]

The maintenance of cultural knowledge through painting was a significant consideration of government support, especially for the Arts Board, but the link was also representative of Aboriginal views in which the paintings were considered an intrinsic part of the artists' relationship to country and ceremony. To accept this link was to acknowledge that painting as an economically valuable activity and looking after country comprised a single endeavor. While the implications of this position were hardly consonant with the rationalist terms of cost accounting, regarded as excessive or extraneous to the business of painting, they were regarded as appropriate for the Aboriginal Arts Board. Within that institution, self-determination could mean that Aboriginal definitions of art and value might prevail. Here was an incongruity between the government's enterprise approach and Aboriginal priorities, one that Edwards endeavored to manage in his distinctive style, as did the art advisers at Papunya Tula.

People like Edwards applied their own, often distinctive, histories and trajectories to the formulation of stances toward Aboriginal art. As it happened, Edwards was particularly interested in the Papunya paintings, and with the Arts Board he worked with more than his usual creativity to find ways to satisfy the artists' need for financial support to continue their painting.

Career and Cause: Cultural Maintenance and the Living Arts

Considering the career of Edwards offers further insight into the development of the Aboriginal Arts Board and presents another dimension of the social field

in which Aboriginal art was framed, developed, and validated. Not only does Edwards represent the administrative style of a new breed of public servants, as I will discuss further on, but his interest in "the living arts" was fundamental to the history of Papunya Tula, in which painting was never seen simply as an economic enterprise.

Edwards began as an amateur prehistorian in South Australia, without a university degree.[13] His official work with the local fruit marketing board, a job he could do at night and early morning, left him free to pursue his interest in recording Aboriginal sites and protecting cultural heritage (Edwards 1994). Eventually Edwards's publications on the material heritage of Aboriginal people led to his appointment as curator of ethnology at the South Australian Museum, where he was excited to recognize, in the 1960s, that many of the craft traditions that had produced prehistoric material culture in Australia still survived. His concern to allow such traditions to thrive, to be preserved, grew into an interest in what he called "the living arts." The living arts and culture itself, he came to believe, were necessary for Aboriginal survival. This became, for him, the raison d'être for governmental support such as that provided by the newly created Aboriginal Arts Board, of which he was the first director.[14] Cultural maintenance became a key component of Edwards's approach, based on his interest in material heritage and his association with prominent Aboriginal traditionalists.

His framework of maintaining the living arts represents another distinct formulation of the significant value of acrylic painting, but it is somewhat different from Fannin's "spiritualization" or Bardon's emphasis on artistic creativity. Edwards's support of Papunya painting through the Arts Board tended to emphasize its basis in local knowledge and practice—preservation as a living art. This formulation, partly a response to painters' desires to renew their inspiration by visiting their sacred sites, and partly an interest among some art advisers to participate in such knowledge, is exemplified in the role of R. G. (Dick) Kimber as art adviser in the mid-1970s.

In 1975, at Edwards's behest, Kimber (who shared Edwards's interest in material culture) was seconded from the Department of Education to an art adviser position with Papunya Tula, bureaucratically defined as part of a research and education project. Kimber understood his role as combining development of the sales of Papunya paintings with education and improved documentation. Documentation served a double role, contributing also to the preservation of the living culture in the form of frequent trips with men to visit the sacred sites represented in their paintings. The work of art adviser—and that of painting—should help to preserve, as Bob Edwards wrote to Kimber in a letter of acknowledgment, "an ongoing inter-

est in an Aboriginal way of life." Such policies of cultural preservation were in notable contrast to the shifting trajectory of an Aboriginal arts and crafts industry increasingly imagined in purely economic terms—of self-sufficiency, Aboriginal employment, and accountability of the tax dollar. Although the latter were to prevail, their actual consequences depended largely on what was accomplished by the Arts Board and the public servants who saw it as their mission to direct their entrepreneurial skills to accomplish Aboriginal objectives.

Public Servants: A New Breed

Participants in Whitlam's new government, a new breed of public servants experienced the times as heady. One of the original members in this new bureaucracy was Anthony Wallis—at first a program officer in the Aboriginal Arts Board, then managing director of Aboriginal Artists Agency and later of Aboriginal Arts Australia—who had studied anthropology as an undergraduate at Sydney and had begun a career in documentary cinema with Film Australia. Wallis described Whitlam's government as being "like America's New Dealers, in saying that one needed entrepreneurial managers and capable people running government. They brought in excellent people, and increased the salaries to make it attractive. This was not liked by business people, but it resulted in forward-thinking and creative people" (Wallis 1996).

At the Aboriginal Arts Board (aab), people's sense of dedication to the cause was profound. Participation in the aab was not yet a bureaucratic career choice, not a crystallized or routinized trajectory in public service. Retrospectively we may get a clearer idea of who these people were, or at least of the necessity to understand their cultural and historical particularity. As the aab's first executive officer, Bob Edwards shared the impression held by many in that "first wave" that they were "different" from those who came later. According to Edwards, the early Art Board was full of people "who were not concerned to make money, but to do a job."

Managing the transfer of money in ways supportive of Aboriginal interests may have been the biggest contribution of these new public servants. Edwards was a critical figure in sustaining the fledgling arts and crafts industry and doing so in ways meaningful to Aboriginal participants. It was the support of the Aboriginal Arts Board that kept the Papunya Tula cooperative afloat in the 1970s. Such funds seem to have paid for the largest number of paintings—stockpiled for museums or purchased for international exhibitions.

This was hardly a simple bureaucratic commitment; it became Edwards's voca-

tion. Perhaps his greatest contribution was orchestrating a market for Aboriginal art. His early career in marketing in South Australia gave him the unique skills to do so, and he combined business acumen with a penchant for remaining somewhat in the background. But he knew how to make bureaucracies and rules work and used those skills at the AAB to make possible the Aboriginal cultural activities that were his real passion.[15] "Most paintings are of superb quality," he advised in an internal memo at the Arts Board, "and should be stock-piled for museums and exhibitions in order to enable the artists to continue painting." Donating collections of paintings to the Korean government and the Canadian government — or to Australian museums, as in the case of a 1978 Art Board gift of twenty earlier Pintupi paintings from Yayayi to the Art Gallery of South Australia (V. Johnson 1996b, 24) — was an explicit policy, supported by the Aboriginal members of the Art Board.[16] Works sent overseas for exhibition should be given — left there — rather than returning to clog the Australian market. Thus, through a subtle comprehension of the market, demand, of a sort, was maintained and activity sustained in communities. The flow — or stream — of products was maintained.

Articulating Policy: The Meaning of Painting

The market for Aboriginal acrylic paintings developed within a distinctive institutional and governmental framework that placed painting within a complex configuration of Aboriginal arts activity. In these early days, whatever value Edwards and others at the Aboriginal Arts Board understood to exist in the paintings, their relevance to "the Aboriginal problem" was also necessarily articulated within another, possibly contradictory, regime of value — that of economic concerns. These articulations have themselves been forms of culture making, but culture has not been made so much out of whole cloth as in coordinating or reorganizing the relationships between dissonant values. It is important to understand the level at which the articulation of these administrative practices took place. How were they engaged with social action, when — for example — representatives of the Department of Aboriginal Affairs attempted to assess the significance of Arts Board policy for their Aboriginal clients? This is what the ground-level sensibility of ethnography reminds us.

Questions that emerged in the third meeting of the Aboriginal Arts Board in August 1973 illustrate the central policy issues, and the understandings — the local administrative discursive grid — that dominated the way in which painting was articulated. It was surely not yet "fine art." The principal question concerned arts and crafts work as an economic enterprise, a derivative of administrative moves by the

Department of Aboriginal Affairs, which had made gainful "work" for Aboriginal people in crafts. In activities modeled presumably on development schemes to link Aborigines to the economy, policy makers spoke of "craftworkers." "Craftworkers," available as a category of activity that could be supported, had been receiving "training allowance," a small government stipend imagined as preparing Aboriginal people for some sort of work but functioning routinely as a form of welfare. In this framework, administered by those who managed and oversaw Aboriginal settlements, painting was a way for Aboriginal people to make money. Fair enough, but hardly a step toward the recognition of this work as "art," so one would hardly be surprised to learn that "the first realization that Aboriginal work could circulate as fine art came as something of a revelation" to the directors of Aboriginal Arts and Crafts (Nicolas Peterson, personal communication, New York, 1995).

Comparing the differing accounts of Aboriginal art delineated in this chapter, it should be clear that the grids for administering indigenous welfare, broadly conceived, were hardly of a piece, and their existing conformation was not necessarily commensurate with emerging definitions of painting. The classificatory turmoil was evident at the time and has been left behind in the Arts Board files, so that I am able to trace a movement. The Aboriginal Arts Board presented a problem. How would administrators coordinate the emergence of new institutional structures such as the Aboriginal Arts Board and the AACP with existing arrangements such as the "training allowance" scheme? This is the question a representative of the newly reorganized Department of Aboriginal Affairs brought to the Aboriginal Arts Board about "Arts activities in the Northern Territory." How would the new administrative arrangements alter the somewhat contrived flows of funding to communities built on previous definitions? Many Aboriginal people, he noted, were receiving payment of "training allowance" for craftwork, and these were about to be terminated (McHenry 1973).

The increased support for Aboriginal Arts and Crafts was apparently going to be one solution. Thus at the same meeting it was announced that the Centre for Aboriginal Arts and Craftsmen in Alice Springs had been started with support by the Capital Fund of the Department of Aboriginal Affairs (DAA). While the Centre came to be the principal site for selling arts and crafts, with this development, it was expected that the six Yayayi painters would no longer be supported on training allowance.

The two government institutions differed, therefore, in the way in which the values of enterprise and culture were integrated. In its inception, Aboriginal Arts and Crafts had little to do with what the government funded formally as "the arts,"

emanating more within the arena of Aboriginal Affairs and being delineated more as an economic enterprise, as a means of economic development for Aborigines. What effect could this discursive formulation have? In its early days, the Company did employ an Aboriginal educator, Faye Nelson, who went around to schools teaching children about Aboriginal culture. The educational activity was a contradiction and an ongoing problem. Because this position cost money—but could not be said to make money—Nelson was eventually let go, with some "bit of a furor" (N. Peterson, personal communication, 21 November 1995).

5 Burned Out, Outback: Art Advisers Working between Two Worlds

Geoff Bardon was the first, in the Papunya area, to serve in the role of what came to be known as art adviser or arts coordinator, a building block of what ultimately became the Aboriginal arts and crafts industry.[1] Support for Bardon's position emerged in such an ad hoc way that one might be surprised to learn that it has become institutionalized. The art adviser is perhaps the pivotal role in the brokerage, or mediation, of Aboriginal cultural products to the marketplace and the wider public. "Bosses" and employees at one and the same time, they epitomize the moment of circulation, facing the values and expectations of both the local community and the varyingly defined "outside" — the government, the market, collectors, dealers, and so on. They live, moreover, subject to the tyranny of distance that defines life in the Outback — the distance not only between Papunya and Alice Springs but also between Alice Springs and the large southern cities of Australia, and even overseas. These are people whose lives straddle the communication between the bush and the metropole.

I knew many of the art advisers for Papunya Tula, and I enjoyed their generosity in sharing knowledge and appreciated their support for my own research. Indeed, our lives intersected so much at the time that we learned a great deal from each other. They were often students of the art movement, significant theorists of their own engagement and practices. If anyone knows what was involved in making Aboriginal fine art, it should be these women and men. They had to do what I understood to be a nearly impossible undertaking, moving between conflicting regimes of value, and their presence in this text is fundamental. It is their experience of Aboriginal culture and its mediation that interests me in this chapter. As occupiers of the intercultural space that concerns me, too, their lived realities illuminate the structures and potentials of this space as it was transformed by policy and market changes and came to offer different strategic opportunities.

According to their different dispositions and histories, they worked out distinc-

tive arrangements, structurings that are expressed in the tone and stance of their words. To accommodate their voices, I draw heavily not only on my own ethnography but also on reminiscences and interviews with art advisers, on their writings, and on a range of documents that have been made available to me. To ground the story, I use excerpts from an unpublished report that Papunya Tula art adviser Andrew Crocker (1981b) wrote when he left his position in 1981.

In 1973 and 1974, more or less once a month, Peter Fannin would drive his old Land Rover out from Papunya over the corrugated dirt track to Yayayi. The distance was only twenty-six miles, but in those days the miles represented a significant insulation. Rumors circulated about when he would come, how much money he would spend, how many paintings he would buy. Without telephone or even radio connection, and only the most limited motorcar travel, there was a good deal of room for uncertainty. If Fannin was expected, the painters would begin in the morning to bring out their paintings at the camp on the edge of the community near the creek bank where they worked, standing them up against trees or laid over old blankets. In the distance, alert ears would hear his motor approaching. "*Yurtilpi.* He's coming." When the Land Rover entered the Yayayi camp, dogs would bark and chase it, and children would shout with excitement. Fannin would drive through the camp and park beside the painters.

During this period, six painters were regularly at work for Papunya Tula, producing their 24 × 36 inch canvas boards. Charley Tjaruru Tjungurrayi, Shorty Lungkarta Tjungurrayi, Freddy West Tjakamarra, John Tjakamarra, Wuta Wuta Tjangala, and Yala Yala Gibbs Tjungurrayi worked as "full-time" painters. If one combines their training allowances of $A60 per fortnight or $A120 per month with the expected four paintings, painting for them alone would bring in $A360 per month, and several other "part-time" painters might also sell four paintings per month. Painting did add considerably to the overall resources in the community and to the project of self-determination.

On his monthly visit, Fannin, pipe in hand, would negotiate sales with the painters, who always wanted to sell more paintings, at higher prices. Papunya Tula's funds were often insufficient to make the expected number of purchases, and Fannin sometimes paid for paintings out of his own salary, hoping to recoup the outlay when promised government funds arrived or when the proceeds of promised sales were realized. Frequently, painters believed they were owed more money from earlier sales, and they grumbled about being "cheated." They always complained at the prices they received. The money from the paintings was almost instantly turned into cash, which circulated in the camp among the painters' relatives. For some it bought food, for others clothing, and for others it became the

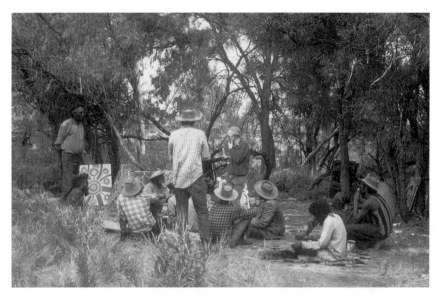

The art adviser Peter Fannin discusses the price of purchase with a gathered group of men in the painters' camp, Yayayi, N.T., June 1974. Photo by Esras Giddy, courtesy Ian Dunlop.

stakes in card games that sprang up among the young and middle-aged as players tried to turn their small sums into amounts large enough to buy a car.

The purchase of paintings was a public event. The painters and the other men gathered in front of Fannin while he joked with them and discussed the paintings one by one (above). At Yayayi, however, Fannin could rarely stay more than a few hours before he had to return to his base in Papunya, where he wrote letters requesting funds and planning exhibitions, worked over the accounts, annotated the larger part of the paintings, and dreamed of a future for Papunya Tula. At Yayayi, then, the painters had less access to the adviser than they would have had at Papunya, and they typically felt that they were neglected. The situation seems quite specific in its particulars, yet it represents the fundamental features of the kind of representation entailed by the art adviser relationship.

The art adviser position now seems obvious, even necessary, but it had a beginning. According to Nicolas Peterson (1995), when Bob Edwards was curator at the South Australian Museum in the 1960s, he became interested in maintaining or preserving the traditional skills still extant in remote Aboriginal communities. In 1966, while on an expedition filming rituals at Yuendumu as part of a salvage project initiated by the Australian Institute of Aboriginal Studies, Edwards saw how difficult it was for Aboriginal people to access the materials they needed for what was becoming their "craft" (and which defined them re-

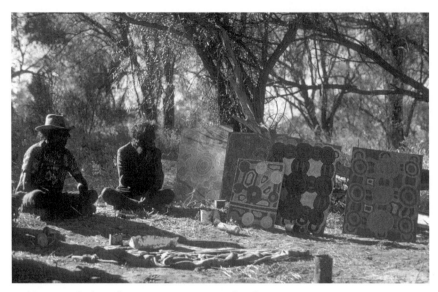

Freddy West and John Tjakamarra arrange paintings for sale, Yayayi, N.T., June 1974.
Photo by Esras Giddy, courtesy Ian Dunlop.

ciprocally as "craft workers"), particularly the *ininti* (bean) trees necessary for making shields. These resources had been used up in the immediate vicinity of the settlements on which most Aboriginal people lived, so the people needed access to motor vehicles in order to maintain their "craft skills." This problem was to be solved through the institution of what were called "craft advisers," a position that began by looking at traditions *in* communities in the light of modernity and modernization. In a report entitled "Encouraging the Arts among Aboriginal Australians," Ulli Beier (1968) had proposed the concept of "craft advisers," but the impetus for art advisers developed in the National Aboriginal Arts Seminar of 1973. By 1981 there were fourteen full-time and three part-time advisers in Australia, funded by the Aboriginal Arts Board at a total cost of $A288,000 (Peterson 1983, 64).

The Role

> The secretary is . . . their employee. This renders him vulnerable to the artists' whim as far as hiring and firing are concerned. At the same time, it largely defuses the perennial criticism of profiteering at the Aboriginals' expense. Windfall profits fall to the company (i.e., the artists) and in any case the company has hitherto borne a loss. (Crocker 1981a, 2)

The art adviser's role has had a distinctive and discernible structure, underlying a lived reality. The structuring of the position has followed from its place in the chain of connection between Aboriginal painters and a diverse outside. The difficulties of art advisers are well known; burnout was quite common as a social fact and an explicit topic of conversation. Over the first several years of operation, Papunya Tula averaged one adviser every two years, a figure in line with the experience of art coordinators more widely.

In the 1981 marketing study directed by Timothy Pascoe, the authors wrote that "craft advisers are the first link in the marketing chain. Their duties are diverse and challenging, frequently involving social and community support work unrelated to artefact production. The job is demanding, lonely and not well paid" (Pascoe 1981, 9). This seems an understatement. The overwhelming nature of the tasks of mediation is evoked clearly in the enumerative description from Peter Fannin. When he requested help in 1974 from the Department of Education, Fannin's desperate letter related the following duties as falling on the "organiser" to the movement:

Ordering and preparing art materials
Assessing values of paintings and making payments
General social welfare of the artists (there are 40)
Developing use of new materials and techniques
Promoting sales
Assisting artists to visit ancient sites
Ensuring that accounts and legalities meet the requirements of the Auditor
 General
Regularly visiting satellite settlements
Facilitating travel of artists on [Arts] Board business
Preparing summaries of the relation of the art to known anthropology
Describing the cultural significance of each painting (Fannin 1974a)

This is a wide range of duties and skills. Accounting skills, salesmanship, anthropological knowledge, and even exhibition planning had to be combined with the ever-present and enormous obligations for travel and attention to "the general social welfare" of forty artists. "Especially when it is considered how often these duties necessitate traveling the 320 hard miles to and from Alice Springs," Fannin continued, "this is clearly an impossible assignment. Setting an impossible assignment is bad economy. Too much time is lost in considering what essential duties shall be sacrificed." As Fannin's letter suggests, the stress of art advising was structural.

As Papunya Tula's art adviser from 1980 to 1982, Andrew Crocker (1981a) recognized that the fulcrum of the advising pivot was one's employment by an Aboriginal group in the service of their "self-determination." Although the funds for their salaries may come from government grants of various sorts, art advisers were usually employees of Aboriginal communities or cooperative companies within them. An adviser worked for the company and on behalf of its members. However, his or her decisions on behalf of this collective welfare could often lead to conflict with individual painters or even with the group as a whole. Complaints were exceedingly common.

One significant area of disagreement was payment, in a system that places considerable weight of judgment on the adviser. Usually, for example, the producers in local communities sold their work to the cooperative, which was overseen or managed (as an enterprise incorporated under Australian law) by the art adviser. In such sales, a price would be agreed on by the artist and the adviser, but it rested on the adviser's shoulders to decide in effect "what the market will bear," to bring his or her judgment about what existed outside the community to the painters. Advisers all have reported constant requests for loans ("booking up") or advances, which threatened the liquidity of the cooperative, and they had to convince the painters to sustain their company price structure by asking for equivalent prices when they sold privately to buyers other than the company.

Furthermore, as the custodian of the cooperative's funds, the adviser was responsible for the appropriate bestowal of funds and continuity of the corporation — in ways that may conflict with the customary practices of Aboriginal community life. Painters may need transportation to funerals or initiations and expect help from the adviser, use of "the company's vehicle" — even though such usage might conflict with other priorities of the company or the terms of governmental grants.

Responding to Pascoe's 1981 report, *Improving Focus and Efficiency in the Marketing of Aboriginal Artefacts,* Crocker decided to offer his own observations on the role of company secretary (as he called it) at Papunya Tula Artists. He did so with a characteristic acerbic confidence, combining his experience in the bush with a baronial distance quite different from Fannin's sense of immersion and beleaguered wit. It may be necessary to read between the lines, but Crocker's tone and message confirm Fannin's experience while insisting on a more reserved separation from local immediacies:

> The job of Secretary is an arduous one. I found it impossible to complete all the tasks which I deemed were necessary, let alone take other initiatives.

Much tedious routine is required which is not intellectually taxing. All sorts of indignities beset one. They have to be tolerated good-humouredly in order not to get too depressed. It is moreover not always easy to see what the Aborigines are getting out of it all. I believe it is necessary therefore to have an incumbent who is both aware of these things and endowed with certain qualities. He (or she) must run the Company profitably because there can be little more conducive to despair than an illiquid enterprise. He must not come to the job so much because he is dependent upon it as because he wishes to make a contribution. . . . The point is that the artists are the employers. They are generally extremely reasonable. There are rare occasions however when demands are made upon one which if acceded to would require acting against one's view of what is correct. There is usually a way out but in my opinion it is quite wrong not to remain true to oneself for fear of incurring displeasure and dismissal. Furthermore, to act in such a way would be a disservice to people for whose benefit one is ostensibly there. The incumbent ideally should either be qualified to work elsewhere or be of independent means in order to preserve his integrity. (Crocker 1981a, 5)

Crocker's stance put less emphasis on one's relationship to local people—a "fear of incurring displeasure and dismissal"—and more on one's responsibility to the enterprise. Integrity may involve, at its most basic level, judgments about a painting's marketability. Payment would perhaps satisfy the producer but might endanger the cooperative's financial viability over time. The responsibility for these decisions always lies fully on the shoulders of the adviser, and the success of an adviser might very well rest in his ability to make such decisions acceptable. Diplomacy is essential. As Crocker wrote, "It is sometimes impossible to refuse a painting from an artist even if it appears poor. This is because it is undiplomatic to refuse an old man's work to which he ascribes a fair deal of spiritual importance and which he purports to have painted largely on the strength of a personal relationship with you. In those circumstances chide gently the defects and use the price mechanism vigorously" (1981a, 2).

The art adviser's worth and reputation are never evaluated at the local level alone. Crocker's own estimation of his success would presumably not depend on what his "employers" thought of him, whether they liked him or recognized his sacrifices on their behalf. In this respect, however, he may have differed from many others, but he seems to have cared deeply that his work be viewed as a contribution to an enduringly valuable cause.

In the narrow view, such feelings are external to the functions served by the adviser, functions better defined by their position in the economic chain. Payment, of course, is a key moment in the circulation of paintings. While price agreement is needed, how payment actually occurs varies. At Papunya Tula, the artist is immediately paid the sum agreed, paid up front, so to speak. At Yuendumu, home of Warlukurlangu Artists cooperative, the artist is paid only a portion—with the full amount coming when a sale occurs. This ties up less of the cooperative's cash and frees the adviser from ultimate arbitration of price but forces the artist to wait for full and final payment. With either system of payment, an additional 25 percent or more is added to the artist's price by the cooperative to cover costs, although the sum raised is usually inadequate to meet costs.

From this point, the objects move outward. It is easiest to show this initially as a marketing structure. In the 1970s, objects were sold either to Aboriginal Arts and Crafts (the government marketing group) at a small markup (in the 1970s, it was sometimes a further 20 percent) or to a local retailer, usually a tourist shop. In Alice Springs, only a few venues existed in the 1970s, but in more recent years, there have usually been more than twenty such outlets. Paintings might also be sold to someone who had specially commissioned work. When it was operating, Aboriginal Arts and Crafts (operating the Centre for Aboriginal Arts and Craftsmen) would add a further markup of about 100 percent, making retail prices in Alice Springs 150 percent higher than the price received by the artist.

Not infrequently, especially in the early days, producers would circumvent this route. They might sell directly to local retailers in town, or to white workers and residents—and sometimes to a store manager trying to set up an unscrupulous side business—in their settlement communities. Advisers have always recognized the problems posed by this competition, "bootlegging" and "piracy" as Crocker called it when it reached extremes. At times, such sales could be advantageous, because the company did not have to lay out money to cover the entire output of the painters. Crocker maintained, too, that the artists' freedom to sell established the notion that the company would not buy everything, of whatever standard. But it would be disastrous for "outsiders" to buy all the best paintings, leaving the inferior ones for the company—and such circumstances often brought the adviser into conflict with others in the community. The adviser's attention, in some views, must be to the long-term structure of pricing. Again, Crocker articulated this responsibility in concrete terms as identifying the adviser with the market: "Avoid the temptation to sell the best paintings to friendly schoolteachers etc. at a dis-

count. The best paintings are the bread, butter and cake of the Company. More and more, as the art becomes recognised and in demand, there will be one price, a world price. This is what you should aim at and express. With this in mind do not be upset that you cannot sell good work at high prices in Alice Springs. You will sell them later, for more, elsewhere" (Crocker 1981a, 24). Art advisers and dealers, of course, are concerned about the effect of such variations on price structure. Cheap sale within communities might bring down the overall pricing of paintings on the market. However, in the 1970s, this market was only imagined. Despite an early critical success and interest, there was a terrible problem of oversupply of Papunya paintings and relatively little demand.

Papunya Tula: Robbing Peter to Pay . . .

Peter Fannin was the arts adviser (or "organiser," as he preferred to be called) in the Papunya area, from 1973 to 1975, when I was living at the Pintupi community of Yayayi. In these early years, the art adviser operated primarily between the Aboriginal community (Papunya, and later including Yayayi) and the Arts Board, and less with a differentiated market. Arts Board grants were the lifeblood of the cooperative. Not only did such grants fund Fannin's position, but the Arts Board and Aboriginal Arts and Crafts were the principal buyers of the paintings from Papunya and Yayayi.[2] Fannin's correspondence to the Aboriginal Arts Board speaks eloquently of the cash flow problem and the difficulty of his workload. The art adviser's preoccupation—as gleaned from Fannin's and others' prolific written accounts of the situation, as well as my own field experience—has the feel of "robbing Peter to pay Paul."

Twenty-six miles west of Papunya, Yayayi had a number of the original members of Papunya Tula, but the community had branched out to a new location. This meant that Fannin's obligations were geographically dispersed beyond the Papunya–Alice Springs circuit. Resident in Papunya, Fannin occupied a house there provided by the government that became something of a center for the painters in the community. They called it the "artists' house," indicating their view of the structure of authority—that he occupied it on their allowance. Fannin rarely went to Yayayi more than once a month. Despite his sincere effort, and their personal affection for him initially, the painters at Yayayi were chronically unhappy with the infrequency of his buying visits. No doubt they were jealous of his attention to the "east side"—words by which they referred the painters in Papunya itself who were from different language groups (Arrernte, Warlpiri, Luritja, Anmatyerre). At Yayayi, the Pintupi painters mimicked the way Fannin

held his pipe and the way he stroked his goatee when about to complain to them that he had no money. Sometimes, indeed, they had to wait even longer between visits, when there was no money, because there were insufficient sales (or grants) to maintain the capital to buy more paintings. Fannin claimed at the time, truthfully, that the company did not have money to purchase the paintings the men had produced. This was difficult for the painters to understand or to believe, and even more difficult for them to accept. Fannin saw that the aims of whites and Aborigines have not always agreed, but to his credit and in spite of the pressures he endured, he claimed to see some common aims as well. He struggled mightily to sustain this sense.

The desperate accountings and pleas from such advisers recorded in Papunya Tula's files—now lodged at the Australia Council—are so many, and so continuous throughout the years, that they tell a story in their own right. They involve the problem of cash flow, the difficulty of providing documentation, and the problems of transportation to maintain service to the producers and to the market. The litany of vehicle failure, repair, and destruction on these poor dirt roads is almost as impressive as the struggles with cash.

For example, on receiving news of a grant for $A8,500, Peter Fannin requested that he be allowed to use it to clear the existing overdraft for his salary from the company. The lateness of grants, he wrote to Anthony Wallis on 20 May 1974, had led "to serious liquidity problems. In fact, business was suspended for several weeks through sheer inability to write a check that wouldn't bounce." At Papunya and Yayayi, responsibility for such a slowdown rested with Fannin. Presumably, part of the problems was the intermittent cash flow at the Arts Board and Aboriginal Arts and Crafts. Delicately, Fannin broached that subject, too:

> Chris Fondum [who worked at AAB] tells me the salary and corroboree cheques are posted. The "canvasses for Canada" cheque is with us. A.B.T.F.[3] Darwin has come good with $1000 back salary money, and Aboriginal Arts and Crafts have paid us some $1500 that was outstanding, and bought a good bit of old stock. So when we resume on Monday, we'll have liquidity again. . . .
>
> So I cannot escape the task of trying to persuade the artists to reduce their output. Wish me luck! Help with cost in using my landrover to stimulate artifact production [alternative source of cash] would be appreciated. As to vehicles for the men, if we can't get them, we'd better say so. Basically I gather it is because the death-rate for aboriginal vehicles has been too high. I think the men will understand this, even if they don't like it. (Fannin to Wallis, 20 May 1974)

Making the market work would not coincide with the desires of his "employers." Nor were they likely to obtain the vehicle they had been seeking. With all this pressure, however, Fannin still had to look forward to the future, planning exhibitions, even if it wasn't clear how to pay for them. "I am planning to do two things that I'm pretty sure we can't afford," he wrote to Wallis. "One is to outlay $1500 for an exhibition of canvasses in Melbourne, and the other is to employ casual assistance for book-keeping and organisation of photographs and records. I'll try to accumulate my own money sufficiently to backstop these if necessary" (ibid.).

The letter outlines what it meant for paintings to be produced at a rate that greatly outpaced the market demand and the company's ability to purchase them. Here Fannin delineates his strategy of slowing down production—a strategy undertaken again later by another adviser, Dick Kimber.

Back out in Yayayi, my notes show, the painters were unhappy about a slowdown. They were angry about Fannin's failure to buy their paintings, about his "sitting down" in Papunya when he could not visit for lack of funds. He knew what he faced there, too. "Wish me luck," he wrote in one memo, anticipating a difficult meeting with the Aboriginal members of Papunya Tula as their employee. All the while, the fiscal survival of Papunya Tula was being eked out through intermittent and often stopgap provisions from the Arts Board, delayed payments for earlier purchases, and small grants to make up his salary from the Aboriginal Benefits Trust Fund. In the midst of these rather dire conditions, Fannin still contrived to gather funds to lay out in preparing an exhibition in Melbourne. As it turns out, he even used his own money to get things moving.

The movement really could not take off without exhibitions. Yet without capital, Fannin knew he could not offer paintings for exhibition. In reply to a request from the Aboriginal Arts Board for paintings for an exhibition, Fannin wrote to Bob Edwards from his dusty, disorganized office: "You must curse my letters! Reams of paper to file or throw away, whinges about money, and usually an apology for not being able to produce what you want, when you want it!" After discussing "some beautiful paintings" of late, he went on: "I think we should enter the Caltex and Alice prizes in Alice Springs over the next few months, so after all that raving, there aren't any canvases I can let you have! Photographs of the Mick Ngamarari [sic] I've bought, and the rather Rabalaisian Limpy [Limpy Tjapangarti] are enclosed, so you'll know the sort of thing that's coming" (Fannin to Edwards, 10 August 1974).

Only then did Fannin reply to the Arts Board's request, saying that he couldn't acquire more paintings because he hadn't the cash. "So . . . what can you have? The answer is, until money comes through from Craft Council or A.A.C., anything we don't have to pay for! And that is 21 small boards and 10 big heavy ones" (ibid.). In

the meantime, he had the time-consuming project of documentation to do: "After reading Munn, a fair bit of re-writing is called for. In many cases this will move a painting from marginal to good. But it will take time" (ibid.).

The Work of Documentation

If maintaining the cash flow was a problem, as these letters indicate, so was the work of annotating the paintings, or documenting them ethnographically. This was a significant part of the art adviser's job, since the time of Bardon. Fannin felt that this work was so demanding that he required additional help. He claimed in one letter that preparing 137 paintings (annotating, documenting, etc.) purchased by an Arts Board commission of $A10,000 for an exhibition in Lagos would take him three months of work. This stream of circulation, however, would only "keep the men at 1/4 to 1/2 of what they would like to output. Better, I guess, than a poke in the eye with a pointed stick, but I still think Australia is missing out on a lot of treasure by understaffing this project" (Fannin to Edwards, 18 November 1974).

This documentation was regarded as a significant contribution to the value of the paintings, especially in a fine arts market, or, as Morphy (1983a) called it, "a primitive fine arts" market. Such work could improve the value of paintings, as Fannin noted. Partly such documentation creates a guarantee of "authenticity" and of "uniqueness," since the annotations identify the producer and give some indication of the "Aboriginal meaning." They have certainly come to be an important part of valuation. Thus, when I asked Daphne Williams and Dick Kimber in July 1991 about the Australian Museum's acquisition of the Papunya Tula Collection in 1979, they emphasized the lengths to which the museum had gone to reconstruct documentation. Indeed, when Williams defended the sale, which some have criticized, she argued that the company could not have expected top price for these paintings anyway, since they lacked appropriate documentation.

There has always been ambivalence about the extent or detail of documentation appropriate for sale, both on ethical grounds and with an eye to sales. Some even regarded curiosity about the iconography as intrusive, and the painters themselves have been more or less enthusiastic to provide details to different people. Clearly involvement in documentation varied among advisers, and the women serving in this role may have had less access to men's stories. Andrew Crocker, for example, initiated a reduction in documentation, just as he asserted a reduction in production—both directed to a market of higher quality. "While certain collectors have a special interest in the ethnographic dimension of the work[,] the main selling factor is the visual impact—the aesthetic dimension" (1981a, 9). Practically, he argued,

Table 1 The average price paid to artists for
paintings of various sizes, September 1974

Size	Price
8 × 24″	$5
18 × 24″	$17
30 × 24″	$37
49 × 32″	$80
66 × 19″	$80
78 × 66″	$300
132 × 66″	$600

Source: Fannin, letter to Edwards, 23 September 1974.

such collectors—of "primitive art," really—would be few and not able to sustain a demand. They would seek only very early works or paintings by those who had hardly painted before. Moreover, collectors of "ethnographica," he pointed out, "seek ancient artefacts. Modern imitations are less attractive" (9). His insistence that "it may be necessary to sell *less* numerically in order to sustain good prices" (5) also, as I remember, brought him into conflict with the painters' immediate wishes that he buy *their* paintings. This was part of a rationale, however, for selling Papunya work "primarily as contemporary art. This meant actually making the effort to remove it where possible from associations with ethnographic material. I consider that promotion in this way has largely been responsible not only for the recent successes of the enterprise but also for an increased interest in the wider ramifications of Aboriginal art" (9). While recognizing the importance of the stories to the painters, "in cultural terms," Crocker did "not think the annotations are of much use save as a certificate of authenticity . . . perhaps an analogy with a title for a painting" (19). He suggested brevity.

As part of preparing paintings for sale, Fannin always claimed to be dramatically slowed by the need for documentation. Even when Kimber took over in 1975, he found a "mountain" of paintings that needed to be documented in order to be of value to any sort of collection. Fannin estimated that the number of paintings that could be sold on the "fine arts-ethnology market and the number that can be annotated with due care, represents a figure between 200 and 400 paintings a year. Unfortunately, the men, especially at Yayayi, have to regard painting as 'work' in the whitefella sense. They expect to get paid twice—once for sitting down and doing it, again for selling at the end. This attitude produces some 1200 paintings a year" (Fannin 1974a).

It cannot be overstated that the pressure from the painters for payment and purchase of substantial numbers of paintings was enormous, even when—as in Papunya's first several years—the cooperative's stock (or backlog) was already reaching levels of five hundred paintings or more. Fannin ended up leaving the position for medical reasons—a second bout of "nervous exhaustion"—after rolling his vehicle over on one of the tiring trips he made on a dangerous sandy road between Alice Springs and Papunya. The stress comes preeminently in the difficulty of intercultural communication across these domains of value and expectation. No doubt this was why painters felt the necessity of explaining their views of value to me. Where there has been a history of cheating and suspicion, communication is vexed.

Why All This Work? And Why Do It?

The art coordinator's job is not (usually) just an economic or business mediation, which makes it both desirable and destructive. Working for Aboriginal people—as the adviser position has always been conceived—is not a single-stranded job. As I so often heard, Yarnangu (Aboriginal persons) expect the advisers, like other local whites, "to help Aboriginal people." In this expectation, Yarnangu do not distinguish whites from other local residents, their "relatives," who help each other. But for most art advisers, this level of expectation and demand has not only been exhausting but also generally conflicts with more specific demands of the job. Bardon, Fannin, Kimber, Kean, Crocker, and Williams—all the art advisers at Papunya Tula have had to make arrangements with these projections of moral personhood. All have had trouble when they tired or outright refused to help, just as they were praised at other times for helping.

Obligations to the general social welfare of the painters drain advisers of their energy and goodwill, as Christine Lennard, a former adviser at Yuendumu, described:

> That's one of the things that helps create the burnout that everybody talks about so much, you know. Everybody becomes so involved on that scale. And you're still trying to keep all the business side of things together and keep up the demands of galleries and people from outside, white people from outside the community's expectations and what the associations are going to be able to perform and do. I mean, you burn out because everybody will have you driving them to their relatives here, hunting here, "move this wagon, move that fridge, move everything," you know? And, at the same time, "Why haven't my paintings sold? Why haven't you sold this to that

person that was here? Why didn't they buy mine?" You know? You just go bananas. (Lennard 1991)

There are other ways, equally pressing, in which the art adviser's role cannot be limited to the work of economic mediation. This deviation from economic rationalities, of course, can be part of the pleasures of the job. From early on, the relationship of the art enterprise to what was called "cultural knowledge" was a significant consideration in government support. Support for cultural preservation or cultural maintenance was clearly enunciated in the cultural policy of the Aboriginal Arts Board. This understanding of painting also represents Yarnangu views at Papunya, in which the paintings were centrally part of their relationship to country and ceremony (Myers 1989, 1991). To accept this linkage about the significance of painting and reasons for its support was culturally appropriate, acknowledging Yarnangu views that painting and looking after their country made up a single cultural domain of activity. Self-determination, then, doubly implied a rejection of the claims of a modernizing impulse that would separate the economically valuable activity of painting from religion, and painting from "being a relative."

The art adviser, however, is a participant in two worlds. Within his or her daily life, these conflicting values were and are always at play—between completing the annotations and the account books and taking the painters out to the bush. There could be no simple solution. How advisers managed these syntheses—their identification with, or performance of, distinctive Western or Aboriginal discourses and values—varied. John Kean's relatively strong postcolonial enactment of local Aboriginal values differed from Andrew Crocker's more reserved but unpatronizing focus on creating a market, on what must be achieved for Papunya Tula as an enterprise "in the Aboriginal interest." Dick Kimber, based strongly in the biracial, bicultural worlds of Central Australia, would typically expend more effort at rationalizing intercultural arrangements, acknowledging white concerns with a view to long-term accommodation in Alice Springs. If Kean, especially as a young man, was the most adamant in bringing Aboriginal values to bear on cultural exchange, Crocker's cultural politics ignored what he called "the path of least resistance." Subsidization, for example, should not detract "from the Aboriginal's ability to discern the economic realities in whose framework they now live. To delude them further about the realities is to decrease their ability to come to grips with them, mobilizes public opinion against them and does them a disservice" (Crocker 1981b, 4).

The quality of knowledge desired of an art adviser gave travel with the painters value, too, and for some advisers such travel—visits to the painters' country (to

their traditional homelands)—was the most satisfying part of their job. Since the beginning of Papunya Tula, and throughout the early documents at the Aboriginal Arts Board, one significant component of acrylic painting was its link to cultural maintenance. This meant allowing Aboriginal people to visit their country, sites of cultural significance through the Dreaming, where they could renew and transmit their knowledge and draw inspiration from the contact. It has often been noted how the quality and intensity of paintings increases after such visits. Art advisers were frequently asked to take painters out to visit sites that were difficult to access, and one reason for granting vehicles to the painters' cooperative was to accommodate such visits. I drove their vehicle on the first such visit by Yayayi painters to the Western Desert in 1974, after the Arts Board had provided them with a Land Rover, but earlier Peter Fannin had been undertaking these visits to more nearby sites. When Dick Kimber was advising Papunya Tula (1976–1978), such visits were his principal focus (Kimber 1988, 1990). Kimber's description of a journey to the Ilbili area of the Ehrenberg Range in 1976 with a party of nine Aborigines is eloquent of the impact—of the "strong interlock between art and the country"—that he was dedicated to facilitating (1988, 73–76). The party traced some of the sites of the Honey Ant Dreaming to find Tatata, a great gathering place for ceremonies:

> Eventually Parta called a halt.[4] The immediate country seemed very nearly featureless. There was a sandhill away to the south and some scattered low bushes and dead trees close at hand. Old Parta, a pensioner with legs crippled with age, virtually leapt from the vehicle. What on earth could he see? He had stated that Tatata was marked by a large tree, the northern-most bough of which bent like a pointing arm to the rock-hole. There was nothing like this here—or so it seemed. But Parta was running now, his excitement lending youth to his legs. He stopped 100 metres from the vehicles and beckoned us to him. We hurried forward. And there, in a flat rock surface, were the small Tatata rock-holes. And pointing to them was the northern-most limb of a dead tree; we had all been searching for the living tree of Old Parta's youth....
>
> For Parta it had been a key point in his homeland. He recalled camping here after good rains. His father had speared *malu*, the red kangaroo, in the light *mulga* scrub country and had ground a stone axe to a fine edge by the rock-hole. His mother and other women had gathered seeds and ground them beside the rock-hole too. And he and his boyhood friends had been old enough to hunt alone, and had caught goannas, "bush rats" and other small "bush tucker" animals near the sandhill. It had been a place of happiness for him now.
>
> He searched for Tjapananga, the man of the Dreaming who resided at

Tatata as a block of stone. We found Tjapananga. The rains of decades had eroded the soil and he had fallen over. We lifted him to his feet and chinked his base with loose bits of stone, then left him with the arm of the tree reaching out to him. (75–76)

These visits had a significant effect on painting, even one that might be converted to value within a regime of enterprise. Although time and cost were a problem, Andrew Crocker wrote, "It is clear . . . that such renewal of acquaintance with sites of importance inspires exceptional work. So does the showing of interest in the sites and their related mythologies" (1981b, 6). For instance, in early winter 1981, the Pintupi were deeply engaged in separating themselves from Papunya and attempting to initiate a move out into their own country. This had been preceded by a series of trips out to visit the western country, and a trip undertaken by Andrew Crocker (and me) with Wuta Wuta Tjangala in May 1981. Shortly thereafter, Wuta Wuta began to paint the large Yumari painting that has been frequently reproduced as *Yumari, 1981* (see plate 6).

A less obvious value of these visits was that they provided some of the most significant moments of shared fellowship and identification with Yarnangu people and their culture. Kimber and Kean, particularly, took great pleasure in facilitating the Papunya painters' visits to their home countries. Crocker, too, found satisfaction in such visits, recording the joyous singing of Wuta Wuta and his relatives during one such journey. However much this might have been consonant with Yarnangu interests and values, and however clearly significant it was to those who made the visits, the travel could conflict with the economic survival of the painting enterprise: "Time and cost are a problem," wrote Crocker (1981b, 6).

The contradictions of their role, the different claims placed on them, were not lost on the advisers. "To be away for any length of time with one group," as Kimber wrote in a note to Crocker, "disadvantages the other groups re preparation of materials, sales, etc." (26 December 1983). There could certainly be too much of this, and Kean's interest in bush trips—much praised by those with whom he traveled—was seen by some to compromise the time spent on other duties. A more central conflict involves the provision of time and money from the government budget for vehicles and travel. The conflict was real and challenging to Western values and the rationalizing impulses of cost accounting.

Local Knowledge

The advisers were a highly varied lot, and the commonality they evidenced lay mostly in their proximity or availability to Aboriginal communities and their

goodwill. In later years, and in other communities, the role became more structured and bureaucratized, but its essential contradictions remained.

The pleasures and pangs of this work, what makes it interesting and challenging, are less the experience of romantic encounter with artistic "Others" than the personal relations, the incongruities of local knowledge, and the emotional dichotomies of living within a field of highly charged cultural difference. Over time, the sociological and cultural backgrounds of art advisers in Central Australian communities have changed, toward a greater emphasis on individuals from an arts background and more middle-class origins, and away from those whose prior experience of working with Aboriginal people would define their relationships. Thus the incongruities of local knowledge have been differently experienced and managed, but they seem always part of the orientation or self-fashioning of advisers.

Dick Kimber had perhaps as close and sympathetic a relationship with Papunya Tula and Aboriginal people generally as any coordinator. The burly and bearded Kimber, who grew up in South Australia, began as a secondary school teacher in Alice Springs with a substantial interest in local history, material culture, and Aboriginal heritage and with a flair for telling a colorful yarn. One of the most important whitefellas in the emergence of Papunya Tula, Kimber's interest in Yarnangu lives and ways has made him a close friend and confidant to a wide range of Aboriginal people in Central Australia. Possessing immense knowledge of the inner workings of Papunya Tula and close friendship with many of its participants (Megaw 1982), Kimber has the gift of embracing the rough totality of Aboriginal experience.

Like many who engage with the immediate world of Aboriginal painters, the incongruities of mixing these worlds and their dissonant regimes of value continue to intrigue Kimber. And again like most advisers, he can only engage these incongruities with appreciative humor. In that spirit, when I asked him about the early days of acrylic painting, he remembered the ironies of the first Centre for Aboriginal Arts and Craftsmen in Alice Springs. Aboriginal practices, expectations, and informality were far removed from the sanitizing influences of aesthetic modernism, and the Yarnangu could sometimes be found scrounging the town dump for discarded meat.

Such moments surely express a certain immediate reality for art advisers, a gritty context so often seen as scandalous to those farther away. For Aboriginal men in 1974, former hunter-gatherers, there was nothing untoward or embarrassing about recovering food that had been discarded, nor were particular body parts considered unacceptable; meat was meat, and aging meat was perfectly all right. To outsiders, however, this would only bespeak a poverty, desperation, and depravity that did not inform the painters' self-understanding.

In the circulation of paintings, such knowledge of their context—so strongly present for the advisers and the anthropologist—was often lost, stripped away, or, as Andrew Crocker (1987) admonished, *denied*. Cultural difference was sustained in the annotation or the photograph of the painter, but the incongruities of copresence—whether harassment, alcohol abuse, violence, and poverty or political assertiveness and claims of prestige—were difficult to accept publicly. Yet these incongruities were the substance of countless conversations that advisers had in the service of finding an adequate framing of what was, for them, "reality." As in many similar intercultural settings, it has been important to understand "what the Aborigines really want."

The Painter and the "Unfortunate Incident"

> Remember, though, Aboriginals have to be *put* on planes, *met*, etc. If anyone wants to do these projects, make sure they budget for taxis to and from Alice Springs in case you are not available to drive. (Crocker 1981b, 26)

The kind of experience Kimber drew on in his reminiscence—a twinge of exoticism and difference that can be contained—was not the only form of local knowledge, however. Other, more confrontational experiences of proximity have posed far greater duress for advisers. Sometimes there are flare-ups of intensity when integrity, authority, or dignity are thought to be questioned. Threats of "sacking" or even of violence can be sparked out of longer histories of suspicion and racial inequality, histories for which the present adviser becomes a projective screen. For the adviser, these provocations can be daunting, even if they are little different from what transpires in conflicts among Yarnangu themselves.

One case, drawn from the Papunya Tula files archived at the Aboriginal Arts Board, provides a striking example of the tension of the art coordinator role and replicates the general form of such "social dramas" (V. Turner 1974) in mediating cultural difference. I will follow the case as reported by the art adviser in some detail, showing that these conflicts are not single stranded but instead involve dissonant values deployed by social actors in a complex social field. Indeed, social dramas are often moments in the readjustment of social relations and priorities among values. The relationship between advisers and painters—situated in a racially charged social field that was coming under scrutiny in the mid-1970s—had just such an uncertain quality. Even a committed and longtime associate of Aboriginal people could find it difficult to maintain equanimity under the provocations of the job, mediating Aboriginal demands and Arts Board delays and unresponsiveness. In this sense, the case evinces more cogently the dilemmas of

the intercultural social field than anything about the particular identities of the parties involved. These identities are somewhat disguised here, but the quotations are drawn from the art adviser's letters in Papunya Tula's file at the Aboriginal Arts Board (Papunya Tula file no. 76/840/022 IV), in which the adviser explains a contretemps he had with Papunya Tula's Aboriginal director in what I am calling "the painter and the 'unfortunate incident.'"

The painter "Tj." was one of the founding artists of Papunya Tula and an early member of the Aboriginal Arts Board. This particular conflict emerged around getting Tj. from Papunya to Melbourne for an Aboriginal Arts Board meeting, where he served as representative of Papunya Tula Artists. With only eleven days of warning, Tj. had been notified by the Arts Board that he would be wanted in Melbourne for a meeting. He needed to travel from Papunya to Alice Springs and from there, by plane, to Melbourne. This sort of abrupt notification is rather typical of the communications problem of settlement life and the differing expectations of Yarnangu and whitefellas about their shared concerns.

Shortly before he was due to leave, Tj. sent the art coordinator a telegram asking that he be picked up and brought in from Papunya. Conveniently, Papunya's community adviser was in Alice Springs at the time, and he offered to arrange for Tj. to come in with a vehicle operated by the Aboriginal Legal Aid Service.

Midmorning of the next day, the art coordinator dropped in to the Centre for Aboriginal Arts and Craftsmen to see if all was ready for Tj.'s flight. Instead there was trouble. The women working at the Centre were upset: Tj. had subjected them to a stream of angry outbursts and had left in a fury. Something had gone wrong with Tj.'s trip. When located in the enclosed area behind the Centre's building on Todd Street, Tj. was drinking beer. What began with Tj.'s "friendly 'Hullo' almost immediately became an angry abuse," the art adviser wrote. "In the end he was quivering with anger, swearing." Tj. insisted that he had been "treated as a 'rubbish myall,'" claimed that Legal Aid was 'onto' the art adviser as well as a security officer, and said they were sacked."

As he attempted to talk more calmly with Tj., even enlisting the support of two of the latter's companions, the art adviser's frustration at what he regarded as unfair allegations must have overwhelmed his judgment. He grew angry and expressed himself about the unreasonableness of Tj.'s claims for special treatment, complaining that when *he* went to Papunya, he took his own swag, took his own food, helped wherever and whenever he could, and "got bludged upon by all-and-sundry for money, food, and to act as a taxi." Tj. may have been taken aback temporarily, but while he "looked a little ashamed, smiled and shook hands, it wasn't 'all-over.'"

The art adviser was obviously upset and embarrassed by the conflict, particu-

larly over losing his temper. Although he viewed Tj.'s claims of neglect as excessive, the adviser still had to provide an account for what the painter would say when he arrived at the Arts Board meeting, where he promised to denounce the adviser. The reasonableness of the adviser's actions is sketched out in "whitefella" terms, but also as apparently reasonable in Aboriginal terms, drawing on the ways in which Tj.'s friends had participated. The adviser's reconstructed chain of events is informative: "Tj. was picked up [in Papunya] by the Legal Aid driver, together with [his friend]. He brought his own swag with him [to Alice, a four-hour drive], which suggests to me that he intended sleeping with relations somewhere [in town]. Late in the afternoon or early in the evening, he simply left his swag at the back of the Centre without seeing anyone and immediately went to the Hotel Alice Springs [a public bar]. . . ." After some drinks,

> Tj., [his friend,] and one or two other men arrived back at the rear of the Centre at least half-drunk and with a carton of beer. At this stage, Tj. appears to have evinced no concern about anything at all. . . . Subsequently, the security officer arrived and was aware of a small group of Aborigines, whom he requested to "move on." According to [two of Tj.'s companions], he was not aggressive about it. It is true that he has a dog and a pistol, but total nonsense — according to [one of the friends] — that he actually drew the pistol.
>
> [The friend] was prepared to move, apparently believing that the guard's complaint was legitimate because they were drunk and had the carton (he told me this). However, Tj. became angry — possibly in part a reaction of fear because of the dog and the (holstered) pistol. In the end his abuse and shouting were so great that [the friend] told the security-officer to throw Tj. out! Tj. and [his friend] "moved on," and spent the night in the bed of the Todd River. It was a cold night, but they had Tj.'s swag, and [his friend] appears not to have been perturbed by anything.
>
> On the morning of the next day, Tj. went to Legal Aid [the principal agency at this time providing recourse for Aboriginal grievances] and raged at "them" about his treatment by the security officer, and because [his friend] had not — on the instant's notice — been totally provided for on a visit to Adelaide.

In those days, the government-funded Aboriginal Legal Aid service was seen as being available to "help Aborigines," to provide whatever legal advice and services Aboriginal people needed. Often, as in this case, the grievances were quite personal. After this, Tj. returned to the CAAC, where his "swearing and general abuse" — and probably threats — upset those working there for the rest of the day.

Refusing to be mollified by those in the Centre, Tj. "returned to the rear of the Centre to drink beer."

This was where the art coordinator, late on the scene, had his definitive confrontation with the painter. Eventually relations "eased off," but there was no time to buy any clothes for Tj. or allow him to clean up. The adviser got him and his friend to the plane, and when he left, he wrote to Bob Edwards, "Tj. seemed calm and friendly."

As the adviser wrote, too, this kind of anger was part of a larger pattern with Tj., who has a considerable temper. How does one write of such a delicate context while struggling to respect Aboriginal autonomy? The adviser explained that Tj. had previously also

> told the Community Adviser and all white staff at Papunya that they have been sacked. He has done this in a rage, and has greatly offended people by his manner. I can now readily see why.
>
> As I said, I am prepared to accept full responsibility for what happened. I believe Tj.'s drunken state, his fear, his affront at not being known by the security officer, and his sense of outrage at being ordered on, all resulted in a reaction which in turn resulted in rage. . . . Perhaps we should have picked him up at Papunya, but I think our decision was a fair one under the circumstances, and I also think that the problems were largely of Tj.'s own making.

Although the art adviser says that he was "continuing with the work," the status is problematic because he had been "sacked." The letter ends with his waiting to hear the outcome of Tj.'s meeting with the director (Edwards) to know where he stands.

What is clear is that Tj. was not only frightened by the threat of the security officer but also angry at the insult to his pride and dignity — at being treated like a "rubbish myall."[5] This reflects not only Aboriginal values in which mature men expect to be treated with respect but also the changed circumstances aligned to self-determination. Particular understandings of authority, prestige, and control were at work in Tj.'s formulation (Myers 1980a, 1980b). As the local representative on the Arts Board who had made the Papunya requests, Tj. viewed or presented himself as the agent who had obtained the relevant government grants for Papunya Tula. This redistribution, as it were, should make him the legitimate mayutju, or boss, deserving respect and deference. During this same period, I can say, the head of the Yayayi Village Council claimed authority in that community on the grounds that *he* had gotten money from the government for them. Indeed, just as Yayayi's

head councillor claimed the truck purchased on this grant as his own, there were disputes about the ownership (or control) of Papunya Tula's vehicle, which Tj. regarded as "his own." It should not be surprising, then, that "Tj. claimed the CAAC [Centre for Aboriginal Arts and Craftsmen] as *his*," and wanted to kick out those who had not respected him—including the art adviser. This is what it meant, in part, to be what Crocker called "an employee." The employees—the art advisers—were regarded as having to respect, to listen to, their Aboriginal "bosses."

Like similar conflicts I witnessed over the years, both in the situation of art advisers and also in other domains, the "unfortunate incident" was an expectable manifestation of "indigenization" or "Aboriginal self-determination." As a response to a denial of his expectations of respect and relatedness, the painter's outburst followed a well-known pattern for the organization and expression of anger (Myers 1988c). The event itself clearly evidences a conflict of interest between two versions of doing the art adviser job, of working "for" Aboriginal people. One can understand why, as Andrew Crocker noted later, art advisers might well need to be persons of independent means if they are to exercise their own judgment.

Mediating—or working under the guise of—Aboriginal values has presented a difficult challenge to art advisers. The adviser's good faith and effort to understand the impossible dilemma of his encounter with Tj. testifies eloquently to the conflict-engendering nature of such engagements, but his situation resonates with many others. Advisers have faced frequent denunciation by artists displeased with the money they receive for a painting, the lack of a commission, or simply the failure of an adviser to help him or her (with money, transportation, etc.) when help is needed. There are considerable cultural gulfs here, and sometimes the adviser has been surprised and even personally hurt at what he or she takes to be a lack of gratitude or understanding on the part of the painters.

Identifications: Managing Dissonance

While difficult experiences may dominate the everyday life of art advisers, as they are narratively managed, they also inform in complex and often indirect ways the broader mediations these advisers make. Many advisers faced difficulties, but from different backgrounds—whether they identified with the bush life and Aboriginal people, as in the case of the young, art-knowledgeable John Kean, who began work in 1979, or whether they took their difference for granted. Andrew Crocker, the tall, angular, blond-haired Englishman who worked for Papunya Tula from 1980 to 1982, paraded around Alice Springs wearing khaki "Bombay bloomers," speaking in a markedly "Pommie" accent, and taking—as this chapter shows—al-

Andrew Crocker at the S. H.
Ervin Gallery, Sydney, in 1981.
Dinny Nolan Tjampitjinpa
and Paddy Carroll Tjungur-
rayi from Papunya traveled
with Crocker to Sydney to
create a sandpainting in the
grounds adjacent to the
gallery. Photograph by
Jennifer Steele.

most a singularly market-oriented approach to the job he described as "Company Secretary."

At the outset of his personal homage to Charley Tjaruru, Andrew Crocker (1987) felt obliged to draw attention to the "anomaly which strikes those who visit the settlements: the apparently dismal adjustment to Australian suburban slum living contrasted with the beautiful paintings which emanated therefrom." Crocker took his cue from a painter's answer to his question "Why do you paint this story?" The painter answered, "If I don't paint this story some whitefella might come and steal my country," posing the disparity between the local context and the destination of art as a contrast between the aestheticizing context of painting's collection and exhibition with that of its production: "Those who deal with Aboriginal art as agents, managers, gallery owners and investors or patrons rarely if ever show signs of paying the blindest notice to what is a very obvious statement within the art itself. Further they appear to pay little heed to the context of circumstances in which the artists find themselves and out of which the art is born" (Crocker 1987, 11–12). And, he points out, these circumstances in 1987 included land rights for Aborigi-

nal people in Australia: "The fact remains that to this day many of the artists and their families are denied recognition of their traditional territorial title" (ibid.).

Crocker's resolution of the adviser's identity dilemma, it appears, was to become a champion. In the passage I have just quoted, he challenged the aesthetic preoccupations of "the self-styled supporters of the Aboriginal enterprise" who ignore the political dimension of their artistic output (12). Significantly, Crocker adopted this position not from any illusion about his shared identity with the painters, but rather from a position he established within Western standards. The tone of objectivity is striking: "It almost goes without saying that it is not possible adequately to appraise an art form without considering the social context in which it arises. It simply does not happen in our own society. Further, where artists make certain assertions in their work I feel that we should pay the courtesy of listening to them if we patronise them. It seems to me more than distasteful to collect their work while turning a stony face to what they say or to their circumstances" (10). It is hard, he admonished the reader, "to conceive of such blindness to the content or context in respect of European artists" (12).

There is also another context on which Crocker insists. Always ready, it seems, "to divert the reader's mind . . . from notions of floods of masterpieces spilling gracefully from the Western Desert" (Crocker 1981a, 3), he drew back the curtain and presented the local context in his introduction to one of the first catalogs published by Papunya Tula. The art adviser wanted the reader to know the real field of intercultural production:

> The job of myself and my predecessors is a very arduous one. It is one of absurdly long hours and long, dusty drives. Circumstances of camp life conspire to ruin a masterpiece in a trice. Unsalable work must be tactfully haggled over using European criteria where they are not necessarily appropriate. Hours are wasted in Alice Springs battling outrageous demands—I see no reason why this observation should not be warts and all—from inebriated Aborigines. Some sectors of the European community, in turn, display not a little intemperance and resentment towards the autochthones and projects which involve them. . . . None of this was unforeseen but these facts can conspire to consume an awful lot of emotional capital. Again, none of this has prevented my deriving pleasure, knowledge and pride from my association with the artists and their families. (Crocker 1981a, 3)

But Crocker does not—cannot, really—insist on the heroism of sacrifice. The stiff upper lip is what offers itself as available and appropriate for a mediator of art. It is the market first; cultural politics can follow later, if at all.

Hobnobbing: The Tyranny of Distance

Crocker addressed himself strongly toward the broadest framing of an external—even international—market. Promotion was critical, which meant hobnobbing with those who had money and influence. "The further one might go from Alice Springs, or Australia," he wrote, "the better is, or could be, this market" (Crocker 1981b, 8). He realized the necessity of keeping an eye on the way the art is promoted. Because the remoteness of Alice Springs made this difficult,

> You simply have to get on the plane and visit exhibitions, outlets, and so on. It may be that you will have to go specifically for this. Alternatively, the opportunity may arise of doing the same thing if you undertake ancillary activities—e.g. dancing trips, lectures. These items may appear pointless expenses. *I really feel that personal contact with numerous interested parties was the key to getting various projects off the ground,* with subsequent publicity and sales. . . . It is moreover on trips such as these that you can visit individual collectors eager for authentic Art News from the Outback. The cost was repaid many times over. (Crocker 1981b, 8; italics mine)

However much self-irony there is here, of art adviser as conveyer of "authenticity" from the remoter areas, Crocker illuminates the practice of selling—where the seller's knowledge is vital to his or her success.

The movement of acrylic paintings into contemporary art, for Crocker, necessarily involved intensifying personal relationships outside of Alice Springs, not just outside of Papunya and Yayayi. This attention to the outside brought him, predictably, into difficulties locally, from Aboriginal people and whites. Whites particularly were often critical of his attention to wealthy patrons or connoisseurs who did not know or embrace the necessary proximities to Aboriginal life that might entitle them to acceptance by the insiders. If, as Daphne Williams later made clear to me, the art cooperatives needed people they could trust to represent them fairly and honestly in the market, such outsiders were conversely eager for just such "authentic Art News." The Melbourne art dealer Gabrielle Pizzi particularly appreciated the experience of working with Daphne Williams, she said, because "she's very sharing," allowing Pizzi to get "closer." Personal knowledge can be important to many in the market. Crocker must have borne many such visitors with sufferance, and some without.

Crocker's attention to the creation of a mature market made him reluctant, or so he said, to allow those in proximity to purchase the better examples of Papunya paintings at lower rates. It also meant attention to promotion, to opportunities

for articles in glossy arts magazines, and to opportunities for exposure at cultural events such as festivals, biennals, and so on (Crocker 1981b, 10), all of which violated the growing construction of a Central Australian inwardness, a boundary against outsiders and the incursion of mainstream commercial values.

Andrew Crocker was an unusual presence in this jealous environment of identification, and how he made his way to Papunya always seemed a little mysterious. Crocker drew more than the usual criticism as an arrival on the Central Australian scene. He had no background in the arts, being an accountant (it was said) by training.

But Crocker had a way of drawing on his connections, just as he saw the marketing of Papunya painting as needing to reach the wealthier tastemakers with whom he tried to hobnob. Some have suspected that Crocker was actually promoting himself through the art adviser job, that he wanted field experience so that he could move up in Survival International, in the particular upper-class-structured world that he found attractive. Indeed, he was said to travel so much that no one could get in contact with him to purchase paintings.

To many in the close world of the Aboriginal scene, therefore, Crocker seemed an interloper. Crocker was not popular either in Central Australia or at the Arts Board. His style of self-presentation was regarded as affectation—not only his colonial-style Bombay bloomers but also his writing. Only Crocker would insist on the circumflexed old-fashioned British spelling of "rôle" in the catalog for Papunya Tula, *Mr. Sandman, Bring Me a Dream* (Crocker 1981a), and his writings reveled in numerous other minor pedanticisms. I well remember the irritation his sarcastic asides and refusals caused among the young Pintupi men who were my friends. Although he had considerable humor, in the context of a relatively egalitarian Central Australia — especially within the community of those who serviced the Aboriginal communities — Crocker's swaggering lack of concern for opinion often made him seem (to Aborigines and whites) too preoccupied with himself, too self-important. These behaviors intimated a capacity for "promotion."

He did have many social connections, and these wider connections were supposed to help the painters economically. His own arguments for occupying this kind of outside perspective less involved with the local scene were cogently made, in writing at least (Crocker 1981a), as essential for the selling of the art. Crocker was fond of the painters, especially of Charley Tjaruru, but in a climate in which identification with the Aboriginal cause was paramount, he was perceived nonetheless as seeming to draw on the prestige of his association with Aboriginal painters as capital in forming relationships with whites.

Whether it was self-promotion in Andrew Crocker's case, I cannot judge. Art

advising—which many in Central Australia have taken up with no real background—can become a springboard for further careers. If people can withstand the pressures, in my experience, such positions bring considerable cultural capital in the form of connections with important people and institutions in more metropolitan settings and continued access and knowledge of remote, local communities. The judgments of advisorial success, therefore, are often subject to dispute.

Crocker claimed to have turned Papunya Tula around financially, for example, when he sold its collection to wealthy industrialist Robert Holmes à Court. And many attribute the growing success of the painting to his insistence on promoting it as contemporary art (V. Johnson 1990a). But others have pointed out that the money from this sale was used in activities more beneficial to his reputation than to the cooperative—that is, in publishing *Mr. Sandman* and in making a trip to the United States with two painters as part of an extended Aboriginal art and dance tour.

Despite his tendency to rub some people the wrong way, Crocker managed to get considerable publicity for the Papunya painters. After he resigned as adviser, he continued to organize exhibitions—not only in Australia but also in England—and pioneered the solo exhibition (Crocker 1987) with a retrospective of his friend Charley Tjaruru's work. Over the years, too, Crocker was very close to Charley Tjaruru, bringing him into the limelight as a painter in Australia and overseas and hosting him at his home in Somerset.

After Crocker's resignation, he was replaced in 1982 by Daphne Williams, who remained art adviser for many years. Williams, again, was very different from her predecessors. A longtime resident of Alice Springs, Williams was a far cry from her cosmopolitan and artsy predecessors. She has been described by some as "cagey," "paranoid" (about the threat of other art cooperatives), and "slightly resentful about other classes of people's behavior" by some of her competitors, but it is widely agreed she has served the cooperative better than any other coordinator. Like Dorothy Bennett, perhaps, another successful woman in the Northern Territory who developed Aboriginal art in the Top End, Daphne Williams brought the skills that come from small business—not the ambition to change the world, to champion underdogs, or to transgress bourgeois norms and cultural politics. Williams has rarely written about Papunya Tula art or its people. But she is an extraordinarily shrewd businesswoman, fiercely loyal to the company and its members, and she has gained enormous respect from most who have dealt with her. Describing her as "a remarkable lady," Dick Kimber called her the key figure over the past twenty years: "Through her integrity the artists have themselves retained integrity" (Kimber 1993, 235).

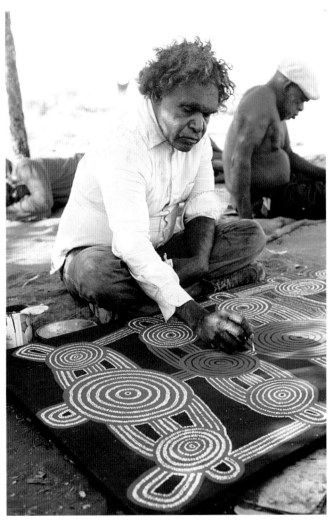

Plate 1. Freddy West Tjakamarra at work on an acrylic painting,
Papunya, N.T., 1981. Photo by Fred Myers.

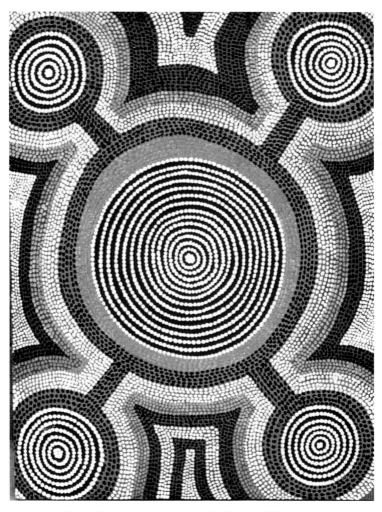

Plate 2. *Kantawarranya*, painting 70, by Yanyatjarri Tjakamarra.
Copyright courtesy Aboriginal Artists Agency Ltd., Sydney, Australia.
Photo by Fred Myers.

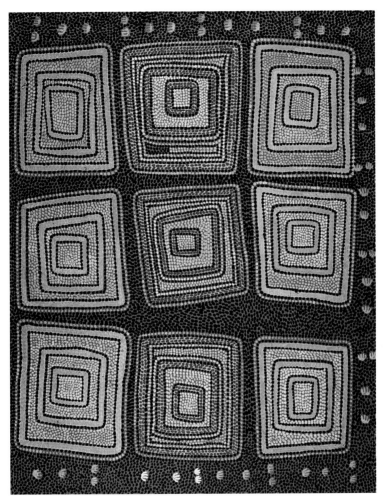

Plate 3. *Yiitjurunya*, painting 153, by Yanyatjarri Tjakamarra.
Copyright courtesy Aboriginal Artists Agency Ltd., Sydney, Australia.
Photo by Matt Kelso.

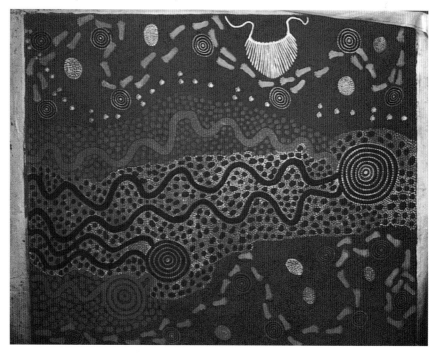

Plate 4. *Tjunti, Big Map of Country*, painting 259, by Yanyatjarri Tjakamarra.
Copyright courtesy Aboriginal Artists Agency Ltd., Sydney, Australia.
Photo by Fred Myers.

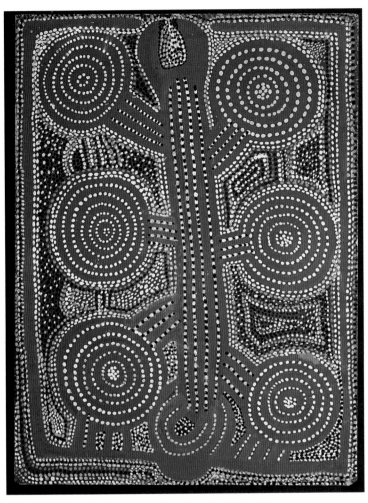

Plate 5. *Tjurrpungkunytjanya*, by Charley Tjaruru.
Copyright courtesy Aboriginal Artists Agency Ltd., Sydney, Australia
and permission from John W. Kluge. Photo by Fred Myers.

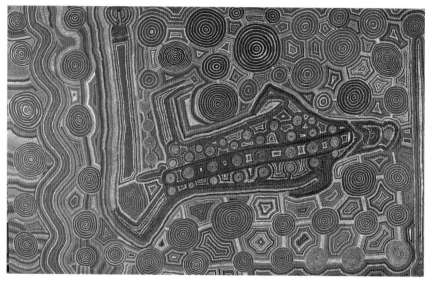

Plate 6. Wuta Wuta Tjangala's masterpiece *Yumari 1981*.
With permission of the National Museum of Australia. Copyright courtesy
Aboriginal Artists Agency Ltd., Sydney, Australia.

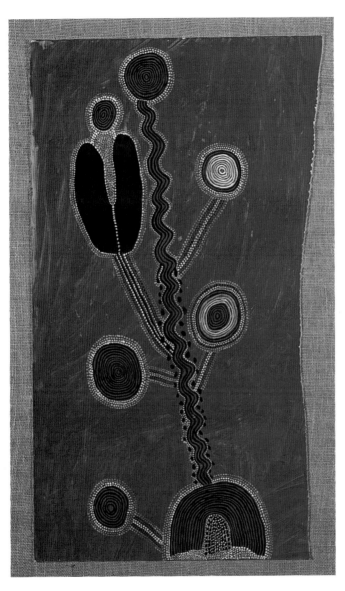

Plate 7. Wuta Wuta Tjangala, *Old Man Dreaming at Yumari*. 1973.
With permission of the private collection of John W. Kluge.
Copyright courtesy Aboriginal Artists Agency Ltd., Sydney, Australia.

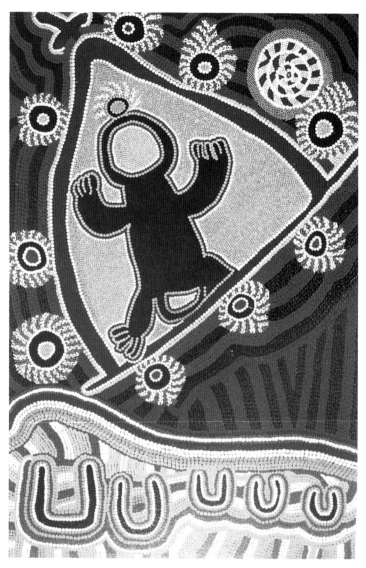

Plate 8. Linda Syddick, *ET*. 1991. 2002 Artists Rights Societye (ARS), New York/VI$COPY, Sydney. Photo by Fred Myers.

In overseeing the rising success of Papunya Tula, however, Williams has faced some different structures: working between and among different dealers, government and private, and fending off the predatory incursions of a market increasingly greedy to skim off the best of Papunya Tula's painters and leave the cooperative behind. A curator in Sydney described her in 1991: "She's a good trooper," Ace Bourke told me, praising her loyalty to the community. At the same time, he noted how well she had negotiated the sales of Papunya Tula paintings, first through an exclusive arrangement with Anthony Wallis, when he ran Aboriginal Arts Australia, and later in her special relationship with Gabrielle Pizzi in Melbourne: "Isn't she clever? She sort of manipulated both Anthony Wallis *and* Gabrielle Pizzi. She's very smart."

Bourke, as a curator, understood the power an adviser might have in controlling access to important painters, or — as dealers called it — "product": "Well, she's got the artists . . . I suppose she's operating from a powerful position." And he praised her acuity in keeping the flow of good painting, the marketing that sustains the distinctions of quality between "fine art" and "tourist work" — between "high" and "low":

> She's very good though at the marketing, the production; trying to keep it down rather than rest people that aren't painting well. So that's why the hyenas that circle the art world are a worry to her, because they're, like, encouraging [bad work] . . . I mean she's trying to rest painters if their work hasn't been good enough. She does have a vision and a plan and it works. And then the way she categorizes [work] and class A goes off to Gabrielle in New York and class B stays in the shop in Alice Springs. She's very good. (Bourke 1991)

Williams did not begin with these connections. If Crocker was seen as an outsider to the local scene, Williams was resolutely local. She had worked for several years in the mid-1970s at the Centre for Aboriginal Arts and Craftsmen, where she managed the front gallery, dealing with the tourist public and sales. Later she moved to Papunya, where she worked for the Village Council for a short time before becoming art adviser. In her first years at Papunya Tula, there was doubt about her capacity to do the job. The usual complaints against art advisers were raised by painters who felt displaced in the transition, and in the jealous world of Aboriginal art, her style drew criticism. Andrew Crocker, who had helped her get the position initially, wrote a critical report — which Dick Kimber, another predecessor, diplomatically questioned. Crocker mentioned complaints about Williams's unwillingness to make her house open to the painters, her inability to undertake long

bush trips, and her complaints ("earfuls") to the painters about their behavior. All this was no doubt partly true, as Williams had a very different style of relationship, with her eye on the business and the long term rather than the adventure of art advising.

Williams seems to have become integrated responsibly and personally within the community in a thoroughly nonideological fashion. For example, she adopted a neglected Aboriginal boy, Francis, and maintained a close connection with his Aboriginal family, taking bush trips with him and his family and consulting them on appropriate matters. When I have met her on my many visits, she has never failed to fill me in on people's lives, whether we are in Alice Springs or Warlungurru. She remembered that "Freddy [West] had lost young Dixon" (his son, who was shot). A troubled boy who took to petrol sniffing, Dixon had no end of troubles. But, said Daphne, "I always loved Dixon, I just felt so sorry for the kid. I used to go and drag him out from behind the bushes, with all his petrol tins and make him help do the priming. I was really upset when Dixon died" (D. Williams 1991).

Williams speaks of Aboriginal children in exactly the same tone that she does of her own, and this has been the mode of her relationships to the painters and their families, the relationship of neighbors in a small town. Appearing to ignore the cultural difference that is often exoticized, her small-town style can fool the cosmopolitan eye.

Williams has been reluctant to undertake many promotional journeys, possibly because she was not confident about her relationships to cultural institutions, but also significantly because she feared draining the Company's funds for her own glory. She did not accompany Papunya Tula's painters to New York for the Asia Society exhibition but left the cultural capital and exposure of such an opportunity to others. Crocker wondered if this style would be successful, especially Williams's lack of interest in traveling. She wasn't sure whether touring trips, popular with the cooperatives in the late 1980s and 1990s, sold many paintings: "We never did a lot of them. We did some, but I guess usually we only did if people wanting them to go put up the money. Because we could only afford it rarely."

If someone should travel, she was inclined for it to be the artists: "I sort of feel that we shouldn't do too much of that, because there are other things that need to come. . . . See, we've got artists like Pansy and Michael Nelson, people who can travel on their own" (D. Williams 1991).

Williams is extraordinarily perceptive and attentive to the business, however. This presents itself as a difficulty because of the remoteness of Alice Springs from those who would buy or mediate the sale of the art. It would be best to sell directly,

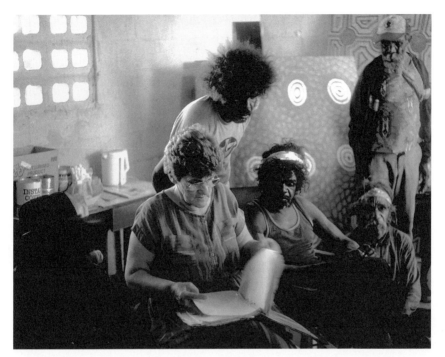

Papunya Tula Art coordinator Daphne Williams collecting documentation for the paintings, initial point of purchase at painters' shed, Warlungurru (Kintore), 1988. Photo by Fred Myers.

of course, because the Company would regain the money for paintings it laid out to the painters. Visits from dealers from down South did not always inspire her to the immediate action I might have expected, until I learned that "they've had difficulty paying us" or that "they only buy a few paintings."

At the same time, an adviser's allegiance to her community's interests can evoke negative judgments from those bruised by the competition. In 1991, another dealer down South, clearly frustrated at trying to get access to paintings to sell "down here, so far away," complained that Williams didn't understand what good art was. "Daphne has no arts background, no eye," she said. "She probably doesn't know the difference between a Braque, Picasso, Miro." Williams would tell her someone's work wasn't very good, such as Charley Tjaruru's recent paintings, whose "rough work" she loves — and wouldn't sell them to her: "They were so wonderful. We were down on our knees with votive offerings. I could sell one every day," she told me.

This jealousy and criticism is the other side of the coin of the art adviser's dilemma. Dealers complain of the difficulty of access, the secrecy about what is avail-

able, the sense of paintings being held back from them—what Crocker called "authentic Art News from the Outback." Dealers need art advisers who can recognize what they want and like.

Williams understands cogently how the money angle works in relation to quality. Under her direction, Papunya Tula did well, clearing out its older stock. She realized that a dealer who was selling in the United States, Howard Rower (see chapter 11), was "not buying first-class stock. He negotiated a price. There's some quite good paintings in there and some that are pretty terrible. He said he's got a basement area where he wouldn't display the best. . . . He'll cover his money. Probably double it, because some of the paintings are quite good. Some of his paintings, though, have been around for years" (D. Williams 1991).

A short visit with Daphne Williams can teach anyone about the stresses of art advising. At any moment during such conversations, the phone might ring, or a visitor might come to the door, interrupting. As she turns back from the phone, Daphne tells me she has had a call from the Warlungurru Council Chairman. "His son is trying to pressure me into paying his airfare to Ayers Rock. He's married to a girl from down there."

"I guess this is why most art coordinators don't last long," I say.

"He puts so much pressure on me. . . . Now if you have an argument with someone like Timmy [Payungu], it upsets you so much that you get a bit tearful. Johnny pushes so much that you can't stand it."

Williams seems to place herself very differently from many other advisers, and in the maturing years of the Aboriginal art market, she has protected Papunya Tula against incursions by work from other cooperatives and by what Ace Bourke called "the hyenas of the art world." She also struggles with tendencies within the communities that threaten the cooperative's survival, such as the impulse to increase the number of paintings and artists. Daphne Williams educates the painters about the realities of the market that Crocker argued was essential, but she clearly does so in her own, nonbombastic manner:

> We've scaled down a bit on the people who aren't shareholders whose works were just not worth. . . . But the pressure to let them paint is coming from relatives who didn't want to have to give them a bit of money when they sold their [own] paintings. That's really what it is. You have Freddy West [a shareholder painter] with someone, saying, "You've got to let him paint. Mainly if he's getting his own painting money, he's not going to hassle Freddy when he sells *his* paintings. Then, I've started this business that they can still paint if you want them to, but it means that *you'll* have to pay.

Loyalty from the newer artists is a problem, even undermining the ability to get work for an exhibition. The problem is that Williams was not necessarily on the spot when the paintings were done. She acknowledges that "people say perhaps we should be out here all the time. We'd never survive, actually, being out here all the time. The pressure . . . it'd be the end of me." I asked her about Warlukurlangu, the Warlpiri cooperative, whose art adviser resides in Yuendumu, noting that the advisers there don't seem to last as long as she had. Ignoring my comment about the rate of resignations, Daphne contrasted their payment scheme: "They don't pay up front. It's much easier for them. If we didn't pay up front, we'd have much more money. You count up the money to see if there's enough for the next trip out. You know, it's only been a couple of years the whole time I've been on the job where we haven't sort of been hoping that check would come in before. . . ."

Margaret Carnegie, a wealthy patron of the arts and well-connected figure in Australia, successfully proposed Williams for an Order of the British Empire, but Williams modestly has no ambition for herself beyond what she has accomplished for Papunya Tula. Nor has she adopted her relationship with Aborigines as a basis for legitimacy and cultural capital that can be exchanged "down South." Working as art adviser has not been part of a larger plan, a career trajectory on which it would become a point of development.

Helping and Being: Changes in the Land

Art advisers, "working for the Aboriginal people," especially in the wake of self-determination, were expected to help in the multiplex ways consonant with the values of personhood one could anticipate in kin-based relations. At the same time, especially in the 1970s and early 1980s, the industry was structurally incoherent in comparison to public service occupations. What future might there be for art coordinators, subject to threats of dismissal by disappointed or disgruntled Aboriginal employers? Indeed, what career trajectory is there for those who gain knowledge and experience of local Aboriginal cultures and art in the difficult circumstances of community life should they choose to move on?

The younger art advisers in more recent years in Central Australia often come with a bit more professional background, and possibly they are less engaged in the sacrificial practices that seem to have defined the earlier generation. They are extremely conscious of the job's structural components. Geraldine Tyson, recently coordinator at Warlukurlangu (Yuendumu) Artists, was a fine arts graduate from Queensland and clearly knows the art scene in the cities. When I spoke with her in 1994, the job of art adviser, she told me, "involves everything from meeting

Boutros-Gali to distributing blankets for welfare, to making tea for old men, to taking people out for bush tucker." It is exhausting, making for eighty-hour weeks. Tyson herself used to work at private galleries, but, she said, a lot of that experience was useless at Yuendumu.

More and more of the advisers do have some arts experience, but it does not necessarily lead to a trajectory integrated within the art world. The attention an adviser gets down South may not come to much in the long run. Tyson thought that for some art advisers, there is "clearly a desire to find the kudos that come from being the go-between to artists, from having this knowledge, curating in a way." But it is not part of the *real* art scene, in her view, not part of advancing in that world: "One is out of the gossip, not able to go to the cafés and parties, where information and stuff circulates. In that world, one is something of a resource, but not *in* it."

The question of "why do it?" might be "who does it?" The arts coordinators are still a varied lot. It is too simple to accept the usual explanation of white people working in Aboriginal communities as being misfits, malcontents, and do-gooders. Some might be considered, as one commentator suggested, as "wounded" persons—persons for whom acceptance or recognition by Aborigines could be especially meaningful or for whom a measure of personal esteem can be recuperated from mediating Aboriginal values and knowledge. It is not as if those involved in the Aboriginal arts and crafts industry do not themselves give a lot of thought to these motivations. A friend I interviewed

> stressed the way in which the earlier art advisers were too caught up in what he called "the angst of it all," in their relations to Aborigines and the daily demands and tribulations. This was, he thought, not surprising, given that they could be fired in a moment. [The interviewee] was very interested in "how the advisers get involved in identification with Aborigines, how they are 'manipulated'" by them, which he thinks is only human nature. "They admire these men, their knowledge of ritual and country," and so on. (field notes, 1996)

This interviewee was inclined to see a kind of joint selection taking place in the mutual regard, almost a synergy between dimensions of Euro-Australian and Aboriginal cultural forms. He understood the relationships each adviser formed— Geoff Bardon with Tim Leura, Peter Fannin with Kaapa Tjampitjinpa, John Kean with Eddie Etiminja, Andrew Crocker with Charley Tjaruru, and so on. The particular relationships, he thought, evidenced a kind of interest in what he called "spiritual" or "religious experience" that is common among the art advisers. Such a term, for him, indicated not so much religion as generally understood, but rather

"the admiration, the knowledge, the acceptance." Such experience or connection, I noted him to say, "would be 'spiritual' for an Australian" (field notes, 1996).

For Peter Fannin, the personal sacrifice was justified by the importance of the nonmaterialistic culture of the Aborigines, which should be of importance to the larger society, accompanied by a sense of their undervaluation. At another level, for Fannin as for many of the subsequent art coordinators at Papunya, there was a complex attraction involving one's acceptance by the Aboriginal artists and the identity provided as their representative to significant government and art world persons.

This identity has a certain instability, however, founded on the need for "love" or attachment from the Aboriginal, which is both psychologically and politically the sine qua non of a white person's legitimacy and the Achilles' heel of advising. Thus it was a tragic moment for Fannin when the incommensurability of his position came face-to-face with that of the Aboriginal. Peter had recovered from a first incident of rolling his car over on the dirt track, had gone back to work too early, rolled his vehicle in a road accident, and spent all his money (his own savings, given out as payments to the painters in lieu of outside support). When Dick Kimber saw Fannin on "his second recovery," he told me years later,

> [Peter] said he saw Kaapa [the Papunya painter with whom he was closest], and Kaapa said something like, "That's all right, we'll get another one [i.e., another whitefella]." And that devastated him. That devastated him because he put his life into that, you know, and so he was just another discarded whitefella—which is reality when you look at the history of Papunya or any other community. White guys come and go. It doesn't matter; if someone goes, someone else *does* come, you know. So that was reality, but it hurt poor Peter greatly and he never had anything more to do [with the art]. (Kimber 1991)

It is within the intercultural social space of these strong and motivating personal relations and the powerful and continuing Aboriginal demands that art advisers must define themselves.

Life in the Bush

Recently it has sometimes just become a "crowd in the bush," but as the pressure for genuine experience of Aboriginal artists increases — as collectors, dealers, and bureaucrats seek to make firsthand contact — so also is there an increase in the friction and struggles over identity. It is clear that amid all the pressures from belonging to an Aboriginal community, the identifications — and desires — surrounding the art

coordinator's membership are powerful, desires that express themselves in claims over the ownership of the Aboriginal, attempts to formulate the relationship in a stable form. Often this assertion of identity is manifested in hostility from those who live *in* communities toward the outside art world. As Felicity "Flick" Wright described this roller coaster when I interviewed her in Adelaide in July 1991, "You know how proprietary whites get about the art. Because people are always sucking up to you, you get to think you're pretty important. That's why I got out. I thought I needed some perspective."

Not only does the outsider, so to speak, threaten to supplant the local adviser's identity (based on association with, and knowledge of, Aboriginal people), but he or she also does so without the sacrifice necessary to transform one's identity. From this point of view, the collector's or dealer's claims about the source and foundation of Aboriginal painting often seems hilariously romantic and idealistic, even if the art advisers and other locals cannot themselves adequately give form to the more complex and dialectical realities (of violence and compassion, of dirt and artistry, of identity and alterity) in which Aboriginal culture is formed (von Sturmer 1989). Thus yet another art coordinator told me a singularly illustrative story about a French curator whose visit to Yuendumu was "very disappointing" because the dirt and squalid conditions the curator found did not square with her expectations of "spirituality."

Advisers complain, sometimes with contempt, about those "who don't even know how to live in the bush," and their feelings often extend, as well, to those of an "artistic" type whose aesthetic appreciation is regarded as a kind of appropriation that attempts to remove the painting from its place in the bush. It is too easy for them. The opposition can even include Aboriginal bureaucrats, constructed discursively as unconnected to the bush, as in complaints about Lin Onus, a famous Aboriginal artist from Victoria and then chair of the Aboriginal Arts Committee. Discussions of "us" and "them," space and identity, appear in stories that art advisers tell about powerful people with whom they engage. Notice that art coordinators, apparently, can be on a first-name basis with figures of national prominence, so that a complex identity of affiliation and sacrifice is produced in such narratives:

> Lin came on a big tour to central Australia, when was it? The end of '89? We'd seen nobody from the Australia Council come through ever before. I don't think anybody had visited. They fund you, you know, and they haven't got a clue what it's like in the bush. Lin came through on a "fact-finding" mission, to find out the "right" and "wrongs" that had been going on. And it was just wild. He sat there and he said things like "Oh, it's shameful that you're

working out of these conditions, and that there's this and this and this." And "we should fix this and this and that . . ." And he went off, and they had said, "Yes, we're giving you some scrub." But no money had come in to the bank.

And this was, maybe in October when he arrived in the community, for this amazing "fix-up" situation of everything. By the end of December, when I was due to go out for holidays, we still hadn't received that check from the Australia Council. He had promised to go back and find out what had happened to it and get it processed and sent off to us. And I'm ringing him up, and he said, "Oh look, I'm really sorry! I was having my own exhibition and I forgot about it." And I said, "Oh look, that's great Lin, that you've got your own show and things are going well for you. But guess what? We're not eating." (Lennard 1991)

Broadly, the opposition between bush and metropole organizes the art adviser's identity as suffering — "We're out here slogging it out" — to redeem an Australian guilt over the situation of Aboriginal people. The opposition is frequently marked: almost all of the art advisers have stories of promises not kept by whites or outside agencies, and at the same time, the theme of "who cares most about Aborigines" underlies the competition among those who attempt to represent them.

This, by the art adviser's account, is only part of what they endure and face on a daily basis. They do so with a kind of grim humor, full of awareness of human foibles, white and black — of adamant collectors (one "stamping his little feet" for access to desired paintings); of bureaucrats full of goodwill but not really any more in the thick of it; of visitors who would transpose the imaginary painters for the gritty realities of intercultural production and circulation. "You see," Flick Wright told me, "that's the thing about being there, . . . that so often people would come up and project their insanity on to you. You really needed a 'sanity indicator' so that you could plug it in once a day! The arts will do it to you!" (F. Wright 1991).

For art advisers, there is always going to be conflict, with the people one represents as well as with those outside the community. A delicate balancing act at best allows them to maintain equilibrium. But in the end, their own emphasis is on their relationship with the painters. One cannot, obviously, like everything about people, Aboriginal or otherwise. It is a hard life out there. My own view, informed by sensibilities established in remote communities, is that the people who get along with the painters are those who enjoy the humor Yarnangu bring to everyday life, who appreciate their ability to tolerate hardship, and who take pleasure in the way they move through the landscape. And those who have a sense of humor. Life is pretty funny out there, one way or another.

6 The "Industry": Exhibition Success and Economic Rationalization

Curators from Australia's museums of natural and scientific history take note: currently at the Art Gallery of South Australia is an exhibition that questions whether it is now appropriate for science-based museums to hold key ethnographic items or collections. At issue is the dividing line, already shaky in the extreme, between what are worthy ethnographic items worthy of scientific study and classification and those that are by any measure, works of fine art. —Peter Ward, "Aboriginal Art: A Crucial Perspective"

The period beginning in 1981 was one in which the discourse of economic rationalization came to dominate the framing and structure of the industry of Aboriginal arts and crafts, while exhibition success marked a change in the fortunes of Papunya Tula Artists. Commoditization—and commercialization—was both the threat and promise of the Aboriginal arts and crafts industry and the cultural policies that underwrote its existence. Through a combination of state support for a cultural formation that was "good" for the state and economic processes that further transformed the new commodity, in this period Aboriginal art became a new social fact. In the broadest perspective, the shifting formulation of Aboriginal arts—between bureaucratically relevant categories such as "enterprise," "cultural renewal," or relatedly "social welfare activity" (generating community esteem)—should be seen as the intersection of different technologies of intervention into Aboriginal life. This involves tracing not only changing discourse and cultural policy but also the changing formulations of Aboriginal acrylic painting as it became subject to different relationships to the Australian state and groupings of people within the nation.

In this reorganization, different sectors of Aboriginal people also struggled to have their views prevail. The issues of commercialization, artistic individualization, and a framing of their activity as "art" brought Aboriginal activists, the Australia Council for the Arts, and those concerned with community production into

conflict. The influential Aboriginal activist Gary Foley, who became the head of the Aboriginal Arts Board, not only held but publicly proclaimed "deep reservations about the Aboriginal arts and crafts industry and about growth in the number of exhibitions of Aboriginal art" (B. Wright 1984a). Foley's position was said to involve "a deep dislike for capitalist free enterprise society and its exploitation of art, regarding it as intrinsically anti-Aboriginal" (ibid.).

Foley had other agendas as well, since he was struggling to bring about Aboriginalization of the Aboriginal Arts Board, and this conflict demonstrated the conflict between Aboriginal values and those that might be promoted by the marketplace. Foley was opposed within the Australia Council by its chairman, Dr. Timothy Pascoe. Director of the study discussed in chapter 4, Pascoe wanted to keep Aboriginal arts *within* the province of the Australia Council, because, he said, Aboriginal art has "so much to offer us Westerners." These were not grounds likely to appeal to those asserting Aboriginal autonomy and fuller frameworks of indigenous sovereignty. Nor would his inclination toward individual volition and artistic individuality appeal: "I think in the final analysis it's really up to individual artists to make a conscious and informed decision for themselves."

Indeed, Pascoe was the champion of reorganizing the governmental subsidy of these activities to rationalize commercial success, a position he shared with the minister of Aboriginal Affairs, Clyde Holding. Quite apart from Foley's resistance, others perceived Pascoe's proposal to be threatening to the interests of local communities. Natascha McNamara, the Aboriginal woman who headed Aboriginal Arts and Crafts at the time, strongly disagreed with the reorganization of subsidies and the intensification of an "enterprise" (i.e., principally economic) strategy away from one aimed more at cultural maintenance. Reportedly, her politics were grounded in a distinctive identification with the complex needs of communities, rather than the abstractions of centralization. She feared the overemphasis on individual artists and commercialization that would result (B. Wright 1984b).

While these examples of Aboriginal political activism failed within the confines of the arts and crafts industry itself, they represent a larger changing role of Aboriginal activism that was being felt in Australia's national consciousness. This was occurring at just the time when the nation's economic resources were declining and the government was turning toward an emphasis on enterprise and economic rationalization.

This next period in the acrylic painting phenomenon (1981–1989) is one that I identify as central to new formations of national consciousness. During this time, acrylic painting began to receive legitimation through substantial purchases by

prestigious Australian cultural institutions, but the balancing act of economic and cultural value that existed previously (see chapter 4) was an unstable one. As emphasis turned toward Aboriginal employment and what came to be called "the arts and crafts industry" (Altman, McGuigan, and Yu 1989), increasing scrutiny was given to budgets for Aboriginal Affairs, under the rubric of "enterprise." While advisers sought grants to support painting and other craft activities from whatever programs they could identify, these were lodged principally in policies aimed at employment and development. This management orientation and the consequent studies—also responding to concerns about the supposedly wasteful uses of these budgets by increasingly assertive Aboriginal actors—intensified the contradictions among ways of evaluating the worth of Aboriginal acrylics. Focusing on remuneration, the enterprise framework fundamentally contradicted any notions of Aboriginal arts as comprising a domain of cultural autonomy and regarded the Aboriginal painter as a kind of worker or (poor) citizen like any other. Yet (as we shall see) the problem of autonomy—as "cultural authenticity"—could not really be suppressed as part of the value of paintings.

The structure through which work moved in the 1970s involved the local cooperatives and the arts coordinators, the Aboriginal Arts Board, and Aboriginal Arts and Crafts. Money and problems of sale were the major difficulties, and it seems as if the enterprise was kept afloat by the exhibitions organized around the world involving the Aboriginal Arts Board. Among these were the Peter Stuyvesant Collection exhibition, *Art of Aboriginal Australia,* in Toronto as part of the World Craft Conference (1974); another curated by Anthony Wallis for the Second World Black Festival of Arts in Lagos (1977); The Australian National University and College Tour of *Art of the Western Desert* (1975–1980); the *Washington Expo '74* in Spokane; *Art of the First Australians* (1976–1978), which toured U.S. cities; an exhibition, *Paintings by the Central and Western Desert Aborigines,* at the Realities Gallery in Melbourne (1977); and a contemporary Australian landscape exhibition, curated by Bernice Murphy, sent to Indonesia in 1978.

In the 1980s, government policy toward arts and crafts was increasingly formulated in treatments of this domain as an industry more than an activity of cultural preservation. There was simultaneously the emergence of a familiar sort of cultural hierarchy, a more structured art world for one tier of the industry's products—with the increase of public, journalistic attention, a growth in institutional recognition and acquisition, and an expansion of retail galleries, collecting, and curatorship.

The movement toward economic rationalization in Aboriginal arts and crafts was overdetermined. Overall, the Australian government under the Labor Party

PAPUNYA TULA ARTISTS AND THE ABORIGINAL ARTISTS AGENCY
WITH THE FESTIVAL OF SYDNEY PRESENT...

ABORIGINAL SAND PAINTINGS
OF THE WESTERN DESERT

IN THE GROUNDS OF
S. H. ERVIN GALLERY
OBSERVATORY HILL SOUTH END OF THE HARBOUR BRIDGE
JANUARY 7th - 11th

Exhibition poster from
Sydney ground painting
at the S. H. Ervin Gallery,
1981.

leadership successively of Bob Hawke and then Paul Keating—corporatist in ori-
entation (Alomes 1988) and given to managed consensus for the economy—was
trying to remove government from enterprises. The 1980s were characterized by
the growth of marketing surveys and government policies that emphasized Ab-
original employment and the arts and crafts industry as keys to Aboriginal devel-
opment (Altman, McGuigan, and Yu 1989; Peterson 1983), on the one hand, and
to a greater accountability of the tax dollar, on the other hand. This trajectory not
only diverged from the cultural critique model of appreciation expressed in art
adviser Peter Fannin's comments about nonmaterialist culture; it also threatened
the complex policies of cultural preservation initiated by Bob Edwards and under-
taken by the Aboriginal Arts Board—whose support had declined appreciably by
1986. Such changes mark a shift in Australian national political discourse away
from cultural maintenance and toward economic rationalization and enterprise
accounting.

Especially after 1985, discussions and evaluations of Aboriginal arts and crafts
followed economic discourses. These changing constructions—a term I use to
index their historicity—define or shape understandings of Aboriginal cultural
production in interesting ways. Among the main concerns identified for the "in-
dustry" have been the "stability of the stream of production" and the "effect of

marketing on quality." In studies made to investigate these effects, art "products" have been differentiated into categories of commodities that reflect the mediation of the market formed through Western consumer categories and Aboriginal intentions. Clearly, such categorical differentiations also entered into the practices of marketing.

The Pascoe Study

The 1981 Pascoe study, *Improving Focus and Efficiency in the Marketing of Aboriginal Artefacts,* really ushered in the new era. Commissioned by the Australia Council (overseeing the Aboriginal Arts Board), the study was particularly concerned with the relationship between commercial activity and cultural integrity but took a strongly economic orientation and produced a special kind of knowledge of the circulation of Aboriginal products as an industry. To understand its effect, it is useful to explore the way in which this study mediated the relationship between conflicting regimes of value.

The study identified and evaluated different effects for different kinds of products. For example, it found that a few kinds of products sold by AACP made up a disproportionate share of the total production and sales. "Paperbark landscapes," "small bark paintings," "small carvings," and "boomerangs" were 80 percent of the items sold and 40 percent of the sales value. Thus such items — of low economic and cultural value (for the Aborigines) — were the dominant product groups. This suggested a strong market orientation in Aboriginal production, rather than a production emanating from routinized tradition. Other components of the study also suggested that Aboriginal economic need was the strongest spur to production: more production came from communities that had fewer alternative sources of income support. The worry was that such an orientation to the market in selling artifacts would lead to a tendency to produce small souvenirs and to a deterioration in quality. In other words, would such commercial engagement undermine traditional skills and orientations? On the other hand, the report argued, because "quality items" gained a better hourly rate, the effect of this pattern of remuneration was actually positive on valuing skills and did not destroy the "artistic system." Thus commercial activity was *not* deleterious to maintaining the standards of Aboriginal cultural integrity (Pascoe 1981, 16).

Despite its mediation of economic and cultural regimes of value, the study seems to have paved the way for a different approach in cultural policy — the shifting formulation already mentioned between bureaucratically relevant categories such as enterprise, cultural renewal, and social welfare activity. Yet there is no doubt that the discourse of economic rationalization was ascendant, subsuming

other forms of value within its own. Rather than bemoan such a discursive shift, we need to understand the process through which forms of Aboriginal material culture become commodities as one in which their properties enter into a process of symbolic transformation.

Marketing Surveys as Forms of Cultural Practice

The circulation of Aboriginal material culture is a varied phenomenon, with distinct streams — "product classifications" — through which objects move. Recognizing that different classes of objects have different sorts of value and properties for consumption, marketing surveys are forms of cultural practice that both represent and transform the social phenomenon of intercultural circulation. Such surveys rely on existing implicit notions of value in delineating their versions of what Arjun Appadurai (1986) called "the social life of things," as these classes of objects have different sorts of value.

The original four categories of objects recognized by Aboriginal Arts and Crafts, for example, were arranged in terms of the notion of value inscribed in a theory of cultural change as one-directional acculturation. The categories "traditional," "transitional," "adapted," and "market" marked an inexorable Westernization. Borrowing from Nelson Graburn (1976), the 1981 marketing survey adjusted these frameworks to clarify how the streams of objects might be differentiated according to the intersection of two other axes of value, representing respectively considerations of Aboriginal cultural value and of Western aesthetic value. "As a basis for marketing analysis," the study said, "we have found it useful to designate artefacts as having high or low cultural value for Aboriginals and separately as having high or low western aesthetic appeal. Given that artefacts are produced in one culture for sale in another, we feel that it is helpful to make this cross over explicit" (Pascoe 1981, 20). The resulting four-cell matrix that defines types of artifacts (page 190) has a strong resemblance to the matrix James Clifford (1988d) identified for the taxonomy of the Western art-culture system (page 191).

It is interesting to compare the Pascoe diagram with Clifford's diagram of the "art-culture system" (1988d, 224; see also chapter 8 of this volume, with its implication that if "traditional" culture items (high Aboriginal cultural value) become original and singular, they can move into the area of the art-culture system marked off as "art." They can become masterpieces, rather than artifacts, and enter into the economy of the art museum and the art market, rather than the ethnographic museum; or if they become too commercial and reproduced and therefore of "low" Aboriginal cultural value, they become tourist art.

The cells of the marketing diagram on page 191 also delineate for each group

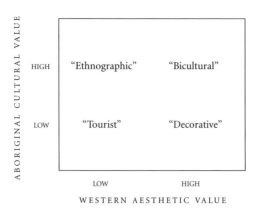

Classes of Aboriginal artifact (after Pascoe 1981, 20).

of objects the "likely customers and therefore the type of marketing needed to reach them" (Pascoe 1981). Such delineations mark off different social biographies. *Ethnographic artifacts* were said to be "of high cultural significance for Aboriginals but crude or unappealing to Westerners." Examples of this category include rare utensils, tools, and sacred items. They were thought to be suitable for "keeping places" (indigenous storehouses or museums), museums, or serious collectors of tribal and primitive material, and to need limited and personal presentation in sales.

The category of *bicultural artifacts,* which include the acrylics, was seen as being "of high cultural value for Aboriginals and aesthetically appealing to non-Aboriginals." Along with acrylics, quality but nonsacred bark paintings and carvings would fit in this class as objects, said—as Clifford might later have concurred—to be "suitable for art collectors as well as museums and collectors of ethnographica." According to the study, works in the category of bicultural artifact needed presentation in specialist commercial gallery surroundings (Pascoe 1981, 21).

Two other categories of object were also delineated in the grid. *Decorative artifacts* were those of "low cultural value for Aboriginals but of high aesthetic appeal for non-Aboriginals," exemplified perhaps by such items as Ernabella batiks or Tiwi silk-screened scarves. These could be relevant for art collectors, but more importantly they would attract people seeking decorative material. Such objects need display in the surroundings of a quality gallery or gift shop.

Finally, *tourist artifacts* would be "of low Aboriginal cultural value and low western aesthetic value." Items such as paperbark landscapes, boab nuts, necklaces,

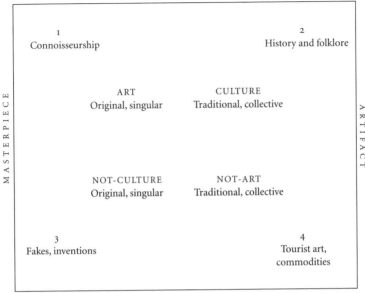

The art-culture system (after Clifford 1988, 224).

and cheap carvings—a large sector of the market—were mainly for purchase by tourists and people giving inexpensive gifts. This kind of work needed a different kind of marketing: "brisk and efficient presentation in inexpensive tourist and gift shops" (Pascoe 1981, 21).

The so-called bicultural artifact was indeed a category of object in which expansion took place. Papunya paintings entered into the category of contemporary Australian art precisely through exhibition and marketing that focused on quality. This identification of the paintings' singularity and originality would appeal to connoisseurship, accomplishing the movement between categories posited by Clifford's understanding of the Western art-culture system. How their content, their Dreamings, entered into such valuation still needs to be considered as a component of their appeal, however. First, I wish to follow the pattern established for them as bicultural artifacts.

In the period already documented in earlier chapters, throughout the late 1970s, demand was slight, and rather than encourage painters, the art advisers felt they had to slow down production, "to put the brakes on." Every now and then there was an order for a big canvas, and the expectations of economic return were high: "They all wanted a motorcar" (Kimber 1991).

Kimber remembered a telling event about how prices were set then, when some of the restraint was lifted. It shows the complicated negotiations in which apparently commercial values were fixed, and it also shows a good deal about the good-humored way one art adviser managed his relationship with the Aboriginal painters:

> I remember that Anitjarri [Yanyatjarri Tjakamarra] painting. All the blokes gathered. Everyone used to do that touching of it,[1] which they don't bother to do now. It was always that real revelation sort of thing. . . . And I said, "All right. I'm gonna make it *your* business. You tell me what you want for the painting." And they all bloody point to Anitjarri, you know . . . and I think they all did appreciate it genuinely. And then someone said, "Anatjarri." He whispered, "Might be thousand dollars." And they're all waiting for me to say, "a thousand fucking dollars!"
>
> And I said, "Do you reckon? Do you reckon a thousand dollars, was it?" And I said, "All right." And they were dumbfounded. I'm sure they were dumbfounded, and I thought, "Right, I've let them establish the rules. So that bloody big painting is a thousand dollars," which was an *extraordinary* sum at that time. (Kimber 1991)

But this was not an ordinary market, in which prices were set by demand, by consumer desire. Kimber immediately followed his remembrance with another, articulating something of the viewpoint of the Yarnangu painters:

> Then, of course, the next thing I remember — there was a painting about *this* [much smaller] size came along about a week later. And Old Walter said, "That might be a thousand dollar, Tjakamarra" [addressing Kimber by his local classification].
>
> I said, "Sorry, but I can't pay the same." And I thought, "Shit, I'm in strife now." And he says, "Same Dreaming; got the same power." You know, the whole notion. I mean, he knew he was pushing. But he was an old bloke. He saw it as the same. We always had tremendous difficulty with this. I mean, basically we sold them on size. (Kimber 1991)

Pascoe's categories did not prevail at the point of production. Part of the appeal of Papunya Tula painting must be that Western aesthetic values did not enter local estimations of worth. A Dreaming was a Dreaming.

At Papunya Tula, the lack of demand described by Kimber continued through the time of John Kean as art adviser (1977–1979) and into Andrew Crocker's time (1979–1981). Some independent collectors began to be interested — such as Tim

and Vivien Johnson (T. Johnson 1990), although many of their purchases were reportedly of inexpensive "finds" they dug out of stocks that were available. Sales in 1979 to 1980 were a mere $A36,000. There were small exhibitions here and there, and a few Papunya artists came to Flinders University as artists in residence, hosted in large part as a consequence of Professor J. V. S. Megaw's scholarly interest (Megaw 1982). In 1979, the Australian Museum (an ethnographic, rather than fine art, venue) in Sydney bought the Papunya Tula Arts Collection, or "permanent collection," as it was known. One might regard the relinquishing of the permanent collection as an act of desperation, but it was believed to be financially critical for bringing Papunya Tula to "an even keel" (D. Williams 1991).

Legitimation Processes: Art or Anthropology?

The process of legitimation began in a significant way in 1980, when the Australian National Gallery in Canberra purchased its first acrylic painting, Mick Wallangkarri Tjakamarra's *Honey Ant Dreaming* (1973). Also in 1980, the South Australian Art Gallery made its first major purchase of a Papunya work (by Clifford Possum Tjapaltjarri, *Man's Love Story* [1987]) and hung it in its display of *contemporary* Australian art, an act of curating by Ron Radford that Vivien Johnson (1996b) regards as particularly significant. In 1981 acrylic paintings were included for the first time in an exhibition with other contemporary Australian art in *Australian Perspecta 1981: A Biennial Survey of Contemporary Australian Art* at the Art Gallery of New South Wales. Curated by Bernice Murphy (1981), the exhibition included some of the larger canvases that painters had been developing in Papunya in the late 1970s, with elaborated ranges of the artists' countries. As Vivien Johnson, the principal historian of Papunya painting, insists, "It was the inclusion of three of these vast compendiums of Western Desert culture . . . (including the 8.3 metre Ancestral Possum Spirit Dreaming [also known as *Napperby Death Spirit Dreaming,* (1980)] by Tim Leura Tjapaltjarri and Clifford Possum Tjapaltjarri) . . . that ended the long denial of Aboriginal art by the Australian art establishment" (1990a, 14). The other Papunya paintings were Clifford Possum and Tim Leura's collaborative *Warlugulong* (1976) — unearthed from an overdue accounting of stock of the Aboriginal Arts Board collection in 1981[2] — and a similarly large painting by four Pintupi men (Freddy West, Charlie Tjapangarti, John Tjakamarra, and Yala Yala Gibbs Tjungurrayi) entitled *Tingarri Story* (V. Johnson 1994, 88).

The timing of these purchases coincides with the very different ideological orientation and style of Andrew Crocker as manager of Papunya Tula. Neither ethnologically oriented nor Australia identified, Crocker sought to turn the enterprise

into one with a sounder business footing. Overall, Johnson attributes the break-through to Crocker, to an orientation that he emphasized. "The new manager," she writes, "had a different attitude towards the paintings from all previous incumbents of the Papunya job. . . . His insistence that the paintings be seen as contemporary art rather than ethnographic artifacts had undoubted effectiveness as a promotional strategy in attracting the art world's attention to works it had previously thought of only in the context of an ethnographic museum" (V. Johnson 1990a).

This was a period in which it is possible to trace a realignment of acrylic painting, along lines sketched by Crocker, as art rather than anthropology. This meant not only less attention to "cultural conservation" (V. Johnson 1994, 79) but also a further scaling down of production and greater attention to "quality" both in materials and execution. His strategy was to secure a niche in the collectors' market for "museum quality" work.

The processes of legitimation for Papunya Tula paintings as works of recognized quality and distinctiveness were well under way in the early 1980s as the pace of museum exhibition increased. Moving out of the ethnographic museum and more regularly into the art gallery context, these exhibitions still frequently included what looked to be an ethnographic component: the presence of Aboriginal painters, providing demonstration of acrylic paintings or—in some cases—of "ground painting." Thus what was described as "an exhibition of sandpainting" took place at the National Gallery of Victoria, in March 1981, with Charley Tjaruru Tjungurrayi and Willie Tjungurrayi chanting and painting. Accompanying them as "company manager," Andrew Crocker told reporters at the event that "he was asked to send painters to do a sand painting at the gallery and to 'promote knowledge of the Aboriginal'" (Melbourne Sun News, 13 March 1981). Not every exhibition was a success, but even in failure, the structure of value into which the paintings were entering can be delineated.

The broader sociohistorical context for this more high art interest has become more discernible now, as part of the growing interest of Australia's artistic avant-garde in its own region. From the late 1970s, when Tim Johnson began to collect inexpensive paintings, to visit Papunya, and to insert himself into the plans to display "traditional sandpainting" in art gallery contexts, there was an emerging concern for cultural convergence (McLean 1998).

Australian artists at this time faced a particular predicament of marginalization as provincial outsiders in the international art world. Indeed, in a kind of high-culture parallel to cultural imperialism generally, the growing influence of an international modernist avant-garde in Australia, emanating from the United States, was a source of anxiety. The anxiety of influence, as it is frequently invoked, threatened to make Australian artists invisible and render them powerless.

Tim Johnson was prominent among the Australian artists who participated eagerly in a reaction against the supposedly international but North America-based formalist modernism. Conceptual art and performance art provided artistically a "series of alternative strategies"—along with "artist-run cooperatives, collective art production, and other art practices that shared a focus on the dematerialization of the art object"—to serve this opposition (Lumby 1994, 18). Australian conceptual art, especially, was rooted not only in a reaction against the commodification of the art object—central to its significance in the United States—but as much in a desire to reply to the perceived cultural imperialism of the American art scene. Thus the critique of modernism was given a distinctively Australian orientation in its adaptation, where it "was linked from the outset to a series of ongoing questions about the nature of nationality, identity and locality" (18). There was an aggressive empowerment in this adaptation, quite in keeping with a certain kind of cultural confidence in Johnson. Terry Smith remembers that "the idea around 1970 was that the main imperative of conceptualism—the fundamental, radical questioning of art itself—could be undertaken anywhere, including here. That is what set up the conditions for the conceptual movement in Australia. We dreamt of an avant-garde which wasn't confined by the international art movements" (T. Smith 1993).

This was a social space in Australia as much as it was an art practice, the alternative space of the radical fringe in Sydney, the ambience Roger Benjamin (1995, 58) describes for Tim Johnson. With an artistic emphasis on ideals of utopian cooperation, the collaborative performance of jazz and rock music, and the models of Aboriginal and Native American cultural tradition, Johnson was part of an Australian art movement in which the shift away from the dream of a universal formalist language was accompanied by a rigorous reconsideration of national, local, and regional cultural forms and traditions (Lumby 1994, 18).

Individually distinctive within a broader field, Johnson's fascination with, and championing of, acrylic painting resonates with the emergence of a new stance. Australians of this period wrestled with a range of influences from the United States, and the manifestations within the arts were perhaps the most articulate of the expressions of a new national identity emerging among the younger elite (D. Thomas 1995, 33).

Thus the Australian artwork of the 1970s combined two sets of questions. The marginal status of Australian artists in relation to the international art world framed a set of questions about identity and culture, but the rapidly changing racial and ethnic composition of Australia's population had also prompted a broader reconsideration of national identity (Hamilton 1990). This process of reconsideration and debate, "in which Australian identity emerges as a process of imagining

what Australia might look like" (Lumby 1994, 22), is the content of such an identity. The artists of this period are singularly concerned with "the interplay of cultural identities" and the "flux of cultural identity," and they explore the process of constructing identity itself.[3]

If Johnson's personal engagement with Papunya painting appears meaningful within this framework, from my perspective, this orientation has a more general bearing on the new interest in Aboriginal painting—and this at a time when "painting" was regarded by many critics as a finished business. The argument that Tim and Vivien Johnson gave Crocker was that the paintings—or some of them—should stay in Australia: that they were noteworthy art. The paintings should go into the collection of contemporary *Australian* art.

Johnson claims to have had influence—as an artist—over curators, but his was not the only sort of influence. The ambience of the avant-garde art scene in Sydney, where Johnson lived, was far different from the rather refined upper-class Spring Street apartments in Melbourne of other collectors such as Beverly and Anthony Knight (owners of the Café Alcaston) or their influential neighbor Margaret Carnegie, but artists such as Johnson have (and can get) cultural capital and influence. Indeed, several of my Australian friends distinguished broadly between the hipper, more yuppie context in which Aboriginal art circulates in Sydney and the wealthier Catholic boarding school patronage offered in Melbourne. Both kinds of Australian collectors came to understand themselves as acknowledging Aboriginal cultural activity and its relevance for the Australian nation. If Margaret Carnegie eventually inserted Aboriginal art into the National Gallery of Victoria, where she was on the board of directors, the Johnsons operated more through the connections forged in contemporary painting and culture, Sydney style. But both found themselves drawn not only to the art but to the producers of it, and they understood the inclusion of this painting as a significant response to the increasingly visible claims of Aboriginal people in Australia.

Publicity for Papunya painting began to accelerate with visits of painters to cosmopolitan venues. Sometimes these activities were carried out in apparent competition with the travels overseas by the arts coordinator. The Papunya-based schoolteacher-poet Billy Marshall-Stoneking—later director of a movie about Nosepeg Tjupurrula—brought Nosepeg, Mick Namararri, and Tutama Tjapangarti to Sydney. His avant-garde cultural connections through literature allowed them to exhibit paintings at a new Sydney venue for art, music, and poetry recital set up by fashion designer, retailer, and cultural philanthropist Elaine Townsend (Neller 1981). The Aboriginal men paid their own fares to Sydney to promote this exhibition, demonstrating their painting techniques to students at the

Sydney College of the Arts and their singing to students at selected high schools. At the same time, they established an enduring profile for Marshall-Stoneking as a cultural broker between Aboriginal and Western artists. The critical response in Sydney, to their presence as much as to their work, emphasized cultural worth and the exotic nature of Aboriginal cultural production (Neller 1981).

The rate of exhibition was intensifying. In Queensland, an exhibition entitled *Aboriginal Art, Past and Present* came from the permanent collections of the Museums and Art Galleries of Northern Territory—the earliest substantial collections of Papunya painting. Designed to tour the South Pacific Art Festival of the previous year, the show had also appeared at the Second Wilderness Congress in Cairns and the Melbourne International Centenary Exhibition.

More publicity, again of a quaintly primitivist sort, came when a painting of Wuta Wuta Tjangala's was presented to the Australiana Fund collection. This fund had been set up in 1976 to raise money for furnishings and works of art to decorate Australia's four official residences. Hardly the kind of work that must have been anticipated when the fund began, the painting's "none-too-subtle sexual" reference to the Yumari story of the Old Man having intercourse with his mother-in-law (see page 115) drew attention in the press when it was accepted by the prime minister's wife (Cazdow 1981).

Unquestionably, the most important event of 1981 was the inclusion of several Papunya paintings in *Australian Perspecta '81*. It should be noted that no single-artist exhibitions were produced, largely in cognizance of Aboriginal values and the art cooperative's policy that refused (as many dealers have complained) to accept the principal categories of collecting and connoisseurship.

By 1982, the paintings were beginning to receive some criticism in art writing. Terence Maloon wrote "of the difficulty of assessing new Aboriginal paintings": they were exhibited in modernist style, in the white-walled interior of a Sydney art gallery, untitled, and "nobody has explained either the artists' intentions or what the paintings are about." Maloon realized the difficulty of assessing these paintings within the criteria of contemporary Western art: "It is curious, then, to see how they survive the dislocation from their present culture and how they adapt from the sunlight of the western desert to the white walls of a Sydney art gallery. For better or for worse, it is the strongest and most beautiful show of abstract paintings I have seen in a long time. But I want to resist dazzlement for a moment and reflect on some of the problems the show raises" (Maloon 1982). Yet the paintings' value lies largely in their answer to the crisis of belief that plagues modern art. Thus, Maloon argued, "The gap between the origination and the unsuccessful reception of the artist's message doesn't ultimately matter. . . . The best art sur-

vives such dislocations. The artist's imaginative investment, his belief, gives the work an energy, an aura, an urgency that can be sensed regardless of his specific meanings."

In 1982 there were publicized demonstrations of painting in Perth and an exhibition at the Georges Gallery in Melbourne (Frater 1982), at which Andrew Crocker expounded lengthily and publicly on the difficulties of his job. Commercial connections and links to tourism's opportunities are evident in the collaboration of government bodies. Opened by the chairman of Qantas Airways, *Art of the Western Desert* was supported by the government-run Aboriginal Artists Agency. Anthony Wallis and Daphne Williams chose twenty-eight paintings for the show, in keeping with Papunya Tula's continued incorporation within the system of government control over marketing. By 1983, however, the contemporary art dealer Gabrielle Pizzi had rented out Roar Studios in Melbourne for a private exhibition.

There were numerous discussions at the time about the "gulf of understanding" between white and Aboriginal, and the translatability of this work (McKay 1982). Crocker emphasized as always the contemporary nature of the painting, but he was quite candid about this gulf, the unanswerable problems of regarding the enterprise in conventional art categories. "It strikes me that we are not entirely certain why these artists choose to paint today," he was reported to say. "We do not know, either, how proximate the paintings are to the original designs or how close to the purpose of the originals . . . we are in a quandary about the desirability of evolution. We are unsure about the desirability of the artists being subjected to substantial cash sums for their paintings. We are particularly unsure about their criteria for assessing the merit of their work" (McKay 1982). In these comments, Crocker was outspoken on what he regarded as an ethnocentric and paternalistic—not to say primitivist—white attitude that insists the art should not change from its traditional base: "These artists are not fossils, they really do have a claim to be contemporary artists in their own right."

Reframing

Museums collect and exhibit; they choose. In choosing some examples and genres over others, they necessarily participate in rankings of value, in the creation of hierarchies and canons. Crocker considered it essential to have "museum quality" paintings as part of his strategy to establish two qualitative tiers of painting within the market, the high-quality works being of considerably more value and distinction than those sold more as tourist mementos.

Such activities of placement have been the subject of outpourings of critical and

scholarly writing about art worlds. It is well understood that recognition by cultural authorities — whether state galleries or significant private collections — legitimates the value of objects and informs others that such objects are distinctive and worthy of preservation. For producers, such placement of their work is critical to success, a demonstration of value to other consumers. Thus artists' biographies always include their exhibitions and collection history as evidence of their value.

Apparently, the movement into the category of fine art also entails an emancipation from possession within the framework of anthropology, where objects might be exhibited not for their own distinctive quality but as part of a broader context in which any painting could indicate a range of activity. Vivien Johnson remembers the transition in her brief history of the movement:

> Only ten years ago, Aboriginal art in Australia seemed firmly relegated to the museums and gift shops. If it found a place in the art galleries, it was somewhere in the vaults with the rest of the "Primitive Art." . . . right through this period, the very qualities of Papunya painting which have since earned it international acclaim as the first art by a tribal people to bridge the gulf between the ethnographic and modern art contexts in western culture caused it to languish in obscurity. . . . Then suddenly, after a decade of rejecting them as an exotic part of the souvenir trade, leading public art galleries and museums in Australia began to collect Papunya paintings in the early '80s — and to hang them in displays of contemporary Australian art. (V. Johnson 1990a, 16)

The movement to fine arts views seems to have required the rejection of anthropological context and ethnographic museum display. The official discourse of aesthetic modernism is, after all, "looking" rather than "knowing." Aboriginal activists, too, preferred their cultures to be exhibited in the same venues as those of European artists — and not among the flora and fauna of Australia.

From Legitimation to Success

From the point of view of sales, however, not much changed until Andrew Crocker sold the twenty-six paintings from the *Mr. Sandman* catalog in 1981 to Western Australian businessman Robert Holmes à Court — for more than $A35,000 (Irving 1983, 4). Kimber maintains that this projection of Papunya Tula's reputation grew out of Crocker's style of marketing:

> It was Holmes à Court buying things that set off the market. You know how it was going, little waves and troughs. In 1978, we hadn't done any better than 1971. It just muddled along.

Andrew Crocker really set it off. He used the phone. . . . He'd call nationally, internationally. He called up Holmes à Court. I reckon that was the key to it. There's the big upmarket bloke. Only Bond and Packer could also have had such an effect. (Kimber 1991)

Although the purchase gave a further push of legitimacy to the movement, Holmes à Court did not pay a large price. This collection then was sent to France, where it was shown at the Australian Embassy in Paris during the celebrated autumn festival of 1983.

It was when Daphne Williams took over as art adviser in 1982 that Papunya Tula's earnings began to grow. Papunya Tula sales went from $A382,595 in 1985–1986 to $A595,168 in 1986–1987 to $A1,050,395 in 1987–1988 (the year leading up to the Australian Bicentennial). This was an extraordinary, unprecedented rate of growth and size of sales, far exceeding that of other art cooperatives. Not only was the work suddenly the subject of enormous publicity, but in fact Papunya Tula's sales were the highest of any art center in Australia. There are obviously a number of facilitating factors for this upsurge—the approaching Australian Bicentennial and the accompanying growth of tourism (Altman, McGuigan, and Yu 1989), for example—since the whole Aboriginal arts and crafts market grew during this period. The placement of acrylic paintings in the category of fine art was critical to that economic success.

During this period, however, there was little activity through private galleries of the sort likely to handle "bicultural artifacts" (Pascoe 1981). Sales to the ordinary tourist market, even with support from AACP, were unable to satisfy the producers' aspirations at Papunya. The 1981 marketing survey shows that less than 5 percent of all sales were of acrylic paintings. During the 1980s Papunya Tula's growth and development was sustained principally through sales of paintings to museums and governmental collections, not through the enterprise of private dealers. Even when private sales began to pick up, a substantial number went to the public sector; until the 1990s there were never many collectors or investors, nor was there a large market for arts and crafts outside the government. The production of the Aboriginal art phenomenon was not a simple case of consumer interest. According to Anthony Wallis, and supported by other materials I have seen, there were never many collectors or investors. When Wallis took over Aboriginal Arts and Crafts (which had been renamed Aboriginal Arts Australia) in 1986, he doubled the sales in just one year from $A1.5 million to $A3 million—mostly from sales to government offices such as the High Court of Australia, the Parliament House art collection and the government-owned Artbank (which rented out art to gov-

ernment offices).[4] Altman, McGuigan, and Yu (1989) reported, correspondingly, that there were few big private collectors, and that the "boom" (of the late 1980s) might be endangered once the major museums and galleries had "caught up" by purchasing collections. The same sort of phenomenon occurred with the boom in sales for the Top End community of Ramangining, which was inflated by the massive purchases of billionaire collector John Kluge, who was buying $A500,000 in a year. As Wallis put it, this was not a "steady stream."

There were some significant secondary sales, of course, such as Margaret Carnegie's highly publicized 1987 sale of Clifford Possum and Tim Leura's *Napperby Death Spirit Dreaming* (1980) to the National Gallery of Victoria for a reported $A150,000. Acquired to mark Australia's Bicentennial, the painting's purchase through the distinguished Felton Bequest Fund marked a significant step. Sales to the public sector (even secondary ones such as Carnegie's) and growing publicity from exhibitions created an impression of a boom, of massive success. Despite the publicity, however, few Australians were really interested in, or knew much about, Aboriginal art, even at the time of the 1993 review of the industry.

Wallis told me of a conversation he had with the director of Blaxson's Gallery, a general art gallery located in a major department store. They were really impressed when they heard he did $A3 million in sales. They'd never actually made *any* profit in ten years (Wallis 1995). Their exhibitions of art were sustained, it seems, to give some class to the overall retail operation. The Blaxson's anecdote indicates a sense of the art market as full of wizardry, a staging through smoke and mirrors. The process by which objects acquire stature and value is amusingly figured in *The Wizard of Oz*, when the dog pulls back a curtain to show the wizard as a little man turning cranks on a machine to create the illusion of power and authority. This is a normal part of art market practice, but this sort of staging was shaped in a particular way because of the inescapable connection of "Aboriginality" to changing formulations of Australianness.

Aboriginality and Australianness

At the same time, therefore, as the pressures toward economic rationalization were being realized in the organization of an arts and crafts industry, another—apparently contradictory—cultural shift was equally noticeable. This involved the increasing formulation of Aboriginal culture as central to a distinctive Australian national imaginary linked to its land and oriented away from its European ancestry or its American "big brother" (Hamilton 1990). Not only did the Australian government need to respond to growing visible Aboriginal protest about inclu-

sion, but the commodification of its tourist market gave Aboriginal art and culture new value.

The combination of these processes is indexed by the widespread acquisition of Aboriginal art for government offices and more explicitly and dramatically in the selection in 1985 of Papunya Tula painter Michael Nelson Tjakamarra's design for the mosaic forecourt at the new Parliament House in Canberra, dedicated on 9 May 1988.[5] "Our Aborigines," as Australians can still be heard to say, remain important to new constructions of Australian national identity in a more general context.

The contexts for this shift were both specific and general. The circumstances of Australia's Bicentennial in 1988 provided both the resources and occasion for renewed cultural production around issues of national identity as Australians were faced with the necessity of staging themselves in public, not only for themselves but also for the large tourist audience expected to visit. Predictably, these stagings became occasions of protest and potential redefinition — as with activist Burnum Burnum's reverse "discovery" of Britain — in which enduring hierarchies of value were contested and became unstable. Aboriginal political activists placed themselves at center stage in the ensuing "debates" by contesting the celebration of "discovery," and many Aboriginal organizations refused funding related to the Bicentennial. Nonetheless the event still supported the exhibition of Aboriginal culture and art on a new scale, allowing it to play a significant role in the context of celebrations of "Australia."

During this period, despite these protests, representations of "the Aboriginal" were also in the general form of a primitivism that has received considerable attention from critics in the arts during the 1980s (especially for the complex role of the "primitive" in constituting the "modern"). These critiques pointed squarely and accurately to motivations for the new national attachment to Aboriginality: to the themes of nostalgia for an organic relation to place, of a tie with a premodern Australia, and also of a specifically Australian modernist interest in the Other, inspired by the Vietnam War's impact in pushing Australians toward the international counterculture (Hamilton 1990; Lattas 1990, 1991, 1992; Myers 1991; T. Miller 1994).

As in the case of Native American culture at important times in the United States, Aboriginal forms have provided Australians with a native, local identity, a means to distinguish themselves from a European colonial past. This transformation was well under way by the late 1970s, and its specific history needs to be rehearsed briefly here as the context for the emerging connections between aesthetics, politics, and economics that valorized Aboriginal acrylic painting as a national object.

It might be useful to step back and place the development of the Aboriginal arts and crafts industry and the ascendance of acrylic paintings in a broader perspective of a shifting Australian cultural imagination and cultural struggle. The question of why Aboriginal painting (and Aboriginal identity) could come to exercise such a hold on Australian national identity is a pressing one, especially since it is clear—both from the surveys of Aboriginal arts and crafts and from the growing political power of immigrant ethnic groups—that Aborigines do not constitute such a valuable subject for even the majority of Australians. Who, then, has developed this formulation of national consciousness, and what does it represent? The sociologist Pierre Bourdieu regards such questions as central to the field of cultural production: "The field of cultural production is the area *par excellence* of clashes between the dominant fractions of the dominant class, who fight there sometimes in person but more often through producers oriented towards defending their ideas and satisfying their 'tastes,' and the dominated fractions who are totally involved in this struggle" (Bourdieu 1993, 102). An account would have to begin with the changing place of "culture" in Australian life following on the 1960s Liberal Party's "culturalist" support for wider tertiary education and the growing number of Australians with advanced education.

In September 1973, shortly after I began my fieldwork and during Papunya Tula's infancy, the Australian government made its costly and controversial purchase of American painter Jackson Pollock's *Blue Poles* for the not-yet-built Australian National Gallery. The consequent social drama marked, according to Lindsay Barrett's 1996 study of "Whitlamism,"[6] Australia's shift outside the ambit of its colonial British heritage and toward cultural allegiance—on the part of Australia's *new* elite, a tertiary-educated administrative class—with a kind of "modernist internationalism" identified with America, an American internationalism. This allegiance began to falter with the economic downturn of the mid-1970s and Australia's detachment from the "American century." As Serge Guilbaut (1983) argued in his landmark study of aesthetics and politics, within the landscape of Cold War politics, abstract expressionism had come to stand for concepts of freedom and freedom of expression, and this defines the significance of *Blue Poles* in Australia. Consonant with the commitments embodied in the Australia Council for the Arts (discussed in chapter 4), Whitlam's government had declared itself obliged to ensure an environment in which human beings could develop their full potential, an environment that included access, in the geographically isolated nation, to what were perceived to be the "Masterpieces of Civilization" (Barrett 1996, 47). *Blue Poles* stood as the government's statement of its cultural maturity, international relevance, and modern outlook (48). The shift in colonial identity, position, and allegiance occurred during a period "in which many of the nation's social and cul-

tural theorists and bureaucrats—from Robin Boyd and Donald Horne to Barry Humphries—were attempting to redefine and/or recreate notions of an 'authentic' Australian identity and sense of being" (48).

Many Australians, however, identified the painting with the abuse of personal freedoms in the old and degenerate centers of Europe and North America—describing the painting as "vomitlike," and "painted by an alcoholic." The purchase of *Blue Poles,* then, delineated a new alliance and new opposition salient in Whitlamism (and central to the emergence of Aboriginal art) between the traditional intellectuals and the new administrative class (a bureaucratic bourgeoisie of public servants, teachers, academics, community workers, culture workers) against the traditional working-class Labor voters, tabloid editors, and conservative politicians. If the long-reigning Liberal Party of Robert Menzies, rooted in the traditional economic elite, had been the support of the conservative Academy of Australian Art (deeply hostile to abstraction in art), Whitlamism as the political expression of the new bureaucratic bourgeoisie—overseers of the resource-based industrial democracy—had a different trajectory as they emerged from the position of what Bourdieu in his study of cultural production calls "the dominated fraction of the dominant group" and moved away from Labor's die-hard traditionalists. This ascendant bourgeoisie legitimated itself through a commitment to extend services to the growing urban areas in the form of new public sector programs. By the 1990s, indeed, the heirs to Whitlamism in the Labor Party had come to view the state as responsible for the well-being and creativity of its subjects.[7]

Yet this moment of modernist internationalism served mainly to validate the significance of art and culture, as the globalizing forces of the international political economy cut Australia loose from an identity as America's junior partner and sent its economy into decline. *Blue Poles,* to speak metonymically, opened up a new aesthetic space (abstraction) that came to be filled with Aboriginal art as its content—in ways reminiscent of the development of the Southwest Indian art market in the United States after World War I. While Australians—and especially Australians of this class—came to embrace the value of human beings developing to their full potential, they discovered that there were masterpieces of civilization at home, allowing Australians to develop their potential without borrowing from others and even to contribute to the whole, thanks to "our Aborigines."

Barrett's delineation of this rising Whitlamist class is suggestive for my purposes here, indicating how a national imaginary might be tied to changing political economies and produced by specific social sectors. Indeed, while Aboriginal art—and Aboriginal identity—gained a place in the Australian national imaginary (Ginsburg 1993a, 1993b; Hamilton 1990), this place appears to have been sustained

by the taste and hegemony not of the working class or the immigrant ethnic groups or the elite of the old squattocracy but of the historically distinctive class fraction of university-educated public servants and bureaucrats who took over the Australian Labor Party. These technocrats are presumably the people into whose offices one-third of Papunya Tula's paintings, purchased by Artbank, went, and whose "cultural" (national) identity is expressed through such appropriation. There is therefore a revealing link between economic rationalization and the cultural re-evaluation of Aboriginal art, a linkage whose compromise formations make the artistic success of acrylic paintings a significant national symbol.

The increasing profile of Western Desert painting coincided with an interest in "ethnic" and non-Western art that has burgeoned over the last decades throughout the West. It is clear that positive critical reception — the critical gaze — from outside secured a sense of value in the enterprise of Aboriginal art and acrylic painting *in* Australia. For example, although he later became a great champion (Crossman 1990), James Mollison (director of the Australian National Gallery, 1977–1989) was completely uninterested in Aboriginal work until 1980.[8] This reception, then, was important for the cultural value assigned to the Aboriginal, as well as to the monetary worth of the paintings.

These sensibilities and imaginings were produced in particular, located social actors — namely, those of the professional managerial class. My evidence for this is more anecdotal and inferential than I would like, although it is implied by Lattas (1990, 1991) as well as Barrett (1996). The results of a 1993 (MacMillan and Godfrey 1993) marketing survey, conducted in several cities, suggested that the new interest in Aboriginal art as part of Australian national culture was not shared by a majority of Australians. The largest part of the market for Aboriginal arts and crafts was in 1993 still overseas customers (travelers and tourists). Only 38 percent of adult Australians had ever bought Aboriginal arts and crafts, including T-shirts. The Australians who did buy were likely to be high-income earners and those with at least some tertiary education; these were also said to be the people most likely to visit displays. And the most popular items were not fine art but rather weapons, clothing, carvings and sculptures in wood, and accessories with Aboriginal designs. Despite the enormous publicity of the 1980s, studies of focus groups found that most Australians had "only a limited experience of Aboriginal people and their arts."

Such information suggests the cultural themes held to be dominant in the formulations of popular Australian intellectuals should be located within a more definite context of ideological struggle — in a specific, globalizing political economy and in the tastes (or identities) of a specific class fraction (Bourdieu 1993) — a frac-

tion that is to be understood as the professional managerial class. These were, it seems to me, those who participated most definitively in the Whitlam "revolution." I think we have seen their brothers and sisters elsewhere—in *The Songlines* (Chatwin 1987), for example, as the quirky whites of the Aboriginal industry, trying to find an Australian identity in these absolutely non-European practices. These were people who, for their own identity, needed to constitute Australia as an authentic cultural space, and they put intellectual energy toward the creation of an authentically Australian culture as "culturally productive." Academic work on popular culture, cultural policy, and Aboriginality has a distinctive and salient profile in Australia. If Australia is unusual in the amount of activity and the recency of its attempt to create a national culture through the state's cultural policy, its intellectuals and managers are deeply engaged with it—in contrast with the relatively more marginal relationship between intellectuals and state practice in the United States.

The managed economy is not, as one might expect, at odds with these new national imaginings; the two are instead deeply connected. Cultural export has played an important role in Australia's self-conception. As Toby Miller has suggested to me, Aboriginal art must be understood as part of what he called "Australian triumphalism," along with Australian cinema, pop music, and live theater. Forms of cultural production that received international recognition, these industries have been supported by government subvention with international marketing boards, and so on. This international recognition is the national form of the Lacanian mirror in which one finds one's identity. What Australians produced for export became a part of themselves.

These sensibilities did not spring from nowhere. They were produced and mediated, because generic interest would not have been enough. I will consider the institutions of this cultural production more fully in subsequent chapters, but it is useful to delineate them briefly here.

The pace of exhibition and review picked up significantly in the late 1980s. Probably the most successful of such occasions was *Dreamings: The Art of Aboriginal Australia* in 1988 (Sutton 1988), produced by the Asia Society Gallery and the South Australian Museum, which spellbound audiences in New York, Chicago, and Los Angeles (and the subject of chapters 8 to 10). The more inclusive 1993 *Aratjara: Art of the First Australians* introduced Aboriginal and Torres Strait Islander art to audiences in England, Germany, and Denmark, while the National Museum of African and Oceanic Art in Paris showed *La Peinture des Aborigènes d'Australie* (Myers 1998). Locally, a number of important exhibitions focused on art from Papunya, including *Dot and Circle: A Retrospective Survey of Aboriginal Acrylic*

Paintings of Central Australia (Maughan and Zimmer 1985), *The Face of the Centre: Papunya Tula Paintings, 1971–1984,* and *East to West: Land in Papunya Tula Painting,* as well as broader surveys of Western Desert art such as *The Inspired Dream: Life as Art in Aboriginal Australia* (West 1988) and *Mythscapes* (J. Ryan 1990). These were accompanied by the rise of solo exhibitions of artists—from Charley Tjaruru and Clifford Possum Tjapaltjarri to Michael Nelson Tjakamarra and Pansy Napangarti. These exemplify the modernist style of exhibition that began to emerge through commercial galleries such as Gallery Gabrielle Pizzi in Melbourne and later Christopher Hodges's gallery, Utopia Art Sydney. This trend was also evident in the Australia-wide galleries of Aboriginal Arts Australia through the efforts of director Anthony Wallis and managers such as Ace Bourke and Gabriella Roy.

Unquestionably, art criticism—the institutional domain in which aesthetic value is appraised—is important (Myers 1994) in providing a basis for discrimination and has both national and international dimensions. Criticism and curatorship have both been necessary for the structure of art selling as a means to establish connoisseurship or "quality control"—knowledge of the range of objects and their relative worth. Exhibitions are the raw material of art critical writing and curatorship, since they provide occasions for its practice by bringing objects into the arena of evaluation. This, of course, was what the Aboriginal Arts Board had been trying to do in organizing cultural performances and selling exhibitions around curated shows.

The Effect of the "Industry"

My emphasis in considering the "middle period" of acrylic painting and the development of the Aboriginal arts and crafts industry has been on the material practices of cultural production, the infrastructures through which an Aboriginal practice and product moves on the way to becoming something like a commodity. The issue has not been the meaning or evaluation of a particular painting but rather the question of how the broader category of Aboriginal fine art is manufactured and sustained as a commodifiable activity.

My claim is twofold. First, I have tried to show that the paintings were subsidized by the state first as a solution to the "Aboriginal problem" and then as an aspect of the production of national identity—which has always struggled to place Aboriginal people in relation to the state through policies and practices ranging from destruction to assimilation to self-determination. Second, the machinery of the state was mobilized to this end by a particular set of agents and the Whitlamist concern with culture. In this view, represented by the class fraction I have elsewhere

called "the Wizards of Oz" (Myers 2001b), Aboriginal culture had been something unassimilable with which they had to deal, but here it could be assimilated—either economically or culturally. My use of the image of the wizard is intended. The agents of this class are involved in the production and circulation of imagery, mobilizing, often to good ends, the tricks of the bureaucratic machinery of Oz (the colloquial term for Australia) to create—as with the mythical Oz of the story—the structures of Australia against an unknown and magical landscape.

From the local Aboriginal perspective around Papunya at least, painting provided something that had value for "Canberra" (the state), something through which they could negotiate a meaning for their presence. They were giving or showing to Canberra images of intrinsic, ontological value, even images that asserted their Aboriginal right of being on the land. While other groups had skills, or labor, and so on, Aborigines had art and land.

Because of the substantial absorption of acrylic production by the government and by galleries in the context of Australia's changing self-definition and the wizardry of its new managers, acrylic painting came to broader attention as a success. It became its own "thing," a social fact, acquiring an aura that combined its economic success, aesthetic recognition, and Aboriginal authenticity. These paintings are somewhere between the pure commodity (value defined in market discriminations) and the Aboriginal artifact (value defined by their use as signs within a community). This Aboriginal presence in them was critical to their value: consumers preferred to "buy direct from makers rather than retailers" and "to buy only genuine, original hand-crafted Aboriginal arts and crafts" (MacMillan and Godfrey 1993). Correspondingly, the meaning or story associated with the items was considered to be an important dimension. The contradiction was heavily borne by the art advisers, who mediated between two systems of value—between the Aboriginal emphasis on the equality of their paintings as all (equally, more or less) representative of the Dreaming and the art market apparatus of aesthetic discrimination.

The discursive effect of the development of an arts and crafts industry is more far-reaching, however. Now that the category of Aboriginal fine art is a social fact, now that the paintings have status as commodities, dealers want to exploit them to their own ends just as the government wants to divest itself of its subsidizing role and subsume Aboriginal art to the economic. As I will try to show, as a signifier, "Aboriginal fine art" is coming to be further separated from its cultural base as the selling of Aboriginal art is increasingly dominated by the structures of the Western art market, in which the need for discrimination and quality control defines the practice of its mediation.

The most recent period in the acrylic painting market might most aptly be characterized by what art adviser to Yuendumu Christine Lennard called "settling out." It has involved an emphasis on connoisseurship, a delineation of a hierarchy among painters, and a movement away from the emphasis on Aboriginality and national identity. This transformation in the discursive formulation of acrylic painting follows on the dismantling of centralized marketing in the 1980s, which resulted not only from conflicts over centralization, spearheaded by arts coordinators, but also from attention to the economic rationality of government subsidies, articulated by the government's own accounting and by private retailers. Both were set in motion, as it were, by overall emphases on rationalization, and they represent a further stage in the social and institutional mediation of cultural and economic value in these objects of material culture. One is following, in these events, the emergence of a specific history of commoditization — a kind of separation of Aboriginal objects from one context in social relations to another.

The Contest over Centralization and Local Control

Despite the positive results of centralized marketing, Aboriginal Arts Australia (AAA) was dismantled in the late 1980s. Then under the control of the Aboriginal Development Commission, AAA came under attack from the arts centers and coordinators in 1987 when minister for Aboriginal Affairs Clyde Holding announced the policy of intensifying centralization of marketing through Aboriginal Arts Australia. With all funding for art centers to be passed through this agency, the proposal was perceived as threatening to the arts coordinators. As Christine Lennard reported,

> 1987 was when the Association of Northern and Central Australian Aboriginal Artists started their action against Aboriginal Arts Australia. They boy-

cotted the Company. The minister for Aboriginal Affairs had suggested that all funding for Aboriginal arts and crafts centers be handled through Aboriginal Arts Australia, and so everybody boycotted the company. They were really pissed off about that! They didn't want it moved from the Australia Council. So there was no dialogue at all between the art centers and the Company. (Lennard 1991)

According to Jon Altman (1988, 53), writing in the catalog to the *Inspired Dream* exhibition, "The Minister's aim was that returns to artists should be increased by such industry restructuring; it was implied that inefficiencies in the industry occurred at community crafts centres" (see also Hewett 1989, 9). Under Holding's proposal, arts and craft centers and their advisers would be controlled and funded by the Aboriginal Development Commission through Aboriginal Arts Australia (ibid.).

The arts coordinators and the Aboriginal art centers, however, represented this proposed centralization as an attack on the autonomy and independence of local Aboriginal communities. They responded in March 1987 by forming the Association of Northern and Central Australian Aboriginal Artists (ANCAAA), meeting at the Northern Territory Museum of Arts and Science in Darwin. In this way, the artists from sixteen communities sought "to protect their collective interests and to assert their right to a decisive say in the marketing and promotion of their art" (Cazdow 1987a). When negotiations broke down over the issue of centralization, a boycott was staged: these communities refused to send their products to Aboriginal Arts Australia. The ban lasted until Holding ceased being minister for Aboriginal Affairs, but by September 1987, the company's galleries in Darwin and Melbourne had closed. From this dispute, and other unsettling developments in Aboriginal arts and crafts, a parliamentary review of the Aboriginal arts and crafts industry was commissioned by the new minister for Aboriginal Affairs, Gerry Hand.

The art market for the Aboriginal arts and crafts industry is not a monolithic system. Its momentary integrations have to be understood as complex mediations of internal contradictions. At issue is not so much a naturally occurring art market but the cultural organization of economics, what Altman (1988) called "the economic basis of cultural reproduction." In following the history of this conflict, we may better understand what stakes were involved, who the different parties were, and how they came to interpret the events in the way they did.

The conflict between local Aboriginal communities and AAA involved a complex framework of competing and intersecting interests and values, and a structure of politics that has an uncomfortable history in a period in which Aboriginaliza-

tion as a formulation of the long-standing policy of self-determination papered over significant differences among different Aboriginal histories and interests. According to Altman, the problem of centralization crystallized a more particular threat: the producers and their representatives believed that the arts and crafts industry was "in danger of being increasingly dominated by southern Aboriginal and non-Aboriginal interests" (1988, 53–54). Without the accountability of the Sydney-based company to them, the local communities feared that a more centralized marketing body would overly "influence what is ordered, sold in the market and ultimately produced" (ibid.). In the end, the art centers prevailed, and Aboriginal Arts Australia was liquidated in 1992, putting an end to centralized government marketing.

What occurred in the policy field of Aboriginal art was an extended case of conflict—what anthropologists have learned to understand as a "social drama" (V. Turner 1974)—in a developing intercultural field. In the phases of this conflict, previous hierarchies of value or paradigms—especially those prevailing between an emphasis on cultural and economic value—were restaged and reorganized. Altman, McGuigan, and Yu described a number of "structural tensions in the operations of a government-supported marketing company," among which was a fundamental tension "between the national marketing company and community-based Aboriginal art centres" (1989, 233–35). The conflict, more particularly, was between "the existing and jealously guarded independence of Aboriginal art centers and the perceived need of the company to have a monopolistic share of the Aboriginal arts and crafts retail market to be commercially successful" (234; see also Peterson 1983).

Two other tensions were pragmatically incorporated in the dominant one—the tensions between centralization and decentralization, on the one hand, and between commerce and culture, on the other: "Community-based art centres are decentralised and provide a model to ensure Aboriginal cultural self-determination, whereas a national marketing company must be administered centrally and must pursue goals of commercial viability" (Altman, McGuigan, and Yu 1989, 234). However, these values were not arrayed simply in the model of structural opposition in which community centers embody decentralization and Aboriginal values. The formulation of the company as entirely economic was itself problematic, embodying a tension or a trade-off between "commercial objectives and social and cultural goals." The Altman report quoted Nicolas Peterson's submission:

> From the outset of government involvement in the marketing of Aboriginal art and craft there have been two conflicting objectives. On the one hand Aboriginal art and crafts have been seen as the basis for an economically self-

sufficient industry which, once established, should run independently of subsidy. On the other hand the government has been aware that it is through Aboriginal art and crafts that one of the most positive and acceptable images of Aboriginal people and their culture is made available to the public. (Altman, McGuigan, and Yu 1989, 235)

Whatever balance or equilibrium had been sustained in the integration of Aboriginal cultural maintenance, self-determination, economic support for Aboriginal communities, fiscal accountability, and economic rationalization in the Aboriginal art market fell apart in 1987.

After the Fall

In fact, Aboriginal Arts Board funding of arts centers had declined in real terms between 1979 and 1985, even though the ratio of sales to subsidy had increased (Altman, McGuigan, and Yu 1989, 28). By the mid-1980s, rationalization of a diverse and dispersed industry was on the policy agenda (163), funding responsibility for Aboriginal Arts Australia had been transferred from the Australia Council (the Arts Board) to the Aboriginal Development Commission (ADC), and there had been talk of incorporating Aboriginal art centers into the Department of Aboriginal Affairs and of "streamlining arts funding" (164).

With the demise of centralized marketing, a substantial number of private dealers and galleries moved in. Indeed, the government marketing system had not been that popular with retailers. Submissions from some disgruntled dealers to the parliamentary review—in the wake of the ANCAAA strike—expressed their resentment over the AAA's mild monopoly over access to producers and over having to compete economically with an enterprise subsidized by the government. Adrian Newstead, director of Coo-ee Aboriginal Gallery in Sydney, had particularly strong views on this matter, as evidenced in his submission to the Review of the Aboriginal Arts and Crafts Industry. He was no less adamant when I interviewed him two years later. I asked him, "Do you think they [the government galleries] are being gradually replaced by . . . ?" He replied, "Commercial galleries? Of course they are. And so they bloody well should be. We've had to compete with an agency that was heavily subsidized by the government, making it, you know, unfairly in competition with us. I mean, why should they get any subsidy? I mean, it was supposed to be an Aboriginal-owned company. It's never been owned by Aboriginal people" (Newstead 1991).

In any case, buoyed by reality or illusions of success, the retailing of Aboriginal

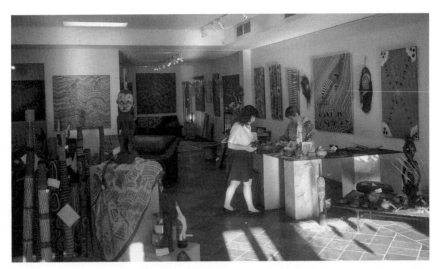

Gallery Gondwana, Alice Springs. Photo by Fred Myers.

arts and crafts does not lack for players. By 1989, AAA represented only 6 percent of the specialized outlets (of ninety-one identified), although its turnover was disproportionately high, still 16 percent in 1988, although down from the 40 percent of 1980 (Altman, McGuigan, and Yu 1989, 65). The practices of retailing, and the identification of distinctive streams of art products, have led to differentiation in outlets. These differentiations really depend most of all on the discrimination of a class of "fine art." As Wallis and his compatriots at AAA had recognized, people would not pay large sums of money to buy paintings in a shop cluttered with tourist souvenirs. Not uncommonly, specialists establish different outlets to straddle different market segments, so the Dreamtime Aboriginal Art Centre has tourist venues in the Argyle Centre in Sydney, a fine art gallery in the Paddington area of Sydney (Hogarth), and so on. Coo-ee has an "emporium" for tourists and a nearby gallery for collectors (75).

The Gallery Gondwana in Alice Springs is a useful example, a "mixed outlet" with pretensions to fine art modernism. Roslyn Premont, who initially operated the government gallery, the Centre for Aboriginal Arts and Craftsmen, in Alice Springs, operates this gallery; it is one of twenty-four venues for selling Aboriginal art that I identified in Alice Springs in 1991 (page 214). The atmosphere is modernist, with track lighting and a skylight effect that creates an airy feeling. Various kinds of minimalist music provide a contemplative background. In recent years, Premont has tried turning it into a more "upscale" fine art gallery, according to local visitors, "without all the clutter of tourist stuff." This has not been success-

A tourist art shop in Alice Springs, 1991. Photo by Fred Myers.

ful, because people as tourists did not feel comfortable coming into the space. In 1991, when I visited, the music of the Irish singer Enya was playing in the background, music whose effect was thought appropriate for selling "art" rather than "souvenirs." When I first interviewed Premont, I was wondering if she promoted a New Age quality in Aboriginal art, but she avoided that topic and described the way music sets a background in which the sale of art can take place, by making customers less self-conscious as they settle into "looking":

> I find that the music, the type of music, is also really important. Then you can see them settling, the way they walk, and taking their time, and you know, take a few deep breaths, and then start just looking, . . . just sit and look. Because it's really hard, I think. A lot of art that people think is magnificent — the art pieces — if you're just kind of rushing around and not having the time to look. . . . And so often, people that have come earlier in the week, we've said, "Come. Just look around. Take your time. Don't rush. Look. Look, and let your eye get adjusted. And then see if you come back."
>
> And invariably, we get our sales. . . . But it's good for people to take the time and just to watch and feel the painting, and then make the decision of what *they* want. So we do get a lot of people over days that will come back several times. (Premont 1991)

For cash flow, however, it proved important to have a range of cheaper items and tourist stuff. The Gondwana Gallery shop had returned to the "clutter," to a

mixture of styles, but Premont was opening a second shop that would have more Indonesian items (furniture, and so on) for cash flow from tourists, as well as items that locals might buy. The strategy seems to involve both levels of goods. After all, how many people will turn up in Alice and pay $A5,000?

The differentiation of outlets—and especially the sustaining of a higher end of fine art—requires a particular self-presentation by retailers as knowledgeable. Interest in "buying direct from makers" and in buying "only genuine, original hand-crafted Aboriginal arts and crafts" reflects the value of the items as mementos or souvenirs of travel, needing to be indexed to a location and people. Correspondingly, the meaning or story associated with the items was considered to be an important dimension. For such visitors, art represents a mnemonic of tourism. In this sense, and for this category of consumer, such art is a turn (or "return," as some might have it) to an aesthetic in which objects are memorable not because of intrinsic value but as a consequence of the effect they have on their viewer at specific times and places.

On the other hand, the interviewees of the marketing survey undertaken in 1993 (MacMillan and Godfrey 1993) believed that local retailers (in cities) would carry only low-quality stock, while best-quality artwork would be available only at the source of production. This information suggests a combination of interest in "authenticity" and personal significance (associated with the producer and the consumer's connection) and a concern to get the best value. There is a corollary defining the terms of a dealer's self-presentation, as knowledgeable and connected with producers: "In the event of buying Aboriginal art from a local source, consumers often felt that they would need to obtain reassurance and guidance in purchase from an art expert or dealer. Understanding the meaning and stories associated with Aboriginal art was also thought to be a means of assuring authenticity."

Selling Aboriginal Art

Knowledge is critical in mediating sales of objects, in making them fine art. This is not particular to Aboriginal art (Plattner 1996; Savage 1969). Where information is lacking on value, as is the case with Aboriginal forms, the seller's mediation becomes ever more important. For good Western art, the question is the track record of the artist; this is somewhat harder to show for Aboriginal artists, although dealers are moving in that direction. Thus, in Alice Springs, as the market changes, dealers are also attempting to enter it on other terms related to their closeness to supply, upgrading their own reputations as connoisseurs and sources. One such practice involves taking the stories that come with paintings that a re-

tailer might get from an arts cooperative and copying it onto their own gallery stationery—so that *their* gallery appears to be the authenticator, the source with close ties to the producer.

Even if the largest part of the market has been tourist mementos, the separation and reaggregation of tourist and fine art is an ongoing issue. Fine art seems to require a less cluttered context—a presentation or framing of the product and its separation from other products. The segment of the tourist market that would buy $A400–500 items is apparently small, but galleries have evolved to engage these persons. The reason Aboriginal Arts Australia's Kent Street gallery in Sydney was good, Anthony Wallis told me, "was that it looked classy. It had books in it," and so on. "People could feel they were getting educated and that they were getting something worthwhile." Younger tourists whom he classified as "backpackers" would more typically buy this art. They were, he said, even willing to pay from $A2,000 to 3,000 for a painting: "They thought it something authentic."

This account presents fine art as being secured and legitimated by the (modernist) context of the gallery, which Wallis aimed at creating. This context contrasted strongly with venues such as those in Sydney's tourist district, the old area of the original harbor known as "the Rocks," with their more jumbled interior displays. People don't want to pay large sums of money for something that looks like part of a tourist enterprise. Note the importance, then, of the presentation or framing of the product and its separation from other products.

Competition

The opening up of the market has introduced another set of meanings through the effects of intensifying competition for sales. With at least 161 different venues for selling Aboriginal art and crafts, identified in the Altman report database, one finds a good deal of competition among them, and among the art centers. As the arts and crafts industry has become less a cultural question and more of an enterprise, many participants see this development as both threatening to the raison d'être of the activity and chaotic personally, as well. Describing the ups and downs of several well-known advisers, Christine Lennard (from Warlukurlangu Artists at Yuendumu) explained the instability for arts coordinators, contrasting the cooperatives that have been able to establish a profile:

> There's a lot of new faces trying to get into the act of it, and it's good for the
> community to have something for people to be doing and an enterprise that
> they can be involved in that comes from their culture rather than a whitefella-

imposed thing, maybe. There's an oversupply in some areas, like down here in the Centre everybody's going for the dots. I mean there's only so much dot painting that can be! . . . Even painters like at Ernabella—who are doing so superbly with all that batik and everything—that's slowing down. The batiks are slowing down and they're now moving into dots. Utopia [where batiks used to be done, too], that whole thing's changed out there, and it's dot painting now that people are doing out there. It's like that's become the thing to do. That's where the money is made. I don't know. But *there's an oversupply and overdemand,* I think, especially with the mediocre stuff. (Lennard 1991; italics mine)

The change that Lennard sees is "haphazard." With so many communities turning to the popular medium of dot paintings, there is a competitive struggle as the objects take on the formal properties of commodities: "Everybody's trying to promote their community and get a little bit ahead, you know. Come up with an idea that's going to get a slightly higher profile for their community, to promote those artists. So, you've got a future for them, rather than being wiped out. I don't think the market is so big that it can cope with such a huge number of players in it, you know" (Lennard 1991).

Settling Out?

Increasingly, participants discuss the movement of the paintings in terms that delineate the structure of the fine arts world, where value is sustained by distinctiveness, trajectory, and quality control. The common phrase I heard was "settling out," referring to the drying up of demand for any old kind of acrylic painting—colloquially known as "dots for dollars"—and a discrimination of quality. This will mean that there will be a different market for work regarded by retailers as lesser quality, which might have to move to outlets of a different order.

A well-known, sharp-tongued curator with a long career in Aboriginal art draws a somewhat bitter picture and to some extent celebrates the return to "quality," "taste," and "discrimination." In an extended interview, defending the continuing existence of good art despite commercialization, Ace Bourke said,

I think what's going to happen with Aboriginal art is that a few people have had a good run under the Aboriginal umbrella, but now it's just coming down to the Gordon Bennetts, the Tracey Moffatts, the Trevor Nichols, I mean, the real artists. The ones who just compete on an international art front. It's just going to be as simple as that. The novelty of Aboriginal things has worn off,

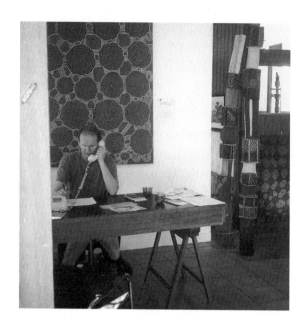

Curator and art specialist Anthony "Ace" Bourke at work in his position at the Hogarth Gallery, Sydney, August 1991. Photo by Fred Myers.

particularly from the media's point of view. I mean, they're just not interested. They think it's yesterday's news. In fact the art is extraordinarily gorgeous. You know, the dot paintings are an extraordinary phenomenon in the world . . . history of world art, well, this century especially. So it's just especially good and it's got something to say, there's real weight behind most of it. So it's very simple why people are interested in it. And the interest has only just begun. And there are real problems like overproduction. Too many paintings indiscriminately evolved . . . it's shaking out. Getting better rather than worse. (Bourke 1991)

The curatorial realities to which he refers are illuminated in the following discussion of a show at the Aboriginal Artists Agency, where he had once worked, and about which he was somewhat ambivalent: "These days you don't get a package deal. You have the good artists, and the bad ones can just go fuck themselves. You know, *why carry them?* It's just unprofessional and it's just not how it's done. . . . [This] just shows . . . amateurism as far as I'm concerned. Why carry a bad artist? You don't sell anything. You don't do the artists any good, and it just makes you look bad. It takes away from a good show" (Bourke 1991). Although in this case the discussion is more of urban-based artists, Bourke's curatorial position is quite at odds with the expectations of painters at places such as Papunya and Yuen-

Art dealer Gabrielle Pizzi, representing Papunya Tula, in her high modernist gallery, Melbourne, August 1991. Photo by Fred Myers.

dumu, who have expected—as Gabrielle Pizzi said—"that all work there would be purchased on completion" (Kronenberg 1995, 7).

In these accounts, which express the common understanding of how a fine art market is structured, if standard practices prevailed, the good would survive, and the so-called weaker painting would dry up. "I was finding it increasingly hard," Pizzi said in an interview,

> to promote Aboriginal artists, both in Australia and internationally, when their work was simultaneously being sold in tourist shops and vanity galleries. The problem can be traced back to 1971–1972, when a policy was instituted at Papunya that all art produced there would be purchased on completion. That policy has subsequently been adopted by many other Aboriginal communities. . . .
>
> Whatever the work, it is always purchased. That means mediocre work is finding its way onto the market and, more damagingly, is being sold in commercial outlets, and this can lead to a destabilisation of the market. (Kronenberg 1995, 7)

Pizzi described how important dealers were surprised at the "lack of control in the market" and wanted an assurance that if they decided to promote a particular artist's work, they would not find work of varying quality by the same artist

in tourist galleries and shops around the corner. Nor will they expect to have it handled by another dealer who might compromise their "professional integrity and reputation" (8).

This is not simply a hostile position that greedy dealers take over and against Aboriginal interests. There was in fact a great concern about a "flood of poorer" work being marketed by those who wanted to make a quick dollar, and this was distinguished from responsible participation in the market. Thus Ace Bourke of the Hogarth Gallery in Sydney appreciated what Daphne Williams, the longtime and highly successful adviser to Papunya Tula, had accomplished, as we have seen in chapter 6.

The Institutional Production of Fine Art

Bourke drew explicit attention in these comments to a subject that lies at the heart of the matter—that is, the necessity of discrimination for the fine art market to function. Eric Michaels had perceived this problem in 1988 when he remarked on "the curious fact that almost nothing of this work is ever designated 'bad'—a lacuna that would not seem to make it easy to sell anything as especially good, either" (Michaels 1988, 59). Of course, one part of such a discrimination has involved the differentiation of retail outlets—earlier proposed in the Pascoe report—according to their emphasis on tourist souvenirs or on objects to be engaged as fine art.

What goes unsaid and assumed is the role of institutions in a mature art world, the significance of what Lawrence Alloway (1984) once called "the art network" in creating the possibility of telling good from bad. It was precisely these institutions that came into attention in a workshop held in 1990, organized by Jon Altman and Luke Taylor, that resulted in the publication *Marketing Aboriginal Art in the 1990s* (Altman and Taylor 1990).

Indeed, public institutions—art museums and art galleries—did engage significantly in educating the art-buying public, with acquisitions and increasingly knowledgeable education programs. Luke Taylor, an anthropologist and then curator at the National Museum of Australia, made this clear:

> Direct support of the industry is perhaps the gilt edge to the less immediate and less visible, yet crucial, promotional role carried out by public institutions. By keeping Aboriginal art in the public eye, disseminating information and encouraging informed debate about the works, public institutions play a key role in expanding understanding about Aboriginal art, educating public tastes and inevitably expanding the potential audience and the market.

Such education is now a crucial facet of the arts industry. . . . It requires on-going research of the collections and the dissemination of knowledge through publications and educational programs that accompany exhibitions.

The market too is coming to be infused with similar concerns. For example, publications by dealers are seen as a crucial aspect of their activity. For dealers to maintain a long-standing reputation they must supply their investors with the information that not only provenances the work, but also provides some more developed analysis of the works and the artist in question. (L. Taylor 1990, 31)

In the face of a problem enunciated by "specialist retailers" of Aboriginal art — of mainstream commercial galleries getting on the bandwagon and stealing their clients — Vivien Johnson, a scholar of Aboriginal art and herself a significant collector, discerned another significant feature of the market's structuring. Insisting on the right of Aboriginal artists to explore the wider possibilities of the circulation of their work through the mainstream art system, she points out the place of smaller retailers on a pyramid of cultural production. They can — as independent record companies have done — "foster emerging talent which then moves on to greater exposure and income through the majors" (V. Johnson 1990b, 39). A further problem, she argues, is to sustain the small buyer market by keeping a rational pricing structure, for this market should provide "the broad base of support which the fine art sector of the industry needs . . . if it is to move beyond dependency on public or major private collector patronage" (41).

Fine Art: Beyond Aboriginality?

The remarks of Christopher Hodges, who represents Papunya Tula in the gallery Utopia Art Sydney, extend this analysis of the new market and the changing place of Aboriginal fine art. Hodges's central concern is the development of connoisseurship or knowledge as a basis for appreciation of painterly artistic value — as a way to discriminate quality. This requires educating the viewer, the capacity to know individual styles through research, something in which a good dealer must engage. I asked him whether he thought it took a lot of work for exposure and training of people's eyes to start to recognize where invention lies for acrylic painters:

Yes, because if you examine any number of Aboriginal artists' works, and you look at them cold, without any kind of research, it's very difficult to tell who has done what. But if you looked at twenty painters from the Renaissance, that had painted *The Last Supper*, say, to the person that hasn't researched

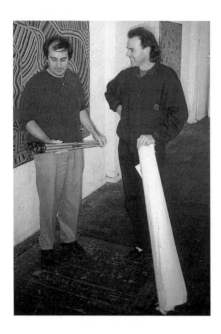

Christopher Hodges
and associate at
Utopia Gallery, Sydney, 1991.
Photo by Fred Myers.

that area, there is still the trouble of picking who did what. But to the person who puts the proper amount of study in, . . . that scholarship is rewarded. Like, you and I could easily look at any of the Pintupi painters, and the ones that stand out, you can pick them no problem at all, because you are picking a personal style which supplants itself on top of the form. So if I pick a painting, if I pick a Pintupi painting, usually—you know 90 percent of the time you can pick who did it. The 10 percent you can't pick are the artists who haven't got great personal strength. (Hodges 1991)

At this point, Aboriginal fine art—articulated for the high-priced world of collecting and discrimination—is becoming detached from its base in Aboriginal cultural practices. Hodges continued:

There's no doubt in my mind that every one of the artists that is producing work at the moment is producing it for a marketplace, and knows it gets exhibited. They're not producing it for sacred ceremonies. It's a viable income-producing form of labor. And so I keep pushing the point very hard. . . .

Their paintings are influenced by what's happening to them. They're important statements about the big issues. And the fact that it's abstract, fitted in with the Western tradition of abstract painting? So, abstract painting had lost its punch by the late seventies; it had run full cycle until it was pretty

much looking up its own navel. And so when this stuff came along, it was full of content; it was powerful; it had all the energy in it; and it was volatile. And most of the art at that time had lost its real vitality. And so it went into the art world as a fresh, new thing, which continued a tradition that had begun in completely different cultures. We use the phrase "beyond Aboriginality." And the idea was that once the work had transcended the specific culture, it still has an effect on people who know nothing about the specifics of the work. *The best pictures, they hit you. That ability to hit, even though there's no cultural records. It really makes a difference.* (Hodges 1991; italics mine)

Entering into this fine arts world does not, in Hodges's view, necessitate indulging in "primitivist nostalgia" for the "noble savage." Hodges was clear that what he expected to sell was painting, rather than Aboriginality, and the expensive paintings are sold on the basis of knowledge — moving buyers ever further toward "stronger" art, more demanding of knowledge and background. Thus, Hodges told me,

There's a mixed thing there. Some of our best collectors aren't interested at all in the stories. They look at the work. And once they started building their confidences to the point where they trusted their judgment, just in the same way they trust their judgment of European paintings, they bought strong works, and they bought stronger and stronger works. At the decorative end of the Aboriginal art market, the collectors tend to work away from that into tougher and tougher pitches as their confidences go. . . .

Now as far as the Aboriginality goes, some people like the idea of the noble savage, something we're knocking on the head constantly. I know Aboriginal people that are absolutely charming, witty, delicate, soft people and I know some who are absolute mongrels and I know every sort of type in between. So I constantly say to people, "Aboriginal people are just like every other group of people. There's good, there's bad, and ugly." We don't get involved in Aboriginal politics of any kind. So people who want to come in and talk about political issues, as far as I'm concerned, that's the business of Aboriginal people, and has nothing to do with me. (Hodges 1991)

Establishing a fine art market, however, does not involve only separating the work aesthetically from the politics of Aboriginal culture. When Hodges explains his idea of appropriate relationships as involving what he calls "proper representation," one discerns the competition among dealers. "Proper representation" is exactly what most of the so-called reputable dealers believe is not occurring.

There's a lot of potential to do things internationally with this art. There's lots of chances to go and show this work to a larger audience. But it's got to go out in the proper way. It's got to go out supported well, to go out with the same care the work of the top white artists takes. . . . If that's going to happen, it means cooperation from everybody on a long-term call. Ninety-nine percent of the people involved with Aboriginal art, I reckon they just rank out of it [are worthless]. The places that show art in Sydney, most of them started out as tourist shops who have become galleries. . . . So they come from a background of splitting their options three ways. (Hodges 1991)

This sort of comment is not uncommon among dealers. Indeed, "representation" could be said to have become meaningful entirely within this entrepreneurial environment.

I believe in representing artists. To do the right thing for your artists, you have to support them. You have to work together. But your aim is to develop their reputation so that they have a long-term future in the arts. Now because of the exploitation by opportunists who don't understand the art market, who don't understand anything about art, wouldn't know a good painting if they fell over it . . . many of the major artists . . . are basically hugely undervalued, because the opportunists stop proper representation occurring. If, for example, Wuta Wuta Tjangala had been a white man, then before he died, his paintings would have been ten times the price they were. And it's because of the exploitation. The entrepreneurs have just undermined the pricing. Every time somebody is nominated, you know—like Emily Kngwarreye—they took advantage of all the efforts that had been made by everybody before that. Coventry Gallery actually mounted an Emily Kngwarreye show. Gabrielle Pizzi mounted one, and Hogarth Gallery has mounted an Emily show. (Hodges 1991)

This was obviously the point of the competition but clearly reflects the difficulty in the unsettled art market. The dealers all struggle with opportunists and entrepreneurs who have no long-term involvement, which seems to be understood as the stabilizing force. In the case of Aboriginal art, the rules that have applied for white artists—the rules of a mature art market—were not yet fully in force.

These concerns about blockages and access to product are ubiquitous among dealers. Judith Beehan, proprietor of the Chapman Gallery in Canberra, positioned to sell to civil servants and foreign visitors, talked easily about how she became interested in Aboriginal art. Her story is formulated within the existing discourses of art's effects and her institutional location. Her interest began, she told

me, when she saw a painting by Johnny Warangkula from Papunya—*Wild Potato Dreaming*, she thought it was—at an event organized by the curator of the National Gallery, James Mollison, before it had even opened. The other works there were "all German expressionist type," she said, which she "hated." Looking at the Gallery's new acquisitions (itself a moment of privilege), "Nobody else responded like I did; they had to scrape me away." This recognition voices the authenticity of a connoisseur's response, a true eye that can be trusted.

Her interest whetted, she wanted to know where to get more of these paintings, but Mollison and the rest were cagey: "Everything about Aboriginal art has been very secretive." Indeed, the leitmotiv of the interview was that she couldn't get enough paintings, couldn't get what she wanted: that people control them and only let you have a little bit. She could easily sell more, and she discounts the view that they couldn't have been sold before. This was a consequence of the government monopoly. If commercial galleries had known of it in the 1970s, she told me, "They would have sold it, would have jumped for it. But it was kept hidden." Even later, she complained, Anthony Wallis—director of Aboriginal Arts Australia, the government marketing service—wouldn't let her have any, and he certainly wouldn't let her find out how to get it herself.

Beehan is still suspicious of why Papunya Tula's coordinator won't give her more: "I want the stars," she said. When I interviewed her, she was in possession of a painting by Yanyatjarri Tjakamarra, for example, worth $A7,000, and had had it for six months. Usually she wouldn't be allowed to have it that long without paying. This is difficult for private retailers, who must put up their own money and prefer the consignment system. What happens, she said, is that advisers say, "I'll let you have one Ronnie Tjampitjinpa, but you have to take these other [up and coming] people, too." Beehan complained that she couldn't sell those painters, but she "could sell as many Ronnies as she could have." She wonders whether the art adviser was telling her the truth when she said she had nothing or whether she was actually giving them to someone else (Beehan 1991).

Ace Bourke has complaints about competition, too, however, and seems to dream of a curatorial autonomy that is denied him in the mercurial world of Aboriginal art:

> We've got Balgo [the Balgo art cooperative], and Balgo showed at Co-ee earlier in the year and wanted to show in Kent Street later in the year. And I'm the monster because I said no way. I'm just sick of it. . . . They can be as amateurish as they like. [If] they're going to show with someone, they're going to show with me and they're going to show once a year and I'm not interested. They can just drop out or drop dead. It's not like a big chocolate

cake you share around; you know, have a go at the Hogarth and then move on to Kent Street. (Bourke 1991)

Bourke's own curatorial career was somewhat threatened by a growing insistence on Aboriginal curatorship, and despite his being comfortably ensconced in a safe, "rich gallery," Bourke's sense of instability was also aroused by gallery competition. Freely laying about him with the cheerful malevolence of art world discussion, he was particularly annoyed by a struggle with Coo-ee. "They just think they invented Aboriginal art," he complained, "but they just stumbled onto it a few years ago."

Hodges—like the other dealers—sees the future of the Aboriginal fine art market to lie in a system familiar to Western art, but here in the new guise of his version of "proper representation": "I think what we're trying to do is take the brave step. Everybody that has ever bought an Aboriginal painting goes out with cash and gets the painting. What we're saying to them [is] if you want to be really successful in art, that's got to go." Thus Hodges outlined two problems, the "shonky entrepreneur" and the Aboriginal lack of "loyalty" to a representative. In Hodges's view, then, the future of the Aboriginal art market will follow the settling out of the finer artists from the others, not the continuing endorsement of Aboriginal identity per se:

> It's these sorts of things that worry me. I firmly believe that given another ten years, the quality of this art is going to be really recognized. I think at the moment it's not really recognized. A few museums and institutions are collecting sensitively and conscientiously, and a few individuals, in the politics of the art world, are right there. The art houses see it as a new way of making some money. The fast buck merchants have all put a dollar in, but lost it mostly. But it'll be ten years and people will say, in the eighties, some of the best stuff was really the Aboriginal stuff. There are people who still write articles about it today in that paternalistic, historical sense: this is blah-blah, it's not contemporary art. And then they say, like Peter Schjeldahl said in New York, "This rectangular canvas is imprisoning the Aboriginal." Bullshit!
>
> You know Lindsay Bird is a Utopia man, and he's a great painter. Lindsay, you give him a square, he'll paint another square. You say, "Lindsay here's a circle," he'll paint you a circle. You give him a square he doesn't like, and he'll say, "Not that one." If he doesn't happen to want to paint a picture, he won't paint one. It's like taking a painting into John Walker and say, "Hey John, paint me a big painting tomorrow." He says, "Piss off, I don't want to do it." There's no difference.

When all this stops, and people really look at it, and the entrepreneurs have dropped out, and we have people capable of making judgments about Aboriginal art the same way they are capable of making judgments about white art, with the same degree of scholarship and commitment. And you'll have somebody say, "Turkey Tolson's stripe paintings from the late eighties, early nineties, those are the best paintings he ever did." I think that's what will happen. (Hodges 1991)

This is part of bigger changes afoot in the significance of race and Aboriginality, it would seem, as noted by Ace Bourke:

It's an interesting time in Aboriginal art and in Aboriginal affairs. Everything has to be much more accountable. . . . I think people really have to perform now. I think Aboriginals have to perform; they're not going to just coast anymore. . . . I think now they are going to be questioned, and by people like me. They've got the jobs we're shut out from. They're half our age. We want to know why they've got them and we want to see what their vision is and we're going to really watch how well they do it. (Bourke 1991)

No doubt the views of gallery directors such as these are a factor in the situation, but we should probably not take them entirely at face value. As agents with particular interests, their endorsement of "individualism" — recognition of individual artists — does not look the same to other participants. For example, the dealers such as Pizzi and Newstead have argued for a controlled market based on a dealer loyalty system with relatively few "outstanding" artists. This is sensible for the market, but not always what the artists' need — a point made years before by Andrew Crocker. While a dealer loyalty system may provide substantial benefits even to cooperatives, it cannot satisfy the entirety of indigenous interest in painting or income, nor can it sustain the cultural base of painting. To others, this formulation of the market is too narrow. Over time, Howard Morphy pointed out to me in 2001, there has been a continual annual increase in the total of works sold. This represents a differentiated market — the two tiers — which has benefited the art centers and the indigenous artists overall. A differentiated market may be necessary and good, or so those working directly with local artists insist. Like many artists, they recognize the significance of both fine art and tourist quality work, each supporting the other but with inevitable tension. In any case, while gallery owners may believe that they have the key to identifying the works of true quality, as their comments suggest, quality in art is notoriously difficult to identify. Claims to know it — as in the arguments about who should be showing Emily Kngwarreye — show

us the extent to which dealers thrive on getting in ahead of other dealers. Dealers have their own agendas. They do not like government competition, as we saw, and they want control over a limited supply. So individualism particularly enticing for them, an expression of their social situation.

With their emphasis on discriminating quality, the dealers and their clientele nonetheless occupy a significant place in the production of an Aboriginal fine art. They comprise the segment of the market that is the equivalent of the cultured class and its habitus identified by Pierre Bourdieu (1984) in *Distinction*. This is a different taste class than the public servants who endorsed Aboriginality. Public servant interest brought Papunya painting into national recognition through an initial market development, and I believe this taste sustains the broader sales, but they play a relatively minor role in the development of the set of distinctions applied by the dealers and associated with that habitus.[1]

The tension is inescapable. The way that the dealers operate on the basis of individuality and a star system may work against the local community ideology, once protected by the government's objectives in generating an indigenous economy of art and craft workers. What is afoot at the local end of these maneuvers may be rather depressing. Sales in some communities have declined, and the "unscrupulous" dealers have been able to get into the market. According to at least two recent accounts I heard, Papunya Tula is having trouble now that is indicative: a problem keeping the artists. The cooperative is undermined by people who want access to the communities but do so by sowing discontent among those people who are not selling well at the time. This is something that has long been visible: people are angry because their paintings aren't being sold, and so somebody else in Alice says, "They are robbing you." The artists have begun to sell to anybody in town, and dealers are coming up to Alice Springs to take advantage of this. Indeed, one rumor has been that a gallery down south had managed to have an assistant from Papunya Tula act as its agent, going around the structure of the cooperative and sending work acquired on buying visits directly to the gallery. One "mixed outlet" from Melbourne is also reputed to have an agent in Alice, and they pay the artists with cars—which they have right there. This is very attractive for artists and indeed has long been among their material aspirations for the work. In another case, one of the shop owners in Alice Springs is telling Timmy Payungu that Papunya Tula Artists doesn't look after him properly and the dealer will do so, to get him to paint for him.

One of the problems with this is that these dealers cannot really provide provenance, which is absolutely critical for selling paintings at the high end. Before, they could guarantee authenticity for buyers—with a number on a painting that linked

it to a document. As a result of these changes, I understand, the market has now turned to the earlier period of the art, as these pieces are inherently limited in number, controllable, and linked to more culturally isolated times. Apparently the paintings from that early period are going for large sums. Johnny Warangkula's *Water Dreaming at Kalipinypa* (1972) was resold at a Sotheby's auction for more than $A400,000.

These changes may challenge the authenticity of the work, both commercially and culturally. One view holds that after the generation passes for whom this art is really linked to ceremony and traditional concerns, then the movement will die. What people buy it for, in this view, is that connection with Aboriginal culture, and the painting is becoming more and more of a commercial deal. But it may also be that the demands of the art market always move on, and here they move from Papunya to Yuendumu to Balgo, as different explorations take place from a basic cultural repertoire.

8 Materializing Culture and the New Internationalism

By the late 1980s, Aboriginal art had achieved an unprecedented popularity and exposure in commercial and State public galleries, culminating in the Dreamings exhibition which opened in 1988. Significantly, Dreamings was not organised by art curators, critics, theorists or historians, but by the anthropology division of the South Australia Museum which, under Peter Sutton, effortlessly presented Aboriginal art as a continuity of traditional and contemporary practices that engaged with Aboriginal relations to land in religious, colonial and postcolonial contexts. The impact of the Dreamings exhibition was profound. Before 1988 Aboriginal art had barely penetrated New York; by 1989 it was clear to most commentators that "the acrylic movement has revolutionised the way we see Aboriginal art," both in Australia and overseas. — Ian McLean, *White Aborigines*

Unstable Moments

Newspaper journalists and Australian art critics began regularly to announce the "success" and "value" of Australian Aboriginal acrylic paintings by the early 1980s (McLean 1998). In these accounts, the exhibition and enthusiastic reception of these works not only in Sydney and Melbourne but more importantly in major cultural centers such as New York and Paris served to legitimate the work as "art." This was not merely another instance of Australia's famous "cultural cringe." It was also a recognition that value requires an appearance of objectivity, of disinterest, of distance. This valuation was earnestly sought outside the galleries of fine art in Australia that had already begun to recognize the paintings. The significance of such work for the Australian nation partly depends on the external regard.

Seen in a broader context, the discourses of "art" had become a significant arena in which images and identities of Aboriginal and other non-Western cultural Others—with various minority groups as well—were produced, transformed, and

circulated transnationally. Arjun Appadurai and Carol Breckenridge (1988, 1) have called this arrangement "the global cultural ecumene." However, a closer examination of the venues and activities that make up this ecumene is needed. It is not obvious at all, for example, why there came to be an interest in Aboriginal art or what more generally drove the new interest in indigenous identities and non-Western arts.

These questions have been very much a part of the constitutive debates about multiculturalism and the representation of culture,[1] debates that continue to reflect changes and challenges to the prevailing hierarchies of cultural value in many countries. It might not be surprising that the entry of Aboriginal painting into the category of fine art was questioned and debated, but it was surely unexpected—even ironic—at the time that some of the challenges would emanate from radical cultural critics as much as from the more conservative sectors of cultural guardianship. These challenges show the growing instability of the discursive and disciplinary division of labor in representing culture and also the changing contexts of cultural production itself, as Terence Turner (1993) noted.[2] I want to point out, then, that the representation of Aboriginal culture was no longer an enterprise managed under the authority of anthropology, as evidenced in the popularity of Bruce Chatwin (1987), Marlo Morgan (1994), Stephen Muecke (1992), and Bob Hodge and Vijay Mishra (1991). As the raging cultural studies wars show (Muecke

Asia Society flyer for
*Dreamings: The Art of
Aboriginal Australia.*

1992, 1996; Trigger 1993), this was no minor matter for those of us practicing anthropology. And those of us working in Australia's remote communities—with land claims and the recognition of indigenous rights still a salient preoccupation—were not entirely prepared to give our attention to the processes of circulation and exhibition that were stretching the boundaries of our discipline.

I do not intend to renew these disciplinary battles, but I do believe there is merit in returning to these scenes of strife ethnographically (and ethnohistorically). As far as I can see, the recognition of Aboriginal art did not just "happen." Someone—people—made it happen, and what they made happen was quite specific. To understand its emergence, therefore, one should consider quite concretely how exhibitions came into being and what parties negotiated and articulated their production. Through this ethnographic engagement with the more practical dimensions of circulating material culture, we can shed some light on the real social formations in which the representations of Aboriginal culture are produced and circulated—social formations in which anthropologists like me were active, embattled, and reconstituting our own practices.

Critical theory in the arts approached these processes from their point of intersection with familiar Western institutions. On this basis, some analysts have given a badly needed theoretical priority to the questions of circulation and exhibition that seem to be at issue. Many readers will be aware how critics, suspicious of the uses of the category "art," have deconstructed the ways in which "the primitive" or "the Other" have been represented in the West. These interventions were both brilliant and illuminating, but one can see in retrospect that these debates were as much about modernism in the arts as they were about the actual situations of non-Western people. Much of the criticism of the exhibitions of Aboriginal art also drew on what amounts to a specific counterdiscourse—namely, the arguments developed about Western uses of non-Western objects in the wake of the New York Museum of Modern Art's much-publicized exhibition of 1984, *"Primitivism" in Twentieth Century Art: Affinity of the Tribal and Modern* (Rubin 1984). Critical commentary on this exhibition made it a watershed in the consideration of the category "primitive," drawing attention to the significance of the "primitive" Other for the Western self-construction of modernity and modernism (e.g., Clifford 1988a; Foster 1985; McEvilley 1985; Rubin 1984; Torgovnick 1990; and Rhodes 1995). Thus, this commentary argued, the purported (and sometimes "triumphal" or self-congratulatory) recognition of these products of non-Western cultures did not constitute a genuine encounter with them in their own terms. Instead, such exhibitions put other cultures to work in the service of "our" own ideological categories. James Clifford, for instance, writes in his influential review:

The MOMA exhibition documents a *taxonomic* moment: the status of non-Western objects and "high" art are importantly redefined, but there is nothing permanent or transcendent about the categories at stake. The appreciation and interpretation of tribal objects takes place within a modern "system of objects" which confers value on certain things and withholds it from others. Modernist primitivism, with its claims to deeper humanist sympathies and a wider aesthetic sense, goes hand-in-hand with a developed market in tribal art and with definitions of artistic and cultural authenticity that are now widely contested. (Clifford 1988a, 198)

Analysis in this mode has had the merit of acknowledging the importance of the emerging "traffic in culture." It has nonetheless done so from the point of view of the metropolitan center, treating the intercultural processes involved in the movements of objects and revaluations from the international periphery to the center rather ambivalently, as examples of colonial domination (Manning 1985; Foster 1985) or even "ethnocide" (Fry and Willis 1989). The focus of such analysis has been on discourse and the concomitant gaze — on structures in which the Other is reduced to his or her value as defined by the gaze of the dominant West. The central texts for such criticism were, of course, by Foucault (1971, 1973), Said (1978), and Derrida (1977) — the major analyses of representation or knowledge as a form of power or domination. Indeed, as Bennett (1995) has argued, the very birth of the museum display of other cultures is connected to the construction of an audience as articulated by their superiority to the products and cultures displayed before them.

Attempts to evaluate Aboriginal paintings *have* seemed necessarily to reflect the discourses of Western culture (Myers 1991, 1994a), rather than articulating a distinctive voice for those supposedly represented. In this way, the evaluations continue their contribution not only to ethnocentrism but also to cultural domination. This has seemed to me to erase the possibility of any agency on the part of the "natives" and also to ignore the rather complex intersections and reorganizations of interest that are inevitably involved in any production of culture. When the processes of circulation and exhibition are considered up close, one wonders if this dreary and monolithic critical view does justice to the work of cultural exchange. As Nicholas Thomas (1991) has argued more generally about cultural exchange, the conceptual frameworks of domination and appropriation hardly seem to exhaust the import of exchange over time. In failing to address any aspect of the agency of production, through which representations are actually made, these frameworks betray a Saussurian heritage in a theory of signification that can hardly imagine

change (Sahlins 1981). With the expectation that these matters look different if we step outside of what has been largely a textual criticism of representation, I want to consider the broader activity of discursive *production* in which the representation of culture is significant. Exhibitions are not, after all, simply the instantiation of preexisting discourses. As participants can tell us, exhibitions are real-life organizations of resources, imagination, and power — in short, social practices.

Ethnography alone may not be able to articulate the existing structures that define its contexts, that which is "outside" the ethnographic event itself. But since ethnography is beginning to explore the many sites that are now of relevance to people whose lives are not bound to single locations, it might — as George Marcus has argued (1998) — contribute to the theoretical apprehension of the broader structure that we have called "the global cultural ecumene." What does seem sure is that textual criticism is not enough. Terence Turner's work (1993, n.d.) has gone farther than many of the postmodern critiques of representation in exploring the broad structure of the current emerging system of value. He recognizes the relationships of indigenous and culturalist movements to what he calls the "contemporary global conjuncture," an ironic relationship insofar as the expansion of capitalism and consumerism has intensified the value of culture and indigenous identities (which were once supposed to disappear):

> As the conjunctural forces in the late-capitalist world favoring the development, political recognition, and social valuation of cultural and subcultural identities gather momentum, the prospect is for the steady proliferation of new cultural identities along with the increasing assertion of established ones. What I have called the *conjuncture* thus increasingly takes on the character of a metacultural framework, bringing into being a metacultural network of forces, institutions, values, and polices which fosters and reinforces the proliferation of cultural groups, identities, and issues in the public domain. (T. Turner 1993, 427)

Turner suggests a connection between globalization, the expansion of capitalism and consumerism, and the emergence of culture as a major political and ideological force. His argument would anticipate that "the polarization of the commodity fetish," as he puts it (n.d., 11), or the increased alienation of the control over the production of exchange value from the power of consumers to satisfy needs has resulted in a valorization of identity in social life — making consumption and identity an important vector of contemporary life. This polarization would therefore valorize forms such as the Aboriginal paintings as embodiments of the struggle for the continued production of collective identity and personhood.

Outlines of Turner's scenario—or something like it—are recognizable in the Australian case. While undertaken in the expectation of payment and not for their own consumption, Pintupi acrylic paintings were almost entirely defined at the point of their making by their own goals and meanings. The entry of the paintings into the international art market coincides with significant changes in the whole structure and process of the definition of meaningful local identities in a national/international world order. But their value nonetheless continues to rely on their authenticity, their capacity to represent Aboriginal self-production.

This relationship is partly reflected in the experience of participant-observers like myself, struggling (or stranded) in the spaces previously segregated by academic divisions of labor. In parallel, the arrival of Aboriginal art and painters in New York led me to rethink more critically some of the assumptions that undergirded practices of ethnographic representation, and thereby to recognize the necessity for a broad concern with the signifying practices involved in the construction of Aboriginal culture as part of an unsettled, unstable field of cultural production.

The ways in which the modern-primitive relationship was conceived by critics have been anachronistic in light of the more complex contemporary global conjuncture, a modernist analysis for a postmodern world. The responses of anthropologists have been no less anachronistic, driven by our association or complicity (Marcus 1998) with a *specific* form of the local (the remote community) that may no longer be ethnographically the only or even the central locus of cultural production. In much of what follows, I will myself be part of the evidence for this assertion and also the entry point into considering the emerging field of cultural production of what I shall call "Aboriginal art," a field that brings about new alliances of interests and categories of persons.

Recontextualization

Aboriginal art emphatically acquired the status of fine art with a much-publicized show in 1988 at the Asia Society Galleries in New York, *Dreamings: The Art of Aboriginal Australia* (Myers 1991; McLean 1998; Sutton 1988). If I was apprehensive about this change before the exhibition, I was even more taken aback, in its wake, to learn with how much certainty the terms of this circulation and its success were challenged in the world of art criticism. I will consider these critical and interpretive challenges later; here my emphasis is on the entry of Aboriginal culture into new technologies of objectification (D. Miller 1995). What actually happens when such objects circulate into an international art movement? To ask what actu-

ally *does* happen in circulation, at the sites of exhibition, is to ask how they are produced, inflected, and invoked in concrete institutional settings. These "fields of cultural production" (Bourdieu 1993) have distinctive histories, purposes, and structures of their own. The story of how Aboriginal acrylic paintings got to the United States or to France contributes to our understanding of a still-emerging historical moment and replaces the unfortunate suggestion of a monolithic West with a more diverse sense of institutional mediations. As I shall argue, this cultural production of an Aboriginal art should be considered in part an objectification of the connections among a set of elites, segments of different nation-states, building an Aboriginal art that is not entirely identical to that objectified through the emergence of Australia's Whitlamite professional-managerial class. These intersections constitute one moment or constellation of a new cultural internationalism.

In the next chapters, I grapple with the movement of acrylic paintings outside of Australia and into cosmopolitan processes of exhibition — dimensions of what I want to conceptualize as "circulation." The metaphor of movement, however, can be misleading in the representation of what are, after all, sociocultural formulations of time-space. What do the paintings move between? It is surely not simply between locations of physical space. To say that it is a movement "between cultures" not only fails to be specific enough, but the spatialization suggests less of a change in context (meanings) than travel between reified, stable, or bounded entities somehow independent of people. How are we to conceive of the "intercultural"?

This circulation should not be treated as an unprecedented and extraordinary circumstance of sacred objects (inalienable possessions, gifts) becoming mundane things (commodities) but should instead be seen as a specific example of the "recontextualization" (Myers 2001a; N. Thomas 1991) that characterizes the movement of objects between "regimes of value" (Appadurai 1986). An approach such as the one Arjun Appadurai (1986) outlined in following "the social life of things" through different phases (commodity, gift) has the merit of avoiding the reification of culture as a thing or a cause. To follow paintings in circulation draws attention to the role of human subjects (and possible differences and contestation) in redefining objects, reduces the typological opposition between so-called types of societies, and allows us to recognize a range of possible meanings and values available to participants for understanding the paintings (see also N. Thomas 1991).

An interesting location for the study of institutionally complex meaning production, the exhibitionary field of cultural production (Bourdieu 1993) has its own logic, which may conflict at times with the logics of commoditization. The concept helps in delineating the distinctiveness of this field as a venue for defining the relationships among people and things from the commodity process. Bourdieu's con-

ception of a field of cultural production provides, moreover, a useful framework for recognizing the dynamic part participants play in defining the value of objects. Analysis can draw on "what the natives know," but it is not identical with that. Indeed, because there are many different kinds of "natives" in this exhibitionary complex, much analysis is part of the field itself. One should therefore approach the exhibition of Aboriginal acrylic paintings, the production of representations, as the complex social process it is.

Let us turn, then, to the events in New York surrounding the popular exhibition of examples of Australian Aboriginal visual culture at the Asia Society Galleries (6 October–31 December 1988). *Dreamings* drew the largest attendance (27,000 visitors) of any exhibit ever held at the Asia Society. On display were 103 objects, mainly of five types and from four different cultural areas in Australia: wood sculptures from Cape York Peninsula, bark paintings from Arnhem Land, acrylic paintings and shields from Central Australia, and small carved pieces known as *toas,* or message sticks, from the Lake Eyre region. The exhibition—combined with a magnificent catalog (Sutton 1988), symposia that included Aboriginal artists, films, a lecture, and a sandpainting performance by two Papunya Tula painters—made a great impact in New York, before traveling to Chicago, Los Angeles, and then back to Melbourne and Adelaide.

In this event, Aboriginal painting became indisputably recognized as fine art. The venue was not a natural history museum, and the objects were not displayed simply as ethnology but were mounted as art in galleries that have exhibited Bhutanese ceramics and Chinese painting. In addition, Aboriginal people and their culture were recontextualized by bringing into a single arena a number of distinctive discourses for representation. I will describe here the material processes and institutions in which the recontextualization was accomplished in order to help explain just how the category of "art" operated at the end of the twentieth century. The exhibition not only provides a basis for discussing how Aboriginal people relate themselves to universalizing discourses such as "art" (potentially possessed by all humans) but also shows how dramatically the position and practice of anthropology has been challenged and changed by the new "traffic in culture."

These events on another continent have had relevance for Aboriginal people living in Kintore, Papunya, and Yuendumu in part because they embody a central condition of contemporary Aboriginal life: increasingly, Aborigines are faced with defining themselves in relationship to the universalizing discourses of the West. Aborigines—or more properly, perhaps, "the Aboriginal" and "Aboriginality"— are signifiers; that is, in a variety of discourses, they stand for something.

Many Aboriginal attempts to sustain the realm of local meanings and values (which ethnographers like myself have depicted in monographs in the past) now

occur within the social relations of formations such as exhibitions. The questions that ought to be asked are whether and to what extent local (community-based) social orders are *defining themselves*—their meanings, values, and possible identities—autonomously in relation to external powers and processes, whether and how they are transformed in relation to new powers and discourses, and whether or how what had been local meanings are now being defined dialectically (or oppositionally) with respect to discourses available from the larger world.

The Field Comes to New York: Learning One's Place

In 1987, friends in Australia sent me a newspaper clipping from which I learned that there was going to be an exhibition in New York at the Asia Society Galleries. It seemed that the themes of *finding* this art, of its spiritual significance, were the fairly common ones reported over the years in the popular press; this wasn't groundbreaking research (Michaels 1988). Still, I couldn't read the clipping without a strong twinge of possessiveness. Who was the man organizing this, I wondered? And why hadn't this Andrew Pekarik, based in New York, called *me?* I felt I had rightfully established myself at least as the local "expert" on just these people. My book about Pintupi Aborigines (Myers 1986a)—now some of the best known of Aboriginal painters—had been published the year before.

Eventually, I discovered that the Australian with whom the show was being organized was anthropologist Peter Sutton. A friend and a generous colleague, Peter had done the kind of extensive and insightful fieldwork we anthropologists respect; he had also helped me a great deal when I first went to Australia, so I was deeply indebted to him. But his area was the Cape York Peninsula rather than the Western Desert, and he specialized in language, not art. I wasn't aware that Peter had become a curator at the South Australian Museum and had developed his interest in Aboriginal art, and news of the catalog and exhibition he had done with Philip Jones (Jones and Sutton 1986), *Art and Land,* hadn't reached me. When Peter arrived in New York for discussions with the Asia Society people in early 1988, he diplomatically invited me to have dinner, and that was the first official knowledge I had of the plans.

The next I knew of the exhibition was when I was asked, as an expert, to review the application for funding from the National Endowment for the Humanities. Indeed, the exhibit was well conceived and promised to promote greater understanding of Aboriginal society in the United States. I knew also that I would not be able to take part in the exhibition; by this time, I had already received grants to return to Australia for further research.

238 Painting Culture

Finally, I received a phone call from the Asia Society. Did I have any recommendations for lecturers? As chance would have it, one of the most famous Australianists was teaching at the City University of New York. Try Dr. Mervyn Meggitt, author of *Desert People* (1962), I told them. Our own university department might collaborate with their film programmer to expand the focus on Aboriginal art as aesthetics with a film series on the current situation of Aboriginal people in Australia.

I was surprised to receive a call a few weeks later asking me if I would come and talk to Pekarik. He wanted to know whether I had any ideas to add to the exhibition, and principally whether I would be willing to give some training to their docents for the show. Although I couldn't possibly work with the docents, since I was going to be away for four months, it occurred to me that a genuinely "local" voice was still missing. To accompany the show, however, I suggested that the Australian curators in the exhibition see about getting a videotape that represented an *Aboriginal voice* for these paintings. Rather than having only the texts and interpretations mediated through whites, they could have the painters directly explaining to the audience what the significance of the paintings was by means of inexpensive video technology. Several paintings were from Yuendumu, a settlement that had developed its own media center (Warlpiri Media Association) in the 1980s (Ginsburg 1991, 1993a; Michaels 1986, 1988), so it would be fitting if their own video makers could produce this work.

I expected to have no part in the exhibition at this point, but when I arrived in Alice Springs, I bumped into one of the organizers, Chris Anderson, on the street. Hearing that coworker and video maker Faye Ginsburg and I planned to visit Yuendumu, Anderson asked us to see if we could get the video made. We ended up making *Visions of Dreamtime*, which appeared as a supplement to the show in the entry foyer of the Asia Society. (A rather longer and glossier film, made by Michael Riley and the Aboriginal film unit of the Australian Broadcasting Corporation, with a similar interpretive goal for this exhibition, was also installed.) Soon after, Peter Sutton invited me—as a resident New York "Aboriginal specialist"—to take part in a two-day symposium (with experts and Aboriginal artists) on Aboriginal art to accompany the Asia Society show. I agreed.

Imagining the First Referent

The idea of an exhibition of Aboriginal art was first suggested to the director of the Asia Society Galleries, Andrew Pekarik (by training an art historian), by the Australian consul general in New York, John Taylor. As consul general (and formerly

head of the Department of Aboriginal Affairs), Taylor was interested in articulating possible areas of interest in Australia for Americans — both of general cultural value and potentially commercially significant touristic value — especially building up to the 1988 Australian Bicentennial that was itself produced for both internal and tourist spectacle. The growing phenomenon of Aboriginal art would fill both bills, in demonstrating a distinctive Australian possession.

The Asia Society was a significant institutional choice. Inaugurated after World War II, with the substantial help of John D. Rockefeller III, the Asia Society mediates relations of culture and commerce between the United States and Asia. The acceptance of Australia as being within the society's Asian mandate was something of a stretch for the Asia Society (and a coup for Taylor), even though Australia was at the time trying to reconfigure itself as part of the Asian economic sphere.

Pekarik did not know, he says, what New York artists — much less the other clientele of the Asia Society — would make of these works in what an Australian friend of mine humorously called "a temple of blue-rinse civilization." Possibly, the content of Aboriginal culture could be fitted to tropes of Asian spirituality. One of the features of the Aboriginal work that Pekarik thought worthy of bringing to American audiences was something Lévi-Strauss had occasion to draw on in *The Savage Mind* (1966): the apparent asymmetry of a relatively simple material life and the richness and complexity of their intellectual and artistic pursuits (Cazdow 1987b). According to my conversations with Peter Sutton, Pekarik "knew he was doing something dangerous, but it might just lift the Asia Society out of a small, tasteful, refined and dowdy end of the cultural institutions market."

Pekarik subsequently gained the collaboration of the South Australian Museum through its curator, Peter Sutton. Even with Sutton's support, Pekarik told me, it took him over a year to convince Lester Russell, the head of the South Australian Museum in Adelaide (sam). The museum houses one of the largest collections of Australian Aboriginal visual cultures but had never itself engaged in a substantial international exhibition; its collection would provide the bulk of the show. Of Russell, Sutton said, "I think he was worried that it was a distraction from our main game and that we might be exploited like bird dogs. This is a recurring theme in Australian reactions to the interest shown in us by people in the big time of Europe and North America" (Sutton, personal communication, 12 October 1999). The more entrepreneurial and internationally oriented Bob Edwards (then head of the National Museum of Victoria, in Melbourne) proved influential in persuading Russell, after visiting Pekarik in New York.

Sutton has described for me the complex structure and process of their collaboration for an exhibition in which he was the guest curator:

As we discussed the possibilities, initially by phone U.S./Australia and then here, Pekarik got more and more relaxed about the idea of me carrying the main conception, commissioning and editing the catalog contents, drafting ancillary written materials such as those two booklets and the wall labels, and then chairing the symposium in which you took part. In 1987 Pekarik and I traveled all over the country consulting origin communities and living artists, meeting up with Chris Anderson in the Center, Philip Jones at Lake Eyre, and so on. I went to New York for meetings with the N.Y.C. location's exhibition designers, and later worked through the text with the geniuslike Judith Smith, who helped with style and technical matters, and worked through the catalog layout and design with Peter Oldenburg and Osa Brown. I was there for the symposium but . . . was not flown over for the ritual opening. That was attended to by Lester Russell as director. (Sutton, personal communication, 31 August 1999)

Andrew Pekarik's accounting of the exhibition has some different emphases. His comments and the notebooks of his travel to Australia that he generously made available to me offer a sense of what was a *Bildungs* experience for him. The notebooks begin on 22 February 1986, with his arrival in Sydney—where he has drinks with the eminent Australian intellectuals Donald Horne (then chair of the Australia Council for the Arts) and David Williamson (the playwright and screenwriter). The next day he has lunch with politicians and industrialists whose mining companies have interests in Aboriginal land and whose wives have supported the arts: people of economic and cultural capital, vital for fund-raising and potentially with interests that could intersect with Aboriginal art and culture. Dinner was with Australian curators, field buyers of Aboriginal art, and officials of the Department of Aboriginal Affairs.

Pekarik's pathway over the next weeks and for the following year and a half took him through range of distinctive interests, including well-connected intellectuals and wealthy Australian women who spend part of the year in New York, collectors such as Margaret Carnegie and Richard Kelton, the radical Aboriginal activist Gary Foley (then head of the Aboriginal Arts Board), as well as art advisers and Aboriginal painters in several remote communities. An anthropologist who wanted to study cultural circulation would have done well to follow Pekarik as he visited museums, curators, arts supporters, and almost anyone who might help him trace the outlines of Aboriginal art, inquired into the histories of exhibition and performance, and at the same time found himself embroiled in politics.

Pekarik recognized how "the Australia Council is highly politicized, serving a

quasi-governmental role that is meant to demonstrate interest in minority causes without taking direct responsibility or spending much" (Pekarik notebook). Gary Foley was suspicious of the exhibition plans, since he was reportedly embroiled in a dispute with the South Australian Museum over the discovery of Aboriginal remains in their basement. Foley claimed to have technical authority over granting export licenses for Aboriginal material and saw this as leverage he might apply against the SAM until the dispute was resolved. Pekarik was learning, however, that Foley's was only one voice. Others, including a senior Aboriginal bureaucrat, claimed that they "could deal with him."

From its early days, then, the exhibition was produced within the context of ongoing political struggles between representatives of urban and remote (or, as many put it then, "traditional") Aboriginal people. Representatives of these different sectors of Aboriginal life often had contrasting views of what could and should be exhibited about Aboriginal culture. These constituted the particularities of the field of cultural production into which Pekarik entered and which the exhibition, inevitably, mediated. It seems, in retrospect, that Pekarik's connections were largely to various whites involved in promoting Aboriginal culture and most intensively to those who identified themselves with "traditionals." Thus the mediation whose production he oversaw was not between a simple Aboriginal Other and the West.

When interviewed during his 1987 planning visit to Australia, Pekarik told the journalist Jane Cazdow that he expected the exhibition to have a big impact on American artistic circles: "I think it is the sort of thing that's going to be of great interest to working artists. We want it to inspire and influence the contemporary art world in New York." Brand new to most Americans, Aboriginal art would blow onto the international art scene like a breath of fresh air: "Not only is it visually stunning, but it has this tremendously complex intellectual and spiritual content that is generally lacking in Western art" (Cazdow 1987b, 9). These themes were unquestionably a conscious choice, and one should not imagine that Pekarik did not appreciate a wider variety of Aboriginal cultural production than appeared in the exhibition.

Nonetheless Pekarik did not imagine a radical exhibition. He acknowledged that people wanted a *safe* way to incorporate Aboriginality, and they wouldn't be interested in urban art: "There is too much pain. They don't like accusatory art. People want something they can feel more positive about" (Pekarik, New York, 10 July 1990).

In preparation for the exhibition, Sutton took Pekarik on a tour of the remote communities involved, where he was shown something of local life in the hope it

would help him understand the art (Cazdow 1987b). Already in 1987, his visit was receiving attention in the Australian press. This was probably not the usual experience of an art historian or curator but is common enough for those working with Aboriginal people. This trip involved some of the extensive consultations undertaken by anthropologists Peter Sutton, Chris Anderson, and Françoise Dussart — among others — to maintain a responsible representation of Aboriginal concerns. In a subsequent unpublished defense of the exhibition in this regard, Sutton reports "talking to well over 100 people in thirteen locations across Australia." He describes "unprecedented efforts to involve a wide range of Aboriginal people in the event. In by far the majority of cases we consulted with ritual groups or other locally constituted widely drawn sets of people with interests in the works under consideration for the exhibition" (P. Sutton n.d., 1). Moreover, these consultations were extensively involved with the "strategics" of the exhibition: "A detailed list of factors such as the loan arrangements, the non-commercial and educational approach, the role of the book, Aboriginal participation in the exhibition symposium, fees and permissions, etceteras, was gone through with each group." Thus Pekarik was exposed to the mediation of Aboriginal and Western exhibitionary interests.

Pekarik had the job of finding other U.S. venues for the exhibition (eventually in Chicago and Los Angeles), setting up loan arrangements, and securing funding. The pursuit of funding began with his earliest discussions recorded with John Taylor, when the names of prominent possible connections who might be solicited were floated. The search for funding — corporate or private — is illuminating of the structure of cultural production in museums, and the connections between business and culture. The Asia Society worked through its trustees and other connections but also hired consultants who could make connections to corporations. The Asia Society's profile established a distinctive framework, triangulating between Asia, the United States, and Australia. After all, Pekarik's initial contacts and backing in Australia follow the pathways of the Asia Society — those with an interest in Asia and also, as Australians, in their own country. This intersection, or the objectification of these interests, selects those people — some imagined, some real — as the logical mediators. In the planning for the exhibition, then, one can see the articulation of an organization for producing knowledge in the very global cultural conjuncture Turner discerned.

Pekarik's funding solicitations for the Asia Society were directed to corporations "interested in visibility in Australia" and Australian corporations working in the United States. Another pathway to funding was art itself. Australians of distinction living in the United States, and with an interest in the arts, were approached

for support. There was a certain sense to this, of course, but my point is how a constellation of interests is articulated into a project and what opportunities for access are opened up to those of wealth. Following the pathway of previous articulations, the concrete form of cultural capital, a director of the Asia Society Galleries would make rapid headway into the heart of Australia's world of influence. The cultural production of an Aboriginal art, then, should be considered in part an objectification of the specific connections among these elites, segments of different nation-states. They constructed an Aboriginal art that was not entirely identical to that objectified through the emergence of Australia's own Whitlamite professional-managerial class. While Sutton and Anderson might themselves be identified with the latter, the exhibition was always understood partly as being directed to an American audience of which they were always conscious (P. Sutton n.d., 1990).

Consultants are, of course, another category of persons—whose knowledge and networks are their cultural capital. Those who had worked intensively on Australia, in the context of the American-Australian Bicentennial Commission, for example, reappear in Pekarik's notebooks as having knowledge and connections that could be of use to the producers of the exhibition. This was becoming, very nearly, an autonomous field of cultural production.

In the midst of this, Pekarik maintained his enthusiasm for the content of the exhibition. His goal was to put the art on the map. Recognition had to be produced, and the machinery of this production was familiar to him. As he explained to me, "I see it as a network—museum, collectors, dealers, the artist. It doesn't work unless they're all in it together" (Pekarik, personal communication, New York City, 10 July 1990). "Dealers [and others in the art world]," he said, "have bought into a myth, that this artwork has some sacred power that transcends the normal working of the world."

Support for this exhibition was not as forthcoming, apparently, as those at the South Australian Museum had hoped. They did succeed in getting NEH Planning and Implementation Grants, but little corporate sponsorship came about, despite professional fund-raising consultants and considerable application. The Westpac Bank in New York (an Australian bank) gave a little. Mobil Oil ended up supporting an Australian symphony orchestra at the United Nations instead, saying they thought Aboriginal art was "too unusual." Pekarik said that the Asia Society was looking for $150,000, but "I would have accepted fifty gratefully. Basically, nobody cared that much." The Australian American Bicentennial Foundation solicited applications for crosscultural events and found funding for three other major projects, but not this one—the only one having to do with Aboriginals.

In Australia the only support came from the museum community. Disappointed, Pekarik concluded, "You can't tell me that's anything other than racism. The Australians were not behind this at all" (Pekarik, 10 July 1990). In the end, funding for the exhibition was provided by the National Endowment for the Humanities, Friends of the Asia Society Galleries, the Andrew Mellon Foundation, the Starr Foundation, and Westpac Banking Corporation.

In addition to the exhibition itself and a comprehensive scholarly catalog (P. Sutton 1988), the gallery offered video displays, a lecture, films, a two-day symposium with anthropologists and Aboriginal artists, and a sandpainting onstage by two painters from Central Australia—a considerable reduction of the organizers' original ambitions. All of these events were intended to provide a sociocultural and historical context for the tokens of visual culture on display. From planning to completion, the show changed from the original proposal, which had planned a more elaborate analytical framework for organizing the display topically. Although the original NEH funding application had stressed more holistic themes in the exhibition, in the final realization there were no separate places for topics of concern such as Aboriginal conceptions of "pattern," the formal imaging of the body, individual creativity, or the relationship between the perceptual and the conceptual. These topics were well developed in the catalog and the brochures that Peter Sutton wrote for the exhibition, however.

The official rubric of the show—its construction of Aborigines—is expressed in a piece of publicity that said that the objects displayed show "the extraordinary vitality of Aboriginal art. It is the oldest continuous art tradition in the world, and is flourishing with new energy and creativity in contemporary media. The works in the exhibition represent the 'Dreamings,' the spiritual foundation of Aboriginal life." But what was actually produced at the Asia Society?

Display

Inside the Park Avenue entry, visitors to the Asia Society were met with a huge (201 × 700 cm) acrylic painting entitled *Possum Spirit Dreaming*, attributed to the well-known Central Desert painter Clifford Possum. After paying their fees, viewers entered the C. V. Starr Gallery on the first floor, where a map on one wall and a facing large photograph of the desert landscape overlaid with text introduced them to the exhibit and the Australian continent. Text panels broached a series of issues deemed necessary to place the objects in a meaningful context, to give some idea of what significance they had for those who made them and to develop topics relevant for the exhibit as a whole. Throughout the exhibit, the anthropological

imperative to provide understanding through cultural context was in tension with the apparently more accessible visual forms. These were displayed in the modernist installation style—isolating individual objects in spare, neutral-colored interiors (Staniszewski 1998, 117) spotlighted to highlight their beauty.

The first panel, entitled *Dreamings,* briefly explained the mythico-religious ordering of the Aboriginal world with reference to an Arnhem Land bark painting, *Crab Dreaming,* on one side, and a Western Desert acrylic painting entitled *Wild Yam Dreaming* on the other. Directly opposite this text was an exhibit labeled *First Impressions,* referring to the first impressions Europeans had of Aboriginal people. Here prints made of the Aboriginal inhabitants of Queensland by early travelers were combined with examples of shields from museum collections that resembled those in the prints. This combination could offer a degree of reflexivity for the exhibit as a whole: embodied in the prints is the stance of other, earlier Europeans looking at Aborigines. For many viewers, however, the prints undoubtedly functioned to locate the artifacts as authentically, historically part of an Aboriginal world we can no longer see directly.

At the next stop, *Dreaming Places,* the wall text was flanked on one side by an Arnhem Land bark painting of a fish, said to represent an ancestral being at the place, and, on the other side, by an acrylic painting from the Aboriginal community in Balgo, W.A., said to represent water among sand dunes. Beside this space was a rather moving, self-contained treatment of Aboriginal representations of dogs—including some lovely models of dogs, a painting of dogs that was said to be related to a myth about dogs who live on the sea, and some magic sticks or charms used to get lost dogs to return.

The fourth topical development was labeled *Dreaming Stories,* a cluster that combined an acrylic painting by Clifford Possum on one side with a Tiwi bark painting, *The Death of Purrukapali,* on the other. Purrukapali is the Tiwi mythological culture hero who began "death." The final topical category, *Dreaming Symbolism,* illuminated some of the differing graphic conventions of Western Desert acrylic art and Arnhem Land bark painting.

From this more didactic series, the viewer proceeded to the larger part of the gallery, which was devoted entirely to bark paintings. These paintings were organized not only to show something of the historical developments in the form (from the late nineteenth century until the present) but also to show how the human body was represented, the possibility of alternative representational perspectives on the same mythological object (using the Tiwi sun woman as a case), and differing means of representing the same object (catfish).

The viewer was directed next to exit the Starr Gallery and head upstairs. There,

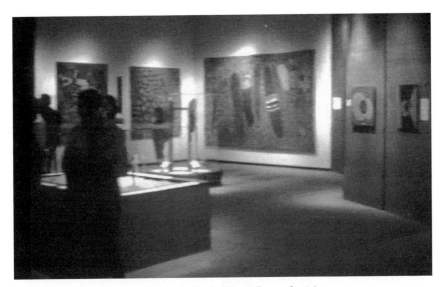

The exhibition of Papunya paintings in the Rockefeller Gallery at the Asia Society, *Dreamings*, November 1988. Photo by Fred Myers.

in the Ross Gallery, a panel combining photographs and text explained the history and context of acrylic painting. In a space behind the panel, audiences could view an ongoing (and self-repeating) thirty-five-minute video about the significance of Aboriginal art, the high-production-value video that had been made by self-identified Aboriginal media makers — the director Michael Riley and the Black Film Unit at Film Australia. When facing the panel, the viewer was surrounded by several striking wooden sculptures from Cape York Peninsula, exhibited in glass cases. A selection of photographs of women engaged in ritual activity at Yuendumu led into the large Rockefeller Gallery, in which were displayed most of the acrylic paintings.

The acrylics were interspersed with one case of four Central Desert shields with designs, a case of toas from the Lake Eyre region, and a few more powerful wooden figures from Cape York. With the mythological foundation of the designs already conveyed earlier in the exhibit, in the display of acrylics on this floor, one could attend again to more formal matters: one could view different paintings of the same story by one man — an arrangement to illustrate individual artistic creativity — or recognize in paintings of the same story by two different women the alternatives and selection of representational choice. One could also engage the different stylistic emphases of painters, contrasting the use of bright and bold colors from Yuendumu with the more muted and controlled panels from Papunya.

On the whole, one could leave the exhibit with an impression of the variety of forms of representation deployed by Aboriginal people in Australia, which certainly was one aim of the curators. There was, however, little comment on this in reviews. It seems either that the acrylic paintings—as "contemporary art"—stole the show for the reviewers, demanding commentary, or that the "spirituality" of Aboriginal visual culture became the focus. Although the barks and the acrylics are essentially contemporaneous, both produced for sale out of their own local visual traditions, the spatial organization of the exhibit, with the acrylics at the end of the visitor's journey, was seen by more than one reviewer as reflecting a temporal order in which the barks represented an earlier development in the same series.

Genres of Display: Crossing the Boundaries between Ethnography and Art

> As an exercise in the penetration of the metropolis by thought from the alleged margins of the world, *Dreamings* was inherently and intentionally subversive. Part of its story was that people could make marvelous meanings and marvelous objects within a tradition that had little room for personal creativity or "originality," where people preferred to look after meanings and relationships rather than artefacts, where the social rather than the individual was the basis of value, and where production and consumption could proceed without an accompanying religion of accumulation. These are hard stones to swallow on Park Avenue and Exposition Boulevard. (P. Sutton 1990, 178)

As Barbara Kirshenblatt-Gimblett (1991) has noted, the European (i.e., Western) tendency in display has been to split up the senses and parcel them out, one at a time, to the appropriate art form. Conventional museum exhibitions follow a pattern of partiality, of fragmentation in sensory apprehension by prioritizing the visual, which inevitably draws what is exhibited toward the classification as "art." Thus, she maintains, "When reclassified as 'primitive art' and exhibited as painting and sculpture, as singular objects for visual apprehension, ethnographic artifacts are elevated, for in the hierarchy of material manifestations, the fine arts reign supreme. To the degree that objects are identified with their makers, the cultures represented by works of art also rise in the hierarchy" (416). Of course, this was not the accidental but the intentional goal of the Asia Society's display techniques. In large part, the exhibition conformed to the modernist genre of display of the autonomous art object in installations that do not distract from the viewer's relatively unmediated confrontation with the work.

We must remind ourselves of what we take for granted about display, assumptions that are called more clearly into consciousness when one enters a museum with an Aboriginal person from the bush. Kirshenblatt-Gimblett reminds us of these: "One sense, one art form. We listen to music. We look at paintings. Dancers don't talk. Musicians don't dance. Sensory atrophy is coupled with close focus and sustained attention. All distractions must be eliminated—no talking, rustling of paper, eating, flashing of cameras. Absolute silence . . ." (416).

The paintings are hung at eye level, identified by artist, date, and title—but also by the language group of the artist. Some details of the story in the painting are provided, enough to identify the painting as narrative. To make the choice of genre clearer, the objects are presented *as* paintings, signaled as such by the installation; they are not presented in terms of the equally available oppositional avant-garde, or experimental, even postmodern, practices.

I say "in large part," however, because the wall labels and thematic groupings were more pedagogical than modernist fine art viewers would normally expect. In this sense, there was some hybridization, blurring the boundaries between art and ethnography, so that the paintings/objects were recuperated somewhat as objects of ethnography (Kirshenblatt-Gimblett 1991) and restored to context by the symposium and the sandpainting performances, as well as by the catalog (P. Sutton 1988). The Australian curators did not, as far as I can see, believe they could trust in the unaided or unmediated viewer's eye to engage these objects as "art" in the way that was intended. Instead, viewers were offered active, acknowledged mediation. The aim, however, was to transport the objects into a vocabulary of art, accepting a priority of the visual—even the formalist visual. That the dominant narrative, that this is art, was mildly undermined by the contextualization of the sandpainting and the symposium reflects the ambivalence of the South Australian curators themselves: this is art, but not exactly. Sutton understood this to be a subversive exhibition in that way, as not quite reinforcing the prevailing understandings of art. There were several elements to this subversion. Part of it lies in the double marginality of the curators to what they take as a center of power—Australian, and not only Australian but from the more provincial Adelaide (rather than Sydney or Melbourne), and anthropologists rather than art critics or curators. "Curation and writing by a group of Adelaide anthropologists and historians, rather than by people from the mainstream art world, has raised some interesting questions. Contrary to expectations, perhaps, we have not tried to present the works under a specifically anthropological model of culture, even though that kind of approach has inevitably influenced our vision of things" (P. Sutton 1990, 177). The blurring of genres is acknowledged, too, as the curator defends himself against a complaint

powerfully articulated in Australia that anthropologists cannot (or should not) acknowledge Aboriginal work as art (T. Johnson 1990; McLean 1998; Crossman 1990, 32).

In two distinctive ways, the exhibition crossed the boundaries between ethnography and art. One involves the question of quality, and the other involves context. The issue of quality comes into focus most clearly in Sutton's unpublished reply to John von Sturmer's 1989 review in the Australian journal *Art and Text*. The journal, it must be pointed out, is deeply expressive of Australian reservations from the periphery about the United States and American cultural hegemony. Sutton responds to "von Sturmer's flak," which accused the South Australian Museum of trying to convert itself from a storehouse to a treasure house, abandoning its implied proper role as a paradigm of completeness rather than a palace of excellence:

> This is sheer invention. We are interested in both representivity *and* the exceptional. We collect Aboriginal kitsch, for example not because it is rich home-decorator's treasure-trove, but because it is part of the real fabric of Aboriginal self-imaging in our time and says a lot more than just that. And our book explicitly denies that aesthetic excellence as experienced by curators is the primary criterion for determining what goes in such an exhibition. By including a considerable number of what most curators and art consumers would regard as visually humble pieces in *Dreamings*, we sought to subvert this particular form of domination and, yes, to *represent* what Aborigines have asserted to be the force, the formal propriety, and the other emotional-rational meanings, of their works. (P. Sutton n.d., 1)

The curators were trying, in other words, to have it both ways in addressing their own ambivalence and the sociocultural schemata that position objects — to make this art *and* ethnography. Such a representation would be to acknowledge in the Western space of art what Aborigines assert about their objects.

The provision of context has been one of the questions that have divided the installation of Aboriginal paintings as ethnology (artifact) or as art. A working curator, Sutton embraces the irresolvable problem: "We have also tried to walk that difficult road somewhere between the scholarly and the widely accessible. I have to confess that I initially had nightmares in which half the recipients of our efforts thought *Dreamings* was too obscurely academic and the other half thought it was just shallow popularisation" (P. Sutton 1990, 177). He declares himself unambiguously away from the avant-garde, experimental approach and for information: "Whatever the audiences want or do not want, Aboriginal art that is presented in urban institutional venues without any explicit attempt to enlighten the audi-

ence about its cultural underpinnings is thereby trivialised, misappropriated, and gagged—that is, its capacity to influence thought, in addition, to influencing visual repertoires, is suppressed" (177).

Nonetheless, as Sutton acknowledges, the exhibition and the very imagination of Aboriginal art relies on a specific ontology of the visual and technologies of reproduction that cannot constitute the indigenous experience of Aboriginal paintings. Thus, he maintains, the concept of a picture and the idea of the pictorial are unhelpful in describing Western Desert paintings. These paintings

> are statements of meaning beyond ordinary sight. . . . This immediately places the "artist" into the role of specialised giver of meanings, the reducer, the selector, the one who encapsulates the whole, or quotes from the whole, making something that is a part but is nevertheless a thing in itself. . . . The painting or carving is a granting to us of a *particular* sighting of place—and thus the social and spiritual position of its maker is revealed at the same time.
>
> The individual is not authoring, or authorising, the image; the image authorises and in that sense defines the one who executes it. . . . And yet clues to personal style abound. (P. Sutton 1992, 30)

Sutton was insistent that the exhibition should challenge the conceits of his audience, conceits of the art world about the individual, about the artistic process.

Framing: Art and Culture

So it was, in the way of preparation, that Aboriginal paintings and sculpture were recontextualized in New York City—within a field of cultural production articulated in the institutions and discourses of a prevailing art-culture system. Movement, destabilization, and dynamics are highly visible processes in the social life of things. But changing intersections of different levels of circulation cannot be understood simply as a "breakdown"—either as art into commodity, authentic to inauthentic, or as simple appropriation. The case of Aboriginal Australian acrylic paintings illustrates a transformation of what are essentially Aboriginal inalienable possessions (sacred designs) as they circulate through the state (where they are seen as having the economic and cultural potential for addressing its "Aboriginal problem") into commodities and then into fine art—supposedly emptied of ethnicity—as curators elevate their value in Western terms into a museum's inalienable possessions. The different levels of circulation and different forms of inalienability are articulated through the connection of distinctive institutional contexts.

Movements between regimes of value are not unusual. My friend and colleague Annette Weiner recognized such movement in the framework she developed for considering the processes in which individuals or groups created value in objects as they used them as "commodities" or "treasures"—alienable or inalienable possessions (Weiner 1992). An object's value, she argued, may shift through time as individuals or groups are forced or elect to enter treasures into the marketplace or as an ordinary commodity becomes revered by a collector or family members and takes on the value of an inalienable possession—one that cannot be replaced by another.

Clifford (1988b, 222) has identified another dynamic of value production in what he discusses as the modern art-culture system, the cultural machinery through which "objects collected from non-Western sources are classified into two major categories: as (scientific) cultural artifacts or as (aesthetic) works of art." This system, it is argued, "classifies objects and assigns them relative value. It establishes the 'contexts' [in the sense of the "commodity context" envisioned in Appadurai 1986] in which they properly belong and between which they circulate" (Phillips and Steiner 1999, 223).

In his model, Clifford describes how regular movements ("traffic") toward positive value can occur: "These movements select artifacts of enduring worth or rarity, their value normally guaranteed by a 'vanishing' cultural status or by the selection and pricing mechanisms of the art market" (1988b, 223). An area of frequent traffic in the system, he writes, is the one we have seen transected in the Asia Society exhibition—linking the context or zone of art (distinguished by connoisseurship, the art museum, the art market) with that of culture (history and folklore, the ethnographic museum, material culture, craft). Indeed, "things of cultural or historical value may be promoted to the status of fine art . . . from ethnographic 'culture' to fine 'art'" (223–24). This movement within the system involves representation of works as original and singular, as masterpieces—and the meanings or values embedded in such distinctions (Beidelman 1997). Not surprisingly, author and date labeled the paintings at the Asia Society, even while their tribe or origin was maintained. Moreover, the paintings that were selected are forever valued after the exhibition for their appearance in such an important event—which becomes part of the paintings' own history.

This is a system many scholars and arts practitioners now intuitively understand. I should point out that this art-culture system might be theoretically distinguished from the rather Simmelian understanding of value—things are valuable because they are difficult to obtain—articulated in Weiner's conception of inalienable possessions. What is perhaps less obvious is that this historically spe-

cific art-culture system is actually what some anthropologists would recognize as a structure or schema of value-producing activities. It is a schema that organizes or mediates (Fajans 1997; T. Turner 1973) the relationships between distinctive fields of material culture, "mutually reinforcing domains of human value" (Clifford 1988d, 234), and the activities in which they are embedded. "In the early twentieth century," Clifford writes,

> as *culture* was being extended to all of the world's functioning societies, an increasing number of exotic, primitive or archaic objects came to be seen as "art." They were equal in aesthetic and moral value with the greatest Western masterpieces. . . . This was accomplished through two strategies. First, objects reclassified as "primitive art" were admitted to the imaginary museum of human creativity and, though more slowly, to the actual fine arts museums of the West. Second, the discourse and institutions of modern anthropology constructed comparative and synthetic images of Man drawing evenhandedly from among the world's authentic ways of life, however strange in appearance or obscure in origin. (234–35)[3]

As Clifford's diagram of the art-culture system (1988d, 224; see page 191, this volume) implies, the classifications — "art" and "culture" — are rooted in, or linked to, distinctive institutions and practices that they mediate: art museums, art history, anthropology, natural history. Underlying the movement of Aboriginal painting into the category "fine art" are concrete examples of the practices and institutions that shape the process of classification (for others, see Beidelman 1997; George 1999). The movement of Aboriginal paintings into the zone of fine art necessitates the recognition of the art gallery rather than the natural history museum, aesthetics rather than context, and perhaps art history rather than anthropology. Yet the recontextualization of Aboriginal objects may also have transformed the context of fine art itself.

The global cultural ecumene exemplifies a predicament that Ken George (1999) described as "objects on the loose." This is not only a case of non-Western objects. As Steiner (2001) has shown in the historical example of abstract modern art (Brancusi's *Bird in Space* sculpture) being subject to duty as raw materials, as nonart because nonrepresentational, objects may not fit their categories of classification. In the art law case he describes, the placement of art in distinction from ordinary utility and commerce was contested. Steiner draws attention to the role of borders as sites of negotiation and transaction over the definition of things — indicating the human agency and knowledge involved in acts of classification (Steiner 1994). "At each point in its movement through space and time," he notes, "an ob-

ject has the potential to shift from one category to another, and in so doing, to slide along the slippery line that divides art from artifact and from commodity." These border sites are also, then, potentially sites of anxiety, where definitions are contested, subverted, and threatened, where objects may take on the form of "fetishes" (Pietz 1986; Spyer 1998), perhaps threatening—as *Bird in Space* did— "the very essence of American cultural identity" (Steiner 2001) or, in this case, the identity of the practitioners of art and anthropology.

9 Performing Aboriginality at the Asia Society Gallery

Life is translation and we are all lost in it. — Clifford Geertz, "Found in Translation"

The Asia Society produces programs and publications on the arts and cultures of Asia, presenting some eight special exhibitions each year; previous exhibitions had included *The Real, the Fake, the Masterpiece, The Chinese Scholar's Studio,* and *Akbar's India.* It has a staff organized for such activity — design consultants, catalog editors, fund-raisers, performance coordinators, and so on — and relies, moreover, on a network of designers and consultants who work in other cultural institutions in New York, from the China Institute and Japan House to the Metropolitan Museum of Art.

As one might expect, this history and institutional context provided a framework for the presentation of Aboriginal paintings, a framework that is neither that of an art museum or gallery nor that of a museum of natural history — the two exhibitionary complexes most commonly considered by scholars. Although the Asia Society could very well use the discursive formulations of art developed and deployed in dedicated museums of art, it has a somewhat more pointedly educational slant — dedicated to promoting "understanding of Asia and its growing importance to the United States and to world relations." Nonprofit and nonpartisan as it may be, the Asia Society is not a public institution in the same fashion as many museums considered in the literature. A somewhat hybrid cultural institution, the Asia Society is nonetheless organized within the parameters made possible by other institutions of display and exhibition and their presumption of audience, visuality, and knowledge.

Exhibitions are a distinctive technology of presentation that faces the problem of representing a totality or entity greater than itself (M. Ward 1996, 458). Different types of exhibition address the problem in distinctive ways and signify their

object accordingly. For example, art exhibitions since the nineteenth century have tended to be either the monographic or restrospective show or the "art movement" show. Scholars have pointed out that museums of history and memory or universal expositions (Mitchell 1989) have and had distinctive formats as well, and they have recognized that their capacities to represent a larger totality have relied on events besides the exhibition narrowly conceived.

There has also been a trajectory in the development of the institutions of exhibition as they have become increasingly public (rather than private) and legitimated through their attendance: they have become involved in producing "events." These include not only exhibitions, which are different from permanent installations, but also a range of other educational activities and public programs (Bennett 1995). The more general effort to make museums "eventful" should be recognized as part of their emerging structure, a movement that is making museums something more like public forums than temples of civilization as they enter into spaces of the bourgeois public sphere in which controversial interpretive exhibitions might be held and symposia might bring interlocutors face to face. They are, that is, shaped by the broader social context — democratization, popularization, "Disneyfication" — and its changes.

In the *Dreamings* exhibition, the Asia Society had proposed not just to exhibit art but to communicate about a relatively unknown culture through its art. It promised to introduce to the public both the "amazingly complex and rich culture of Aboriginal Australians, and the strength of this surviving and adapting culture as manifest in the vibrant artistic productions of the last 100 years" (Pekarik 1987). In formulating the value of Aboriginal painting in this way, the exhibition repeatedly tapped into particular connections between art and spirituality. The theme was especially marked in the punctuating events, which followed the grooves of an American preoccupation with Eastern spirituality and wisdom.

This was to be, as the NEH Implementation Proposal outlined, "a unique international exhibition" that would "reveal the creativity and depth of an extraordinary artistic *heritage*" (Pekarik 1987; italics mine). Furthermore, it was "to demonstrate that traditionally-minded Aboriginals have been able to preserve and invigorate a tradition that stretches back over twenty thousand years. This exhibition will also indicate the depth of cultural and spiritual meaning that lies behind many of the designs in these paintings."

One attempt to draw these problems into the exhibitionary complex itself was a two-day performance of sandpainting that brought two Aboriginal artists to the stage of the Asia Society Galleries. On 4 and 5 November 1988, two Aboriginal men from Papunya Tula Artists spent the weekend afternoons constructing a

sandpainting for an audience on that performance stage. Both well-known acrylic painters, Billy Stockman Tjapaltjarri and Michael Nelson Tjakamarra came from Papunya to show their culture. One of two events that brought Aboriginal participants in person to the process of representing their own art and culture, the two-day sandpainting was meant both to show something of the origin—the cultural and ritual context—from which acrylic paintings had developed and also to fill a cultural slot in the Asia Society's paradigm of programming.[1] Functioning as one in a set of representations of Aboriginal culture and a signifier of an emerging construct of Aboriginality, in this case, the performance by genuine Aboriginal people authenticated the presence of the Other in the paintings. If for some, the chance to see the actual Aboriginal painters was the *real thing,* asserting the genuine *presence* of the Other in the paintings, for others their presence raised prominent questions.

Interpretive Practice and Making Culture

I have chosen to focus on this event because, like the exhibition itself, the sandpainting represents a recognizable type of intercultural transaction. The performance of Australian Aboriginal cultural practice in a multicultural location is similar to others—increasingly taking place in venues ranging from art galleries and museums to rock clubs, such as the Wetlands in New York—that are important contexts for the contemporary negotiation and circulation of indigenous peoples' identities. For both indigenous performers and their audience-participants, this kind of "culture making"—in which neither the rules of production nor the rules of reception are established—is fraught with difficulties. Generally, such spectacles of cultural difference are scrutinized critically by anthropologists and other cultural analysts on questions of both authenticity and of inequalities in the representation of difference (e.g., Fry and Willis 1989). This makes them, in my view, all the more worthy of sustained attention.

The way in which the performance was stitched together discursively and practically is illustrative of a significant set of quandaries that, once buried in the handbooks of anthropological method and epistemologies, have come to occupy center stage in cultural study and the politics of difference. These quandaries—about ethnocentric projections, about the position of the observer-participant, about advocacy—are no longer external to the phenomenon. Translation *is* the ethnographic object. In the examination of concrete events such as making a painting, representation—anthropological and otherwise—becomes tangible as a form of social action. I also want to suggest that the uncertainties, the unsettled under-

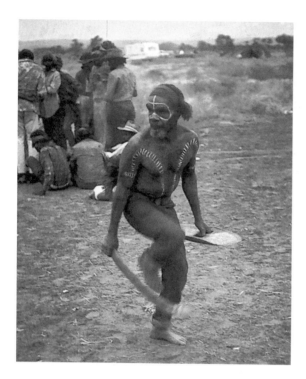

Shorty Lungkarta Tjungurrayi performs a secular dance for visitors from Arnhem Land. Yayayi, 1974. Photo by Fred Myers.

standings, are central to comprehending the variable production of cultural identity in different contexts—what I am calling (after Fox 1985 and Ortner 1989) "culture making" or, more specifically for an Anmatyerre man and a Warlpiri man, "becoming Aboriginal."

The event bore certain similarities with other presentations of indigenous art that have arrived from the old settler colonies from time to time (in Wild West shows as well as in the display of art). But I would suggest that the Aboriginal Australian cultural forms emerging in contemporary intercultural practice should not be segregated from the indigenous forms produced in other conditions: although they may be *new* demonstrations of spirituality and authenticity—that is, redefinitions and rediscoveries of identity worked out in the face of challenging interrogations from an Other—they are no less sincere or genuine as cultural expressions in this response to history.

Terms

With what do the Aboriginal performers understand themselves to be connecting? This culture making has a context, and we would do well to remember that

the translation of indigenous Australian culture to an American audience emerged from its particular dialogues.

However physically remote the people in Aboriginal communities may be, the relationship between them and the dominant society is mediated by Euro-Australian terms of Aboriginal self-determination, citizenship, and welfare dependence in a liberal state. In Australia, as elsewhere, indigenous people are struggling to find a voice and to define the terms of their situation in ways that will strengthen their own sense of autonomy, their local traditions and histories. Many recognize that to some extent they will have to work with the terms of the dominant society if they are to gain any cultural or economic advantage; others find it inexplicable that white society fails or is unable to recognize *their* terms. The comments and participation of Aboriginal painters in the *Dreamings* exhibition show precisely the extent to which the people I know are willing or able to recognize such terms.

The terms of discourse during the exhibition were, as numerous theorists of identity have argued, multiple and shifting (Bhabha 1986; Butler 1990; Ginsburg and Tsing 1991; Hall 1990; Spivak 1987). It should hardly be a surprise that, in recent years, Aboriginal people have increasingly come to be indexed by their artistic production, by products that stand for their identity. In many respects, the art world has constructed this new scene, the arena in which the Other — non-Western, non-white, nonmale — is being constructed and its use contested. Notably, even when the Other was invited to represent himself/herself/themselves in the 1980s, most frequently it was the "artist" who was invited to speak — be it Trinh T. Minh-ha, David Hwang, or Michael Nelson Tjakamarra. Around the artists, and sometimes through them, deep debates about the adequacy and legitimacy of representations of culture have been taking place.

Indeed, the dominant discourse about such performances still revolves around a view that indigenous people (natives) should present *themselves*. This position, once the oppositional critique of previous representational frames, tends to dismiss intercultural productions of identity. Those justly outraged and overwhelmed by guilt at the terrible things that have been done to Aboriginal people, for example, still represent them too often as merely victims or passive recipients of the actions of others. Thus the predominantly Euro-Australian art critics in Sydney and New York once dismissed Aboriginal acrylic painting as an inauthentic commodification (e.g., Fry and Willis 1989; P. Taylor 1989). For the art world, this is a judgment that reduces Aboriginal painting to insignificance (Price 1989), and it erases from our sight the ways in which Aboriginal people use painting to define and gain value from the circumstances that confront them.

In this light, it seems to me that most analyses of cultural performance would do better to address these events as forms of social action. In treating the sandpaint-

ing performance as social action, I am questioning the rather haughty treatments of exhibitions as texts outside the real activity of participants. Resorting neither to the tropes of romantic resistance nor to those of devastating domination, we should recognize the intersecting interests involved in the production and reception of such events. In addition to pursuing such an approach here, I want to argue that the significance of such events in the life courses and projects of participants goes well beyond the moment of their performance. An ethnographic perspective can draw attention to the neglected temporal dimension of such events of cultural objectification by considering the historical trajectories that bring the various players together.

Identity

The performance and circulation of collective identities by Australian Aboriginal people raise some central issues. One, as I have already suggested here and elsewhere, is the significance of cultural performances in Western settings, not just for the communication of aspects of an already existing collective Aboriginal identity, but as perhaps a central context of its very production and transformation. The other issue is the existence and production of an *Aboriginal* identity, as opposed to the less categorical and more temporary local identities that Aboriginal people had typically produced (or objectified; see Myers 1988a) for themselves in social action in the past. I remind the reader that there were no *Aborigines* until the Europeans came. There were, instead, people from Walawala, or Warlpiri people, or people of Madarrpa clan.

Before substantial contact and Euro-Australian settlement, the permanent, essential alterity of "us" and "them" was impossible—even if the Other (a self-other contrast) was a necessary condition of one's own definition.[2] There can be no doubt that the category "Aboriginal" was externally imposed—as settlers of European descent used the category to denote the original inhabitants of the continent who had no framework (or need) to grasp themselves as an identity (a difference) in opposition to some other sort of people. Indigenous people were quite able to do so, of course—as they typically extended the indigenous category of "human person" (e.g., *wati,* "man," or yarnangu, "person," for Pintupi; *yapa,* "person" for Warlpiri; *yolngu,* "person" in Northeast Arnhem Land) that had differentiated "real people" from other sorts of persons (or subjects) to contrast with "whitefellas" (Keeffe 1992; Myers 1993). To some, the very category "Aboriginal," therefore, reeks of its colonialist origins as the form of the indigenous people's domination and exclusion. Embraced by the descendants of the first inhabitants,

however, it has the potential of laying claim to a temporal priority that has moral power in claiming rights to land (as the concept of "First Nations" has in North America).

In contemporary life, there are undoubtedly numerous contexts in which collective identities are critical dimensions of social action, but a central arena for the performance and critical discussion—that is, the objectification—of cultural identity has been in the arts (Kirshenblatt-Gimblett 1995; Lippard 1991). Following a long history in which first objects representing their activities and beliefs, and then films, were circulated in museums and exhibitions, Aboriginal people have been participating increasingly as embodied representatives of their culture and identity in such endeavors, displaying their culture in external contexts in the form of "performance." These performances are always mediated, always enter into a ground prepared by existing genres—genres of pedagogical "instruction," avant-garde "shocks of the new," "nostalgia for the loss of spiritual wholeness," and so on. Moreover, if the performers, somewhat cosmopolitan visitors to a range of cultural festivals and performances, bring a sense of audience and intention, the audience participants bring at least two preexisting, sometimes overlapping, cultural frames for this sort of performance of cultural difference. One, more political and instructional, frame is the performance of ethnicity—where cultural difference indexes collective and (potential) political identity. This frame probably derives from the nineteenth-century folkloristic interests with national minorities, but it is now a significant discursive framework for the presentation of Third and Fourth World people (Graburn 1976; Paine 1981). The other frame, well established at a setting such as the Asia Society—where a typical presentation would concern Tibetan, Chinese, or Japanese art and performance—is that of coming in contact with a cultural form that is assumed to possess something of an "aura" of sacred tradition or aesthetic originality (W. Benjamin 1968). This was expressed in the most common piece of publicity circulated by the Asia Society, which extolled "the extraordinary vitality of Aboriginal art. It is the oldest continuous art tradition in the world, and is flourishing with new energy and creativity in contemporary media. The works in the exhibition represent the 'Dreamings,' the spiritual foundation of Aboriginal life."

Sandpainting was part of a group of events intended to help place the art objects on display in a sociocultural and historical context (Pekarik 1987). As an event, the performance also provided the sort of action that brought additional publicity—and attention—to the exhibition. Both the nationally syndicated *MacNeil-Lehrer News Hour* and National Public Radio produced news segments based on the performance.

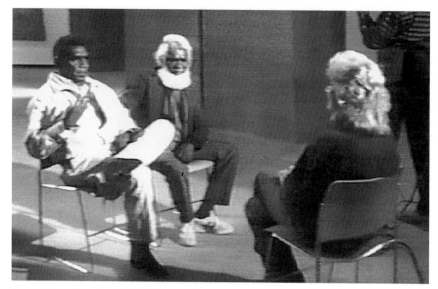

Joanna Simon interviews Billy Stockman and Michael Nelson for
the *MacNeil-Lehrer NewsHour*, 1988. Photo by Fred Myers.

The responsibility for arranging the sandpainting belonged to the curators from
South Australia (anthropologists Peter Sutton and Chris Anderson), who negoti-
ated for over a year with men from the Papunya Tula Artists cooperative. How-
ever, it was the Asia Society staff who *insisted* on this inclusion—to help show
something of the roots of the acrylic paintings in ritual life. The sandpainting
event, billed as "Traditional Sandpainting by Aboriginal Artists," cost $10 to attend
and attracted a more-than-respectable seven hundred visitors on its two weekend
afternoons. The rubric for the construction of a sandpainting was that such ground
designs constitute *one* of the traditional bases for the contemporary production of
acrylic designs on canvas. While the South Australian curators agreed to negotiate
for a performance, the secret/sacred (i.e., esoteric) nature of men's ritual and the
conventions for its display (well known to anthropologists) were problems, be-
cause performance in a fully public context would violate the prevailing rules for
the production of such symbolic forms.

The Anthropologist at Home

My own participation in this event was even more informal than had been my ap-
pearance in the symposium. When the Papunya artists arrived, men I had known
for several years, I visited with them and offered to make videotapes documenting

the event and trip for them to take back to show in Papunya. I spent most of the days of their visit to New York either shooting video and talking with them or, informally as a participant, providing anthropological knowledge to the audience. My ability to take on these roles was enhanced by Chris Anderson's interest; as the anthropologist who organized the sandpainting event from the South Australian Museum, Anderson was as interested as I in having a document of this unusual intercultural event. The Asia Society only videotaped the painting itself.

Ritual

Sandpaintings are typically constructed as part of ritual—including songs and reenactments of ancestral activities—in which all those present are essentially participants. "Showing" in Aboriginal Australia is definitively not "showing" as it has been understood in most Western contexts—not free and democratic but a vital component in an economy of exchange. Sandpaintings are neither independent entities nor performances for an audience of spectators; they are ritual constructions to which, like most forms of religious knowledge in Central Australia, access is restricted. Only initiated men would ordinarily be permitted to see these paintings. In that simple sense, the activity of constructing a sandpainting at the Asia Society was something new. And how to manage the painting in such a way as to adhere sufficiently to the restrictions on such knowledge had been discussed at meetings among the Aboriginal artists before they came to the United States. The artists had to protect themselves from criticism from others with rights to the designs and from possible spiritual dangers from misperformance. They were certainly cognizant of the possible jealousy of other men, although they had discussed their plans at length with others at Papunya. When Michael was interviewed by Joanne Simon from MacNeil-Lehrer, for example, and she asked him about the meaning of the dots in the acrylic paintings, he told her politely but firmly, "I can't tell you that name." Such knowledge was restricted.

Each of the men did a painting for which he had rights as what is called "owner" in Aboriginal English, or kirta in Warlpiri, rights that can be conceived of—for simplicity's sake here (but see Meggitt 1962; Munn 1973b; Maddock 1981; Myers 1986a)—as rights to designs and stories, including the right to perform them, obtained through a father who was also kirta. Such rights are differentiated from another complementary set of rights to the same objects, songs, and stories, which belong to those who are "managers," or kurtungurlu. Bill Stockman's painting was of the Budgerigar Dreaming, and Michael Nelson's was, typically, more ambitious; it included four different Dreamings to which he had rights: Possum, Kangaroo,

Flying Ant, and Snake. Such paintings would have been undertaken by several men under normal ritual conditions.

The Painters and Their Purposes

Two Aboriginal men were chosen and agreed to do the sandpaintings. An important criterion in their selection, which was taken in conjunction with the advice of Daphne Williams (then art adviser to Papunya Tula Artists) and a meeting of the artists themselves, was that both men spoke English relatively well. Their previous experiences of intercultural activity—they were used to representing or mediating their identities—meant they would be comfortable traveling to New York and communicating with people here. The Warlpiri painter Michael Nelson Tjakamarra is an intense, thoughtful, and complex person, the youngest son of a ritually very important father (and grandfather), who was long overlooked in favor of his rather glamorous older brother (V. Johnson 1997). Although the younger of the two men on this trip, Michael had achieved considerable reputation for his painting—especially for the design he did that was reproduced in a huge mosaic in front of Australia's recently completed Parliament House. One of Michael Nelson's paintings was in the *Dreamings* exhibition and was reproduced as the cover image for the catalog. But Michael had taken up painting only recently, and the older man, Billy Stockman Tjapaltjarri—Michael's classificatory brother-in-law—enjoyed a reputation as a painter from the earliest days of Papunya painting in 1972. Distinguished by his silver hair and full-bearded "elder" appearance, Billy had served as a member of the National Aboriginal Congress and a delegate to the Aboriginal Arts Board, visited the United States and France with earlier exhibitions of Aboriginal work, and traveled as one of the Aboriginal representatives to the Second World Black Festival of Arts in Lagos, Nigeria, in 1978. Other men could have come instead of these two, but they were likely choices, given the circumstances.

Why they wanted to come and what they wanted to communicate were more complex. First, there was the interest of a trip to a distant country and, second, the considerable prestige they expected to enjoy when they returned to Papunya because of their experiences and connections abroad. Such a value on relations from "far away" as a bulwark of one's own identity has roots in traditional Aboriginal life (Myers 1986a). At lunch one day after the sandpainting, the two men began to discuss the politics of their home community with me and expressed a sense that their own positions and control should be more significant than they currently were. Partly on these grounds, the videotape I was making was important to them: to show others.

In New York, the explicit purpose of their coming and their construction of

the sandpainting was to show Aboriginal culture to people of the world—so that people would understand and respect their culture. However obvious this might seem, the communication was hardly straightforward. Members of the MacNeil-Lehrer interview team, for example, were unable to recognize the significance of the painters' comments relating to Aboriginal identity, painting, and the dominant society; and the men, reciprocally, were highly critical of the way that the questions had been asked—too abrupt, too sharp. This is quite a common formulation Aboriginal people make of their difference from whites, especially in regard to the processes of recognizing persons, and of communicating and acquiring knowledge (Keeffe 1992). Ironically, these processes were fundamental to the entire project of communication and respect for cultural difference envisaged by the exhibition.

The painters were clear about their intentions when they arrived in New York City (Françoise Dussart, personal communication, 11 November 1988). As Michael Nelson said when we had a lunch break during the sandpainting, "I'm representing Aboriginal culture here." And he—and Billy Stockman—wanted this to go well. I believe that this act of representing has some of the significance for the men that the successful performance of ceremonies has in the local contexts. It certainly was an artistic challenge to Michael, who insisted on coming early to the Asia Society to check out the stage and conditions. Performing the ceremonies in ways that worked with the news media was distressing, given the disparity between Michael's emerging cosmopolitan identity as an artist and their take on him as an "exotic." Michael was a bit distressed about the day spent with the MacNeil-Lehrer people, who took the men to the Carnegie Delicatessen and the Central Park Zoo, a nearby venue where they could film them "visiting New York" and "being Aboriginal" (Billy talked to the animals). Michael, a different sort of performer from Billy, wanted to talk about the "art" (John Kean, personal communication, 12 November 1988). He expressed an expectation to be paid for appearing in a "film," a particular concern about control of images long an issue with Aboriginal people. At the same time, given his fame in Australia, he *had* expected to see himself on television in New York, and he was initially somewhat disappointed in the apparent lack of interest. However, after discussion with some of us, he decided that the publicity for their work—that it would be seen "all over America, right around"—would help sell paintings.

Event

Preceded by a short lecture on the first day by anthropologist Chris Anderson and comments by Beate Gordon, director of performances at the Asia Society, the

event began on each afternoon at about one o'clock and consisted principally of the two men sitting on a raised stage with each working at his own painting, applying acrylic paint and a fluff (wamulu) made from wild daisies to a sand surface. Wearing long trousers but with their torsos and faces covered with red ocher, the two men were mostly alone onstage, although the former art adviser to Papunya (John Kean) brought materials on and off for them. On the first day, the men decorated themselves only in red ocher and headbands, but on the second day, they painted designs on themselves before coming onstage. Drawn from the repertoire of the Tjartiwanpa ceremony involving a snake (known as Jaripiri) associated with a place called Winparrku, the body designs had nothing to do with those on the ground, but they stood for a bigger idea, of context—the relation of song, dance, and myth to sandpainting: for ceremony. In addition, they were designs considered viewable by women and noninitiates, and rights to them are shared by Nelson and Stockman.

Facing the seated audience of the large, sloping auditorium, the painters were surrounded by tins and small containers for the acrylic paint they were using and bags of fluff made from plants they had brought from Central Australia. The stage had been covered with three tons of special reddish sand brought in from Long Island. A single break was held during each afternoon, during which the men went backstage for a rest.

Much of the Asia Society's emphasis in framing this event was on the dramatic dimension of the men "painting up" and on the (eventual) "disempowerment" of the paintings as the climax of the event. At two points, the men performed a dance—a modification of performances that men enact in contexts quite different from those involved with the paintings they were doing but which were chosen because they revealed no restricted knowledge. This ceremony was one they could show without concern—having rights to it and given its public status: "Because it's an easy one [not 'dear'], you know. I can sing that song [as an owner of the Dreaming] and he [Stockman] knows how to dance. Also we picked out the Snake Dreaming because everybody can look at it. Even in Central Australia when video team comes they can see it. It's clear [there are no restrictions on public performance]" (Michael Nelson, quoted in Kean 1989, 13).

For these performances, Michael Nelson, his back turned to the audience, sang the words of a song from the Tjartiwanpa ceremony and provided percussion by clapping together two boomerangs while Billy Stockman danced the conventional movements across the stage behind the paintings. On the first such occasion, Billy did only a single dance, but in subsequent appearances of this sort, he did four different dance sequences. The second day built toward what was advertised as

the "disempowerment" of the sacred images of the sandpaintings, which was performed by each man throwing sand on and disrupting the image of the other.

The disempowerment was a new twist, owing considerably (I believe) to the Asia Society's previous performances of Asian religious art. Nonetheless the framework of such performances has become conventional in recent years for Central Australian people. Cultural improvisation is not new, even for the "bushiest" and least experienced of Aboriginal people. For example, ground paintings were similarly produced to accompany exhibitions in Sydney and Melbourne in the early 1980s, and painters from Papunya accompanied an arts group sponsored by Aboriginal Artists Australia that performed throughout the United States in 1981. Aboriginal women have likewise been performing their dances in arts festivals around Australia with considerable regularity and enthusiasm. These experiences, reported back by participants to their compatriots at home, provide the basis for a genre of cultural performance that is still partially unfixed.

Another dimension of the event was the alternation of long periods of silence —with the audience simply watching the painters—with the presentation of background information by specialists, especially Chris Anderson and Françoise Dussart (and on occasion me), and questions from the audience, addressed, by request of the painters, to those "white people who know about Aboriginal traditions." Unintentionally, this created a rather bizarre concatenation of meditative, observational silences and pedagogical overlays on a distanced and (apparently) unattainable pair of performers. It led one visiting Australian artist (Christopher Hodges, shortly thereafter to become a dealer of Aboriginal art) to complain, in writing as well as in the lobby of the Asia Society, that the event was "like a diorama." Hodges's complaint suggests that the presence of Aboriginals in the sandpainting performance, ironically, violated the convention that the Others should speak for themselves—a convention that had been rigorously observed in the symposium that preceded this event by two weeks. An artist himself, Hodges had recently visited Central Australia and had combined his sense of Aboriginal painters' copresence (Fabian 1983) with the more general critical stance toward such representational practices.

Performance

The event, however problematic from the point of view of Aboriginal practices, made perfectly good sense in its slot within the Asia Society, which has hosted performers from many different cultural traditions, ranging from Kathakali dancers to Chinese singers. Beate Gordon, the Asia Society's director of performances,

introduced the event to the audience by emphasizing "distance," "uniqueness," "difference," and "sacred ritual" (although her own concern with authenticity was ironically undermined by her emphasis on the newness of the event).

Anthropologist Chris Anderson then took over, attempting to explain the inexplicable—what people would be seeing (or not seeing). Notice how he gets caught up in contradiction with the prevailing frame of interpretation:

> The performance today, I'd like to explain, is not really a performance as such in that it's not a dramatic event. . . . It's not a ceremony in that this work is normally done with many more Aboriginal people involved. It's very much a *social* event. It's a deeply *religious* event, and it's an important political event. In that sense, *this* is not a ceremony because there are too few people. It's a very strange context for them and so what they've done. . . . It took a long time of talking, perhaps a year or so of discussion. . . . It wasn't just a matter of negotiating with two individual people about the whole thing. There was a much larger social universe that had to be consulted before we could really get agreement on how it could be done. . . .
>
> I just thought I'd mention that it *is* special and that they have modified the designs to some extent so that they can do them. . . . Normally men doing this is secret and only open to initiated men. . . .
>
> They're only showing you the top part, the outside part. Other layers are too important, too powerful, too dangerous for settings like this. In fact, any setting outside the normal one in which the ceremony that the event is part of would be too dangerous. So they have modified it.

Anderson went on to tell the listeners that the painters had to make adjustments, which represented the flexibility, creativity, and ongoing continuity of an Aboriginal culture that was once conceived as static and doomed. For the men, he says, the performance is a denial of just this view. Their culture is alive; they are *here.* And the conditions of performance do not interfere with *their* understandings of the sacred. As Anderson explained, "Because it's sacred doesn't mean we have to adopt this reverential attitude towards it. The men see this—and this is the reason they're doing it—they want to present their culture and their worldview to non-Aboriginal people and particularly to Americans. So they are happy if you have questions and want to look."

The Aboriginal men regarded this performance very seriously, and they were proud of how they comported themselves. They wanted approval and recognition, which required sustaining an illusion: Billy Stockman was finished with his painting by the end of the first day but had to keep painting over it during the

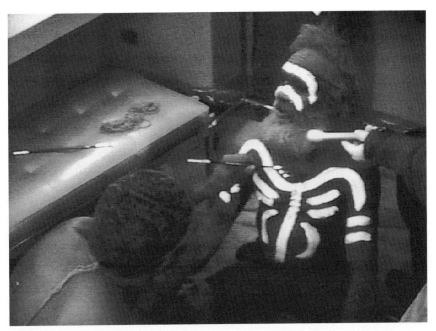

Billy Stockman and Michael Nelson backstage at Asia Society Galleries, 1988.
Photo by Fred Myers.

second day; Michael Nelson was concerned that people not be so close as to see how the ground had cracked, but felt that he had been able to cover it sufficiently with paint to hide it.

Backstage at the Asia Society in the dressing room, with its mirrors and makeup lights, the chatter and conversation were markedly different from the silence on-stage behind which the painters moved in their own space (above). Realizing how participants talk about ritual performance in ordinary contexts, I told them I was impressed that they were able to sing and dance alone—without "shame" or "em-barrassment" *(kunta)*. Michael said it *was* hard, with so many people. But "we [are] representing our country."

At times, the men's conception of performance in this context and their concen-tration of effort had unforeseen effects. Quite significantly, the two had insisted they did not wish to answer questions while they were painting onstage; this would interfere with their concentration for work, and they didn't seem to want this kind of intrusion. They were, they said, very happy with our help in that respect, al-though in listening to what we said, they had suggested some elaborations of what they would like people to know. The result of this interpretive practice was the

alternating periods of questions and anthropological talk about what the audience could see on the stage and the periods of hushed silence as people just watched.

The silence is untypical of Aboriginal ritual events, especially in the preparatory stages, when forms of sociability such as chatting, card playing, and ceremonial singing accompany the ground painting. Silence at the Asia Society added a sense of a reverential, meditational concentration that is not at all obvious—if present—in the original ritual contexts. Many of the audience members commented on this quality of the event, and Chris Anderson anticipated this in the comments I described before. Anderson may still have been forced to play into this framework of "spirituality" by not owning up fully to this event as a sort of commodity, although he did say that men had left out parts, that they decided to show what was only a part of a larger event. Despite these disclaimers, so to speak, many in the audience did not seem to grasp how different the context really was.

What was this? people wanted to know. Was it a ritual event? A commodity? What was being performed? Much of the emphasis in framing the event and discussion from the audience, especially on the second day, centered on (1) the theme or drama of the "disempowerment" of the paintings at the end (a theme that came from the Asia Society's advertisement for the event and that I take to be derived from the comparative religion tradition that is significant at the Asia Society), or (2) the men's painting themselves with designs (although the body designs were not from the same Dreaming as the sandpaintings, which nobody mentioned to the audience).

For the men, this fused genre was not a ritual, although it shared many features with ritual: before coming to New York, for example, the men had been careful to obtain permission for the performance of this knowledge and design with others at Papunya who had rights to it. So although it was not exactly a ritual, the men saw it as a performance that, like ritual, was expressive of their identity: their local identities as persons defined by their relationship to land-based ceremonial forms, their identities as mature (initiated) men with ceremonial knowledge, and their identity as Aboriginal (in contrast to whites).

The men were authentic, but conventions of authenticity were problematic throughout the event. The men discovered this when they considered forgoing the Asia Society's hard-sought three tons of Central Desert–looking sand trucked in from Long Island. Because the sand did not take water and produce a smooth surface the way Central Australian soil does, the men said they preferred to paint the designs on the masonite-board floor—which itself had a reddish tone. The Asia Society representative breathed deeply for a moment and said, "This is supposed to be *sand*painting; we advertised *sand*painting." Faced with this, the men graciously gave in.

Audience

The response to the sand construction was complex and varied among the audience and the performers. Cross-cultural communication is, in any case, complex and difficult. We cannot satisfy ourselves in accounting for this event by simple recourse to the Aboriginal point of view. We may know their intentions and goals, but in this sort of improvisation, to use a word appropriate for such performances, no one quite knows what the categories are. Neither the artists nor the audience had a fixed and accepted framework within which to place the event. The anthropologists seemed uncomfortable, as well, with the departure from convention and from the "authentic" or, at least, uncomfortable that the audience might take the new for the "authentic" context.

The audience brought to this event a number of frames, including (1) that it was a ritual (was this going to bring power to New York?), and (2) that religious activity was intrinsically meditative, contemplative (the silence was wonderful). The director of performances for the Asia Society stressed the uniqueness of this event (never seen in the United States). A number of spectators were anthropologists, some were artists, but most were part of the cultured middle class who attend similar kinds of educational events in New York. Not many of the people we encountered knew much about Aboriginal art. The Asia Society's typical events—Kathakali dancers, for example—are more clearly performance than this. What audience members took from their participation was varied, undoubtedly, but suggested a set of frameworks that belong comfortably within the categories of Western culture but recognize the limitations of their knowledge.

Let me give two more examples as illustration:

> *Audience member:* "What I like about it also, is that you are dealing—I don't know if this is characteristic when it's really done in Australia—but there is this mixture of a casualness and a precise attention at the same time, so that you can come in and out. They seem to have a sort of relaxed attitude about it, so there is that sort of aspect to it. They are both very precise and concentrated but also sort of relaxed, get up, go around and get things to drink."

And finally:

> *Audience member:* I'd never seen it, of course none of us has ever seen anything like this, since this is the first time it's been done in the United States. I think the show is a major show, in this country. I don't know that much about the art myself, but aesthetically I find it very pleasing. I also like the idea of art, culture, art being part of the whole culture, the whole society. Too many westerners tend to separate it into separate categories. We forget that

even for ourselves, art grew out of our religion, our history. It was part of our whole life, not one separate category. But it's wonderful to see these things and to learn about them. To get this one-world global picture.

This was certainly not the last performance of Aboriginal culture in the United States, and the genre and its conventions have continued to emerge. Subsequent events, such as the "Walkabout Tour" in 1991, which involved two other Papunya painters with two Euro-Australian poets, attempted to evoke other—perhaps more avant-garde—relationships between cultural traditions. New Age contexts have represented another arena for elaboration. This emerging genre, then, seems a good example of the necessity of differentiating the phases of "encoding" and "decoding" in the process of cultural production (Hall 1993).

One should remember that however troubled and imperfect they may be as incidents of representation, the effects of such events may outlast the moment. I think no one really knows what "happened" on the stage, whether spiritual energy and danger were invoked or negotiated, or whether Aboriginal relations to place were securely signified. It is not insignificant, I think, that a seven-year-old boy whose mother brought him to see the sandpainting was so captivated that four years later he did a school project on an imaginary trip to a foreign country on Aborigines in Australia.

Conclusion

I have tried to create the sense of the Aboriginal performance at the Asia Society as an *event,* a social engagement among participants with varied cultural and political backgrounds, trajectories, and purposes. It is particularly important to sustain this perspective if one is to grant any real value to the position(s) adopted by the Aboriginal performers in their improvisations. The view of these events simply as moments in a longer history or structure of domination or subjugation, however accurate they might ultimately prove to be, ignores the play and possibilities of the event as a form of social action that is not necessarily reducible to a past or future social state. Not only is there much for us to learn about the experience of such intercultural transactions by this attention; there also seems to be little alternative. A postcolonial ethnography, one that does not articulate itself within the existing relations of knowledge and power, should attend to these actors' considerations over our own critical judgments.

I have continued to hear some of my anthropological colleagues bemoan the growing interest in "representation," as if representation were outside of the object

of ethnography and not a part of social practice. As I have tried to make clear, representation has become increasingly significant as a social practice through which indigenous people engage the wider world. Therefore I intend for this ethnography of some unsettled events to provide an example of the increasingly common situation in which cultural translation is no longer confined either to anthropology or to the academy. This is what I mean when I refer to the destabilization of fields of representation. As might be suggested by ongoing and passionate debates about cultural homogeneity or heterogeneity, about multiculturalism, cultural pluralism, and the recognition of "difference," such translation constitutes a major dimension of social life itself. It goes on regularly and commonly, if imperfectly.

The status of cultural production has been inflected with a further consciousness in its new context: for Aborigines, to make a painting now is also sometimes "representing one's culture." They do so, of course, not always in the times and places of their own making or choosing; instead, they—and I, as ethnographer— operate in a variety of local settings and mediate pragmatically and intellectually between cultural traditions. Aboriginal people do indeed produce their identities partly in relation to discourses emanating from the West, but these discourses are not monolithic, not invariant, and the social contexts in which practices of representation operate have varying effects and significance.

Both Michael Nelson Tjakamarra and Billy Stockman Tjapaltjarri held complex views concerning the domination of Aboriginal Australians by the larger white settler society. Indeed, since the 1970s Billy has frequently deployed the image of an Aboriginal struggle with whites for control over resources in local and national-level disputes. Nor was Michael Nelson naive about the social and cultural inequalities in which his daily life took place. These are as obvious to both men as have been the negative evaluations of Aboriginal life and culture, of their "nakedness" and "ignorance." Yet in their performance at the Asia Society, they constructed themselves and enacted this cultural politics in a nonconfrontational fashion, drawing on an ongoing indigenous tradition of practice whose importance they continued to uphold *in its own right,* and not just as a counter to external judgments. In this subjectivity, demonstrating something they hold as self-evident, they resemble other Aboriginal people who have found Australian colonialism to be morally unintelligible (Rose 1984; Rowse 1996). At least until recently, Michael still seemed to have retained a belief in the possibility that white Australians will respond morally to the demonstration of Aboriginal ownership of land self-evidently embodied in ritual and painting (Myers 1991, 51–52)—that they might recognize Aboriginal "Law."

This form of Aboriginality represented a part of the identity performed at the

Asia Society. One could say that in their agreement to perform a version of an indigenous ritual practice, the men accepted the position assigned to them as "primitives," but in doing so, *they* set the terms: (1) they made the decision to come, both individually and as part of an Aboriginal collective; (2) they chose not to talk during the performance; additionally, in the construction and evaluation of what counted as a "performance," (3) they assumed the identity of performers and artists and thereby added a degree of discursive consciousness and intercultural awareness to the available conception of what indigenous persons are like.

The event itself was a fused genre; it was demonstration and work display fused with the aesthetics of performance art.[3] Its commentary, didacticism, and documentary aspects likened it to demonstration and work display, but as in performance art, we were invited to watch "real people" (not actors) in process in real time, unscripted, engaged in activities from their everyday lives and conducted in open view. To the degree that these process performances are framed as an aesthetic event and enjoyed in themselves (rather than as a vehicle for communicating something else), they are like performance art. This accounts in part for the audience responses, which ranged from "learning" (curiosity satisfied) to "aesthetic experience" (transport).

The relevances of this performance were several, direct and indirect, economic and cultural. The most concrete material effects of their performance, of course, were felt in the market, where convincing appearances establish value for Aboriginal art, one of the few nondegrading economic possibilities available to Aborigines. Events such as this performance made the exhibition newsworthy and from that point of view increased non-Aboriginal people's exposure to Aboriginal paintings and culture more generally. Perhaps more significantly in this case, the ability of the performers to enact the ritual foundation of contemporary acrylic painting provided an anchor of commercially valuable authenticity for this more hybrid work as a product of the indigenous imagination (Price 1989).

The significance of these material effects — in this and other exhibitions and performances — does not end there, however, because Aboriginal art producers clearly feel that such recognition enhances their cultural power. As with indigenous people elsewhere, Aboriginal people see themselves often to be taken more seriously overseas than at home. Thus the constructions of Aboriginal culture that take place in foreign venues have significant consequences for processes of Aboriginal self-production. Ironically, many Aboriginal attempts to sustain the realm of local meanings and values — a long-standing concern of Aboriginal cultural life — may be occurring now in these newly developing forms of social practice that are in other ways transnational.

Of course, these social relations are not those in which still-dominant indigenous conceptions and practices of Aboriginal personhood were previously reproduced. And this is precisely what arouses the suspicions of critical theory that condense around—even reproduce—debated notions of authenticity, commodification, spectacle, or hybridity. To be useful, critical readings of emerging forms of cultural production must overcome not only the continuing nostalgia for a cultural wholeness but also the concomitant reification of the concept of culture as more of a structured given than an imperfect fiction that is ambiguously mediated by multiple and shifting discursive moments (T. Turner 1993).

The questions that ought to be asked about the politics of current forms of Aboriginal cultural production are whether and to what extent local (community-based) social orders are defining themselves—their meanings, values, and possible identities—autonomously in relation to external powers and processes; whether and how they are transformed in relation to new powers and discourses; and whether or how what had been local meanings are now being defined dialectically (or oppositionally) with respect to discourses available from the larger world. Thus our interest in events such as the Asia Society performance lies in a closer examination of cultural mediation as a form of social action in uncertain discursive spaces, of unsettled understandings—in short, of culture making. The concept of culture making, as Sherry Ortner (1989) shows, allows a more direct focus on relationships between collective social experience and the performance of individual identity. This perspective can go beyond the common postmodern view on intercultural performances that limits the interpretation of such events to their ironic aspects and denies the distinctive agency of the culture makers as well. Such a view suggests the difficulty that occurs when once-standard anthropological notions of culture and of the passive "culture bearer" are imported into the processes of intercultural transaction (Clifford 1988d).

In asking what such performances of Aboriginality accomplish, one faces the problem of conceptualizing a type of intercultural transaction that has raised suspicion on two fronts. Anthropologists have been disdainful of the apparent naïveté and ethnocentrism of audiences, while avant-garde critical cultural theorists have concentrated on the representation (and display) of cultural Others as an ideological function within the dominant (Western) system (e.g., Clifford 1988d; Foster 1985; Manning 1985; Trinh 1989; Torgovnick 1990). Despite their power to discern inequality, such insights have not captured the more shifting and subtle constructions and disjunctions of actual communicative (or performative) practice. Thus my recourse to the notion of such events as occasions of culture making is an attempt to recuperate the ethnographic experience of this intercultural performance

and my own engaged exposure to the perspectives of its participants. To ask where (or how) culture is being made brings us closer to the Aboriginal point of view and practice and the significance it gives to the interests of Western audiences (Hall 1993, 398). The emphasis on how dominant cultures "produce" their Others has, it seems to me, gone as far as it can with confident sermonizing on colonial processes; what is needed is a more ethnographic attention to the meaning of such transactions to participants (Clifford 1988d, 1991), to what these Others make of us, however unequal the power relations through which such mediation takes place.

If culture making is taking place, then one must take seriously the audience and its role — as the Aboriginal performers did. In contrast to stances that might render the Aboriginal participants too simply as passive victims of the subjectivity — or gaze — of others, one needs a more complex approach to articulating the powers and processes through which discursive formations operate and are realized in people's lives. Far from being the condition of their subjection, the audience's gaze is crucial to the Aboriginal performers as an authentication of their experience. To ignore this exchange analytically is to exclude arbitrarily much of what is an Aboriginal self-defined humanity, as one who should be respected and heard, their own powers and understandings; this would be a double erasure.

It would not have been too difficult to turn this history of Aboriginal identities and gropings toward translation into "farce," so full of ironies and fabrications is it. In place of such treatments of exhibitions as texts outside the real activity of participants, I suggest that one consider events like this as forms of communicative action — performance — in which participants attempt "to encompass what is alien to one's imagination" (Rowse 1991, 2), performances in which neither the rules of production nor the rules of reception are established. It may be difficult for critical theory grounded in Western thought to grasp such "performance" and its theatricality without suspicions about its authenticity, as Dening (1993) has argued. To foreground the disjunctions — humorous as they undoubtedly are — fails to recognize the sincerity and purpose of the Aboriginal participants to make something of themselves and their cultures known, to "objectify" themselves not only as a type of people but also as worthy of international attention and respect. Such an approach fails, as well, to capture the important quality of performance itself: *to connect* (V. Turner 1982). Such pragmatic and contextually specific mediations of cultural traditions are the stuff of cultural production from which we should draw our understanding of postcolonial realities.

10 Postprimitivism: Lines of Tension in the Making of Aboriginal High Art

The construction of Aboriginality in Australia has been achieved through a variety of processes, in various places and at various levels of society, giving rise to a complex interaction between the loci of construction. At the local level, the most striking line of tension may seem to lie between what Aboriginal people say about themselves and what others say about them. But crosscutting this is another field of tension between the ideas of Aboriginality (and non-Aboriginality) that people of all kinds construct and reproduce for themselves, and the constructions produced at the national level by the state in its various manifestations, the mass media, science, the arts and so on. — Jeremy Beckett, "Colonialism in a Welfare State"

Dreamings was an objectification and transformation of Aboriginal culture. As with any cultural form, the value the Aboriginal paintings were intended or projected to have in production, by their makers, encounters a different context when they are placed in relation to other kinds of value by those who subsequently acquire or deploy them. Just as sacred objects may circulate against the value of a wife and affines, of personal maturity and autonomy in the process of social reproduction, so do Aboriginal acrylic paintings engage distinct regimes of value in the state, in the market of tourist commerce, or in art galleries.

The *Dreamings* exhibition met with an extraordinary critical reception. Reviews in the major publications and periodicals — from the *New York Times* and *Time* to *Art in America* — signaled the apotheosis of acrylic painting as a fine art. Yet the reviews mark an unsettled transition, of debate and disagreement as well as celebration. I was captivated by the flurry of interest in Australian Aboriginal acrylic paintings in the 1980s and after — in exhibitions, articles, and contentious reviews. From the occasional article by Terence Maloon in the *Sydney Morning Herald* in the early 1980s, when he was almost the only writer taking this work seriously, production increased to a trickle and then a flood in Australia, leading up to the internationalization of such writing occasioned by the *Dreamings* exhibition. Yet

by 1988 there were still no specialist art writers for Aboriginal art, and relatively few books on the topic. As Peter Sutton (1988) indicated, and as Fry and Willis (1989) decried, Aboriginal art was very much a "field in the making," whose relationship to other domains of knowledge and value was still uncertain.

The origin of this chapter lies in my sense of disjunction at the sheer variability and the highly contestatory nature of critical art writing about the *Dreamings* exhibition. In my view, the reviews represent a moment in the complex encounter not generically between "the rest and the West" but between acrylic painting and the art-culture system, a system in which — as Clifford makes clear — objects can move (or be moved) from the category of "culture" (artifact) to that of "art." But this transition also involves a movement in the system, embodied in disciplinary practitioners and institutional specializations and dynamically registering changes in the material relations of cultural production.

Art and Culture

The Asia Society exhibition was addressed to a Western category of art, a category that Paul Oskar Kristeller ([1951] 1965), Raymond Williams (1977), and other scholars tell us only came into form after the Middle Ages. The objects placed on display were not intended primarily to represent the equally available categories of history, material culture, or religious artifacts — alternative forms of cultural capital that were available. Rather, the expectation was to produce a view of Aboriginal culture people as creative, resilient, and dynamic — as producers of art.

As we will see, however, the exhibition's framing engaged with a more complex art field than might have been imagined, illuminating a less monolithic and stable, more dynamic art-culture system (Clifford 1988d; see also Phillips and Steiner 1999; Plattner 1996) than the apparently simple category of art once implied. Thus the eruption of art writing and interpretations of the exhibition and these paintings in 1988 was astonishing, given its virtual absence earlier.

No one should think that I started with such an awareness of my placement within a historical trajectory. Originally, what most impressed and disturbed me was the opposition between art writing and anthropological knowledge, which I further understood as a disjunction between local and cosmopolitan accountings of the objects. I was involved in what grandiosely might be called an "interpretive struggle" that I only later understood to be a moment in the emergence of a field of cultural production. The dynamics I describe involved both the anthropological local versus the art-writing global and the struggles among the different players who embodied the regulating values of the art-culture system — from gal-

lery owners to critics to government policy makers. They were all players in the varying domains, or loci of construction, within which Aboriginal paintings were made to represent Aboriginal culture as an objectification — as Jeremy Beckett so powerfully recognized (1988, 191).

Disjunctions

My research with Pintupi-speaking people had taken me to a number of local communities far to the west of Alice Springs since 1973. Even in these remote communities, the Aboriginal producers of acrylic paintings lived in a world complexly related not only to the Australian state (through welfare payments and other forms of services) but also to an international world of images (films, videos, television), music (country and western music, rock and roll, gospel), and clothing (especially, for men, the cowboy/stockman attire of jeans, boots, and Western shirts). Evangelical activity competed with religious movements of cultural revival and intensification, but indigenous meanings continued to dominate local discourse. Such intermingling of culturally heterogeneous forms is, of course, one of the principal problems for contemporary cultural theory. A decade and a half after painting was first adopted as an activity, then, was it a means through which Central Desert people added their voices to the cultural discourses of the world? Or was it more evidence of cultural homogenization?

My experience suggested that the disjunction between the arenas in which meanings were produced and circulated was more complex than a narrative depicting the simple commodification of sacred forms. There was a sense of spatial and cultural incongruity that accompanied the globalization of cultural processes, when people in New York City discussed and evaluated the meanings of Aboriginal objects and the intentions and lives of their producers.

The gap between how the producers accounted for their paintings and what significance they were made to have in other venues was profound. In all the interpretive activity devoted to Aboriginal paintings, I have found Meyer Rubinstein's insightful review to grasp best the elusive situation that I am labeling as disjunction:

> But for now, as our two worlds meet upon the site of these paintings, we and the Aborigines are in similar positions: neither knowing quite what to think. For both societies the appearance of these paintings is relatively recent and their nature and role is still being discovered. They are in limbo between two homes, sharing their functions and sense of belonging with both, but not fully

explicable in either's language. They are, like those ancestral beings whose journeys they depict, traversing a featureless region and giving it form. In the words of an Aboriginal man trying to explain Dreamings to an anthropologist, "You listen! Something is there; we do not know what; *something*." (Rubinstein 1989, 47)

We cannot understand these processes by attempting to transcend the gap. Rubinstein's discussion conceived of the engagement of critical discourses with their subject not just as the encounter between reified, hypostasized cultural categories ("art" and "Dreaming" or Tjukurrpa), as has occurred in the past in the structures of "primitivism," but as human *activity* that should be examined (see also Becker 1982, 131–37; T. Turner 1980). Aboriginal objects are not simply or necessarily excluded by Western art critical categories; they may in fact contribute to or challenge these discourses for the interpretation of cultural activity in productive ways. They can hardly do so, however, if interpretation accepts a stable category of "art" as its horizon of translation.

Construction: Aboriginal Culture as Art

In previous chapters, I have discussed in detail the range of indigenous accountings available for this activity. They included, it might be remembered, painting as a source of income, painting as a source of cultural respect, painting as a meaningful activity defined by its relationship to indigenous values (in the context of self-determination), and painting as an assertion of personal and sociopolitical identity expressed in rights to place.

The representations of the acrylic paintings offered by whites primarily constructed a *permissible* Aboriginal culture, a representation that meets the approval of the dominant white society's notions of a "common humanity." The reasons for this are complex, but let me start with the initial framing devices. Most of the constructions of acrylic paintings interpreted them within the rubric of art, providing the link that criticism offers, according to Michael Orwicz, in "negotiating relationships between culture, on the one hand, and a range of social and ideological formations, on the other" (1994, 2). This linkage occurred at two levels: (1) the assertion and demonstration that Aboriginals have art and value it, that the tradition is very old (implying that they are able to preserve things of value), and that therefore their culture is vital and worthy of respect; and (2) that this "art" contributes something important — something different or challenging — to the world of art. It will be clear that much of the construction of Aboriginal activities as art drew heavily on a variety of themes in modernist discourse, ranging from visual inven-

tion to human creativity and the loss of spirituality in the West's modernity. These constructions, then, can be seen as fundamental to the intercultural production of Aboriginal painting as a fine art.

The presentation of the objects at the Asia Society's exhibition drew partly on such "humanistic" representations. As we have seen, according to its publicity, the exhibition showed "the extraordinary vitality of Aboriginal art . . . the oldest continuous art tradition in the world." Of the many significations in this theme, one bears immediate tracing. The scientifically reported thirty-thousand-year history of visual culture on the Australian continent has considerable salience for contemporary *urban* Aboriginal people, another set of subjects, who treat this history in much the same way that the French conceive of their prehistoric cave paintings. The appearance of "art" in the Australian archaeological record precedes Lascaux, so often regarded popularly as the first evidence of civilization. In the context of the Australian Bicentennial of 1988, celebrating European settlement (or invasion) of the continent, this representation offered for Aboriginal people an image of cultivated Aboriginal ancestors creating works of art while Europe still lacked aesthetic vision. Moreover, in stressing that this tradition of visual culture is continuous, the museum publicity attests to the survival, renewal ("flourishing"), and contemporary creative potential ("extraordinary vitality," "creative energy") of Aboriginal culture. The roots of this potential lie in the Dreamings, identified as the "spiritual foundation of Aboriginal life." Let me retrace some of the stories this work was found to tell.

The Spiritual Is Political

> Ordinary Australians, who may have had trouble dealing with the poverty, customs, and appearance of Aborigines, have finally been able to respect their artform. For Westerners, beautiful artifacts are the accepted currency of cultural accomplishment. (Pekarik 1988, 52)

As this formulation indicates, Aboriginal art was easily made to stand in for Aboriginal culture and identity. This synecdoche — a part for the whole — had a political cast. There was the hope of improving the condition of Aboriginal people in Australia by gaining appreciation of their achievements.

The themes of Jane Cazdow's article in the 1987 *Australian Weekend Magazine*, reporting on the art boom and leading up to the exhibition we are considering, are illustrative of the stories in which the paintings were embedded, especially in Australia, where concern for the status of Aboriginal people is most prominent. Cazdow (1987a) emphasized three themes: the financial and morale benefits to Ab-

original communities; the controversy about the loss of "authentic" Aboriginal art as, according to one collector, "the number of Aboriginals raised in traditional tribal societies is dwindling" (15); and the significance of the art's success for black-white relations.

Cazdow reported that the (then) minister for Aboriginal Affairs, Clyde Holding, believed that the boom in Aboriginal art was important in gaining respect for Aboriginal culture, "in creating bridges of understanding between Aboriginal and white Australia" (15). According to Holding, "Many Australians have been taught that Aboriginal people have no traditions, no culture. . . . When they come to understand the depth of tradition and skill that's involved in this area, it's a very significant factor in changing attitudes" (15). The capacity of the success of these paintings to signify for black-white relations depends largely on art's standing for the generically (good) human.

Many writers have drawn on explicit Aboriginal constructions about the political significance of their representation of places, as did the Australian fiction writer Thomas Keneally in his *New York Times Magazine* piece on the *Dreamings* show. Keneally asked rhetorically what these men and women were "praising" in their work. The answer he offered frames this work in the politics of Australia: "Aboriginal concern with land rights, the development of a movement of return to traditional homelands, and the need for money make these paintings—which signify inherited rights to land for traditional Aboriginal people—more than art for art's sake" (Keneally 1988, 52).

Visual Invention

> I like the way they move the paint around.
> (John Weber, personal communication, New York, 1989)

Visual inventiveness provided another register for the paintings. Another important story, more recognizably "modernist"[1] and more typical outside of Australia, where the politics of Aboriginality were not prominent, was that Aboriginal paintings were "good" art, describable in the conventions of contemporary Western visual aesthetics. In *New York Magazine*, art critic Kay Larson wrote: "Modernism has allowed us to comprehend the Aboriginal point of view. . . . Aboriginal art at its best is as powerful as any abstract painting I can think of. I kept remembering Jackson Pollock, who also spread the emotional weight of thought and action throughout the empty spaces of his canvas" (Larson 1988). Larson acutely suggests the way in which acrylic paintings occupied an aesthetic space in Australia

cleared by abstract expressionism (exemplified in the earlier purchase of Pollock's *Blue Poles*). But as art critic Nicolas Baume (1989, 112) noted, the Aboriginal paintings did not simply repeat the familiar for Larson. That, after all, would not have qualified them to be good art. Rather, the paintings asserted their *differences,* their challenge to contemporary norms.

Roberta Smith (1988) used features of this same modernist discourse to build a different story. In her review in the *New York Times,* Smith judged that the exhibition "can unsettle one's usual habits of viewing," presenting a "constantly shifting ratio of alien and familiar aspects, undermining the efficacy of designating any art outside the mainstream." But her judgment was that "this is not work that overwhelms you with its visual power or with its rage for power; it all seems *familiar* and *manageable*" (italics mine). Smith recognized that the paintings were based on narratives and motifs handed down through generations, but for her, "The more you read, the better things look, but they never look good enough. The accompanying material also suggests that these same motifs are more convincing in their original states" (Smith 1988).

Smith was open to the possibility of this art but fell back to formalist and modernist regimes of value. Others disagreed, but the important point is that the critics assimilated these forms to a historically and culturally specific discourse of art that focused on creative invention and the way a painting, essentially self-designating, organizes color and other values on a two-dimensional surface.

Spirituality and Modernity

Still other evaluations suggested that the acrylics offered a glimpse of the spiritual wholeness lost, variously, to "Western art," to "Western man," or to "modernity." Robert Hughes's glowing review of the Asia Society exhibition in *Time* drew precisely on this opposition: "Tribal art is never free and does not want to be. The ancestors do not give one drop of goanna spit for 'creativity.' It is not a world, to put it mildly, that has much in common with a contemporary American's—or even a white Australian's. But it raises painful questions about the irreversible drainage from our own culture of spirituality, awe, and connection to nature" (Hughes 1988, 80). According to Hughes—himself an Australian expatriate in New York—their "otherness" occupies a world with little in common with that of the (American, middle-class) reader, one in which the artistic values of individual creativity and freedom were not relevant. Nonetheless Hughes insisted that their very otherness should itself be meaningful for us as a contemporary alterity to our values. In this, too, he recognized specific features of Aboriginal life lost on non-Australians.

An American line of evaluation followed this discourse in a different direction, asking if the acrylic paintings could be viewed as a conceptual return to our lost ("primitive") selves. This was definitively suggested in Amei Wallach's subtitle: "Aboriginal art as a kind of cosmic road map to the primeval" (Wallach 1989). Many of the visitors to the Asia Society certainly embraced this sort of New Age spiritualism.

Creativity as Cultural Renewal

Within the context of Australia more specifically, "creativity" could take on distinctive value. The significance of artistic activity among Aboriginal people was often embedded in a slightly different narrative of self-realization through aesthetic production — although still formulating potentially universalistic meanings. Addressing conceptions of Aboriginal culture as inevitably on the course of assimilation, Westernization, or corruption, many observers asked if these paintings were not evidence of cultural renewal, creativity, resistance, and survival (Isaacs 1987; Myers 1989; P. Sutton 1988; Warlukurlangu Artists 1987; cf. Fry and Willis 1989), if they should be seen as an assertion of indigenous meanings rather than as homogenization. Isaacs's 1987 review of a Sydney exhibition of paintings from the communities of Balgo and Yuendumu used the rhetoric of "cultural explosion" as creativity and strength — in opposition to "purity" as restraint, governmental, and bureaucratic. Isaacs's construction must be seen as an interpretation that implicitly countered the commonly held Australian views of "the Aboriginal" as tradition-bound, incapable of change and innovation (as Strehlow [1947] emphasized), unable to enter into the twentieth century, and doomed to extinction.

Contexts: Why Aboriginal Painting Is Good (Australian) Art

What made acrylic painting good art in Australia? It is important to reiterate an earlier point (see chapter 6) to clarify how the discourses that developed around Aboriginal acrylic painting intersect with themes familiar in recent theorizing about "nationalism" (B. Anderson 1983) and "national imaginaries" (Ginsburg 1993a). This intersection owes much to the Australian concern to create a national identity in which, increasingly, Aboriginal people or culture figure (B. Attwood 1996; Beckett 1985, 1988; Gelder and Jacobs 1998; Lattas 1990, 1991, 1992), strongly motivating the signifying potential of indigenous art for (some) Australians.

Reflecting on the significance of Aborigines and Asians in Australia, Annette Hamilton has suggested that a concern with Others emerges most clearly at the

same time as the sense of national identity is most threatened by emergent trends of internationalization and new forms of internal cleavage. In writing about the national imaginary, Hamilton suggested "that under world conditions of the past two hundred or so years, and more so recently, the problem of distinguishing a national self has moved to the forefront precisely as it is challenged by social economic and political mechanisms which undercut the prior senses of national, ethnic, local, class or trade-specific identities" (Hamilton 1990, 16). These were certainly the conditions of Australia's postcolonial realignments—emphasized particularly by the Bicentennial context and later by the effects of the High Court's Mabo decision to recognize Native Title. Whatever the broader schema, Hamilton's analysis maintained that recent developments in Australia manifested not a rejection but an appropriation of—identification with—certain features of the "Aborigine" as image (19).

The significance of the Aboriginal as a sign was established by its placement in these historical contexts. Some dimension of Aboriginality participated in multiple circuits of meaning and emerging value, such as tourism and the export of national culture. Later, gallerists may have tried to distance themselves from Aboriginality, but in the late 1980s, the support and recognition of Aboriginal art was seen by most of its promoters as a way to promote appreciation for the accomplishments of Aboriginal culture. Such appreciation, it was believed, would not only provide a basis for self-esteem for a long-disenfranchised racial minority but also support recognition for the value of Aboriginal culture and land rights in a context of increasing struggle with Euro-Australian and foreign interests, a struggle evidenced in the mounting campaigns by the mining companies in Western Australia.

There was an important combination of interests involved in promoting appreciation for Aboriginal artistry and spirituality. Many white Australian artists who opposed the dominant, rationalist, and materialistic white culture were attracted to Aboriginality as an indigenous local expressive form. In an earlier period, Aboriginal art had been configured as a source for a distinctive Australian identity, a configuring mediated through the association of some anthropologists (A. P. Elkin, F. McCarthy) and artists such as Margaret Preston, whose work attempted to draw on Aboriginal motifs.[2] It is significant of the *new* moment that Elkin's *Aboriginal Men of High Degree* was republished in 1977; its representation of Aboriginal mysticism met with considerable popular enthusiasm among those who also attempted to establish Australia's regional identification with Southeast Asia.

Another intersection between the identities of a spiritual and natural Aboriginality (which was seen as respecting the land) and oppositional Australian cul-

ture was forged in the environmental movement, which was opposed to uranium mining in Arnhem Land and hydroelectric development in Tasmania. These economic developments were derogated by some as serving primarily the interests of foreign economic exploiters, by others as expressive of the continued devastation of environmental relations by a mechanico-rationalistic culture, and so on. Such themes are expressed in a number of popular-culture forms, including the films *The Last Wave; Dead Heart; Priscilla, Queen of the Desert; Crocodile Dundee; Picnic at Hanging Rock;* and so on.

Through the production of such signifieds, the mysterious interior of Australia, a place long resistant to the purposes of (white) man in Australian lore,[3] comes to stand for Australian identity as a spiritual/Aboriginal center—identified with Australia's natural flora and fauna as well—on which to define an identity opposed to foreign industrial control. Various meanings of Aboriginality are constituted in such processes of political incorporation. They are not made up from whole cloth. Instead, meanings draw on images of Aborigines constructed in earlier historical experience (Hamilton 1990)—especially the dichotomizing, ambivalent respect for the "wild bush black" and contempt for the "detribalized fringe campers," "mission blacks," and "half-castes." For example, the "wildness" of the bush Aboriginal—an image focused on the bush, nature, mystic power, and tribalism—while it "held a threat to the normal functioning of station life" "also marked Aborigines as somehow able to transcend everything which European civilization (itself a fragile flower on the frontier) was able to offer" (Hamilton 1990, 25). Recent constructions draw on these earlier images, manifesting, according to Hamilton, a particular form of desire: "the wish to move into the mystic space and spiritual power which has been retained from the earlier construction of 'good' Aboriginality, and to somehow 'become' the good Aborigine" (25).

An emphasis on self-determination through land rights, and ultimately an ideology of self-realization in culture, were bases for the inclusion of Aboriginal themes in the creation of a specifically Australian identity—or at least an identity for a specific class fraction of Australians. Finally, the difference of Aborigines later allowed them to be figured as a symbol of exoticism and wildness (Morton 1991), to be sought out and consumed in a growing tourist industry that was attempting to market the "true heart" of Australia. This was not, of course, the only objectification of, or discourse for, Australian identity, as Kapferer's 1988 discussion of Anzac Day and the "digger" hat makes clear (see also Inglis 1990; White 1982). Other, more radically modernist, positions were also articulated.

Nor could Aboriginal painting be assimilated to a unified art field in Australia. In what might be seen as an embrace of postmodernism rather than postcolonial-

ism, many theoretically oriented Australian artists were suspicious of the very convergences and valorizations of indigeneity outlined in the foregoing paragraph, seeing such interest in difference as too close to a moribund modernist primitivism. This was part of a larger political position articulated by an influential group of Australian critics and practitioners in their attempts to distinguish themselves from the influence of American art and a uniform, universal, progressive internationalism that was actually centered in the United States (Burn et al., 1988). In the postmodern world they espied, there was no center or periphery, no local as opposed to the global—only a new universal globalism (McLean 1998, 117). For example, Imants Tillers, a Latvian-born Australian artist, rejected Aboriginal art's adoption as Australian art, a form of cultural convergence he regarded as cultural colonialism: " 'Cultural convergence' is attractive as an idea because it offers a painless way to expiate our collective guilt . . . while simultaneously suggesting an easy solution to the more mundane but nevertheless pressing problem of finding a uniquely Australian content to our art in an international climate sympathetic to the notion of 'regional' art" (Tillers 1982, 53; quoted in McLean 1998, 116).

The stakes of Aboriginal painting's entry into the discourse of art, then, were complex and cannot be reduced to a simple, uncritical good. Such attitudes reflected not only a theoretical disappointment among the art practitioners of urban Australia but also a real jealousy. Indeed, the developments in Aboriginal art redefined the broader framework of Australian art.[4] In any case, the debates in Australia about an appropriate national art remind us that the doctrines of art theory constitute another context, to which I turn.

Aboriginal Painting

The assimilation of Aboriginal acrylic painting into modernist art narratives need not imply that acrylic paintings are simply the equivalents of Western forms. Critical discourse, modernist or not, was not so simpleminded. The question was whether this placement of the acrylics "into the existing structures of popular art theory" was appropriate, or whether, as the New York dealer John Weber held, "A new vision demands a new system of critical thought" (Weber 1989). Let's not forget that the art market sells "new vision."

Most writers on the art recognized it to be decoratively pleasing and fitting comfortably enough within the visual expectations of the Western tastes for kinds of formalism of the 1960s and 1970s and the busy surfaced acrylic work of the 1980s. Thus Aboriginal art emerged at a conjuncture in which it not only suited the development of national identity but also fit without discomfort on corporate

walls and into preexisting collections. John Weber—who is known for supporting conceptual and minimal art and exhibits the work of site-specific artists such as Richard Long and political artists such as Hans Haacke—was the first (and only) significant gallery owner in New York to take on the work. Weber attempted to show that the work's entry into the art market demanded a *rupture* in critical constructions, as something more than 1970s formalism. Weber wrote of the need for "an art dialogue sympathetic to the intent of this work . . . to engender a deeper understanding and appreciation of what the viewer sees and subsequently feels and thinks" (ibid.). If a new set of art critical theory was necessary to elucidate this new art, Weber's discussion suggested that it should engage four central features: (1) the vitality and compositional complexity of the paintings, (2) their site-specific quality, (3) their political message, and (4) their narrative subject matter.

The issues articulated in Australia about the significance of difference become quite different in the U.S. context, where the market thrives on new trends, discoveries, and novelty.[5] The growing interest in "the art of the Other" was seen by many to be precisely part of this larger phenomenon of late capitalism—the hallmark property of which was said to be its "consumption of difference" (Foster 1985). Australian critics could compare the popularity of Aboriginal art to the "flavor of the month" (Fry and Willis 1989), raising suspicion about a world system that might profit from the circulation and consumption of difference. Within a system of art classification that is suspicious of utility and celebratory of authenticity and human freedom, the production of difference would not be "authentic."

Weber's comments were revealing of the accommodations a prominent dealer thought it would take for these paintings to enter into the fine art market. He argued that the current "commercial onslaught" in the marketing of the acrylic paintings threatened the continued existence of the movement. This was also an institutional problem: "As Australia has not previously generated an art movement of international significance, the art power structure [there] is at a loss to deal professionally with the fast emerging Aboriginal scene" (Weber 1989). Only one commercial gallery—Gabrielle Pizzi's, which has exclusive rights to Papunya Tula Artists—had what he considered to be a "well thought out program of group and one person shows of this work" (ibid.).

Deconstruction: Against Humanism

For yet another set of critics, the appreciation of Aboriginal acrylic paintings and their placement comfortably *in* the art world was problematic. Proponents of a critical-pluralist postmodernism rather than a celebratory apolitical multi-

culturalism, like Clifford (1988d) in the United States and Moore and Muecke (1984) in Australia, argued that the sort of humanism deployed in such representations makes the culturally different too familiar. Such difference, they maintained, should challenge the universality and natural status of Western categories (also see Shohat and Stam 1994). Famously, Clifford wrote, "We need exhibitions that question the boundaries of art and the art world, an influx of truly indigestible 'outside' artifacts" (1988d, 213). From this position, the acrylic paintings — as they were inserted in the art scene and gathered for exhibitions as fine art — were seen as confirming the power of the formerly colonial masters to determine what matters.

Some writers did not think the art had to be represented this way, preferring the tack of what Clifford (1988d) called "surrealism" to that of "familiarization." This is part of what lay at the heart of the somewhat hyperbolic and nasty but inspired review by John von Sturmer (1989). An anthropologist himself, von Sturmer grasped the significance of this critique of such tranquil notions of humanity, of the repression that stands as an obstacle to grasping the internal life of Aboriginal people:

> One senses that there is something of the same destructiveness [as that of the narrator of Dostoevsky's *Village of Stepanchikovo*, who in the name of certain ideals would destroy the whole household] directed at Aboriginal societies, that that they too can only be treated as spectacle, as tableau. Is it because they lie beyond the possibility of a truly lived engagement? It is still the case, as it has been from the very beginning, that they do not live according to "civilised" notions of society, refinement, propriety, group welfare or personal well-being. They fight too much, they drink too much, fuck too much, they are too demanding, they waste their money and destroy property. But a lack of restraint, caution, or calculation is not necessarily an absence or a failing. It can be a superfluity. A refusal: a refusal to accept the repressive principle. (von Sturmer 1989, 139)

The postmodern deconstruction of a pallid humanism points out the loose ends in attempts to make "them" look more like "us." This deconstruction located a weakness that is common in projects of imagining difference and one with which anthropologists are familiar (Marcus and Fischer 1986). Is it any wonder, therefore, that anthropologists who were engaged in the construction of Aboriginal culture were surprised by the ferocity of the critique of *our* familiarizing rhetoric that "they" have "art" (Michaels 1988; P. Sutton 1988; von Sturmer 1989; Fry and Willis 1989)?

The generic critique of the "humanistic" did not comprise the full range of de-

construction's attack. In more specific and limited ways, the construction of the paintings as art was also questioned variously by revealing the essentially economic motivation of Aboriginal painting and the contrast between the supposed spirituality of the art and the destruction of its civilization by white settlement. Faced with other popular representations of Aboriginal people as drunks, as lazy, and as a morally dispirited remnant, many were critical of hopeful, poetic, and romantic representations of Aboriginal cultural and spiritual renewal.

The Loss of the Other

Those who joined in this sort of criticism, however, were not necessarily believers that all progress must be in the direction of Western forms and Western morality. The discernible mingling of the world orders was just as upsetting for those who liked authenticity, who wanted Aborigines — or any Others — to remain entirely in the precapitalist spiritual world order.

Peter Schjeldahl's 1988 review in the short-lived New York periodical *Seven Days* offered the strongest projection of discomfort in imagining difference. Schjeldahl found the acrylic paintings not "other" enough, too accessible, and thereby essentially representative of the domination and destruction of Aborigines by whites. "The paintings are seen as a means to build independent wealth and self-esteem for a people gravely lacking both," wrote Schjeldahl. "In problem-solving terms the idea is impeccable. But the paintings are no good." It was probably praiseworthy to attempt to show good benefits for Aboriginal people, but this particular liberal solution would not wash: the paintings exhibited the final domination of Western categories. So he told his readers, "Don't go looking for that power of strangeness at the Asia Society."

Once upon a time, the mere interest in things Aboriginal in a metropolitan center such as New York would have been seen as a triumph over ethnocentrism. Yet Australian critics Fry and Willis criticized the emphasis on representing Aboriginal culture as the "spectacular primitive" because it diminished "Aboriginals to a silenced and exoticized spectacle" (1989, 159).[6] They decried as "ethnocide" the manufacture of "Aboriginal culture" in the process through which "experts" who "trade in the knowledge of 'the other'" make their own careers (159–60). And if anthropologists once railed against art critics for the imposition of Western aesthetic categories on objects produced in other cultural contexts, some critics (Rankin-Reid 1988) attacked anthropologists and curators for their emphasis on the "ethnographic," for focusing on the narrative and "mythological" content of the acrylic paintings — as a primitivizing device that precluded appreciation of the "patently visual accomplishments of the work."

From the point of view of the Aboriginal painters who came to the Asia Society in New York, however, these positions must have seemed terribly distant, if not patronizing. They were art world battles. How, I wondered, was one to compare Schjeldahl's disappointment with the self-esteem expressed in comments made to me by Michael Nelson Tjakamarra when he visited New York for the Asia Society show? Fresh from his participation in the Sydney Biennale of 1986 and from successful commissions not only for designing the forecourt mosaic of Australia's new billion-dollar Parliament House but also to paint a BMW (V. Johnson 1997), Nelson believed that people were really interested in his work and the work of other "traditional" people. "They want to see paintings from the Centre," he said, contrasting this attention with the lack of white interest in the work of urban Aboriginal artists.[7] This contrast made sense to him in his own culture's terms in which religious knowledge — associated with traditional Aboriginal life — would be the basis for recognition. The issue, it appears now, was not their confidence. What appeared as "accommodation," rather than resistance, was a lack of concern about perceptions that flowed from their genuine confidence. They knew that "something *was* there." Indeed, the difference of acrylic painting was too easily incorporated at that time into Western image practice. Only later did Australian copyright law recognize the images as Aboriginal intellectual property and identity, and not simply as modernist images to be reproduced, acknowledging in its fashion an Aboriginal revelatory regime of value.

Despite *their* assurance, however, Aboriginal people's expectations that knowledge of their culture's foundation in the Dreaming will result in recognition of their rights are not entirely fulfilled. The answer to such a question rests not so much on the qualities of the object, or even in the structural relations between cultural groups, but in the capacity to make one or another set of meanings prevail or even visible. Who, then, has the power to make one or another set of meanings prevail?

Critical Practice: "Origins" and Destinations

Fry and Willis maintained a suspicious and deconstructive stance toward an emphasis they saw on Aboriginal painters as "all traditional people who have little experience of cities" (1989, 159–60). They found the same emphasis on the theme of the "spectacular primitive" at the Paris display of artists and their work from all over the world, *Magiciens de la Terre,* where Warlpiri men from Yuendumu built a ground painting in the spring of 1989. However, while Schjeldahl was disappointed and angered at the domination of the authentic in the new medium and its recontextualization, Fry and Willis took an opposing position in stressing that

"the marketing of contemporary Aboriginal art can be seen as a form of soft-neo-colonialism, through which Aboriginal people are incorporated into commodity production (with the attendant reorganization of social relations)" (116). An attack on the painting's authenticity, their criticism also directly challenged the claim of the painting's continuity with, and renewal of, Aboriginal culture. Because "traditional beliefs and practices have to be reconfigured according to the relative success or failure of the commodity there is thus no continuity of tradition, no 40,000 year-old culture, no 'time before time' " (116). Faced with a hybrid form, they rehearse, then, Geoff Bardon's earlier despair about the problematic relationship of money and economic necessity to art, and they extend this to a view that the paintings and their culture are *products* of fragmented cultures but read according to the meaning systems of the dominant culture (116).

There seemed to be no closure for the question of what one saw in these cultural productions. Drawing on a mixture of Marxism and a poststructuralism that was highly critical of presumed essences and continuities, for Fry and Willis, "in Australia, the romantic recovery of the past as a pre-colonial life is impossible. . . . The return to the old culture is therefore really a new culture built upon the signs of the past" (160).

For these critics, displays of art as indigenous culture could not be the basis for Aboriginal self-identity, being oriented largely "for the gaze of the colonizer and on terms and conditions set by the dominant culture" (160). Rather than providing forms for the development of Aboriginal self-determination, "in the appropriation of Aboriginal culture, careers in 'white' society are being made." In this social field, moreover, the career advancement of these white experts was said to depend on the reproduction of "the primitive." Far from being a token of authenticity, "in this process, 'Aboriginal culture' becomes a culture from which Aboriginal people are excluded either literally or by having to assume subject positions made available only by 'the oppressor' " (159).

Not surprisingly, therefore, Fry and Willis claimed that they had no authority to speak on behalf of what Aboriginal people meant. As one of the curators, anthropologist Peter Sutton, noted, this position has the appearance of being politically more satisfactory in the avoidance of submitting "their" meanings to "our" categories, yet to hold such a position was still to assume one knows the impact of colonial practices on these subjects. Here, then, were outsiders who knew more than the participants but did not bother to talk with them, outsiders whose representational practices directly thwarted the representations of Aboriginal painters.

Fry and Willis were not alone in showing little interest in finding out what the Aboriginal people were doing, saying, or understanding in these events. They pre-

sumed, following Eric Michaels (1988), for instance, that "looking"—as in attend-ing a Warlpiri ceremony—is the privilege of domination. This is not necessarily or simply so in Aboriginal cultures, however, where the revelation of forms to the sight of the uninitiated is a gift that carries responsibilities. In showing their paintings, Aboriginal people may require that to have seen something is to be re-sponsible for understanding it.

Nonetheless, the point of such criticism was that the terms and conditions for the display of indigenous culture were set by the dominant culture and that the ex-change was massively unequal. Was this, as Fry and Willis claimed, "ethnocide"— a cultural erasure accomplished by "obliging them to transform themselves to the point of total identification, if possible, with the model proposed to or upon them" (Clastres 1974, in Fry and Willis 1989, 116)? Or has the discourse of Aboriginal par-ticipants come to have its own effect on some of those around them and on the meaning of the objects they produce?

National and International Fields of Cultural Production

The critical controversy about the acrylic paintings was a form of cultural produc-tion within a specific intercultural space. Clearly, a wide variety of accountings of Aboriginal art existed, and these were, in significant ways, addressed to each other. They shared what Bourdieu (1993) described as an important property of a field of cultural production, a "space of the possible." They engage Aboriginal painting from the historically established problems and discourses of their fields. Further-more, they address the value of acrylic painting (and Aboriginal culture) for its collectibility—its distinctiveness as part of, or illustrative of, a narrative: of the nation, of art's progress, of human distinctiveness, of human freedom, of innova-tion and creativity. These critical acts of representing culture involved evaluating or judging the acceptability of acrylic painting's insertion into existing regimes of value, (1) as a component of Australian national heritage and identity and (2) as offering what I heard the American performance artist Spalding Gray recently de-scribe as the fundamental contribution of art: "a fresh perspective on life," as ex-pressive of a human freedom outside of mere utility. The themes of nationalism and modernism, respectively, represent frameworks of collecting and exhibiting art—as embodying national identity (and part of the nation's patrimony, a trope of romanticism) or as embodying art's (autonomous) history or progress (the trope of international modernism). In both kinds of discursive space, as will be clear, the "primitive" and the "native" figure strongly but differently.

If all of these different discourses might be applied, as they have been, we have

to ask how some — rather than others — get crystallized as more authoritative, become culture. The theoretical positions thus delineated were not necessarily exclusive to any national tradition, but they were articulated broadly within national fields of art's cultural production, distinctive public spheres of criticism organized around modernism in the United States, and around convergences between postmodernism and national identity in Australia. If the United States has imagined itself the center of a single, international, cosmopolitan history of art (Guilbaut 1983), the Australian convergence drew on the complex history of Australian painting itself and the continuing preoccupation with center-periphery questions — that is, with how Australian art defines itself within an international perspective (Burn et al. 1988).

One can see that the question of whether these were just artifacts or whether they were works of art was an important concern of Euro-Australians. The categorization argued implicitly against the supposed inferiority of Aboriginal cultures and for the inclusion of Aboriginal cultural activity in the "Family of Man." For Wallach (1989), this question was deployed to contrast what one might call "mere art" with something deeper and more primeval, while Schjeldahl (1988) deflected the pressure to have his judgment of the painting extend to an evaluation of Aboriginal culture in itself.

Difference and Art Doctrines: The United States

Typically, U.S. critics intervened on behalf of the universal, the internationalist perspective of art as a more or less autonomous domain of human activity. American critics seemed deeply interested in the modernist questions of quality and originality, of whether such works challenge Western visual conventions (Larson 1988; R. Smith 1988; Schjeldahl 1988). This was a notion given particular value as being consistent with goals of innovation, progress, and freedom in Western art production, where novelty has great market value. Where Larson found "good" art, Roberta Smith (1988) and Schjeldahl (1988) saw weaker versions of 1970s neo-expressionist abstraction. Smith was interested in the capacity of the work to challenge the usual habits of viewing, but suspicious of what she called the "mercantile intent" of the exhibition, introducing the acrylic paintings to the New York art market. Mercantile intent, commerce, practicality, utility — these threaten artistic value, both from the domain of the practical (artifact) and from the domain of the commodity. Art has been supposed to transcend (if not criticize) use value, opposing the latter by being a domain of freedom and creativity. The art-culture system articulated a particular moral place for art, defining a distinctive (and en-

during) value for art within the structure of culture. The dominant structure de-
lineates art as transcendence and freedom from utility and practicality or decora-
tion, differentiates art from craft as physical material or skill of execution (see also
Plattner 1996, 4–7). Indeed, this enduring system of classification has replicated
and transformed (in the era of capitalism) an older (medieval) hierarchy in the
liberal arts—between the mind and the body, between spirit and matter, between
ideas and labor. Art is conceptual. It should advance our cultural vision; it should
overcome our ordinary relations to the world, replicating in the era of capitalism a
system of classifying and valuing domains of activity as spirit versus matter, ideas
versus skill.

Art doctrines forged in the context of larger ideological concerns about art
and the world—chiefly, it would appear, against the threat of mass culture, kitsch,
the market, and commodification (C. Greenberg [1939] 1961)—seem to have been
more comfortably American, in the heart of the global capitalist engine. The sort of
modernist aesthetic distance that emphasized the autonomy of the aesthetic field
from the intercultural or the political was relatively uncommon in Euro-Australian
reviews. More discernible in reviews emanating from the Australian context was
the sense of a cultural predicament constituted by Aboriginal culture's insertion
into the same space as Western cultural forms. This represented a tension of what
Nicholas Thomas has called "settler primitivism" (1999; see also Myers 2001a), as
distinct from a more general "modernist primitivism."

Difference and the Predicaments of Settler Primitivism: Australia

For nonindigenous Australians, Aboriginal painters necessarily have a marked
cultural identity that cannot be ignored or bracketed. Although Euro-Australians
also seemed to be concerned with the related critical question of whether the
acrylic paintings challenged Western conventions of the artist as individual pro-
ducer (Cazdow 1987b; Michaels 1988; Stretton 1987, 32; Isaacs 1987), they did so
from a different viewpoint. The Australian question about the relationship of aes-
thetic activity to everyday life in Aboriginal societies deployed a long-standing
avant-garde critical concern about the growing division between art and life, but
its emphasis was on measuring out some positive value for Aboriginal cultural
life within the Australian nation. This political value accrued to Aboriginal cul-
ture's difference from a West drained of art and spirituality in its pursuit of ma-
terial paradise. Australian-born critic Robert Hughes's 1988 review mediated just
this concern—the Australian-inflected primitivism about the value of an Aborigi-
nal way—to the broader, international Western interest in the "primitive." Other

elements of the Australian-written reviews participated in this context, as when Hughes and Keneally claimed that the paintings signified the worthiness of Aboriginal survival and consequently the dilemma and indictment of modern Australia's history and treatment of their forebears as less than human. These critics shared such a view not only with the Australian-based curators but also with the Asia Society's director, Pekarik, who had acquired a sense of its relevance on his travels in Australia.

Another set of questions had, in my view, a similar provenance, if a differing conclusion, challenging the celebration of "traditional" Aboriginal culture—the primitive—as a means of ignoring the actualities of Aboriginal presence. Fry and Willis (1989), the cosmopolitan critics from Sydney, had asked whether these objects represented a corruption and degeneration of an authentic Aboriginal vision and spirituality brought on by the commodification of the marketplace. Was this an entry of individualism into Aboriginal social relations through the corrupting flow of cash and the marketing techniques of individual shows (Michaels 1988; P. Taylor 1989)? Or should these objects be regarded as evidence of a cultural renewal, creativity, resistance, and survival?

Throughout 1987 and 1988, discussions of Aboriginal art appeared in every section of Australian newspapers—business, home decoration, cultural affairs, and news. The stakes in delineating a stance toward this work were significant, involving to some extent a reimagination of Australia as a nation. Clearly, however, in the popular imagination the critical acclaim and reception for this work provided some legitimation for recognition of value in the culture of their Aboriginal contemporaries. Australians of European descent were less at ease with the more politically challenging confrontations of Koori (urban Aboriginal) art, which frequently holds white Australia to account for its racism and history of conquest.

However, the terms of the positive Euro-Australian response, I want to argue, were not simply outright approbation, unmediated. The U.S. reviews registered a recognition, but they lacked the knowledge or exposure to really engage the paintings as "art," leaving only an ahistorical modernism. The generic appreciation in the United States had not been inflected by the variety and number of exhibitions only beginning to take place in Australia, while Australian criticism reflected an attempt to find an aesthetic discourse in which to frame the embodied Aboriginal aspirations.

This would have been the import of Jennifer Isaacs's 1987 review of the colorful Balgo and Yuendumu exhibition at the Blaxland Gallery, mentioned earlier as an account that emphasized the paintings as "cultural explosion." Isaacs thoughtfully embraced a pluralism compatible with postmodern art theory in emphasizing that

the admixture of European materials and venues for Western Desert visual culture (i.e., canvas, acrylics, and exhibitions instead of bodies, ochers, and ceremonies) was not a loss of authenticity or cultural subordination. Subordination, obviously, would imply a product that was not an expression of inner spirit and therefore not "good" art (Errington 1998; Phillips and Steiner 1999; Price 1989). The hybridization, Isaacs argued, represented an explosion of creativity, even breaking the bounds of the wrongheaded (to her mind) restraints for cultural purity urged by some advisers in the use of traditional ocher colors only. Such policies—which she characterizes as "bureaucratic"—are reminiscent, in her construction, of earlier policies for Aborigines that advocated separate development and postulated an unchanging Aboriginal culture.

Clearly, this framework of renewal and hybridity should also be recognized as articulating a stance within the Australian art debates—toward cultural convergence. Here two logically separate but socially intertwined institutions and discourses merge. For Isaacs, formerly a project officer of the Aboriginal Arts Board and a university-educated Whitlamite, the work of acrylic painting was testimony to Aboriginal cultural survival and dynamism—a far cry from the "dying race" image that was once used to legitimate Australian aspirations to the land occupied by people who, it was claimed, could not adapt to change; its "hybrid" creativity represented an aesthetic value to respect, the florescence of a powerful tradition in new circumstances. This rhetoric strikes a chord for many Australians because it rejects earlier views of impending Aboriginal extinction and also speaks strongly to those discourses of the art world that emphasize creativity and innovation.

Although such creativity may be something we can all appreciate across cultural boundaries, it would appear that Isaacs also had a further agenda, defining another—even more distinctly Australian—form of shared discursive space. The artistic forms were made sensible, she claimed, by their referent—the Australian landscape—which was ultimately available to *any* Australian. One must presume, therefore, that these Aboriginal productions were a contribution to an (emerging) Australian culture that is grounded in its landscape through Aboriginal heritage (P. White 1982).

Moral Stances/Cultural Boundaries: Parallax

The most noticeable feature of the nonindigenous writers about Aboriginal acrylics in this period was their concern to define a moral stance, to place their interpretation in the context of what they think will happen to Aboriginal people, to

justify their own situation in relation to the indigenous presence. It is striking now how little these writers considered the Aboriginals' views of their own lives and futures, to consider the Aboriginals' future as *they* encounter it, in ways that reflect what theorists have referred to as "agency."

This is partly a result of generic appropriations of Aboriginal art, as if there were a single history or entity represented by an exhibition of paintings. Informatively, just such tropes were common in representations of Aboriginal art that have inscribed objects in narratives of a pan-Aboriginal identity, for example as signs of an Aboriginal resistance to whites (Kleinert 1988; V. Johnson 1988). This frame may not at all suit the intentions of local producers. Especially during the 1980s, "Aboriginality"—as pan-Aboriginality—remained a problematic dimension of Aboriginal identity production, only one among various local identities. Indeed, to many Aboriginal painters, paintings were not usually seen as done by those with whom one identifies simply by virtue of their being "other Aborigines," but rather by a "mother," a "father," a "one-countryman," and so on. It is questionable whether specific Aboriginal histories can be defined coherently in general terms such as *the* Aboriginal encounter with whites. These have been mainly *our* terms, rather than those familiar to Aboriginal societies, in which—until recently—importance was given more to dyadic, specific relations. As soon as they come to be redefined as white/black, and they have been so defined by some Aboriginal people, there is a difference.

On such issues, these statements actually pointed to a difference within the category of *Aboriginal* critics, namely, that indigenous producers and viewers from the urban areas have been somewhat more likely than the remoter people (whose traditions have been less disrupted by contact) to embrace "an Aboriginal history" and to view paintings as "Aboriginal," expressive of a deeper identity—an imagined community—shared with all descendants of the indigenous inhabitants (V. Johnson 1997, chap. 7; Onus 1990). For all these Aboriginal subjects, however, the recognition of their painting implied a recognition of their persistence and cultural survival. While there continues to be evidence that participation in an imagined community of "Aboriginal culture" reflects historical ruptures between urban and remote Aboriginal people, the practices of urban art have been changing through experience and self-criticism—both with respect to care about wrongly appropriating designs from traditional communities as representing Aboriginality and in terms of engaging specific histories. As the urban Aboriginal artist Fiona Foley said in an interview: "For me some of the Aboriginal people have to look more closely at what they are doing. There are still a lot of Aboriginal artists who feel they can take imagery from anywhere. I think more than being

Australian they have to be true to themselves, research their own history and where they come from and look at the images from their particular area and then branch out" (quoted in Isaacs 1990, 12).

One should not be surprised that the texture of moral issues looks very different as the paintings and their producers circulate in new contexts. The Aboriginal in the Asia Society in New York City was not the Aboriginal over whom white Australian writers or moralizers are stricken by conscience. For an American audience at the Asia Society, the presence of Aboriginals and their paintings was far less defined by a sense of the European conquest as constituting the relations between them: the painters were not America's victims so much as they were a generic Otherness.

Translation: Generic Value

These categorizations of art, creativity, or humanity matter in more than merely academic ways insofar as they can imply differing representations of cultures. To say that Aborigines do not have "art," however qualified by insisting that the category is a distinctively historical one in the West, without hierarchical and evaluative significance, can easily be read as racism. Any anthropologist with the experience of trying to explain this issue to nonspecialists should recognize the practical problem.

In an important sense, what Aboriginal producers say about their work — their own discourse for its interpretation — draws primarily on an indigenous tradition of accounting, and it is this discourse (frequently) that anthropologists have sought to present as the authentic meaning. But as one must learn from the appearance of the acrylic paintings in New York and elsewhere, this knowledge of the Aboriginal culture, persons, and traditions of image making — knowledge of what Aboriginal painters say about their work — does not necessarily recognize the potential and significance of these forms to engage interest from those concerned with visual images in our own culture.

I believe that the engagement with art criticism as a competing practice of interpretation does offer something for anthropological understanding. At the very least, art theory's concern with the boundaries between art and nonart, both as a modernist evaluative process (i.e., is it art?) and as a postmodernist critically problematized oppositional practice (i.e., what does it mean to define such boundaries?), is a critical part of the dominant structures through which Aboriginal people are producing themselves in the contemporary world. Thus the reception of the paintings raises the broader questions not only of the capacity of indigenous

people to objectify their meanings into the discourses for their reception but also of the specificity of different institutions of intercultural space.

The examples I have presented suggest that Aborigines were triangulated by a series of discourses—which might represent positive benevolence, political support, sympathy, or renewed racism—in which Aborigines themselves were central but usually absent. Aboriginal accounts entered more explicitly into that Derridean world in which all signification exists in a context of other representations, in which there is no transcendental signified outside of representation.[8] Is it possible for Aboriginal actors to make their practices have just the meanings they claim? Could there genuinely be dialogue between their conventions and those of the art world?

In the art-culture system, the diversity of criticism addressed to the Asia Society exhibition was part of the discursive practices that define fine art, moving objects from culture to art. The very fact of the debates validated the acrylic paintings as objects worthy of broader consideration. This was exactly what John Weber desired in his plea for a "new art critical theory." What a dealer does, after all, is to find paintings and transform them into art by selling them. The acrylic paintings not only have a meaning but were being made to have a meaning about the nature of human creative activity, and made into salable fine art.

That does not mean that the translations are adequate. Indeed, the available discourses largely fail to explain the meaning at the Aboriginal level. At best, the Aborigines were considered to be co-opted; at worst, they were not considered at all. It should be clear that my anthropological association with the painters made it difficult to accept at face value criticisms of the acrylic movement that derogated the local focus on the "continuity" and "authenticity" themes as a "constructed primordialism"—to borrow a term from Arjun Appadurai (1990). Most Pintupi and Warlpiri painters have not constructed primordial identities, "origins," principally in opposition to wholly external Others, as in various nationalisms—not, that is, as an ethnic discourse of Aboriginality. The application of critical theory was misguided here, emanating from a different history.

Aboriginal people's primordialisms are constructed, of course, but they are frequently constructed and sustained in relation to processes different from colonial ones. They are constructed in complex systems of similarity and difference— totemisms, if you will—in which larger collective identities are only temporary objectifications, shared identities produced for the moment (Myers 1986a; Sansom 1980). "Country," as most Aborigines would call the places represented in acrylic paintings, the token of the painter's identities, represents the basis for objectifications of shared identity through time. Critical theory has its own history, its own past, that it brought to an indigenous moment.

Critical art theory was struggling with the local message because of its own pre-occupation with the global processes that were seen as threatening to make all the world the same, all processes and forms substitutable for each other. It was such a fear of cultural homogenization at work — the incorporation of Aboriginal products into European fine art — that underlay much of the art critical writing.

So rather than accepting an unapproachable gap between Aboriginal painting and critical accounting, I suggest that here is where the engagement between the traditions of anthropology, indigenous painting, and art criticism might occur. I will make two interventions — on placedness and specificity — against generic, undialogical art criticism and toward local art histories.

It should first be pointed out that such one-way narratives deny any "indige-nization," despite the fact that the potential of such indigenization is what is ulti-mately of interest in Aboriginal paintings. The identities that many acrylic painters have produced on their canvases are not uprooted or deterritorialized. On the contrary, the link to specific places is their very claim (Appadurai 1990, 2–3). It is surely ironic that as art theorists Deleuze and Guattari (1987) placed their bets on "nomadology" as a way to find a path through this placeless, rhizomatic (late capitalist) world, so did the late Bruce Chatwin, a refugee from the art world on a romantic search for the "nomad" representing some imagined version of a cease-less human urge for wandering, seek out Australian Aborigines (Chatwin 1987). Aboriginal Australians, however, are precisely those who insist on *not* being dis-placed.

The situation of Fourth World people should not be compared too loosely with other postcolonial circumstances that currently inform much of cultural theory (Shohat and Stam 1994). Pintupi — or Warlpiri or Anmatyerre — claims that the paintings are from the Dreaming or that they are expressive of an ontology in which human beings gain their identity from associations with places *do* express a historical struggle, but initially at least they have done so in their own right, not simply in recognition of a colonizing threat from outside. To see these claims — their identities — as "our" product (as from colonialism) is to colonize doubly by denying Aboriginal people their own histories.

If art theory failed to grasp what the activity meant to the painters, their criti-cal responses only skirted the question of its appeal. I want to consider what this appeal might be and what it suggests about the contribution Aboriginal acrylics might be making as art. The appeal of the paintings is not, I suggest, as ineffable as the best critics suggest.

Ironically, the paintings have significance, even in these terms, in art theory and for the buyer because of their local meanings for Aboriginal people, the associa-tion they represent for buyers between an artist and a place. As forms acceptable

to the art world, Aboriginal acrylics offer a powerful link to particular locations in a world that is said—according to most postmodern theorists—to have "no sense of place" (Meyrowitz 1985). What the acrylics represent to their makers resists this sort of commodification: all places are *not* the same. Painters can only produce images from their own local area, all conceived of as different.

In Warlpiri artist Michael Nelson Tjakamarra's explication of the meaning of the paintings, one traces the "original meanings" in the emergence of something that is new: an Aboriginality that is also becoming defined in opposition to Europeans:

> White people don't really fully appreciate these dreamings that we paint. These dreamings are part of this country that we all live in. Europeans don't understand this sacred ground and the law that constrains our interaction with it. We've been trying to explain it to them, to explain what it means to us. For the sake of all Australians, we try to show them that this is our land. We try to show them our dreamings which are part of this country that we all live in. But white people don't even recognize our ownership of it. We paint all these pictures and they still can't understand. They want them as souvenirs to hang on their walls but they don't realise that these paintings represent the country, all of this vast land.
>
> In other countries, they're all right; the land belongs to them, it's their country. We belong to this country; that's why we keep saying that we want our land back. (Michael Nelson at the Sydney Biennale 1986, quoted in Nairne et al. 1987, 221)

Michael Nelson Tjakamarra deployed here the same principal discourses that an anthropologist was most likely to encounter. His statement reminds us that indigenous discourses were not some intrinsic bottom line, but that they take shape in the context of contemporary politics in Australia: their goal, their intent, is not displaced.

I do not mean to say that the "place meaning" of acrylic paintings is the totality of their signification or that the signification of this meaning is the same for all consumers. Given the regular association of purchasing the paintings with tourist travel to the area in which they are produced and located, for instance, I suspect that some particular thrill accompanies knowing the place that is represented in such utterly unfamiliar signs that hold a different meaning for "Others." For Westerners, this both valorizes the travel—to a place that is genuinely different—and the painting as a sign of that difference.

Moreover, what is at stake in a sense of place in Australia is different from what it is for consumers from overseas. In Australia, for some, the places of Aboriginal people are places before history, a place in the Outback often coded as more pri-

meval — a frontier in which Euro-Australians are fascinated to know that some *real* "stone age" hunting and gathering people still live (Myers 1988b). This primordial spirituality at the heart of Australia, especially at Ayers Rock but also (in a way) in each painting, provides links with tourism and travel away from the solid domesticity of suburban homes and the rational order of "white science" (see Fiske, Hodge, and Turner 1987, 119–30, for a discussion of these themes). The Aboriginal and the Outback, the "difference" they have to offer, are increasingly the source of Australia's self-marketing for the international tourist industry. These constitute an important dialectical dimension of emerging formulations of Australian national identity: something essential outside and before the nation that lies also at its heart, central to its identity, these significations give Aboriginal representations of place a particular value. The painting represents this mystery, in a way, by being the token of what the place/country is prior to or outside its appropriation into the uses and purposes of white society. Australians, therefore, can obtain such tokens and display them as representations of some part of themselves on their wall.

Their appeal is the sense of their rootedness in the world — although this rootedness or the sense of place is what appeared to some of the critics to be undermined by the apparent cosmopolitanism of the painters and the circulation of their products. It is not that Western art critics understand the specific information or details of the Dreaming places that are usually the subject of the paintings, but rather that the fact of these relations fulfills a nostalgic sense of the loss of attachment to place. The specific understanding of a story is not so important as that it signifies so rich and unselfconscious a sense of connection.

It is not accidental that this sense is what informs postmodernism so strongly. There is a great irony of historical accident in this: the paintings make their way into the art market by virtue of their strong formal similarity to abstract expressionism, a movement defined by its detachment from specificity and location. Postmodernism looks to the margins of a dominant culture and minority voices not only for a critique of oppression but also out of a genuine concern to reroot high culture to sources of the sensory and the intellectual delight in everyday life. This is what can be found in the descriptions of the "creative process" in Aboriginal communities — a sense of the cottage industry, with painters sitting out in the sun, making images without the European's requisite Sturm und Drang.

Specificity: On Longing — a Contemporary Aboriginal Painter

I began the chapter with mention of the gap that Meyer Rubinstein perceived between our critical discourses and their objects. Is this impasse unbroachable? Are

criticism and our critical discourses inevitably ethnocentric, only the projection of a bounded Western culture? When John von Sturmer critiqued the humanistic framework of presentation at the Asia Society, he also presciently questioned the generic quality of treating the works as (simply) "Aboriginal," of ignoring the specific local histories through which painters' points of view were objectified in these hybrid forms. The paintings are not just local expressions but engagements with the intercultural, already partly cosmopolitan.

The engagement of critical discourses with their object need not be an encounter between reified, hypostasized cultural categories ("art" and "Dreaming"); it can produce new theory, learn from "culture-in-the-making." Aboriginal paintings may in fact contribute to, or challenge, other critical discourses for the interpretation of human activity in productive ways. But this does not occur in generic considerations of "the Aboriginal." If acrylic paintings are to become fine art, criticism must go beyond a simple translation of the iconography or embrace of origins. The painting deserves a critical discourse that offers more than the recognition of placedness or authenticity. That there is a fuller horizon in the visual language of the painting is something I learned myself only over time from the painters and their paintings.

I have come to regard Linda Syddick—whom I knew originally as Tjungkaya Napaltjarri, daughter of my close friend the painter Shorty Lungkarta—as the first Pintupi modernist painter. Because of her development of Christian themes and her interest in Western popular culture, her paintings are challenging to many critical conceits of what might be "authentic" Western Desert painting—transmitting an understanding of the Dreaming and placedness. Indeed, her work shows that critical understandings of place in Aboriginal painting remain as limited in understanding the activity as were the former categories of primitive art. Let me try to illuminate what I take to be the internal life of her painting.

I knew that Tjungkaya had been born in the bush, but she seemed to have turned her back on the traditions embraced by Shorty in moving to a fringe camp in Alice Springs where she lived with a part-Aboriginal initiated Arrernte man— somewhat outside the local Pintupi community. From her mother, I had learned that Tjungkaya's biological father had been killed by a revenge expedition when Tjungkaya was a baby, speared by the killers and thrown into the fire while her mother crept off and carried her to safety.[9]

Among the most important of Linda Syddick's early paintings, to her, were those I was shown in Alice Springs in early July 1991. The two paintings were set up as a series and, I was told by the dealer Roslyn Premont that they represented "her story" (page 306). The first painting shows "her father being speared and put on

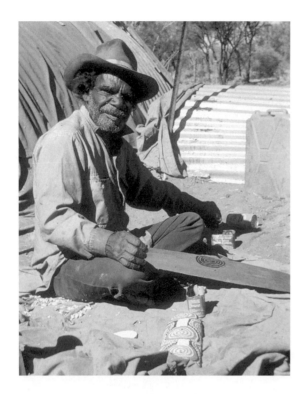

Shorty Lungkarta
Tjungurrayi painting shield at
Yinyilingki, N.T., July 1979.
Photo by Fred Myers.

the fire and her mother hiding near the fire." The second painting's iconography, I was told, represents "spears—men spearing the clouds and washing away the blood." That is, they cause it to rain and cleanse the earth. Why were these a set?

I was also interested to discover that Linda (Tjungkaya) had made a name for herself as a painter of Christian religious images—such as the Ascension and the Last Supper (page 308). There is an interesting hybridity here, to be sure. Apparently, the painting of the Ascension draws on the fact that "men of high degree [Aboriginal shamans] were buried with their arms and legs tied up," which is how Linda painted Jesus in this image. Initially, therefore, I thought her work might be interesting as an introduction of historical narrative into Pintupi painting, informative as an indication of how Pintupi people might experience over time the loss of a parent through violence,[10] and revealing as to the impact that becoming Christian can have. What should one make of her using the iconography of Pintupi painting to tell Christian stories? I thought the second painting referred to her state of mind, perhaps a Christian sort of peace, not recognizing any deeper links in the image.

There is, however, a deeper understanding of these images, both as artistic com-

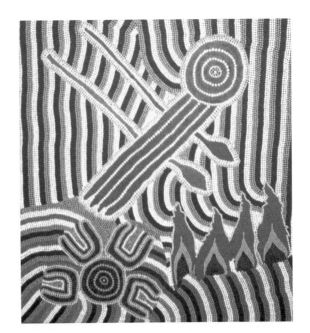

Linda Syddick's painting *Father's Body Thrown in Fire*, 1991. 2002 Artists Rights Societye (ARS), New York/ VI$COPY, Sydney. Photo by Fred Myers.

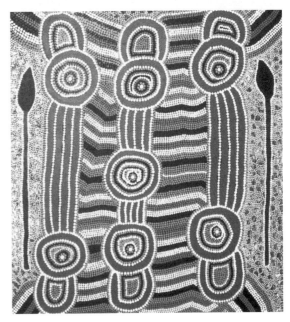

Linda Syddick's painting *The Cleansing Rain*, 1991. 2002 Artists Rights Societye (ARS), New York/VI$COPY, Sydney. Photo by Fred Myers.

munication and as evidence of the way in which place and its representations might convey significance for Pintupi. A few years later, I spoke with Linda over the telephone to her home in Taree in South Australia, where she was living with her current husband, a white man (who had met her when he was a dentist for the Aboriginal health service in Alice Springs). I learned that the second painting, of the "cleansing rain," concerned Emu Men, ancestral beings who were "perishing" (dying of thirst) at Walukirritjinya. The Emu Men got some "clever men" to fashion spears and to use a magical pearl shell, throwing spears into the sky to bring a cleansing rain. This story is part of the Tingarri cycle, usually portrayed by men, but the key to understanding its significance is its identification with Shorty. Because his father had died at Walukirritjinya, Shorty was ceremonially in control of its stories and ritual. Thus the second painting is identified with Shorty and Shorty's place or country, while the first, of the spearing and fire, was of her first father, Riinytja.

For awhile Linda faced "trouble" in doing this painting, accused of doing wrong, as a woman, in painting Tingarri stories. This is relevant to understanding the painting because of the vehemence with which she insisted she had the right to paint it. Her own country was considerably further to the west, but before he died, Shorty Lungkarta had told her she could paint *his* country, the Tingarri there. Despite jealousy from some of her sisters, Linda was insistent on her right to paint Shorty's country, insistent on what this meant about *their* relationship. The emotional tone helps understand why the paintings were supposed to be a set. If the cleansing rain represents Shorty Lungkarta, then his fathering of her — indexed not just in the painting's iconography but also in the transmission to her of the right to paint his country — represents a settling of the upset of the first loss, signified by the fire. Iconographically, this occurs at another level of mediation: water soothes the fire, cleanses, makes grow, cools the pain. The activity of painting, which comes from Shorty and is enabled by his giving to her the right to paint his place, is an activity of objectification, of recuperating identity. In this way, Linda's paintings represent a powerful symbolic formulation of loss, estrangement, and redemption, but they represent these through a visual language that uses the construction of place as a vehicle for articulating identities.

This is a powerful theme for Linda Syddick, and it is helpful to recognize its relationship to other modes of expression. Her situation is equally articulated through her continued embrace of indigenous ritual in the form of *yawalyu* (sometimes called "love magic"). Through her possession of yawalyu, Linda/Tjungkaya partly defines herself as an Aboriginal woman, as having the power and knowledge to get a man and otherwise engage the world, as different from whites; but Linda's invo-

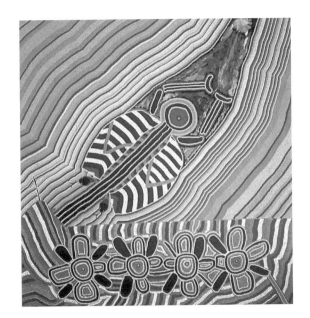

Linda Syddick's painting
The Ascension, 1991. 2002
Artists Rights Societye (ARS),
New York/VI$COPY, Sydney.
Photo by Fred Myers.

Linda Syddick's painting
The Last Supper, 1991. 2002
Artists Rights Societye (ARS),
New York/VI$COPY, Sydney.
Photo by Fred Myers.

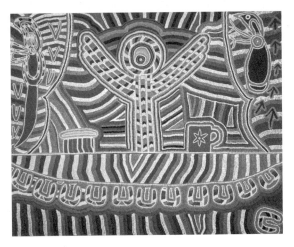

cation of yawalyu as part of her identity helps us understand the imagery of her painting. Such ritual addresses many of the feelings that Linda is concerned with herself, having moved to South Australia with this husband after the sequential deaths of three children, events that recapitulated the primary loss of her father. Her loss, or losses, have been crushing—a father to violence, three children at an early age, two husbands. In its songs, yawalyu frequently articulates feelings of sadness *(ngaltu)*—not just of the longing to overcome separation and desire, of love magic premised on the desire to be recognized by certain others, of a man's sadness at his distance from a daughter.

Linda's concern with loss and salvation is palpable. It is the story of the loss of her first father and her life being cleansed and repaired by her second father, Shorty, who gave her—in his adoption and in the transmission of his country—a new life. Unexpectedly, it is also the story of the substantial body of paintings she did of ET, the extraterrestrial figure in Steven Spielberg's film of that name: the alien estranged from home (see plate 8). She watched this Hollywood film absorbedly, over twenty times. "Linda is fascinated by this movie," Ros Premont, her dealer, has written. "Her empathy was sparked by ET longing to return home" (Premont 1993). These are the feelings—homesickness, pining, grief, loss—that Central Desert Aborigines articulate in song and ceremony. These are feelings signified in and through places, as Walukirritjinya and its story of bringing the rain do for Linda. And this is the story of Christianity, offering similarly a salvation from her loss and estrangement—the loss of her children, of her father, and to some extent now of her culture.

In the Pintupi context of understanding, places such as Walukirritjinya are already objectified. Shorty Lungkarta gave Linda the right to paint it, and doing so is central to her. The specific iconography of the place, the story elements of its fashioning in the Dreaming, which are already socially objectified and define it as a token of identity and exchange, takes on a doubled use that is part of its aesthetic function. It is not only the possession of the place and the right to paint that establishes an identity; the specific imagery of the spearing of the clouds and the cleansing water poetically heals the loss of her first father in the fire. Herein, at least in part, lies Linda's artistry, in conveying this complex understanding of place, loss, and identity.

Her paintings extend and discern in painting practice a particular formulation of identity, loss, and replacement that must have had long standing in Western Desert life. Distilling this cultural formation, she articulates a more general longing—one we can now see to have been imagined more concretely in practices we regarded narrowly as love magic. Her painting of loss, redemption, and longing is

a reflection of states of being and an economy of desire defined by Pintupi under-standings of sorrow — *yalurrpa* — as the loss of an object fundamental to one's iden-tity. Linda Syddick's work shows what and how a place signifies, in its relationship both to local Aboriginal identities and also to an engagement with wider themes of disruption and loss, often implicitly coded within the meanings of place itself as a social formation for her. The activity of painting, which comes from her adoptive father and is enabled by his giving her the right to paint *his* place, is an activity of recuperating both a father and an identity. In grasping this, we better grasp Linda's artistry — as perhaps the first "modern" Pintupi artist — in conveying this complex understanding of place, loss, and identity.

Linda's paintings are therefore recognizably forms of culture making. Their active construction of an identity is graspable — as Rubinstein says, "Something is there!" — if one understands what it means to paint and to "have a country." These are elements of the art she makes, merging two typical stories of what inspires artists' work — in Aboriginal and modernist contemporary Western settings. Her claim to her father's country is also autobiographically a claim to her own indi-vidual identity. This work has an interiority, a development that depends on an indigenous language extended into Linda's own situation, but it also approaches the recognizable story of individual artists piecing together their lives. Inevitably, the generation after that of Shorty and Wuta Wuta (her mother's brother) has more complex ranges of influence than they did, and painters like Linda may be less driven by the protocols of her father's generation. Nonetheless, in this work one sees how she pulls these pieces together in her making of Aboriginality, draw-ing on many frames of experience. Her paintings not only are an example of this sort of construction, but they also — as good art should — offer us Linda Syddick's insight into it.

The account by an anthropologist, but in the direction of art criticism, may show some of the problem of interpreting an emerging cultural activity of acrylic painting, one for which the appropriate sensibilities were not discursively elabo-rated and shared between producer and audience. For the formal construction of these paintings to become intelligible communication for white Australians, then, some local art history — ethnographic and historical understanding — is needed.

Circulating Discourses of Art: Blurred Genres

The Asia Society exhibition illustrates the complicated situation of contemporary anthropology, the blurring of disciplinary and cultural boundaries, insider and outsider of the processes we describe, positioned equally by the discourse of others.

What should the place of ethnographic practice be in this situation? I believe we should not be in the position of challenging the claims of those who inscribe art practices as "spiritually redemptive," but rather explore how these practices are put to work in producing culture, treating these formulations as signifying practices linked to others.

The place of ethnography may better be conceptualized by drawing an insight from recent work on art worlds, but extending the notion of such communities to the more difficult sectors of culturally different work and divided audiences. Faye Ginsburg (1993a, 1993b) has eloquently argued in her work on indigenous media makers that anthropologists — like other critics and activists — are involved in the crucial task of creating a discursive space for these new intercultural phenomena. The African-born critic and film theorist Manthia Diawara (1993) situates his work and that of other black intellectuals as engaged in creating a "black public sphere." The Aboriginal anthropologist and cultural critic Marcia Langton has also argued for the necessity of a new critical discourse for the reception of contemporary Aboriginal media of all sorts. In a position paper she wrote for the Australian Film Commission regarding the assessment of Aboriginal film proposals, Langton pointed out a "need to develop a body of knowledge and critical perspective [having] to do with aesthetics and politics . . . on representations of Aboriginal people and concerns in art, film, television or other media" (Langton 1993, 6).

Rather than rejecting some reviews and embracing others, the ethnographer should consider the enterprise at hand as one in which these representations might be considered as the foundations of a broader critical discourse that will constitute the history and context for Aboriginal painting in the emerging intercultural art world. From this point of view, Aboriginal painting is not seen only as failed authenticity or failed Western art. This work, now engaging with a complex art world, is developing its own critical discourse, its own sensibilities. Such a discursive space is created out of exhibitions, reviews, performances, symposia, and so on, and is therefore suited to ethnography's special talent for finding meaning in the often ephemeral nature of daily events — even art openings — when culture is continually produced and reproduced.

Conclusion: Convergences

As the reviews of the Asia Society exhibition show, by the late 1980s, the apotheosis of Aboriginal fine art had become suspect as the dominant notion of art was coming under criticism and debate. Acrylic paintings entered into a set of ongoing

debates within the art-culture system precisely about its organization of value—
the debates between modernism and postmodernism as frameworks for ascribing
value to cultural activity. The interrelations of these debates and their intersection
with primitivism, which had been the principal framework of interpreting non-
Western forms, provided a "system of common reference" (Bourdieu 1993) that
betrayed itself repeatedly in critical accounts of the exhibition of acrylic paintings.
It was through this set of common references and its contestation in the 1980s that
acrylic paintings were being categorized and evaluated.

These debates concerned not only the nature of art as a category of understand-
ing in our culture but also the applicability and criticism of such a concept as a
universal one. Although the debates have been passionate, and often misunder-
stood, they have revealed a fundamental structure of values through which objects
are made meaningful as art.

It is no accident that the apotheosis of the acrylic paintings coincided with a mo-
ment in which art world critical practices made treatment of the Other (women,
homosexuals, so-called Third World people) a fundamental question. Modernism
itself, its structure and codes, was coming to be seen as an ideological formation,
as subordinating or managing a difference that was threatening to a constructed
Western identity (Clifford 1988d; Foster 1985). The sense of hierarchy and exclu-
sion as defensive strategies underlies much of the critical work and gives weight to
the notion of the Other as a kind of fetish. From this point of view, art's attempt at
self-definition (autonomy) should be understood not as a neutral fact of a cultural
domain but as a form of cultural production itself, as an exclusionary boundary-
maintaining activity, a hegemonic exercise of power through knowledge.

Critical treatments like this, forged specifically against MOMA's *Primitivism* ex-
hibition in 1984, implicated modernism as an ideological structure in which value
was constructed or denied through representation (Guilbaut 1983; Barthes 1957).
What critics pointed out as a specifically modernist construction of "the primitive"
—timeless, unchanging, traditional, collective, irrational, ritualized, "pure"—was
not determined by its object but in a dialectical relationship with the notions of
the individually heroic modern person as rational, individual, progressive, self-
conscious and changing.

The postmodernist critiques were not analyses of the production of culture, but
they revealed disjunction. They accepted the importance of cultural difference as a
critical challenge to universalistic notions of aesthetics that tended either to make
hierarchies of different forms of human expression or to strip distinctive forms of
expression of their particularity and challenge to the conceits of this system. From
this point of view, the framework of art—conceived of as a universal dimension

of human expression—may make the Aborigines more appealingly human in our sense, but it does so by accepting the terms of a universalizing discourse that is, in many ways, opposed to the specificity of local meanings and conventions. In the critiques, specific doctrines of Western art—such as modernism—were recognized not simply as ethnocentrism but as ideological formations, as instruments of power. Anthropological explanations were no less part of such formations, but to recognize this, it would be necessary to place them fully within the object of study—to objectivate our own intellectual work. From my encounter with the *Dreamings* exhibition, I came to realize that critical mediation has engaged or constituted specific public spheres in which questions about cultural worth or significance are debated—in which value is established.

Drawing on two insights from Pierre Bourdieu, I have tried to place these debates in more limited social locations as concrete human social practices. The first insight concerns the treatment of the modernist valorization of "disinterested aesthetic contemplation" as a bourgeois class position or habitus—one exclusive of other classes (Bourdieu 1984), asking whose taste is being objectified through the appropriation of acrylic painting. The second insight concerns the social and historical conditions that have made possible the "autonomy" of different fields of cultural production, "where what happens in the field is more and more dependent on the specific history of the field, and more and more independent of external history" (Bourdieu 1993, 188)—asking about the emergence of a semiautonomous field of Aboriginal art.

Placed within a specific intercultural space, the critical appropriations of Aboriginal acrylic painting reveal the partial destabilizing of the parallel boundaries between indigenous art worlds and the West, but also those between anthropology and Western art writing. What I mean by this, again, is that previously segregated or insulated disciplines and social worlds—the worlds that once divided "tribal" and "modern" art between them—have been brought into new sorts of association, and that these may collaborate in producing new kinds of knowledge. Anthropological and art writing are increasingly part of the same social field, in which cultural production takes place precisely across boundaries previously essentialized in notions of "culture" as timeless or notions of "taste" as disinterested. These emerging forms of difference—innovation or creativity, if you like, in one world with complex terrains of power and discourse—demand their own theory or criticism for their sensibilities to be grasped.

One significant consequence of the emergence of Aboriginal acrylic painting and critical writing about it is the development of new discourses for considering cultural activity. From an ethnographic location, grounded more in earlier experi-

ence of Aboriginal painters in their own settings, I am arguing that it is only in attempting to analyze and recognize how these discursive spaces are produced and contested that we can begin to resituate the categories and hierarchies of value in ways that will reveal the outlines of an intercultural space.

In an essay on multiculturalism, itself an arena most highly developed in the arts, Terence Turner argued that the current global cultural conjuncture has made for "the steady proliferation of new cultural identities along with the increasing assertion of established ones" (1993, 17). The principal discourse of Aboriginal painters emphasizes their works as vehicles of self-production and collective empowerment. As Danto's 1964 conception of an art world might suggest, these are not necessarily interpretations that are outside the processes of representation themselves. Indeed, the interpretations almost surely represent an engagement with emerging theoretical discourses in the arts that emphasize, in the framework of multiculturalism, "the self-definition, production and assertion of cultural groups and identities in general" (T. Turner 1993, 17). Yet as Fiona Foley has claimed it should (Isaacs 1990), Aboriginal painting does so from its own particular histories and conceptions of collectivity and power. These differences, or particularities, are what make this work of interest to the art world—both contributing to its development of a general theory of cultural activity such as "art" and drawing on it for a historical frame. It is in this way, with its recognition of cultural activity more generally as concerned with the capacity for self-creation within particular histories, that criticism might achieve a more general and transcultural value in this historical conjuncture even while it is built on the recognition of differences and disjuncture.

11 Unsettled Business

Although it may be produced by Aboriginal people, in many ways Aboriginal art can be seen as a product of non-Aboriginal culture. Art has no meaning and function beyond the conditions which allow it to become visible. It is not primarily produced for the consumption of Aboriginal audiences (who may have a variety of reactions to a range of art-making practices), but for the institutional art world which first sanctioned its appearance and now seeks it out to be featured in galleries, museums, books and journals. The meanings are not buried in the works, they are actively constructed through the agencies of art criticism, journalism, context of appearance. . . . The paintings do not produce useful knowledge for those who view and buy them; for the purchaser they are tantalizing tokens of Otherness, an Otherness which cannot threaten, and is in a subordinate position because of its dependence on the system of commodification as it operates within a neo-colonial context. — Anne-Marie Willis, *Illusions of Identity*

The movement of acrylic painting, and Aboriginal art more generally, into the open market and its removal from the protection of the government company Aboriginal Arts Australia has had fundamental consequences. One of these consequences has been the development — or settling out — of an Aboriginal fine art and the beginnings of connoisseurship. As outlined by Chris Hodges and Ace Bourke in chapter 8, this reorganization has resulted in steps toward the discrimination of qualitative differences in painting, separating "tourist art" from "fine art." Another consequence can be traced in the highly unsettled and fragmentary business of dealing the paintings. This has turned out to be every bit the entrepreneurial free-for-all that was feared. Indeed, one of the strongest proponents of private retailing, Adrian Newstead of Coo-ee Aboriginal Art, described the process in which more and more potential retailers have entered this market: "Nowadays," he told me in 1991, "there are people springing up all over the place . . . You don't know who to believe anymore; who are the good guys and who are the bad guys" (Newstead 1991).

Christopher Hodges, it will be remembered, had argued for what he called "proper representation." In the terms that have been dominant in the relationship between dealers and artists in the Euro-American and Euro-Australian systems, such representation is usually "exclusive": a dealer invests in the development of the career of his or her artists, and the dealer, along with the artist, reaps the rewards jointly, as partners (Plattner 1996). The failure of such a system to be sustained in the case of Aboriginal painters is bemoaned by most dealers. It is not simply that the dealers are in a competition for "product," as one dealer called the art she sold. Aboriginal painters have also not recognized the exclusivity of their contracts with dealers, even — surprisingly — for the painters' cooperatives that founded the art movement. Faced with hungry or demanding relatives or the need for a quick dollar for any number of reasons, few artists hesitate to sell their canvases to whomever will buy them. As was the case many years ago, when my own purchases were justified because "these are our paintings, we can sell them to anybody" (Charley Tjaruru), the painters regard the paintings as their inalienable property.

The Aboriginal art market has been unstable, therefore, and roiled by scandal, rumor, and media sensationalism. In the midst of this, to some extent, dealers have gone about their business of trying to sell paintings, and I describe in this chapter some of the structures for selling this art outside of Australia, in New York. This, however, is only part of the way in which the movement of Aboriginal art into commodity status challenges or subverts other values attached to these objects, as they partially resist and partially accommodate commodification. I argue that the scandal of commodification is not what it appears to be. The rumors and scandals may be understood, in part, as struggles over fixing the place and limits of Aboriginal culture's appropriation by the market.

As Vivien Johnson has insisted repeatedly, Aboriginal regimes of value have been surprisingly effective in their continuity. "The struggle for self-representation before a predominantly non-Aboriginal audience," she has written, "is not a move in the self-fascinated games of the art world" (1987). Rather, "it is a deliberate move on that world, to interpolate the voice of the 'Other' into the ethnocentric discourse of the dominant culture, subverting it from within." Thus "The authenticity of Aboriginal art persists notwithstanding the all-too-obvious consequences of insertion into a western art context. The artists themselves steadfastly decline the mantle of Otherness held out to them as some sort of protected status. The political and social imperatives which underpin the whole enterprise are far too urgent for that" (1987). The sustaining of Aboriginal notions of cultural property and identity through copyright, urged by Wandjuk Marika as long ago as 1973 (Isaacs 1995; V. Johnson 1996a; Marika 1986), *has* been something of a *terra nullius* deci-

sion, an insertion of Aboriginal views into the broader Australian framework of cultural production and circulation. What seemed an unlikely and unrealistic wish on the part of older Aboriginal people—that the Euro-Australian society would recognize their culture if they revealed it to them—has proved more the case than anyone would have imagined. Johnson has posed this success of Aboriginal culture in two ways, in terms of the struggle for self-representation and the struggle for control over cultural property, struggles whose outcomes have not been the outright fall into commodification anticipated by Willis (1993).

Yet this is not a simple or secure victory. It is rather a moment in the ongoing reworking of the intercultural space I have been describing for a late capitalist settler state. My argument is that Aboriginal fine art is an objectification of the moral ambiguity of the boundaries of blacks and whites. The circulation of Aboriginal fine art does not erase the tensions within which whites and blacks cohabit so much as it creates a sphere or forum for discussing what Aboriginality and Aboriginal identity might be in relationship to whites. Indeed, value and scandal may be interrelated, necessary for the evolution of discourse on ownership and authenticity, on what constitutes Aboriginal painting.

What is taking place is a reworking, an attempt to fix or stabilize the significance of Aboriginal image making. In Aboriginal regimes of value, no one can use your image; it is an inalienable possession (Weiner 1992). Such a regime of value, lacking the market and mechanical reproduction, did not imagine the ways in which such technologies could detach signs from those who make and circulate them. Yet the accommodation has not been unidirectional. Whites had thought it impossible for Aboriginals to retain some of the values they held to exist in their images. The roil of scandal and rumor follows the contest over the hierarchy of values that will be recognized to adhere to these objects as distinctive regimes of value are brought into contact.

Selling Aboriginal Art in America: Far from the Madding Crowd

> I have argued that the core features of the art market create asymmetrical information between buyers and dealers, which heightens risk and anxiety in buying transactions, and that the solution is normally found in social relations. Embedding a purchase transaction within a long-run, generalized, personalized relationship lowers risk. (Plattner 1996, 200)

Although there are a number of important American collectors, the selling of Aboriginal art in the United States has not been as successful an enterprise as it has been in Australia. For one thing, it seems clear in retrospect, there has not been

an adequate density of events—exhibitions, cultural activities, political events—
to sustain attention on Aboriginal art in a competitive market. There have been
numerous attempts, and more than a few selling exhibitions in rented venues, as
well as art-dealing shops, have tested the air in the wake of the Asia Society ex-
hibition and Australia's Bicentennial. There were at least three different shows of
acrylic paintings in Soho in 1989, typically undertaken with a poor selection of
paintings in a rented space. One such exhibition, however, was able to call on Aus-
tralia's consul general and the Australian curator then at Hartford's Wadsworth
Atheneum, Patrick McCaughey, to provide a framework of propriety, although
the deployment of a team of caterers at the opening in "digger hats" and khaki
shorts might have undermined the integrity of the portrayal of the work as fine
art—not to speak of its lack of respect for the position of Aboriginal people. Sub-
sequent rumor had it that the organizer of this exhibition was himself a used-car
salesman from Sydney who had acquired the paintings by seeking out artists in
the creek bed of Alice Springs.

The most important dealer to take on Aboriginal art in New York, and in the
United States overall, was John Weber, whose participation in the acrylics market
was discussed earlier. In Weber's gallery, the acrylics were hung to emphasize their
role as aesthetic objects, uncluttered with complex labels or identification. No in-
formation was presented about specific content. Only the name of the painter, the
date, and title were given, although an accompanying catalog traced some of the
general historical tradition related to the production of these images. This mini-
malism has a reason. A trainee at the gallery told me that presenting the paintings
in this minimal way allows connoisseurs to feel good about their knowledge.

In the end, Weber succeeded in placing one of the Papunya Tula paintings in
the contemporary art collection of the Metropolitan Museum of Art, a placement
commonly cited as guaranteeing the value of acrylic painting as "real art." At an
exhibition in New York in 1992, for example, along with the citations of National
Aboriginal Art Awards won by those in the show, we were informed that "Anitjarri
Tjakamarra has been involved since the beginning of the Papunya movement. His
work has been included in the collection of 20th Century Art at the Metropoli-
tan Museum of Art in New York." In spite of this advertised success, however,
Weber found that acrylic paintings were not about to conquer the Soho scene, and
Papunya Tula heard little more from him.

It was left to another, less fortified and art world–grounded gallery to carry on
the attempt to make Aboriginal art a presence in New York. The Australia Gallery
occupied a small space in Soho—south of Houston, a few blocks from my office
and my apartment. The owner of the Australia Gallery was an American, a man of

middle age and somewhat unconventional bent. Howard Rower grew interested in Aboriginal art indirectly. With money from the stock market and real estate investments, he supported circuses, and through his involvement with Circus Oz and its performers, he gained a connection to Australia and Aboriginal art. According to my conversations with Rower, he was not in it for the money; he told me that he wanted to help his Aboriginal neighbors in the Northern Territory, where he had purchased land.

The space at the Australia Gallery was attractive and modernist — not standing out in any way from the rest of Soho's aesthetics. Its selling practices, however, may have been unconventional.

Rower was nearly always upset about the small numbers of people buying Aboriginal art. Although he was, in 1991, one of only four dealers in the United States (only two of them serious), sales were always a problem. He thought that the work, such as that exhibited in December 1991 in the *Women of Utopia* show, was strong and the prices were very reasonable, but sales were never adequate. At low prices such as he maintained, with paintings ranging usually from $1,000 to $4,000, he told me, "You have to sell a lot of paintings to stay in business." The gallery had to pay three employees, along with rent and renovation costs. If one sells paintings from $25,000 to $50,000, only a few clients are needed. But at $1,000 to $4,000, you need a lot. If there were one hundred people who bought a painting each year, that would do it, but the gallery lacked a regular set of clients. This is not surprising, given the dealer's lack of a track record in the field.

In his study of the St. Louis art market, anthropologist Stuart Plattner has written convincingly about the problem of buying and selling art. His analysis shows that the ways in which dealers and clients manage risk defines a significant nexus of art market negotiation: "Buyers' insecurity about their aesthetic judgment can distort the transaction with anxiety and risk. One way the gallery allays this anxiety is to have a scrapbook with reviews of artists' prior work, feature stories about them, lists of prior art shows and of collections owning the work and any other information that can make a potential buyer feel that knowledgeable people value the artist's work" (Plattner 1996, 147). Such practices offer information to buttress judgments of value and worth for objects without obvious use value. Dealers may also cultivate a client's relationship to artists, but the point is that dealers must prove themselves over time and demonstrate that their knowledge productively reflects the values of the art market. Here Rower's approach may have been unsuccessful. He was genuinely puzzled about how to get interest going in Aboriginal art. "I wish I knew how," he told me. "A lot of people have enough money to buy this art. It is very inexpensive vis-à-vis other art."

This was a relatively small operation, then, with limited capital. My understanding is that Rower tended to buy paintings in bulk, from Papunya Tula, for example, taking a substantial number of the paintings that were left behind by others. Although good examples of Papunya Tula work, these paintings were not of museum quality. His strategy seemed to be to buy inexpensively and hope that the market in the United States would accept this quality as adequate, given the control over pricing.

There were a number of attempts to bring people into the gallery and to otherwise expose people to the art. These involved openings—with free wine and sometimes didgeridoo performances that drew on a general interest in Australiana—and other kinds of events. Drawing groups of seventy to one hundred people, spilling out into the street on a weekday evening, these openings were often attended by relatively young and not always serious buyers. I would see a few regular freeloaders who similarly attend our anthropology department's colloquiums, and more than a few who gravitate toward the general atmosphere of Australia. A performance could draw as many as two hundred spectators, as did the opening of the *Bush Tucker Dreaming* exhibition in 1992, where a young white didgeridoo player entertained the crowd.

Galleries such as Rower's strive to represent themselves as legitimate and to demonstrate that the work they are selling has been validated by others. This is what Plattner means when he says that they try to "make a potential buyer feel that knowledgeable people value the artist's work" (Plattner 1996, 147). One way of doing that is to circulate works from the gallery's inventory in exhibitions. For example, the Australia Gallery arranged a show at the Aldrich Museum of Contemporary Art. All the works were from the Australia Gallery, not all of them or even most for sale in that venue. Subsequently this show was to return to the Australia Gallery, where it was billed as an exhibition curated by the relatively prestigious Aldrich Museum.

Little was sold at the Australia Gallery. In search of better returns, Rower changed his personnel and found a new acting director, turning from an Australian with experience in the primitive-art trade to a younger person with a stronger interest in contemporary art. David Betz, the new director, planned a greater focus on urban artists and varying media of work, such as prints. He favored introducing these artists, he said, because he thought "the younger generation of artists are more accessible, interesting, and acceptable to people here"—that is, in New York. Echoing Plattner's delineation of other entrepreneurial strategies, he said that "the generation of Turkey Tolson, Wuta Wuta Tjangala can't come here and talk to people. Their lives can't be communicated and known. People who buy

art want to be able to get into the artist's life. Their paintings [those of the traditional men] are strong, but that's all people can get. The other painters' lives are something people can get into, can know" (Betz 1993).

Thus he imagined that the younger painters, who had been to art school, would be more marketable, meaning that the issue of Aboriginal identity and artistic identity, which is central to these artists, would better connect to buyers. It is also true that this work was more affordable. In any case, the move to this work and to a diversity of artistic production for sale provided an economic strategy for the gallery rather like those of many smaller galleries elsewhere (Plattner 1996) that cannot afford to specialize in one kind of art. The strategy of product diversification was not, of course, isolated to New York, as the Altman (Altman, McGuigan, and Yu 1989) report makes clear, and the very existence of these new products owes a good deal to the marketing foresight of Anthony Wallis and Adrian Newstead in Australia, who pioneered these developments.

Timing, they say, is everything, and nowhere more so than in the art market. The Australia Gallery had difficulty making the transition from the art environment of the 1980s. During that boom, in Aboriginal art as well as in other kinds of work, "this stuff was just sold," as one knowledgeable man told me. "Now," he said, "you need an idea. You need to do something more." In Australia, there was a context that could drive the sale and interest in Aboriginal art, but in the United States, something else was needed. Those with stronger roots in the art world found fault with Rower's strategy, and many of them thought he didn't have enough of an idea of how to present the art. It was, I was told, "more like his real estate business. You buy a building and everything in it. Rower bought consignments and leftovers, rarely the first quality stuff."

These critics, however, had to acknowledge how hard it was to get the best-quality stuff when you visit Aboriginal communities. There is not that much first-quality work, and it is reserved for galleries and shows. Thus the dealer's reputation and successes in sales go into the evaluation of what work he will be allowed to have. This structure means that a dealer must have a track record or an enormous base of capital from which to work. It means that there is competition among dealers for "product," as they sometimes call it, and a competition over artists. This competition has led to serious problems in the fine art industry, possibly even to fraud and forgery of work.

The Australia Gallery was perhaps an unusual case. After two directors and a change of names, it eventually disappeared. Other personas and other styles of selling may be more durable in the United States. Young dealers like David Betz, who later founded the Postmodern Primitive Gallery out of his loft near the Man-

hattan Bridge in 1995 and eventually moved to San Francisco, are more in tune with the art world. Betz has proceeded by acquiring the kind of knowledge of Aboriginal communities, of collections, and of niches that have allowed him to build a business. While it is difficult to know about such businesses, where clients are a closely guarded secret, Betz seemed originally to represent clients involved in the secondary market, rather than principally to represent artists in Australia. Such work might involve finding a client for a painting held by John Weber and getting a part of the sales commission. What is clear is that Betz had greater ambitions and developed a profile and clients on the periphery of the major galleries, with activities such as exhibitions at the Susquehanna Art Museum in Harrisburg, Pennsylvania. Starting from the less-than-swanky but large and well-kept loft on the end of Chinatown, Betz's openings had a young and hip crowd, showing a connection to the art and culture world of New York that was very different from Rower's. At the same time, Betz was obviously in the business, and through repeated trips to Australia and a humble respect for those he meets, Betz acquired a reputation as a fair dealer in Central Australia.

Urban Legends

It should be lost on no one, then, that even the young and newer dealers—like almost everyone I meet—complain about what they see as the "changes in the art business" in Australia. There commercial dealers of the sleazier sort are seen to be undermining the local art cooperatives. In 1995, for example, one dealer had a representative in Alice Springs who was driving out to Aboriginal communities and buying paintings that would otherwise have gone through the cooperative that belongs to the community itself. This strategy brings instant money to the artist, who then needn't wait for the monthly turn of the cooperative's cycle. Indeed, businesses of this newer sort—which would have been much harder to do before 1989—may employ former workers from Aboriginal communities who have forged relationships with the painters in other contexts, relationships that become points of entry for unknown dealers. Because the communities are small and spread out now, it is difficult for the cooperatives to keep control. Ironically, these new dealers have arrived on the backs of those retailers who only recently had complained about the government-funded cooperatives controlling and limiting their access. But as one dealer is reported to have said blithely, "All you need to get into the art industry is money" (Michael Hollows, quoted in Finnane 1999b).

 While the dealers may recognize that the art cooperatives are doing poorly, they have their own complaints about working *with* them. A dealer trying to establish

himself now in New York told me that the cooperatives are hard to work with. Excusing himself from the ethical imperative to work with indigenous community groups, he is inclined, it seems, to work directly with artists, to represent them. There is a price incentive to do so because of serious problems in maintaining the pricing structure. For example, he told me, the cooperatives charge sums that are such that when you see the painting down south, a similar one by the same person will be sold retail for the price he has just paid at the point of production. Indeed, this reflects the problem of the artists not being loyal to the cooperative, and selling at various prices. These are all issues that dealers such as Gabrielle Pizzi have been discussing for years. There are no doubt many economic problems involved with Aboriginal art cooperatives. Some of the money goes into paying overhead, which may include the employment of nonindigenous workers. Also, the painters often don't get their money for a long time. This consignment problem may not be the fault of the cooperative, but it isn't uncommon.

Finally, this dealer felt he had not been able to get the best paintings from cooperatives for exhibition. It was not only that the cooperatives preferred to offer them to other dealers or collectors; they would not hold on to excellent ones for a show. He told me they had been having cash problems at Papunya Tula, and that they were selling good paintings by the older "name" artists for less money than they should. Indicating the difficulty this created for the market and price structures, he referred to the practice as "dumping."

The Corruption of Late Capitalism

At the same time, however, the individual art dealers have been having their own problems. A plan to create an association of Aboriginal art dealers is coming to fruition. Demanding ethical practice in return for accreditation, it will presumably oversee some of the problems with forgery and fakes that are threatening the trade. There remains the question of including Aboriginal people in this process. Some unscrupulous dealers continue to control their painters, giving them poor pay for their work and reaping a huge profit for themselves. Few dealers would admit to this practice, of course, although allegations about "others" (named and unnamed) abound. Each dealer has a stake in *claiming* integrity and close association with Aboriginal people. But dealers with a longer-term interest *should* genuinely be supportive of a more ethical relationship in dealing, and supportive of a better kind of association. Fakes would really harm one's investment in well-provenanced Aboriginal paintings and threaten the possibilities of establishing accurate provenance, on which price depends.

Whatever the incentives, unscrupulous practices are common. Competition over artists is rife. I have witnessed dealers ask painters to make another version of a painting they have seen in the art cooperative's gallery, sending down an employee to copy the annotations. They may provide free or cheap transportation — an "art bus" — from remote communities for painters who want to come into town, with the provision that they paint in the gallery and sell their work to the dealer. The fear expressed over this practice is that the incentives of instant cash — or access to alcohol — may be used to lower the price of the paintings, with potential disruptions in the marketing structure of fine art. For anyone who plans the usual course of building up and representing an artist and his or her career, this "commercial onslaught" in the marketing of the acrylic paintings does just what John Weber (1989) knowingly described — it threatens the continued existence of the movement.

This untrammeled competition, however, can sink even lower — into outright exploitation. A dealer in Alice Springs, I was told, typically manipulated artists in a strategic way, counting on the desperation to sell. A painter would come in with four paintings, asking for $A1,000 each. The dealer would ask him to sit down and have a beer, then a few more. When the sky was turning dark, the dealer would say it was "time to go, but the banks are closed and I only have $A500. How about that for the paintings?" The painter would say yes, because he wants the money to go out and drink. The word used repeatedly to refer to what is happening in the world of dealing Aboriginal art is "greed."

These stories circulate as the urban legends of the Aboriginal art scene, and the closer one gets to Alice Springs, the more detailed and varied they become. In the very midst of the rise of connoisseurship and a fine art market, there are hundreds of stories depicting the other side of the new scene of Aboriginal fine art — of battles and scandals taking place that involve forgery, frauds, and the structuring of the art market. Everyone involved in Aboriginal art experiences this unsettled state, the Aboriginal participants as much as those who report in the press. The sometimes attacked art dealer David Cossey (1998, 31) wrote the following prescient and revealing comments that Kathleen Petyarre made to him about the pressures of being an artist: "I don't want to end up like that old lady" — a reference to her aunt, the famous painter Emily Kame Kngwarreye. "Everybody fighting over canvas all the time." Thus did Kathleen comment on the enormous pressure Emily felt from family members and the multitude of art dealers scrambling for her paintings (Kathleen Petyarre, quoted in Cossey 1998, 31). And while the reputations of some dealers no doubt deserve the tarnish they are receiving, the integrity of the Aboriginal painters is also implicated. With it also has been tarnished the authenticity or sincerity of their painting as something more than tourist deco-

ration, a view signified in the question mark in the title of a recent controversial ABC documentary for the *Four Corners* program, "Art from the Heart?"

There are four basic themes—all concerning the cultural (racial or ethnic) identity of this art, its motivations, and its implications—that have emerged in this stage of the market. These are clearly evidenced in newspaper representations and other forms of discussion in the public sphere. These public scandals have involved the following elements:

1. Forgery or fraud, by which I mean paintings done by non-Aboriginals and passed off as "Aboriginal," or paintings signed by famous Aboriginal painters but not actually painted by them (for example, the Kathleen Petyarre case [McCulloch 1997c, 3], the Turkey Tolson case [McCulloch-Uehlin 1999, 1, 4], and the Elizabeth Durack case [McCulloch 1997d, 14–21]).

2. The amount of money early Aboriginal art has brought in secondary auctions and the poverty of the painters (the Johnny Warangkula case [Daly 1997, A15; Daly and Ryan 1997, 1; Busfield and Donegan 1997, 5; C. Ryan 1997, A10; Ceresa 1997, 5], and the arguments about the exploitation of Emily Kngwarreye [Greer 1997; McDonald 1997]).

3. The infringement of indigenous cultural rights in the appropriation of painting images to make carpets, resulting in a landmark copyright ruling by the Australian court (Hessey 1994, I 5; V. Johnson 1996a).

4. The avid interest in, and large sums of money being paid for, early acrylic paintings (including Sotheby's sales of $74,570 for Anitjarri Tjakamarra's *A Cave Dreaming* in June 1996, quickly surpassed in 1997 by $206,000 for Johnny Warangkula's *Water Dreaming at Kalipinypa,* $123,500 for Shorty Lungkarta's *Untitled* from 1972, and $103,700 for Shorty's *Water Dreaming* [Daly 1997, A15, 22]), a publicity campaign no doubt supported by Sotheby's itself, with the concern that these historically significant paintings would be "lost to the U.S." (Sweetman 1997, 4; McCulloch 1997b, 5; C. Sutton 1997, 23; A. Attwood 1997, A23).

What about "forgeries"? What happens when the work is passed off as being painted by an Aboriginal person and becomes part of the prime minister's collection? Is the scandal that one can't tell the difference between a painting done by an Aboriginal and one done by a white? Is a good painting a good painting, no matter who paints it? Or does an Aboriginal abstract-like painting—such as one by Emily Kngwarreye, energetic and lyrical in its use of color like any New York or Sydney abstract of the 1960s—take on additional layers of meaning and ambiguity by virtue of being Aboriginal?

And what about Turkey Tolson's admission that he signed works done by others?

Surely this admission affects the value of works he has signed, since his signature is no longer evidence of his execution and the paintings' part in *his* story. What do people own, therefore, when they buy one of these paintings? Some art dealers, of course, might benefit in the short term, if they can have a few more Tolsons to sell, because his signature makes a painting worth more than others. But the revelation of the practice threatens the overall structure of investment. Here it is not the absolute Aboriginality of the painting that is compromised, because some authorized Aboriginal person executed the painting, and yet the sincerity of the sign is threatened when the commercial motive appears to dominate. Michael Hollows replied to the allegations about Tolson's work by insisting that Turkey substantially reworked any paintings to which he put his name, in that way making them properly—by market standards—bearers of his signature (McCulloch-Uehlin 1999, 4). However much these art market considerations must be recognized, the problem of Aboriginality and a deeper authenticity remains lurking in the shadows.

Did Turkey's participation in these practices represent a compromise of some deep identity on his part? Or was he, rather, caught up in an art market game that has consequences for him, but whose ethics and standards were different than his? To those of us familiar with Turkey's history, there is another thread to consider in the story. It seems that Turkey, one of the leading figures of Papunya Tula Artists and a past chairman of it, identified himself with Michael Hollows's gallery in Alice Springs, the Alice Springs Aboriginal Desert Art Gallery, and painted substantially for them. This is the kind of situation that Daphne Williams has long bemoaned, maintaining that artists should have loyalty to the company that is owned by them and through which their name has been made. This may have especially been so in Turkey's case, where personal loyalties were at issue—since Turkey and his family had been the closest friends of Daphne Williams herself. One can only presume that she felt betrayed. But perhaps Turkey left Papunya Tula because subsequent art advisers were unable to provide him with the attention he needed or expected. Whatever the details and personal motivations, the circumstances are clearly those of the race for product, the competition for "name" artists, a competition that has led dealers to vie with each other for the affections, loyalties, and paintings of Aboriginal artists. The artists believe they have the right to sell to whomever they please, but must now find themselves uncomfortably placed in the corruption of the system.

Frequently, these accusations and allegations are themselves instruments of competition between dealers, struggling for control over the market and particular named artists. A famous recent case involved the revelation that Kathleen Petyarre's award-winning painting *Storm in Atnangkere Country 11* (it won the

$18,000 1996 Telstra National Aboriginal and Torres Strait Islander Award) was actually done largely—or at least partly—by her Welsh-born white husband, Ray Beamish.[1] Equally interesting is that the allegation and resulting controversy seem to involve rivalries between art dealers—with Melbourne dealer Hank Ebes opening up this case (McCulloch 1997c, 3). Later, Beamish began to paint in Melbourne at Hank Ebes's gallery in Burke Street. One rumor I heard was that Ebes was led to expose the Petyarre-Beamish collaboration in order to embarrass Aboriginal art curator Djon Mundine, who had always insisted that one can tell when an Aboriginal has painted something—since Mundine was on the jury that awarded the prize to Petyarre. Others insisted that the exposure was motivated by the desire to embarrass a competing dealer, David Cossey, for whom Petyarre painted. These interpretations—whose truth we cannot know—are part of the urban folklore that has come to define the world of Aboriginal art as virulently commercial and competitive.

That the painting was acquired by the Northern Territory Museum and Art Gallery as part of its collection of Aboriginal art points to a central problem and a serious instability in the Aboriginal art market—again reflecting on the critical criterion of knowledge and anxiety (Plattner 1996). How does one know an Aboriginal painting when one sees one? What makes a painting "Aboriginal"? What is to be made of paintings done in similar style by non-Aboriginal people? Petyarre asserted that the Dreamings were hers and that Beamish was not "the author of any of the paintings signed by me." The question of authorship is fairly critical for the entire art market. Buyers want to know who painted the work they purchase. They want to know, furthermore, where such a work might fit into the history of the painting movement, or into one painter's place within it, and so on. Forgeries and misattributions threaten this structure and impede the development of any serious value.

Similar stories have long circulated about the works of the highly esteemed Anmatyerre painter Emily Kngwarreye ("Experts have warned paintings being sold as Kngwarreye creations may have actually been painted by other members of her tribe working as an organised 'school' to produce works in her style" reported the *N.T. News* on 10 January 1997). Represented by several different dealers and often working in different styles, Emily had a prodigious output, and her work was in great demand. When she died, dealers from across Australia attended the funeral. One dealer told me that "a lot of people were doing copies and fakes of Emily, too, and I was told that some very recent Emilys were turning up shortly after she died." Emily's production was a lifeline for her dealers, and something they needed to protect. At the "sorry business" (her funeral), there were reportedly

accusations against those suspected of forgery, who would be profiting short-term from the value of her name on a painting but would be endangering the investments of those who owned "authentic" paintings that they planned to sell.

Finally, there is the case of the white Australian artist Elizabeth Durack, who painted pseudonymously as an Aboriginal man, Eddie Burrup (J. MacDonald 1997, 7; S. McCulloch 1997a, 21, 22; McCulloch 1997d, 14–21). The revelation of this circumstance provoked outrage in some Aboriginal quarters. Lenore Nicklin reports that "when Djon Mundine discovered that Eddie Burrup was really the 81-year old West Australian painter Elizabeth Durack, he was furious. Here was cultural appropriation at its worst. 'It's a fucking obscenity,' he said. 'It's like Kerry Packer pretending to be Mahatma Gandhi' " (Nicklin 1997, 22). The accounts of Durack's painting under the name of her invented identity are complex. Although many must have suspected that the large prices and attention being received by Aboriginal art would be an attraction for any white artist, Durack's invention does not appear to be a case of appropriating Aboriginal identity and images purely for profit. A member of a famous pioneering family and a longtime friend of Aboriginal people in Western Australia, Durack described the invention of Eddie Burrup as more of an alter ego. McCulloch (1997d, 23) reports that "in creating Burrup, Durack felt, insofar as it was a conscious decision . . . that he became a conduit for her huge and somewhat eclectic reservoir of knowledge about the Aboriginal world." Durack saw painting as "Eddie" as working within the spirit of reconciliation and was shocked at the misunderstanding of the works and her reasons for doing them. One Aboriginal response was Mundine's: "She's from the squattocracy. Elizabeth Durack saying she mixed with Aboriginal people is like Prince Charles saying he mixed with nannies. I'm sure she played with Aboriginal children when she was a little girl, but she came home and slept between white sheets" (Mundine, quoted in Nicklin 1997, 22). This judgment evaluates Durack's Aboriginality (or lack thereof) as the basis of the right to participate as Aboriginal, policing the identity boundaries in a particular way that refuses a common Western fantasy of personal and artistic self-invention. Mundine's comments here reflect a position he has articulated frequently in relation to the growing number of "wannabes": One does not become Aboriginal so simply as an act of invention. One gallery director, Edmund Capon of the Art Gallery of New South Wales, claimed that the issue of identity was irrelevant, a position in line with a recognizable position of art's universality: "I don't give a hoot who painted it. I care about the picture. I don't see it as fraud because the painting itself is going to be judged on the painting itself; it's not going to be judged on who painted it" (Capon, quoted in McCulloch 1997a, 2).

But complex identifications in place, hybrid identifications not confined to racial or ethnic identity, are coming to be more commonly acknowledged in contemporary Australia, including Durack's close and enduring relationship with Aboriginal people such as Jeff Chunuma, with whom she grew up, a respected member of the Waringarri community. Less severe but still critical, disapproving but still her "son," Chunuma is reported to have passed on his community's response as follows: "You tell 'im 'e's got to come up here, sit down and talk to us. It's no good what 'e's doing. That old man behind her shoulder. She got to stop doing that" (Jeff Chunuma, quoted in McCulloch 1997d, 19). There is respect and sadness in these Aboriginal responses, more than simple denunciation. According to the acting director of the Kimberley Aboriginal Law and Cultural Centre, Kimberley Aborigines, many of whom respected Durack, were shocked and saddened: "We are upset that someone who claims to have an understanding of and respect for our Aboriginal culture should act in a way that can only be interpreted otherwise. . . . My chairman has instructed me to say that in Aboriginal law no one can take another's work for another's identity. We are ashamed for Miss Durack and are deeply saddened by what she has done" (Wayne Bergmann, quoted in MacDonald 1997, 7).

Susan McCulloch has suggested that the reaction to Durack's impersonation was "generally milder in the West—from both Aborigines and others who know the Duracks well from the family's longstanding pastoral connection with the Kimberley. Durack, they said, had been speaking for Aboriginal people through her art for years, and while her Aboriginal creation may have been misguided, it was based on altruistic motives and a genuine attempt at cultural bridge-building" (McCulloch 1997a, 2).

Nonetheless, in this case, Mundine correctly recognizes a larger picture, that Aboriginal people's right to control their culture and art is being transgressed. This was summed up in Kay Mundine's statement on behalf of the National Indigenous Arts Advocacy Association: "The question of people from other groups taking cultures and using them for their own commercial or artistic purposes—it shows a complete lack of understanding and respect for the people who she says she's representing" (Kay Mundine, quoted in McCulloch 1997a, 3–4).

These issues have all become part of Australia's national conversation with itself and have led the well-known Australian intellectual Germaine Greer to decry such developments as "selling off the Dreaming" (Greer 1997, 5; for a reply to Greer's controversial views, see McDonald 1997, 9). In her argument, Greer follows an earlier line of criticism set down by Anne-Marie Willis, questioning "the progressive agency of Aboriginal art for Aboriginal people" (1993, 125). In fact, Greer's

denunciation only delineates quite clearly the difficulties of managing two on-going problems for the contemporary life of Aboriginal culture: its authenticity in contexts of copresence with the market (commodification) and with white society itself (cultural identity). There is some irony in the fact that Greer articulates a concern for an authenticity of identity, just when the market and cultural theorists had thought that the strictures of primitivism — imagining the only culturally authentic work to be that produced in isolation from the West (Phillips and Steiner 1999; Price 1989) — had been overcome. Insofar as Aboriginal or indigenously derived practices might continue to adhere to acrylic painting in the market — for example, in the apparent lack of concern either to represent proper (Western) authorship or to accept exclusive contracts with dealers — there *has* been complicity with unethical art dealers. The exposure of these circumstances has been publicly embarrassing and damaging to the viability of the art market, even scandalous, but also quickly forgotten after the fact.

Negotiating Identity

It would be easy to imagine that we know what was wrong or what was at issue in these scandals, but I believe the question is far from settled. Indeed, the scandals represent, instead, a significant moment in the conceptualization or institutionalization of cultural property. Intellectual copyright law may allow for compensation to occur for unauthorized use of designs, but — as most supporters of this remedy acknowledge — copyright does not represent fully what is at stake in the problematic circulation of acrylic paintings as cultural artifacts. A range of values attach to the objects we know as acrylic paintings, each of these properties coming — at varying times — into vision as salient. Copyright payment cannot, for example, remedy the threat or harm to cultural identity, cannot represent the history of genocide encoded in these objects. Yet there is no question that for many viewers, owners, and producers of the paintings, this history is vitally represented in their very being. The question of what kind of object these paintings might be is not resolved in the legal imagination, as the growing interest in the frauds, forgeries, and misrepresentations indicates. How, in fact, these objects might be represented in property law is not a simple question. Just as how modern art objects would be represented in tax law became an issue in the United States (Steiner 2001), it seems not at all clear to me that Aboriginal peoples' rights over their designs or even the concrete objects themselves will be seen to be severed absolutely by the act of sale.

The point of my writing in this fashion is to insist that the circumstances sur-

rounding Aboriginal art do not indicate a "strange condition." As any student of Harold Garfinkel and ethnomethodology would recognize, the meaning of an object is open to negotiation in social action. This is not so much to insist that any meaning whatsoever can be constructed, but rather to claim that social dramas (V. Turner 1974) or tournaments of value (Appadurai 1986) are common ways in which contested evaluations of meaning or value are made evident. Many meanings may be attached to objects, even those entering into commodity status, and these meanings may not simply disappear when objects are bought and sold. Rather, the hierarchy of such meanings or value may be problematic—just as stealing bread might be regarded less as "theft" (classified as an act of thievery) if a person or his or her children were starving. One might claim that the rights of possession over property were less important than the obligations to starving kin. It is not that either the property value or the kinship value attached to this action is expunged; rather, they are subordinated in some sort of hierarchy.

Similarly, I believe, we should regard the attempts at stabilizing the meaning of Aboriginal painting—where meanings and values subordinated in one representation are not completely erased but continue to adhere to the objects. One might say that in this regard these objects have resisted the process of simple commodification, by retaining a series of properties and values that are not reduced by the market and that recognize the interests of those beyond the owner. This, one presumes, is a limitation of any attempt to conceive of objects and relations of cultural property within the regime that has been developed for property in general. These objects typically defy the framework of "possessive individualism" (Handler 1985). Moreover, Durack's impersonation of an Aboriginal may not be a criminal act; it is not, however, a "theft" of identity as if identity were a form of property, either. The Aboriginal criticisms suggest that her painting as an Aboriginal was problematic because she hadn't asked anybody or discussed it with a relevant Aboriginal community. This seems to reflect considerations similar to those that became visible when Tim Johnson painted, *with* permission, with the dot style. He did so not *as* an Aboriginal person but through an identity they had accepted. While such a performance was acceptable to some, it might not have been acceptable to all Aboriginal people who had rights to those designs, but this does not make it different from the situation of Aboriginal people performing their identities—a performance that is always dangerous and subject to counterclaim and retaliation.

What are we to make of these scandals? I think we should recognize that they reflect the very process of hybridization, of objects that cannot be made to fit easily into the categories of conflicting regimes of value. Do these exposures, then,

discern a loose thread in the well-intentioned, sympathetic construction of "Aboriginal fine art"? Does the apparent motivation of the painters for monetary reward necessarily imply a loss of the genuine Aboriginality—the sincerity for the Dreaming—that should underlie their projects, an alignment of Aboriginal painting with art's proper authenticity: "from the heart"? If so, then Ace Bourke and Chris Hodges have been misguided to announce the "end of Aboriginality," an end that for some seems to threaten Aboriginal art (and culture) with the possibility of simple commodification, marked by named painters making simulacra of their earlier successful paintings at their dealers' behest. Surely, what is taking place is not a simple commodification, not a reduction of objects to quantitative exchange value, but rather a reorganization of the hierarchy of values adhering to the objects.

But if Aboriginality is not the principal content of the paintings, what is the threat from non-Aboriginal painters painting in an Aboriginal style, or disguising themselves as Aboriginal? Here is a point at which fraud can occur, and in which the painting's indexical connection to Aboriginal people and their cultural project can be faked in the sign's detachment from persons in the market. Indeed, Aboriginal curator Djon Mundine's claim—that you can tell when a painting has been done by an Aboriginal person—is perhaps mistaken. And if that is the case, what happens to the claim that this art is valued just because it is *good* art (not because it is good *Aboriginal* art), deserving of entry into the nonghettoized category of "contemporary art"? Contrarily, then, why can't white artists paint "Aboriginal art"? Are we reaching a new stage in the detachability of these signs—as music reached earlier?

What is at issue in this boundary activity are the possibilities of what I call, after Lomnitz (1994), "corruption." The Durack case, of impersonating an Aboriginal identity in painting, does not constitute a crime, but it may be the most upsetting of the cases for Aboriginal people. Tolson's willingness to sign paintings executed by his relatives is unproblematic for them. It seems to me that we should be able to recognize the effects of these corrupting practices on cultural identity, now highly valued in the contemporary cultural conjuncture as explained by Terence Turner (n.d.). Complaints from Aboriginal people framed in terms of copyright (V. Johnson 1996a, n.d.) and about the stealing of their culture conjoin with equally long-standing concerns for Aboriginalization and self-determination for Aboriginal people within Australia, which has typically meant allowing them to speak for themselves, to represent themselves. To do so, of course, requires an uncorrupted sphere in which Aboriginal people can know themselves, communicate. Presuming to speak in their voice, however, corrupts their opportunities for

self-determination. Put more analytically, there is a deep structural issue about the possibility of forming an identity.

The scandals, then, demarcate potentials to cause harm, harm that may occur from the mismanagement of cultural properties. Bruce Ziff and Pratima Rao have attempted to delineate precisely the nature of claims about cultural appropriation, to explore what the injuries could be. Thus, from considerations of work on this topic in Canada, they write,

> When concerns about cultural appropriation arise within various domains, several claims tend to emerge. One is that cultural appropriation harms the appropriated community. This claim is therefore based on a concern for the integrity and identities of cultural groups. A second complaint focuses on the impact of appropriation on the cultural object itself. The concern is that appropriation can either damage or transform a given cultural good or practice. A third critique is that cultural appropriation wrongly allows some to benefit to the material (i.e., financial) detriment of others. A fourth argument is that current law fails to reflect alternative conceptions of what should be treated as property or ownership in cultural goods. This is a claim based on sovereignty. (Ziff and Rao 1997, 8–9)

The availability of acrylic paintings in the art market raises the question of how they are to be treated, by whose rules, and whether there are in existence meaningful regulations to manage these objects and the interests they represent in an adequate way. In summary, concern over cultural appropriation may involve (1) prevention of cultural degradation, (2) preservation of cultural goods as valuable objects, (3) deprivation of material advantage, or (4) failure to recognize sovereign claims. How to convert these perceived injurious experiences into culturally meaningful bases for dispute and action is a significant problem.

These more abstract considerations allow us to understand the cases of scandal because they clarify what the central values are that are under threat. Most of the accounts are deeply weighted to the Euro-Australian point of view, and the fear of being tricked or duped—that they are buying mere commodities under the sign of something heartfelt and authentic. Aboriginal understandings of their imagery and their identities are actually quite clear, and they are not to be explained by recourse to representing cultural property in the framework of "possessive individualism" (Handler 1985). The dominant question framed by Aboriginal people about identity is quite similar to that of First Nations people in Canada and the United States.

I must tell a story to clarify the defensiveness that accompanies the question

about identity. At a small conference on Native American art history held a few years ago, Marcia Crosby confronted — perhaps confounded — the non-Native people with her question about who they were. "We want to know," she said, "who you are, why you want to study us? We don't know you." At least one of the senior white participants misread the implications of this question, defensively perceiving it to be an exercise in boundary maintenance or essentialism. He denounced the question in liberal terms — as ghettoizing, as leading to the converse claims of white rights and white exclusivism, which he deplored. If Native people want to close themselves off and say only Native people can learn their traditions, what would be wrong with whites claiming similarly?

Apart from the power issue, this speaker misread the question as if Native identities could be conceived in terms of possessive individualism, as something one *has*. At any gathering, Native people typically identify themselves as coming from one or another community — as do Aboriginal Australians. They do so not to claim themselves abstractly as indigenous in a legalistic manner; rather, this identification announces their accountability to a community — that their representations and actions will be accountable to some recognized body of Native people. In Australia the question is also one of accountability — of the answerability of one's representations to a community, of being recognized and responsibility for what one does. That is what being a Native person means, far more than "blood quantum."

The Metis filmmaker Loretta Todd has been eloquent on First Nations ideas about ownership in the context of cultural appropriation, of property in terms of relationships that are far wider than the exclusivity of possession and rights to alienate that dominate European concepts. Rosemary Coombe has brilliantly summarized the implications of Todd's position in its challenge to the legalisms of property law:[2]

> First Nations peoples are engaged in an ongoing struggle to articulate, define, exercise and assert aboriginal title, not only in terms of a relationship to territory, but in a relationship to the cultural forms that express the historical meaning of that relationship in specific communities. . . .
>
> For Native peoples in Canada, culture is not a fixed and frozen entity that can be objectified in reified forms that express its identity, but an ongoing living process that cannot be severed from the ecological relationships in which it lives and grows. By dividing ideas and expressions, oral traditions and written forms, intangible works and cultural objects, the law rips asunder what many First Nations people view as integrally related — freezing into categories what Native peoples find flowing in relationships. For those sym-

pathetic to their ends to attempt to reduce these claims to assertions of intellectual property rights is simultaneously to neglect significant dimensions of Native aspiration and impose colonial juridical categories on postcolonial struggles in a fashion that reenacts the cultural violence of colonization. (Coombe 1997, 92)

Coombe's conclusion is equally suggestive of what is at stake in the current round of Aboriginal art scandals — namely, the reevaluation of some of our long-unquestioned but historically developed concepts of art and property: "Colonial categories of art, cultural and authorial identity are deeply embedded in our legal categories of property, but the claims of others to objects and representations may well force these Western categories under new forms of scrutiny" (93).

Another indigenous filmmaker, Frances Peters from Australia, spoke similarly to Todd of the accountability one has to a community, but she rejected the alternative (easy) essentialism of embedding oneself in "community." Peters also recognized the exacting tensions of such accountability. "I haven't lost faith," she told Jackie Urla in an interview, "but I can't romanticize 'the community' ": "That's my problem with the idea that came up in the film series round table last night; the idea that as native filmmakers we have to be accountable to the community. Which community? Our communities have become bureaucratized and class-stratified. Accountability is riddled with fear of being made to feel guilty, or that you aren't Aboriginal enough. It's a power thing" (Peters, quoted in Urla 1993, 105). Visiting in New York, Peters discussed the position of being an Aboriginal producer, of "never seeing their work as existing apart from the mediation of social relationships" (Ginsburg 1993b, 96), even more poignantly:

Unlike you, we can't remove ourselves from the programs we're making because they're about us as well. And because they are about us, we always have that responsibility to our Aboriginal culture and country. A lot of program makers don't. It becomes a 9 to 5 job. You come to work, you make a program as an observation, and basically, in many ways, you can walk away from that.

So, we can't walk away and just make a program on a different theme next time, you know. Non-Aboriginal filmmakers — when they're making programs about different topics have the luxury of saying, "Well, I've dealt with the disabled, and next week it's going to be about women and next week it's going to be about X. . . ." And ultimately, you're not really answerable to a hell of a lot of people. You're either answerable to your executive producer, to a certain section of the community or society, or whatever. But we, with every program that we make, are ultimately responsible to a larger Aboriginal

community. And we can't remove ourselves from that responsibility. (Peters, quoted in Ginsburg 1993b, 96)

Whatever the value of copyright and intellectual property considerations in benefiting Aboriginal people, and they are many (V. Johnson 1996a), ultimately what is at stake is the right to deploy images of oneself in ways that one wishes to control. While various legal remedies may match such rights to a degree of profit, Aboriginal people expect this and more. And this expectation, indeed demand and struggle for more, has had effects, as the cases indicate, in bringing the mediations proposed by Western categories of property and identity under new forms of scrutiny.

The connections I discern in the formulations emanating from different indigenous peoples are not at all accidental. As Terence Turner has argued, there is a connection between globalization, the expansion of capitalism and consumerism, and the emergence of "culture" as a major political and ideological force. This has valorized indigenous cultures in many settler societies. Turner's argument is that developments in late capitalism — what he calls "the polarization of the commodity fetish" (T. Turner n.d., 11), or the increased alienation of the control over the production of exchange value from the power of consumers to satisfy needs — have resulted in a valorization of identity in social life. This has made consumption and identity an important vector of contemporary life, with the struggle over the continued production of collective identity and personhood the only possible area left for political and social action. Vivien Johnson has insisted repeatedly that we must attend to "Aboriginal art's power to speak to such contentious issues as Indigenous connections to land, cultural and intellectual property rights, and the stolen generations" (n.d., 16) — its capacity to bear cultural witness. "The effect of highly publicised artistic and literary fraud," she writes, "has been to undermine the capacity of Aboriginal art to bear this potent form of cultural witness. These impostors subject the entire body of Indigenous art to cultural harm when they mock its ability to speak its own truths to mainstream audiences and to impart visions of Aboriginality" (16).

What concerns Aboriginal critics, and where the threat of corruption lies, is in the production of collective identity. Durack-type misrepresentations threaten to insert into the Aboriginal conversation and Aboriginal representations of identity a voice that is not only not racially Aboriginal but also not accountable to Aboriginal communities and conventions. The criticisms of Durack are clear on this score.

There is, however, a further corruption threatened by the irresponsible art

dealers and the structure of the art market that drives them. As I have tried to show, the logic of this market orients dealers to gain control over painters and their production. Because Aboriginal painters may sell their works to whoever is ready to pay for them when money is needed, dealers are inclined to bring the acrylic painters into town to work, where they can acquire the works as soon as they are completed and where, they hope, other dealers will not get there first. The dealers complain that otherwise they cannot get the best quality paintings or enough of them.

These activities presume that the painters' inspiration will be unaffected by locale, but experience suggests something different. Art advisers have learned that painters do not work well on the production line, that they may need vacations from painting or new inspiration, that their inspiration might be renewed by trips to visit their country or by participation in ceremonies. Dick Kimber certainly learned this in working with the painters in the 1970s, and Daphne Williams views the painters' movement to the towns as deeply troubling—not to the number of paintings they can do, but rather to the kind of consciousness they bring to the activity. Painters are part of communities and networks of relationship. It is through connection to their communities and events in them that the painters might acquire new inspiration that can be brought back into their painting.

For this renewal to occur requires something like a partnership, of the sort that classical dealer-artist relationships have involved. A good dealer does *not* sell everything an artist paints, but tries to keep only the best work on the market, encouraging the artist to keep his or her standards high. The fly-by-night dealer, gaining access perhaps for a short time to a name artist, has no long-term interest in the artist's development. He wants, rather, the immediate production. Indeed, he wants paintings that are recognizably those of the artist, often meaning simulacra of earlier successful designs. This is a source of corruption on the market, but it is also a corrupting influence on the painter, whose removal from community life and accountability is an intervention in the relationship of the artist's painting and cultural identity.

Turkey Tolson's artwork was threatened by corruption, but not because he was painting for money. Most of the painters do that, and they have become—as did Emily Kngwarreye—a source of money for their relatives, whose demands are intense and never ending. They paint their identities in their paintings, and the paintings are exchanged for cash—but in the broadest terms, the painter is trying to manage this identity in the midst of an onslaught of desire. Turkey's work was threatened by corruption because the conditions of his presence in Alice Springs— his need for more regular money and the needs of his dealer for "product"—drew

him away from the experiences that informed his painting. Ultimately the scandals revolve around the dispossession, appropriation, or corruption of the principal good that indigenous people may have in the contemporary cultural conjuncture — their identity.

It should be said, too, that the demand for Aboriginal art is itself specific, articulated within a particular niche of the market that may make it possible or profitable for some kinds of dealers to exploit fraud and forgery. The work of the "name" painters is associated with an art movement that has been recognized now as unusual, vital, and historically significant. Unlike those of living white artists, for example, the Aboriginal paintings are bringing substantial sums and are much more difficult to establish provenance for. Knowledge, therefore, is not adequate, and buyers cannot be certain of the status of paintings. At the prices they bear, which are substantial but not crushing, buyers are willing to take a chance, and some entrepreneurs can seize on this as an opportunity to make money — but not a career in dealing art.

These boundaries, and their policing, are significant issues, issues broached by the detachability of the sign from its connection to actual identities. A significant comparable case, suggested by a colleague in New York, might be American jazz and its "universality." When Miles Davis chose a white piano player (Bill Evans) for his combo, to some this was evidence that "race did not matter," that people couldn't tell whether or not a black person was playing the music. If conservatives in the United States were happy to show that "race doesn't matter," the fact that a white person's painting might win the N.T. Aboriginal Art Award may question some of the issues papered over in common constructions of Aboriginal art. For example, proponents of acrylic painting as fine art — such as John Weber — have insisted that Aboriginality doesn't matter, that who painted a work does not matter: this is just good art, or "I like the way they move the paint." This might imply that no special pleading is needed for Aboriginal art, that this is art that works in the modernist sense. But what if this work is not produced by an Aboriginal person? Should this matter? It matters to the Aboriginal people of Central Australia, for whom designs are inalienable dimensions of their identity, for whom forgery is theft. As other Aboriginal people, with different histories, have pointed out, white Australia has taken their land, and now they want to take the only thing that is left, their culture.

Special pleading for an ethnic category of art may fly in the face of theories that emphasize the formal features of art, where the artist's identity is held not to matter. Clearly, however, the artist's identity *does* matter here, and the producers themselves insist that it does. They insist, in addition, that such an identity is not

severed at the point of sale—for example, in their expectation that future reproductions should result in compensation, and in their continuing accountability for what happens from their art's circulation. We must recognize, therefore, that the question of what kind of objects these are has not been settled, and it has not been settled by the dicta of whites only. In the circulation of acrylic paintings through a range of intercultural spaces, a public sphere of discussion has been created that continues to evolve an understanding of these objects and their implications as part of a specific history. This evolution has—and must continue to—come to terms with the ability of this art to "speak its own truth" (V. Johnson n.d.), precisely the capacity that the painters have long understood it to have. At least part of the truth it speaks, it should be recognized, is its inalienability from the persons and culture that have been able to produce such an expression.

Epilogue: Blackfella/Whitefella

Marcia Langton (n.d.) has seen the scandalmongering as part of an ongoing and intensifying culture war in Australia, whose base lies in white anxieties. This resistance to the rise of Aboriginal regimes of value can be palpable, but so is the ever-increasing visibility of Aboriginal cultural production. In August 2000, the prestigious Art Gallery of New South Wales and Papunya Tula Artists opened a magnificent retrospective exhibition in Sydney, *Papunya Tula: Genesis and Genius,* focusing on the past thirty years of work. The exhibit received major critical attention and publicity, kicking off the Olympic Arts Festival that led up to Sydney's hosting of the Olympics in September. Curated by an indigenous curator, Hetti Perkins, and with approximately 150 paintings (from fifty artists) from the entire period of the movement, including almost all the most celebrated examples of Papunya art that had been sold for record prices, this exhibition announced definitively the recognition of Aboriginal fine art. For me the event occasioned a long hoped for reunion with Pintupi painters, including Bobby West—the son of my closest friend Freddy and my own first friend at Yayayi in 1973. For Bobby, the retrospective was an occasion for pride, as he said, especially in his father's painting. Even so, at the Radio National interview (18 August 2000) occasioned by the opening, the questions from Michael Cathcart carried a probing nuance. Was this really fine art, or was it just a kind of sentimental recognition of Aboriginal culture? "Fred Myers," he asked me, "what's your take on this? Is it fair to see this kind of art as part of a worldwide phenomena in art, or do we need to see it within a purely Aboriginal context?" Pressing further, the question revealed a concern for the authenticity of current Western Desert art:

I suppose the issue that I wrestle with, Fred, is when you walk down the mall there in Alice Springs and there are all those art shops there, you do wonder—well, I do as a white onlooker—how the art is being transformed by passing through that shop. Whether I'm looking at work that I would like to buy, if I had enough money to buy it, with the eye of how would it look in my living room and perhaps because I want to take something back from Alice Springs that speaks to me with an encounter of Aboriginality? But I do wonder if the shop somehow filters out what the artist put into it, whether the work has one meaning for the artist but another meaning for the buyer, if you see what I mean? (Michael Cathcart, Radio National, broadcast interview, 18 August 2000)

These probings so paralleled the suspicions circulating in the scandals of the previous several months that most of us understood them to be phrasing that point of view. Marcia Langton's first response was to draw attention to what she called an "excess" of appropriation that betrays a policing of whiteness, and ultimately a trivializing of indigenous culture. But, she insisted, "If you stand in front of some of these paintings, it is surely not possible to walk out of the gallery with the low level apprehension of Aboriginal art that is now circulating in Australian popular media. It is surely not possible" (Marcia Langton, Radio National, 18 August 2000).

A deeper response came the next day at the symposium, where Langton made the fundamental point that viewers of Aboriginal art expect that looking at the work will itself reveal its value and meanings. Instead, she told the audience, responding to the paintings requires work—the work of scholarship, research, and attention, just as we cannot understand Renaissance art merely by looking. Indeed, she said, her own understanding of Western Desert culture was not something she simply knew because of her Aboriginal identity but was acquired over a long period. How could it be otherwise? Or do we think that Aboriginal paintings are somehow transparent?

At the end of the events opening this retrospective, the Western Desert Aboriginal rock and roll group the Warumpi Band played in the art gallery's main hall, a space usually restricted to the serious gatherings associated with fine art. The words of their celebrated song "Blackfella/Whitefella" were an anthem to the mixed crowd, black and white, pressed together in the new combination objectified in the acrylic paintings:

Blackfella, whitefella,
It doesn't matter what your color
As long as you're a true fella
As long as you're a real fella.

It isn't color, but recognizing the reality of Aboriginal lives, that matters. And then the refrain, "Are you the one who's gonna stand up and be counted?" And that we did, hundreds of us, black and white, old and young, remembering a common cause and a cultural future that, like the paintings, finds new combinations of white and black. Songs with the specificity of the Western Desert and even Arnhem Land locations of band members—"Kintorelakutu" (back to Kintore) and "My Island Home" (Elcho Island)—now circulate as part of a more abstract currency, for young Australians white and black, in ways similar to the circulation of Western Desert acrylic paintings for other identities inside and outside of Australia. The Warumpi Band has been a favorite of the young urban indigenous activists and artists as much as for those in the bush. Urban indigenous cultural activists such as Hetti Perkins, Brenda Croft, and Marcia Langton danced to the beat along with older representatives of other generations and other locations, white and black. The Papunya Tula painters Bobby West, Kenny Williams, Warlimpirrnga Tjapaltjarri, and Charley Tjapangarti knew this music, rock and roll emanating from their own community, and responded to it as a welcome, even if they knew that so much else of their experience could only be mysterious. So the band played—in what may have been one of its last performances—weaving together another pattern of the threads already articulated in the retrospective of Papunya Tula Artists and in Australia's emerging cultural convergences.

The Papunya Tula show was a cultural and political triumph, but in its very success there is a political paradox to which Marcia Langton was responding. As this brief epilogue of my own journey implies, the circulation of Western Desert acrylic painting brings it to the question of "blackfellas" and "whitefellas"—to problems of race in Australia. Indigenous Australians are increasingly celebrated in contexts such as the Papunya Tula retrospective. The wider conditions for their lives, however, remain poor, and they may be becoming even worse. The present government (of John Howard) has abolished some of the Labor Party's special programs (e.g., to support Aboriginal participation in higher education) and has refused any movement toward national reconciliation, attempting to dismiss the claims made about the degree of government complicity in the "forced" removal of part-Aboriginal children from their families (Manne 2001). There has been broad support for Aboriginal causes, but also very negative media representation of Aboriginal people, Aboriginal societies, and their "pathologies." To stand up and be counted seemed more important than ever.

Men make their own histories, but they do not do so in times and places of their own choosing. — Karl Marx, *The Eighteenth Brumaire of Louis Bonaparte*

Blackfella/Whitefella

When I first encountered Aboriginal art in the field in 1973, its presence seemed to reflect an effort to shore up the losses Pintupi and other Aboriginal people were experiencing in the aftermath of various governmental policy regimes, most recently that of "assimilation." The reversal of that sense of despair and marginalization twenty-seven years later in August 2000 at the opening of the major art retrospective at the Art Gallery of New South Wales (AGNSW) was extraordinary and exhilarating. These people who had been considered Australia's most primitive of primitive twenty-five years ago were now among those chosen to inaugurate the Olympics as part of Australia's presentation of itself to the world. This is a sign of the value their work now has.

For the four senior men who came with the exhibition to Sydney, young adults and teenagers when I met them, the official honoring of their fathers and themselves is a broad recognition of the "truth" of their painting and its ultimate value, even as their land in Western Australia (the source of its value) has just been repatriated under Native Title as of this writing. The exhibition has also bridged a historical and social rupture that once — and still sometimes — divides Australia's indigenous people themselves: remote and urban, tribal and assimilated, categories of historical experience that were once embedded in the colonizing distinction of "full-blood" and "half-caste" people, with the latter more subject to policies of government intervention and removal.

The fact that Hetti Perkins, a thirty-four-year-old "post–Civil Rights" urban cultural activist and part of a new generation that has historically had little contact

with remote people, played so active a role in curating this show is another kind of reversal of the historical separation of more remote, traditional people from their bicultural, urban-dwelling indigenous compatriots. Indeed, the reactionary policies of the Liberal Party, in power since 1996, were reversing the whole movement toward recognition of Native Title and reconciliation with Aboriginal people, a situation that was uniting Aboriginal people across other kinds of social difference.

As the curator of the exhibition and the curator of Aboriginal and Torres Straits Islander Art at the AGNSW, Hetti Perkins announced some of the significance the exhibition might have when the opening was launched. The Papunya Tula movement, she said, allowed Aboriginal Australia to reclaim the Continental Interior. "Desert painting—popularly known around the world as dot painting—is a different way of imaging the landscape, so it's a real challenge to this accepted sort of Australian landscape tradition. . . . It has not only imaged the landscape in a different way, but it has conveyed a different understanding of the landscape: an Indigenous understanding of the landscape" (Perkins 2000). The exhibition's inclusion in the Olympic Arts Festival departed from the politics of some Aboriginal organizations that had chosen to boycott events, in protest against recent government policies against the move toward reconciliation (see Manne 2001). Perkins maintained that being involved in the art exhibition did not deny the right of anybody else "to protest or have their say at this time when there is an International focus on Sydney." Indeed, she pointed out that "the issues that this exhibition raises are in many ways political. It's the story not only of a great and wonderful art movement; but is also the story of colonisation, dispossession, and displacement. Some of these people suffered massacres and have been displaced from their homelands, suffered extreme poverty and so on. So I don't think any of those issues go away at a time like this" (Perkins 2000).

The retrospective *Papunya Tula: Genesis and Genius* at the Art Gallery of New South Wales crystallizes the accomplishment of acrylic painting and its makers over a quarter of a century since boards were first introduced. There are many histories—indigenous, personal, intercultural—that can be brought into visibility and renegotiated through the circulation and recognition of the art. The cascading of these histories into each other is what struck me when I arrived as an invited speaker in Sydney on 15 August 2000, expecting to spend some time with the four painters—all old friends—who had come down from Warlungurru and Kiwirrkura to make a ground painting for the opening. At the art gallery, I found the men at the garden restaurant overlooking the beautiful park known as the Domain, where the curators and the painters were eating.

Bobby West, Charlie Tjapangarti, Kenny Williams, and Warlimpirrnga Tjapalt-

jarri were all standing expectantly behind a table in the garden when I arrived. This encounter—after so many years—was both intense and awkward until we reestablished the intimacy we had shared. Despite the passage of years, Bobby was embracing and friendly, the obvious leader and connector on this trip. Because of our previous history, the men and the curators made me a part of the events. Bobby asked repeatedly if my daughter (who has a genetic disorder that prohibits plane trips) had gotten any better—wondering, no doubt, if we could travel out to his country as I had once done so often. He wondered if I had gotten the messages he sent to me through the Ngaanyatjarra Council.

Bobby, now forty, is a man who hopes to keep the memory of the past alive. Did I have pictures of his father, Freddy West Tjakamarra, who had been my closest friend? In fact, I was anxious to clear with the four painters the slides I was planning to show in my talk on Saturday. The prohibition against images or names of the dead being displayed is now one of the cultural traditions that they have accommodated to circumstances, as applying only to more limited contexts. For the purposes of our symposium and to explain the history of Papunya Tula, they told me, it was fine to show these pictures of their deceased relatives. In fact, they wanted copies themselves and asked me to bring them in for prints to be made.

The ground painting was under construction on the bottom floor of the art gallery. It was quite large. They had decided to do Tjuntupurlnga, a claypan associated with the Tingarri Dreaming, near Yaruyaru. This place had belonged to Bobby's mother's father (Wili Tjungurrayi), a man who had died shortly after being resettled in Papunya in the early 1960s. Warlimpirrnga is also connected to the site. They had brought a huge lot of red and white wamulu, colored and crushed bush daisies, packed in post office boxes, applying the fluffy substance to the sand placed on a boxlike enclosure of perhaps 12 × 10 feet. They leaned over the edge or sat cross-legged on the sand to apply the wamulu in concentric circles and connecting tracks. It was done with great concentration but without ceremony or singing.

When I brought the slides in on Wednesday, the men looked at their friends and relatives excitedly. Bobby selected several for Wuta Wuta's son Maatja (Martin) and others for Shorty Lungkarta's relatives. I felt myself being reconnected and able, at last, to repay some of my indebtedness to my teachers. Reminiscing with the photographs from 1973, I was astonished at Bobby's memory—of what music tapes I had brought from the United States and what we had done the first time we went out hunting. I came to realize that Bobby's commitment to memory, to keeping continuity with the past, was an essential part of how he understood the exhibition.

Papunya Tula painters making a sandpainting at the Art Gallery
of New South Wales, August 2000. Photo by Fred Myers.

That Wednesday night, at the President's Council Viewing, an exclusive first
private show of the hung exhibition, Bobby took me through the show back to its
beginning to see the quotation from his father, Freddy West, one of the original
painters and my friend. Pointing at the words and then to his father's painting,
Bobby glowed in the deep respect this showed for his father and his accomplish-
ments. And this, clearly, was what he wanted to bring together in some way with
his own memories.

On Thursday morning, we made our way back to the gallery, where Bobby and
the others were finishing their ground painting. They could paint this for public
display, he said, because it was "an easy one" (not dangerous to uninitiated people).
A German TV crew, who expected to broadcast to 80 million viewers, captured the
finishing touches. The painters were unfazed, happily talking to their old friends
and new ones at the gallery. The goal of the exhibition for the painters and Papunya
Tula was to obtain a dialysis machine and service at Kiwirrkura or Kintore, by sell-
ing the large collective paintings they executed for an auction. Additionally, many
friends of Papunya Tula donated some of the finest paintings from their collections
for sale.

In interviews with journalists, Bobby was asked whether they did ground paint-
ings "like these" in the bush. Bobby explained that they usually painted the designs

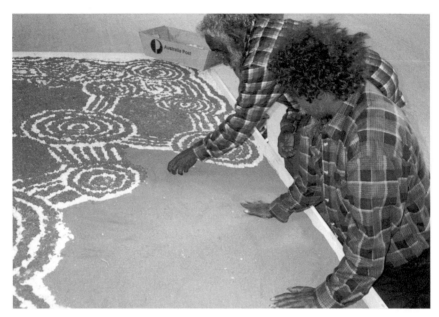

Papunya Tula painters making a sandpainting at the Art Gallery
of New South Wales, August 2000. Photo by Fred Myers.

on the body. He was also asked why the exhibition was important for him. As he
explained, "I walked in [here, the gallery] and I looked at them, and I feel—you
know—happy. I saw that my father did it, and my uncles, my grandfather, and I
was happy. It was really long time to see it [since I had seen them], some of these
little canvases. They did it a long time ago, in 1971 and 1974. And I got a shock
when I saw. It's really good, you know? And we feel really proud for our family
[who] did it, long time ago" (B. West 2000). His comments throughout the inter-
view were clear—that the paintings are for him an expression of the identities and
histories of his family, his relatives. His favorite painting, he said, was the one done
by his father, Freddy West Tjakamarra:

> That one there. It's a really old one, painted in 1971. They did all these can-
> vases, really old ones. They are not really big ones, only small ones, some of
> them. Some are medium, some large. They did it in canvas, all this. Dream-
> time, the place they putting in the canvas. It's good to have and we feel proud
> for my family did it and my grandfather and my father did it.
>
> This is place called. . . . You know. *Wati Kutjarra* [Two Men] Dreamtime.
> That's east of Kiwirrkura, northeast. *Wati Kutjarra*. Dreamtime story. The
> place is called Tipurnnga, near Kiwirrkura.

Hetti Perkins's introduction to the journalists on the same day emphasized the political and cultural circumstances of Western Desert painting, a history of a larger sort, but one that could embrace a broader indigenous perspective involving their dispossession and suffering.

That evening, we took a limousine to the official opening (below), with a special pass by "Lady Macquarie's chair," a historical Sydney site near the gallery. The throng of attendees was impressive in this capital of Australian culture, including Aboriginal activists, art people, and anthropologists. There were close to a thousand people in the main hall, having wine and milling around. When Bobby spoke, he chose to do so in Pintupi. He asked me to translate—a recognition of a twenty-seven-year history that extended back to his parents in whose camp I had learned to speak. Although he spoke briefly and directly, the blood rushed through my head as I struggled to keep pace in language. What was most present was our linkage through his father, Freddy.

Dinner that night was paid for by Molly Gowing, an older woman of the Australian elite whose fortune had been built in the Gowings Department Store. She has been a long-standing benefactor to the AGNSW's Aboriginal art collection. A commanding presence, she sat with the now-celebrated manager of Papunya Tula, Daphne Williams, and gathered around us a number of the various people who

Papunya Tula artists arrive at the Art Gallery of New South Wales for the opening. Left to right: Paul Sweeney, Charlie Tjapangarti, Warlimpirrnga Tjapaltjarri, Bobby West Tjupurrula, Daphne Williams, Kenny Williams Tjampitjinpa. 17 August 2000. Photo by Fred Myers.

have worked with Papunya Tula, over the years—the painters and speakers for the symposium to come. As always with the paintings, there was business afoot. Christopher Hodges explained that he was trying to get the AGNSW to buy the Kiwirrkura painting executed for the dialysis auction. It needed to be at least $A100,000, he thought. An interested collector feared that Americans would buy the historically significant painting and take it from the country. "We have to keep it in Australia," he said to me, taking account of my accent, "but our dollar is low."

Bobby—always thoughtful—had other concerns, equally reflected in his comments about the paintings and what they meant to him. As we were returning to the hotel, he talked about the land claim with the Western Australia government. "Western Australia is hard," he said. "They keep delaying. Old people have been struggling to get our land back. They're all passed away. . . ." In his words, I heard a sense of tragedy, of sorrow, but also of determination. "When we get Kiwirrkura," he said, "I want you to come out there and stand with me at the handover."

However, the show could not escape the inevitable questions that have plagued the work for three decades. They emerged clearly in a radio interview with Michael Cathcart from the Australian Broadcasting Corporation, whose questions seemed to betray the scandal-tinged suspicions circulating in the newspapers all that winter. Is it *really* art? What about how it fits into international fine art? These were questions about Aboriginality and the politics that surrounded indigenous people during the approach of the Olympics.

Later that day, we gathered back at Hetti's office at the art gallery and then left by taxis to go to Sydney's Opera House for the dusk event of the Olympic Arts Festival. This was the day of indigenous events, a complex and somewhat contested performance that both announced the indigenous presence and sought to separate itself from any endorsement of the government. This event had a set created by the urban Aboriginal artist Fiona Foley and a performance by the Bangarra Dance Theatre. Through Hetti's good graces and influence at the protocol office, we non-indigenous camp followers (without special invitations) were included with the painters and seated with them in the front row, center, out in front of the Opera House. From here, it seemed to me that people like Brenda Croft, Hetti Perkins—two indigenous artists and curators formerly part of the groundbreaking Sydney-based Boomalli art collective—and Marcia Langton represented a new and active center of emerging indigenous cultural activists. Their confidence in themselves made it easy for them to accept whatever contributions an anthropologist like me could offer, just as they found it easy to accept the place I had come to have with the Pintupi painters through a long and close association. I was honored to be included in what I felt to be a new stage in the production of indigenous cultural life,

one that could draw on past and present. The event itself was set in the moment of dusk turning to night, with the distinctive smell of burning gum leaves, their smoke wafting over us in just the way such smoke is incorporated in many indigenous ceremonies of cleansing. It reminded me, as it must have reminded others, of the bush and the smokes of the campfires.

The feeling was one of openness, of inclusion, as if a contemporary Aboriginality were opening itself outward, drawing on its many pasts—indexed in acrylic paintings and their stories as well as the movements elaborated by the dancers—to make a place for a public indigenous world. These were fusions, hybridities, combinations—just as the singing at the performance drew mainly on Arnhem Land songs from Australia's tropical north but managed, as well, to find something recognizable by my Western Desert companions. This was something to which people could belong, a cultural formation with which whites, as well as blacks, could establish a relationship. The activists, with their cell phones ringing and their clothing bespeaking a cosmopolitan embrace of style and art, were also respectful of the dignity of those from remote communities. Indeed, they were determined to overcome the historical divisions between bush and city by accepting their place in a cultural movement that includes actors and artists, hunters and stockmen, as well as boxers and footballers.

Despite the xenophobic fears of Aboriginal culture that characterize Australia's recent "culture wars" (Langton n.d.), the opening events were a kind of utopian multicultural space, valorizing Aboriginal cultural production as a vital part of the Australian nation, culminating in the enthusiastic dancing of the entire crowd—young and old, black and white, hippies and cultural elite—to the Warumpi Band's anthem "Blackfella/Whitefella." Its refrain "Are you the one who's gonna stand up and be counted?" expressed the moment. It is no easy or permanent identification but expressed the shared sentiment of support for the strong cultural and political presence signaled by the show of Aboriginal worlds. The band and the song are the favorites of many of the cultural activists, expressive of their world in a way that the cosmopolitan music they also like is not. And yet blackness too has its anxieties, and the older activists may wonder at the identification of the hipper young people who "don't feel black like we do." These, however, are the world invoked and evoked by the objects made in a faraway place.

Perhaps it is easier to clarify the new organization of interests and sensibility articulated by the paintings by recognizing their relationship to the musical phenomenon of the Warumpi Band, also from Papunya, which made its mark in the late 1980s as the first Aboriginal band to receive widespread national recognition. Flows of culture through music and art worlds have a synergy that is discernible

even if they may articulate, as these do, different aspects of an emerging sensibility. Known for their representation of an Aboriginal milieu in the bush and for their hard-driving rock and roll, Warumpi had made the movement from the lyric emphasis of folk music, a space of assimilation and protest, to a genre that enabled it to embrace protest within the broader language of countercultural resistance and sensibility. Like some other indigenous-based bands of this time, Warumpi developed a special appreciation for Aboriginal language, singing of the bush and its experiences, and it put this focus to electric guitar and bass. The voicing of their songs is strongly connected to Aboriginal English and a choice of Creole words (i.e., "humbug") that bespeak the conditions of Aboriginality, but not the authenticity of "pure traditions" as much as the new mixtures of drinking, jail, camping, adventure, and family. Focused on language and the experiences, translated through the more universalizing medium of rock and roll, they were one of the first Aboriginal bands to be showcased as an opening act by a major, recognized Australian band—Midnight Oil—when it made its own trip to the desert "heart" of Australia. Noisy, aggressive, in-your-face, Warumpi transmitted a feeling for the life in a mixed world. They were not yet deploying indigenous musical practices as Yothu Yindi would later, and in this sense not indexing an authenticity of tradition.[1] A transformation, then, is represented in the music of Warumpi, a transformation that took place in and through the collaboration of the white countercultural schoolteacher Neil Murray and his Papunya compatriot Sammy Butcher, combined with the singing of the Top Ender George Rurrambu. They were truly a mixed band but were identified mainly as "Aboriginal," even though their Aboriginality at one time came to be policed by urban activists who tried to force Murray from the band. In this way, in its music, culture, and personnel, Warumpi was an expression of the emergent mixing of indigenous and white counterculture, a rejection of the Anglophilic or even the middle class—and in this lay the band's appeal for a new Australia rather similar to the appeal of the dot paintings. Both represent forms of collaboration between white and black, mixings of sensibility, a shifting of Aboriginal specificity into terms more easily assimilated within the sensibilities of the broader population.

Making Culture

A project like this, a book twelve years in the writing, undoubtedly needs a summary conclusion and a reminder of its fundamental theme. This is a book about the representation of culture and about the significance of such representations in the lives and identities of indigenous people in a settler state. I began this project out of dissatisfaction with the all too common ways in which intercultural rela-

tions had come to be articulated within broad theories whose concepts of "appropriation" and "gaze" defined relations predominantly in terms of the power of the West, once again erasing the subjects. I was disturbed not only by the implied dismissal of the cultural and intercultural projects of the objects of these gazes but also by the historical sweep of such dismissals. The sense of agency, of failures as well as success, of personalities and tribulations, must be part of the story, and they have as well a general import. As an anthropologist who had long worked in one local instance, I was more aware of the particulars of such places and the actual institutional articulations through which the intercultural occurred. It is in such circumstances that one finds collusions, complicities, and alliances of interest that cross the supposed boundaries of culture and power. In such circumstances, re-articulations may be proposed, imagined, or invoked that can enter into the world of culture making.

I use the term "culture making" to characterize the production of an Aboriginal fine art because it does not erase the agency and creativity of the painters themselves. It refuses outright any reification of culture and accepts the unstable or fraught object we actually experience. My subject ultimately is about culture making, seen through the lens of the transformation of Western Desert Aboriginal acrylic painting into fine art. At its simplest, this has been a problem in cultural categories, and yet, as we have seen, the production of these categories and the work of interpreting cultural forms within them are hardly simple. What I call the "intercultural production" of an Aboriginal fine art occurs not in a generic engagement of "us" and "them" but through historically and institutionally specific mediations—in this case of art, of Aboriginal administration, and of governmentality. The social dimension of interpretation makes all such activity fundamentally negotiation. Interpretive struggle (or contestation) is the most visible instance of a process of semiosis that should always be conceived as open-ended rather than closed and final.

Mediation across or between cultures is not different in kind from *any* other communicative act, insofar as communication necessitates action through conventional forms and has the capacity to transform those conventions. The point is to imagine conditions of cultural heterogeneity, rather than those of consensus, as the common situation of cultural interpretation. Thus the appreciation by Western viewers of Aboriginal painting, however different its conventions and local understandings might be, is not profoundly different from the appreciation of a cubist painting by viewers who might be previously experienced only in Renaissance perspectives. Nor, possibly, is it very different from the process by which children in any Western culture learn to appreciate artistic work.

I take the phrase "unsettled business" as standing for many dimensions of my

project in this book. Not only is the transformation of Western Desert image making into acrylic painting and fine art an incomplete process, in the sense of its remaining caught between regimes of value—governmental, economic, revelatory—but the transformation of ritual into commerce represents a movement of Aboriginal "business" into something else. Furthermore, the structure of the Aboriginal arts and crafts industry is, as we have seen, in the throes of a bitter and complex competition among dealers. Finally, the movement of Aboriginal cultural activity into the broader cultural ecumene, as I have delineated it, is part of a larger process of reorganization and repositioning, one that destabilizes the boundaries between disciplines and our practices as well as those between us and the people about whom we write.

The institutions of the Aboriginal arts and crafts industry—which came into something like their current forms in the 1970s and 1980s—provide the arenas within which meanings, identities, and values are produced and circulated in the cultural flows managed within nation-states such as Australia that are subject to the processes of redefinition in a global economy. Within these institutions, the objects we call acrylic paintings can be said to have a social life, a biography (Appadurai 1986; Kopytoff 1986), in which they come to be identified as "fine art." This book has explored how the material culture of Aboriginal fashioning has made its way into the broader world through a series of institutions and discursive practices, formations that mediate or translate between different kinds of value—monetary and ritual, for example—and between different regimes of value.

There are many strands to my discussion, by means of which I hope to have provided readers with historically specific information about the intercultural space of Aboriginal art, as well as a broader argument. The broader argument emanates from the perhaps surprising fact that acrylic paintings and their makers have carried indigenous meanings and values into the space of the Australian nation and of other art world(s) abroad. In the process, they have no doubt been recontextualized themselves, but they have also reorganized the contexts—the regimes of value—into which they have entered. My central goal has been to show in a persuasive, concrete ethnographic fashion something of the *effectiveness* of Aboriginal painters and their work on their larger context, the effect of their own practices of bringing the "truth" as they understand and visualize it into the presence of audiences. That this has occurred partly through processes outside of their control or agency, as part of a global cultural conjuncture, should not distract us from recognizing that such genuine engagements and transformations have taken place.

Traffic in Culture: On Knowing Pintupi Painting

I began the project with dissatisfaction. The responses to Aboriginal acrylic painting that I read initially were often quite simplistic, relatively uninformed, and ethnocentric. At times, they were perceptive and even startlingly illuminating. Rather than rejecting some and embracing others, in following the larger problem of how culture circulates, I have tried to show that the ethnographer should examine this very enterprise—in which these representations might be considered as the foundations of a broader critical discourse that will constitute the history and context for Aboriginal painting in the West, the conventions for its interpretation and also of its innovation. In this way, Aboriginal painting is not seen either as failed authenticity or as failed Western art; rather, it develops its own critical discourse, its own sensibilities. Such a discursive space is created out of exhibitions, reviews, performances, symposia, and so on—each a distinctive form of representation—and is therefore suited to ethnography's special talent for finding meaning in the often ephemeral nature of daily events when culture is continually produced and reproduced.

The contemporary traffic in culture in this domain connects not simply the Aboriginal community and the Western market. It also connects distinctive disciplinary traditions with respect to the rather vexed object of "Aboriginal acrylic painting"—an "awkward relationship" between what I would call a "localism" (which I identify with anthropology) and a "cosmopolitanism" (which I identify with what I will loosely call "the art world"), as the objects and activities observed by anthropologists circulate as new forms of difference.[2] For those of us working in the field of Aboriginal art, these awkward relationships extend far beyond the academy. They have been part of the very texture of life in Aboriginal communities for more than twenty-five years, ever since arts coordinators first joined anthropologists, schoolteachers, and a range of other outsiders engaged in representing Aboriginal culture.

At one time, I—like many anthropologists—might have regarded the growing authority of an art critical discursive regime as an intrusion of ethnocentric values, perhaps as a challenge to what James Clifford understands as "ethnographic authority" (1988c), and attempted to rebut its terms, empirically or epistemologically. I am arguing here for a different response, one that recognizes the sociocultural significance of regimes of representation and the changing circumstances in which indigenous identities are produced and circulated. In this way, one can regard the circulation of acrylic paintings as an extension of the agency of their makers, subject to varying responses and actions beyond their making.

The processes involved in transforming the ways and venues in which cultural difference is circulated are themselves sociocultural phenomena. Representations, their production, and their circulation are social facts that should be studied. We need not reject the possibility of more or less adequate representations (Myers 1988b) but should instead recognize that competing accounts are themselves cultural formations as much as they might be factual errors. These are processes of which anthropologists, like others, are inescapably a part. It has been necessary to characterize anthropological interpretation as one among many competing discourses in the representation of Aboriginal cultures, because that is how I came to experience my knowledge as a participant in different sets of social practice.

It is not simply that the practice of representing culture is becoming more widespread and problematic. The contexts of anthropological interpretations are also shifting, and I have explored these shifts by including the course of my own involvement in discourses about Aboriginal visual forms. My goal has been to illuminate the process of knowledge production and representation in a more phenomenological manner, to show how such knowledges occur. This warrants a reflexive undertaking.

The first part of this section's title, "Traffic in Culture," refers ambiguously and generally to the project of ethnography—the description and translation of situated cultural practices to an audience of readers—as well as to my own practice and career as an anthropologist, but I also intend it to capture the larger set of social processes in which cultural interpretation, translation, and circulation occur. The second part of the title, the mandatory postcolon(ial) coda, "On Knowing Pintupi Painting," refers specifically to the problem of *knowledges* of Western Desert acrylic painting and ambiguously to the problem of knowing the painting or knowing the people painting.

The story of the paintings and their circulation is one of commodification, of the transformation of cultural activity into a form that can be bought, sold, circulated, and appreciated as aesthetic form or representative of Aboriginal tradition. Ordinarily, one thinks of this process as one of depersonalization, but the world of Aboriginal art, the social and cultural contexts from which the paintings emerge, is actually a personal one. To see any of this simply as a characterization of *others* would be unfair and would misrepresent the fundamental ways in which representations are activated and put into play.

From the beginning—or in the beginning—of my fieldwork in 1973, I perceived the relationship of art buying and dealing to the local Aboriginal people to be highly fraught. This was so not only because all monetary transactions seemed to end up with recriminations, and were therefore rigorously to be avoided, but also

because I did not want to be identified or too much associated with these other whites who were officials, authorities, or representatives of these relations. Such people were "bosses," a role I understood to derive from the colonial situation and one I wished to avoid having imposed on me.

For Aboriginal people, the art movement has been a positive experience, in general, but from my experience, involvement in the art scene often seems, for whites, to occasion some sort of trouble. There are jealousies about recognition and policy disagreements among those associated with the art movement (although they are largely supportive of the Aboriginal interests). There have been struggles to gain access to prized paintings, or to be the best friend of this or that artist, and disagreements in taste and about strategy in the promotion of different artists. There have been doubts that Aboriginal artists could be recognized as individuals at all. As I have written repeatedly, the advisers have found the position of mediating between the artists and the market to be very difficult. They have faced frequent denunciation by artists displeased with the money they receive for a painting, the lack of a commission, or simply the failure of an adviser to help him or her (with money, transportation, etc.) when help is needed. There are considerable cultural gulfs here, and sometimes the adviser has been surprised and even personally hurt at what he or she takes to be a lack of gratitude or understanding on the part of the painters. Buying paintings, economically beneficial and even necessary as it can be for recipients, often creates bad feelings and unmet expectations.

Being in the remote new outstation of Yayayi further isolated me from this "white world" and what I saw as the glib certainties of knowing and understanding Aboriginal culture. My relative isolation also emphasized the immediate scene of daily life, what I call "the local." This ethnographic and moral commitment also meant that while I knew a good deal about the practical goings on of Papunya Tula Artists, and I documented all their paintings at Yayayi, my knowledge was too resolutely—and in retrospect, self-righteously—local. The view that we are all *in* the picture agrees well with my sense that the knowing of Western Desert art is complex.

So as an American working in Australia, I have been both outsider and insider on the subject of Western Desert painting. The processes that accompany the art scene are disruptive and unpredictable, and I tried to control my relationship to the dangers posed by it. To follow the continuing Yarnangu claims for their work as an extension of their traditions of Dreaming-based visual forms, to explain how their culture viewed these forms, seemed to be what anthropologists do. While I was fairly self-conscious about the politics of this position—that is, I wanted to be helping Aborigines—I was certainly not fully reflexive about the role of "help-

ing" as itself a construction, or about the relationship of my presentation of their claims to other white practices of defining their objects or the significance of their activity. In a sense, I knew these things, but I didn't know what to do with that knowledge.

Often what now seem significant events felt too trivial to report at the time, even as I recognized them to represent principles that recurred. There was and wasn't a kind of market experience in the purchase of paintings that conflicted with the largely sentimental reasons for which I, for example, wanted the paintings as tokens of personal relationships. How to define the relationship between painter or "producer" and "buyer" was problematic for everyone involved, Aboriginal and non-Aboriginal. I don't think my motivation, and the contradiction it sustains, were terribly different from that of others who have entered into relations over art, but good faith was often not enough. So, I thought then, better to steer clear.

Obviously, it is no longer possible or desirable to "steer clear," especially when the "awkward relationship" between ethnographic knowledge and the concerns of art's circulation is a fact, when—as James Clifford observed of "theory" and its localizations—"every center or home is someone else's periphery or diaspora" (1989, 179). Nor is it enough to fall back on the "ironic" mode of distancing oneself from the multiple disjunctures or on Hegelian marches of Reason. Knowledge is "located," as I have argued elsewhere (Myers 1988b), and not merely in some grand sociology, as Karl Mannheim's initial explorations suggested, but in specific contexts of production. Location is almost everything, but not quite.

Perhaps we can gain some purchase on the relationship of knowledge in its plural sense—to insist on a neologism "knowledges." I have often thought one should compare the "anthropology" of which I speak with that suggested by Strathern (1987) in a famous discussion of anthropology and feminism. For Strathern, the conflict between anthropology and feminism evoked the question "With whom do you identify?" However, the anthropology that is practiced in a settler society such as Australia instantiates a different problem of identification. Thus my emphasis has been on the situatedness—even the awkwardness—of translation, rather than on an attempt to surmount the issue of identification. Here the anthropologist's position—usually as a white person mediating or translating knowledge to a white audience—is one of formulating Aboriginal cultural practice not in terms of some pure difference or by transcending time and place but in a "familiarizing" (Clifford 1988d) relationship precisely to those representations and practices that encapsulate Aboriginal people as an indigenous minority within a dominant nation-state. Representations of culture and history, constructed by anthropologists or others,

are significant to the immediate concerns and objectives of formulating indigenous identities.

In casting the relationship of anthropology to what I will call—very crudely—"the art world" as one of localism to cosmopolitanism, I place anthropology as a disciplinary tradition engaged with context, with the way painting is embedded in, and engaged with, a range of events and practices. This kind of anthropology finds its pleasure (or success) in discovery, especially the discovery of the unexpected—that painting is really politics and not really aesthetics, for example. Yet the anthropologists engaged with Aboriginal acrylic painting needed the art world and its theories, just as it appears the art historians have needed anthropologists to do the translational work of creating the phenomenon. Any audience needs some bridge of translation—some temporary "universal" in which the practices of others can be inscribed. If the anthropologist hoped for Aboriginal success in ways that would bestow dignity and recognition on Aboriginal culture, then he or she needed the creation of art markets and frames for the appropriation of Aboriginal culture by distinctive institutions. The problem for anthropologists has been that the very success of the art implies this appropriation of the particular to something broader—and thus, possibly, a sense of loss.

But however awkward, the engagement with the art world—critics, historians, dealers, and collectors—has not, in the end, been one of loss. Indeed, questions deriving from art history direct one's attention to a variety of data that had been left unconsidered.

Beyond Boundaries

How did these objects go from being items of material culture to entering into the distinctive class of objects we know as "fine art"? In pursuing this question, I mean to engage directly a set of well-known and much discussed problems of the boundaries that are held to delineate "art" from "nonart," "primitive art" or "craft" from "fine art," and so on.

Despite the ongoing critical treatment of these categorical frames, however, my own ethnographic fieldwork illuminated how effectively the categories continue to exist as social forms. The story I attempt to tell here, then, is one in which these boundaries—between "primitive" and "modern," between "primitive art" and "fine art"—are symbolic constructions *within* emerging social fields. The constructions represent points on a trajectory of symbolic transformation for a range of objects. What makes the issue of these categories of even greater interest is that these typically hierarchical categorizations of cultural phenomena—mappings of

cultural activity that Bourdieu (1984) described in the concept of "distinctions" — intersect and overlap another set of processes connecting local or peripheral contexts of cultural activity with more cosmopolitan or central ones, both national and global. And so, I wondered, what did my local knowledge of Pintupi painting have to say to all this—and what did these new knowledges, so to speak, have to say to me? Knowledge of what the Pintupi painters said and did no longer seemed quite enough to answer these questions.

My empirical problem, therefore, has been twofold: asking not only how acrylic paintings circulate and represent Aboriginal people and Aboriginal culture, but also how acrylic paintings became fine art. We know that these are rather unstable categories, as critics have argued, so my two questions are not really distinct. It is precisely this trajectory of transformation or of cultural production that I am considering, focusing on its institutional basis.

The theoretical starting point, for me, has been with an uninflected base of material culture, and the question is how (some) objects become fine art. How do objects (or practices) circulate within the category of "art," recognizing the category itself not as free-floating but as a socially and historically constructed formulation, a formulation produced and sustained through a series of practices and institutions?[3] There have been advantages in beginning with a focus on intercultural objects and activity, on cultural forms and practices that circulate not only through boundaries of cultural difference conceived of in ethnic terms but also through boundaries of difference conceived under the sign of cultural hierarchy. Both involve the movement of objects through distinctive institutions and social fields that classify them, give them their meaning and value. The framework of analysis focuses on *circulation* (or movement) and *institutions,* rather than relatively static cultural categories.

The study becomes, then, something of a local art history, asking how Aboriginal cultural work became "art." As Hadjinicolauo (1978) and Danto (1964, 1986), among others, have argued, the construction of an object or activity as art, its differentiation from an ordinary object that might look the same, is a *social process*— and one that is not simply equivalent to the subjective recognition of its aesthetic value, not applied (as Danto puts it) on the basis of perceptual criteria. This is a point that Hadjinicolaou (1978, 6) has stated clearly in emphasizing that his own historical study "is devoted to the theory and practice of the discipline of art history and not to aesthetics." Again, even more than Danto has made clear, this is quite a specific history. The art world involved in the circulation of Aboriginal acrylic painting is a particular one, shading over into a broader framework outlined by Bourdieu (1993). The "interculturality" of the art world I have described

for Western Desert painting surely represents conditions of cultural heterogeneity that, far from being unusual, should probably be viewed as the theoretically basic social condition. This kind of art history is not simply the history of styles and objects, or the history of artists, or the general history of civilization (Hadjinicolaou 1978, 17) — and this is a perspective that has special significance for the study of intercultural activities.

In this study, I have learned not to imagine obstacles to the recognition of Aboriginal cultural production simply as those of "pure culture" or the "ethnocentrism" of "Western culture." I conceive them as being a product of the specific history and institution of a distinctive art world. One cannot argue that where once there was blindness to Aboriginal art's aesthetic qualities, now there was vision. Something was accomplished in the movement of these objects into the category of fine art, an accomplishment that involves — as Danto might argue — a change in the way they were framed. The aesthetic recognition gained by the paintings as art was *produced* in specific historical action and context. A history of this art needs to do more than engage in cultural critique. It must analyze cultural production.

The argument I am making is that the analysis of these new forms of cultural production needs to be more than semiotic, more linking of the practices and contexts in and through which value is established. This is the potential of the focus on activities of cultural production, particularly those that transform or link previous contexts. The case of Aboriginal acrylic paintings would seem to have utility in exploring other histories in which regimes of value become linked, and I will take the liberty of drawing out some of the implications of this case.

One can discern two principal but interrelated theoretical circuits of cultural production in which such paintings were produced, circulated, and finally emerged as fine art. I have thought of the circuits of cultural production as two distinctive regimes of value, or spheres of social life, in which the capacity of art objects to mark difference is articulated. The first regime of value is built around the specific *market* for art, with its capacity to establish distinction (difference) and hierarchy of value in objects, and perhaps, thereby, in subjects. I refer to the second as the *governmental* regime. In the Australian case, this represents a regime of value in which the settler state is concerned with the problems presented by the existence of different categories of people (Aboriginal, Anglo-Celtic), the economic support of Aboriginals, and the question of national identity (see also Ginsburg 1993a).[4]

In other nation-states, of course, art's capacity to mediate or reorganize internal differences and similarities is regulated by the specific interests and values involved there, but the parallels are cogent. Roughly speaking, what should be observed in this case is the complex indexical convergence between the values of the

two different regimes: there is not only the economic value of Aboriginal painting that operates as a solution to the poverty of Aboriginal people but also the indexical relationship of acrylic paintings as an indigenous form within Australian national space. The movement between regimes is a movement between contexts, reorganizing the values of each. Aboriginal acrylic paintings are constructed as meaningful—not only through museums and fine arts galleries, but also within the practices and policies of the funding procedures of bureaucracies concerned with the quite different discourses of Aboriginal employment, economy, and the market. Or perhaps they are constructed as meaningful through the concerns of the national and state educational establishments or even through the agencies of the state intended to "help" Aborigines. The sociocultural significance or value of these paintings is surely composite and varied.

Fields of Force

Two significant problems should be traced further. One of these concerns the rise of autonomous spheres or fields of cultural production, as delineated sociologically by Bourdieu (1993) but represented concretely in the cases here by the growth of Aboriginal painting into a fine art. In such processes, it should be noted, standards and conventions are produced that allow producers and consumers/collectors to evaluate the quality of work. The direction of such standards in autonomous art worlds is toward self-referentiality—away from the utility value of objects and toward what emerges from the comparison of objects, what makes one different from another. This is a feature of a special kind of market, no doubt, but it shares with other markets the significance of the circulation of information between consumers, producers, and dealers.

This canon, to call it by its name, is established within a specific history and privileges innovation, development, and stylistic novelty rather than immediate use value. What needs to be understood about this process is that the market regime does not replace other regimes of value so much as it reorganizes them. Here the development of a fine art market, focused on quality, transforms the relationship between ordinary production and that aimed at the luxury consumer. With that, as well, one must recognize that the production of the artist is linked to the production of the new subject, distinguished by the consumption of these new products.

Objects such as Aboriginal paintings instantiate the dilemma of how one translates the value of heritage, memory, tradition, and the like into exchangeable value. That this conversion takes place is certain: people buy and sell these objects for money. And yet the producers complain that the buyers need to be "educated"

so as to give them appropriate value in return. This allows us to engage the second problem I want to outline: What is going on with what is called "commoditization"? Perhaps we understand the commodity and commoditization less well than we have presumed. Appadurai (1986) recognized how difficult this was and chose to expand the framework of commoditization to include many more circumstances of circulation—so that even Trobriand kula valuables could be conceptualized in his terms as a kind of commodity, in a tournament of value. The value of this shift is that boundaries are not placed around different kinds of exchange; it recognizes—as has been argued here—that different types of exchange may coexist within a social space. What needs to be recognized and explored further is the market, not as a separate domain, but as a structure of symbolic transformation. It does not necessarily erase all the distinctions embodied in objects: acrylic paintings are still valued for their connection to a tribal past, to authentic producers. It is not always the case that the market's domination is complete: other systems of value may coexist, and their meaning may be reconstructed in relation to the presence of market practices. We must imagine that commodities and commoditization practices are themselves embedded in more encompassing spheres or systems of producing value. Such systems not only recognize the existence of distinct regimes of value but combine and reorganize the activity from these various contexts into more complex mediations as what Annette Weiner might have articulated as "hierarchies in the making"—in a word, culture making.

Conclusion

That is what I have hoped to explain—why the circulation of these paintings has been so promising and so problematic. The hopes of the Yarnangu painters at Papunya, Yayayi, Yinyilingki, and beyond for new levels of connection and recognition, the expectation of renewed value for their own cultural forms—this is all part of what the paintings have achieved. Equivalence has not been easy to work out, but in the long view, it is clear that the original insistence on the power of their paintings has been borne out. The effects of the painting movement have been remarkable, far beyond what my early literal translations had imagined. I understood what the painters said, of course, but I would never have anticipated the effects they had in producing a recognition of their value and power across cultural boundaries. They have contributed to the accomplishment of land tenure security, of establishing a significant identity for those whose Dreamings they are, and they have made a kind of Aboriginality knowable to those who view them. In this way, they have evidenced the power they were said to have.

Appendix: A Short History of Papunya Tula
Exhibitions, 1971–1985

1971　First consignments of paintings to Alice Springs from Papunya, shown by Pat Hogan, July, for
　　　Alice Springs Show Day (Maughan 1985, 21).

　　　Kaapa Tjampitjinpa's painting *Gulgardi* shares first prize for Caltex Art Award, Alice Springs.

1972　Old Mick Tjakamarra wins Caltex Art Award.

　　　Northern Territory Museum of Arts and Sciences (later renamed Museums and Art Galleries of
　　　the Northern Territory) purchases 105 early Papunya works.

　　　*Symbolic Paintings Derived from Sandpaintings and Drawings by Pintupi and Warlbiri Artists
　　　from the Papunya Settlement.* Northern Territory Museum, Darwin. July.

　　　*Wailbri and Pintubi Art: An Exhibition of Traditional Aboriginal Art of the Wailbri and Pintubi
　　　Tribes of Central Australia.* Farmer's Blaxland Gallery, Sydney. Mounted by Department of
　　　the Interior and traveled from 1972 to 1974.

　　　Incorporation of Papunya Tula Artists, 16 November.

1973　*Wailbri and Pintubi Art.* Gallery 67 Perth. Organized by Robert Edwards. Complemented travel-
　　　ing exhibition of Department of Interior.

1974　*Aboriginal Art from Papunya.* Anvil Art Gallery, Albury.

　　　Aboriginal Art from Papunya. Primitive Art Gallery, Argyle Centre, Sydney.

　　　Wailbri and Pintubi Art. Residency Museum and Art Gallery, Alice Springs. Finish of Depart-
　　　ment of the Interior show.

　　　The Art of the First Australians. Australian Museum, Sydney. Organized by Australia Council.

　　　Art of Aboriginal Australia. Presented by Rothmans of Pall Mall Canada, Aboriginal Arts Board,
　　　and the Peter Stuyvesant Trust. Begins touring Canada for eighteen months. Several paintings
　　　from Yayayi 1973–1974.

1975　*Art of the Western Desert.* Australian National University. Organized by Aboriginal Arts Board
　　　and the Peter Stuyvesant Trust. Traveled to all Australian states (forty-four venues) between
　　　1978 and 1980. Was granted to the Peter Stuyvesant Trust by the Australia Council and later
　　　gifted to the Art Gallery of Western Australia.

1976　*Art of the First Australians* tours United States as part of Bicentennial.

1977　Artists from Papunya Tula go to Second World Black and Africa Festival of Arts and Culture,
　　　Lagos, Nigeria.

　　　*Paintings by the Desert Tribes of Central Australia and Carvings by the Tiwi Tribe of Bathurst and
　　　Melville Islands.* Realities Gallery, Melbourne.

Paintings by the Central and Western Desert Aborigines. Staff Common Room at Christ College, Oakleigh, Victoria, in conjunction with the Realities Gallery.

1978 Aboriginal Arts Board presents the Art Gallery of South Australia with twenty paintings from the Western Desert, including several from Yayayi 1974.

Pintupi Paintings. The Collectors Gallery of Aboriginal Art Sydney.

1979 Artists in residence at Flinders University (supported by AAB, AIAS, Flinders University). Organized by Vincent Megaw. Flinders buys large collection of unsold Papunya Tula paintings.

1980 Australian National Gallery acquires its first Western Desert painting, Mick Wallangkarri Tjakamarra's *Honey Ant Dreaming* (1973).

Art Gallery of South Australia includes Clifford Possum's *Man's Love Story* (1978) in rehang of contemporary Australian art.

Several large canvases and twenty smaller works from 1976–1977 are sold to the American collector Richard Kelton by Papunya Tula.

Papunya Tula: Aboriginal Art of the Western Desert. Macquarie University, curated by Tim and Vivien Johnson.

1981 *Aboriginal Artists of Australia* tours five U.S. cities. Accompanied by *Mr. Sandman, Bring Me a Dream* exhibition, organized by Andrew Crocker. Sold to Holmes à Court, it tours to Paris, Vienna, Rome, and Lisbon as *Papunya: Aboriginal Paintings from the Central Australian Desert.*

1981 Dinny Nolan Tjampitjinpa and Paddy Carroll Tjungurrayi create a sandpainting in grounds adjacent to the National Trust's S. H. Ervin Gallery.

Australian Museum (Sydney) acquires Papunya Tula Artists Collection.

Australian Perspecta. Art Gallery of New South Wales includes Papunya paintings as part of contemporary Australian art.

Aboriginal Australia, organized by Australian Galleries Directors Council and the Aboriginal Arts Board, shown at National Gallery of Victoria.

1982 *Master Works of the Western Desert.* Gallery A, Sydney.

Art of the Western Desert. Georges Gallery, Melbourne.

1983 *D'un Autre Continent, L'Australie, le rêve et le réel.* Western Desert Painters (Warlpiri) go to Paris.

Recent Australian Painting (1970–1983). Art Gallery of South Australia, had section on Western Desert.

Aboriginal Art Past and Present. Art Galleries Board of the Northern Territory. Traveled to Papua New Guinea, South Pacific Arts Festival.

XVII Bienal de Sao Paulo: Australia. São Paulo.

Perspecta 83. Art Gallery of New South Wales, Sydney.

1984 *Painters of the Western Desert* (March). Adelaide Festival of the Arts.

Aboriginal Dreaming: Painters of the Western Desert (August). Art Gallery of South Australia, Adelaide.

Papunya and Beyond (September–October). Araluen Arts Centre, Alice Springs.

1985 *Dot and Circle: A Retrospective Survey of the Aboriginal Acrylic Paintings of Central Australia.* Royal Melbourne Institute of Technology, curators, Janet Maughan, Jenny Zimmer, Vincent Megaw.

The Face of the Centre: Papunya Tula Paintings, 1971–1984. National Gallery of Victoria, curated by Annemarie Brody.

First Aboriginal Women's Art Festival. Adelaide.

Notes

Introduction

1 I conducted fieldwork at Yayayi, Northern Territory (N.T.), from 1973 to 1975, at Yayayi and Yinyilingki, N.T., in 1979, at New Bore and Papunya, N.T., in 1981, at Balgo, Western Australia (W.A.), and Lajamanu, N.T., in 1982 and 1983, at Kiwirrkura, W.A., in 1984, and at Kintore, N.T., and Kiwirrkura, W.A., in 1988. This work has been supported at various times by the National Science Foundation, the National Institute of Mental Health, the Australian Institute of Aboriginal and Torres Strait Islander Studies, the National Geographic Society, the Central Land Council, the National Endowment for the Humanities, the New York University Research Challenge Fund, and the John Simon Guggenheim Memorial Foundation. In addition to those institutions, further support for writing various segments of this book has come from the National Endowment for the Humanities, the American Council of Learned Societies, and the Institute for Advanced Study, School of Social Science.

1 Truth or Beauty

1 I follow Jakobson (1960) in understanding the referential function of communication to point toward a context beyond itself, to convey information about it, and to see this "message" as only part of the meaning of a total act of communication.

2 The Pintupi word would be *wantingu,* "to leave" or "to lose," in the sense of letting go. Nancy Munn (1970) has interpreted something like this usage to represent the way in which ancestral beings leave behind their potency, their sacred objects.

3 The few photographs I do have from this period are of paintings I purchased either for others or for myself.

4 In using the phrase "stitched together," I am drawing both on King and McHoul's very useful article on the Queensland Aboriginal Act of 1896 (1986) and on Barbara Myerhoff's rendering of Shmuel, the tailor, as her chief informant in *Number Our Days* (1978).

5 This indicates it is Pinny's painting and his story, no matter who did the physical work.

6 Discussing Aranda churingas in *The Savage Mind* (1966), Lévi-Strauss suggested that what might be valuable about such objects and designs is precisely this sort of historicity, an indexical guarantee that the event really did happen.

7 This small painting on the dish resembles very closely one portion of a famous painting Wuta Wuta later did of the same site, *Old Man's Dreaming* (1983), now held at the Art Gallery of South Aus-

tralia. In the latter version of the Yumari story, the central ovals include the features of the rocks at Tilirangarranya, particularly in the largest oval. (Wuta Wuta Tjangala, Art Gallery of South Australia, 242 × 362 cm.)

8 The model of signs that I favor here is from C. S. Peirce, one in which all signs require other signs as their interpretants—in endless semiosis.

2 Practices of Painting

1 An auction of an engraved stone churinga at Sotheby's in New York in October 1994 brought $34,000.

2 Megaw (1982) is mistaken in placing this painting as having been done in 1979. It was painted in Papunya during my stay there in the first half of 1975.

3 My thanks to Nicholas Thomas for suggesting this connection.

3 The Aesthetic Function and the Practice of Pintupi Painting

1 It should be noted that the emphasis on aesthetic form as I am discussing it here does not imply that other dimensions or qualities of form might not be relevant as part of the Pintupi practice of painting. For example, Nancy Munn (personal communication, 1997) has pointed out that while meaning may be manifest in form, as much Western aesthetic theory would have it, form may also be manifest in the meanings—that there might be other ways in which meaning and form are connected.

4 Making a Market

1 See Papunya Tula File, Australian Council/Aboriginal Arts Board 76/840/022 II: 6/1/72, "Conversation with Geoff Bardon Art Teacher at Papunya School." This is further amplified in the discussion of Jenny Isaacs and Nugget Coombs, hereafter.

2 Nancy Munn told me she was forbidden to have her tent in the "Aboriginal camp" at Yuendumu in the mid-1950s.

3 That the painters were almost entirely male is probably a consequence of the relationships that Bardon initially had in forming a group of painters, which would have been principally with men. Aboriginal women of ritual standing, likely participants in painting, would not be on such close terms with a white man. Additionally, most white people involved with Aboriginals during this time believed that ritual life—from which the paintings derived—was almost exclusively a male prerogative, a position subsequently criticized by Diane Bell (1983). It is certainly the case that at this time, the male painters took great pains to ensure that women in their community would not see the paintings, lending credence to the view that painting was necessarily "men's only."

4 Some aspects of policy attempted to eradicate the bodies also through practices of racial separation. Officially ended in 1937, another form of assimilation had the children of mixed European and Aboriginal parentage removed from their Aboriginal parent and educated with other "half-castes"—who would, it was expected, through continued separation from "full-bloods" become "white." The memories and consequences of this for Aboriginal people and their identities are movingly recalled in Archie Roach's song "They Took the Children Away."

5 The legal framework for the implementation of this policy was provided in the Welfare Ordinance of the Northern Territory Legislative Council (1953) that replaced the Aboriginals Ordinance (1911–1947). Thus, in an important report for the Department of Aboriginal Affairs on Papunya's history and future, Davis, Hunter, and Penny (1977, 23) summarize these policies: "It was expected in addition that the settlement would train useful black citizens, neat, clean and well-advised, who would perhaps gradually migrate to 'better places.' It was thought at the time that the first main fruits would come after ten years or so, when there would be an increasing number of Aboriginals who had regular jobs in the wider economy."

6 Papunya Tula File, Australia Council/Aboriginal Arts Board, 76/840/022 II.

7 "It seems to be the unstated but obvious policy in the Northern Territory," she wrote, "that nothing can get going amongst the Aborigines without the supervision of welfare officers in an official or unofficial capacity" (Papunya Tula File, Australia Council/Aboriginal Arts Board, 76/840/022 II). This was obviously a significant enough problem that the support staff took the problem to Dr. Coombs himself.

8 Thus in 1981, according to a marketing study conducted for the Aboriginal Arts Board (to which AACP was then affiliated), the total subsidies and assistance provided to Aboriginal arts and crafts ($A1 million) was about the same as the revenue received by producers (Pascoe 1981). The study argued that this was a tiny amount compared to the major sources of subsidy to Aboriginal communities. Grants from DAA to Aboriginal communities in 1979 and 1980 were on the order of $A128 million, not including other funds from normal commonwealth and state agencies, such as health, education, and welfare.

9 In the early days, Aboriginal Arts and Crafts sold mostly bark paintings, and acrylic paintings were of little concern, but the problems of managing supply were similar to those that arose later with acrylic. Nicolas Peterson (personal communication, New York, 21 November 1995) remembers that the bad bark paintings were burned regularly—to keep supply down and quality up. They were certainly not anticipating the boom developments that later occurred or even the possibility of achieving fine art status.

10 This Arts Board also had its roots in cultural policy developments emerging internationally. Robert Edwards, deputy principal of the Australian Institute of Aboriginal Studies and formerly curator at the South Australian Museum, became the acting executive officer in 1973, following his organization of a major conference on museums and cultural heritage the year before. An important dimension of this conference was a report on the role of Aboriginal people in museums, resulting in a significant UNESCO report. By some accounts, the reigning ideas of the Aboriginal Arts Board emerged from that conference.

11 Delegates to the Aboriginal Arts Board met not only in Sydney but also variously in places closer to remote Aboriginal communities.

12 For some activists, therefore, self-determination could be achieved only by Aboriginalizing the bureaucracy itself.

13 During the hard days of the depression, his father had refused to allow him to continue his education, but he had been inspired with an interest in local history and cultural heritage—rock art and stone tools—by an aunt and other contacts with the Geographic Society.

14 There may be a redemptive dimension as well in his trajectory. Edwards had deployed an earlier version of this synthesis of culture and economics in his plans for a tourist site at Cave Hill, an idea he may have brought back from a year abroad as a Churchill Fellow in England. He is re-

membered unkindly by some for this plan, in which local Aboriginal people were supposed to gain an economic benefit from visitors to a cave filled with rock paintings. The project ended in great dissatisfaction among the Aboriginal people (Wallace and Wallace 1977).

15 It is also reported that Edwards was one of several people recognized by the Australian Tax Office as a valuator of Aboriginal art. Such valuations were necessary whenever work was donated to a museum or art gallery, since contributors could receive tax relief at 100 percent of value. Apparently, according to one interviewee, whenever he had the opportunity, Edwards placed the value of Aboriginal art as high as possible, thereby driving up the pricing structure.

16 These paintings were annotated by me when they were done in 1974.

5 Burned Out, Outback

1 I will use the terms "art adviser" and "art coordinator" interchangeably throughout the text, although in some communities these have been distinguished.

2 Fannin's salary initially came half from a grant from Aboriginal Benefits Trust Fund, applied for by the Papunya men, and half from the Aboriginal Arts Board. This seems to have been a continuation of what was arranged for Geoff Bardon in 1972, in which the Aboriginal Arts Advisory Committee of the Australian Council for the Arts granted half Bardon's salary to free him from teaching at Papunya. Apparently, they arranged for the Office of Aboriginal Affairs' Arts, Crafts, and Cultural Activities section to make $A3,500 available as half salary (Ken Farnum letter to Barry Dexter, OAA, 14 March 1972).

3 Aboriginal Benefits Trust Fund (ABTF) was an agency providing support for various projects on the basis of application. Community advisers and others helped communities to apply for such funds as a means of channeling capital to Aboriginal projects.

4 This refers to Parta (Old Bert) Tjakamarra, an important custodian of the Honey Ant Dreaming, know as Old Bert to most whites.

5 The word *myall* is a derogatory term for an ignorant bush native.

6 The "Industry"

1 Kimber is referring to the way in which Aboriginal men "touch" *(pampula)* ritual and sacred objects, placing the hand flat on the surface reverentially.

2 This masterpiece was originally offered to the Australian National Gallery and refused, put back into storage at the Aboriginal Arts Board, and eventually purchased by the Art Gallery of New South Wales.

3 Johnson's is, of course, only one formulation of Australia's national obsession, where "painting becomes the infinite imagining of a nonindustrial nirvana, and the artist an alchemist whose action brings together exponents of exquisite and elusive cultures on the grounds of future possibility" (R. Benjamin 1995, 59). Indeed, his fusion of Aboriginal and Chinese painting "led to identifying myself as an Australian artist in that I was starting to see Australia as part of Asia instead of as part of Europe" (Zurbrugg 1991, 50).

4 In 1986 Wallis took over management of Aboriginal Arts Australia, which had been losing $A800,000 per year. In three years, Wallis brought this enterprise to no operating loss.

5 See V. Johnson 1997, 82–92, for extended discussion of the politics that made available this objec-

tification of indigenous identity into prominent national space. Briefly, Michael Nelson believed this mosaic's placement in the center of Australia's national government was a recognition of Aboriginal concerns, and his design represented a Dreaming story identified with a reconciliation. Nationally oriented activists, including some from the Canberra area (especially Kevin Gilbert), objected to the participation in the Australian government and insisted that Tjakamarra didn't have the right to put his Dreamings in another person's country. First, Gilbert—perhaps playfully, considering majority stereotypes—told the national press that Tjakamarra's design was actually a form of sorcery against the government (Kleinert 1988; V. Johnson 1988). Tjakamarra took this literally and was horrified. Gilbert later withdrew the claim, but Tjakamarra understood him to have said that the "wrongful" placement of the Warlpiri mosaic in Canberra Aboriginal country might occasion sorcery against him and responded that he had consulted with Warlpiri elders in doing this. This initial debate among the different sectors of the indigenous polity was followed by a later contention when Tjakamarra threatened to tear up the design when he came to believe that the federal government was going back on its commitment to reconciliation.

6 Barrett's dissertation borrows heavily from Serge Guilbaut's 1983 study of abstract expressionism's relationship to the Cold War, linking aesthetic doctrines to politics.

7 In her M.A. thesis, Lisa Stefanoff (2000) argues that large segments of the Australian population understand themselves in terms of some kind of identification with "the government." The government is experienced and addressed as a creative and thus moral agent responsible for education, employment, and the redistribution of capital through the provision of public services including welfare payments, national broadcasting, and industry development schemes that have covered national interests ranging from mining to feature filmmaking. From this perspective, as Stefanoff argues for other minority groups, Aboriginal art became another instantiation of a state-administered multiculturalism, of the nation's ideals of identity-across-difference politically and institutionally sanctioned.

8 Anthony Forge, personal communication, Canberra, 1980.

7 After the Fall

1 I thank Howard Morphy for insisting that these points needed to be addressed.

8 Materializing Culture and the New Internationalism

1 I am using the term "multiculturalism" in its most general connotation "as an ideological stance towards participation by . . . minorities in national 'cultures' and societies" and to mark the 'changing nature of national and transnational cultures themselves" (T. Turner 1993, 411). As Turner remarks, "*multiculturalism* tends to become a form of identity politics, in which the concept of *culture* becomes merged with that of ethnic identity."

2 I do not mean to suggest that Turner is the first to note these changes, which have been articulated powerfully in different ways by Clifford (1988d), Clifford and Marcus (1985), and Marcus and Fischer (1986). See also my own considerations in Myers 1986b, 1988b, 1991.

3 It should be noted that what is described here might be considered a framework of objectification, through which a new subject ("humanist man") is constructed. The point would be that the value-producing structure is generated in the process of objectification (D. Miller 1987). Recently,

Phillips and Steiner (1999) have criticized the enduring binary schema of "art" and "artifact" — a schema that, they argue, has masked the key third term that since the nineteenth century has become central: commodity.

9 Performing Aboriginality at the Asia Society Gallery

1 The other event was a symposium, which I intend to analyze in a later publication.

2 My conception of identity (Myers 1993) — as a construction of similarity and difference produced in sets of contrasts — draws most immediately on Lévi-Strauss (1962, 1966) but also owes much to the tradition of social theory in the creation of a self *in relationship* to an "Other" (Mead 1934; Sartre 1948; Taussig 1993).

3 I am grateful to Barbara Kirshenblatt-Gimblett for this formulation.

10 Postprimitivism

1 I am using the term "modernism" in the specific way outlined by Nigel Blake and Francis Frascina, who say that by this term they "refer to those new social practices in both 'high art' and 'mass culture' which engage with the experiences of modern life, with *modernity*, by means of self-conscious use of experiment and innovation." The term "modernism," they go on to say, should not be confused with "Modernism," which represents one particular, much-contested account of modernist art practices, one that stresses "art for art's sake, artistic autonomy, aesthetic disinterestedness and the formal and technical characteristics of modern art" (Blake and Frascina 1993, 127).

2 There was an earlier history of Aboriginal art. Elkin was a nationalist modernist, a position he shared with Preston. Preston was pivotal in organizing one of the first exhibitions of Aboriginal art, at the National Museum of Victoria in 1929, opened by Elkin. She was influential in Fred McCarthy's exhibition of Aboriginal art in 1941 at a Sydney department store (McLean 1998, 89–91; see also N. Thomas 1999).

3 The masculine reference is meant to be specific here.

4 I am indebted to Terry Smith for pointing this out to me.

5 Meanings also varied in the circulation of Aboriginal acrylic paintings to France in the early 1990s. I have published an account of the exhibition of Aboriginal art in France elsewhere (Myers 1998), and space has prevented me from considering it in this book.

6 The Australian art historian and critic Roger Benjamin made effective reply to Fry and Willis shortly after, in a follow-up piece in *Art in America* (R. Benjamin 1990).

7 To follow Hamilton's (1990) terms, the acrylics of "traditional" Aborigines represented the "good" Aboriginal, which viewers or buyers can incorporate — a spirituality, respect for land, and so on, of people at a distance (Fabian 1983) rather than people who would be seen as contemporaries competing for the same life-space.

8 One should consider the significance of these critical positions in terms of theoretical questions about empiricism, deconstruction, and representation. Here I only mention that Derrida's *Of Grammatology* (1977), and his general criticisms of ethnology, have had a central influence on the critics' response to the language of "authenticity" and "origins."

9 For a fuller account of this story, see Myers 1986a, 168–69.

10 The issues of grief, loss, and orphan status are significant questions in my monograph.

11 Unsettled Business

1 Another important account of the Petyarre-Beamish debate is West 2000. Francesca Merlan (2001) has a lengthy paper on "authenticity" and the art scandals that I have read since finishing this chapter. I believe we have very similar views, but her essay cogently clarifies the ongoing role of the concept of "tradition" and "authenticity" in representing Aboriginal culture.

2 I am quoting Coombe in this chapter, and I am indebted to her understanding of the issue. However, my thinking has been deeply influenced by conversations with Loretta Todd and Frances Peters when they were fellows at the Center for Culture, Media, and History at NYU in 1992 and 1993. I thank them for their open discussions and thoughtfulness.

12 Recontextualizations

1 I am indebted to Steve Feld for helping me articulate these insights about the musical sensibility of Warumpi.

2 I borrow the term "awkward relationship" from Marilyn Strathern's 1987 essay on the relationship between anthropology and feminism. By using the term "the art world," drawn from Becker 1982 and Danto 1964, I refer to a range of persons and institutions oriented particularly toward questions of visual form. I recognize that art historians, critics, connoisseurs, curators, collectors, and dealers may be situated very differently with respect to art practices, but this is a topic I cannot take up here.

3 I recognize, and have done previously (Myers 1994a; Marcus and Myers 1995), the contribution in a similar vein of social historians of art such as T. J. Clark, Linda Nochlin, Nicos Hadjinicolaou, and Svetlana Alpers.

4 Faye Ginsburg, particularly, has drawn attention to the role of the state and its interests in such formations. In the contemporary context, she argues, they have been concerned to promulgate the image and production of the "high-tech primitive."

References

Alloway, Lawrence. 1984. *Network: Art and the Complex Present.* Ann Arbor: UMI Research Press.

Alomes, Stephen. 1988. *A Nation at Last? The Changing Character of Australian Nationalism, 1880–1988.* Sydney: Angus and Robertson.

Altman, Jon. 1988. The Economic Basis for Cultural Reproduction. In *The Inspired Dream: Life as Art in Aboriginal Australia,* ed. Margie West, 48–55. Brisbane: Queensland Art Gallery.

Altman, Jon, Chris McGuigan, and P. Yu. 1989. *The Aboriginal Arts and Crafts Industry.* Report of the Review Committee, Department of Aboriginal Affairs. Canberra: Australian Government Publishing Service.

Altman, Jon, and Luke Taylor. 1990. *Marketing Aboriginal Art in the 1990s.* Canberra: Aboriginal Studies Press.

Anderson, Benedict. 1983. *Imagined Communities.* London: Verso.

Anderson, Christopher, and Françoise Dussart. 1988. Dreaming in Acrylic: Western Desert Art. In *Dreamings: The Art of Aboriginal Australia,* ed. Peter Sutton, 89–142. New York: George Braziller and Asia Society Galleries.

Appadurai, Arjun. 1986. Introduction: Commodities and the Politics of Value. In *The Social Life of Things: Commodities in Cultural Perspective,* ed. Arjun Appadurai, 3–63. Cambridge: Cambridge University Press.

———. 1990. Disjuncture and Difference in the Global Cultural Economy. *Public Culture* 2 (2): 1–24.

———, ed. 1986. *The Social Life of Things: Commodities in Cultural Perspective.* Cambridge: Cambridge University Press.

Appadurai, Arjun, and Carol Breckenridge. 1988. Why Public Culture? *Public Culture* 1 (1): 5–9.

Art Lovers Warned of Emily's Fakes. 1997. *Northern Territory News,* 10 January.

Attwood, Alan. 1997. From Desert Dreaming to Art-House Dealing. *Melbourne Age,* 17 May.

Attwood, Bain. 1996. The Past as Future: Aborigines, Australia, and the (Dis)course of History. Introduction to *In the Age of Mabo: History, Aborigines, and Australia,* ed. Bain Attwood, 1–16. Sydney: Allen and Unwin.

Bakhtin, Mikhail. 1981. *The Dialogical Imagination.* Austin: University of Texas Press.

Bardon, Geoffrey. 1972. Letter to Australian Council for the Arts. Papunya Tula File, Australia Council/Aboriginal Arts Board 76/840/022 II, 26 January.

———. 1979. *Aboriginal Art of the Western Desert.* Sydney: Rigby.

———. 1990. The Gift That Time Gave: Papunya Early and Late, 1971–72 and 1980. In *Mythscapes: Aboriginal Art of the Desert,* ed. Judith Ryan, 10–17. Melbourne: National Gallery of Victoria.

——. 1991. *Papunya Tula: Art of the Western Desert.* Melbourne: McPhee Gribble, Penguin.

Barrett, Lindsay. 1996. The Prime Minister's Christmas Card: Modernism and Politics in the Whitlam Era. Ph.D. diss., University of Technology, Sydney.

Barth, Fredrik. 1975. *Ritual and Knowledge among the Baktaman of New Guinea.* New Haven: Yale University Press.

Barthes, Roland. 1957. *Mythologies.* Paris: Éditions du Seuil.

Baume, Nicholas. 1989. The Interpretation of Dreamings: The Australian Aboriginal Acrylic Movement. *Art and Text* 33:110–20.

Becker, Howard. 1982. *Art Worlds.* Berkeley: University of California Press.

Beckett, Jeremy. 1985. Colonialism in a Welfare State: The Case of the Australian Aborigines. In *The Future of Former Foragers,* ed. Carmel Schrire and Robert Gordon, 7–24. Cambridge: Cultural Survival.

——. 1988. Aboriginality, Citizenship, and Nation State. *Social Analysis* 24 (special issue, *Aborigines and the State in Australia*): 3–18.

Beehan, Judith. 1991. Interview by author, Canberra, 12 July.

Beidelman, Thomas O. 1997. Promoting African Art: The Catalogue to the Exhibit of African Art at the Royal Academy of Arts, London. *Anthropos* 92:3–20.

Beier, Ulli. 1968. Encouraging the Arts among Aboriginal Australians. Report to the Australian Council for the Arts. Sydney.

——. 1986. Papunya Tula Art: The End of Assimilation. In *Long Water: Aboriginal Art and Literature* (special issue of *Aspect,* no. 34), ed. Ulli Beier, 32–37. Sydney: Aboriginal Artists Agency.

——. 1988. Geoff Bardon and the Beginnings of the Papunya Tula Art. In *Long Water: Aboriginal Art and Literature,* ed. Ulli Beier and Colin Johnson, 83–100. Sydney: Aboriginal Artists Agency.

Bell, Diane. 1983. *Daughters of the Dreaming.* Melbourne: McPhee Gribble.

Benjamin, Roger. 1990. Aboriginal Art: Exploitation or Empowerment? *Art in America* 78 (July): 73–81.

——. 1995. "Jointly and Severally": The Johnson Way of Art. In *Antipodean Currents: Ten Contemporary Artists from Australia,* ed. Julia Robinson, 58–69. New York: Solomon Guggenheim Foundation.

Benjamin, Walter. 1968. The Work of Art in the Age of Mechanical Reproduction. In *Illuminations,* 217–51. New York: Schocken.

Bennett, Tony. 1995. *The Birth of the Museum: History, Theory, Politics.* New York: Routledge.

Benterrak, Krim, Stephen Muecke, and Paddy Roe. 1984. *Reading the Country: An Introduction to Nomadology.* Fremantle, W.A.: Fremantle Arts Centre Press.

Betz, David. 1993. Interview by author, New York, 23 January.

Bhabha, Homi. 1986. The Other Question: Difference, Discrimination, and the Discourse of Colonialism. In *Literature, Politics, and Theory,* ed. Francis Barker, 148–72. New York: Methuen.

Birdsell, Joseph. 1970. Local Group Composition among the Australian Aborigines: A Critique of the Evidence from Fieldwork Conducted since 1930. *Current Anthropology* 11:115–42.

Blake, Nigel, and Francis Frascina. 1993. Modern Practices of Art and Modernity. In *Modernity and Modernism: French Painting in the Nineteenth Century,* ed. Francis Frascina, Nigel Blake, Briony Fer, Tamar Garb, and Charles Harrison, 50–140. New Haven: Yale University Press in association with the Open University.

Boas, Franz. 1927. *Primitive Art.* New York: Dover.

Bourdieu, Pierre. 1977. *Outline of a Theory of Practice.* Cambridge: Cambridge University Press.

——. 1984. *Distinction: A Social Critique of the Judgement of Taste.* Cambridge: Harvard University Press.

——. 1993. *The Field of Cultural Production.* New York: Columbia University Press.

Bourdieu, Pierre, and Loic Wacquant. 1992. *An Invitation to Reflexive Sociology.* Chicago: University of Chicago Press.

Bourke, Anthony "Ace." 1991. Interview by author, Sydney, 27 June.

Brody, Annemarie. 1985. *The Face of the Centre: Papunya Tula Paintings, 1971–1984.* Melbourne: National Gallery of Victoria.

Broome, Richard. 1996. Historians, Aborigines, and Australia: Writing the National Past. In *In the Age of Mabo: History, Aborigines, and Australia,* ed. Bain Attwood, 54–72. Sydney: Allen and Unwin.

Burn, Ian, Nigel Lendon, Charles Merewether, and Ann Stephen. 1988. *The Necessity of Australian Art: An Essay about Interpretation.* Sydney: Power Publications.

Busfield, Wendy, and John Donegan. 1997. Artist Paints a Grim Picture. *Herald Sun,* 3 July.

Butler, Judith. 1990. *Gender Trouble: Feminism and the Subversion of Identity.* New York: Routledge.

Caruana, Wally. 1993. *Aboriginal Art.* New York: Thames and Hudson.

Cazdow, Jane. 1981. Tamie Does a Double-Take at Frank Painting. *Weekend Australian,* 10 October.

——. 1987a. The Art Boom of Dreamtime. *Australian Weekend Magazine,* 14–15 March, 1–2.

——. 1987b. The Art of Desert Dreaming. *Australian Weekend Magazine,* 8–9 August, 6.

Ceresa, Maria. 1997. Master Painter Will Settle for a Toyota. *Weekend Australian,* 5–6 July.

Chatwin, Bruce. 1987. *The Songlines.* New York: Viking.

Clastres, Pierre. 1974. *Le grand parler: Mythes et chants sacrés des Indiens guarani.* Paris: Éditions du Seuil.

Clifford, James. 1988a. Histories of the Tribal and the Modern. In *The Predicament of Culture,* 189–214. Cambridge: Harvard University Press.

——. 1988b. On Collecting Art and Culture. In *The Predicament of Culture,* 215–51. Cambridge: Harvard University Press.

——. 1988c. On Ethnographic Authority. In *The Predicament of Culture,* 21–54. Cambridge: Harvard University Press.

——. 1988d. *The Predicament of Culture.* Cambridge: Harvard University Press.

——. 1989. Notes on Theory and Travel. In *Traveling Theories: Traveling Theorists,* Inscriptions special issue 5, James Clifford and V. Dhareshwar, 177–87.

Clifford, James, and George Marcus. 1985. *Writing Culture.* Berkeley: University of California Press.

Cohodas, Marvin. 1999. Elizabeth Hickox and Karuk Basketry. In *Unpacking Culture,* ed. R. Phillips and C. Steiner. Berkeley: University of California Press.

Collman, Jeff. 1988. *Fringe-Dwellers and Welfare: The Aboriginal Response to Bureaucracy.* St. Lucia: University of Queensland Press.

Coombe, Rosemary. 1997. The Properties of Culture and the Possession of Identity: Postcolonial Struggle and the Legal Imagination. In *Borrowed Power: Essays in Cultural Appropriation,* ed. Bruce Ziff and Pratima Rao, 74–96. New Brunswick, N.J.: Rutgers University Press.

Coombs, H. C. ("Nugget"). 1978. *Kulinma: Listening to Aboriginal Australians.* Canberra: Australian National University Press.

Cossey, David. 1998. Australia's Painted Oases of the Mind. *Times* (London), 3 April.

Cowlishaw, Gillian. 1999. *Rednecks, Eggheads, and Blackfellas: A Study of Racial Power and Intimacy in Australia.* Ann Arbor: University of Michigan Press.

Crocker, Andrew. 1981a. Introduction to *Mr. Sandman, Bring Me a Dream,* ed. Andrew Crocker, 1–3. Sydney: Aboriginal Artists Agency and Papunya Tula Artists.

——. 1981b. A Life in the Day of . . .: Observations on the role of Company Secretary at Papunya Tula

Artists Pty. Ltd. with Possible Relevance to Craft Advisers in Aboriginal Communities Elsewhere. Unpublished manuscript.

———. 1985. Potentials and Pitfalls: Directions and Dangers in Aboriginal Art. In *Dot and Circle: A Retrospective Survey of the Aboriginal Acrylic Paintings of Central Australia,* ed. Janet Maughan and Jenny Zimmer, 45–49. Melbourne: Royal Melbourne Institute of Technology.

———. 1987. *Charlie Tjaruru Tjungurrayi, a Retrospective, 1970–1986.* Orange: Orange Regional Gallery.

Crossman, Sylvie. 1990. De Tiepolo à Maxie Tjampitjinpa (1971–1972 et 1980): Entretien avec James Mollison. In *L'Eté Australien à Montpellier,* ed. Sylvia Crossman et J.-P. Barou, 31–32. Montpellier: Musée Fabre Galérie Saint Ravy.

Daly, Martin. 1997. Art World's Sale of the Century. *Age,* 4 July.

Daly, Martin, and Chris Ryan. 1997. A Painting by This Struggling Artist Has Just Sold for $206,000 but He Won't See a Cent. *Age,* 2 July.

Danto, Arthur. 1964. The Artworld. *Journal of Philosophy* 61:571–84.

———. 1986. *The Philosophical Disenfranchisement of Art.* New York: Columbia University Press.

Davila, Juan. 1987. Aboriginality: A Lugubrious Game? *Art and Text* 23 (4): 53–58.

Davis, Elizabeth. 1999. Art, the Culture Market, and Expatriates. *American Anthropologist.*

Davis, K., John Hunter, and David Penny. 1977. *Papunya: History and Future Prospects.* Canberra: Department of Aboriginal Affairs.

Deleuze, Gilles, and Félix Guattari. 1987. *A Thousand Plateaus: Capitalism and Schizophrenia.* Trans. Brian Massumi. Minneapolis: University of Minnesota Press.

Dening, Greg. 1993. The Theatricality of History Making and the Paradoxes of Acting. *Cultural Anthropology* 8:73–95.

Derrida, Jacques. 1977. *Of Grammatology.* Trans. Gayatri Spivak. Baltimore: Johns Hopkins University Press.

Diawara, Manthia. 1993. The Black Public Sphere. *Afterimage.*

Dussart, Françoise. 1988. Women's Acrylic Paintings from Yuendumu. In *The Inspired Dream: Life as Art in Aboriginal Australia,* ed. Margie West, 35–40. Brisbane: Queensland Art Gallery.

———. 1993. *La Peinture des Aborigènes d'Australie.* Marseilles: Editions Parentheses.

———. 1997. A Body Painting in Translation. In *Rethinking Visual Anthropology,* ed. Howard Morphy and Marcus Banks, 186–202. New Haven: Yale University Press.

———. 1999. What an Acrylic Can Mean: The Meta-ritualistic Resonances of a Central Desert Painting. In *Art from the Land: Dialogues with the Kluge-Ruhe Collection of Australian Aboriginal Art,* ed. Margo Boles and Howard Morphy, 193–218. Charlottesville and Seattle: University of Virginia and University of Washington Press.

Edwards, Robert. 1994. Interview by author, Sydney, 18 May.

Eliade, Mircea. 1973. *Australian Religions: An Introduction.* Ithaca: Cornell University Press.

Elkin, A. P. 1977. *Aboriginal Men of High Degree.* St. Lucia: University of Queensland Press.

Errington, Shelley. 1994. What Became Authentic Primitive Art? *Cultural Anthropology* 9: 201–226.

———. 1998. *The Death of Authentic Primitive Art and Other Tales of Progress.* Berkeley: University of California Press.

Fabian, Johannes. 1983. *Time and the Other.* New York: Columbia University Press.

Fajans, Jane. 1997. *They Make Themselves: Work and Play among the Baining of Papua New Guinea.* Chicago: University of Chicago Press.

Fannin, Peter. 1974a. Letter to Department of Education. Australia Council, Aboriginal Arts Board, Papunya Tula Artists Correspondence, file no. 76/890/001, 12 October.

———. 1974b. Letter to Kate Khan. Papunya Tula Archives, Aboriginal Arts Board, 25 September.

———. 1974c. "Papunya/Yayayi Art: A Report to the Aboriginal Arts Board, June 1974." Australia Council for the Arts Files, 26-5-74.

Farnham, Ken. 1972. Letter to Barry Dexter, director, Office of Aboriginal Affairs, 14 March. Australia Council files.

Finnane, Kieran. 1999a. Dot Painting Media Glut, Sensationalism? *Alice Springs News,* 19 May.

———. 1999b. National Newspapers under Fire as Dot Painting Row Escalates. *Alice Springs News,* 5 May.

Fiske, John, Bob Hodge, and Graham Turner. 1987. *Myths of Oz: Reading Australian Popular Culture.* Boston: Allen and Unwin.

Foster, Hal. 1985. The "Primitive" Unconscious of Modern Art, or White Skin Black Masks. In *Recodings: Art, Spectacle, Cultural Politics,* 181–208. Seattle: Bay Press.

Foucault, Michel. 1971. *The Order of Things: An Archaeology of the Human Sciences.* New York: Pantheon Books.

———. 1973. *Madness and Civilization: A History of Insanity in the Age of Reason.* Trans. R. Howard. New York: Vintage.

Fox, Richard. 1985. *Lions of the Punjab: Culture in the Making.* Berkeley: University of California Press.

Frater, Alexandra. 1982. Aboriginal Art Blossoms in the Desert. *Age,* 10 July.

Fry, Tony, and Anne-Marie Willis. 1989. Aboriginal Art: Symptom or Success? *Art in America,* July, 109–17, 159–60.

Geertz, Clifford. 1973. *The Interpretation of Cultures.* New York: Basic Books.

———. 1983. Found in Translation: On the Social History of the Moral Imagination. In *Local Knowledge: Further Essays in Interpretive Anthropology,* 36–54. New York: Basic Books.

———. 1995. *After the Fact: Two Countries, Four Decades, One Anthropologist.* Cambridge: Harvard University Press.

Gelder, Ken, and Jane Jacobs. 1998. *Uncanny Australia: Sacredness and Identity in a Postcolonial Nation.* Carlton, Vic.: Melbourne University Press.

Gell, Alfred. 1992. The Technology of Enchantment and the Enchantment of Technology. In *Anthropology, Art, and Aesthetics,* ed. Jeremy Coote and Anthony Shelton, 40–66. Oxford: Clarendon Press.

———. 1999. *Art and Agency: An Anthropological Theory.* New York: Oxford University Press.

George, Kenneth. 1999. Objects on the Loose: Ethnographic Encounters with Unruly Objects—a Foreword. *Ethnos* 64 (2): 149–50.

Ginsburg, Faye. 1991. Indigenous Media: Faustian Contract or Global Village? *Cultural Anthropology* 6 (1): 92–112.

———. 1993a. Aboriginal Media and the Australian Imaginary. *Public Culture* 5:557–78.

———. 1993b. Station Identification. *Visual Anthropology Review* 9 (2): 92–97.

Ginsburg, Faye, and Anna Tsing, editors. 1991. *Uncertain Terms.* Boston: Beacon Press.

Gow, Peter. 1996. Aesthetics Is a Cross-Cultural Category: Against the Motion (2). In *Key Debates in Anthropology,* ed. Tim Ingold, 271–75. London: Routledge.

Graburn, Nelson, ed. 1976. *Ethnic and Tourist Arts.* Berkeley: University of California Press.

Green, Ian. 1988. "Make 'im Flash, Poor Buggar": Talking about Men's Painting in Papunya. In *The Inspired Dream,* ed. Margaret West, 41–47. Brisbane: Queensland Art Gallery.

Greenberg, Clement. [1939] 1961. Avant-Garde and Kitsch. In *Art and Culture: Critical Essays.* Boston: Beacon Press.

Greenberg, Reesa, Bruce Ferguson, and Sandy Nairne. 1996. *Thinking about Exhibitions.* New York: Routledge.

Greer, Germaine. 1997. Selling Off the Dreaming. *Sydney Morning Herald,* 6 December.

Guilbaut, Serge. 1983. *How New York Stole the Idea of Modern Art: Abstract Expressionism, Freedom, and the Cold War.* Trans. Arthur Goldhammer. Chicago: University of Chicago Press.

Hadjinicolauo, Nicolas. 1978. *Art History and Class Struggle.* Trans. Louise Asmal. London: Pluto Press.

Hall, Stuart. 1990. Cultural Identity and Diaspora. In *Identity: Community, Culture, Difference,* ed. J. Rutherford, 222–37. London: Lawrence and Wishart.

———. 1993. Encoding, Decoding. In *The Cultural Studies Reader,* ed. Simon During, 90–104. New York: Routledge.

Hamilton, Annette. 1990. Fear and Desire: Aborigines, Asians, and the National Imaginary. *Australian Cultural History,* July.

Handler, Richard. 1985. On Having a Culture. In *Objects and Others,* ed. George Stocking, 192–217. Madison: University of Wisconsin Press.

Healey, J. J. 1978. *Literature and the Aborigine in Australia.* St. Lucia: University of Queensland Press.

Hessey, Ruth. 1994. Designs on the Future. *Sydney Morning Herald,* 15 December.

Hewett, Tony. 1989. The Trouble with Black Art. *Sydney Morning Herald,* 29 April.

Hiatt, L. R. 1962. Local Organization among the Australian Aborigines. *Oceania* 32:267–86.

Hodge, Bob, and Vijay Mishra. 1991. *Dark Side of the Dream: Australian Literature and the Postcolonial Mind.* Sydney: Allen and Unwin.

Hodges, Christopher. 1991. Interview by author, Sydney, 28 June.

Hogan, Pat. 1985. Notes and Inventory for the Early Consignments of Pintupi Paintings. In *Dot and Circle: A Retrospective Survey of the Aboriginal Acrylic Paintings of Central Australia,* ed. Janet Maughan and Jenny Zimmer, 55–57. Melbourne: Royal Melbourne Institute of Technology.

Hollinsworth, David. 1992. Discourses on Aboriginality and the Politics of Identity in Urban Australia. *Oceania* 63:137–55.

Hughes, Robert. 1988. Evoking the Spirit Ancestors. *Time,* 31 October, 79–80.

Inglis, Ken. 1990. Kapferer on Anzac and Australia. *Social Analysis* 29:67–73.

Ingold, Tim. 1993. The Temporality of the Landscape. *World Archaeology* 25 (2): 152–74.

Irving, Kim. 1983. New Wave Aboriginal Art. *Centralian Advocate,* 16 March.

Isaacs, Jennifer. 1987. Waiting for the Mob from Balgo. *Australian and International Art Monthly,* June, 20–22.

———. 1990. Fiona Foley on Aboriginality in Art, Life, and Landscape. In *The Land, the City: The Emergence of Urban Aboriginal Art,* special issue of *Art Monthly Australia,* ed. Wally Caruana and Jennifer Isaacs, 10–12. Canberra: Arts Centre, Australian National University.

———. 1995. *Wandjuk Marika: Life Story, as Told to Jennifer Isaacs.* St. Lucia: University of Queensland Press.

Jakobson, Roman. 1960. Closing Statement: Linguistics and Poetics. In *Style in Language,* ed. T. Sebeok, 350–77. Cambridge: MIT Press.

Johnson, Tim. 1990. "The Hypnotist Collector": An Interview Conducted by Richard MacMillan. In *The Painted Dream: Contemporary Aboriginal Paintings from the Tim and Vivien Johnson Collection,* 21–37. Auckland: Auckland City Art Gallery.

Johnson, Vivien. 1987. Art and Aboriginality 1987. In *Art and Aboriginality 1987,* 2–4. Portsmouth, U.K.: Aspex Gallery.

———. 1988. Among Others: Reply to "Black Canberra." *Art and Text* 30:98–99.

———. 1990a. The Origins and Development of Western Desert Art. In *The Painted Dream: Contemporary Aboriginal Paintings from the Tim and Vivien Johnson Collection*, 9–20. Auckland: Auckland City Art Gallery.

———. 1990b. Private Collectors and the Aboriginal Art Market. In *Marketing Aboriginal Art in the 1990s*, ed. Jon Altman and Luke Taylor, 37–42. Canberra: Aboriginal Studies Press.

———. 1991. The Dreaming: Where Existence and Essence Converge. In *Australian Aboriginal Art from the Collection of Donald Kahn*, 7–24. Miami: Lowe Art Museum.

———. 1994. *The Art of Clifford Possum Tjapaltjarri.* East Roseville, N.S.W.: Craftsmen House.

———. 1996a. *Copyrites: Aboriginal Art in the Age of Reproductive Technologies.* Sydney: National Indigenous Arts Advocacy Association and Macquarie University.

———. 1996b. *Dreamings of the Desert: Aboriginal Dot Paintings of the Western Desert.* Adelaide: Art Gallery of South Australia.

———. 1997. *Michael Jagamara Nelson.* East Roseville, N.S.W.: Craftsman House and G+B Arts International.

———. n.d. Cultural Brokerage: Commodification and Intellectual Property. Manuscript.

Jones, Philip, and Peter Sutton. 1986. *Art and Land.* Adelaide: South Australian Museum.

Kapferer, Bruce. 1988. *Legends of People, Myths of State: Violence, Intolerance, and Political Culture in Sri Lanka and Australia.* Washington, D.C.: Smithsonian Institution Press.

Karp, Ivan, and Stephen D. Lavine. 1991. *Exhibiting Cultures: The Poetics and Politics of Museum Display.* Washington, D.C.: Smithsonian Institution Press.

Kean, John. 1989. Papunya Tula Artists on Park Avenue. *DEET Aboriginal News*, April, 12–13.

———. 2000. Getting Back to Country: Painting and the Outstation Movement, 1977–1979. In *Papunya Tula: Genesis and Genius*, ed. Hetti Perkins and Hannah Fink, 216–23. Sydney: Art Gallery of New South Wales and Papunya Tula Artists.

Keeffe, Kevin. 1988. Aboriginality: Resistance and Persistence. *Australian Aboriginal Studies* 1:67–81.

———. 1992. *From the Centre to the City: Aboriginal Education, Culture, and Power.* Canberra: Aboriginal Studies Press.

Keneally, Thomas. 1988. Dreamscapes: Acrylics Lend New Life to an Ancient Art of the Australian Desert. *New York Times Sunday Magazine*, 13 November, 52.

Kimber, Richard. 1977. Mosaics You Can Move. *Hemisphere* 21 (1): 2–7, 29–30.

———. 1981. Central Australian and Western Desert Art: Some Impressions. In *Mr. Sandman, Bring Me a Dream*, ed. Andrew Crocker, 7–9. Sydney: Aboriginal Artists Agency and Papunya Tula Artists.

———. 1985. Papunya Tula Art: Some Recollections, August 1971–October 1972. In *Dot and Circle: A Retrospective Survey of the Aboriginal Acrylic Paintings of Central Australia*, ed. Janet Maughan and Jenny Zimmer, 43–44. Melbourne: Royal Melbourne Institute of Technology.

———. 1988. Late Contact History: 1956–1988. In *Wildbird Dreaming: Aboriginal Art from the Central Deserts of Australia*, ed. Nadine Amadio and Richard Kimber, 69–78. Melbourne: Greenhouse Publications.

———. 1990. *Friendly Country—Friendly People: An Exhibition of Aboriginal Artworks from the Peoples of the Tanami and Great Sandy Deserts.* Alice Springs: Araluen Arts Centre.

———. 1991. Interview by author, Alice Springs, 1 July.

———. 1993. Central, Western, Southern, and Northern Desert. In *Aratjara: Art of the First Australians*, ed. Bernhard Lüthi and Gary Lee, 221–79. Dusseldorf and Cologne: Kunstsammlung Nordrheim-Westfalen and DuMont Buchverlag.

————. 1995. Politics of the Secret in Contemporary Western Desert. In *Politics of the Secret,* Oceania Monographs 45, ed. Christopher Anderson, 123–42. Sydney: University of Sydney.

King, D. A., and Alec McHoul. 1986. The Discursive Production of the Queensland Aborigine as Subject: Meston's Proposal, 1895. *Social Analysis* 19 (August): 22–39.

Kirshenblatt-Gimblett, Barbara. 1991. Objects of Ethnography. In *Exhibiting Cultures: The Poetics and Politics of Museum Display,* ed. Ivan Karp and Stephen Lavine. Washington, D.C.: Smithsonian Institution Press.

————. 1995. Confusing Pleasures. In *The Traffic in Culture,* ed. George Marcus and Fred Myers, 224–55. Berkeley: University of California Press.

Kleinert, Sylvia. 1988. Black Canberra. *Art and Text* 29:92–95.

Kopytoff, Igor. 1986. The Cultural Biography of Things. In *The Social Life of Things: Commodities in Cultural Perspective,* ed. Arjun Appadurai, 64–91. Cambridge: Cambridge University Press.

Kristeller, Paul Oskar. [1951] 1965. The Modern System of the Arts. In *Renaissance Thoughts and the Arts.* Princeton: Princeton University Press.

Kronenberg, Simeon. 1995. Why Gabrielle Pizzi Has Changed Her Mind about Aboriginal Art. *Art Monthly Australia* 85 (November): 70–79.

Kupka, Karel. 1962. *Un art a l'état brut* (The Dawn of Art). Lausanne: La Guilde du Livre.

Langton, Marcia. 1993. *Well, I Saw It on the Television, and I Heard It on the Radio.* Sydney: Australian Film Commission.

————. n.d. Culture Wars. Manuscript.

Larson, Kaye. 1988. Their Brilliant Careers. *New York Magazine,* 4 October, 148–50.

Lattas, Andrew. 1990. Aborigines and Contemporary Australian Nationalism: Primordiality and the Cultural Politics of Otherness. *Social Analysis* 27 (3): 50–69.

————. 1991. Nationalism, Aesthetic Redemption, and Aboriginality. *Anthropological Journal of Australia* 2 (3): 307–24.

————. 1992. Primitivism, Nationalism, and Popular Culture: Time, Aboriginality, and Contemporary Australian Culture. In *Journal of Australian Studies,* special issue, *Power, Knowledge, and Aborigines,* ed. Bain Attwood and J. Arnold, 45–58. Melbourne: La Trobe University Press.

Layton, Robert. 1992. Traditional and Contemporary Art of Aboriginal Australia: Two Case Studies. In *Anthropology, Art, and Aesthetics,* ed. J. Coote and A. Shelton, 137–59. Oxford: Clarendon Press.

Lennard, Christine. 1991. Interview by author, Alice Springs, 4 July.

Leske, Everard. 1977. *Hermannsburg: A Vision and a Mission.* Adelaide: Lutheran Publishing House.

Lévi-Strauss, Claude. 1962. *Totemism.* Chicago: University of Chicago Press.

————. 1966. *The Savage Mind.* Chicago: University of Chicago Press.

Lippard, Lucy. 1991. *Mixed Blessings: New Art in a Multicultural America.* New York: Pantheon.

Lockwood, Douglas. 1964. *The Lizard Eaters.* Melbourne: Cassell Australia.

Lomnitz, Claudio. 1994. Decadence in Times of Globalization. *Cultural Anthropology* 9 (2): 257–67.

Long, Jeremy P. M. 1964a. The Pintubi Patrols: Welfare Work with the Desert Aborigines. *Australian Territories* 4 (5): 43–48.

————. 1964b. The Pintubi Patrols: Welfare Work with the Desert Aborigines—the Later Phases. *Australian Territories* 4 (6): 24–35.

————. 1970. *Aboriginal Settlements: A Survey of Institutional Communities in Eastern Australia.* Canberra: Australian National University Press.

————. 1993. *The Go-Betweens: Patrol Officers in Aboriginal Affairs Administration in the Northern Territory, 1936–74.* Darwin: North Australia Research Unit (Australian National University).

Lumby, Catharine. 1994. The Art of Flux: An Australian Perspective. In *Antipodean Currents: Ten Contemporary Artists from Australia,* ed. Julia Robinson, 16–25. New York: Solomon Guggenheim Foundation.

Lüthi, Bernhard, and Gary Lee, eds. 1993. *Aratjara: Art of the First Australians.* Dusseldorf and Cologne: Kunstsammlung Nordreheim-Westfalen and DuMont Buchverlag.

MacDonald, Janine. 1997. Brush-Off for Durack Paintings. *West Australian,* 8 March.

MacMillan, Gordon, and Liz Godfrey. 1993. *Aboriginal and Torres Straits Islanders Arts and Crafts: Research Report.* Sydney: Mingatjuta Consulting Services, AGB McNair.

Maddock, Kenneth. 1972. *The Australian Aborigines: A Portrait of Their Society.* London: Penguin.

———. 1981. Warlpiri Land Tenure: A Test Case in Legal Anthropology. *Oceania* 52:85–102.

———. 1991. Metamorphising the Sacred in Australia. *Australian Journal of Anthropology* 2 (2): 213–31.

Malinowski, Bronislaw. [1922] 1984. *The Argonauts of the Western Pacific.* Prospect Heights, Ill.: Waveland Press.

Maloon, Terence. 1982. Aboriginal Paintings: Strong and Beautiful Abstracts Survive the Cultural Dislocation. *Sydney Morning Herald,* 25 August.

Manne, Robert. 2001. In Denial: The Stolen Generations and the Right. *Australian Quarterly Essay,* no. 1.

Manning, Patrick. 1985. Primitive Art and Modern Times. *Radical History Review* 33:165–81.

Marcus, George E. 1998. *Ethnography through Thick and Thin.* Princeton: Princeton University Press.

Marcus, George E., and Fred R. Myers. 1995. *The Traffic in Culture: Refiguring Art and Anthropology.* Berkeley: University of California Press.

Marcus, George E., and Michael M. J. Fischer. 1986. *Anthropology as Cultural Critique.* Chicago: University of Chicago Press.

Marika, Wandjuk. 1986. Painting Is Very Important (Story as Told to Jennifer Isaacs). In *Long Water: Aboriginal Art and Literature* (special issue of *Aspect,* no. 34), ed. Ulli Beier, 7–18. Sydney: Aboriginal Artists Agency.

Marshall-Stoneking, Billy. 1988. The Power of the Song. In *Long Water: Aboriginal Art and Literature,* ed. Ulli Beier and Colin Johnson, 107–14. Sydney: Aboriginal Artists Agency.

———. 1990. *Singing the Snake: Poems from the Western Desert, 1979–1988.* North Ryde, N.S.W.: Angus and Robertson.

Maughan, Janet, and Jenny Zimmer, eds. 1985. *Dot and Circle: A Retrospective Survey of the Aboriginal Acrylic Paintings of Central Australia.* Melbourne: Royal Melbourne Institute of Technology.

Mauss, Marcel. [1938] 1985. The Category of the Person. In *The Category of the Person: Anthropology, Philosophy, History,* ed. Michael Carrithers, Steven Collins, and Steven Lukes. New York: Cambridge University Press.

———. [1925] 1990. *The Gift: The Form and Reason for Exchange in Archaic Societies.* Trans. W. D. Halls. New York: Norton.

McCulloch, Susan. 1997a. Artistic Licence or Fraud? *Weekend Australian,* 15–16 March.

———. 1997b. Dreaming Art Awakens Overseas Demand. *Australian,* 10 April.

———. 1997c. Galleries Stamp Beamish Name on Black Art. *Australian,* 24 December.

———. 1997d. What's the Fuss? *Australian Magazine,* 5–6 July.

McCulloch-Uehlin, Susan. 1999. Painter Tells of Secret Women's Artistic Business: I Signed Relatives' Paintings. *Weekend Australian,* 17–18 April.

McDonald, John. 1997. Putting Dr. Greer in the Picture. *Sydney Morning Herald,* 13 December.

McEvilley, Thomas. 1985. Doctor, Lawyer, Indian, Chief. *Artforum* 23 (3): 54–60.

McHenry, Ray. 1973. Quoted in minutes of third meeting, Aboriginal Arts Board, Darwin, 11–13 August.

McKay, Andrew. 1982. The Dreamtime Finds New Life. *Sydney Morning Herald,* 13 July.

McLean, Ian. 1998. *White Aborigines: Identity Politics in Australian Art.* Cambridge: Cambridge University Press.

Mead, George Herbert. 1934. *Mind, Self, and Society from the Standpoint of a Behaviorist.* Chicago: University of Chicago Press.

Megaw, Vincent. 1982. Western Desert Acrylic Painting—Artefact or Art? *Art History* 5:205–18.

———. 1985. Contemporary Aboriginal Art—Dreamtime Discipline or Alien Adulteration? In *Dot and Circle: A Retrospective Survey of the Aboriginal Acrylic Paintings of Central Australia,* ed. Janet Maughan and Jenny Zimmer, 51–54. Melbourne: Royal Melbourne Institute of Technology.

Meggitt, Mervyn J. 1962. *Desert People.* Chicago: University of Chicago Press.

Merlan, Francesca. 2001. Aboriginal Cultural Production into Art. In *Beyond Aesthetics,* ed. Chris Pinney and Nicholas Thomas. 2001. Oxford and New York: Berg.

Meyrowitz, Joshua. 1985. *No Sense of Place: The Impact of Electronic Media on Social Behavior.* New York: Oxford University Press.

Michaels, Eric. 1986. *The Aboriginal Invention of Television in Central Australia, 1982–85.* Canberra: Australian Institute of Aboriginal Studies Press.

———. 1987a. The Last of the Ethnographers. *Canberra Anthropology.*

———. 1987b. Western Desert Sandpainting and Post-Modernism. In *Yuendumu Doors,* ed. Warlukkurlangu Artists, 135–43. Canberra: Australian Institute of Aboriginal Studies.

———. 1988. Bad Aboriginal Art. *Art and Text* 28:59–73.

Miller, Daniel. 1987. *Material Culture and Mass Consumption.* Oxford: Blackwell.

———. 1995. Consumption as the Vanguard of History. In *Acknowledging Consumption,* ed. Daniel Miller, 1–57. London: Routledge.

Miller, Toby. 1994. *The Well-Tempered Self.* Baltimore: John Hopkins University Press.

Mitchell, Timothy. 1989. The World as Exhibition. *Comparative Studies in Society and History* 31:217–36.

Moore, Catriona, and Stephen Muecke. 1984. Racism, Aborigines, and Film. *Australian Journal of Cultural Studies.*

Morgan, Marlo. 1994. *Mutant Message Down Under.* New York: Harper Collins.

Morphy, Howard. 1977. "Too Many Meanings": An Analysis of the Artistic System of the Yolngu of North-east Arnhem Land. Ph.D. diss., Australian National University.

———. 1980. The Impact of the Commercial Development of Art on Traditional Culture. In *Preserving Indigenous Cultures,* ed. Robert Edwards and Jenny Stewart, 81–94. Canberra: Australian Government Printing Service.

———. 1983a. Aboriginal Fine Art—the Creation of Audiences and the Marketing of Art. In *Aboriginal Arts and Crafts and the Market,* ed. Peter Loveday and Peter Cooke, 37–43. Darwin: Australian National University, North Australian Research Unit.

———. 1983b. "Now You Understand"—an Analysis of the Way Yolngu Have Used Sacred Knowledge to Retain Their Autonomy. In *Aborigines, Land, and Land Rights,* ed. Nicolas Peterson and Marcia Langton. Canberra: Australian Institute of Aboriginal Studies.

———. 1984. *Journey to the Crocodile's Nest.* Canberra: Australian Institute of Aboriginal Studies.

———. 1989. From Dull to Brilliant: The Aesthetics of Spiritual Power among the Yolngu. *Man* (24): 21–39.

———. 1992. *Ancestral Connections*. Chicago: University of Chicago Press.

———. 1996a. Aesthetics Is a Cross-Cultural Category: For the Motion (1). In *Key Debates in Anthropology*, ed. Tim Ingold. London: Routledge.

———. 1996b. Empiricism to Metaphysics: In Defense of the Concept of Dreamtime. In *From Prehistory to Politics: John Mulvaney, the Humanities, and the Public Intellectual*, ed. Tim Bonyhady and Tom Griffiths, 163–89. Carlton: Melbourne University Press.

Morphy, Howard, and Margo Boles. 1999. *The Art of Place: Dialogues with the Kluge-Ruhe Collection of Australian Aboriginal Art*. Seattle: University of Washington Press.

Morris, Meaghan. 1988. *The Pirate's Fiancée: Feminism, Reading, Postmodernism*. London: Verso.

Morton, John. 1991. Black and White Totemism. In *Australian People and Animals in Today's Dreamtime*, ed. David Croft, 21–52. New York: Praeger.

Mountford, Charles P. 1977. *Nomads of the Western Desert*. Sydney: Rigby.

Muecke, Stephen. 1992. *Textual Spaces: Aboriginality and Cultural Studies*. Kensington, N.S.W.: New South Wales University Press.

———. 1996. Cultural Studies and Anthropology, Reconciliation? *Oceania*.

Mullin, Molly. 1995. The Patronage of Difference: Making Indian Art "Art, not Ethnology." In *The Traffic in Culture: Refiguring Anthropology and Art,* ed. George Marcus and Fred Myers, 166–200. Berkeley: University of California Press.

Munn, Nancy. 1966. Visual Categories: An Approach to the Study of Representational Systems. *American Anthropologist* 66:939–50.

———. 1970. The Transformation of Subjects into Objects in Walbiri and Pitjantjatjara Myth. In *Australian Aboriginal Anthropology*, ed. R. Berndt, 141–63. Nedlands: University of Western Australia Press.

———. 1973a. The Spatial Presentation of Cosmic Order in Walbiri Iconography. In *Primitive Art and Society*, ed. Anthony Forge, 193–200. Oxford: Oxford University Press.

———. 1973b. *Walbiri Iconography*. Ithaca: Cornell University Press.

Murphy, Bernice. 1981. *Australian Perspecta 1981: A Biennial Survey of Contemporary Australian Art*. Sydney: Art Gallery of New South Wales.

Myerhoff, Barbara. 1978. *Number Our Days*. New York: Simon and Schuster.

Myers, Fred. 1976. To Have and to Hold: A Study of Persistence and Change in Pintupi Social Life. Ph.D. diss., Bryn Mawr College.

———. 1980a. A Broken Code: Pintupi Political Theory and Contemporary Social Life. *Mankind* 12:311–26.

———. 1980b. The Cultural Basis of Politics in Pintupi Life. *Mankind* 12:197–214.

———. 1986a. *Pintupi Country, Pintupi Self: Sentiment, Place, and Politics among Western Desert Aborigines*. Canberra and Washington, D.C.: Australian Institute of Aboriginal Studies and Smithsonian Institution Press. (Republished 1991, University of California Press.)

———. 1986b. The Politics of Representation. *American Ethnologist* 13:138–53.

———. 1988a. Burning the Truck and Holding the Country: Forms of Property, Time, and the Negotiation of Identity among Pintupi Aborigines. In *Hunter-Gatherers, II: Property, Power, and Ideology*, ed. David Riches, Tim Ingold, and James Woodburn. London: Berg Publishing.

———. 1988b. Locating Ethnographic Practice: Romance, Reality, and Politics in the Outback. *American Ethnologist* 5:609–24.

———. 1988c. The Logic and Meaning of Anger among Pintupi Aborigines. *Man*.

———. 1989. Truth, Beauty, and Pintupi Painting. *Visual Anthropology* 2:163–95.

———. 1991. Representing Culture: The Production of Discourse(s) for Aboriginal Acrylic Paintings. *Cultural Anthropology* 6 (1): 26–62.

———. 1993. Place, Identity, and Exchange: The Transformation of Nurturance to Social Reproduction over the Life-Cycle in a Kin-Based Society. In *Exchanging Products, Producing Exchange,* ed. Jane Fajans, 33–57. Oceania Monographs 43. Sydney: University of Sydney.

———. 1994a. Beyond the Intentional Fallacy: Art Criticism and the Ethnography of Australian Aboriginal Acrylic Painting. *Visual Anthropology Review* 10 (1): 10–43.

———. 1994b. Culture-Making: The Performance of Aboriginality at the Asia Society Galleries. *American Ethnologist* 21:679–99.

———. 1998. Uncertain Regard? Understanding an Exhibition of Aboriginal Art in France. *Ethnos.*

———. 2000. Ways of Placemaking. In *Culture and Environment,* ed. Howard Morphy and Kate Flynn. Oxford: Oxford University Press.

———. 2001a. Introduction: The Empire of Things. In *The Empire of Things,* ed. Fred Myers. Albuquerque: SAR.

———. 2001b. The Wizards of Oz: Nation, State, and the Production of Aboriginal Fine Art. In *The Empire of Things,* ed. Fred Myers. Albuquerque: SAR.

Nairne, Sandy, in collaboration with Geoff Dunlop and John Wyver. 1987. *State of the Art.* London: Chatto and Windus.

Nathan, Pam, and Dick Leichleitner Japanangka. 1983. *Settle Down Country.* Malmsbury and Alice Springs: Kibble Books and the Central Australian Aboriginal Congress.

Neller, Shelley. 1981. Honey Ant Dreaming of Another Time and Place. *Australian,* 1 September.

Newstead, Adrian. 1991. Interview by author, Sydney, June.

Nicklin, Lenore. 1997. Dream Meets Reality. *Bulletin,* (Sydney), 8 July, 20–23.

Onus, Lin. 1990. Language and Lasers. In *The Land, the City: The Emergence of Urban Aboriginal Art.* Special Issue, *Art Monthly Australia,* ed. Wally Caruana and Jennifer Isaacs, 16–19.

Ortner, Sherry. 1989. Cultural Politics. *Dialectical Anthropology* 14:197–211.

Orwicz, Michael. 1994. *Art Criticism and Its Institutions in Nineteenth-Century France.* New York: Manchester University Press and St. Martin's Press.

Overing, Joanna. 1996. Aesthetics Is a Cross-Cultural Category: Against the Motion (1). In *Key Debates in Anthropology,* ed. Tim Ingold, 260–66. London: Routledge.

Paine, Robert. 1981. Norwegians and Saami: Nation-State and Fourth World. In *Minorities and Mother Country,* ed. Gerald L. Gold, 211–48. St. Johns, Newfoundland: Institute of Social and Economic Research.

Pannell, Sandra. 1995. The Cool Memories of Tjurunga: A Symbolic History of Collecting Authenticity and the Sacred. In *Politics of the Secret,* ed. Christopher Anderson, 108–22. Oceania Monographs 45. Sydney: University of Sydney.

Pascoe, Timothy. 1981. *Improving Focus and Efficiency in the Marketing of Aboriginal Artefacts.* Report to the Australia Council and Aboriginal Arts and Crafts Pty. Ltd. Sydney: Arts Research, Training, and Support.

Pekarik, Andrew. 1987. Dreamings: The Art of Aboriginal Australia. NEH Implementation Grant Proposal.

———. 1988. Journeys in the Dreamtime. *World Archaeology,* November–December, 46–52.

Perkins, Hetti. 2000. Interview on Radio National, 18 August.

Perkins, Hetti, and Hannah Fink, eds. 2000. *Papunya Tula: Genesis and Genius.* Sydney: Art Gallery of New South Wales and Papunya Tula Artists.

Peterson, Nicolas. 1983. Aboriginal Arts and Crafts Pty Ltd: A Brief History. In *Aboriginal Arts and Crafts and the Market,* ed. Peter Loveday and Peter Cooke. Darwin: North Australia Research Unit.

———. 1995. Interview by author, New York, 21 November.

Phillips, Ruth B., and Christopher B. Steiner. 1999. Art, Authenticity, and the Baggage of Cultural Encounter. In *Unpacking Culture: Art and Commodity in Colonial and Postcolonial Worlds,* ed. Ruth Phillips and Christopher Steiner, 3–19. Berkeley: University of California Press.

Pietz, William. 1986. The Problem of the Fetish, I. *Res* 9:5–17.

Plattner, Stuart. 1996. *High Art, Down Home.* Chicago: University of Chicago Press.

Poirier, Sylvie. 1991. L'art de Balgo. In *Yapa: Peintres Aborigènes de Balgo et Lajamanu,* ed. Barbara Glowczewski, 29–110. Paris: Baudoin Lebon Editeur.

———. 1996. *Les jardins du nomade: Cosmologie, territorie, et personne dans le désert occidental australien.* Munster: Lit Verlag.

Povinelli, Elizabeth. 1995. *Labor's Lot.* Chicago: University of Chicago.

Premont, Roslyn. 1991. Interview by author, Alice Springs, 3 July.

———. 1993. Tjankiya (Linda Syddick) Napaltjarri. In *Australian Perspecta 1993,* ed. Victoria Lynn. Sydney: Art Gallery of New South Wales.

Price, Sally. 1989. *Primitive Art in Civilized Places.* Chicago: University of Chicago Press.

Rabinow, Paul. 1986. Representations Are Social Facts. In *Writing Culture,* ed. James Clifford and George Marcus. Berkeley: University of California Press.

Rankin-Reid, Jane. 1988. Colonial Foreplay. *Artscribe International,* September–October, 12–13.

Rhodes, Colin. 1995. *Primitivism and Modern Art.* New York: Thames and Hudson.

Richman, David. 1982. *Reading Georges Bataille: Beyond the Gift.* Baltimore: Johns Hopkins University Press.

Roe, Paddy, and Stephen Muecke. 1983. *Gularabulu: Stories from the West Kimberley.* Fremantle, W.A.: Fremantle Arts Centre Press.

Roheim, Geza. 1945. *The Eternal Ones of the Dream.* New York: International Universities Press.

Rose, Deborah Bird. 1984. The Saga of Captain Cook: Morality in Aboriginal and European Law. *Australian Aboriginal Studies* 2:24–39.

Rowley, Charles D. 1972. *The Destruction of Aboriginal Society.* Canberra: Australian National University Press.

Rowse, Tim. 1991. "Interpretive Possibilities": Aboriginal Men and Clothing. *Cultural Studies* 5 (1): 1–13.

———. 1996. Mabo and Moral Anxiety. *Meanjin* 52 (2): 229–52.

———. 2000. *Obliged to Be Difficult: Nugget Coombs' Legacy in Indigenous Affairs.* New York: Cambridge University Press.

Rubin, William. 1984. Modernist Primitivism: An Introduction. In *"Primitivism" in 20th Century Art: Affinity of the Tribal and the Modern,* ed. William Rubin, 1–84. New York: Museum of Modern Art.

Rubinstein, Meyer R. 1989. Outstations of the Postmodern: Aboriginal Acrylic Paintings of the Australian Western Desert. *Arts Magazine,* March, 40–47.

Ryan, Chris. 1997. An Artist's Fate Puts the World in the Picture. *Age,* 5 July.

Ryan, Judith. 1990. The Mythology of Pattern: Papunya Tula Art, 1971–89. In *Mythscapes: Aboriginal Art of the Desert,* ed. Judith Ryan, 24–55. Melbourne: National Gallery of Victoria.

Sahlins, Marshall. 1981. *Mythical Histories and Metaphorical Realities.* Ann Arbor: University of Michigan Press.

Said, Edward. 1978. *Orientalism.* New York: Pantheon.

Sandall, Roger. 1967. *Emu Ritual at Ruguri.* Canberra: Australian Institute of Aboriginal Studies. Film.

Sansom, Basil. 1980. *The Camp at Wallaby Cross.* Canberra: Australian Institute of Aboriginal Studies.

Sartre, Jean-Paul. 1948. *Anti-Semite and Jew.* Trans. George J. Becker. New York: Schocken.

Savage, George. 1969. *The Market in Art.* London: Institute of Economic Affairs.

Schjeldahl, Peter. 1988. Patronizing Primitives. *Seven Days,* 16 November.

Shohat, Ella, and Robert Stam. 1994. *Unthinking Eurocentrism: Multiculturalism and the Media.* New York: Routledge.

Silverman, Martin. 1972. Ambiguation and Disambiguation in Fieldwork. In *Crossing Cultural Boundaries: The Anthropological Experience,* ed. Solon Kimball and James Watson. San Francisco: Chandler.

Smith, Bernard, and Terry Smith. 1991. *Australian Painting, 1788–1990 (with the Three Additional Chapters on Australian Painting since 1970 by Terry Smith).* Melbourne: Oxford University Press.

Smith, Roberta. 1988. From Alien to Familiar. *New York Times,* 16 December.

Smith, Terry. 1990. Aboriginal Art Now: Writing Its Variety and Vitality. *Contemporary Aboriginal Art 1990–0000 from Australia.* Redfern and Glasgow: Aboriginal Arts Committee and Third Eye Centre.

——. 1993 (Interview with Terry Smith) The Minimal-Conceptual Nexus, Neo-Conceptualism and Art History. *Agenda* 26–27 (winter).

Spencer, Baldwin, and Frank J. Gillen. 1899. *The Native Tribes of Central Australia.* London: Macmillan.

Spivak, Gayatri Chakravorty. 1987. *In Other Worlds: Essays on Cultural Politics.* New York: Routledge.

Spyer, Patricia, ed. 1998. *Border Fetishisms: Material Objects in Unstable Spaces.* New York: Routledge.

Staniszewski, Mary Anne. 1998. *The Power of Display: A History of Exhibition Installations at the Museum of Modern Art.* Cambridge: MIT Press.

Stanner, W. E. H. 1956. The Dreaming. In *Australian Signpost,* ed. T. A. G. Hungerford, 51–65. Melbourne: F. W. Cheshire.

——. 1965. Aboriginal Territorial Organization. *Oceania* 36:1–26.

Stefanoff, Lisa. 2000. Partying with the Faggerati: Some Problems of Australian National Art and Originality in the early 1990s. M.A. thesis, New York University.

Steiner, Christopher. 1994. *African Art in Transit.* Cambridge: Cambridge University Press.

——. 2001. Rights of Passage: On the Liminal Identity of Art in the Border Zone. In *The Empire of Things,* ed. Fred Myers. Albuquerque: SAR.

Strathern, Marilyn. 1987. An Awkward Relationship: The Case of Feminism and Anthropology. *Signs* 12:276–92.

Strehlow, T. G. H. 1947. *Aranda Traditions.* Melbourne: Melbourne University Press.

——. 1964. The Art of the Circle, Line, and Square. In *Australian Aboriginal Art,* ed. Ronald Berndt, 44–59. New York: Macmillan.

——. 1970. Geography and the Totemic Landscape in Central Australia. In *Australian Aboriginal Anthropology,* ed. Ronald Berndt, 92–140. Nedlands, W.A.: University of Western Australia Press.

Stretton, Roberta. 1987. Aboriginal Art on the Move. *Weekend Australian,* 5–6 September, 32.

Sutton, Candace. 1997. New York Dotty over Bark Art. *Sun Herald,* 27 April.

Sutton, Peter. 1988. The Morphology of Feeling. In *Dreamings: The Art of Aboriginal Australia,* ed. Peter Sutton, 59–88. New York: George Braziller/Asia Society Galleries.

———. 1990. Dreamings: The Story Thus Far. *Bulletin of the Conference of Museum Anthropologists* (23): 176–78.

———. 1992. Reading "Aboriginal Art." *Australian Cultural History* (11): 28–38.

———. n.d. Reply to von Sturmer. Manuscript.

———, ed. 1988. *Dreamings: The Art of Aboriginal Australia.* New York: George Braziller/Asia Society Galleries.

Sweetman, Kim. 1997. Black Art May Be Lost to U.S. *Mercury,* 5 April.

Tatz, Colin. 1964. Aboriginal Administration. Ph.D. diss., Australian National University.

Taussig, Michael. 1993. *Mimesis and Alterity: A Particular History of the Senses.* New York: Routledge.

Taylor, Luke. 1990. The Role of Collecting Institutions. In *Marketing Aboriginal Art in the 1990s,* ed. Jon Altman and Luke Taylor, 31–36. Canberra: Aboriginal Studies Press.

Taylor, Paul. 1989. Primitive Dreams Are Hitting the Big Time. *New York Times,* 21 May, H31, 35.

Thomas, Daniel. 1995. LAND versus PEOPLE. In *Antipodean Currents: Ten Contemporary Artists from Australia,* ed. Julia Robinson, 32–39. New York: Solomon Guggenheim Foundation.

Thomas, Nicholas. 1991. *Entangled Objects: Exchange, Material Culture, and Colonialism in the Pacific.* Cambridge: Harvard University Press.

———. 1999. *Possessions: Indigenous Art/Colonial Culture.* London: Thames and Hudson.

Thompson, Liz. 1990. *Aboriginal Voices: Contemporary Aboriginal Artists, Writers, and Performers.* Sydney: Simon and Schuster Australia.

Thomson, Donald. 1975. *Bindibu Country.* Melbourne: Nelson Press.

Tillers, Imants. 1982. Locality Fails. *Art and Text* 6.

Tonkinson, Robert. 1978. *The Mardudjara Aborigines.* New York: Holt, Rinehart and Winston.

———. 1982. Outside the Power of the Dreaming: Paternalism and Permissiveness in an Aboriginal Settlement. In *Aboriginal Power in Australian Society,* ed. Michael Howard, 115–30. St. Lucia: University of Queensland Press.

Torgovnick, Marianna. 1990. *Gone Primitive: Savage Intellects, Modern Lives.* Chicago: University of Chicago Press.

Trigger, David. 1993. Australian Cultural Studies: Radical Critique or Vacuous Posturing? *Anthropological Forum* 6 (4): 68.

Trinh T. Minh-ha. 1989. *Woman, Native, Other.* Bloomington: Indiana University Press.

Tsing, Anna. 1994. *In the Realm of the Diamond Queen.* Princeton: Princeton University Press.

Turner, Terence. 1973. Piaget's Structuralism. *American Anthropologist* 75:351–73.

———. 1980. Anthropology and the Politics of Indigenous People's Struggles. *Cambridge Anthropology* (winter).

———. 1991. Representing, Resisting, Rethinking: Historical Transformations of Kayapo Culture and Anthropological Consciousness. In *Colonial Situations: Essays on the Contextualization of Ethnographic Knowledge,* ed. George Stocking, 285–313. Madison: University of Wisconsin Press.

———. 1993. Anthropology and Multiculturalism: What Is Anthropology That Multiculturalists Should Be Mindful of It? *Cultural Anthropology* 8 (3): 1–19.

———. n.d. Indigenous and Culturalist Movements in the Contemporary Global Conjuncture. Manuscript.

Turner, Victor. 1969. Introduction to *Forms of Symbolic Action,* ed. Robert Spencer. Proceedings of the American Ethnological Society. Seattle: University of Washington Press.

———. 1974. *Dramas, Fields, and Metaphors.* Ithaca: Cornell University Press.

———. 1982. *From Ritual to Theatre.* New York: Performing Arts Journal Publications.

Urla, Jacqueline. 1993. Breaking All the Rules: An Interview with Frances Peters. *Visual Anthropology Review* 9 (2): 98–106.

von Sturmer, John. 1989. Aborigines, Representation, Necrophilia. *Art and Text* 32:127–39.

Wallace, Phyl, and Noel Wallace. 1977. *Killing Me Softly: The Destruction of a Heritage.* Melbourne: Nelson.

Wallach, Amei. 1989. Beautiful Dreamings. *Ms.,* March, 60–64.

Wallis, Anthony. 1995. Interview by author, New York, 21 December.

———. 1996. Interview by author, New York, 1 January.

Ward, Martha. 1996. What's Important about the History of Exhibition. In *Thinking about Exhibition,* ed. Reesa Greenberg, Bruce Ferguson, and Sandy Nairne, 451–64. New York: Routledge.

Ward, Peter. 1984. Aboriginal Art: A Crucial Perspective. *Australian,* 18 September.

Warlukurlangu Artists. 1987. *Yuendumu Doors: Kuruwarri.* Canberra: Aboriginal Studies Press.

Watson, Christine. 1996. *Kuruwarri,* the Generative Force: Balgo Women's Contemporary Painting and Its Relationship to Traditional Media. M.A. thesis, Australian National University.

Weber, John. 1989. Papunya Tula: Contemporary Paintings from Australia's Western Desert. In *Papunya Tula.* New York: John Weber Gallery.

Weiner, Annette. 1980. Reproduction: A Replacement for Reciprocity. *American Ethnologist* 7:71–85.

———. 1992. *Inalienable Possessions: The Paradox of Keeping-While-Giving.* Berkeley: University of California Press.

West, Bobby. 2000. Interview on Radio National, 18 August.

West, Margaret. 2000. Eye of the Storm. In *Transition: 17 Years of the National Aboriginal and Torres Strait Islander Art Award,* ed. Margaret West. Darwin: Museum and Art Gallery of the Northern Territory.

———, ed. 1988. *The Inspired Dream: Life as Art in Aboriginal Australia.* Brisbane: Queensland Art Gallery.

White, Harrison C., and Cynthia A. White. 1965. *Canvases and Careers: Institutional Change in the French Painting World.* New York: Wiley.

White, Richard. 1982. *Inventing Australia: Images and Identity, 1688–1980.* Winchester, Mass.: Allen and Unwin Australia.

Williams, Daphne. 1991. Interview by author, Alice Springs, 1 July.

Williams, Nancy M. 1986. *The Yolngu and Their Land: A System of Land Tenure and the Fight for Its Recognition.* Canberra: Australian Institute of Aboriginal Studies.

Williams, Raymond. 1977. *Marxism and Literature.* Oxford: Oxford University Press.

Willis, Anne-Marie. 1993. *Illusions of Identity: The Art of Nation.* Sydney: Hale and Iremonger.

Wolf, Eric. 1982. *Europe and the People without History.* Berkeley: University of California Press.

Wolfe, Patrick. 1991. On Being Woken Up from the Dreamtime. *Comparative Studies in Society and History,* 197–234.

Wright, Brett. 1984a. Aboriginal Art Moves Up into the Culture Market. *Sydney Morning Herald,* 26 January.

———. 1984b. Arts Company Split over Expansion Plan. *Sydney Morning Herald,* 25 January.

Wright, Felicity. 1991. Interview by author, Adelaide, 6 July.

Wyndham, Susan, and P. Ward. 1988. Dreamtime in Manhattan. *Australian Magazine,* December, 17–18, 38–49.

Ziff, Bruce, and Pratima Rao. 1997. Introduction to Cultural Appropriation: A Framework for Analysis. In *Borrowed Power: Essays on Cultural Appropriation,* ed. Bruce Ziff and Pratima Rao, 1–30. New Brunswick, N.J.: Rutgers University Press.

Zurbrugg, Nicholas. 1991. Gordon Bennett: Between the Lines. In *Antipodean Currents: Ten Contemporary Artists from Australia,* ed. Julia Robinson, 40–51. New York: Solomon Guggenheim Foundation.

Index

attempts to control supply of paintings by, 135, 156–57, 159, 191–93; career benefits of work of, 125, 173–74, 180, 292; difficulties of, 147–83, 208, 326, 355; and individual painters, 19, 58, 78, 170, 173–74, 180–81; and local knowledge, 142, 161–65, 170–71, 174, 181–83; for Papunya Tula Artists, 209–10; and prices of paintings, 27, 72–75, 126, 155, 192; turnover among, 151, 181; work of, 3, 73–76, 123, 125–28, 131, 133–34, 138, 141, 147–83, 186, 208, 326. *See also* Bardon, Geoff; Cash; Crocker, Andrew; Exchanges; Fannin, Peter; Hogan, Pat; Kean, John; Kimber, R. G.; Williams, Daphne

Art and Text (journal), 250

Artbank, 200, 205

Art cooperatives. *See* Balgo art cooperative; Papunya Tula Artists; Warlukurlangu Artists cooperative

"Art-culture system" (Western): Aboriginal art within, 120–46, 252–53, 311–14; art as non-utilitarian in, 122, 293, 294–95, 319; individual artist in, 59–61, 218–23, 225–28, 294–95, 331, 333–34; taxonomic distinctions in, 21–22, 189–91, 233; universalizing discourses of, 123, 237, 253, 271–72, 280–82, 288–90, 293–94, 312, 313, 328, 353, 357. *See also* Art: two-tiered categorization of Aboriginal; Fine art; Value(s)

Art Gallery of New South Wales (AGNSW), 78, 144, 184, 193, 328, 339, 342–50

Artifacts: vs. art, 21, 83–84, 184–208, 237, 248–54, 278, 289, 294, 369 n.3

Art in America, 277

Artist's Country near Kurkuta (Yanyatjarri Tjakamarra), 104

Art market: Aboriginal paintings in, xvii, 6, 78–79, 119, 205, 224, 315–41, 352, 359–61; creation of, for Aboriginal paintings, 120–46, 172–79; display venues for, 190–91, 194, 197, 199, 207, 213–15, 219–20; periods in Aboriginal, 124, 185–86, 209. *See also* "Art-culture system"; Authenticity; Cash; Collectors; Commissions; Commodities; Dealers; Fine art; Galleries; Knowledge; Painting(s); Prices; "Primitive fine arts market"; Quality; Sales; Value(s)

Art of Aboriginal Australia exhibition, 186

Art of the First Australians exhibit, 186

Art of the Western Desert exhibition, 186, 198

Asia: and Australia, 240, 243, 285

Asia Society Gallery, New York, 176, 255, 261; *Dreamings* exhibition at, xvi, 3, 206, 230, 235, 237–54, 262–63, 266–71, 273–74, 281

Assimilation: as government policy, 2, 122, 126, 129–31, 208, 342

Association of Northern and Central Australian Aboriginal Artists (ANCAAA), 209–10, 212

Audience: change in, 66–67; for Aboriginal paintings, 315–41. *See also* Collectors; Criticism: art; Dealers; Exhibitions; Government

Australia: Aboriginal art exhibitions in, 65, 78, 120, 174, 186, 196–97; Bicentennial of white settlement of, 9–10, 200–202, 240, 244, 281, 285; marginalization of art in, 194–95, 204, 294, 303; tourism to, 9–11, 198, 200, 202, 240, 285, 286, 303. *See also* Aborigines; Government; National identity; Painting(s); Whites

Australia Council for the Arts: and *Dreamings* exhibition, 241–42; as funding provider for art cooperatives, xvii, 125, 132–35, 156, 182–83, 210, 212; Papunya Tula Artists files at, 156, 165–66; and Pollock painting, 203; as promoter of Aboriginal paintings, 184, 185, 188. *See also* Aboriginal Arts Board

Australia Gallery, New York City, 318–21

Australiana Fund, 197

Australian Broadcasting Corporation, 239, 348

Australian Embassy (Paris), 200

Australian Film Commission, 311

Australian Institute of Aboriginal Studies, 149

Australian Museum, 158, 193

Australian National Gallery, 193, 203, 205

Australian National University and College Tour, 186

Australian Perspecta '81 exhibit, 78, 193, 197

Australian Weekend Magazine, 281

Authenticity: art advisers' promotion of, 158, 159, 172; challenges to, 19, 196, 229, 292, 297, 316, 324–39; dealers' attempts to provide, 215–16; of Linda Syddick's paintings, 304; of performances, 257, 259, 265–71, 331, 345–46; value as based on, 21–23, 63, 72, 208, 235, 253, 274. *See also* Documentation; Forgeries; "Intercultural space"; Knowledge; Legitimation; "Recontextualization"; Truth; Value(s)

Awards: for Aboriginal art, 124, 134, 157, 318, 327
Ayers Rock, 178, 303

Bakhtin, Mikhail, 21
Balgo art cooperative, 58–59, 66, 81, 105, 225, 365 n.1; art from, 246, 284, 296
Bangarra Dance Theatre, 348
Bardon, Geoff, 22, 142, 158, 160, 180, 292, 368 n.2; and origins of Aboriginal acrylic painting, 2–3, 69, 124–28, 131–33, 147, 366 n.3
Bark paintings, 10, 63, 68, 105, 118, 188, 190, 367 n.9; in *Dreamings* exhibition, 237, 245, 246, 248
Barrett, Lindsay, 203, 204–5
Barunga, Albert, 139
Beamish, Ray, 327
Beckett, Jeremy, 277, 279
Beehan, Judith, 224–25
Beier, Ulli, 150
Bell, Diane, 366 n.3
Benjamin, Roger, 195
Bennett, Dorothy, 174
Bennett, Gordon, 217
Bennett, Tony, 233
Betz, David, 320–22
"Beyond Aboriginality," 223
"Bicultural artifacts," 190, 191–93, 200, 235, 315–41
Bird, Lindsay, 226
Bird in Space (Brancusi), 253, 254
"Blackfella/Whitefella" (song), 340, 349–50
Black Power. *See* Activism and agency
Blake, Nigel, 370 n.1
Blaxland Gallery, 296
Blaxson's Gallery, 201
Blue Poles (Pollock), 203–4, 283
Boas, Franz, 80, 84, 105, 118
Body. *See* Designs; Touch
Boomalli art collection, 348
Bourdieu, Pierre, 54–55, 76, 293, 313, 358; on class factions, 203, 204, 228; on fields of cultural production, 236–37, 360
Bourke, Ace, 175, 178, 207, 217–18, 220, 225–27, 315, 332
Boyd, Robin, 204
Brancusi, Constantin, 253, 254
Breckenridge, Carol, 16, 231

Brown, Osa, 241
Bruno, Paul, 73–74
Budgerigar Dreaming, 263
Burnum, Burnum, 10, 202
"Burrup, Eddie," 328. *See also* Durack, Elizabeth
Bush Tucker Dreaming exhibition, 320
Butcher, Sammy, 350

CAAC. *See* Centre for Aboriginal Arts and Craftsmen
Café Alcaston (Melbourne), 196
Caltex Art competition, 124, 134, 157
Canada: Aboriginal art in, 120, 144, 156, 186; First Nations people in, 333–35
Canberra (Australia). *See* Government
Cape York Peninsula, 237, 238, 247
Capitalism. *See* Cash; Commercialization; Commodities; Globalization
Capon, Edmund, 328
Carnegie, Margaret, 179, 196, 201, 241
Cars, xv, 27–29, 71, 76, 150, 152, 156, 162–63, 165–69, 191; paying painters with, 228
Caruana, Wally, 82, 85
Cash: exploitation of painters with, 323–24, 326, 337; maintaining flow of, to painters, 133, 134–38, 141, 148–49, 152, 154–60, 178–79, 323; for paintings through art advisers, 3, 121, 124, 128, 131–33; Pintupi people's need for, 1–2, 25–29, 124–28. *See also* Cars; Painting(s): economic motivations for; Papunya Tula Artists: collective economic goals of; Prices; Sales
Castine, Graham, 26
Cathcart, Michael, 339–40, 348
A Cave Dreaming (Yanyatjarri Tjakamarra), 325
Caves: in the Dreaming, 35, 40, 42; painting in, 2, 21, 36, 281, 367 n.14; paintings of, 88, 92, 104, 109, 111, 117
Cazdow, Jane, 242, 281–82
Central Australian Aboriginal Media Association, 10
Central Mt. Wedge (Karinyarra), xvi, 116
Central Park Zoo (New York City), 265
Centre for Aboriginal Arts and Craftsmen (CAAC), 145, 154, 164, 166, 167, 169, 175, 213
Ceremonies: and Aboriginal art, 3, 32, 35–36, 51, 54–58, 60, 62–63, 66, 69–70, 141, 161, 266, 337; as activities of exchange, 5, 39; Pintupi participation in, 2, 35–36, 43, 46, 47–50, 62–63,

32–33, 63, 80, 83, 84, 98, 118, 342, 352; non-economic values of, 3, 5, 18–20, 24, 32–33, 36, 38, 50, 62–64, 71, 80, 120–22, 141, 186, 192, 235, 259, 273, 280, 293–94, 331; number produced by individual artists, 60, 124; as owned by individual painters, 65, 316, 317; as part of Aboriginal art industry, 124, 200; political aspirations objectified in, 5, 116, 170–71, 196, 208; process of, 58, 60; as representing Aboriginal identity, 5–6, 10, 18, 24, 38–39, 83, 112–14, 116, 121–22, 280, 361; rights to specific designs in, 19, 24, 30, 40, 42–43, 47, 56–58, 65–66, 83, 84, 113, 263, 266, 270; sizes of, 61, 70, 72, 88, 95, 103, 104, 116, 148, 159, 192; as social practice, 20, 22, 23–30, 54–79, 81–82, 106, 116, 118, 358; templates for, 36, 82, 88–106, 122, 222; "training allowances" for, 64–65, 132, 148, 159; valorization of Aborigines through, 142, 274–76, 278, 280–81, 285, 291, 295–98, 361; visual elements in, 34–39, 58, 60–63, 85, 88–106, 109. *See also* Abstraction; Aesthetics; Art advisers; Art market; Authenticity; Bark paintings; Colors; Commissions; Copyright; Designs; Documentation; Dreaming; Exhibitions; Fine art; Identity; Papunya; Papunya Tula Artists; Performances; Place; Prices; Quality; Sales; Sand drawings; Spirituality; Stories; "Traditional" art; Truth; Value(s); Work

Paintings by the Central and Western Desert Aborigines exhibit, 186

Pakarangaranya (place), 94

Pan-Aboriginality, 12, 260–62, 298, 304. *See also* Indigeneity: politics of

Pangkalangka 1981 (Charley Tjaruru), 117

Pangkarlangu (Short Legs). *See* Short Legs stories

Papunya (place): and Aboriginal art, 73–77; acrylic painting's invention in, 5, 21, 124; art advisers' residence in, 3, 149, 155, 175; government officials in, 126; history of Pintupi people at, xv, xvii, 1–2, 81, 108, 114, 116, 129–30, 132, 155; social organization of painting at, 57–79. *See also* Painting(s); Papunya Tula Artists; Warumpi Band

Papunya Tula: Genesis and Genius exhibition, 339–50

Papunya Tula Artists: and Aboriginal Arts Board, 139, 141, 142, 162, 163; as Aboriginal-owned cooperative, 128, 147, 152, 326; catalogs published by, 78, 115, 171, 173–74, 199; collective economic goals of, 19, 128, 197; exhibitions associated with, xvii, 77–78, 176, 191, 206–7, 320, 339; files of, 156, 165–66; formation of, 128; galleries with rights to work of, 288; government support for, 121, 124–25, 127, 132–33, 137, 142, 143, 155; museum collections of, 158, 193, 197; Myers' documentation of works for, 86–119; number of artists involved with, 120, 128, 148; and overseas painting demonstrations, 237, 245, 256–57, 262, 272; painters' lack of loyalty to, 228, 326; painting sales through, 3, 13, 64, 65, 72–75, 117, 120, 124, 125, 131, 133–34, 142, 148, 152, 154–55, 177–79, 193, 199–201, 205; private dealers for work of, 221, 228; turnover among art advisers at, 151, 181; withdrawal of centralized marketing for, 211. *See also* Art advisers; Cash; Pintupi; Work

Paris exhibitions, 200, 206, 230, 264, 291

Parliament House (Canberra), 200, 202, 264, 291, 369 n.5

Pascoe, Timothy, 151, 152, 185, 188–93, 200, 220

Patrimoieties, 56

Payungu, Timmy. *See* Tjapangarti, Timmy Payungu

La Peinture des Aborigènes d'Australie exhibition, 206

Pekarik, Andrew, 238–45, 281

Penis: Old Man's, xvi, 25, 43, 110–11, 115–17

Penny, David, 367 n.5

Performances: activism as part of, 259–76; ceremonial, 56; of ethnicity, 255–76; as hybrid constructions, 249–50, 255, 257, 259, 264–76, 331, 345–46; painting, at exhibitions, 194, 196–98, 237, 245, 248, 249, 256–76, 343–46. *See also* Ceremonies; "Recontextualization"; Rituals

Perkins, Hetti, 339, 341, 342–43, 347, 348

Perspecta '81 exhibition, 78, 193, 197

Perth (Australia), 65, 198

Peters, Frances, 335–36, 371 n.2

Peterson, Nicolas, 149–50, 211–12, 367 n.9

Petyarre, Kathleen, 324–27

Phillips, Ruth B., 369 n.3

Photography, 25, 30, 31, 80, 116, 126, 157, 247, 265, 344

Picnic at Hanging Rock (film), 286

Pilintjinya (place), 92, 98, 102, 104

Fred R. Myers is Professor of Anthropology at New York
University. He is the author of *Pintupi Country, Pintupi Self:
Sentiment, Place, and Politics* (1991), and the editor of *Empire
of Things: Regimes of Value and Material Culture* (2001).

Library of Congress Cataloging-in-Publication Data
Myers, Fred R.
Painting culture : the making of an aboriginal high art /
Fred R. Myers.
Includes bibliographical references and index.
ISBN 0-8223-2932-8 (cloth: alk. paper)
ISBN 0-8223-2949-2 (pbk.: alk. paper)
1. Art, Pintupi—Australia—Western Desert (W.A.)
2. Pintupi (Australian people)—Material culture—Australia—
Western Desert (W.A.). 3. Painting, Australian aboriginal—
Australia-Western Desert (W.A.)—Marketing. 4. Acrylic
painting—Australia—Western Desert (W.A.)—Marketing.
5. Art as an investment. 6. Cultural property—Protection—
Australia—Western Desert (W.A.) I. Title.
DU125.P48 M94 2002 759.994′089′9915—dc21 2002009560